In memory of Mahmood T. Diba

♦

ROYAL
PERSIAN
PAINTINGS

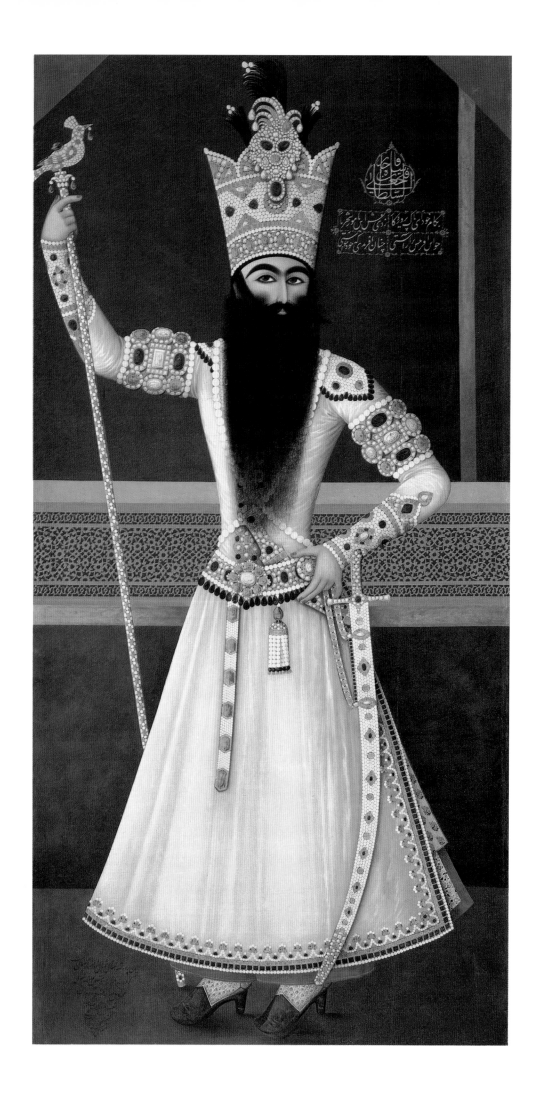

ROYAL
PERSIAN
PAINTINGS

The Qajar Epoch
1785–1925

Edited by Layla S. Diba,
with Maryam Ekhtiar

Essays by

B. W. Robinson ✦ Abbas Amanat
Layla S. Diba ✦ Maryam Ekhtiar
Adel T. Adamova ✦ Afsaneh Najmabadi
Peter Chelkowski

I.B. TAURIS PUBLISHERS
in association with
BROOKLYN MUSEUM OF ART

This volume accompanies the exhibition *Royal Persian Paintings: The Qajar Epoch 1785–1925*, organized by the Brooklyn Museum of Art.

Exhibition Itinerary:

Brooklyn Museum of Art, October 23, 1998–January 24, 1999

The University of California, Los Angeles, at the Armand Hammer Museum of Art and Cultural Center, February 24–May 9, 1999

Brunei Gallery of the School of Oriental and African Studies, University of London, July 5–September 26, 1999

Royal Persian Paintings: The Qajar Epoch 1785–1925 is made possible in part by the National Endowment for the Humanities, dedicated to expanding American understanding of history and culture, as well as by Massoumé and Fereidoun Soudavar in memory of their sons Alireza and Mohammad. Major support is provided by The Hagop Kevorkian Fund, National Endowment for the Arts, The Rockefeller Foundation, the Aryeh Family, Hashem Khosrovani, and Nasser D. Khalili. Additional support is provided by the Museum's Asian Art Council, Afsaneh Al-e Mohammad Dabashi, and Mr. and Mrs. Dara Zargar. An indemnity has been granted by the Federal Council on the Arts and the Humanities.

Planning and research for the exhibition were supported by the National Endowment for the Humanities, The Hagop Kevorkian Fund, and the Marshall and Marilyn R. Wolf Foundation. Funds for the catalogue were provided through a publications endowment created by the Iris and B. Gerald Cantor Foundation and The Andrew W. Mellon Foundation.

This publication was prepared by the Brooklyn Museum of Art.

EDITOR Joanna Ekman

For I.B.Tauris:

DESIGNER Karen Stafford

ORIGINATION, PRINTING AND BINDING Bookbuilders Ltd, Kowloon, Hong Kong

Brooklyn Museum of Art

200 Eastern Parkway

Brooklyn, New York 11238-6052

I. B. Tauris & Co Ltd, Victoria House, Bloomsbury Square, London WC1B 4DZ

In the United States and in Canada distributed by St Martin's Press, 175 Fifth Avenue, New York, NY 10010

FRONT COVER Detail, *Nasir al-Din Shah Seated in a European Chair*, signed by Bahram Kirmanshahi, 1857. MUSÉE DU LOUVRE, PARIS (NO. 75)

BACK COVER *Female Acrobat*, attributed to Ahmad, second or third decade of the 19th century. LENT BY THE BOARD OF TRUSTEES OF THE VICTORIA AND ALBERT MUSEUM, LONDON (NO. 60)

FRONTISPIECE *Portrait of Fath 'Ali Shah Standing*, signed by Mihr 'Ali, 1809–10. STATE HERMITAGE MUSEUM, SAINT PETERSBURG (NO. 39)

Library of Congress Cataloging-in-Publication Data

Royal Persian Paintings : the Qajar epoch, 1785–1925 / edited by Layla
S. Diba, with Maryam Ekhtiar : with essays by B. W. Robinson ... [et al.].
p. cm.
Catalog of an exhibition held at the Brooklyn Museum of Art. Oct. 23. 1998–Jan. 24, 1999
Includes bibliographical references and index.
ISBN 1-86064-255-1 (hard). — ISBN 1-86064-256-X (paper).
1. Painting, Iranian—Exhibitions. 2. Painting, Islamic—Iran—Exhibitions. 3. Iran—
Kings and rulers—Art patronage—Exhibitions. I. Diba, Layla S. II. Ekhtiar, Maryam.
III. Robinson, B. W. (Basil William) IV. Brooklyn Museum of Art.
ND984.R68 1998
759.955'074'74723——DC21 98–18387
 CIP

CONTENTS

—— CATALOGUE ——

Catalogue section introductions by Layla S. Diba.
Catalogue entries by Adel T. Adamova, Oleg F. Akimushkin,
Layla S. Diba, Maryam Ekhtiar, Natalia Gritsai, and Anatol A. Ivanov.

NOTE TO THE READER

Catalogue Entries

Contributors to the catalogue are as follows:

AAI	Anatol A. Ivanov
ATA	Adel T. Adamova
LSD	Layla S. Diba
ME	Maryam Ekhtiar
NG	Natalia Gritsai
OFA	Oleg F. Akimushkin

Dates

The system employed for calculating dates, except where exact months and days are specified, is that used in the Calendar Conversion Table in Jere Bacharach, *A Middle East Handbook* (Seattle, 1984). For exact dates (as in dated works of art), we include both A.H. and A.D. dates: e.g., A.H. 1247/A.D. 1831. When a specific month and year in the A.H. calendar is given, the equivalent month in the A.D. calendar is included. *Shamsi* dates have been converted by adding 621, if the date is between 1 Farvardin and 10 Day, or if the month is not known; and by adding 622, if the date is between 11 Day and 29 Isfand.

Transliteration

There is no standard system for transliteration from Persian into English. We have chosen to use a modified version of the *IJMES* (*International Journal of Middle East Studies*) system. For better readability, we have chosen to use diacriticals only partially. Persian and other foreign words, phrases, and inscriptions, as well as titles of books in Persian are fully transliterated. With the exception of proper names containing the *ayn* or the *hamzeh*, diacriticals are not used for proper names (e.g.'s, Fath 'Ali Shah, Sa'ib-i Tabrizi). Place names and the names of cities are not transliterated. Foreign words commonly used in the English language are written as they appear in *Webster's Third New International Dictionary*. For a full explanation of the transliteration system, see the following table:

CONSONANTS

Hamzeh	'	ص	ṣ
ب	b	ض	ż
پ	p	ط	ṭ
ت	t	ظ	ẓ
ث	s	ع	'
ج	j	غ	gh
چ	ch	ف	f
ح	ḥ	ق	q
خ	kh	ک	k
د	d	گ	g
ذ	z	ل	l
ر	r	م	m
ز	z	ن	n
ژ	zh	و	v
س	s	ه	h
ش	sh	ی	y

VOWELS AND DIPHTHONGS

Long		Short		Diphthongs		Other	
ا	ā	‿	a	ـو	aw	(Silent) ه	eh
و	ū	‿	u	ـی	ay		
ی	ī	‿	i				

FOREWORD

The Brooklyn Museum of Art is proud to present *Royal Persian Paintings: The Qajar Epoch 1785–1925*, the first major exhibition exclusively devoted to life-size and monumental painting of the Qajar period in Iran (1785–1925). Organized by the BMA over the course of five years, this landmark exhibition brings to view more than a hundred splendid works of art, many of which have never been exhibited before. By gathering together these remarkable objects of historical interest, *Royal Persian Paintings* explores the art and culture of a dynasty that represented both the last phase of a two-thousand-year-old civilization and the prelude to the modern era in the Middle East.

Royal Persian Paintings is the culmination of the Museum's long-standing commitment to the acquisition, presentation, and study of nineteenth-century Persian art, an area often unrepresented in public collections. The BMA's holdings of Qajar painting, decorative arts, and photography, comprising more than four hundred objects, undoubtedly constitute one of the most representative collections in the Western Hemisphere. Its breadth is largely owing to the efforts of Charles K. Wilkinson, Hagop Kevorkian Curator of Islamic Near Eastern Art at the Museum from 1969 to 1974, who donated the majority of his Qajar art collection, with its nucleus of seven oil paintings, in the 1960s and 1970s. The Museum expanded the collection in subsequent decades under the leadership of Amy G. Poster, Curator of Asian Art, and devoted a sizable portion of the permanent installation of Islamic art to the arts of the Qajar period. Special recognition is due to the executors of the estate of Irma B. Wilkinson – Evan Turner, former Director, Cleveland Museum of Art, and Marielle Semal – who facilitated the distribution of Mrs. Wilkinson's 1996 bequest of Persian paintings (see NO. 29).

A 1987 symposium on "The Art and Culture of Nineteenth-Century Iran," organized by Sheila R. Canby, former BMA Associate Curator, and supported by The Hagop Kevorkian Fund, focused on new research by leading scholars in the field and marked an important initiative in the field of Persian studies. The symposium was accompanied by a checklist of the Museum's Qajar art holdings compiled by Maryam Ekhtiar. A number of the papers from the symposium were subsequently published in a special issue of the journal *Muqarnas* in 1989. In the same year, Maryam Ekhtiar published "The Qajar Visual Aesthetic: Highlights from The Brooklyn Museum Collection," in *Orientations*.

Royal Persian Paintings: The Qajar Epoch 1785–1925 has been a complex undertaking, and the Museum is deeply grateful for the assistance of many organizations and individuals. Grants from the National Endowment for the Humanities and The Hagop Kevorkian Fund supported the initial research and travel. During the planning phase, data was gathered on Qajar works of art held by more than three hundred institutions. This valuable information, now permanently housed at the Museum, established the feasibility of the exhibition. "Historical and Cultural Issues of the Post-Safavid and Qajar Periods," a preexhibition colloquium in 1995, supported by the National Endowment for the Humanities and the Marshall and Marilyn R. Wolf Foundation, provided a lively forum to review the exhibition's scope and themes with leading scholars.

In 1996 a one-year curatorial and conservation study of the techniques of Qajar painting, part of an ongoing series endowed by The Andrew W. Mellon Foundation, provided valuable information on the Qajar paintings in the permanent collection and works in the exhibition. Initial findings of this study are presented in the Appendix of this volume.

The project continued to receive major implementation grants from the National Endowment for the Humanities, The Hagop Kevorkian Fund, the National Endowment for the Arts, and The Rockefeller Foundation. A gift from the late Fereidoun Soudavar and Massoumé Soudavar made in memory of their sons Alireza and Mohammad enabled the project to progress at a critical stage. Funds for the catalogue were provided through a publications endowment created by the Iris and B. Gerald Cantor Foundation and The Andrew W. Mellon Foundation. We are also grateful for donations by the Aryeh family, Hashem Khosrovani, Afsaneh Al-e Mohammad Dabashi, Mr. and Mrs. Dara Zargar, and the many other friends who made this publication possible. I also wish to express my thanks to the BMA's Asian Art Council for more than a decade of dedicated support. For the ongoing support and confidence of the Museum's Trustees, we extend special gratitude to Robert S. Rubin, Chairman, and every member of the Board. We also appreciate the idemnity granted by the Federal Council on the Arts and the Humanities. The exhibition's presentation in London has received major support from the Iran Heritage Foundation. Additional generous support there has been provided by Nasser David Khalili, Hashem Khosrovani, Jaleh Khosrovani Diba, Hosseinali Soudavar, and the Yadiran Foundation.

The exhibition has been a collaborative effort, and I wish to express my appreciation to the many Museum staff members involved. First and foremost, thanks go to Layla S. Diba, Hagop Kevorkian Curator of Islamic Art, who conceived and directed the project. Recognition is also due to Maryam Ekhtiar, Senior Research Associate, who significantly contributed to the research and organization.

We hope that this exhibition will not only provide a thought-provoking examination of a painting tradition of dazzling breadth, creativity, and power, but also illuminate a civilization that has been greatly enriched by its interaction throughout history with many diverse peoples and cultures.

Arnold L. Lehman
Director

PREFACE AND ACKNOWLEDGMENTS

Royal Persian Paintings: The Qajar Epoch 1785–1925 presents for the first time a comprehensive examination of the flowering of Persian painting from the late seventeenth to the early twentieth century. Originating during the later Safavid period (circa 1650–1722) and evolving further under the Afsharid and Zand dynasties (1736–79), later Persian painting, in both life-size and small-scale formats, reached its culmination during the "long century" of Qajar rule (1785–1925). This exhibition provides an opportunity to reappraise the achievements of Persian painting, known primarily through the "miniature painting" of the sixteenth and seventeenth centuries. This major tradition demonstrates a preference for figural painting, which rarely achieved such prominence in the rest of the Islamic world, and also sheds light on the changing perception of Persian identity and its relationship to both indigenous and Western culture.

Until S. H. Amiranashvili's 1940 monograph, *Iranian Wall Painting,* on the Georgian collections of Qajar court painting, Qajar painting was considered only intermittently in scholarly literature and exhibition catalogues. In the 1960s and 1970s, the rich holdings of English public collections in this area were widely published and presented in the publications and exhibitions organized by B. W. Robinson, a pioneer in the field. The year 1971 witnessed the publication of S. J. Falk's *Qajar Paintings,* devoted to the collection of Major Harold Amery and the Rt. Hon. Leopold Amery, prominent English diplomats and statesmen. This collection of sixty-three paintings was acquired for Iran by Her Majesty Farah Pahlavi and became the nucleus of the permanent collection of the Negarestan Museum of eighteenth- and nineteenth-century Persian art in Tehran. The Amery collection, focusing on painting of the Zand and early Qajar periods, complemented important Iranian state holdings of later nineteenth-century painting primarily housed in the Gulistan Palace Museum, Tehran, and still largely unpublished. In 1973 Qajar paintings from the Georgian State Art Museum, Tiflis, the State Hermitage Museum, Saint Petersburg, and State Museum of Oriental Art, Moscow, were exhibited in Moscow, but it was not until the 1996 publication of Adel T. Adamova's *Catalogue of Persian Painting in the Hermitage Museum* that the full breadth of the Hermitage collection of Qajar painting could be appreciated by a wider public.

Royal Persian Paintings: The Qajar Epoch 1785–1925 gathers together for the first time major works dispersed in international public and private collections, not only the better-known collections in England and Russia, but also from hitherto untapped repositories in France, Germany, and Switzerland, among others. Following a chronological and dynastic framework, the exhibition and catalogue explore significant themes of nineteenth-century Persian cultural history: art as a mirror of change, interaction with the West, portraiture and the construction of identity, issues of gender, and the societal context. The catalogue presents interpretive essays by leading scholars that provide the historical, artistic, and social contexts of the period, followed by a comprehensive catalogue raisonné of the works in the exhibition, with section introductions focusing on the art-historical developments of each phase. It is our hope that this exhibition and its accompanying richly documented publication, informed by a revisionist approach to Persian culture, will provide a firm basis for future scholarship and a long-overdue reassessment of this historic artistic tradition.

A project of this magnitude and historical scope could not have been accomplished without the support of many institutions and individuals. We are deeply grateful to them all, although we are unable to acknowledge each individual here.

I particularly wish to thank the directors, curators, and registrars of the following museums and institutions for their outstanding cooperation. In the United States: Malcolm Rogers and Julia Bailey, Museum of Fine Arts, Boston; James Cuno and Ivan Gaskell, Fogg Art Museum, Harvard University, Cambridge, Massachusetts; Rochelle Kessler, Arthur M. Sackler Museum, Harvard University, Cambridge, Massachusetts; Philippe de Montebello, Daniel Walker, Mimi Swietochowski, Stefano Carboni, Patricia Slacer-Booth, Maria Morris Hambourg, Laura Muir, and Trine L. Vanderwall, The Metropolitan Museum of Art, New York; James Weinberger, Don C. Skemer, and Azar Ashraf, Princeton University Library, Princeton, New Jersey; The Art and History Trust, courtesy of the Arthur M. Sackler Gallery, Smithsonian Institution, Washington, D.C.; Milo Beach, Massumeh Farhad, and Bruce Young, Freer Gallery of Art/Arthur M. Sackler Gallery, Smithsonian Institution, Washington, D.C.

We also thank the following private collectors: Mrs. Eskandar (Mimi) Aryeh and Mr. Richard Aryeh; K. Thomas Elghanayan; Leila Taghinia-Milani Heller; Mr. and Mrs. Dara Zargar; and Mohammad and Najmieh Batmanglij.

In Europe we are grateful to the following. In Austria: Gerbert Frodl and Sabine Grabner, Österreichische Galerie, Vienna; Johann Marte and Ernst Gamillscheg, Österreichische National-Bibliothek, Vienna. In France: Pierre Rosenberg, Marthe Bernus-Taylor, and Sophie Makariou-Salinas, Musée du Louvre, Paris; Jean-François Jarrige and Amina Okada, Musée National des Arts Asiatiques-Guimet, Paris. In Germany: Volkmar Enderlein and Almutt von Gladiss, Staatliche Museen zu Berlin, Preussischer Kulturbesitz, Museum für Islamische Kunst. In Russia: Evgeniy Kychanov, Efim Rezvan, and Oleg F. Akimushkin, The Saint Petersburg Branch of the Institute of Oriental Studies, Russian Academy of Sciences; Mikhail Piotrovsky, Vladimir Matveyev, Anatol A. Ivanov, Adel T. Adamova, and Natalia Gritsai, State Hermitage Museum, Saint Petersburg. In Switzerland: Georg Germann and Ernest J. Kläy, Bernisches Historisches Museum. In the United Kingdom: Nasser D. Khalili and Nahla B. Nasser, Nasser D. Khalili Collection of Islamic Art and Khalili Family Trust, London; Philippa Vaughan and Michael J. Pollock, The Royal Asiatic Society, London; Alan Borg, Deborah A. Swallow, Rosemary Crill, Susan Stronge, Anthony North, Christopher Wilk, Sorrel Hershberg, Barbara O'Connor, and Katie Cavanagh, Victoria and Albert Museum, London. We are also grateful to the following private collectors and their staffs: Hashem Khosrovani and Christina Platts, Chempetrol Fiduciary Services; His Highness Prince Sadruddin Aga Khan and Liliane Tivolet, Prince Sadruddin Aga Khan Collection; Mrs. Fereshteh Massoudi Hedayat; F. Farmanfarmaian; and Hydrocarbon Logistics. Finally, we thank the anonymous lenders.

Of the many colleagues, private collectors, and individuals at galleries and auction houses who assisted us, we are particularly indebted to: George Anavian, Richard Aryeh, Sussan Babaie, Peter Chelkowski, Massoud Faramarz-Ansary, Farrokh Ghaffari, Oleg Grabar, Mohammad Ali Karimzadeh, Farhad Kazemi, Ebba Koch, Maryam Massoudi, Massoud Nader, Jamshid Qajar, Abdallah Quchani, B. W. Robinson, Said Sabeti, Maryam Safinia, Muhammad Hasan Semsar, Priscilla Soucek, Jean Soustiel, Marshall and Marilyn R. Wolf, and Ehsan Yarshater. For their assistance in documenting the provenance of artworks in the exhibition, we thank: Marcus Fraser of Sotheby's and William Robinson of Christie's. I owe special thanks to Abolala and Ezzat Malek Soudavar for sharing their experience as well as their passion for Persian art and culture with me.

We are grateful to the many colleagues who supported this project in the Brooklyn Museum of Art: to Arnold L. Lehman, Director, for his creative force and dynamic presence; to Roy R. Eddey, Deputy Director, Linda S. Ferber, Chief Curator and Andrew W. Mellon Curator of American Art, and Kenneth Moser, Vice Director for Collections, who patiently shepherded the project from its initial conception through execution, to Cynthia Mayeda, Deputy Director for Institutional Advancement; and to former Director Robert T. Buck, for his early support. In the Asian Art Department, thanks are due to Amy G. Poster, Curator of Asian Art, who recognized the significance of Qajar painting and gave generously of her time, staff, and organizational talents; Maryam Ekhtiar, Senior Research Associate, who provided invaluable support and collaboration in every phase of the project, particularly in the research, editing, writing, translation, and transliteration of the catalogue; John R. Finlay, former Assistant Curator, who offered advice and support; and Savita Monie, Department Assistant, who furnished assistance and encouragement. Diana Fane, Chairman, Department of the Arts of Africa, the Pacific Islands, and the Americas, and Lisa Rotmil, Research Associate, Department of European Painting and Sculpture, provided valuable advice on issues of interpretation.

In addition, special thanks are owed to Peter Trippi, Vice Director for Development, and his staff, and Darcy Gilpin, former Vice Director, Department of Development, and Dorothy Ryan, former Manager of Government Programs, who played a critical role in obtaining federal support for the project; to James Leggio, Head of Publications and Editorial Services, and to the late James Spero and to Elaine Koss, former heads of the department, whose expertise was critical to the successful publication of the catalogue, and in particular, to Joanna Ekman, for her skill and professionalism in the managing and editing of the catalogue; and to the Conservation Staff, especially Richard Kowall, Carolyn Tomkiewicz, and Nadia S. Ghannam (who collaborated on the Mellon Curatorial-Conservation study of Qajar painting), Antoinette Owen, and Ellen Pearlstein; to Elizabeth Reynolds, Chief Registrar, and her staff; to Cheryl Sobas, former Exhibitions Manager, and her staff, past and present, particularly Michelle Tollini, Sarah Fitzsimmons, and Heidi Vickery-Reich; and to Cathryn Anders, Collections Manager, and her staff. We are grateful to Charles Froom, Chief Designer, Nicolas Guillin, Harold Wortsman, and the staff of the Design Department for the design of the exhibition; to Deborah Schwartz, Vice Director, Education, and Catherine Fukushima, and Frances Yuan of her staff for their collaboration on the public and school programs and the symposium; to Dean Brown, Faith Goodin, and Gregg Stanger in the Department of Photography, particularly for photography for the catalogue; to Patricia Falk, former Officer for Government and Community Relations; to Deirdre Lawrence, Librarian, and the staff of the Art Reference Library; and to Sally Williams, Public Information Officer, and her staff.

I extend my gratitude as well to the participants and advisors of the Museum's 1995 colloquium "Historical and Cultural Issues of the Post-Safavid and Qajar Periods": Adel T. Adamova, Abbas Amanat, Sussan Babaie, Peter Chelkowski, Willem Floor, Afsaneh Najmabadi, B. W. Robinson, Kamran Safamanesh, Ehsan Yarshater, and Maryam Ekhtiar; to the catalogue authors and Mehrdad Izady, cartographer; and to Iradj Bagherzade, Director of I. B. Tauris & Co., and his staff. Throughout the course of the project, interns and volunteers provided invaluable assistance: I wish to thank Yvette Schops, Hadieh Shafie, Molly Trainer, Aya Hasegawa, and Dina Freige.

As curator of the exhibition, I wish to reiterate my profound gratitude, offered elsewhere in the catalogue, to all the individuals and institutions that have so generously provided financial backing.

On a personal note, my deepest gratitude goes to my mother, Leona, for her unfailing encouragement; to my husband, Mahmood, for his assistance with the translation and reading of Persian texts, and his sound advice and inspiration; and to our son, Ahmad-Reza.

Layla S. Diba

LENDERS TO THE EXHIBITION

Prince Sadruddin Aga Khan

The Art and History Trust, courtesy the Arthur M. Sackler Gallery, Smithsonian Institution, Washington, D.C.

Mrs. Eskandar Aryeh

Mohammad and Najmieh Batmanglij

Bernisches Historisches Museum, Abt. Völkerkunde, Bern

Brooklyn Museum of Art

K. Thomas Elghanayan

F. Farmanfarmaian

Harvard University Art Museums, Cambridge, Massachusetts

Mrs. Fereshteh Massoudi Hedayat

Leila Taghinia-Milani Heller

Hydrocarbon Logistics

The Nasser D. Khalili Collection of Islamic Art

Khalili Family Trust

Hashem Khosrovani Qajar Collection

The Metropolitan Museum of Art, New York

Musée du Louvre, Paris

Musée National des Arts Asiatiques-Guimet, Paris

Museum of Fine Arts, Boston

Princeton University Library, Princeton, New Jersey

Private collections

The Royal Asiatic Society, London

Arthur M. Sackler Gallery, Smithsonian Institution, Washington, D.C.

The Saint Petersburg Branch of the Institute of Oriental Studies, Russian Academy of Sciences

Staatliche Museen zu Berlin, Preussischer Kulturbesitz, Museum für Islamische Kunst, Berlin

State Hermitage Museum, Saint Petersburg

Victoria and Albert Museum, London

Mr. and Mrs. Dara Zargar

CHRONOLOGY

1722 Fall of Isfahan

AFSHARID

1736 Accession of Nadir Shah
1739 Sack of Delhi
1747 Assassination of Nadir Shah

ZAND

1750 Accession of Karim Khan
1779 Death of Karim Khan
1789 Accession of Lutf 'Ali Khan

QAJAR

Aqa Muhammad Khan

1785–89 Coronation of Aqa Muhammad Khan, founder of the dynasty
1797 Assassination of Aqa Muhammad Khan

Fath 'Ali Shah

1798 Accession of Fath 'Ali Shah
1799 Appointment of 'Abbas Mirza as Crown Prince and governor of Azarbaijan
1805 First Perso-Russian war
1807 Treaty of Finkenstein with France Treaty of Tilsit
1809 Preliminary Treaty with Great Britain
1812 Definitive Treaty with Great Britain Defeat of Persia by Russia at Aslanduz
1813 Treaty of Gulistan with Russia
1826 Second Perso-Russian war
1828 Treaty of Turkmanchai with Russia
1833 Death of 'Abbas Mirza
1834 Death of Fath 'Ali Shah

Muhammad Shah

1834 Accession of Muhammad Shah
1838 Siege of Herat
1835 Publication of the first lithographed newspaper in Iran by Mirza Salih Shirazi

1844 Rise of Sayyid Mirza 'Ali Muhammad, the Bab
circa 1844 Introduction of photography in Iran
1848 Death of Muhammad Shah

Nasir al-Din Shah

1848 Accession of Nasir al-Din Shah
1850 Execution of the Bab
1851 Inauguration of Dar al-Funun
1850–51 Release of the first issue of state newspaper *Rūznāmeh-i Vaqāyi 'Ittifāqīeh*
1852 Execution of Amir Kabir
1856–57 Anglo-Persian war
1857 Treaty of Paris with Great Britain
1862 Introduction of telegraph into Persia
1872 The Reuter Concession
1889 Britain's establishment of the Imperial Bank of Persia
1891–92 Tobacco concession riots
1896 Assassination of Nasir al-Din Shah

Muzaffar al-Din Shah

1896 Accession of Muzaffar al-Din Shah
1906 Beginning of the Constitutional Revolution
1907 Death of Muzaffar al-Din Shah

Muhammad 'Ali Shah

1907 Accession of Muhammad 'Ali Shah
1908 Establishment of Anglo-Persian Oil Company
1909 Deposition of Muhammad 'Ali Shah

Ahmad Shah

1909 Accession of Ahmad Shah
1911 End of Constitutional Period
1914 World War I

PAHLAVI

1925 Accession of Riza Shah Pahlavi

QAJAR PAINTINGS

A Personal Reminiscence

B. W. ROBINSON

THE EMERGENCE of Qajar painting from the neglect of thirty years ago to its present position as a subject of serious study and enthusiastic admiration, a star performer in the auction rooms, and now the theme of an international exhibition, is indeed a remarkable phenomenon. This evolution is perhaps a part, or possibly the result, of an almost subconscious movement in the Western art world whereby paintings by such artists as John Martin, Frederick Leighton, and the Pre-Raphaelites, and Victoriana in general, underwent a similar enhancement. This movement probably had its origin in the celebration of the centenary of the Crystal Palace Exhibition of 1851, and especially in the exhibition mounted at that time at the Victoria and Albert Museum, which presented a rich sampling of the marvelous productions that figured in the original epoch-making event. The public flocked to it, and seems to have found many of the objects on display very much to its taste. It is natural that this general approval should have been extended to Qajar art (some of which, in its later phase, might be called Persian Victoriana) at much the same time.

The historical background and the evolution of Qajar painting, and analyses of various themes and subjects, are treated elsewhere in this catalogue. I would only add that Qajar painting can also be appreciated as light-hearted and quite innocent of spiritual aspirations or Freudian symbolism. Its purpose was to give pleasure. Let us take warning from Alexander Pope's Sporus, "who breaks a butterfly upon a wheel."

In order to set the scene, I may perhaps be forgiven for falling back, momentarily, on reminiscence. Two incidents combined to arouse my own interest in Qajar painting some forty years ago. First, in the course of unpacking and sorting all the Victoria and Albert Museum objects that had spent the war years in the cool and secure profundity of the Bradford-on-Avon stone quarries, I came across a rather large and heavy circular parcel wrapped in faded brown paper and tied with dusty string. I unwrapped it and, to my great astonishment and delight, found that I had uncovered the enameled gold dish presented by Fath 'Ali Shah to the East India Company — over six pounds of solid gold, with beautiful painted enamel embellishments signed by Muhammad Ja'far and dated to 1818. When "John Company" was abolished after the Indian Mutiny in 1857, the dish had been transferred, along with the rest of the Company treasures, to the Indian Section of what was then the South Kensington Museum, and not being Indian, it was left to hibernate there for nearly a century in its original wrappings.

Subsequent research, preparatory to exhibiting this magnificent object, included a session with Sh. Y. Amiranashvili's great book on the Persian oil paintings in the Tiflis museum (the only book on the subject when it was published in 1940). This prompted me to retrieve from store the dozen or so Qajar oil paintings that the Victoria and Albert had purchased in 1876 for about a guinea apiece. One or two of them, for which the gallery space was not available, were hung in my office, where they

were seen one day by a casual visitor, a small dealer in general antiques. He remarked that he had seen others like them in a house not far from the museum, so I obtained the address from him and wrote, asking if I might call and see them. The owner was agreeable. There was nothing of particular interest among the pictures I was shown until, just as I was taking my leave, the owner remembered that there was one more. He took me down to the kitchen basement, and there, roughly tacked to the deal paneling in the gloom under the stairs, was a large canvas, seven or eight feet in height, almost entirely blackened and with ragged edges, on which I could just make out dim outlines of a large figure. Taking a chance, I asked if it was for sale (the dealer had told me that the owner was not averse to a little trading); he named a very reasonable price, and so the canvas passed into the possession of an anonymous new owner who soon had it cleaned, restretched, and framed, revealing a resplendent state portrait of Fath 'Ali Shah and, in the bottom left-hand corner, damaged but unmistakable, the signature of the great Mihr 'Ali. From then on I never looked back.

Soon after, I contributed an article on the court painters of Fath 'Ali Shah to the *Eretz Israel* memorial volume to my old friend Professor L. A. Mayer published in 1964. It was from about that time that the taste, or the craze, for Qajar art became widespread, though I make no claim to have set it in motion. Persian collectors were especially bitten by it, with the result that the prices of Qajar paintings in the auction rooms soared. For example, a large group of Fath 'Ali Shah's sons that had fetched just over £350 in about 1960 reached the startling price of £200,000 when it reappeared in 1975.

The bane of Qajar painting and the cause of much of the derision and contempt in which it was formerly held is that too much of it has survived. No doubt many bad paintings were produced in Timurid and Safavid times, but time has eliminated nearly all of them and left us, for the most part, only works of quality. At its best (and, like any school of painting, it should be judged at its best), Qajar painting is a worthy successor to the painting of the Timurids and the Safavids. Despite its Western veneer, it continues to celebrate the traditional themes of classical Persian painting – royal magnificence, youthful beauty of both sexes, love of animal forms, and the exploits of heroes – and it carries on and develops the later Safavid tradition of genre scenes and incidents of everyday life. In portraiture and flower painting, the Qajar artists surpassed all their predecessors, and whereas Timurid and Safavid painting is confined to manuscripts and albums, Qajar painting presents itself to us in a variety of forms: painted lacquer, glass (églomisé), painted enamel, and the humble lithograph, in addition to the traditional manuscript illustrations and album pictures.

Royal Persian Paintings: The Qajar Epoch 1785–1925, then, is in the nature of an accolade. It is an unmistakable declaration that earlier writers on Persian painting, who coyly bowed themselves out with the fall of the Safavids, were mistaken in doing so, and that the Qajars have "arrived."

QAJAR IRAN

A Historical Overview

ABBAS AMANAT

HE QAJAR ERA (1785–1925), named after the dynasty that ruled over the Guarded Domains of Persia throughout the period, witnessed some of the most decisive developments in Iran's modern history. From a Western perspective, its beginning roughly coincided with the French Revolution, the drafting of the American Constitution, and the rise of industrial Europe; and its end with the Great War and the dramatic collapse of imperial systems that came in the war's aftermath. From the perspective of Iran's history, the rise of the Qajar dynasty brought to an end a long period of political instability that characterized eighteenth-century Iran. Its demise came after a period of foreign occupation and political turmoil that eventually brought to power Colonel Riza Khan in 1921 and, soon after, the new Pahlavi dynasty (1925–79). In between, Qajar Iran encountered Europe at the height of its expansion and was influenced by its diplomacy, intimidated by its armies, and fascinated, though not fully transformed, by its commercial, cultural, and ideological lure. Resisting the onslaughts of the neighboring Russian and British empires, Iran escaped Europe's colonial domination, but it was not spared from territorial losses, diminishing prestige, intervention in its domestic affairs, and the threat of disintegration.

Beginning as a tribal venture for territorial conquest, the Qajar dynasty soon evolved into the pattern of Persian traditional monarchies with an elaborate court, a sprawling nobility conscious of its privileges, and a growing admin-

istration whose chief officers were frequently victims of their royal masters' desire to dominate the government. The rise of the Qajar state also coincided with the emergence of an almost independent Shi'ite clerical class, the *'ulamā*, who presided over the judiciary and the educational institutions, preached from the pulpits of the mosques, and controlled much of the religious endowments, and whose social status and religious authority were in ascendancy. The Qajars learned to coexist with the *'ulamā* and, despite domestic and foreign challenges, managed to maintain an uneven control over a society beset by economic setbacks, social deprivation, and religious conservatism.

The transitional nature of the Qajar era, as a period poised between the security of the old values and the lure of the new, is evident in its ambivalence toward modernity. Like the neighboring Ottoman Empire, Qajar Iran tried to adjust its political and economic institutions to Western modes of diplomacy, military, and commerce. Later, Iran's material culture, too, began to be influenced by Western urbanization, dress code, health, education, and communication. The legacies of the past persisted, nonetheless. The Qajars' political culture, rooted in centuries of Persian statesmanship, dictated the conduct and demeanor of the ruler, the etiquette of his court and the size of his harem, the organization of the government, and the shah's relationship with the elite and with his subjects. Religious mores and rituals of Shi'ite Islam that governed the life of the individual and regulated his or her relationship with fellow believers also per-

sisted and were even reinforced. Lifestyle, family loyalties, sexual habits, social manners, modes of leisure, artistic and literary taste, and historical perspective were shaped by distinct indigenous patterns that were rooted in the ancient past and had survived centuries of nomadic invasions, home-born tyrannies, and natural and man-made calamities. With Europe on the horizon, confidence in the religious and political order and in the institutions of the past began to erode, yet Qajar Iran did not remain complacent nor did it lose entirely its cultural confidence. The challenge of the world beyond Iran's geographic and cultural frontiers stimulated new directions in art and literature as well as religious thinking, political thought, and even the economy. From the vantage point of a hundred years later, the Qajar era appears distant but distinct, not only because it witnessed resistance (often desperate) to Western domination as well as haphazard efforts to adapt to modernity, but also because much that happened in this period gave expression to some of Iran's contemporary religious, social, and cultural dilemmas.

FROM THE FALL OF THE SAFAVIDS TO THE RISE OF THE QAJAR DYNASTY

The earliest references to the Qajars, a Turkish-speaking people originally from Central Asia, date back to the fourteenth century, when they are mentioned among the Turkoman tribes that immigrated to eastern Anatolia. Thereafter, they can be traced to the interior of the Caucasus around Erivan (Yervan, the capital of the present-day Republic of Armenia), which soon became their territory. As early as the fifteenth century, the Qajar tribe was counted as a minor partner of the Qizilbash, a confederacy of Turkoman tribes that paid allegiance to the Safavid house and in due course made up the military force that brought to power the Safavid dynasty of Iran (1501–1722). In addition to their settlements in the Caucasus, some of the Qajars were brought to the northeastern frontier during the reign of Shah 'Abbas I (r. 1588–1629) and were settled around Merv in Khurasan and Astarabad in Mazandaran to repulse the ceaseless Uzbek incursions. In the eighteenth century, the Qajars of Astarabad, consisting of two subtribal branches and numerous clans, rose to prominence and came to play a visible role in the last days of the Safavid dynasty.[1]

The invasion of the Ghalza'i Afghan tribes and the occupation in 1722 of the Safavid capital, the legendary city of Isfahan, and the eventual collapse of the Safavid empire in the following decade plunged Iran into a period of political chaos, the first of three interregnums in the eighteenth century. With the exception of an important Zand interval, the history of eighteenth-century Iran was marred by tribal violence and fragmentation of the Safavid empire into precarious and quarreling entities, as well as by sporadic Ottoman and Russian invasions and occupation of the western and northern provinces. Further incursion by frontier nomads – the Turkomans, the Afghans, and the Baluch in the east, and Kurds and Arabs in the west – contributed to the decline of the cities, their surrounding countryside, and most of their domestic and international trade. An array of tribal contenders, among them the Qajar chiefs, struggled to fill the widening political vacuum. Fath 'Ali Khan Qajar of the Quvanlu clan, the ancestor of the future Qajar royal house, briefly served as the commander in chief of the last of the Safavid shahs, Tahmasp II (r. 1722–32), before falling victim to a more valiant and ambitious contender, Nadir Quli Khan, later Nadir Shah (r. 1736–47), the founder of the Afsharid dynasty.[2]

A military genius of fierce character, Nadir Quli Khan achieved a meteoric rise to power as Nadir Shah, and his staggering success in building a vast but ephemeral empire stretching from northern India and Central Asia to the Caucasus, Iraq, and the Persian Gulf was the first of various tribal attempts to reconstitute an empire on the scale of the Safavids. Despite early successes – which included an Indian campaign and the capture of Delhi, the Mughal capital, in 1739 – Nadir's enterprise ultimately failed under the weight of his ravaging campaigns, which eroded the country's infrastructure; the lack of cohesion and loyalty among his tribal forces; and his cruel treatment of the Safavid elite and the population at large. His assassination and the ensuing period of dynastic unrest further demonstrated the inability of Nadir's successors to lay an enduring foundation for the Afsharid state. The memories of his conquests and war spoils (including the Peacock Throne and the Mughal royal jewels), his unflinching determination, and his military talent persisted through the early days of the Qajar period and were later glorified during the Pahlavi era.

The breakup of Nadir's empire was followed, a few years later, by the rise to power of another tribal dynasty in southern Iran under Karim Khan (r. 1750–79), the

founder of the Zand dynasty. Karim Khan's fragile mastery over the Lur and affiliated tribes of the south resulted in more than a quarter of a century of political tranquillity, economic recovery (especially in the Fars and adjacent provinces), and artistic creativity. With Shiraz as its capital, Karim Khan's rule, in contrast to Nadir's reign, laid claim only to regency on behalf of a defunct Safavid prince. The bureaucratic elite that presided over the Zand administration was mostly composed of the remnant of the Safavid notables, whose urbane cultural and political perspective was distinct from the rough-and-ready conduct of their tribal masters. In search of security, these officials formed bonds with merchants, clergy, and landlords, and preserved their status and influence. The patronage of art and literature by the same class helped the Safavid artistic legacy to continue to the Zand and later the Qajar era. Karim Khan's own candor and good nature, devoid of the artificiality of court opulence or of the sternness of the Shi'ite clerical tradition, was also receptive to refinements of high culture and good taste. The Zand era, short though it was, is important not only for preserving past traditions, but for its florescence in music, painting, and poetry – all of which influenced Qajar art and literature as well as fostered the reappearance of sufi mystical orders.

The death of Karim Khan soon plunged Iran into another interval of political unrest. For nearly two decades, tribes roaming the countryside frequently threatened cities, entered into momentary alliances with rivals, and fell prey to more powerful warlords. From these tribal chiefs emerged Aqa Muhammad Khan Qajar (r. 1785–97), the founder of the Qajar dynasty, whose quest for power began almost immediately after Karim Khan's death. Aqa Muhammad Khan was the third of the Qajar chiefs to have made a bid for power in the span of half a century (see FIG. 1). For three generations since the time of Fath 'Ali Khan, the Quvanlu Qajars had tried and failed to gain any substantial territory beyond their tribal base in eastern Mazandaran and northern Khurasan. Their internecine conflicts had often been exploited successfully by their enemies and they lacked military resources comparable to Nadir's army or even Karim Khan's.[3]

By the early 1780s Aqa Muhammad Khan was master of the northern provinces. Overcoming rifts among the Qajar clans and among his many brothers, he successfully mobilized the frontier Turkomans and other affiliated tribes of the north into an effective army. In 1786 he made the strategic town of Tehran his capital,

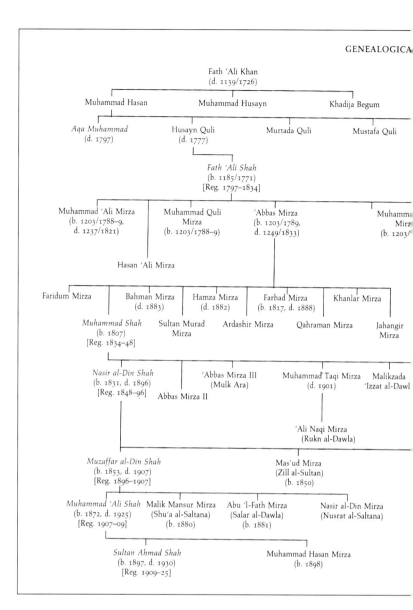

FIGS. 1a,b. *Genealogical tree of the Qajar dynasty.*
From Abbas Amanat, *Pivot of the Universe* (Berkeley and Los Angeles: University of California Press, 1997).

before pushing south to capture Isfahan and Shiraz in a series of campaigns against the Zands. Prevailing over most of his rivals (with the exception of the remainder of the Afsharids in Khurasan), he brought to a halt the long and destructive civil war, put an end to the quarreling Zands, and unified Iran under a stable rule by the mid-1790s. Though his brutal execution of the last of the Zands, Lutf 'Ali Khan, and acts such as his barbaric treatment of the people of Kirman and Tiflis (Tbilisi) forever cast a shadow on the founder of the new dynasty, he nevertheless should be recognized for his single-minded efforts to guarantee Iran's endurance as a unified and sovereign state. A capable but ferocious commander, Aqa

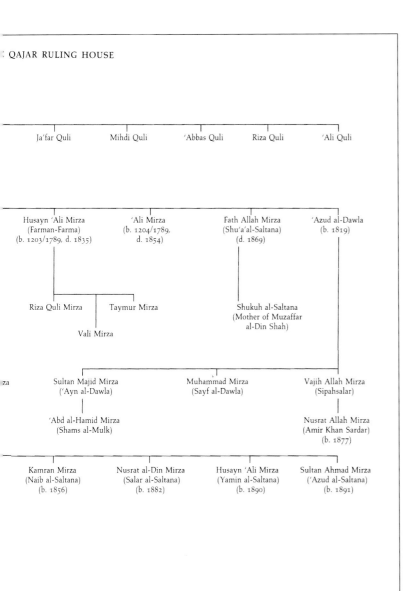

QAJAR RULING HOUSE

Ja'far Quli Mihdi Quli 'Abbas Quli Riza Quli 'Ali Quli

Husayn 'Ali Mirza (Farman-Farma) (b. 1203/1789, d. 1835) 'Ali Mirza (b. 1204/1789, d. 1854) Fath Allah Mirza (Shu'a'al-Saltana) (d. 1869) 'Azud al-Dawla (b. 1819)

Riza Quli Mirza Taymur Mirza Shukuh al-Saltana (Mother of Muzaffar al-Din Shah)

Vali Mirza

Sultan Majid Mirza ('Ayn al-Dawla) Muhammad Mirza (Sayf al-Dawla) Vajih Allah Mirza (Sipahsalar)

'Abd al-Hamid Mirza (Shams al-Mulk) Nusrat Allah Mirza (Amir Khan Sardar) (b. 1877)

Kamran Mirza (Naib al-Saltana) (b. 1856) Nusrat al-Din Mirza (Salar al-Saltana) (b. 1882) Husayn 'Ali Mirza (Yamin al-Saltana) (b. 1890) Sultan Ahmad Mirza ('Azud al-Saltana) (b. 1891)

Muhammad Khan sought to match Nadir's military successes and build an empire on the scale and model of that of the Safavids. Known for his vindictiveness, the Qajar warlord numbered among his victims many members of his tribe and his immediate family. One may trace the origins of Aqa Muhammad Khan's rage, and particularly his grudge against his dynastic enemies, to his family background and childhood experiences. His grandfather, father, and brother all met violent ends, and he himself was captured and castrated in his childhood by an Afsharid prince who hoped to disqualify him from ever ascending the throne. Later in his life he was captured by Karim Khan and was brought to Shiraz as a hostage.

Aqa Muhammad Khan's years of captivity in the Zand court were not in vain. He was canny enough to learn from the experience of his predecessors, particularly Karim Khan, and from his own ancestors' errors. He placed great emphasis on tribal loyalty, but once in power, he was also obliged to recognize the value of the "men of the pen," the class of officials that he recruited mostly from the Zand administration. He was quick to appreciate the value of the urban notables in facilitating the cities' economic recuperation, as well. Though still a warlord more accustomed to the harsh life of the military camp than to the refinements of palace life, he appreciated the symbolism of royal power. This awareness was to give his dynasty an identity distinct from the Safavids, something that neither of his predecessors had been able to achieve. The royal crown that he improvised

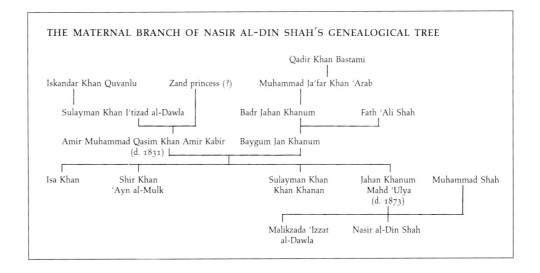

THE MATERNAL BRANCH OF NASIR AL-DIN SHAH'S GENEALOGICAL TREE

Qadir Khan Bastami

Iskandar Khan Quvanlu Zand princess (?) Muhammad Ja'far Khan 'Arab

Sulayman Khan I'tizad al-Dawla Badr Jahan Khanum Fath 'Ali Shah

Amir Muhammad Qasim Khan Amir Kabir (d. 1831) Baygum Jan Khanum

Isa Khan Shir Khan 'Ayn al-Mulk Sulayman Khan Khan Khanan Jahan Khanum Mahd 'Ulya (d. 1873) Muhammad Shah

Malikzada 'Izzat al-Dawla Nasir al-Din Shah

and named after the legendary Kayanid kings of the *Shāhnāmeh* and the reception hall in the Gulistan palace in Tehran that he had erected with marble columns from a Zand palace in Shiraz were testimonies to his royal ambition. His covetous love for jewelry, almost instinctive to tribal warriors, prompted him to extract with great cruelty the remains of Nadir's Indian spoils from the Zand and Afsharid descendants. A devoted Shi'ite in contrast to Nadir, he recognized the influence of the Shi'ite 'ulamā and patronized them, often through his high-ranking officials, in exchange for their allegiance to his throne. By the time that he was assassinated in 1797 in his military camp in the Caucasus by his domestic servants, Aqa Muhammad Khan had laid the foundation of a dynasty that, though still tribal in its military structure, loyalty, and desire for conquest, was stable enough to withstand the chal-

lenges of internal dissension and pressure in the periphery. Having seen the disastrous Zand feuds over succession, he eliminated most potential challengers, both within and outside the Qajar family, to his nephew and successor, Fath 'Ali Shah.

BECOMING THE KING OF KINGS

With the accession of Fath 'Ali Shah (r. 1798–1834), the Qajar dynasty adopted what may be called a monarchical posture (see FIG. 2). Conscious of his status as the

FIG. 2. *Iran and the neighboring regions on the accession of Fath 'Ali Shah in 1798.*
Map by Mehrdad R. Izady.

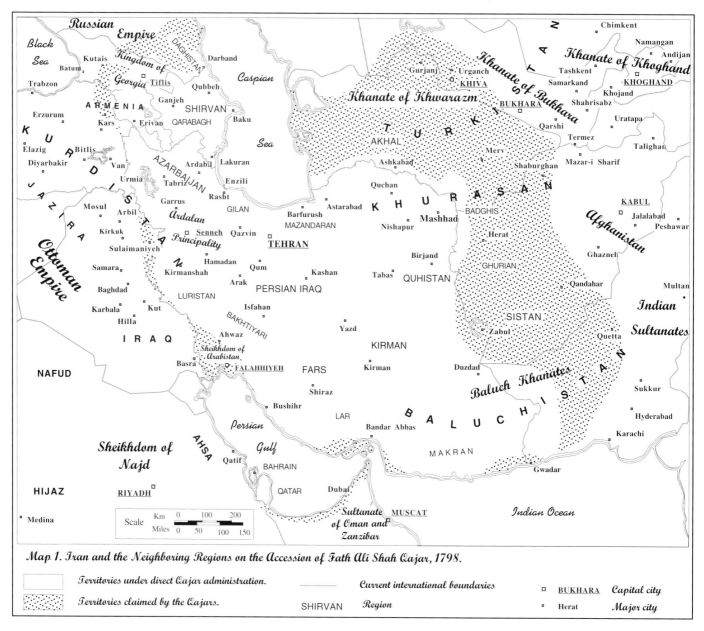

Map 1. Iran and the Neighboring Regions on the Accession of Fath Ali Shah Qajar, 1798.

Territories under direct Qajar administration.

Territories claimed by the Qajars.

——— Current international boundaries

SHIRVAN Region

□ BUKHARA Capital city

▪ Herat Major city

King of Kings (the title of the rulers of ancient Persia), Fath 'Ali Shah was anxious to display the pomp and glory of kingship, in contrast to the rugged simplicity of Aqa Muhammad Khan and his tribal lordship, for the benefit of both his own subjects and his powerful neighbors. Domestically, he still had to overcome the claim to the throne of his own brother and reclaim Khurasan from Nadir's descendants, yet his reign was a period of relative calm and recuperation that continued for nearly four decades despite numerous interruptions. The new shah and his officials were keen to promote a royal image that was the opposite of his predecessor Aqa Muhammad Khan's and conducive to stability, majesty, and elegance. Though no warrior at heart, he upheld his ancestral pride and tribal loyalty and at times even acted ferociously and with a degree of idealized nostalgia for his family's warring past. He appreciated the refinements of the court life more than the hardship of the battlefield. He enjoyed hunting, as did all Qajar kings and princes, and the splendor of the military reviews and preferred the company of poets and artists who were gathered in an informal royal society known as Anjuman-i Khaqan. Most major campaigns of his reign were fought by his senior sons and other Qajar chiefs. He was accustomed to the comfort of the palaces that he built and the seclusion of the huge harem that he had assembled. Known for his avarice, he was fond of displaying his wealth (most of which had been collected by Nadir Shah and Aqa Muhammad Khan) in his extravagant garments and ornaments, in the bejeweled Sun Throne (which later came to be known as the Peacock Throne, after the legendary original, which was destroyed in 1747), and in gifts to his favorite wives. His age brought back in vogue opulent decoration, terraced royal gardens, vast harems, meticulous appearance, and extravagant costume with massive jewels and accoutrements. His extensive court with its highly elaborate etiquette was the subject of many European accounts. Fath 'Ali Shah's more than a hundred sons and daughters, and his harem of a thousand women were on a remarkable scale even by traditional standards. His court was perhaps anachronistic and excessive, but in his own mind it was necessary in order to consolidate the Qajar rule as a legitimate and independent dynasty. Compensating for his uncle's childlessness, he procreated a vast network of offspring in union with women from other branches of the Qajar tribe, the remaining vanquished Zand and Afshar houses and other tribes, and families of officials and urban notables. When he died, he left behind more than a thousand descendants,

who constituted a new ruling elite.[4]

The shah's senior sons, assigned to rule almost autonomously over vast provinces of the empire, also followed Fath 'Ali Shah's example. Each had his own court, army, and offspring on the model of his father. The Guarded Domains of Persia in effect was a conglomerate of kingdoms that, though subordinate to Tehran, were free to conduct much of their own domestic and even foreign affairs. While the crown prince 'Abbas Mirza (1789–1833) was the viceroy of Azarbaijan and almost a partner to his father's rule, his half brothers, Muhammad 'Ali Mirza Dawlatshah, governor of Kirmanshah, and Husayn 'Ali Mirza Farmanfarma, governor of the Fars province, claimed tenure over western and southern Iran. Other princes and Qajar dignitaries also had long governorships in other provinces. Such a decentralized system was bound to intensify the innate rivalries within the royal house among the many eligible sons of the shah who had their eyes on the throne. Ever fearful of his own sons' military prowess, the shah himself on occasion perpetrated competition among the royal princes in the hope of preserving a delicate balance. Beneath the calm and composed façade of courtly grandeur existed much internecine competition, if not outright animosity.[5]

Iran's encounter with European powers added a new dimension to the Qajar internal rancor. While the Gulistan treaty of 1813 with Russia left the door open for future contest over succession, the Turkmanchai treaty of 1828, which concluded the second round of the Perso-Russian wars, ironically guaranteed the right of the vanquished prince 'Abbas Mirza to the Qajar throne. When the crown prince died prematurely in 1833, however, the Turkmanchai guarantee, also confirmed by Britain, did not prevent a war of succession, which broke out a year later, upon Fath 'Ali Shah's death. At least two of the senior sons of the deceased ruler refused to recognize Muhammad Mirza, 'Abbas Mirza's elder son, as the new shah. Only victory in a civil war in 1834 and a combination of domestic and foreign support for the new shah secured his throne and removed the princes from their provincial seats. The system of principalities under Fath 'Ali Shah was thus replaced, with few interruptions and exceptions, by the supremacy of 'Abbas Mirza's family, which continued for the remainder of the Qajar period.[6]

Though European powers had been known to Iranians since at least the seventeenth century, often as a potential ally against the Ottoman threat, it was in the early years of Fath 'Ali Shah's reign that their strate-

gic and commercial interests began to be noticed with a mix of complacency, fascination, and fear. At a time when Iran was in a decidedly disadvantageous position, politically and economically, the advances of the Russian empire along Iran's northern frontiers came as a rude shock to the Qajars, presenting a menace even more serious than that of Iran's traditional rival, the Ottoman Empire. By 1800 Russia had already annexed the Caucasian vassalage of Georgia and was about to advance southward to annex Iran's remaining Caucasian provinces. In the southeast, and later along the Persian Gulf, the rise of British India and its steady annexation of local principalities throughout the subcontinent and its subordination of what was left of the lethargic Mughal empire was viewed with anxiety by Qajar Iran. Nevertheless, for the Qajars, desperately trying to counterbalance Russia's territorial threat, the British in India were a potential ally. The British also considered Iran as a natural partner and dispatched a number of early diplomatic missions to the Qajar court. In 1800 Captain John Malcolm of the East India Company arrived in the Qajar capital at the head of a large mission, bearing substantial gifts for the shah and others, and seeking to establish friendly relations with Iran and to negotiate a defense treaty against the Afghan threat. He was welcomed by Fath 'Ali Shah and his minister Haji Ibrahim Khan I'timad al-Dawleh, not merely as an exotic curiosity to accentuate the splendor of the Qajar court, but as the representative of a powerful ally.

The British were not the only European power offering assistance to Iran. Briefly during the Napoleonic era, a French diplomatic overture and military mission were welcomed by Iran; but like the Ottomans, the Iranians had their hopes dashed when Napoleon set aside his dream of conquering India through alliance with Iran and signed a treaty of alliance with Russia in 1807. Seizing the window of opportunity, the British sent three missions to the Tehran court between 1809 and 1811. In addition to John Malcolm, who came for the second time on behalf of the East India Company, Harford Jones Brydges, a merchant of precious stones turned diplomat, and soon after, Gore Ouseley, a refined English nobleman, arrived from London, accompanied by an entourage and offering British support in Iran's war effort against Russia. Although the treaty of 1813, ratified just after the conclusion of the first round of wars with Russia, promised British military and financial assistance to Iran, the British reneged and refused to fulfil their commitments completely when Iran was again at war with Rus-

sia in 1826, thus adding to Iran's suspicion of British motives. This early episode in Iran's foreign policy and the pattern of rivalry between Russia and Britain, with the occasional involvement of France, set the stage for power politics in Iran for the rest of the Qajar era and through the early part of the twentieth century.[7]

For Europeans, Iran was known as an ancient kingdom with a distinct culture and a long history of interaction with the West stretching back to ancient Greece. Even at the beginning of the nineteenth century, Europeans viewed Iran in the light of its ancient past and the glories of the Safavid period. The stereotype images of Iran and Persian kingship going back to Herodotus and Xenophon were reinforced in early modern times in the works of Montesquieu, Voltaire, and later Hegel — which were themselves based on the accounts of such travelers as John Chardin and Pietro Della Valle in the seventeenth century. For the British, who were already familiar with the Mughal *darbār* (court protocol) in India, Iran and its court held a special appeal, as is apparent in the works of such early observers as Scott Waring, William Ouseley, John Malcolm, Robert Ker Porter, and James Morier. The Persian language, that of high culture in Mughal India, and its literature, as well, were esteemed and studied by the British, especially before Persian was supplanted by English as the lingua franca of India at midcentury. Old preoccupations and new concerns prompted diplomats, archaeologists, and adventurers to explore Iran in search of ancient sites, to collect manuscripts and fine arts, and to record and publish whatever seemed significant for Europe's cultural enrichment and, alternatively, to analyze political and topographic details for maintaining Britain's strategic edge over Russia.

Iran's image gradually deteriorated as the century progressed, and its loss of territory and prestige, and its domestic weaknesses, became more apparent to outsiders. In two rounds of Perso-Russian wars (1805–13 and 1826–28), Qajar Iran not only lost some of its most prosperous provinces in the Caucasus (the present-day republics of Armenia and Azarbaijan), but temporarily forfeited Tabriz in 1827. In addition to the loss of territory and revenue that came about with the treaties of Gulistan (1813) and Turkmanchai (1828), the latter treaty also saddled Iran with a huge war indemnity that almost bankrupted its treasury and stipulated a set of capitulatory concessions with enduring effects. The humiliation of defeat at the hands of Christians was brought closer to home with the upsurge of war refugees and with

the evident failure of the *jihād* (holy war) declared by the ranking *'ulamā* against the Russian enemy. Defeat cast a shadow over not only the very legitimacy of the Qajar state, but also the *'ulamā*, for persuading the state to enter into a conflict with Russia without realizing its dire consequences. The mob violence in Tehran in 1829, which resulted in the massacre of almost the entire Russian mission, demonstrated public resentment of Russian arrogance in their dealings with the defeated Iranians. Perhaps it also reflected the *'ulamā*'s wish to recoup lost credit.

Despite setbacks in frontiers, the reign of Fath 'Ali Shah was a period of calm. One may suggest that under Fath 'Ali Shah the tone for the making of Iran's society was set for the rest of the Qajar period. After decades of insecurity, cities grew in size and their surrounding agricultural hinterlands expanded. The country's population grew from about five million at the beginning of the century to about seven million by midcentury. Smaller towns and villages along trade routes were revitalized, and domestic and interregional trade expanded as the Qajar government was able to provide better security for caravans against nomadic raids. Though tribal population also increased, and pastoral nomadism continued to be a dominant sector of the economy, the Qajars' successful policy of reorganizing the tribes in confederacies and shrewdly manipulating their leadership allowed greater containment of the often-turbulent periphery by the provincial and central governments. Benefiting from this new air of tranquillity were the city notables – consisting of ranking officials, the prominent *'ulamā*, large merchants, landowners, and nobility of Qajar and other extractions – who were able to reassert their control over the villages and the agricultural land in absentia, primarily by acquiring government land assignments (*tuyūl*) and by controlling vast estates earmarked as charitable endowments (*awqāf*). They also invested in urban construction and in regional and long-distance trade. New charitable endowments included bazaars, caravanserais, mosques, colleges, bathhouses, water reservoirs, and other public buildings and complexes. New roads and bridges were built, and the old ones repaired. The gilt mansions of the notables and officials within the city enclosure and their spacious gardens outside the walls, conspicuous signs of their owners' social weight and influence, were comparable or superior to those of Qajar nobility. The notables were instrumental in maintaining stability and peace in the cities and in the countryside and as mediators between the government and the general public. Divided along family, religious, and economic lines, as well as political loyalties, they were also capable at times of unrest of inciting violent clashes between rival city wards or even rival tribes. Relying on many support networks including bazaar guild organizations, *madraseh* (theological seminary) students, city brigands (*lutīs*), villagers, and tribal chiefs, they exerted pressure on the local and central governments, saved their protégés and dependents, squared disputes with their enemies, and added to their own wealth and leverage. Most significant, the ranking *'ulamā* of the Usuli persuasion, the predominant legal school in the nineteenth century, became the pivotal component of the social structure and at times the informal leaders of the community, capable of excising the Qajar officials or excommunicating as heretics those who held unconventional religious views.[8]

MONARCHS AND MINISTERS: CONTENDERS FOR POWER

Throughout the reign of Muhammad Shah (r. 1834–48) and the early years of Nasir al-Din Shah's (r. 1848–96), the Qajar state experienced a painful adjustment to new international and domestic realities. Increasingly, Iran came to play the role of a buffer state between two neighboring powers afraid of each other's expansionist designs. As the Great Game, the contest for supremacy over Central Asia, was played out between Russia and Britain at the Iranian periphery, the Iranian center was also touched by this "cold war." Although neither power wished to colonize Iran, as long as it was possible to keep each other in check, and though both powers committed themselves to the survival of the ruling dynasty, neither hesitated to take advantage of Iran's military and economic vulnerabilities, to treat it with an air of colonial condescension, and, if necessary, to annex chunks of its periphery.

At home, an array of domestic maladies – political, financial, and social – further blemished the Qajar image in the eyes of the Iranian people and outsiders alike. In contrast to Fath 'Ali Shah, the new ruler, Muhammad Shah, was a man of austere character with mystical leanings, withdrawn, and physically unwell. Throughout his reign, the government was dominated by his chief minister and spiritual guide, Haji Mirza Aqasi, a shrewd and self-deprecating manipulator more interested in controlling the shah and securing his own political survival than in managing the state's troubled affairs or tending

the government's diminishing revenue. The reign of Muhammad Shah witnessed even more frequent visitations of cholera and other pandemics, with massive fatalities. To these problems were added extortion and ill treatment of the villagers by agents of the landlords and government tax collectors; economic pressures caused by growing foreign imports and European custom privileges; decline of cottage industries; frequent incursions upon villages by frontier nomads; and urban violence inflicted by city brigands.[9]

The resulting spirit of despair and popular dissatisfaction was best reflected in the rapid growth of the Babi movement in the late 1840s and early 1850s. Originally a messianic reaction to the legalistic Shi'ism of the 'ulamā and their intellectual obscurantism, the Babi movement was the first manifestation of popular protest in modern Iran that challenged, theoretically and in practice, the legitimacy of the Shi'ite establishment and the Qajar monarchy. From the perspective of Iranian religious history, the Babi movement was the first in modern times to break away not only from mainstream Shi'ism, but from Islam itself, to inaugurate a new prophetic dispensation. The idea of renewal as it was expressed in the new Babi dispensation was indigenous to Iran's nonconformist religious environment. The social and political crisis of the period broadened its appeal to the dissidents among the lower 'ulamā ranks, as well as to younger merchants, artisans, and men and women critical of the clergy's excesses, the government's ineptitude, antiquated social and moral mores, and outside economic forces that threatened the very foundation of the social order. Among the many adherents to Sayyid 'Ali Muhammad the Bab (1819–1850), the prophet of the new religion, was Zarrin Taj Baraghani, better known by her titles Qurrat al-'Ayn and, later, Tahireh. A poet and preacher from a well-known clerical family, Tahireh rose to the leadership of the movement before being captured and executed in 1852. She was the first woman to remove her facial veil in public, long before emancipation movements in the Middle East in the early twentieth century. In a series of bloody confrontations between 1848 and 1852, the Qajar government was able to suppress the Babis' armed resistance and eliminate most of the movement's leadership, including the Bab himself, forcing it to go underground. It nevertheless continued to be a voice of dissent and occasional protest for the rest of the century. In its future development, the prevailing current within the Babi movement evolved into the Baha'i religion, which modified the movement's political objectives but remained a source of religious and moral modernism in Qajar Iran despite prolonged persecution. Lynching and mob violence was often fomented against the Babis and, later, the Baha'is, in Qajar Iran by the high-ranking 'ulamā and condoned, if not encouraged, by the state. The alternative Azali Babi current, which remained loyal to Babi political activism, also persisted and later reemerged to play a clandestine but significant part in the shaping of the Constitutional Revolution.[10]

Nasir al-Din Shah's accession in 1848 at the age of seventeen came at a time when not only the Babi movement, but the Davelu revolt in Khurasan, a secessionist revolt against the ruling family led by a rival branch of the Qajar tribe, had brought Qajar rule to the verge of collapse. These crises coincided with the short but effective premiership, between 1848 and 1851, of Mirza Taqi Khan Amir Kabir, a determined administrator and an ambitious reformer. His term of office partially relieved the vulnerable Qajar throne of domestic chaos and foreign intervention while breathing new life into the tattered administration (see FIG. 3). His program of state-sponsored reform primarily sought to overhaul the army, finances, and court in a fashion reminiscent of the improvements of Peter the Great of Russia and Muhammad 'Ali Pasha of Egypt. Like the "men of the Tanzimat" who were responsible for implementing a set of administrative, legal, and other reforms in the Ottoman Empire, Amir Kabir represented a new resolve to enforce substantive reform initiatives from above, and like them, he was a commoner.

Amir Kabir was a representative, and to some extent the product, of the Azarbaijan administration under Crown Prince 'Abbas Mirza. Earlier in the Qajar period, 'Abbas Mirza had pioneered military modernization, employed European officers, dispatched the first group of Iranian students to study in Europe, introduced a European-style military uniform, and even invited Europeans to establish a colony in Azarbaijan. This pro-Western attitude conflicted with the often xenophobic apprehensions of the older Qajar elite and their Shi'ite clerical counterparts. 'Abbas Mirza's provincial minister, Mirza Abu'l Qasim Qa'im Maqam (a celebrated poet and essayist and later the prime minister to Muhammad Shah), supported the crown prince in his modernizing endeavors. In the 1820s 'Abbas Mirza had created the New Army (Nizam Jadid), a modern standing force largely trained by British officers, to counter the Russian threat. During this time Tabriz, the provincial capital of Azarbaijan, became a center for reform-minded Iranians and a point of entry for the

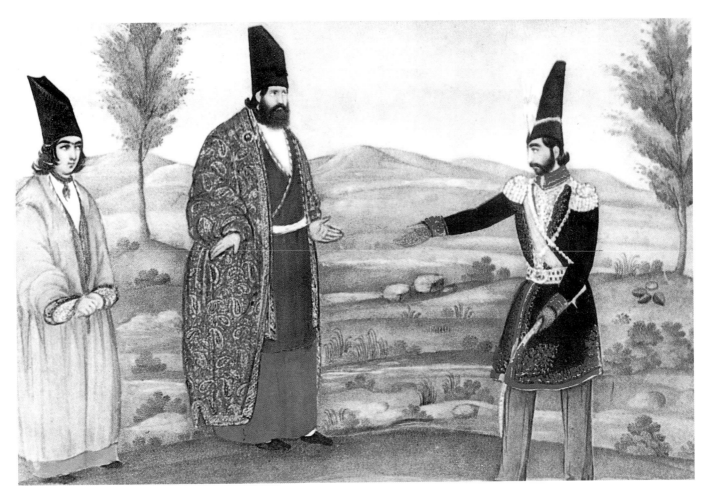

FIG. 3. *Nasir al-Din Shah and Amir Kabir Portrayed as the Abbasid Caliph Harun al-Rashid and His Minister Ja'far Barmaki.*
Folio from a manuscript of *Thousand and One Nights.*
Abu'l Hasan Ghaffari, Sani' al-Mulk. Tehran, completed
A.H. 1276/A.D. 1859–60. Opaque watercolor, ink, and gold on paper.
GULISTAN PALACE LIBRARY, TEHRAN.

earliest Western influences through Russia and the Ottoman Empire. Amir Kabir, son of the chief cook in Qa'im Maqam's household, was brought up and trained to serve as the secretary in the New Army, and it was with the support of this force that he brought the young Nasir al-Din Shah to the throne in 1848. Serving as the prime minister and guardian (*atābak*) as well as the commander in chief of the army, Amir Kabir presided over a monopoly of power unprecedented in the Qajar period.[11] Beyond military and administrative reorganization, Amir Kabir's vision of reform included creating institutions such as a modern military school whose foundations he laid before his dismissal. The Dar al-Funun, Iran's first modern polytechnic, trained cadets and provided engineers, physicians,

interpreters, and musicians, primarily for the army. Long after Amir Kabir's demise, the Dar al-Funun under the instruction of Austrian, French, Italian, and Iranian teachers remained the only institution in Iran that educated generations of administrators and diplomats. Publication of Iran's first regular government gazette and establishment of a center for arts and crafts, the Dar al-Sanayi', were among Amir Kabir's other initiatives. Mirza Abu'l Hasan Ghaffari, Sani' al-Mulk, who later became the chief royal painter under Nasir al-Din Shah, first displayed his talent in the Dar al-Sanayi'.[12]

Amir Kabir's term of office came to an abrupt end with his dismissal in late 1851 and his execution in January 1852. The shah's change of attitude toward his premier was triggered by a long-standing struggle between Amir Kabir and members of the royal family, who under the aegis of the shah's mother, Mahd Ulya, were fiercely at work to retrieve their lost pensions and privileges. His dismissal came only a year after the final collapse of the Babi resistance and just after the end of the Khurasan revolt, at a time when his anticorruption measures were about to take effect. It was as though the Qajar establishment had stomached Amir Kabir's

monopoly of power, his authoritarian style, and above all his attempt to curb the Qajar family's financial and political excesses only as long as it was necessary to defuse the revolutionary situation and consolidate the power of the throne. To the shah, the execution of his premier-guardian was a rite of passage to the world of political adulthood. Each of Nasir al-Din's two predecessors had destroyed his first premier who had brought him to the throne; Fath 'Ali Shah had ordered the execution of Ibrahim Khan Shirazi I'timad al-Dawleh, and Muhammad Shah had had Mirza Abu'l Qasim Qa'im Maqam killed in secret. The Qajar court's pattern of confrontation with its prime ministers decidedly hindered the state's autonomy, as well as its immunity from abuses by the shah and the elite.

The following decades of Nasir al-Din Shah's long reign were characterized by an equilibrium in domestic and international levels, punctuated by compromises in foreign affairs and inconsistent reform initiatives. Iran's attempt to reassert its territorial sovereignty over western Afghanistan, which triggered the Anglo-Persian war of 1856–57 in the Persian Gulf, resulted in the permanent loss of Herat province. This and other military defeats such as the disastrous campaigns of 1860–61 aimed at securing the ancient Merv province (in the present-day Republic of Turkmenistan) convinced the shah and his ministers that the sole option open to Iran was to safeguard its independent and territorial integrity. It was only through negotiation and the complex and often devious game of diplomacy that Qajar Iran could withstand the imperialist threat of Britain and Russia. By playing off the two rivals and sacrificing control over Iran's often precarious periphery, the Qajar state maintained control of Iran's heartland and avoided, at least partially, the most menacing European interference in its internal affairs. It is worth noting that during the second half of the century Iran lost none of its provinces to its neighbors, with the exception of Herat, and that most of the fringe territory lost in Khurasan and elsewhere was only tenuously attached to the Persian center.[13]

Building on the momentum created by Amir Kabir but eliminating after 1858 the very office of prime minister in favor of direct royal rule, the shah embarked on a domestic policy characterized by selective, and often ephemeral, modernization, aimed at asserting his fragile control over a government divided among bureaucratic factions and over an avaricious royal family. Careful not to jeopardize the throne's delicate interplay with con-

servative religious dignitaries, defiant tribal chiefs, and merchants of the bazaar, Nasir al-Din was able to introduce some reforms in the administration and in the army and develop the infrastructure on a limited scale. These efforts were often plagued by insufficiency of funds, owing to the state's inability to increase its revenue and improve its tax-collection methods or to devise new sources of income.[14]

The model of monarchy remained fundamentally intact, however. As in Fath 'Ali Shah's era, the shah occupied the central place in the political universe and, for the majority of the population, elite and general populace alike, remained the quintessential royal exemplar. This image was progressively battered through the century by defeat in war, misgovernment, and tacit rivalry with the 'ulamā. The shah also reverted to the old pattern of assigning large provinces to his sons — Azarbaijan to Crown Prince Muzaffar al-Din Mirza, and Isfahan and a host of adjacent provinces in the south and the west to the powerful Mas'ud Mirza Zill al-Sultan — a practice that hindered centralization and promoted fraternal rivalries and foreign influence.

Nevertheless, Nasir al-Din Shah and his ministers — Mirza Husayn Khan Mushir al-Dawleh (later Sipahsalar) in the 1870s and Mirza 'Ali Asghar Khan Amin al-Sultan in the late 1880s and early 1890s — buttressed the royal facade and refurbished it with reform plans, propaganda, and diplomacy. Mushir al-Dawleh was instrumental not only in implementing new administrative and judicial measures and attempting various developments such as road building, expanding the telegraphic network, and new disease prevention initiatives, but also in realizing the shah's long-cherished wishes to visit Europe.[15]

SEDUCTIVE MODERNITY AND SEARCH FOR AUTHENTICITY

Nasir al-Din Shah's much-publicized 1873 European tour was primarily designed to familiarize the ruler, and the Qajar elite, with material advances and political institutions in the West. Accompanied by a large retinue of princes, statesmen, and attendants, the shah traveled for several months throughout Russia and central and western Europe and was hosted by all major European courts. The impact of this trip, however, proved to be more diplomatic than reformative. Throughout this tour and two subse-

quent European visits in 1878 and 1889, the shah was generally received by royalty as an equal and greeted by statesmen, press, and public with a mix of awe and amusement. Despite the royal retinue's occasional awkwardness with foreign court etiquette, which European eyes were only too ready to note, these tours were successful in reinstating Iran on the Western imperial map as a sovereign state with an enduring kingship and as a resilient nation in need of assistance. In an age that saw relentless breakup and collapse of Muslim states from Morocco to Indonesia, attaining such recognition was no small feat.

The shah brought back from Europe a mixed impression of modernity, which only confirmed his previous convictions. The West was seductive and fascinating for its many material, aesthetic, technological, and military riches yet dangerous as a source of democratic and atheistic ideas. The shah was convinced that heedless conversion to its modern ways would bring social unrest, radicalism and revolution, economic dependency, financial insolvency, and, ultimately, colonial domination. In contrast to the Egyptian and Ottoman open-door policy toward Western capital and Western presence, Iran's response was circumspect and ambivalent. The shah's mixed experience at home with Western capital and Western methods made him especially aware of the potential of modern technology, but it also alerted him to the danger of opening the country wholesale to European material and cultural influences.[16]

The introduction of telegraphic communication proved to be a major boost to the government's efficiency and to the growth of the economy. From the 1860s it was possible for the central authorities, first through the British Indo-European lines and soon after through the Iranian government-run telegraph lines, to communicate rapidly with the provinces and react more effectively to unrest and rebellion, and to protests and petitions. It also enabled the shah and his statesmen to communicate with European capitals directly in attempting to resolve tangled diplomatic disputes that were often protracted by condescending European representatives in Iran. Positive expe-

FIG. 4. *View of Almasieh Avenue and the Gulistan Palace Gateway.*
Mahmud Khan Saba, Malik al-Shu'ara. Tehran, dated A.H. 1288 / A.D. 1871–72. Oil on canvas.
GULISTAN PALACE LIBRARY, TEHRAN.

rience with the telegraph persuaded the shah and his ministers to seek new investment through granting concessions to Europeans. In 1872 Baron Julius Reuter received from the Iranian government a concession for the construction of Iran's railroad, along with a monopoly for the development of the country's natural resources, mines, banking, and industrial potentials. The wholesale bargain proved to be a major embarrassment to the shah and his premier, and a token of their glaring gullibility in the face of greedy European entrepreneurship. Upon the shah's return from Europe, a palace revolt led by the harem and supported by some of the influential princes and by the ranking 'ulamā of the capital forced the shah to repeal the concession and dismiss its chief negotiator, Mirza Husayn Khan Mushir al-Dawleh. The Reuter blunder made the shah more cautious and resilient under economic pressure. It took the British a decade of negotiation to obtain the right of navigation in the Karun river, which was granted to a British company in 1888, and the concession for the establishment of the British-controlled Imperial Bank of Persia a year later. Holding the monopoly for issuing the country's first banknotes, the Imperial Bank transformed Iran's old-fashioned financial and monetary methods and contributed to the emergence of a national market.[17]

Western material and cultural influences began to appear in other spheres. In the area of urban development, Nasir al-Din Shah expanded and beautified the capital in a mixed style of European and Persian architecture (see FIG. 4), apparent in such buildings as the Takieh Dawlat, the state amphitheater built for performing tāzīehs, the Shi'ite passion plays. Changes were also evident in the dress code promoted by the shah himself; in new methods of disease prevention and health care; in familiarity with modern sciences and new mechanical devices and new processes such as photography; in the import of luxury goods, china, fabrics, furniture, and silverware; in the cultivation of new plants and flowers that influenced Iranian eating habits and garden designs and led to the production of new cash crops such as tobacco, cotton, and opium and to the mass growth of the carpet industry for the export market.

Like European architecture and luxury goods, mainstream Western painting was appreciated at both high and popular levels of Persian culture. Patronized by Nasir al-Din Shah, himself an amateur artist, the new Perso-European style was taught in the Dar al-Funun and

popularized by lithographic reproductions in books and newspapers. Works of such Persian artists as Mirza Muhammad Ghaffari, Kamal al-Mulk, who studied painting in Europe, were collected in the private museum in the Gulistan palace. The beloved Persian miniature paintings as well as book illustrations were still commissioned by the court and elite, and the art of Persian calligraphy also thrived. Persian traditional music was classified under master musicians of the Nasir al-Din era into a more comprehensive system known as radīf, which incorporated into the ancient court repertoire many new pieces with folk, nomadic, and religious origins.

The Qajar era was also distinguished by literary innovations within and outside the court environment. In a break with the ornate poetry of the Safavid period, the court poets of the nineteenth century looked for fresh inspiration in the simplicity and elegance of classical panegyrists and epic poets of the tenth and eleventh centuries. Fath 'Ali Khan Saba, the poet laureate of the Fath 'Ali Shah era, based his verse history of the Qajar dynasty on the model of Firdawsi's Shāhnāmeh. He glorified his royal master at a time when the reality of military defeat was too painful to be recorded. In style and content, early Qajar poetry led to new experiments in the writing of history and memoirs, as well as in journalism. Outside the sphere of the court, religious scholarship also thrived. Major works of jurisprudence were produced in Arabic, but many commentaries on the Qur'an continued to be written in Persian by sufi scholars. A much wider audience existed for Persian books of Shi'ite tragedies, legends of 'Ali, and popular eschatology, all narrated from the mosques' pulpits. The ta'zīeh, the prevalent dramatic expression of the Qajar period, was an equally powerful medium for popularizing Shi'ite legends and developing melodic-verse dialogue and a new theatrical language. At the same time, multisequential religious and epic popular paintings came to depict passion plays and Persian heroic legends, often as visual aids to professional storytellers in the urban coffee- and teahouses and to itinerant dervishes performing in village commons.[18] By the turn of the twentieth century, everyday Persian prose, influenced by newspapers and translations of European novels and histories, available in greater number and variety under Muzaffar al-Din Shah (1896–1906) and during the Constitutional Revolution (1906–11), provided the necessary medium and the mindset for voices of dissent, already audible in the last decade of Nasir al-Din Shah's reign.

FROM TOBACCO PROTEST TO THE CONSTITUTIONAL REVOLUTION

The first concrete sign of unrest in the changing Iran of the late nineteenth century appeared during the protest movement of 1891–92. Nasir al-Din Shah, oblivious of the fate of the Reuter concession, granted another monopoly, this time to the British Regie company, for collection, distribution, and export of tobacco, the second-largest cash crop produced in Iran. As widespread protest gained momentum, the ranking clergy, instigated by religious dissenters and activists, began to air the grievances of Persian tobacco producers and merchants. Their call for a ban on the consumption of tobacco was fully

supported by the general public. Widespread urban riots forced the shah to repeal the concession, pay a heavy fine, and temporarily retreat in the face of the triumphant clergy. Four years later, Nasir al-Din Shah was assassinated by a commoner on the eve of his jubilee (fiftieth anniversary of his accession according to the lunar calendar). The assassin was a disciple of Sayyid Jamal al-Din Asadabadi (better known as al-Afghani), perhaps the best-known Islamic activist of the nineteenth century and a sworn enemy of the shah. The assassination demonstrated the Qajar monarchy's vulnerability in the face of popular agitation. It also denoted the end of the period of bliss-

FIG. 5. *Territorial changes in Iran at the end of the Qajar period, 1925.*
Map by Mehrdad R. Izady.

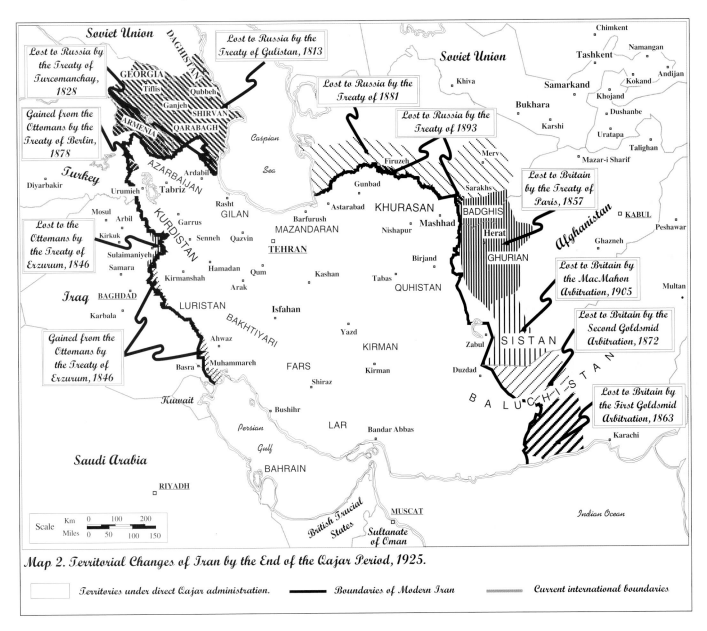

Map 2. Territorial Changes of Iran by the End of the Qajar Period, 1925.

☐ *Territories under direct Qajar administration.* ▬▬ *Boundaries of Modern Iran* ▬▬▬ *Current international boundaries*

ful isolation presided over by Nasir al-Din Shah and perpetuated by the clergy's fear of the West.[19]

Under Muzaffar al-Din Shah, and especially during the short tenure of Mirza 'Ali Khan Amin al-Dawleh as prime minister (1897–99), expansion of modern schools and the growth of journalism and book publication afforded the Persian public new insight into the world beyond Iran. Accounts of new geographical discoveries, descriptions of political conflicts, translations of popular adventure novels, critiques of despotism, and scientific advances defied cultural complacency and raised questions about Iran's time-honored religious and political values. For the popular preachers, greater freedom of speech, especially in the pulpit, provided a chance to air frustration with the government for failing to safeguard the security and economic well-being of its subjects. Dissidents, especially the remnants of the Babis of earlier decades, and varied activists began to organize themselves in secret societies, publish clandestine literature, and try to infiltrate high clerical circles. The sharp edge of criticism was directed toward not only the state for its despotic conduct, but also the Shi'ite 'ulamā for their ignorant defiance of "progress" and "civilization." Merchants and artisans, on the other hand, voiced criticism of the government for submitting to foreign interests, allowing European agents to control the lucrative customhouses, and adopting draconian measures damaging to the marketplace. The Constitutional Revolution thus brought to the surface generations of Iranians' frustration with arbitrary power, privileges of the elite, social and economic insecurity, corrupt officials, intrusive foreign powers, and the conservative 'ulamā.[20]

The establishment of the Iranian parliament (the Majlis) in 1906 and the framing of the Constitution in 1907 heralded a new, and often haphazard, experiment with liberal democracy. Brief and imperfect though it was, the Persianized constitutionalism (mashrūṭeh), particularly after the civil war of 1908–9 and the defeat of the royalists, transformed Iran's old polity and allowed the younger generation of dissidents, sons of clergy and merchants, and members of the Western-educated intelligentsia to enter the political arena. For all intents and purposes, the revolution put an end to the Qajars' personal rule and, to a degree, reduced the influence and privileges of the nobility. The emerging spirit of secular modernism also diminished the status of the 'ulamā and discredited, at least in the eyes of the modernizing urban middle classes, the brand of religion that it represented. Though the revolution's objectives to instill basic notions of individual rights and preeminence of the law (qānūn) were accomplished only partially and ephemerally, the emerging modernist outlook was presented more effectively in cultural and artistic spheres. Poetry, journalism, political writings, and music of the revolutionary and postrevolutionary periods attacked tyranny and obscurantism, and condemned European imperial avarice and deceit while praising the West's modern institutions and liberal principles. These voices lamented Iran's material decline and contrasted its present with an idealized vision of its ancient past. Above all, these artistic and cultural expressions represented the arrival of a new spirit of conscious nationalism – increasingly evident during and immediately after the First World War in the wake of military occupation, fear of partition (see FIG. 5), and widespread famine and disease – a shared sense of national community that was distinct from, but still tied to, the old notion of the Guarded Domains of Persia and the monarchy formerly at its center.

Notes

1. For the general history of the early Qajar period, see Avery, Hambly, and Melville 1991, 3–174; Bosworth and Hillenbrand 1983; Ann K. S. Lambton, "Kadjar," *Encyclopedia of Islam*, 1978, vol. 4, later published in Lambton 1987. See also Dunbulī 1972; Fasa'i 1972, 1–281; R. G. Watson, *A History of Persia* (London, 1866).

2. For the Qajar struggle for supremacy and the internal feud between its rival houses in the eighteenth century, see L. Lockhart, *The Fall of the Safavi Dynasty and the Afghan Occupation of Persia* (Cambridge, 1958), 122–23, 280; L. Lockhart, *Nadir Shah* (London, 1938), 14–15, 24–27, 243–44; and Perry 1979, 62–78, 137–49.

3. See Gavin R. G. Hambly, "Agha Mohammad Khan and the Establishment of the Qajar Dynasty," *Journal of the Royal Asian Society* 50 (1963): 161–74; Avery, Hambly, and Melville 1991, 104–43 (Gavin Hambly); and John R. Perry, "Āġā Moḥammad Khān Qājār," *Encyclopaedia Iranica*, vol.1.

4. For Fath 'Ali Shah, see Avery, Hambly, and Melville 1991, 144–69 (Gavin Hambly), the most concise account to date. Among contemporary English accounts, see Malcolm 1815 and Harford Jones Brydges, *An Account of the Transactions of His Majesty's Mission to the Court of Persia* (London, 1834). Persian studies include Said Nafisi, *Tārīkh-i Ijtimā'ī va Sīyāsī-yi Īrān dar dawreh-i Mu'āṣir*, 2 vols., 2d ed. (Tehran, 1965). See also Abbas Amanat, "Fath 'Ali Shah," *Encyclopaedia Iranica* (forthcoming), and Abbas Amanat, "Courts and Courtiers: In the Qajar Period," *Encyclopaedia Iranica*, vol. 6.

5. For the Qajar princes of the Fath 'Ali Shah period, see Heribert Busse, "'Abbās Mirzā," *Encyclopaedia Iranica*, vol. 6, and Abbas Amanat, "Dawlatshāh, Moḥammad 'Alī Mirzā," idem, 1996.

6. See Amanat 1997, 18–23.

7. For Perso-Russian relations in the early Qajar period, see Muriel Atkin, *Russia and Iran, 1780–1828* (Minneapolis, 1980); Avery, Hambly, and Melville 1991, 326–41 (Firuz Kazemzadeh); A. Tājbakhsh, *Tārīkh-i Ravābiṭ-i Īrān va Rūsiyeh dar Nīmeh-i Avval-i Qarn-i Nūzdahum* (Tabriz, 1958). For Anglo-Persian relations in the early Qajar period, see Avery, Hambly, and Melville 1991, 374–94 (Rose Greaves); Ingram 1979; John Barrett Kelly, *Britain and the Persian Gulf, 1795–1880* (Oxford, 1968); Wright 1977; Michael E. Yapp, *Strategies of British India: Britain, Iran and Afghanistan, 1798–1850* (Oxford, 1980); A. Tahiri, *Tārīkh-i Ravābiṭ-i Bāzargānī va Sīyāsī-yi Ingilīs va Īrān*, 2 vols. (Tehran, 1975). For the Perso-Russian wars, see also Amanat 1993, 35–56, and the cited sources. For the French interlude during the Napoleonic era, see Iradj Amini, *Napoleon et la Perse* (Paris, 1995).

8. For religious developments in the early Qajar period, see Algar 1969; Hamid Algar, "Shi'ism and Iran in the Eighteenth Century," in *Studies in Eighteenth Century Islamic History*, ed. by Thomas Naff and Roger Owen (Carbondale, Illinois, 1977), 288–302; Abbas Amanat, *Resurrection and Renewal: Making of the Babi Movement in Iran, 1844–1850* (Ithaca, New York, 1989); Abbas Amanat, "In Between *Madrasa* and the Marketplace: The Designation of Clerical Leadership in Modern Shi'ism," in *Authority and Political Culture in Shi'ism*, ed. by Said Arjomand (Albany, 1988), 98–132; Said Arjomand, "The Shi'ite Hierocracy and the State in Pre-Modern Iran: 1785–1890," *European Journal of Sociology* 22 (1981): 40–78; Ann K. S. Lambton, "A Nineteenth Century Interpretation of *Jihad*," *Studia Islamica* 22 (1970): 81–92.

9. For the Muhammad Shah period, see Amanat, *Resurrection and Renewal*, 18–29; Huma Natiq, *Īrān dar Rahyābī-yi Farhangī, 1834–1848* (London, 1988); Watson, *A History of Persia*. For Aqasi, see Abbas Amanat, "Aqāsī, Ḥājjī Mirzā 'Abbās Iravānī," *Encyclopaedia Iranica*, vol. 2, and cited sources.

10. For the Babi movement, see Amanat, *Resurrection and Renewal*, and the cited sources. See also Edward G. Browne, *A Traveller's Narrative of the Bab* (Cambridge, 1891); M. Nabil Zarandi, *The Dawn-Breakers*, trans. by Shoghi Effendi (Wilmette, Illinois, 1932). For later development, see M. Momen, *The Babi and Baha'i Religions, 1844–1944* (Oxford, 1981), and Juan R. Cole, *Modernity and Millennium: The Genesis of the Baha'i Faith in the Nineteenth Century Middle East* (New York, 1998).

11. For Amir Kabir, see Amanat 1997, 89–199; Abbas Amanat, "The Downfall of Mirza Taqi Khan Amir Kabir and the Problem of Ministerial Authority in Qajar Iran," *International Journal of Middle East Studies* 23 (1991): 577–99; Adamiyat 1969, and Watson, *A History of Persia*, 385–406. See also Hamid Algar, "Amīr-e Kabīr," *Encyclopaedia Iranica*, vol. 1.

12. For Dar al-Funun, see Ekhtiar 1994; John Gurney and Negin Nabavi, "Dār al-Fonūn," *Encyclopaedia Iranica*, vol. 6; Husayn Mahbubi Ardakani, *Tārīkh-i Mu'assasāt-i Tamadduni-yi Īrān*, 2 vols. (Tehran, 1965), vol. 1, pp. 253–317.

13. For Iran and the great powers, see, among others, Kazemzadeh 1968; Rose Greaves, "Iranian Relations with Great Britain and British India, 1789–1921," in Avery, Hambly, and Melville 1991, 374–425.

14. For aspects of social and economic history of the period, see Issawi 1971; Lambton 1987, 33–222. See also Abbas Amanat, ed., *Cities and Trade: Consul Abbott on the Economy and Society of Iran, 1847–1866* (London, 1983).

15. For Mushir al-Dawleh and his reforms, see Guity Nashat, *The Origins of Modern Reform in Iran, 1870–1880* (Urbana, 1982).

16. For Nasir al-Din Shah and his time, see Amanat 1997; Shaul Bakhash, *Iran: Monarchy, Bureaucracy and Reform under the Qajars* (London, 1978); Nikkie R. Keddie and Mehrdad Amanat, "Iran under the Late Qajars," in Avery, Hambly, and Melville 1991, 174–212.

17. See G. Jones, *Banking and Empire in Iran: The History of the British Bank of the Middle East*, vol. 1 (Cambridge, 1986).

18. For aspects of culture of the period, see Avery, Hambly, and Melville 1991, chapters by Peter Chelkowski (765–814) and Peter Avery (815–69). See also Browne 1959, vol. 4.

19. For the Regie episode, see Firaydun Adamiyat, *Shūrish bar Imtiyāznāmeh-i Rizhi* (Tehran, 1981); Nikkie R. Keddie, *Religion and Rebellion in Iran: The Tobacco Protest of 1891–92* (London, 1966); Lambton 1987, 223–76.

20. For the Constitutional Revolution and its social and intellectual background, see entries by Abbas Amanat, Vanessa Martin, and Said Amir Arjomand, and other subentries, "Constitutional Revolution," *Encyclopaedia Iranica*, vol. 6. See also Afary 1996; Mangol Bayat, *Iran's First Revolution: Shi'ism and the Constitutional Revolution of 1905–1909* (Oxford, 1991); Edward G. Browne, *The Persian Revolution of 1905–1909, 1910*, new ed. with new introduction by A. Amanat (Washington, D.C., 1995).

IMAGES OF POWER AND THE POWER OF IMAGES

Intention and Response in Early Qajar Painting (1785–1834)

LAYLA S. DIBA

The portrait was displayed on an easel at the entrance of the room [the library of East India Company House in London]. When I beheld the beauty of the Qibleh of the Universe, I bowed low until my head was level with his feet.[1]

HIS VERY PUBLIC display of allegiance before a life-size portrait of Fath 'Ali Shah (r. 1798–1834), related in 1809 by Mirza Abu'l Hasan, Iran's first ambassador to England since the seventeenth century, may have been perceived as exaggerated subservience by some of his English hosts. On the other hand, perhaps it was not, since when Abu'l Hasan performed obeisance before another portrait of his master suspended alongside that of King George III (1760–1820) in the Ballroom of the City of London Tavern, the English actually followed suit.[2] European diplomats were well acquainted with the elaborate ceremonial of the court of Fath 'Ali Shah, the second ruler of the Qajar dynasty. As this episode shows, ceremonious veneration of the ruler extended to events and attributes even distantly associated with the shah. In this instance, the Mirza's admiration may have been genuine, given the magnificence of the royal image (FIG. 6).

FIG. 6. *Portrait of Fath 'Ali Shah.*
Signed Mirza Baba. Tehran, dated A.H. 1213/A.D. 1798–99. Oil on canvas, 72 x 42 inches (188 x 107 cm).
ORIENTAL AND INDIA OFFICE LIBRARY COLLECTIONS, LONDON, FOSTER 116.

There is considerable evidence that images of the ruler, in myriad forms, sizes, and media, played an integral role in the nineteenth-century exercise of power, both at home and abroad. In addition, numerous intriguing references document the widespread use of figural imagery in popular and court milieus throughout Qajar society for both religious and secular purposes. This wealth of documentation, largely unparalleled for earlier periods of Persian history, may serve as the foundation for a reassessment of Qajar painting that focuses on the sociohistorical and psychological significance of representation.

Although the significance of painting has frequently been investigated in Islamic and Persian studies since the early twentieth century, this discourse has had little impact on the study of later Persian painting and imagery.[3] The reasons for this neglect are manifold. First, Thomas Arnold's brilliantly reasoned 1928 thesis demonstrating the prohibition of any type of imagery in Islamic culture was so forcefully argued that, notwithstanding subsequent numerous exceptions, its validity for the study of later Persian painting has rarely been questioned.

Second, since many historical sites decorated with mural painting had been subjected to large-scale destruction, scholars for the most part neglected the existing evidence for Persian life-size figural imagery[4] in favor of the more easily accessible and lavishly documented illustrated manuscript tradition. As a result, the study of Persian painting became synonymous with the study of "miniatures," as illustrations of handwritten manuscripts came to be known. Such easily portable items, which were often furnished with provenance, date, and locality, provided the foundations for Western studies of Persian painting.[5] Consequently, art-historical issues of ranking and classification were emphasized rather than questions of content and message.

Third, the current understanding of Qajar painting has been predicated on the limited number of extant paintings and European textual sources. Like illustrations torn from manuscripts, these paintings have been detached from their original architectural contexts and dispersed in the bazaars and galleries of the Middle East and Europe. Their shapes have been altered, their rich varnishes and patinas stripped, and their surfaces inscribed with prominent and legible inscriptions. How could the imagery of these works, thus deprived of their context – the bittersweet legacy of the Western world's passion for collecting – even approximate its original power and impact?

To rethink this question, we first need to redefine our terms. Adopting the term "image" or "representation" (*taṣvīr*) in preference to "painting" (*naqqāshī*) broadens our field of investigation and corresponds more closely to Persian artistic terminology. Interdisciplinary analysis in both Persian studies and other fields provides us with new methodologies and frames of reference to interpret the messages encoded in early Qajar imagery. In addition, a wealth of Persian primary sources published in the last twenty years, as well as archival and unpublished materials, can now be used in conjunction with the better-known European accounts to reconstruct the original architectural contexts and function of images.

The evidence of more than two hundred and fifty years (1650–1900) of uninterrupted history of monumental imagery significantly conflicts with the thesis that the art of painting in Islamic cultures was essentially restricted to nonfigural and geometric designs in the public sphere and strictly limited to small-scale narrative illustrations of manuscripts in the private sphere. In fact, the study of Qajar imagery leads to the inescapable conclusion that Iran possessed a deep-rooted visual culture of long standing that was only briefly interrupted by the introduction of Islamic attitudes toward imagery.[6] In order to reassess the significance of Qajar imagery, this study will first examine the ways in which representation was utilized to consolidate dynastic power during the reign of the founder of the dynasty, Aqa Muhammad, and that of his successor, Fath 'Ali Shah. The second part of the essay will investigate the role of deep-seated beliefs and rituals in the Qajar rulers' innovative use of visual imagery. It will be argued that the use of imagery was not the personal preference of a capricious and vainglorious ruler, Fath 'Ali Shah, as has been maintained in the past: rather, it was the artistic component of a concerted policy of cultural revival and political propaganda intended to equate the Qajar rulers with the glorious Persian past.

IMAGES OF POWER
The Persian Domain

B. W. Robinson's statement that "Persia in the nineteenth century was a land of paintings, as never before or since,"[7] may be taken literally. Images in the form of mural paintings were embedded in the fabric of structures located throughout the country. They included portraits; histor-

ical, literary, and mythological themes; genre, hunting, and battle scenes; and religious subjects.[8] In fact, the entire Persian domain functioned as a lavish stage for images designed to convey the pageantry and splendor of Qajar rule.

By 1835, the year after the death of Fath 'Ali Shah, the land of Iran was endowed with strategically located structures built by the Qajar rulers, family, and ruling classes.[9] More than forty architectural sites incorporating lavish decorative schemes[10] centered around life-size imagery may be identified by that time (see FIG. 7).[11] In addition to wall paintings, many of these structures were embellished with tilework, tents, carpets, and hangings with figural themes. Most strikingly, rock reliefs depicting Fath 'Ali Shah, his sons, and his courtiers were also strategically sited in relation to similar rock carvings and reliefs from Iran's Achaemenid (550–331 B.C.) and Sasanian (A.D. 221–642) past.

It is useful to recall that the land had been devastated by the Afghan invasions and years of internecine fighting throughout the eighteenth century. A program of architecture and reconstruction was indubitably needed, and never had a dynasty sought to dominate the geographical and urban landscape of Iran so systematically as the Qajars, or more accurately, as Fath 'Ali Shah and his administration.

Three distinct types of royal residences were found during the early Qajar period. The first two consisted of small pavilions set within larger enclosed spaces: the walled urban palace complex, or *arg* (citadel), a product of the unsettled conditions of the eighteenth century; and the Safavid-style garden complex with structures (*bāgh va 'imārat*). The third type of royal residence, *takht* (throne), was introduced by the Qajar rulers during the late eighteenth century and consisted of terraced gardens with

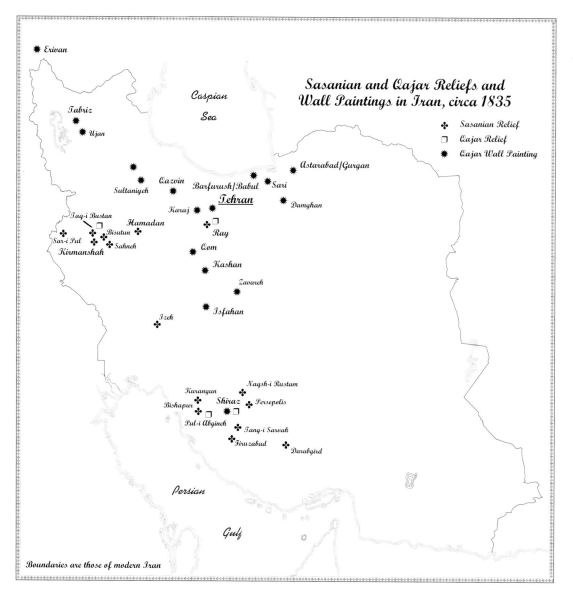

FIG. 7. *Sasanian and Qajar reliefs and wall paintings in Iran, 1835.*
Map by Mehrdad R. Izady.

walls of blind arcading situated on lofty heights or artificially created mounds, surmounted by residential quarters.[12] Palaces of this type reflect an unprecedented revivalism and eclecticism in court-sponsored architecture. They appear to be modeled on both Sasanian prototypes and ziggurat-type palaces of the Elamite period.[13]

Qajar paintings, like the settings for which they were designed, conveyed a sense of grandeur and opulence. Visitors approached these images through a series of ceremonial spaces, courtyards, gardens, and gateways. Images were designed to be viewed from a suitable distance and subservient position; proportions were elongated, features highly stylized, colors saturated, patterns multiplied, and jeweled effects achieved with gilding, built-up gesso, and lacquer.

In royal residences, paintings functioned as units of a rich array of decorative programs. The number of units per cycle varied according to the format and height of the rooms in which they were located. Open porches (*tālārs*) were embellished with three-part cycles; interior spaces, with four-part cycles; and polygonal pavilions, most commonly with eight-part cycles. The impact of each individual painting in a cycle was increased by complex geometric wall schemes combining different shapes and materials.[14]

The Formative Years (1785–97): Aqa Muhammad and the Search for an Image of Power

Although Aqa Muhammad (r. 1785–97), the founder of the Qajar dynasty, is said to have lived spartanly, he introduced some of the traditions of kingship that were refined and further developed by his successor. In the past, the perception of Aqa Muhammad as excessively cruel and avaricious has overshadowed his efforts to unite rival Qajar tribal factions, in order to consolidate the power of the dynasty[15] and to ensure its survival, a policy in which imagery played its part. The Qajar tribes, having faithfully served the Safavids in their rise to power in the sixteenth and seventeenth centuries, considered themselves the Safavids' rightful heirs and sought to emphasize their association with this dynasty.[16] Consequently, Aqa Muhammad appropriated both the monuments and the visual language of Safavid power. The monarch likewise began the process of inventing a new language suited to his personality and the emerging Qajar imperial identity that would be fully articulated in the subsequent reign.

The most prominent symbol of Safavid power was undoubtedly the Chihil Sutun palace (circa 1647–1706) in Isfahan. In 1796 two monumental paintings – *The Vic-*

FIG. 8a. *The Victory of Nadir Shah over the Mughal Ruler at Karnal.*
Aqa Sadiq. Isfahan, circa 1796. Wall painting.
CHIHIL SUTUN PALACE, RECEPTION HALL, ISFAHAN.

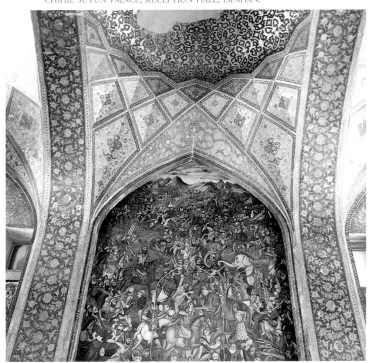

FIG. 8b. *The Battle of Shah Isma'il and the Ottomans.*
Attributed to Aqa Sadiq. Isfahan, dated A.H. 1210 / A.D. 1796.
Wall painting.
CHIHIL SUTUN PALACE, RECEPTION HALL, ISFAHAN.

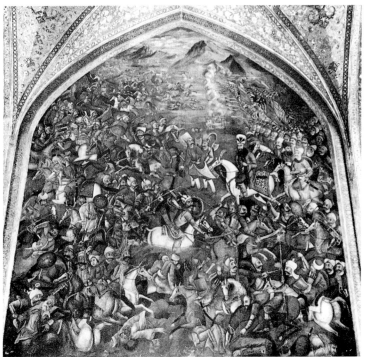

tory of Nadir Shah over the Mughal Ruler at Karnal and *The Battle of Shah Ismáil and the Ottomans* (FIGS. 8a,b) — executed in a compatible style and format, were added to the four existing monumental images of feasting and fighting that decorated the palace's reception hall.[17]

Unlike his nephew Fath 'Ali Shah, Aqa Muhammad did not seek to establish a cult of personality. Nevertheless, by commissioning the restoration of these two paintings in the heart of Persia's ancient capital, Aqa Muhammad astutely sought to identify his own rule with that of heroic figures of Iran's past[18] rather than celebrate his own military victories or territorial gains, which remained to be consolidated.[19]

This commission was far from an isolated event. In 1786 the capital was transferred to Tehran, in northern Iran. A palace residence was erected in the 1780s and 1790s in Aqa Muhammad's birthplace at Astarabad, and palaces, bridges, and other edifices were constructed in the environs of Sari, another area on the southern shores of the Caspian Sea. Furthermore, work on the revival-style Takht-i Qajar palaces outside Tehran and Shiraz was also probably initiated during Aqa Muhammad's reign.[20]

The subjects of the paintings in the Sari public audience rooms (*dīvānkhāneh*) completed in 1781 were identified by European accounts of the 1820s and 1830s as *A Battle of Shah Ismáil with the Turks* and *A Battle of Nadir Shah*.[21] This information is extremely significant since it demonstrates that images that were to embody Aqa Muhammad's vision of power in the Chihil Sutun palace were already in use well before his coronation.

The decorative program of the citadel palace of Astarabad, erected in 1791, was described by James Morier, who visited the site in 1815. An image of the combat of the Persian heroes Rustam and Isfandiar decorated the lofty gateway (FIG. 9),[22] and portraits of "old Persian heroes" graced the audience hall.

From these descriptions emerges an architectural and artistic program identifying Aqa Muhammad with the victories of his immediate predecessors and the glories of ancient rulers. The distinctive features of this formative phase of the Qajar image lie not in what is portrayed, but in what is not portrayed: the person of the ruler himself and scenes of royal feasting are noticeably absent, and female imagery plays an ancillary role at best.[23]

It is known that the countenance of the ruler, wizened and fearsome, frequently induced terror and disgust in those who saw him. The image makers of the period no doubt wisely felt that Qajar political aspirations were better served by avoiding its use. Projecting an image of sumptuous palace life on a Safavid model would also have been inappropriate for Aqa Muhammad, a seasoned military veteran and campaigner. Finally, a prominent display of the beauties of women may have been considered offensive or distasteful.

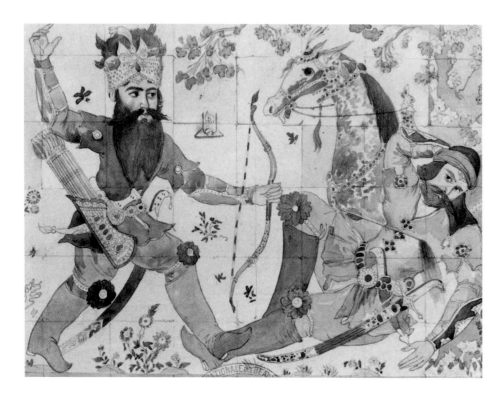

FIG. 9. *Combat of Rustam and Isfandiar.*
Jules Laurens (French, 1825–1901). Circa 1846–47. Watercolor, 5⅞ x 8¹/₁₆ inches (14.9 x 20.5 cm).
ÉCOLE DES BEAUX-ARTS, PARIS, EBA 2191.

The use of the image of Rustam for the Sari gateway deserves comment. The image of a literary figure that bridged court and popular cultures must have been deliberately chosen for its mediating function, since the gateway acted as an interstitial space between the palace's private quarters and the public square where the palace was situated. Traditionally, Rustam was considered as the protector of Persian monarchs and was instrumental in their rise to power, so his image would have acted as a visible reminder of the Qajars' legitimacy.

The ruler was assassinated within a year of his coronation, however, before the royal image makers were able to formulate a personalized iconography of power for him. No images of the ruler are known until the very end of his reign or the beginning of Fath 'Ali Shah's,[24] when a dynastic imagery was devised to celebrate Aqa Muhammad's military victories and his unification of the competing Qajar tribes in the establishment of the dynasty.

The Culmination of Life-Size Imagery (1798–1834): Fath 'Ali Shah and the Construction of the Dynastic Image

The reign of Fath 'Ali Shah was characterized by the consolidation of the machinery of power and the formulation of an appropriate poetic and visual language to celebrate the achievements of his reign and that of his predecessor. This visual display of power, developed beyond any previously accepted norms, was utilized in a concerted program proclaiming the arrival of the Qajar dynasty.

The Court of Fath 'Ali Shah

Most scholars agree that Fath 'Ali Shah's reign began in splendor and ended in military and economic failure. Nevertheless, a significant accomplishment of his rule lay in a literary and artistic revival called Bazgasht (literally "return") – in Hamid Algar's phrase, "a consciously promoted minor renaissance."[25] This renaissance and its expression in life-size painting and imagery played a critical role in the consolidation of early Qajar power.

Although in reality Fath 'Ali Shah's power was limited, he reigned supreme within the boundaries of his own court, enabling him to harness, if only for a brief historical moment, the considerable government machinery and manpower required to create, produce, and display a dynastic image, at once imperial and tribal.[26] Fath 'Ali

Shah possessed ample means to accomplish his goals. From his uncle Aqa Muhammad he inherited a relatively stable country, a treasury bursting with jewels from Nadir Shah's conquest of India, as well as architects, painters, craftsmen, poets, officials, and statesmen steeped in Safavid and Zand court culture and Persian history.[27]

The origins of the ruler's cultural and artistic inclinations may be sought well before his accession in 1798, during his youth and governorship (1794–98) of the province of Fars. Fath 'Ali Shah (known as Baba Khan before his coronation), was born in Damghan in 1771. Little is known of his early education. As heir to the throne, Baba Khan received instruction in his kingly duties, tutoring in Persian literature and poetry, and training as a calligrapher. Samples of his calligraphy and manuscripts from his personal library attest to his disposition toward learning and his refined literary tastes.[28] The young Baba Khan's historical interests must have been further reinforced during this period by exposure to the monuments of Iran's past in the Fars region. Thus, when he began to rule, Fath 'Ali Shah viewed himself as the rightful heir to a tradition of Persian kingship rooted in the past.

The process of empowerment of the Qajar dynasty was pursued on multiple levels with a formidable array of vehicles. Political power was consolidated, and a relatively effective centralized administration, army, and bureaucracy established.[29]

One of the principal vehicles for the expression of power was the propagation of numerous progeny.[30] Fath 'Ali Shah fathered more than sixty sons and forty-eight daughters by almost a thousand wives and concubines.[31] In so doing, he emulated legendary Persian kings such as Kayumars and drew upon deep-seated traditions associating political power with potency and fruitfulness. The flower and fruit metaphors utilized by Qajar chroniclers to describe Fath 'Ali Shah's children make this association abundantly clear.[32] The monarch was thereby following the policies set down by his uncle Aqa Muhammad, who had emphasized the need for solidarity among the rival Qajar factions and the creation of a princely class.

The consolidation of power also entailed the institution of an elaborate court ceremonial, on a scale not seen since the late Safavid period.[33] Ceremonies, diplomatic receptions, and feasts – military reviews, fireworks, celebrations of the Persian New Year – and other occasions for pageantry and displays of loyalty were multiplied.

Every aspect of court culture was devoted to the creation of a suitably imperial court and image. Fath 'Ali Shah was provided with an elaborate titulature encompassing ancient Persian as well as Turco-Mongol appellations. A fitting setting was created through massive architectural programs, both religious and secular, and the traditional duties of kingship accomplished by the restoration of holy shrines and the patronage of the religious authorities. Fath 'Ali Shah's restoration of Safavid palaces, however, was a royal innovation introduced by Aqa Muhammad.[34] In addition, changes in court dress and imperial regalia signified the new reign.

A lavish court of panegyrists, known as the Anju-man-i Khaqan, or Society of the Khan of Khans (a Mongol title adopted by Fath 'Ali Shah), was maintained by the ruler, himself a poet of modest talent, to celebrate his reign. Poets, many from Isfahan, flocked to the court to "record every event and action of the ruler."[35] A style of poetry, emulating the Khurasani poets in its panegyrics and the Iraqi school in its lyrical poetry, was adopted. Chroniclers were commissioned by the ruler not only to write the histories of his predecessors, but to record his own rule as well.[36]

On the orders of the shah, the poet laureate, Fath 'Ali Khan Saba, composed the *Shāhanshāhnāmeh* (*Book of the King of Kings*), an epic intended to equate the Qajars with the heroes of Firdawsi's *Shāhnāmeh*. In its time, Saba's text was thought to equal Firdawsi's masterpiece. The ruler himself is recorded as saying that Saba had surpassed his model, since, in contrast to Firdawsi's treatment by his patron Sultan Mahmud of Ghazneh (998–1030), famed for his stinginess, the poet had been rewarded handsomely for his efforts by Fath 'Ali Shah.[37] By such munificence, the shah clearly aspired to emulate and surpass the patronage of his predecessors, particularly Sultan Mahmud.

Fath 'Ali Shah also embraced a role of traditional Persian kingship through his active patronage of court ateliers. Artists illustrated manuscripts of the *Shāhan-shāhnāmeh* (see NO. 33) and restored great classics in the royal library.

To consolidate his authority, the ruler was frequently seen by his subjects accomplishing his kingly duties. While the first two days of the Persian New Year celebrations were devoted to private court receptions, on the third day the shah appeared to the populace in the portal of the Gulistan palace. The ruler could be seen seated on a chair throne, through an opening that gave out upon the citadel square in which public entertain-ments, gymnastic feats, and recitations of the *Shāhnāmeh* were performed. Such court receptions and public audiences provided occasions in which life-size imagery formed a backdrop: the Gulistan palace portal was decorated at the back with tilework images of Rustam.[38]

The transfer of the court from winter to summer residences, inspections of military campaign sites, and the crushing of rebellions also provided opportunities for the public display of the ruler in the provinces.

As numerous travelers noted, nothing exceeded the splendor of the Persian court on ceremonial occasions. Colin Meredith has argued that since the Qajars possessed neither the aura of divine sanctity nor the support of the royal slave corps of their Safavid predecessors, such visual displays were necessary to create a "mystique of authority" and that this mystique was embodied in the person of the ruler. Meredith's vividly phrased comment that "the Shah formed the center of a revolving pageant which he himself seemed to illuminate"[39] offers a near-perfect description of the image of power for which the painters and designers of Fath 'Ali Shah's court were required to find visual expression. This image was not expressed visually, however, solely in the figure of the ruler.[40] Representations of the ruler alone were generally incorporated into complex decorative cycles, and the majority of royal images showed Fath 'Ali Shah in monumental group scenes of enthronement, hunting (see FIG. 14), and battle crowded with numerous supporting figures.

The subject and style of these compositions has been explained in the past primarily by the revival of Sasanian and Achaemenid traditions.[41] Archaizing influences certainly played their part in constructing this visual language. Dynastic imagery was meant to convey not only the imperial nature of the Qajar dynasty, however, but its tribal roots and potency as well. The sheer numbers of the participants and the constant repetition of images in decorative cycles evoke the collective nature of Qajar tribal society.

The ruler's innumerable sons, critical players in the revolving pageant, proclaimed the monarch's fruitfulness and virility, which in turn became synonymous with the empire's continued prosperity. These images were undoubtedly created to erase the image of impotency associated with the castrated founder of the dynasty. Appropriately, the numerous figurants in these images ultimately embody not an absolute monarchy, but rather the limits of the monarch's power and his need to build a strong political consensus.

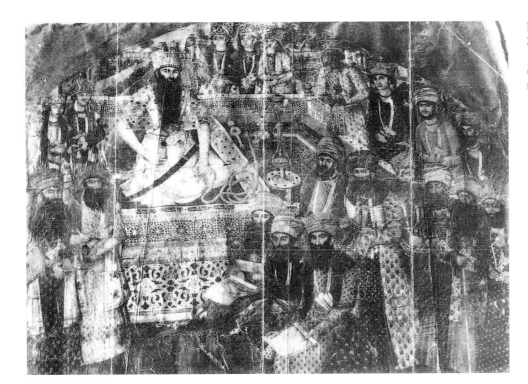

FIG. 10. *Fath 'Ali Shah Enthroned.*
Mirza Baba. Tehran, dated A.H. 1213/A.D.
1798–99. Oil on canvas, 114³/₁₆ x 196⁷/₈
inches (290.2 x 500 cm)
PRIVATE COLLECTION.

Building the Imperial Image

The formulation of the dynastic image can be traced from the early years of Baba Khan's governorship in Shiraz (1794–98) through the imperial commissions of the first two decades of his reign, by which time all major palatine architectural programs had been completed.[42] This massive building program coincided with a period of national confidence and relative prosperity, between the inconclusive results of the first Perso-Russian war (1805–13) and the disastrous defeats of the second (1826–28), which effectively put an end to the imperial and expansionist ambitions of Fath 'Ali Shah.

The construction of a dynastic image was far from Baba Khan's mind during the years in Shiraz. Contemporary descriptions of the figural programs of the palaces built during his tenure reflect the private pleasures and princely pastimes of the heir presumptive, not dynastic aspirations.[43] Their literary subject matter and small-scale format echo the decorative programs of late Safavid mansions and the royal square in Isfahan, and reflect the poetic inclinations of the crown prince.[44] They nevertheless presage the developments of the following phase by the lavish expenditures that they must have required and by a profusion of sophisticated visual imagery.

The emphasis shifted dramatically with the ruler's accession on March 21, 1798. A previously unrecorded painting of Fath 'Ali Shah and his court (FIG. 10), most likely intended for one of the palaces of the Tehran citadel,

vividly illustrates Meredith's comment cited above. Dated A.H. 1213 / A.D. 1798–99 and signed by the painter Mirza Baba, the work is (along with FIG. 6) the earliest recorded official image of Fath 'Ali Shah after his accession. Mirza Baba drew upon his considerable talents as a painter to create an official image emphasizing the magnificence of his master's person, his virility, and the multiplicity of his entourage. The golden radiance of the shah's robe and his jeweled regalia evoke the sacred aura (*farr-i īzadi*) of Persia's ancient kings.[45] The monumentality of the image and the introduction of six of Fath 'Ali Shah's sons and the platform throne were all employed by the Qajar ruler to disassociate himself from his Safavid predecessors, in contrast to Aqa Muhammad's effort to identify himself with them. Prominently displayed verses inscribed on the throne elucidate the image's intent – to show the shah, in his blazing glory with his accoutrements – and proclaim Mirza Baba's pride at having created a prototype dynastic image.[46] The transitional character of this image is evident, however, in Mirza Baba's continued use of the stylistic conventions of Zand painting (see NO. 25).

Nevertheless, our interpretation of this image is necessarily incomplete since it has been detached from its original decorative program, consisting of a cycle of individual images of different themes. Multi-image cycles and monumental compositions of a single or two-part theme are the two principal types of decorative programs of this period.

The first type is best illustrated by reconstructing the cycle of images in the Marble Throne Hall of the Gulistan palace in Tehran citadel (p. 168) as it appeared in the early nineteenth century.[47] The building, which probably dated from the Zand period,[48] was refurbished in 1791, when Aqa Muhammad ordered the transfer of mirrors, oil paintings, columns with twisted shafts, marble panels, and inlaid wood doors from the Shiraz audience hall to commemorate his triumph over Karim Khan Zand.[49]

The audience hall's decoration, incorporating the construction of the Marble Throne, was completed between 1804–5 and 1806–7.[50] The hall's imagery comprised a first register of small polygonal niches with figural representations surmounting a marble dado; a middle register of narrow arched niches with single images and group compositions; and a final register of reverse-glass images in oval format of men and women in European seventeenth-century court costume. The three side walls and arch of the central bay would have held a total of eight or ten paintings. The audience hall, with its throne and images, was reflected and multiplied in the lobed pool situated directly before the structure in the palace courtyard.

The most comprehensive description of the thematic program of the hall was penned in 1824 by the diplomat George Thomas Keppel, who described the subject of three of the paintings (some of which may have been retained from the previous renovation) as Nadir Shah and the Mughal ruler Muhammad Shah, Nushirvan and the Grand Signior, and Iskandar with Aristotle and Aflatun (Plato). Keppel records additional images of a hunt, a battle, and portraits of Fath 'Ali Shah.[51]

The combined images in the niches therefore present the multifaceted guises of Fath 'Ali Shah as warrior, philosopher, hunter, and heir to Persia's ancient kings – visual equivalents of the flattering metaphors devised by his court panegyrists. Depictions of Europeans above the niches refer to the breadth of his domain, and images of women in the side rooms represent the magnificence of his harem.

Although Yahya Zuka, in his study of the Tehran palace complex, maintains that Fath 'Ali Shah made few repairs to the audience hall,[52] these changes certainly appear critical to constructing a sophisticated allegorical visual image, typical of Fath 'Ali Shah's historical and literary interests, that embraced every element of decoration of the hall (as in the Shiraz palaces).

According to the court historian Mirza Sadiq Vaqayi'nigar, Fath 'Ali Shah's carved marble platform throne in the Tehran Throne Hall was constructed by a team headed by the chief court painter, Mirza Baba, from 1804 to 1806.[53] The platform was upheld by figures of female angels, handsome youths, lions, and demons. The platform's balustrade was surmounted by small figurines used to hold bouquets of precious stones, referred to as hyacinths, during ceremonial occasions (seen in FIG. XIV). Inscribed verses by Fath 'Ali Khan Saba state that the throne was modeled on the legendary throne of King Solomon, which literary accounts describe as supported by angels and demons.[54] Given both Aqa Muhammad and Fath 'Ali Shah's eclectic use of the past, the audience hall of the Sasanian palace of Ctesiphon – decorated with images of the victories of Sasanian ruler Khusraw Parviz, and a great throne of the ruler placed at the back[55] – may have provided the model for the decorative scheme of the Marble Throne Hall.

The vision of power encoded in the hall's cycle of images was reinforced by the Solomonic throne and the columns of the defeated Zand rulers. Although the images of hunting and battle recorded by Keppel in 1824 may have included the ruler's sons, in this instance the iconographic program was clearly focused on their father.

The second type of decorative program – monumental compositions of single or two-part themes – was employed during the second decade of the nineteenth century by 'Abdallah Khan, Mirza Baba's successor and chief court architect (*mi'mārbāshī*).[56] His rectangular-format compositions of court gatherings commissioned for the garden complexes of Negarestan and Sulaymanieh were executed between 1812 and 1814. Together, they present a dramatic departure from the compositions of his predecessors. They exemplify a new revival style, at once imperial, dynastic, and tribal, which crystallized the Qajar image.[57]

The Negarestan garden complex and its paintings no longer exist. In its heyday, the garden (situated just north of the Tehran citadel) was a favorite retreat of Fath 'Ali Shah. A cross-shaped pavilion featured tiled representations of Fath 'Ali Shah's ladies with the ruler; the imperial dynastic imagery was reserved for a structure at the far end of the garden.

Fath 'Ali Shah was shown at the center, seated on the Sun Throne in front of twisted Zand columns, surrounded by the royal princes and members of his personal guard. Foreign envoys and high officeholders in two super-

imposed ranks approached respectfully on the side walls of the room. In all, 118 figures are depicted (see NO. 34, FIG. XIV). The isolation of the shah, the uniformity, frontality, and formality of the poses, the repetition, the use of the balustrade to separate the two rows of figures, and the lavish patterning and gilding were skillfully used to convey the magnificence and rigid ceremonial of the imperial court. The three-dimensional imagery, theatrical conception, and iconic stylization vividly communicated the pageantry of the Qajar court to the viewer. The original impact of the paintings was further reinforced by the visitors' approach through kiosks and baths, similar to the steep ascent to the palaces of Sultanieh and Takht-i Qajar, and by their elevation above eye level in the audience hall.

'Abdallah Khan drew upon a range of prototypes in his search to find a visual expression for the grandeur of the court of Fath 'Ali Shah. His indebtedness to the Chihil Sutun reception hall and later seventeenth-century album compositions is clear (see NO. 11). His most immediate source, of course, was the Marble Throne Hall itself, the dynastic symbol par excellence, whose twisted columns and Sun Throne were replicated at the Negarestan. Ultimately, the serried ranks of rigid courtiers bespeak the influence not only of ancient rock reliefs, but also of the ideal image of Persian kingship transmitted through literary sources. 'Abdallah Khan used these manifold historical and visual sources with a remarkable inventiveness, which mirrored the historicizing culture of the Qajar court and thereby created a truly original image of mythical proportions. In its heyday, the Negarestan mural, perhaps more so than any other Qajar representation, successfully projected the desired image of universal power to its audience. However, as the nineteenth century progressed, Europeans were no longer easily impressed by an image of grandeur that flew in the face of the political reality of two Persian defeats in the Perso-Russian wars and the increasing spread of colonialism.[58]

Whatever the judgment of history, an element of fantasy undoubtedly entered into the conception of the imperial imagery of the Negarestan and other palaces of the period. In the frozen time and space of these images, we see Fath 'Ali Shah as he hoped and expected to be perceived by history: in this imagined universe, he is supreme ruler, flanked by a tribe of princes, as envoys of the rulers of the world pay him homage. This image inevitably evokes that of Darius the Great, and the bas-reliefs of envoys bearing tribute that he commissioned for his palace at Tahkt-i Jamshid.

Another variant of 'Abdallah's monumental imperial images, this time emphasizing the tribal nature of the Qajar rulers, is found in the citadel palace of Sulaymanieh in Karaj, the only extant palace with a mural cycle in situ. Commissioned for Prince Sulayman by Sadr-i Isfahani, Fath 'Ali Shah's father-in-law and governor of Isfahan, the murals were completed in 1812–13. The audience hall was embellished with two monumental group scenes, one of Aqa Muhammad and the other of Fath 'Ali Shah (approximately 9 by 16 feet).[59]

The group image centered on Aqa Muhammad depicts the ruler seated on a jeweled platform throne surrounded by the thirteen chiefs of the Qajar tribe wearing armor. The composition acts as a visual equivalent of a genealogical tree or an ancestor portrait, emphasizing the military victories of the Qajars and buttressing the tribe's historical legitimacy. The Qajars' imperial aspirations are conveyed by the painting of Fath 'Ali Shah, shown on the Sun Throne with twelve of his sons, all crowned. The Qajar princes styled themselves "shah":[60] likewise, the princelings are depicted here as kings, supporting Fath 'Ali Shah's title of King of Kings, since he had no foreign vassals to speak of.

The image's primary function as a display of power intended for foreign consumption is corroborated by the numerous European visitors of note who were housed at Sulaymanieh or who were taken there to admire this painting. The inherent contradiction between the Persian perception of their imagery and its aesthetic impact on sophisticated European viewers is illustrated by the English traveler and painter Robert Ker Porter's response to the Sulaymanieh painting. He was escorted to the site in March 1818 by Crown Prince 'Abbas Mirza, who proudly discussed his ancestors and praised the painting itself, which Ker Porter found hard and dry in style.[61]

The citadel palace in Tabriz, the seat of 'Abbas Mirza, and the nearby country palace of Ujan were lavishly decorated with monumental compositions (NOS. 50–52) by painters and designers in 'Abbas Mirza's employ. These flattering portrayals of Fath 'Ali Shah's and 'Abbas Mirza's victories over Russian troops emphasize the Qajar rulers as equal or perhaps superior participants in the Great Game and convey 'Abbas Mirza's qualifications to rule. Other representations of Fath 'Ali Shah with Russian rulers and Emperor Napoleon reflect the often ambivalent relationship of Iran to the colonial powers.

If in Tabriz the Qajar rulers sought to define themselves as equal to European rulers, Isfahan was clearly the

site where they measured themselves in relation to the past. Not only was a new palace – the 'Imarat-i Naw (completed by 1812) – built for Fath 'Ali Shah that was decorated with images of ancient Iranian heroes by the painter Mihr 'Ali, but more tellingly, the monarch redecorated the mid-seventeenth-century palaces of the Hasht-Bihisht for his own use and ordered the restoration of other Safavid structures.[62]

The messages encoded in this palatine imagery were reiterated in both life-size and small-scale imagery of court regalia, lacquerwork, armor, vessels, carpets, and textiles (NOS. 36, 62). Of utmost interest are textile hangings and enameled portrait medallions. In 1817 Moritz von Kotzebuë, attached to the special Russian diplomatic mission that was received by Fath 'Ali Shah in his camp at Sultanieh, described the painted representations of Fath 'Ali Shah's tents.[63] They were designed to surround the ruler, even in the relative informality usually associated with encampments, with all the ceremonial grandeur of the Tehran court. George Keppel, during his 1824 sojourn in Tabriz, also recorded that "canvas walls, *sarpardeh*, painted with fierce-looking soldiers closed in the walks leading to the tent of Prince Qahriman Mirza,"[64] serving both to intimidate the visitor and to protect the owner.[65]

Finally, the cult of the ruler finds its fullest expression on a personal and miniature scale in the enameled portrait medallions worn by members of the royal family and aristocracy as emblems of loyalty or service (depicted in NOS. 47, 71, 72, 76).[66]

Sending the Image Abroad: 1806–22

The early nineteenth century brought the first contacts with European powers and Russia since the early eighteenth century and necessitated the formulation of an image of Persian power abroad. Extant manuscripts of the *Shāhanshāhnāmeh* (NO. 33), anthologies of the ruler's poems, enameled regalia and chargers, and histories of the reign testify to the magnificence of the royal image. Above all, life-size paintings acted as portable vehicles projecting the image of Qajar authority abroad, and were in this way similar to the portraits exchanged between European rulers from the sixteenth to eighteenth centuries. On a subliminal level, such images were expected to provoke in the foreign viewer the same admiration and even veneration that were displayed by the ruler's subjects.[67]

More than fifteen extant single portraits of Fath 'Ali Shah were sent as diplomatic gifts during the first two decades of the nineteenth century (circa 1806–22)

to the rulers of England (and their viceroys in India), Russia, France, and the Kingdom of Sind (in northwestern India). The imagery of the paintings in this group – dated from 1798 to 1822 – conveys the first Persian reaction to the very real possibility of foreign domination. Collectively, they project an implied threat (the ruler's prominently displayed sheathed sword); allude to the ruler's justice (the sword and mace); and evoke an image of wealth (the regalia and furnishings).

A single monumental group composition surviving abroad depicts Fath 'Ali Shah hunting in a verdant landscape with twenty-two of his sons, each and every one identified (see FIG. 14b).[68] Here, perhaps more than in any other image, the scale of the ruler in contrast to that of the multitude of attendants, the power of his steed, and the act of impaling the lion with his lance are utilized to evoke a masculine world of virility and strength. Associations with the Taq-i Bustan relief depicting the boar hunt of the Sasanian ruler Khusraw II (A.D. 590–628) and the paradisiacal pleasures and gardens of the Sasanian glories are summoned forth. On a deeper psychological level, the ruler's power is associated with the defeat of a lion – a seminal image of Achaemenid reliefs. Persian epic heroes such as Rustam, Alexander, and Bahram Gur are known for their combat with lions and sometimes had to defeat lions to attain the throne. Here Fath 'Ali Shah's sons are shown subduing lesser prey, symbolically supporting their father and ruler.[69]

Carved marble bas-reliefs depicting Crown Prince 'Abbas Mirza, probably in imitation of European practices, were also commissioned (see NO. 43). A bas-relief intended as a gift to the English ruler was eulogized in a poem by Fath 'Ali Khan Saba. The poem conveys the prevailing idea that images could act as substitutes for the ruler[70] and reflects the belief that images were endowed with magical powers, as will be discussed in the second part of this essay.

Rock Reliefs and the Crumbling of the Imperial Image

During the second and third decades of the nineteenth century, rival claimants to the throne appeared among the princes of the royal house to challenge their father and his designated heir, Crown Prince 'Abbas Mirza. In the third decade of the nineteenth century, the Qajar monarch and his prince-governors commissioned monumental figural rock reliefs, all but one still endowed with lengthy and prominently placed inscriptions. The reliefs commissioned by Prince Muhammad 'Ali Dawlatshah

(Kirmanshah), Husayn Quli Farmanfarma (Shiraz), and Timur Mirza (Kazirun) show the waning of absolute patrimonial authority of the monarch among his quarrelsome sons.[71]

With these images, the principal sphere for the expression of dynastic aspirations at home shifted from the private world of royal palaces to that of the highly visible public sites where the reliefs were located. More than any other art form of this period, these reliefs vividly articulate the visual display of power and the revival of Achaemenid and Sasanian artistic traditions. Furthermore, by commissioning these monumental public images of themselves, Qajar patrons appeared to be in direct contravention of Islamic law.

In order to maximize their impact, the reliefs were sited in locations associated with Persia's ancient past, popular beliefs, or religious practices (in the same way that rulers arranged to be buried in holy shrines).[72] Husayn Quli Mirza's relief in Shiraz is situated at the Qur'an Gate, through which all travelers to Shiraz pass, near much-frequented shrines, and Taq-i Bustan, the site

of Muhammad 'Ali Mirza's relief, was commonly visited by European travelers.

The visual message of these images was conveyed by universal symbols of royalty and power. Most striking among these is the lion, which evoked subliminal associations with images of combat or submission of this beast.[73] Traces of paint on the reliefs betray an intention to make them appear as lifelike as possible. The message of the reliefs was explicated by surrounding inscriptions as well as by the extremely stylized and symbolic images, thereby appealing to both educated and popular classes.

Although these sites were seen by numerous European travelers,[74] the reliefs were not always successful at communicating their message. By the late nineteenth century, Fath 'Ali Shah's reputation had suffered considerably, owing to the loss of territories in the wars of expansion, the empty treasury, and the rapacity of local governors and agents. Fath 'Ali Shah's inspired *folie de grandeur* had required an immense expenditure of resources, exhausting the nation and blackening this ruler's reputation in history. In his memoirs, 'Abdallah Mustawfi ridiculed Fath 'Ali Shah's attempt to be portrayed as a lion tamer in the relief at Rayy (FIGS. 11a,b). Even more damningly, he added that the ruler propagated "historical lies."[75]

Mustawfi's views reflect the more skeptical attitude of the educated class in late nineteenth-century Iran; but how did Iranian spectators of the early nineteenth century respond? If evidence of the outward respect paid to images and edicts of the ruler is any indication, the populace and courtiers alike were more easily convinced, at least during Fath 'Ali Shah's lifetime.

FIGS. 11a,b. *Fath 'Ali Shah at the Hunt; The Court of Fath 'Ali Shah.*
'Abdallah Khan. Rayy, circa 1820–30. Rock reliefs.

THE POWER OF IMAGES

Religious Beliefs and Court Imagery

Nineteenth-century Iran was, in many respects, a society where superstitious beliefs regarding the power of images prevailed. Investigation of these beliefs is critical to understanding the psychological and emotional significance of life-size imagery during this period.

Scholarly interest in these meanings of pictures has been colored by the perception of Persian culture as highly literate and has been repressed in favor of the study of the narrative constructions of the illustrated manuscript.[76] Scholars of Islamic art may have been reluctant to examine this sensitive issue, disinclined to admit the existence

of ritual practices using imagery that are uncomfortably akin to idol worship.

Royal images were incorporated into the ceremonials and spaces of both court and popular culture during the reign of Fath 'Ali Shah and, to a lesser extent, during the reigns of his successors. The veneration commanded by pictures of Fath 'Ali Shah struck European visitors to Iran in the first two decades of the nineteenth century. Sir John Malcolm noted how a portrait of Fath 'Ali Shah intended for the ruler of Sind was accorded the same respect as the sovereign himself when carried through the streets,[77] notwithstanding the fact that the portrait was already packed in a box and could not even be seen. In 1817 Moritz von Kotzebuë remarked on the respect with which Persians treated portraits of the ruler and observed that the portraits of Fath 'Ali Shah destined as gifts for Tsar Alexander I (r. 1801–25) were carried with great ceremony through the camp at Sultanieh by the officers of the Russian mission, in observance of this custom.[78]

The behavior of Fath 'Ali Shah's ambassador Abu'l Hasan and other Persians toward images of the ruler stands in marked contrast to the sophisticated aesthetic attitudes held by nineteenth-century Europeans. Imagery had long ceased to have such iconic significance in Europe, although state portraits, even in the nineteenth century, continued to act as political symbols.[79]

The veneration of imagery substituting for the ruler on ceremonial occasions continued throughout the nineteenth and early twentieth centuries. According to Haj Mirza Hasan Husayni Fasa'i, on July 6, 1848, a splendid portrait of Nasir al-Din Shah was displayed at a banquet inaugurating a dam in Shiraz. After the local officials had finished dining, they each put a sum of money as an offering (pīshkish) in front of the painting, inclining their heads and bowing from the hips.[80] A circa 1907 photograph of a crowd carrying the portrait of Muhammad 'Ali Shah (r. 1907–9) to the National Assembly (FIG. 12) illustrates how the tradition of utilizing imagery to make the ruler present and visible on ceremonial occasions prevailed.

In addition to such pictures of Fath 'Ali Shah, mural cycles were commissioned for the bazaars of Isfahan and Shiraz. In these cycles, images of Fath 'Ali Shah and his sons were displayed together with battle scenes, hunts, and representations of legendary heroes and poetic themes such as Shaykh San'an. These cycles functioned as intermediaries between the court and the people, in the same manner as the life-size representations of the hero Rustam that were displayed in palace gateways linking court and urban spaces.[81]

European travelers record oral recitations around these life-size images by popular storytellers attended by large public audiences.[82] In a similar manner to poetic recitations at court, the rulers were associated in the public mind with the heroic feats and chivalry of ancient epics and popular myths.

During Fath 'Ali Shah's reign, life-size representations of the ruler were introduced in shrines and royal mausoleums. From this time on, imagery in religious contexts would receive official government sanction in Iran. As we have shown in other spheres, no previous ruler had recognized as keenly the power that images could hold

FIG. 12. *Ceremonial Procession with Portrait of Muhammad 'Ali Shah.*
Photograph, Tehran, circa 1907.

in Iranian society or exploited their use as systematically. This ruler who so readily adopted the language of ancient Iran for his rock reliefs likewise recognized the advantage of associating his image with holy shrines.

In 1794–95 Fath 'Ali Khan Saba composed a poem dedicated to a life-size representation (timsāl) of the ruler. According to Saba, the work was intended as a gift for one of the holiest shrines of the Shi'ite faith, the shrine of Imam Musa ibn Jàfar at Najaf, in present-day Iraq.[83] This otherwise unrecorded painting is also the earliest known life-size image of the ruler, executed when he was still governor of Shiraz. In the year preceding his death, the ruler commissioned a marble sarcophagus with his own life-size image for his tomb in Qum (FIG. 13).

Subsequently, as the use of royal imagery became accepted, similar sarcophagi were commissioned for the tomb of Mahd Ulya, the mother of Nasir al-Din Shah, also buried in Qum, and for the tomb of Nasir al-Din Shah himself in Shah 'abd al-'Azim.[84] The Qajar nobility and merchant class followed suit from the mid-nineteenth century onward, and memorial portraits in tombs became widespread in Tehran and the provinces.[85]

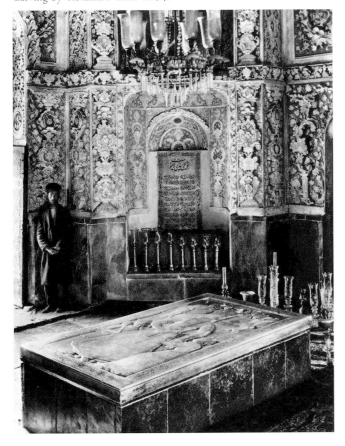

FIG. 13. *Tomb of Fath 'Ali Shah in the Sanctuary of Qum.* Carving by 'Abdallah. Circa 1834.

A life-size image of Nasir al-Din Shah was displayed in conjunction with that of the Imam 'Ali at his funeral, and other images were used as decoration for the Takieh Dawlat theater built by Nasir al-Din Shah for performances of the Persian passion play (tàzieh).[86]

Such practices may be partly explained by deep-seated beliefs that images were invested with life. The elaboration of court ceremonial during the reign of Fath 'Ali Shah and the promotion of a mystique of authority readily explain the incorporation of life-size images of the ruler in court-related activities and popular gathering places. The explanation for the almost-religious veneration expected for these images, the donations of such works to shrines, and the commissions of figural sarcophagi, however, should be sought in the realms of popular piety and ritual beliefs.

Graphic descriptions of superstitious practices associated with images explain the powers attributed to life-size imagery by the court milieu, where geomancy and divination were commonly relied on.[87] A mid-seventeenth-century Persian source records how a "sorcerer" fashioned mutton grease into a figural effigy and utilized pins, candles, and incantations to dispose of his enemy.[88] Similar procedures were used by some members of the religious classes in early nineteenth-century Iran.

A frequently cited incident of 1806 concerns the theologian Mirza Muhammad Akhbari (also known as Nishapuri) of Bahrayn during the first Perso-Russian war. In order to convince Fath 'Ali Shah to abandon his support of one religious faction in favor of another,[89] Mirza Muhammad vowed to have the head of the Russian general Tizianov (known as Ispokhdur to the Turks and Persians) brought to Tehran within forty days. The ritual murder of Tizianov is recorded in two different versions. According to Muhammad ibn Sulayman Tunkabuni's *Qisas al-'Ulamā*, Mirza Muhammad molded a wax figure of the general and decapitated it with a sword.[90] In his history of the Qajar period, Fasa'i based a variant account on an eyewitness description from Lisan al-Mulk's court chronicle:

> *Haj Mirza Muhammad retreated to the hermitage of the shrine of Shah 'Abd al-'Azim, drew a picture of a man resembling Ispokhdur. . . . He had tied a rope round himself and fixed both ends of it at the two sides of the picture. . . . He stared at the face of the man in that picture in such a way that both his eyes were suffused with blood, and he uttered words*

without interruption. He took a knife and dug it into the chest of the picture. Having done this he left the hermitage and said: "Ispokhdur has been killed at this moment." [91]

This is compelling evidence indeed that mural painting performed much the same function in magic rituals as wax effigies. To adopt David Freedberg's phraseology, they literally "re-presented" their subject.[92]

Religious rituals reflected similar beliefs in the negative power of images. Jean Calmard's study of popular seventeenth-century religious ceremonies commemorating the battle of Karbala during Muharram documents the use of effigies of the murderers of the Shi'ite saints at the battle. Such effigies, in the form of painted representations, statues, and straw mannequins,[93] were ritually cursed, burned, and destroyed during the ceremonies and pageants that were promoted by the Safavids as vehicles of state policy.

Calmard's study also documents beliefs in the positive power of images. Portable images of the Imam 'Ali and other Shi'ite saints (*shamāyil*) were used during the same ceremonies and presumably continued in use in the eighteenth and nineteenth centuries for ambulatory public religious rituals associated with the development of the *ta'zieh*.[94]

During this same period permanent images began to be displayed in shrines and mausoleums. Scattered references to the use of memorial portraits in mausoleums of saints occur from the late seventeenth century, although Safavid rulers did not commission images for the decoration of their tombs.[95] We may therefore conclude that the use of imagery in shrines introduced by Fath 'Ali Shah was influenced by the use of devotional images in popular religious practices and the veneration of shrines.

The presence of images in holy shrines (*imāmzādeh*) is documented in Henri Massé's definitive 1938 study of popular customs.[96] Massé also describes sacred water fountains (*saqqākhānehs*), dedicated to the Imam Husayn or 'Abbas, martyrs of the battle of Karbala, decorated with images (see FIG. 35)[97] and the wide distribution of sculptural ornamentation in a variety of burial formats.[98] The use of stone bas-reliefs in tombs by Fath 'Ali Shah and his successors is certainly related to this practice.

Such traditions appear to fly in the face of all accepted evidence regarding the Islamic prohibition against any type of imagery in religious contexts. The attitude of the religious authorities (*ulamā*) toward the use of imagery

may clarify this seeming contradiction. Their position on sculpture and bas-reliefs is relatively well documented and appears to have been dictated by pragmatic concerns rather than by a consistent application of Islamic law.

In the case of the numerous bas-reliefs and rock reliefs of Fath 'Ali Shah and his family, religious censure was avoided. Nor were any objections raised to the traditional-style rock relief of his great-grandson Nasir al-Din Shah (r. 1848–96) and his court at Firuzkuh, commissioned to commemorate the construction of a new thoroughfare, the Haras road, to the Caspian Sea.[99]

When Nasir al-Din Shah overstepped the bounds of traditional kingship in 1888 by commissioning a European-style equestrian statue of himself (see NO. 89), however, the religious authorities protested violently.[100] The form of the sculpture not only subverted acceptable images of Persian kingship introduced by his grandfather, but also symbolized foreign intervention in Persian affairs. This instance demonstrates how easily the line between acceptable forms of royal imagery and idolatry could be crossed in the later nineteenth century. The prohibition of imagery in Islam often led to episodes of the destruction of images. Whereas none of the rock reliefs or bas-reliefs commissioned by Fath 'Ali Shah and his successors show evidence of the mutilation associated with iconoclastic episodes, Nasir al-Din Shah's statue became a hated symbol of Qajar rule and was subsequently torn down.

Reaction on the part of the *'ulamā* toward images most likely depended on the relations between the ruler and religious leaders. Fath 'Ali Shah maintained close relations with the *'ulamā*, whereas his successors had increasing difficulty in maintaining this balance of power. Another explanation for inconsistencies in religious policy may be that images were deemed acceptable when they utilized the vocabulary of ancient Iran or were located in a court context.

The *'ulamā*'s attitude suggests that the use of imagery as political propaganda was accepted in Persian society. Imagery had been effectively used to excite political passions since the sixteenth century, whether against Sunni Turks in the Safavid period or against the Afghans under Fath 'Ali Shah's successor, Muhammad Shah, during the disastrous campaign to conquer Herat.[101] The Tizianov effigy episode also demonstrates the *'ulamā*'s willingness to use imagery for political gain.

The authorities' pragmatic approach must also have been dictated by the prevalence of imagery in a wider socio-

economic context than has been previously known, as was the case with their tolerance of popular religious festivals, which also challenged the traditions of orthodox Islam.[102] One may therefore conclude that iconoclasm in Qajar Iran was sporadic in nature and primarily associated with periods of political ferment.

These numerous instances document that the prohibition against imagery was far less prevalent in Iran than elsewhere in the Islamic world. By the nineteenth century the use of figural imagery had become ingrained in court, popular, and religious practices. Life-size imagery culminated in the early Qajar period, when the manifold uses of imagery at all levels of society mutually reinforced their power.

The quest for dynastic legitimacy during this period led to a concerted attempt to find a visual language common to the two milieus of court and popular culture, which had separate but often overlapping figural traditions. Not only mural painting, but also rock reliefs, shrine and bazaar imagery, and ambulatory processions provided unparalleled public visibility for life-size imagery.

CONCLUSION: IMAGES, HISTORY, AND IDENTITY

Through the constant picturing of himself, his court, and his accoutrements, Fath 'Ali Shah sought to establish his power as leader of the Shi'ite community, mediator between social orders,[103] and heir to the ancient traditions of Persian kingship. Life-size painting of this period was the visual expression of a self-consciously historicizing ruler and culture. As Charles Texier noted in 1838, when viewing the paintings of the Chihil Sutun palace: ". . . [T]he Persians attach great value to these compositions, which constitute their galleries of historical painting."[104] We may infer that images provided Persians with an idealized view of their past, parallel to the better-known epic and oral tradition.

Fath 'Ali Shah consciously utilized imagery as a vehicle for the formulation of a Persian self-image – albeit centered on his own person – well before the better-known manifestations of the Nasiri period (1848–96). He thus emerges a precursor of the later Persian search for identity. Until primary texts of the period are more accessi-

ble, early Qajar imagery – through the intermediary of the imperial and tribal dynastic imagery invented for its greatest patron – provides us with an idealized visual history of how the period pictured itself.

In the final analysis, early Qajar representations present an artificial image of splendor, which did not reflect historical reality. Early Qajar painting and imagery actually constituted a visual "divorce from reality."[105] By the end of Fath 'Ali Shah's reign, royal princes, once the flowers of the Persian garden, became as common as lice, to quote a popular proverb.[106] Palaces and fortresses crumbled, territories were lost. The ruler's image, now tarnished, was no longer venerated and adored.

The indifference of Fath 'Ali Shah's successor, Muhammad Shah, to the monuments of his grandfather, the destruction of Fath 'Ali Shah's palaces in the Tehran citadel by Nasir al-Din Shah in the name of progress, and pure neglect, all but obliterated this chapter of the Persian figural tradition. By the third decade of the nineteenth century, the tide had changed and public opinion had turned against Fath 'Ali Shah. His artistic achievements were only briefly recorded by Persian historians and were appreciated for their documentary value alone by orientalists such as George Curzon and S. G. W. Benjamin.

In seeking to understand the function and impact of royal imagery in the early Qajar period, it is imperative to recall that the emotional and psychological power of these images was based on a great visual heritage. Fath 'Ali Shah's bas-reliefs and images elicited the same reverence accorded to religious images and drew on a tradition of submission to stylized and idealized images of ancient Iranian rulers and their successors. At the same time, the vivid palette, rich materials, and decorative patterning of these images was intended to evoke an aesthetic admiration usually reserved for Persian manuscript painting.

Let us now reclaim for Qajar painting a measure of its original significance as a powerful vehicle for the expression of Persian culture and its aspirations. Whether singly or as elements of decorative ensembles, these works immediately conjure images of immense power, boundless wealth, and potency. Let us return, finally, to the image of Fath 'Ali Shah that so impressed his ambassador. In a sense Abu'l Hasan's comments clarify the intention of the image, from the perspective of the image itself.[107] For what do Qajar pictures want, but to be admired for their splendor, loved for their beauty, obeyed for their power – in short, venerated as the center of the universe!

1. Abu'l Hasan Khan 1988, 75. The Qibleh of the Universe was one of Fath 'Ali Shah's titles. The *qibleh* points the direction to Mecca, to which prayer is oriented.

2. Abu'l Hasan Khan 1988, 90. The veneration of images and effigies, for both political and religious reasons, was widespread in the Western world from the time of ancient Rome and the age of Byzantium. See Belting 1994, 44–45, 102–7. As recently as the reign of Louis XIV of France (1643–1715), images of the ruler were commonly utilized as a means of state propaganda. See Burke 1992, 9. State portraits continued to be displayed in official residences and government administrative offices throughout the eighteenth and nineteenth centuries.

3. See Arnold 1928, 4–13; Nasrin Rohani, *A Bibliography of Persian Miniature Painting* (Cambridge, Massachusetts, 1982), "Islam, Attitude towards the Arts," 153; Freedberg 1989, 55–56.

4. By the Qajar period, there existed a 2,000-year-old indigenous tradition of life-size imagery in painting and sculpture. Although historical and visual sources for the use of imagery in the Sasanian and Ghaznavid eras exist, only the later Safavid period is sufficiently well known to permit an examination of the subject in a broad social context. For overviews, see Morgenstern 1979, vol. 3, pp. 1384–90; and Basil Gray, "The Tradition of Wall Painting in Iran," in Ettinghausen and Yarshater 1979, 313–31. The persistence of this tradition in spite of Islamic strictures against imagery is documented by the striking visual and thematic parallels between Qajar painting and Soghdian and Ghaznavid prototypes. See Soudavar 1992, 14, and Schlumberger 1952, fig. 1.

5. See especially Robinson 1964; Robinson 1983; Falk 1972; Zuka 1963, part I, pp. 19–27, part II, pp. 16–34; individual artists' entries in Karimzadeh Tabrizi 1985–91; and Kleiss and von Gall 1977, 325–29.

6. See Texier 1842, vol. 1, p. 125, for a similar judgment. In other areas of the Islamic world, as well, Central Asian and Indian indigenous traditions of life-size painting and sculpture continued long after the advent of Islam in the seventh century.

7. Robinson 1964, 96.

8. Landscape and still life form separate categories of investigation beyond the parameters of this study. For a brief discussion of this topic, see NO. 64.

9. See Hambly 1991; Jennifer Scarce, "The Arts of the Eighteenth to Twentieth Centuries," in Avery, Hambly, and Melville 1991, 892; Scarce 1983, 329–51.

10. As would be expected, richness of decoration was connected to social class. The public quarters of lesser court functionaries were equipped with more modest decorative schemes featuring niches, and decorated with prints or floral designs; those who could afford it displayed portraits of rulers and princes; further down the social scale, plain whitewashed walls were the standard type of interior decoration.

11. The map here (FIG. 7) is based on a broad selection of foreign travel accounts and Persian sources: see Stuart 1854, 14, 160, 165, 209–10, 265–66; Lerner 1976, 207–60, for Shiraz; Salih Shirazi 1984, 7, for Isfahan; Hunarfar 1965, 750–51; Saba 1962, 214–17, for lost palaces; Vaqayi'nigar n.d., folios 410–48; and Hidayat 1960, 137–38.

12. Four palaces of this type are recorded: Sultanieh; the two Takht-i Qajar palaces in Shiraz and Tehran; and Bar Furush. See Vaqayi'nigar n.d., folios 410–11, 420, 442, 444, and Hambly 1972, 90.

13. For a reconstruction of the Sasanian palace of Shirin near Shiraz, which Sultanieh resembles, see Georgina Herrmann, *The Iranian Revival* (Oxford, 1977), 130.

14. Rectangular, lunette, large and small rounded niches, elongated pointed niches, oval shapes, and medallions were common. For the most lavish example of palace decoration, see the Marble Throne Hall described in this essay.

15. For a balanced evaluation of the ruler, see Gavin Hambly, "Agha Muhammad and the Establishment of the Qajar Dynasty," *Royal Central Asian Journal* 50 (1963): 161–74.

16. This was not the case with the Zands, who were for all intents and purposes erased from the historical record unless they contributed to the promotion of the Qajar image – such as in their role as worthy adversaries in the tradition of Turanians in the illustrations of the *Shāhanshāhnāmeh*. See Robinson 1976a, 244–49 folios, 1240–77.

17. The former is inscribed: "Bi ḥasb al-ḥukm-i shāhanshāh-i dawrān, firaydūnfar Muḥammad Khān Qājār, zi kilk-i Ṣādiq naqqāsh naw shud, nishān va farr-i Nādir Shāh Afshār" (On the order of the King of Kings of Eternity, Muhammad Khan Qajar, with the royal aura of Firaydun, the image and royal aura of Nadir Shah Afshar was renewed by the design of Sadiq the painter). Hunarfar 1965, 574. For the dating, see Texier 1842, vol. 2, p. 130, and Salih Shirazi 1984, 6–8.

18. Although Fath 'Ali Khan Qajar (d. 1726), Aqa Muhammad's grandfather, was Nadir Shah's chief rival for influence with Shah Tahmasp II and Nadir is generally held responsible for his death, Aqa Muhammad nevertheless aspired to emulate his military conquests (Hambly 1963, 171), and Nadir Shah was spoken of with great admiration by Qajar chroniclers such as Dunbuli (1972, 5).

19. Although Aqa Muhammad minted coins in the captured cities of the southern Caucasus (Hambly 1991, 145–46), his ambition to reconquer the former Safavid territories of the southern Caucasus and eastern Iran was only partially fulfilled.

20. See Hommaire de Hell 1855–56, 176. These palaces are usually assigned to the reign of Fath 'Ali Shah (Hambly 1972, 96, n. 40).

21. Saravi 1992, 109–10; James Fraser, *Travels and Adventures in the Persian Provinces on the Southern Banks of the Caspian Sea* (London, 1826), chapter 4, pp. 41–42, and Stuart 1854, 260.

22. Scarce 1988, 333. See also Morier 1818, 376–77.

23. Morier 1818, 376–77, notes that in the Sari palace portraits of women were located in large rooms flanking the audience hall.

24. See Saravi 1992, for exquisite illustrations featuring an idealized Aqa Muhammad from the *Tārikh-i Muḥammadi* (National Library, Tehran, manuscript number and date not given). Since Saravi completed his text in 1796–97, the illustrations cannot be earlier than that date.

25. Algar 1969, 71; see also Gulmuhammadi 1971, 98.

26. Fath 'Ali Shah presents striking parallels with sixteenth- and seventeenth-century European monarchs such as Louis XIV of France and Philip II of Spain (1527–1598), who also utilized art and imagery to consolidate their power. Louis XIV's celebrated phrase "L'État c'est moi" (I am the state) applies equally to Fath 'Ali Shah. See Vaqayi'nigar n.d., folios 388–93, and Mustawfi 1992, vol. 1, p. 37.

27. See Vaqayi'nigar n.d., folios 488–95; Mustawfi 1992, vol. 1, p. 38; Amanat 1993, 37; and Hambly 1991, 152–55.

28. See Anthony Welch, *Calligraphy in the Arts of the Muslim World* (Austin, Texas, 1979), 160–63, nos. 67–68, and Hidayat 1960, 104–5, and Diba 1994, 160–63, nn. 67–68. For a discussion of Fath 'Ali Shah's intelligence and the originality of his poetry, see Hambly 1991, 148. On his erudition, see Algar 1969, 63.

29. Coinage with the image of the ruler was also minted. First cited by Robinson 1964, 96. Priscilla P. Soucek has discussed the significance of this act in an unpublished paper delivered to "Historical and Cultural Issues of the Post-Safavid and Qajar Periods," a colloquium held at Brooklyn Museum of Art, February 24, 1995.

30. Sons were prominently listed first in the enumeration of the achievements of rulers (Vaqayi'nigar n.d., folios 286–87, and Lisan al-Mulk Sipihr 1875, 1965 ed., vol. 2, pp. 125 ff.) See Malcolm Yapp, "Two British Historians of Persia," in *Historians of the Middle East* (London, 1962), 354–55, for a similar emphasis on virility in Percy Sykes's *History of Persia*.

31. See Hasan Gulmuhammadi, *Fath 'Ali Shah va Qiẓāvat-i Tārikh* (Tehran, 1989), 477–89; Jahangir Mirza 1948, 220–21, gives fifty-three sons and sixty daughters. On the size and character of Fath 'Ali Shah's harem, see Amanat 1997, 19.

32. See Fasa'i 1972, 36; Jahangir Mirza 1948, 186. As Abbas Amanat (1997, 8) has observed, the monarch was at the top of the pyramid of a patrimonial society.

33. For the court at the height of its splendor, see Malcolm 1815, vol. 2, pp. 554–57; Ker Porter 1821, vol. 1, pp. 325–29; Pierre-Amédée Jaubert, *Voyage en Arménie et en Perse fait dans les années 1805 et 1806* (Paris, 1821), 202–9; and Dust 'Ali Khan Mu'ayyir 1983, 48–49. For the court in decline, see James Baillie Fraser, *A Winter's Journey from Constantinople to Tehran* (London, 1838), vol. 2, p. 103;

34. See Algar 1969, 46–49, for the ruler's religious patronage; for Safavid restorations, see Salih Shirazi 1984, 6–8; for Fath 'Ali Shah's restoration of the Mongol capital of Sultanieh for his new palace and city of Sultanabad, see Hambly 1972, 89–98.

35. See Hommaire de Hell 1855–56, 185.

36. See Jan Rypka, *History of Iranian Literature* (Dordrecht, 1956), 117–18, for the origins of the term *bāzgasht*. See Fasa'i 1972, xiv, for more than nineteen histories of the period, all but a few unpublished.

37. See Saba 1962, 38.

38. Zuka 1970, 37–38.

39. Meredith 1971, 61.

40. See Ker Porter 1821, vol. 1, pp. 322–23, where he notes that the ruler's sons were arrayed on either side of the throne on ceremonial occasions; and Malcolm 1815, vol. 2, p. 555.

41. Robinson 1964, 97.

42. This conclusion is based primarily on the evidence of European sources corroborated by Vaqayi'nigar n.d., folios 410–48; and Salih Shirazi 1984, passim. Only the Marble Throne Hall in the Gulistan palace and the palaces of Erivan and Sulaymanieh in Karaj are extant. Palaces recorded in sources include those of Qum, Qazvin, Damghan, Kashan, Zavareh; and the 'Ishratayn, 'Imarat-i Badgir, and 'Imarat-i Bulur in the Gulistan palace.

43. Lerner 1976, 213.

44. See Babaie 1994, 166–68, and Karapet Karapetian, *Isfahan, New Julfa: The Houses of the Armenians* (Rome, 1974), figs. 59, 61, 63, for images of the Seven Wonders of the World.

45. See Soudavar 1992, 14, 410–15.

46. "Īn pardeh dilfarīb va farjāh āmad, tashbīh-i basāṭ-i Shāh-i Jamjāh āmad, chun pardeh dar ān tābān mihr, timsāl-i rukh-i Fath 'Ali Shāh āmad, Mīrzā Bābā shabīh-i khusravān naqsh bast, kih az shabīh-i ū qalam-i ṣūratgar qudrat shikast, sanah 1213."

47. The appearance of the hall is remarkably well documented. See Mirza Baba's 1802 watercolor depicting Aqa Muhammad in the hall with a life-size painting of a seated ruler in the background (Robinson 1991, pl. 9). The watercolors of Jules Laurens and Eugene Flandin of the 1840s and late nineteenth-century photographs show how the ideological program of the hall – owing to the very flexible system of niches whose images could be cut out or painted over – was altered under subsequent rulers: at least four different portraits of Fath 'Ali Shah are recorded in the same niche. The current state probably reflects twentieth-century alterations to the late nineteenth-century decoration.

48. See Zuka 1970, 7–8, 47; Perry 1979, 242.

49. Zuka 1970, 46.

50. Vaqayi'nigar n.d., 382–85; first cited in Zuka 1970, 49–50. This scheme and the dynastic message it conveyed was replicated in the palaces of Erivan, Takht-i Qajar Tehran, and Sultanieh. See Adle 1996, 357–65, and Hambly 1972, 89–98, respectively.

51. See Keppel 1827, vol. 2, pp. 140–41.

52. Zuka 1970, 48, cites as additions the images of ancient rulers, beautiful youths and maidens, and verses in praise of the ruler.

53. Vaqayi'nigar n.d., folios 383–85.

54. Ibid.

55. André Godard, *The Art of Iran* (London, 1965), 217.

56. 'Abdallah succeeded Mirza Muhammad Razi Tabrizi as the royal architect (Vaqayi'nigar n.d., folio 432). See Ekhtiar essay in this volume for 'Abdallah's biography.

57. Similar compositions were utilized for the Shiraz palaces of the Takht-i Qajar and Baq-i Naw; see Lerner 1976, 216.

58. George Curzon would label the Negarestan murals a "historical anachronism." Curzon 1892, 338–39. S. G. W. Benjamin, America's first envoy to Iran, perhaps more sensitive to the Qajar ethos, viewed this work as a "magnificent historical painting." Benjamin 1887, 75. Nevertheless, the mural retained its dynastic and artistic significance for the Persian people, to judge from the continued use of the Negarestan palace for Muhammad Shah's private investiture (Zuka 1970, 63), late nineteenth-century renovations, and the life-size copy commissioned in 1904 (before the palace was torn down) from the painter Samsam Zu'lfaqari, Musavvar al-Mamalik (Archaeological Museum, Tehran). Numerous small-scale copies were also commissioned for the European market (NO. 34).

59. It is unclear whether representations of European beauties described by late nineteenth-century travelers were part of the original decorative scheme. See Lady Sheil [Mary], *Glimpses of Life and Manners in Persia* (London, 1856), 115–16.

60. See for instance, 'Abbas Mirza in *Shāhanshānāmeh* text, folio 380 verso, and Amanat 1993, 52.

61. Ker Porter 1821, vol. 1, pp. 303–4.

62. Ouseley 1819–32, vol. 3, p. 372, cited in Robinson 1964, 103–4, and Salih Shirazi 1984, 6–8, 13. Eugene Flandin's illustrations of the Hasht Bihisht palace in the 1840s document the visual presence of images of the ruler and his family in the daily life of his subjects as well as the indifference to the ruler after his death. Flandin and Coste 1845–54, pl. XXXVI.

63. Kotzebuë 1819, 266.

64. Keppel 1827, 329.

65. The appearance of these works may be deduced from surviving complete mid-nineteenth-century examples with life-size images of Fath 'Ali Shah, his wives, and princes. For a royal tent, see *European Oriental Rugs, Carpets and Textiles*, sale cat., Sotheby's, London, April 24, 1991, 16, lot 12; felt hangings are located in the collection of the State Hermitage Museum, Saint Petersburg; Negarestan Museum, Tehran; Bern Historical

Museum; and Private collections, Houston and London. In the late nineteenth and early twentieth centuries, royal imagery came to be applied to carpet production as well. See Parviz Tanavoli, *Kings, Heroes and Lovers* (London, 1994).

66. The taste for such medallions of course reflected the vogue for European portrait miniatures beginning in the Safavid period. In a related development, Fath 'Ali Shah instituted a diplomatic order in imitation of European practices, featuring an image of the Lion and Sun (NO. 55).

67. This view is supported by the inscriptions on more than five life-size paintings of Fath 'Ali Shah describing them as veritable likenesses (*timsāl*s) and holy icons (*shamāyil*s) (see NOS. 39, 40).

68. Robinson 1964, 98. In 1929 the painting was transferred from the India Office Library, London, and installed on the ceiling of the Great Hall of the Rhashtrapati Bhavan, New Delhi. The room's cornice was decorated with small paintings of Persian subjects commissioned from Indian artists. See H. Y. Shavada Prasad, *Rashtrapati Bhawan; The Story of the President's House* (Bombay, 1992), 68–71.

69. This painting is enframed by a versified inscription that reinforces its visual message, as was the case with similar inscriptions on bindings and rock reliefs and other life-size wall paintings commissioned by the ruler.

70. Saba 1962, 626.

71. See Friedrich Sarre and Ernst Herzfeld, *Iranische Felsreliefs und Altertüme* (Berlin, 1910), vol. 2, pp. 31–32 (Kermanshah); a comprehensive study of all the reliefs by Hubertus von Gall and Paul Luft still awaits publication; Waele 1986; Lerner 1991; Hubertus von Gall, "Die Qadjarischen Felsreliefs als Archaeologischer Problem," *Akten des VII. Internationalen Kongresses für Iranische Kunst und Archaeologie*, vol. 6 of *Archaeologische Mitteilungen aus Iran* (Berlin, 1979), 617–18. Lerner 1991, 41, n. 3, and Waehle 1986, 185, cite a total of eight, including a relief at Firuzkuh carved on the orders of Nasir al-Din Shah. To this list may be added a relief, *Fath 'Ali Shah and His Sons Hunting the Stag at Rayy* (Freer Gallery of Art Archives; Herzfeld Archive Photo File 24, no. 17), and another representing the Sasanian ruler Kay Khusraw enthroned (British Museum, 1952.11–21). The relief may be assigned to Shiraz and dated on a stylistic basis to the 1830s.

72. See Massé 1938, vol. 2, pp. 228–37; Lerner 1991, 33; Waehle 1986, 176–77.

73. See Massé 1938, 597, and Z. Bahrani,

"Assault and Abduction: The Fate of the Royal Image in the Ancient Near East," *Art History* 10, no. 3 (September 1995): 363–82, on animism in the Ancient Near East. According to Ker Porter, local villagers at Taq-i Bustan virtually worshipped a statue thought to be that of the Armenian queen Shirin, the beloved of the Sasanian monarch Khusraw Parviz. Ker Porter 1821, vol. 2, p. 171. Such practices illuminate the Qajar rulers' intentions in commissioning monumental rock reliefs.

74. In addition to the travelers cited by Lerner 1991, 41, n. 6, see Keppel 1827, vol. 2, pp. 41–42, Flandin and Coste 1845–54, vol. 2, pp. 247–48, and Henri d'Allemagne, *Du Khorasan au Pays des Bakhtyaris* (Paris, 1911), vol. 3, p. 266.

75. Mustawfi 1992, vol. 1, p. 38. In describing a Sasanian relief, Ernst Herzfeld noted that it was "against historical truth, but a grand gesture that is extremely Persian," a description that applies equally to Qajar reliefs. Herzfeld, *Iran in the Ancient East* (New York, 1948), 315.

76. For a discussion of the repression of controversial issues by art historians, see Freedberg 1989, 338–40.

77. Malcolm 1815, vol. 2, p. 565, first cited in Robinson 1964, 100. This portrait may perhaps be identified with the portrait of Fath 'Ali Shah now in the Calcutta Museum. The extraordinary respect paid to edicts of the ruler is also noted in Malcolm 1815, vol. 2, p. 565. See also James Alexander, *An English Traveler to Iran in 1827* (London, 1827), 155, for the veiling of royal images.

78. Kotzebuë 1819, 248–49.

79. Portraits of the tsar were distributed throughout the empire in official residences and taken into the battlefield. See for instance, an unusual incident of the Perso-Russian wars that occurred in 1806 at the battle of Khannishin (recorded in Dunbuli 1972, 1973 trans., 271, and Lisan al-Mulk Sipihr 1875, 1965 ed., 151): in a desperate attempt to rally his demoralized troops, a Russian general threw the portrait of the tsar into the middle of the battlefield and unbuckled his sword. The possible impact of European practices on Fath 'Ali Shah's use of imagery and the role of the accounts of Persian envoys abroad bears further investigation. I wish to thank Maryam Ekhtiar for this reference.

80. Fasa'i 1972, 279. A photograph – probably taken at the time of Ahmad Shah's (r. 1909–24) accession – of a Salaam in a provincial court, shows a photograph of the young ruler placed in a chair throne as if he were present, and held by two retainers; religious figures and

local dignitaries were required to pay homage to the photograph itself. See Philip Mansell, *Sultans in Splendor* (New York and Paris, 1988), 82.

81. In addition to the Sari and Gulistan portals, extant instances of the Rustam iconography in tilework include the gateway in Simnan and portals in Shiraz. The identification of the ruler with Rustam is seen in the armor adapted by Fath 'Ali Shah, which incorporates a lion's head similar to the headgear worn by Rustam (see NO. 41).

82. See James Morier, *A Journey through Persia, Armenia, and Asia Minor to Constantinople in the Years 1808–09* (London, 1812), 170; J. S. Buckingham, *Travels in Assyria, Media and Persia* (London, 1830), 293; and Texier 1842, vol. 2, p. 131, who describes paintings located in a *charkh-i nokassi*, probably intended as *charkh-i naqqāshi*. According to Maryam Ekhtiar, the word *charkh* may have been used here to designate a dome, perhaps at an intersection or crossroad, and Texier may therefore refer to a crossroad decorated with wall paintings. Sussan Babaie has noted, however, that the term may also be interpreted as a revolving platform decorated with portable images. Oral recitation accompanying life-size imagery is common to both court and folk culture. See Victor H. Mair, *Painting and Performance, Chinese Picture Recitation and Its Indian Genesis* (Hawaii, 1988), 118–20. I am grateful to John R. Finlay for drawing this source to my attention. For a discussion of sung or recited epico-religious texts under the Safavids, see Calmard 1996, 140.

83. Saba 1962, 290.

84. For the information on Mahd Ulya, I am grateful to Mrs. Ezzat Soudavar. For an image of Nasir al-Din Shah's tomb, see Lerner 1991, fig. 8.

85. Dust 'Ali Khan Mu'ayyir 1982, the principal source for the biographies of painters of the Nasiri and Muzaffari courts, records three such instances (278–80). Even the tomb of the Imam Jum'eh of Tehran was decorated with a life-size image of the deceased. Oral presentation by Kamran Safamanesh at the colloquium "Historical and Cultural Issues of the Post-Safavid and Qajar Periods," Brooklyn Museum of Art, February 24, 1995.

86. See d'Allemagne, *Du Khorasan*, 224, for a portrait of Nasir al-Din Shah with the image of Imam 'Ali above, displayed in the Takieh Dawlat at his funeral; Zuka 1970, 294, for paintings of biblical and Qur'anic subjects in the same structure, and Chelkowski essay in this volume for the

87. evolution of religious painting.

87. Fath 'Ali Shah depended on court astrologers to determine propitious timing for events such as diplomatic receptions or the construction of the palace of Sulaymanieh in Karaj (Morier 1818, 387); see also Massé 1938, vol. 1, pp. 242, 247, n. 2; vol. 2, pp. 287, 342, 269). For numerous examples of divination, *rammāl,* and the use of clandestine potions, see Massé 1938, vol. 2, p. 517.

88. *Burhān-i Qāṭi',* a dictionary written in 1651–52 by Muhammad Husayn ibn Khalaf-i Tabrizi for Sultan 'Abdullah Qutb Shah of Golconda. Cited in Massé 1938, vol. 2, p. 314. Although not expressly stated, it is clear from the context that the mutton grease was utilized in the form of an effigy.

89. Mirza Muhammad wished Fath 'Ali Shah to make the Akhbari school of Imamite Shi'ism the official state religion. See Algar 1969, 65.

90. *Qisas al-'Ulamā* (Tehran, 1887), 132. As cited in Algar 1969, 65. Algar notes that this was probably suggested to the mulla by Fath 'Ali Shah's courtiers, who were well acquainted with his skills in divination and astrology. The incident is also cited in Browne 1959, vol. 4, pp. 374–75; and Massé 1938, vol. 1, p. 314.

91. Fasa'i 1972, 112, and Lisan al-Mulk Sipihr 1875, 1965 ed., 79 (Algar 1969, 65, n. 129).

92. Freedberg 1989, 28.

93. Calmard 1996, 141–66. Likewise, during a visit to Shiraz in 1802, the English traveler Edward Scott Waring witnessed an episode of the burning of an effigy of the Caliph Omar (Waring 1807, 42). See also Massé 1938, vol. 1, p. 167. These episodes presaged the mob destruction of statues of Nasir al-Din and Riza Shah, and the twentieth-century burning of effigies of François Mitterand (see Freedberg 1989, fig. 136).

94. Calmard 1996, 179, and Chelkowski essay in this volume.

95. In Isfahan, for instance, the shrines of the theologian Baqir Majlisi, of Sayyid Hujjat al-Islam and of the mystic Mir Findiriski were decorated with representations of the deceased (Hunarfar 1965, 159, 779, and 545 respectively). The continued use of imagery in popular mausoleums is attested by a single shrine in Shiraz, devoted to seven mystics, Haft Tan. See Waring 1807, 38, and Sami 1958, unpag., for images of Moses and dervishes in the shrine.

96. Extant life-size paintings of the Prophet Muhammad dated to the 1830s in shrines suggest the continued use of figural imagery in the nineteenth century (see Ansari 1986, 176–77; Massé 1938, vol. 2, pp. 297, 305, 387).

97. See ibid., vol. 1, p. 226. For images, see *Religious Inspiration in Iranian Art,* exh. cat. (Tehran, 1978), ills. 25–27.

98. Tombs with funerary lions on them were especially common in the area of Fars and Isfahan, and many were recorded by premodern travelers, including a tomb surmounted by a sculpture of a rider. See Massé 1938, vol. 1, pp. 115–18, and also Tanavoli, *Kings, Heroes, and Lovers,* fig. 154.

99. As did the early nineteenth-century reliefs, the Firuzkuh relief completed in 1868 served both as a statement of political power and as a commemoration of a current event. See I'timad al-Saltaneh 1984, vol. 1, pp. 102, 105; Benjamin 1887, 467; for an illustration, Dust 'Ali Khan Mu'ayyir 1983, pl. 171.

100. See Algar 1969, 181–82, and I'timad al-Saltaneh 1984, vol. 1, p. 85; vol. 2, pp. 664–65, for the construction and inaugural ceremonies for the statue; first cited in Ervand Abrahamian, *Iran between Two Revolutions* (Princeton, 1982), 41.

101. See Calmard 1996; Stuart 1854, 283.

102. Calmard 1996, 166.

103. Meredith 1971, 62.

104. Texier 1842, vol. 1, p. 164. This view is reinforced by Texier's subsequent statement that popular paintings in the bazaar built by Husayn Shah (probably intended for the Safavid ruler Shah Sultan Husayn) were inscribed with the names of their protagonists (vol. 2, pp. 131–32) and by the replication of historical compositions throughout the century (see NO. 96).

105. This phrase has been borrowed from Abbas Amanat, who described the poetry composed by Qa'im Maqam, Crown Prince 'Abbas Mirza's vazir, on the Perso-Russian wars as a "literary divorce from historical reality." Amanat 1993, 36.

106. Browne 1959, vol. 4, p. 146. The princes were also satirized by Qa'im Maqam for their antiquated, pleasure-loving lifestyle (Amanat 1993, 51).

107. As suggested by W. J. T. Mitchell, "What Do Pictures Really Want?" *October* 77 (Summer 1996): 73.

FROM WORKSHOP AND BAZAAR TO ACADEMY

Art Training and Production in Qajar Iran

MARYAM EKHTIAR

Artistic exchanges between Europe and Iran reached an unprecedented level during the Qajar period. In the first years of the nineteenth century, the Qajar dynasty not only reinstated economic and political ties with Europe, but expanded them as Iran was swiftly drawn into the sphere of European global expansion. The introduction of Western-style military and educational reforms in the early nineteenth century opened the door to cultural innovations of every kind. The royal *naqqāshkhāneh*[1] (house of painting), a successor to the earlier *kitābkhāneh* (royal library workshop), was among the first institutions to benefit from these innovations and functioned as the primary channel for the flow of Western artistic styles, techniques, and materials into the country. By the second half of the nineteenth century, innovators introduced a new system of "art education" based on European models, whose practices challenged long-established approaches and methods.

In recent years art historians have uncovered documents that provide a clearer idea of the organization and practices of the royal *kitābkhāneh*s during the Timurid (1370–1506) and Safavid (1501–1722) periods,[2] yet none have focused on the Qajar period. This study attempts to fill that lacuna by evaluating art training and production in light of Qajar Iran's growing involvement with Western Europe. It traces this evolution chronologically, beginning with the early and mid-Qajar period (1785–1848) and ending in 1911 with the establishment of Iran's first Academy of Fine Arts, the Madraseh-i Sanayi' Mustazrafeh, by Kamal al-Mulk. Using primary sources in both Persian

and European languages, as well as inscriptions on the artworks themselves, it examines the ways in which Iran's relationship with Europe influenced the royal atelier – its practices and the social status of its craftsmen, hierarchical organization, ultimate objectives, and overall vision. This interaction promoted a transition from the age-old apprenticeship system to one that included artistic training in a European-style academic context. By comparing Qajar workshop practices to those of earlier periods, this study will explore how and to what degree European artistic traditions were assimilated in the activities of the *naqqāshkhāneh*.

For centuries in Iran, "art" was considered indistinguishable from "handicraft."[3] Analysis of the four Persian words for art or craft – *ṣan'at, fann, pīsheh,* and *hunar* – and a tracing of their usage back to the fifteenth century reveals that they were employed interchangeably until the second half of the nineteenth century. At that time, certain handicrafts, especially painting and related arts, were first perceived as "branches of knowledge" akin to geometry and history.[4] An 1862 announcement in the state newspaper *Rūznāmeh-i Dawlat 'Illīeh-i Īrān* inviting students (*dānish āmūzān*) to "study" (*taḥṣil*) painting exemplified the new tendency to equate "art" with "schooling."[5] References to painting as "a course of study" to be completed "in a scientific ['*ilman*] and empirical manner ['*amalan*]" further reinforce this point.[6] Western Europe, specifically Italy and France, served as a model in the Iranian quest to "academize" art in the second half of the nineteenth century. The distinction between "art" and

"handicraft" had emerged in Western Europe during the Renaissance some three centuries earlier,[7] though it was not until the nineteenth century that the public art school appeared in Europe as the primary establishment for the education of the artist.[8]

THE EARLY QAJAR PERIOD (1785–1848) AND ITS RELATIONSHIP TO EARLIER TRADITIONS

Traditionally, the activities of artisans and craftsmen in Iran were tied to the operation of guilds (*aṣnāf*)[9] and workshops (*kārkhāneh*). Whether employed by the royal workshops and guilds (*aṣnāf-i shāhī*) or the local bazaars, artists and craftsmen worked and trained within this system. The *kitābkhāneh,* or royal library workshop, had functioned within the parameters of the Royal Household (Buyutat-i Saltanati) and was considered one of its domestic departments. Despite Iran's increasing interaction with Russia and Europe during the eighteenth and early nineteenth centuries, the practices of the royal ateliers at this time still bore a striking resemblance to those of earlier periods.

The Qajar ruler Fath 'Ali Shah relied on the staff of his *naqqāshkhāneh* for the enormous task of producing magnificent and refined portraits and lavish decorative objects for distribution throughout the provinces of the kingdom and abroad. In fact, an undated progress report pertaining to the state of the arts during the first years of Fath 'Ali Shah's reign reflects the perception in court circles that the arts, which had fallen into decay after the Safavid period, were thriving under Fath 'Ali Shah.[10]

The shah's use of life-size portraits as a means of centralizing power and consolidating diplomatic relations with foreign governments placed portraiture at the center of the early Qajar visual vocabulary.[11] According to the British envoy, Sir William Ouseley: "It was easy to recognize in the handsome and manly countenance of Fateh Ali Shah, those features which I had seen represented by several delineations. Portraits of their king may be found in every town among Persians; large and painted on canvas; or small, on leaves of paper; on the covers of looking-glasses, on *kalamdáns* or pencases, and on lids of boxes; even the most rudely executed presenting, generally, some similitude."[12] In the absence of modern telecommunications, the dissemination of the shah's image throughout his empire and abroad required the production of large numbers of paintings. Intended as integral decorative elements of ambitious architectural programs,[13] numerous portraits were often required for the same structure. Several fully staffed workshops had to work ceaselessly to meet the shah's demands.

Usually, the most successful portraits of the king were executed by the *naqqāshbāshī*s (painter laureates), who painted them in replicate or had them copied by workshop painters. The act of copying (*naql kardan*) the works

FIG. 14a. *Binding to a "Khamseh" of Nizami Depicting Fath 'Ali Shah Hunting with His Family.*
Sayyid Mirza. Tehran, circa 1825. Pasteboard, painted and lacquered, 10 x 14½ inches (25.4 x 36.8 cm).
THE BRITISH LIBRARY, LONDON, ORIENTAL AND INDIA OFFICE COLLECTIONS, OR 2265.

FIG. 14b. *Fath 'Ali Shah and His Sons Hunting.*
Artist unknown. Iran, early 19th century. Oil on canvas, 140 x 205 inches (355.6 x 520.7 cm).
RASHTRAPATI BHAVAN, ASHOKA HALL, FORMER VICEROY'S RESIDENCE, NEW DELHI.

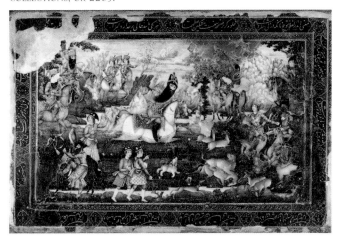

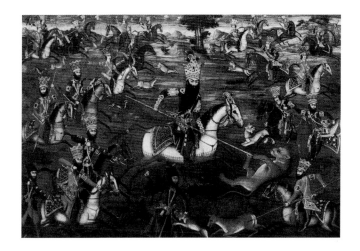

of master painters and adapting them to a variety of scales, formats, and media was a hallmark of both the production system and the training process (see FIGS. 14a,b).[14] As the French architect and archaeologist Charles Texier stated in his discussion of the paintings at the Sultanieh palace: "All paintings of the palace at Sultanieh were made according to a uniform program. It seems that each of the paintings had to conform to the requirements of some official patron. One painting would serve as a model for all subjects of its type, which were then reproduced in both miniature and large scale historic paintings. . . . The other Sultanieh paintings were reproduced almost without variation for different palaces in Isfahan, and they were without a doubt different copies of the original paintings, the copies often indistinguishable from their primary models."[15] Analysis of the painting *Two Harem Girls* (NO. 57) has provided evidence of a production process whereby paintings were executed in large numbers with little variation on a single horizontal canvas and later cut down to suit a given architectural program.[16] Thus, standardization, repetition, and adherence to the rules and concepts of the workshop were the tacit canons of the royal *naqqāshkhāneh*.

Pouncing, a method frequently used for transferring a design from one surface to another in manuscript illustration,[17] was employed in the late Safavid period to transfer designs onto plaster[18] and lacquer objects,[19] and may have been used as a replicating device for paintings on canvas at this time.[20] These very practices and methods were instrumental in reinforcing the visual language and defining the royal aesthetic.

Artists working in the royal *naqqāshkhāneh* were often expected to be proficient in more than one craft and to produce works in a variety of media, a practice also prevalent in earlier periods.[21] This tradition reached its peak during the first half of the nineteenth century with the emergence of versatile (*zufunūn*) artists, such as Mirza Baba and 'Abdallah Khan, and survived into the late nineteenth century.[22] 'Abdallah Khan, for example, was not only *naqqāshbāshī*, or painter laureate, to Fath 'Ali Shah, but also court architect, as well as a skilled enamel painter. He executed some of the finest life-size portrait paintings of Fath 'Ali Shah and his court in various media and supervised the construction of several royally commissioned buildings.[23] Similarly, during his tenure as *naqqāshbāshī*, Mirza Baba not only executed life-size paintings of Fath 'Ali Shah, but painted the fine paintings and the lacquer binding for the *Dīvān-i Khāqān* now in Royal Wind-

sor Library.[24] A technical comparison of the pigments used in painting on canvas with those used in other related media (painting on paper, plaster, lacquer, enamel, wood, cloth, and glass) will determine whether multicrafted artists such as 'Abdallah Khan and Mirza Baba used similar materials and techniques when working in different media.[25] The unique ability of painters of this period to tailor the royal visual language to each medium further contributed to the overall coherence of the early Qajar dynastic image.

During the reign of Fath 'Ali Shah's successor, Muhammad Shah, a noticeable decline in the patronage of public architectural works reduced the demand for large-scale paintings for this purpose. This change ultimately resulted in a decrease in the number of multicrafted artists, and artists increasingly channeled their talents into painting on small-scale luxury objects such as lacquer.

In the early Qajar period, Fath 'Ali Shah's active participation in the production process was central to the establishment of new artistic styles and methods. He posed for his portraits[26] and oversaw their execution. An inscription in the lower left corner of a portrait of Fath 'Ali Shah by the court painter Mihr 'Ali (NO. 39) reflects the monarch's direct involvement in the production of his own portraits: "The painting is a portrait of the King of Kings. It was inspected [in person] by his Majesty receiving his stamp of approval without any changes; by the hand of his most humble slave, Mihr 'Ali, A.H. 1224 [A.D. 1809–10]." This inscription may, in fact, document the shah's approval of a "new type" of portrait in which he was portrayed standing rather than seated in a traditional pose, thereby authorizing the execution of copies based on its model.[27] Fath 'Ali Shah's practice of physically posing for his portrait carried over into the mid-century. Prince Soltykov, the Russian artist who visited Nasir al-Din Mirza in 1838 in Tabriz, depicted the young prince posing for the Russian painter in a drawing (FIG. 15).

The painter laureate was often entrusted with the design and execution of memorial portraits in different media intended for royal tombs. Fath 'Ali Shah, for example, involved himself in the various stages of the production of a carved marble bas-relief portrait, which he had commissioned during his lifetime for his sarcophagus. According to Lisan al-Mulk Sipihr, "the sarcophagus was produced on the palace premises; the Shah would visit the site daily and pressure the masons into completing the job. . . ."[28] During the second half of the nineteenth

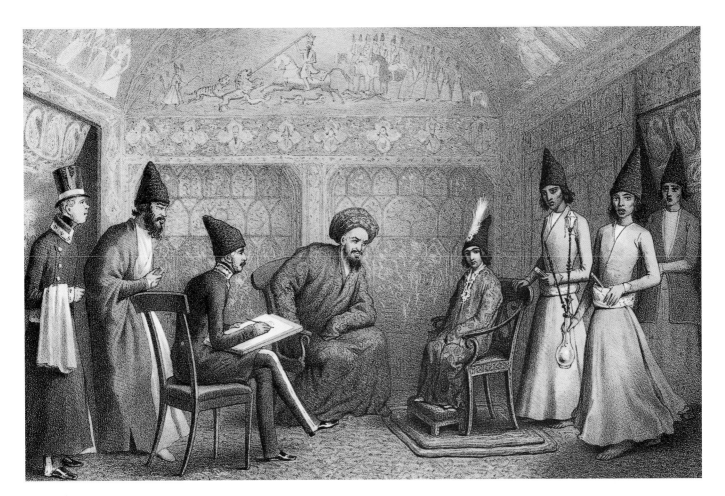

FIG. 15. *Drawing by A. D. Soltykov showing the artist, accompanied by the painter of the Russian mission, painting a portrait of Prince Nasir al-Din Mirza in Tabriz in 1838.*
From A. D. Soltykov, *Voyage en Perse* (Paris, 1851), pl. 15.
BROOKLYN MUSEUM OF ART LIBRARY COLLECTION.

century, such commissions were carried out by graduates of the Dar al-Funun, Iran's first European-style institution of higher learning, and the Madraseh-i Sanayi' Mustazrafeh, who painted memorial portraits of the ruler and his court and provincial governors (see FIG. 16).[29] Moreover, artists serving the provincial governments often looked to the Qajar capital, Tehran, as the epitome of taste and refinement. In this way, the shah's seal of approval ensured consistency and uniformity, and imposed an artistic standard not only in the capital, but throughout the kingdom.

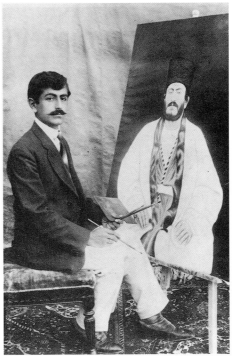

FIG. 16. *Muhammad Khan As'ad, Kamal al-Mulk's student at the Madraseh-i Sanayi' Mustazrafeh, painting a memorial portrait of Husayn Quli Khan Ilkhani (Qashqai Tribal Lord) on an easel.*
Photograph, circa 1915.

Hierarchy in the Workshop

Artistic production traditionally relied on the mastery of the craftsman, who learned the techniques and methods of manufacture early in life and transmitted them to his sons and male family members. Within the apprenticeship system, a student (*shāgird*) would learn a craft by studying and copying (*naql kardan*) the work of a master (*ustād*). After mastering a craft through such copying, the student would then adapt selective elements from the master's work and gradually achieve autonomy. This chain, or *silsileh*,[30] constituted the basis for the transmission of knowledge and skills, and assured a continuity of style and production methods through generations of artists and craftsmen. S. G. W. Benjamin, the first American plenipotentiary to Persia, paints a vivid image of a typical workshop of artists in a stall in the bazaar:

> Picture humble artists clad in white or green turbans and flowing tunics, seated on their heels upon a rug in an open booth by the bustling wayside, or under a spreading chenar in the market-place. If such an artist is prosperous and honored with the favor of the Great, which in Persia is equivalent to the smile of God, then he is content, for he can go on through life laboring cheerfully at his chosen pursuit. . . . Around him on their knees are seated his chagirds, or assistants, who aid him in his labors, and also incidentally learn to start in turn as independent artists. He makes his own colors after receipts learned from his father or his master, and devises varnishes of his own, which add a deliciously mellow effect to the delicate design over which he devotes such patient and loving toil. . . . His chagirds put on the priming, and sometimes laid in the pattern after his suggestion; but he always gave the finishing touches. . . . Such is the life and career of the artist of Persia.[31]

Evidence of such master–apprentice relationships within the Zand (1750–94) and Qajar royal *naqqāshkhānehs* is recorded not only in histories, royal edicts, treatises, chronicles, wedding contracts (*'aqdnāmehs*), and biographical dictionaries (*tazkirehs*), but also on the artworks themselves in the form of signatures and inscriptions.[32]

The training process was informal with little structure, and a master almost always worked individually with a student. Although the process always provided for a senior practitioner, a division of labor (although artists were not always restricted to one aspect of production), and a distinct hierarchy, the criteria for qualification were subjective. Students were required to abide by the rules of the workshop and to adhere to the formal principles of Persian painting, yet there is no evidence to suggest a fixed program of training, systematic means of measuring proficiency, or even a designated place of training.[33]

Members of a workshop (*kārkhāneh*) were required to pass through the successive stages of *pādaw* (errand boy) and *shāgird* (apprentice) before reaching the final and culminating point of their training, that of *ustād* (master). Only the master had the privilege of instructing apprentices in the skills of the trade and promoting them to this rank. In some cases, the rank of master required a master's certificate (*ijāzeh*), which was granted after examination, subject to the approval of the chief of the royal workshop (*bāshī*), or the governor. This entailed the presentation of a fine piece of work for examination and judgment.[34] This was especially true in the Safavid period for artists (including painters) who wished to enter royal service. An artist had to submit a specimen of his work to the *bāshī* concerned, and if the work and the terms of service that he proposed were approved, he was then taken to the Superintendent of the Palace, or Nazir-i Buyutat, with whom the final decision appears to have rested. The *bāshī* would then submit the specimen of work to the shah or might even arrange an interview for the artisan, after which the terms of the settlement were finally agreed upon.[35] In his discussion of handicrafts in the mid-Qajar period, Arthur de Gobineau, secretary of the French mission, claimed that in the 1850s the master craftsmen were selected only after examination.[36] Achieving the rank of master increased the chances for recruitment into the royal establishment.

Acceptance into the royal workshops was not easy for qualified artisans. Priority was given to those who had acquired skills through apprenticeship in the royal workshops, sons of master craftsmen in the royal workshops, and unpaid artisans such as prisoners of war and slaves (slave painters).[37] Outsiders qualified only after proven mastery of the craft. The court often recruited the most talented craftsmen from all reaches of the empire for specific projects. In the Zand period it had been customary for the ruler, Karim Khan, to order the recruitment of the most skilled architects, builders, carpenters, and painters of the kingdom to construct opulent

palaces with lavish reception halls.[38] Since the Safavid period, certain crafts had been concentrated in particular provincial cities and districts. Several Qajar sources point to the late Safavid capital, Isfahan, as "the capital of the crafts," which explains the great effort made to employ craftsmen from that city for various royally commissioned projects. Between 1799 and 1800, Fath 'Ali Shah, for example, is reported to have ordered the governor of Isfahan, Haji Muhammad Husayn Khan Nizam al-Dawleh, known as Sadr-i Isfahani, to recruit the most skilled craftsmen from Isfahan, among them jewelers, goldsmiths, enamelers, and designers, to produce the most sumptuous luxury objects and regalia for his ceremonial use.[39] He issued similar orders for the construction of the Takht-i Khurshid (Sun Throne).[40]

Traditionally, a master first trained his eldest son or nephew and then other members of the workshop.[41] Although family affiliations improved one's chances of gaining workshop membership under the Qajars, they were not required.[42] Many families, nevertheless, pursued and dominated certain crafts, especially painting and calligraphy, and made great efforts not to disclose the secrets of their trade. The Ghaffari, Visal, and Isfahani families are prime examples of prominent lines of Qajar painters and calligraphers. The preeminence of the Ghaffari family of Kashan dates back to the eighteenth century with Abu'l Hasan Mustawfi and culminated in the late nineteenth and early twentieth centuries with Abu'l Hasan Ghaffari, Sani' al-Mulk, and Muhammad Ghaffari, Kamal al-Mulk.[43] In the same way, the multitalented Visal family of Shiraz, starting in the early nineteenth century with the celebrated calligrapher and poet Muhammad Shafi' Visal (1782–1845), has been extensively documented in the history *Fārsnāmeh-i Nāṣirī* and the biographical dictionary *Ḥadīqat al-Shuʿarā*.[44] Muhammad Shafi's six sons were also calligraphers and painters in their own right. The arts of lacquer and enamel painting were no exception to this pattern. Muhammad Ismaʿil, the court painter to the Qajar ruler Nasir al-Din Shah (r. 1848–96), who was responsible for reviving the Safavid and Zand styles long after they had died out, was the son of a painter of Isfahan named Aqa Baba and the younger brother of the painter Najaf 'Ali of Isfahan.[45] His three nephews Muhammad Kazim, Muhammad Jaʿfar, and Ahmad were celebrated lacquer and enamel painters.[46] A wedding contract pertaining to Aqa Najaf's daughter, Safieh Khanum Shahr Banu, further documents the artistic lineage of the Isfahani family.[47]

The most influential and prestigious position within a workshop, however, was that of the workshop chief, or *bāshī*. Not all workshops possessed an independent *bāshī*; some were combined with other related workshops under a joint supervisor.[48] The career of 'Abdallah Khan, Fath 'Ali Shah's *naqqāshbāshī*, exemplifies the extent of the role of the *bāshī* during this period. A *firmān* (royal edict) was issued by Muhammad Shah in 1839 appointing 'Abdallah Khan, his painter laureate (*naqqāshbāshī*) and royal architect (*miʿmārbāshī*), as the Bashi-yi Buyutat-i Saltanati (Chief Supervisor of the Royal Workshops), overseeing the painters, architects, designers, enamelers, masons, carpenters, potters, blacksmiths, spearmen, candlemakers, keepers of the palace, glass-cutters, and gardeners. They were all expected to report to 'Abdallah Khan and follow his orders. He earned this office because of his outstanding performance in the royal *naqqāshkhāneh*; his mastery of a variety of crafts (particularly painting and design); and his efforts in refurbishing various buildings and gardens on the outskirts of Tehran and within the city limits, such as the Qasr-i Qajar, Imamzadeh Qulhak, Arghavanieh, Negarestan, Dilgusha, Lalehzar, and Baharistan.[49] The *firmān* serves as evidence that the combining of several related workshops under the aegis of one chief *bāshī*, a practice that was prevalent during the Timurid, Safavid, and Afsharid[50] (1736–47) periods, persisted into the middle of the Qajar period, and it provides insight into the administration and hierarchy of architectural and artistic programs and projects.

The *firmān* also demonstrates that the *naqqāshbāshī* was regarded as not only painter laureate, but Imperial Designer (Tarrah).[51] 'Abdallah Khan's role as Imperial Designer is further accentuated in an inscription on the carved bas-relief marble portrait of Fath 'Ali Shah on his sarcophagus in Qum. This inscription also outlines a clear division of labor and distinguishes between the organizer (*nāzim*) of this project (Muhammad Taqi 'Aliabadi), the designer (*ṭarrāḥ*) of the image on the sarcophagus (in this case 'Abdallah Khan), the calligrapher (*khaṭṭāṭ*) who penned the inscriptions (Zayn al-'Abidin-i Kashani), and the masons (*ḥajjār*) who carved it.[52] By centralizing a number of professions under one chief supervisor, the shah ensured not only a standard of quality, but a uniformity of design and iconography in a wide range of media and formats. The edict also confirms that 'Abdallah Khan was trained (*tarbiyat yāfteh*) within the apprenticeship system in the royal workshops. After climbing the successive ranks of the hierarchy, he attained the titles

Naqqashbashi, Khan, and Bashi-yi Buyutat-i Saltanati (Chief Supervisor of the Royal Workshops), respectively.[53]

The election and duties of the *bāshī*s under the Qajars followed much the same pattern as in earlier periods. Each *bāshī* of the royal workshop had a dual function: he was responsible for the royal workshops, as well as for corresponding guilds in the town bazaar and sometimes for respective guilds throughout the country.[54] Appointed by the shah or by provincial governors,[55] he served as the liaison in the royal workshop with the bazaar guilds and government. This role, which reached its peak during the Safavid period, was regarded as an instrument of centralization by the government and persisted into the early Qajar period, albeit with much less rigidity.

Among the many duties of the *naqqāshbāshī* was the tutoring of the king in the art of painting. This responsibility continued throughout the Qajar period; even as late as the second half of the nineteenth century, *naqqāshbāshī*s and instructors of painting at the Dar al-Funun, such as Muzayyin al-Dawleh and Isma'il Jalayir, were expected to fulfil this obligation.[56]

During the late Safavid period the *bāshī*s of a particular craft were selected by the members of the workshops (on the basis of outstanding performance in, and unquestionable devotion to, their craft; experience; reliability; reputability; wisdom; uprightness; and religious piety) and then appointed by the shah.[57] The numerous royal edicts of the Qajar period appointing painters, calligraphers, jewelers,[58] and architects to the office of *bāshī* and the inscriptions and signatures bearing this title reflect the continuation of these conventions in the nineteenth century.

Sites of Training and Production

For independent craftsmen, the *ḥujreh* (stall) in the bazaar or in a caravanserai was the primary site of training and production.[59] In the Timurid and Safavid periods the royal workshops (*kārkhānehhā-yi salṭanatī*) were often located within the palace complex,[60] although instances have been reported of members of the royal ateliers or *kitābkhāneh*s who worked outside the palace compound, sometimes even in another city.[61]

Early Qajar sources indicate that the royal atelier or production site was frequently located on the palace grounds, but this was less often the case during the second half of the nineteenth century. The French envoy

P. Amédée Jaubert reported that he was escorted to the royal atelier on his visit to Fath 'Ali Shah's palace in 1806.[62] Writing some five years later, Sir William Ouseley contended that during the course of the production of the monarch's *Dīvān*, the painters in Mirza Baba's workshop had to report daily to the royal atelier, situated in some building connected with the royal library within the precincts of the palace.[63]

Painters working in Fath 'Ali Shah's *naqqāshkhāneh* worked not only on the palace premises, but in close proximity to the shah's throne. In a travel journal of his trip to Tehran in 1812, Mirza Salih Shirazi stated that "on the side [*jabīn*] of the throne-hall [*tālār*] there were several rooms [*urūsī*] with a small marble pool at the center, two for attendants and two for the painters, goldsmiths, and enamelers, who work day and night in the private quarters [*andarūn*] of the shah."[64] Prince Sultan Ahmad Mirza, 'Azud al-Dawleh, verifies this description by stating that "the *naqqāshkhāneh* was situated next to [*janb*] the Marble Throne."[65] The placement of the painters' workshop so close to the shah's throne was probably deliberate. It is possible that this special studio was temporarily set up to expedite the production of the paintings for Fath 'Ali Shah's throne room, the Talar-i Marmar. In this way, the painters would have physical access to the shah at all times and be able to observe directly his movements and facial expressions. The proximity of the painter's workshop to the king's throne also implies the trust and status given to painters by the shah.

Social Status of Artists

Although artists, especially painters and designers, were generally perceived as mere craftsmen, many associated with the royal atelier enjoyed privileges and prestige denied to others.[66] Factors that contributed to their privileged status were their specialized skills and expertise, the monetary value of the materials at their disposal, the patron's direct involvement and interest in their particular craft, and the closeness of their bond with the patron-ruler. The painter's status at court was not necessarily expressed in terms of official political channels or monetary rewards, but in terms of a much more personal channel that connected him directly to the person of the shah. The painter was part of the regalia with which the shah surrounded himself.[67]

Descriptions and registers of craftsmen from the late seventeenth through mid-nineteenth centuries, how-

ever, indicate a shift in emphasis of the position of the painter. Painters of this period were more frequently categorized with craftsmen in the building trade – such as architects, builders, and masons – than with those connected with manuscript production as in earlier centuries.[68] According to Charles Texier in the early nineteenth century, the most talented painters were employed to execute paintings for the shah's palaces and building programs, whereas their subordinates were commissioned to paint miniatures and decorative objects.[69] This change might have been because of the increasing demand in the eighteenth and nineteenth centuries for large-scale paintings for use in architectural structures, as well as the conscious efforts of the Qajars to preserve and restore the buildings of their predecessors.[70]

Moreover, the Qajar patron's increasingly active involvement in the production process and his adamant belief in cultural superiority as central to the ideal of kingship created an intimate bond between artists and patrons that ultimately affected the artist's status. The inclusion of the court painters' self-portraits on royally commissioned artworks serves as evidence of the special relationship between patron and artist. A striking example is found on the lower portion of a scabbard that the artist 'Abdallah Khan embellished, along with the accompanying sword, for Fath 'Ali Shah. The self-portrait of the artist, depicted holding the sword, is crowned by an inscription, which reads: "This face which is seen on the sabre of the Shahanshah is the portrait of one of the servants, fallen at the knees of the king, so that he may be immortal, 'Abdallah."[71] Artists working in the service of governors and local patrons in the provincial capitals frequently had similar relations with their patrons and followed similar conventions.[72]

During the reign of Fath 'Ali Shah, the monarch's reliance on portraits as a means of legitimizing his rule, both at home and abroad, may have elevated the status of the painter by default. In receiving portrait commissions, painters were entrusted with the task of creating images of the ruler that would substitute for him in his absence.[73]

Painters, illuminators, and calligraphers, as members of the royal workshops, were generally considered civil servants and benefited from a variety of privileges,

such as financial security; free board, lodging, and clothing; and favorable work conditions. Two *firmāns* issued by Muhammad Shah in the years 1845 and 1848 verify the favored position of calligraphers and illuminators connected with his court. The *firmāns* concern the Visal family of Shiraz and ensure perpetual financial security to Muhammad Shafi' Visal and his sons through the allocation of a fixed amount from the taxes of Fars province.[74]

Artists exclusively tied to the ruling court had access to the best materials for production and the finest and most advanced models and prototypes (*sar mashq*), both domestic and foreign. It is quite possible, although no concrete evidence has emerged, that the painters of the royal *naqqāshkhāneh* also had the privilege of exposure to the methods and techniques of European painters at court.

Working in the royal establishment also had its disadvantages. Instances were reported in the Safavid period of guild members who were recruited and expected to perform unpaid labor. This form of enforced labor was used, for the most part, for the repair and construction of royal and other government buildings and for work in the royal *kārkhānehs*. The Dutch traveler Engelbert Kaempfer maintained in the 1680s that each autumn the Nazir-i Buyutat summoned the chief architect, who was responsible for the repair of royal edifices, and ordered him to supply necessary labor.[75] Similarly, the Russian scholar N. A. Kuznetsova has contended that the Qajar palace at Sulaymanieh was built by craftsmen forcibly put to work for ten years.[76] Moreover, Fath 'Ali Shah is said to have threatened craftsmen with death if they failed to complete the production of his sarcophagus in a timely fashion.[77]

Occasionally, foreigners were employed to train Iranian craftsmen and artists in new techniques and methods and the use of new technological equipment. European and other foreign artists were not uncommon in the royal ateliers of the Safavids,[78] and their presence increased at an accelerating rate over the eighteenth and nineteenth centuries. During the early nineteenth century European artists were reported to have been considered even for the position of workshop chief.[79] By the middle of the nineteenth century, European and European-educated Iranian artists were entering the royal *naqqāshkhāneh*s in ever-greater numbers.

THE BEGINNINGS OF ART TRAINING AND PRODUCTION IN THE WESTERN MODE (1850–1911)

In 1845 Abu'l Hasan Ghaffari, Muhammad Shah's painter laureate, was sent to Italy to study technical draftsmanship and painting. This painter's artistic career embodies the crucial developments in art training and production in Iran in the first decades of the second half of the nineteenth century. During his sojourn in Italy in 1845–50, Abu'l Hasan studied and copied the works of Italian masters, acquainted himself with the tenets of Italian academic painting, and gained technical expertise in the operation of the lithographic printing press. Upon his return, he was recruited as the illustrator of the state-sponsored gazette *Rūznāmeh-i Vaqāyi' Ittifāqīeh* and was commissioned by Nasir al-Din Shah to design and illustrate a seven-volume manuscript of the *Thousand and One Nights*.[80]

The production of the *Thousand and One Nights* manuscript, which took seven years to complete and included as many as a thousand paintings, required the collaboration of large numbers of skilled artists – painters, illuminators, calligraphers, and binders. A document dated 1852 describes the initial production site as a *ḥujreh* in the newly founded arts and crafts center in Tehran, the Majma' al-Dar al-Sanayi'.[81] Established in Tehran on Muharram 14 A.H. 1269 / A.D. 1852 by Mirza Taqi Khan Amir

Kabir, Nasir al-Din Shah's first prime minister, to promote the "useful arts,"[82] the Majma' al-Dar al-Sanayi' was located at the west end of the refurbished open bazaar called Sabzeh Maydan (FIG. 17). Dust 'Ali Khan Mu'ayyir, who was in charge of the progress of the manuscript, however, reported that the production site later moved to his private residence.[83] Among the articles manufactured in this center were clocks, guns, carriages, European-style military uniforms, and fine paintings. The 1852 document portrays it as a center in which 144 apprentices trained and worked with 45 masters on several royally commissioned projects.[84]

In the painters' stall, one *naqqāshbāshī* (in this case Abu'l Hasan) generally supervised the work of thirty-four apprentices. Owing to a shortage of space, the binders and illuminators had to work in separate quarters.[85] The 1852 report reveals that the celebrated *Thousand and One Nights* manuscript was produced according to the age-old apprenticeship system, despite Abu'l Hasan's exposure to European approaches and methods. While both the 1852 document and the manuscript's colophon point to a clear division of labor and to the presence of several senior practitioners, they provide little information about the actual production process. Extant preliminary sketches for the paintings (British Library, London), however, indicate the use of numerous practice sheets in laying out the composition of each illustrated page. Abu'l Hasan's use of sketches or underdrawings (*nayrang*)[86] before applying colored pigments has also been confirmed by Mirza Sadiq

FIG. 17. *The Majma' al-Dar al-Sanayi' in Sabzeh Maydan, Tehran.* Photograph, 1862.
GULISTAN PALACE ALBUMS, TEHRAN.

Dibachehnigar in *Ganj-i Shāyigān*.[87] We also know that during the course of producing the wall paintings in the Nizamieh palace (Luqanteh), Abu'l Hasan executed the faces, while his apprentices worked on the costume details and other elements.[88] Abu'l Hasan's formative training in the *kārkhāneh* system, combined with his exposure to the precepts of European academic painting and the art of realistic portraiture, distinguished him as an artist with a particularly innovative vision. He played a critical role in setting up the first painting classes as a part of the Dar al-Funun curriculum.

The establishment of the Dar al-Funun in 1851 was the driving force in the later dissemination of art training and production in the European mode. It was not until 1861, the year of Abu'l Hasan's appointment as Director of the State Printing Press and Chief Editor of the state newspaper, that painting was taught on the school grounds. Thus, the introduction of the first art classes in the Western sense in Iran was closely tied to the establishment of the printing press and the creation of the first illustrated state newspaper.

Although none of the sources of the period refer to the Dar al-Funun as the physical site for the first painting classes, they do mention that such classes were initially held in a building opposite the *divānkhāneh* (royal audience hall) of the imperial palace.[89] Painting instruction was thereby incorporated for the first time into the academic curriculum of a school and placed under the jurisdiction of the Ministry of Higher Education (Vizarat-i' Ulum). In this context, painting was explicitly perceived as an "academic discipline" rather than a "handicraft." An announcement (written by Abu'l Hasan himself) in the state newspaper *Rūznāmeh-i Dawlat-i 'Illīeh-i Īrān*, dated Shaval A.H. 1278 / April 3, A.D. 1862, outlines the objectives of these classes, referred to as *maktabkhāneh-i naqqāshī* (school of painting).[90] This marked the first instance in which the two terms *maktabkhāneh* (school) and *naqqāshī* (painting) were so linked in the Persian language. Furthermore, the placement of these painting classes under the domain of the Ministry of Higher Education set a precedent that has prevailed up to the present day.

According to the announcement, classes were modeled on the European academies observed by Abu'l Hasan on his trip to Italy. In his instruction, Abu'l Hasan used the materials and equipment he had brought back from Europe, including printing equipment, paintings, drawings, sculptures, engravings, and copies of paintings by Raphael, Michelangelo, and Titian. He spent one

FIG. 18. *Copy of Rembrandt's "Self-Portrait as a Youth."* Muhammad Ghaffari, Kamal al-Mulk. 1896. Oil on canvas, 24³/₄ x 21 inches (63.5 x 54 cm).
MAJLIS LIBRARY COLLECTION, TEHRAN.

day a week training students in the operation of the printing press and required students to spend the remainder of the time practising (*mashq-i naqqāshī*) and producing replicas on their own.[91] Although intent on following the model of European academies, Abu'l Hasan chose to exclude from his own curriculum many of the courses commonly offered at those institutions: life drawing, anatomy, geometry, and art theory. Instead, he devised a course of study that would not conflict with the existing system of art training and production in Iran.

The act of copying and producing replicas (FIG. 18) had been a dominant feature of the traditional *kārkhāneh* system for centuries, but the motivation for the practice was different under the new system. By replicating European paintings, Iranian artists of this period were not only experimenting with styles, methods, and approaches, but were in essence striving to come to terms with their ambiguous relationship with Europe and to redefine them-

selves within a changing global context. In copying European works, they believed that they were placing themselves on equal footing with the Europeans. Portraits rendered in the European academic style, as well as those painted from photographs, slowly began to overshadow earlier workshop paintings and designs as the artists' most esteemed models. He who was able to execute a flawless copy of a European painting was handsomely rewarded. The value placed on such copies is suggested by an inscription on a now-lost painting by one of Abu'l Hasan's students: "The work of Mirza 'Abbas, copied from a replica of a large painting by Raphael in the State Naqqāshkhāneh, 1861."[92] On another occasion Nasir al-Din Shah requested that the painter Mirza Mihdi Musavvar al-Mulk paint a replica of a painting by an Austrian artist that he had brought back from Europe "so that one could not distinguish the replica from the original," to which Musavvar al-Mulk replied, "Of course your Highness, I can make a copy so that you would not be able to tell one from the other."[93] Thus, the painter no longer merely occupied himself with producing a work that would encode a particular dynastic vision, but was motivated to create a work that would also measure up, in his eyes, to European standards of realism, perspective, chiaroscuro, and modeling. Although copying lay at the core of both systems, old and new, the ultimate objectives, criteria for judging, and motivations behind copying had undergone significant transformation.

A comparison of Iranians' perceptions of their own country's artistic production during the reigns of Karim Khan Zand (r. 1750–79) and Aqa Muhammad Khan (r. 1785–97) with more critical assessments of later periods illustrates the ascendancy of European standards. During the late eighteenth century and the first few years of the nineteenth, texts described Persian paintings decorating buildings as a source of great pride and capable of "provoking the envy of the European painters,"[94] while later references regard them as "replete with flaws" when viewed alongside European paintings.[95]

Along with European artistic styles, the science of photography gave impetus to the Persian artist's desire to depict his subject as precisely and accurately as possible and to probe the psychological nuances of his subjects. I'timad al-Saltaneh, the shah's Minister of Publications, noted the close relationship between the art of painting and the science of photography: "From the time photography was introduced into Iran, it has served the art of painting and portraiture immensely. Landscape [*dūrnamā-*

sāzī], portraiture [*shabīhkishī*], utilization of light and shade [*vā nimūdan-i sāyeh rawshan*], and the application of perspective [*qānūn-i tanāsub*], as well as other features of this art, have been greatly enhanced by photography."[96] Notably, I'timad al-Saltaneh here establishes a basic Persian vocabulary for European terms and techniques related to painting. A 1983 study by Chahryar Adle and Yahya Zuka has confirmed that many portrait paintings of the late nineteenth century were direct copies of daguerreotype photographs.[97] In addition, evidence documenting the use of photographs as models for lithograph portraits has also surfaced.[98]

The Dar al-Funun also generated a new set of criteria for assessing the qualifications of its instructors. The school's administration gave preference to European- or Western-educated Iranians; knowledge of the conventions of European academic painting and expertise in operating Western technological equipment became the main prerequisites for proficiency. The master painter or *naqqāshbāshī* was no longer elected by consensus of the members of his workshop, but was selected arbitrarily by the Ministry of Higher Education and the shah. 'Ali Akbar Muzayyin al-Dawleh was the first *naqqāshbāshī* appointed through the new process.

In 1868, two years after Abu'l Hasan's death, the painting classes at the Dar al-Funun were placed under the direction of 'Ali Akbar Muzayyin al-Dawleh, who remained in this position for about fifty years. A graduate of the Dar al-Funun and the École des Beaux-Arts, Muzayyin al-Dawleh was considered automatically qualified to teach painting and French at the school.[99] Although he was a competent portraitist, Muzayyin al-Dawleh's main forte was landscape and still-life painting.

Aside from a few references to the activities of Muzayyin al-Dawleh's students at the Dar al-Funun, very little evidence has emerged about the painting curriculum at the school after Abu'l Hasan's death. It appears, however, that Muzayyin al-Dawleh used Abu'l Hasan's painting classes as a model for his own curriculum. One of the few descriptions of the painting classes at the Dar al-Funun was given in the 1890s by Lord Curzon, who commented sarcastically on the models used in the painting classes as "European studies from the nude, classical heads and busts, drawings of Christ, pictures of subjects so various as His Majesty the Shah, Andromeda and Landseer's Challenge."[100]

Muzayyin al-Dawleh's greatest contribution, however, was to train the most prominent painters of the late

nineteenth century, many of whom succeeded him as *naqqāshbāshī* and painting instructors at the Dar al-Funun. Among them, Ismaïl Jalayir, for example, set up his studio at the Dar al-Funun, where he both executed paintings and trained students.[101] Upon graduation Abu'l Hasan's nephew, Abu Turab, worked as an illustrator for the Ministry of Publications (Vizarat-i Intibaʿat). Muzayyin al-Dawleh's most esteemed student was Muhammad Ghaffari, better known as Kamal al-Mulk.

Repeatedly referred to by Iranians as "the father of academic painting" or "the second Raphael,"[102] Kamal al-Mulk graduated from the Dar al-Funun proficient in the fields of painting, history, and French, and was granted the title *naqqāshbāshī* by Nasir al-Din Shah in 1882. He subsequently won the opportunity to pursue his studies in Paris, Florence, and Rome on a three-year government-sponsored educational mission. In this case, a diploma from the Dar al-Funun served as a prerequisite for achieving the title of *naqqāshbāshī* and was perceived as a guarantor of a secure and successful artistic career. That the shah periodically visited the Dar al-Funun, demanded the display of the students' paintings for his review, and granted awards to students of painting further reflects the prestige accorded to the school by the ruling elite,[103] as does the inclusion of an inscription on a full-length portrait of Nasir al-Din Shah indicating that the painter (Jaʿfar) had been trained at the Dar al-Funun (*tarbiyat yāfteh-i Madraseh-i Mubārakeh*).[104]

Like his uncle Abu'l Hasan, Kamal al-Mulk spent countless hours studying the works of not the contemporary Impressionist painters, but the great Renaissance and Baroque masters. In his memoirs he repeatedly stressed his admiration for the paintings of Rembrandt, Raphael, and Titian.[105] His exposure to European academic painting inspired him to depict the subtle facial features of his subjects with utmost accuracy and capture their complex psychological states.

Iran's First Academy of Fine Arts (1911–27)

The most significant outcome of Kamal al-Mulk's trip to Europe was the establishment of Iran's first Academy of Fine Arts, the Madraseh-i Sanayiʿ Mustazrafeh, in 1911. The grounds of the early nineteenth-century Negarestan palace were allocated as the site of the academy.[106] The school, under the jurisdiction of the Ministry of Higher Education, was intended to be exclusively

devoted to the instruction and promotion of the fine arts, especially the "science of painting."[107] As painting classes at the Dar al-Funun were given increasingly less attention by the court in favor of new subjects such as music and theater, the Madraseh-i Sanayiʿ Mustazrafeh became the sole modern institution for the training of the "visual arts" in the country. The academy's mission statement explicitly referred to painting as a "science" and delineated the school's primary function as the "disseminator of this science."[108] In this way its founders sought to ensure the training of a new generation of Iranian artists versed in the conventions of European academic painting. Among the courses offered were sculpture, carpet weaving (see FIG. 19), wood carving (*munabbatkārī*), painting on canvas, painting on paper, drawing (*siyāh qalam*), and later lithography. Of the forty-seven students enrolled in the school, thirty-six were specializing in painting,[109] making the Madraseh-i Sanayiʿ Mustazrafeh essentially a painting academy. In later years, instruction in the operation of the lithographic printing press took priority over almost all other subjects taught at the school because only a handful of individuals possessed such expertise, leaving a dire need for qualified individuals who could disseminate this technical knowledge.[110] The prominence of lithography in the school's curriculum may have been instigated, in part, because of the critical role of the press in promul-

FIG. 19. *Painting depicting carpet weavers at the Madraseh-i Sanayiʿ Mustazrafeh.*
Artist unknown.
MAJLIS LIBRARY COLLECTION, TEHRAN.

gating political agendas during the course of the Constitutional period (1906–25).

One of the innovative features of the academy was the weekly display of its students' artworks to the general public. The school's administrators saw these exhibitions as a means of attracting prospective students and publicizing the school, as well as providing students with the opportunity to sell their artworks.[111] The concept of periodic exhibitions was clearly borrowed from the West and was an integral feature of European-style academies of art.[112] Although the practice had been initiated by Abu'l Hasan, Kamal al-Mulk institutionalized and popularized it.

A close examination of the documents and edicts associated with the Madraseh-i Sanayi' Mustazrafeh, the bulk of which have been published, discloses little information about the school's curriculum; most of the documents deal with administrative issues and budgetary questions.[113] What seems evident, however, is that traces of both apprenticeship and European academy-style systems are discernible in the records. The school was a Persian interpretation of a European academy and a space in which the two systems functioned side by side.

Iran's increasing entanglement with Western powers in the second half of the nineteenth century did in fact alter the structure and overall vision of the royal *naqqāshkhāneh*. Although the apprenticeship system was challenged by the infiltration of Western techniques and pedagogical approaches, it was never completely replaced. No single pattern of art training and production prevailed. The introduction of academy-style art training, however, eventually broke down the structure and the ritualized practices of the age-old royal *kārkhāneh* system within the royal context. Apprentices no longer went through the same stages of training to achieve the final rank of *ustād*. Similarly, the *naqqāshbāshīs* of the royal ateliers were no longer chosen through the consensus of workshop members, but were arbitrarily selected according to a new set of criteria by officials in the Ministry of Higher Education. Three critical reasons for this breakdown of the old system were a marked decline in architectural programs, the rise of photography, and the institutionalization of the lithographic print. Members of the Qajar ruling elite soon realized that lithograph portraits and photographs of royal personages and the nobility were capable of serving the same purpose that life-size paintings had fulfilled earlier and began to regard lithographic portraits as a more efficient and economical vehicle for disseminating the royal image.

Although craftsmen continued to produce artifacts using the apprenticeship system in the local bazaars, painting in all its forms became increasingly perceived at court as an academic discipline and a science, and was taught in schools. Moreover, as the century progressed, royal patrons demanded the production of European academy-style portraits that would measure up to European standards of draftsmanship and could be displayed, as in Europe, in the palace galleries. Despite the tendency to "academize" painting in the late nineteenth century, however, many of the practices of the "traditional" workshops carried over into the new academies. Indeed, these new academies exhibited more of the characteristic pedagogical traits of the traditional *naqqāshkhāneh*s than their founders would have liked to admit.

1. During the Zand and Qajar periods the term *naqqāshkhāneh* was occasionally used to refer to a "picture gallery" or a place in which paintings were exhibited and stored.

2. See Tom W. Lentz and Glenn D. Lowry, *Timur and the Princely Vision: Persian Art and Culture in the Fifteenth Century* (Los Angeles, 1989), 150–238; Wheeler M. Thackston, *A Century of Princes: Sources on Timurid History and Art* (Cambridge, Massachusetts, 1989); Marianna Shreve Simpson, "The Production and Patronage of the Haft Awrang of Jami in the Freer Gallery of Art," *Ars Orientalis* 13 (1982): 93–121; Keyvani 1982; Nomi Heger, "The Status and the Image of the Persianate Artist," Ph.D. dissertation, Princeton University, 1997; and Diba 1994.

3. According to *Webster's New World Dictionary*, the English words *art* and *craft* are also almost synonymous and are both defined as "a trade, occupation or profession requiring special skill or dexterity," although the word *art* implies creativity, ingenuity, and a unique ability to impart aesthetic appeal. Seyyed Hossein Nasr defines the words *fann*, *ṣan'at*, and *hunar* in a more general way as "having the capability of doing or making something correctly" and adds that the use of the word *hunar* to translate the modern European concept of "art" is a very recent phenomenon. Seyyed Hossein Nasr, *Islamic Art and Spirituality* (Albany, 1987), 67.

4. The only instance in which "art" in any way approximated an academic discipline before the mid-nineteenth century had been in the education of kings and princes within the royal household.

5. *Rūznāmeh-i Dawlat-i 'Illieh-i Īrān*, no. 518, Shaval 3, A.H. 1278 / April 3, A.D. 1862.

6. *Sharāfat*, no. 60, Ramazan A.H. 1319 / December A.D. 1901. This phrase was drawn from an illustrated biographical entry on the painter Muhammad Ghaffari, Kamal al-Mulk, in this newspaper.

7. In Europe the designation of "art" as a branch of knowledge was a Renaissance phenomenon. The new conception of the artist's position in society entailed a new approach to art education and production. Up to the time of Michelangelo, medieval methods had still remained unchallenged. Pioneers such as Leonardo da Vinci and Giorgio Vasari, the theoretical founders of the first academy of art, deprecated the medieval system of education and rejected the classification of art as mere craft. In fact, da Vinci's primary aim was to sunder art from handicraft. Thus, knowledge became more important than skill and the artist was encouraged to express his vision. No longer limited by the rules and restrictions of the guilds, he was perceived more and more as a humanist. See Nicolaus Pevsner, *Academies of Art Past and Present* (New York, 1973), 34. See also Carl Goldstein, *Teaching Art: Academies and Schools from Vasari to Albers* (Cambridge, 1996).

8. Ibid.

9. *Ṣinf*, the singular for *aṣnāf*, can be defined as a group of city dwellers engaged in the same occupation, working in the same bazaar, headed by their own chief and paying a regular guild tax to the local authorities. See Keyvani 1982, 38; Willem M. Floor, "The Guilds in Iran: An Overview from the Earliest Beginning till 1972," in *Zeitschrift der Deutschen Morgenlandischen Gesellschaft*, no. 125 (1975): 99–116; and Willem Floor, "Aṣnāf," *Encyclopaedia Iranica*, vol. 2.

10. Karimzadeh Tabrizi 1989, 225–28.

11. During his visit to Fath 'Ali Shah's palace, the Russian officer Moritz von Kotzebuë recalled one instance in which Fath 'Ali Shah asked the painter of the Russian Embassy to paint him twice: "One I shall keep for myself, the other shall be for Europe." Kotzebuë 1819, 298. See Diba essay in this volume for a detailed discussion of this concept.

12. Ouseley 1819–32, vol. 3, p. 132.

13. According to Charles Texier, "Among Persians, painting is mainly dedicated to the decoration of buildings: one does not see there [so many] of the framed paintings that are so numerous in our country." Texier 1842, 125.

14. A juxtaposition of the monumental painting *Fath 'Ali Shah and His Sons Hunting* and the lacquer book cover with the same subject by Sayyid Mirza (FIGS. 14a,b) exemplifies the ways in which artists tailored the same compositions to suit various formats and media. Layla Diba brought this juxtaposition to my attention in the preliminary stages of our research for the present exhibition.

15. Texier 1842, 127–28.

16. Toby Falk, "A Qajar Painting of Two Girls," in *The Royal Asiatic Society: Its History and Its Treasures*, ed. by Stuart Simmonds and Simon Digby (Leiden and London, 1979), 110. See NO. 57 for further discussion of this painting.

17. This method involved placing a piece of deerskin or paper over the subject to be copied and tracing the outline carefully onto the new surface. The traced outline would then be pricked with a fine needle. Finally, the pricked outline would be laid on the paper in the required position and charcoal dabbed on it by means of a mesh bag. The charcoal would penetrate the pinholes, forming an outline to guide the copier. See Norah M. Titley, *Persian Miniature Painting* (Austin, Texas, 1983), 216–17.

18. Studies examining the technical aspects of wall paintings of the Timurid and late Safavid periods have found some evidence of pouncing. For the Timurid period, see Lentz 1993, 257–61, and for the late Safavid period, see Mihdi Aqa Jani, "Tāmirat-i Naqqāshī," *Asar* 2–4 (1970). I want to thank Sussan Babaie for bringing the latter article to my attention.

19. Comte de Rochechouart reports that in the 1860s pounces were used by lacquer painters to replicate designs on lacquer objects. Julien Comte de Rochechouart, *Souvenirs d'un Voyage en Perse* (Paris, 1867), 270. The use of pounces to transfer designs onto a variety of media such as manuscript illustrations, lacquer, and enamels has also been documented in the working album of Lutf 'Ali Suratgar, a contemporary of Sani' al-Mulk's. The materials in this album range in style from the late Safavid to the Zand and Fath 'Ali Shah periods. See Diba 1989b, 157–59. Muhammad 'Ali Karimzadeh also documents that, in the mid-nineteenth century, the lacquer painter Muhammad Isma'il used pounces in the production of lacquer mirror cases and penboxes. See Karimzadeh Tabrizi 1985–91, vol. 1, pp. 457–61.

20. The Andrew W. Mellon Curatorial-Conservation study at the Brooklyn Museum of Art investigated whether Qajar painters did in fact use pouncing or underdrawings for the replication of paintings on canvas. Preliminary examination and study of the early Qajar paintings included in this study revealed that not only were most paintings carefully mapped out, as indicated by the distinct pauses in the application of the paint, but painters often produced underdrawings and sketched out their works before applying pigments.

21. For Timurid *zūfunūn*, or multicrafted, artists, see Lentz 1993. The fact that, for example, Muhammad Isfahani, a painter in the atelier of Safavid ruler Isma'il II

(1576–78) had worked as a mural painter, as well as a manuscript illustrator and a poet, illustrates that *zūfunūn* artists, especially those capable of working in different fields of painting, had been active during the Safavid period.

22. Fursat al-Dawleh Shirazi was a late nineteenth-century poet, painter, writer, musician, and engineer who gained the favor of three late nineteenth-century Qajar rulers, Nasir al-Din Shah, Muzaffar al-Din Shah, and Muhammad 'Ali Shah.

23. For example, the Qasr-i Qajar, the Negarestan palace, the Sulaymanieh palace in Karaj. He was also commissioned by Fath 'Ali Shah to oversee the reconstruction and decoration of the 'Imarat-i Chishmeh, a pavilion honoring one of the shah's favorite wives, Tavus Khanum. See 'Azud al-Dawleh 1976, 19. See also Hidayat 1960, vol. 10, pp. 137–38.

24. This manuscript, in the Windsor Castle Library, was taken to England by Fath 'Ali Shah's ambassador, Abu'l Hasan, as a gift to King George III. See Robinson 1991, 874.

25. The Andrew W. Mellon Curatorial-Conservation study explored this question through pigment analysis of a variety of branches of painting (see n. 18).

26. Kotzebuë 1819, 298.

27. See Adamova 1996, 286–87, no. VR–1107. Dr. Adel Adamova brought this point to my attention at the 1995 colloquium "Historical and Cultural Issues of the Post-Safavid and Qajar Periods" at the Brooklyn Museum of Art, February 24, 1995.

28. Lisan al-Mulk Sipihr 1875, 1965 ed., vol. 2, pp. 133–34.

29. Dust 'Ali Khan Mu'ayyir 1982, 278–80.

30. The term *silsileh*, meaning "chain of transmission," used to describe the master–pupil relationship among painters and calligraphers, is a deeply rooted concept in Islamic culture. This term was originally used to refer to the chain of transmission among the *faqīhs* or religious scholars and the sufis or mystics.

31. Benjamin 1887, 314–15, 316–17.

32. Layla S. Diba, for example, maintains that a study of signatures from the eighteenth century provides essential evidence that the core elements of a style had been transmitted from one generation to another and applies this method to the followers of the school of Muhammad Zaman. Some examples of her analysis of signatures are as follows: *Zi ba'd-i Muḥammad 'Ali ashraf shud* (After Muhammad 'Ali was the most noble), implying that there was a student–teacher relationship between 'Ali Ashraf and Muhammad Zaman; *Ṣādiq az Luṭf-i 'Ali*

ashraf shud (Sadiq was the most noble by the grace of 'Ali), implying that there was a master–student relationship between Muhammad Sadiq and 'Ali Ashraf; and *Bāqir az ba d-i 'Ali ashraf shud* (Muhammad Baqir was most noble after 'Ali), implying that a master–pupil relationship existed between Muhammad Baqir and 'Ali Ashraf. Diba 1989b, 149. See also Yahya Zuka, "Ṭarz-i raqam zadan va nimūneh-i az furūtanī-yi hunarmandān-i Īrani," in *Nigāhī bih nigārgarī-yi Īrani dar Qarn-i Davāzdahum va Sizdahum* (Tehran, 1975), vol. 1, pp. 101–4.

33. Benjamin 1887, 278.

34. Chardin 1811, vol. 5, p. 500. See also Keyvani 1982, 93.

35. Ibid.

36. Arthur de Gobineau, *Trois ans d'Asie* (Paris, 1859), 392–404. See also Benjamin 1887, 278.

37. Heger, "The Status and the Image," 136; Keyvani 1982, 169–70.

38. Mirza Sadiq Musavi Nami-yi Isfahani, *Tārīkh-i Gītī Gushā*, ed. by Saïd Nafisi (Tehran, 1984), 96, 158. In 1760 Karim Khan Zand ordered the recruitment of the most skilled architects, builders, carpenters, and painters of the kingdom to construct an opulent palace with a lavish reception hall (Divankhaneh or Dīvan-i Dar al-'Imareh) in Tehran.

39. Yahya Zuka, "Tājha va Takhtha-yi Salṭanatī-yi Īrān," *Hunar va Mardum*, no. 60 (October 1987): 52, 53.

40. Ibid., 50.

41. See Floor, "Aṣnāf," 774; C. G. Wills, *In the Land of the Lion and Sun* (London, 1883), 224; Chardin 1811, vol. 5, pp. 499–500.

42. Polak 1865, vol. 2, pp. 165–90.

43. Diba 1989b.

44. Fasa'i 1972, 1988 ed., vol. 1, pp. 990–1019. Sayyid Ahmad Divan Baygi Shirazi, *Ḥadīqat al-Shu'arā* (Tehran, 1985), vol. 3, pp. 1987–2000.

45. That Muhammad Ismail was the son of the painter Aqa Najaf has been questioned by M. A. Karimzadeh. See Karimzadeh Tabrizi 1985–91, vol. 1, p. 68.

46. Robinson 1970.

47. See Muhammad Ali Karimzadeh Tabrizi, "Āqā Najaf Naqqāshbāshī-yi Iṣfahāni," *Hunar va Mardum*, no. 159 (January–February 1975): 88–92. See also Karimzadeh Tabrizi 1985–91, vol. 1, p. 68.

48. Keyvani 1982, 38. A surviving Safavid *firmān* of Shah Tahmasp I dated A.H. 983/A.D. 1575 assigns to Mulla Hasan Muzahib (manuscript illuminator) a number of responsibilities that are specified in detail: he was to supervise the guilds of the manuscript illuminators, scribes, binders, illustrators, and paper sellers; license persons who were qualified to practice the said crafts; constantly

inspect the raw materials that the artisans used in their work and take action against any artisan guilty of professional misconduct. Keyvani 1982, 81. See also Najib Mayil-i Hiravi, *Kitāb Ārā-ī dar Tamaddun-i Islāmī: Majmū'eh-i Risā'il dar Zamīneh-i Khushnivīsī, Murakkabsāzī, Kāghazgarī, Tazhib va Tajlīd* (Mashad, 1993), xxiv.

49. Karimzadeh Tabrizi 1985–91, vol. 1, p. 302, "Firmān-i Muḥammad Shāh barāyi Mi̇mārbāshī-yi Darbār."

50. For the Timurid period, see Anonymous, *Munsha'āt-i Sulṭān Ḥusayn Bāyqarā*, in Keyvani 1982, 79–80. For the Afsharid period, a *firmān* appointing Mirza Mihdi Khan Astarabadi, known as Kawkab, Nadir Shah's Chief Chronicler, as supervisor of all building projects and gardens of Isfahan serves as evidence that this practice also prevailed during the Afsharid period. The *firmān* states that all the caretakers, engineers, masons, painters, and gardeners were to report to Mirza Mihdi Khan and obey his orders. "Firmān-i Nizārat-i Bāghāt va 'Imārāt bih Mīrzā Mīhdi Khān," in *Nādirnāmeh*, ed. by Muhammad Husayn Quddusi (Mashad, 1960), 552–54.

51. Mirza Sadiq Vaqayi'nigar attributes the design of Fath 'Ali Shah's Marble Throne, the Takht-i Marmar, to Mirza Baba, Fath 'Ali Shah's first *naqqāshbāshī*. In this inscription Mirza Baba is referred to as the designer (*ṭarrāh kilk-i nayrangsāz*) of the Marble Throne. See "Tārīkh-i Jahān Ārā," 1810 manuscript, British Library, London, Rieu MSS Add 22,697, pp. 192–93.

52. Mudarrisi-i Tabataba'i, *Turbat-i Pākān* (Qum, 1966), 87.

53. Karimzadeh Tabrizi 1985–91, vol. 1, p. 303.

54. Keyvani 1982, 81. E. Kaempfer, *Am Hofe des Persischen Grosskönigs (1684–85)*, ed. by W. Hinz (Leipzig, 1940), 87–88.

55. For the appointment and role of the *bāshīs*, see Keyvani 1982, 81.

56. Dust 'Ali Khan Mu'ayyir 1982, 275, 277–78.

57. Muhammad Hashim Asaf 1969, 101–2.

58. Karimzadeh Tabrizi 1989, 160–61, 147.

59. R. G. Mukminova, "Craftsmen and Guild Life in Samarqand," *Muqarnas* (1992): 32. Articles were both made and sold in the *ḥujreh*.

60. Membré 1993, 20.

61. Simpson, "The Production and Patronage of the Haft Awrang," 97, 99.

62. P. Amédée Jaubert, *Voyage en Arménie et en Perse fait dans les Années 1805 et 1806* (Paris, 1821), 210.

63. Ouseley 1819–32, vol. 3, p. 259. In 1864, James Ussher reported that on his visit to the Chihil Sutun palace in Isfahan, the residence of the prince-governor, he was guided to the living quarters of the

"best painter in Isfahan, whose chief employment seemed to be painting penboxes and cases." This was possibly Muhammad Ismail Isfahani. James Ussher, *A Journey from London to Persepolis* (London, 1865), 583.

64. Salih Shirazi 1984, 30.

65. 'Azud al-Dawleh 1976, 58.

66. Keyvani 1982, 49–53.

67. Heger, "The Status and the Image," 190.

68. For the early to mid-Safavid period, see Samia 1980. For the late Safavid period, see Muhammad Hashim Asaf 1969, 100. For the Afsharid period, see Nami-yi Isfahani, *Tārīkh-i Gītī Gushā*, 155. For the Qajar period, see Holtzer 1975, 39–42; and Mirza Husayn Tahvildar, *Jughrāfīyā-yi Iṣfahān* (1877 manuscript; Tehran, 1963), and I'tizad al-Saltaneh 1991, 69–73.

69. Texier 1842, 127.

70. Salih Shirazi 1984, 6, Dunbuli 1972, 69–71. I'tizad al-Saltaneh 1991, 70–72, I'timad al-Saltaneh 1878, 104, 1286. *Rūznāmeh-i Sharaf*, Rabi al-Sani A.H. 1300/ February A.D. 1883, no. 2.

71. V. B. Meen and A. D. Tushingham, *The Crown Jewels of Iran* (Toronto and Buffalo, 1968), 61. The same bond seems to have existed between Muhammad Isma'il, one of Nasir al-Din Shah's painter laureates, and Nasir al-Din Shah. Muhammad Isma'il's self-portrait painting a lacquer object appears on the interior of a royally commissioned penbox dated 1866. See Robinson 1989, 136.

72. The painter Aqa Buzurg included his self-portrait on one end of a lacquer penbox that he produced for his patron Firuz Mirza, prince-governor of Shiraz in the 1850s. See Robinson 1989, 141.

73. Kotzebuë 1819, 302. See Diba essay in this volume for a more detailed discussion of this subject.

74. *Firmāns* reproduced in Karamat Ra'na Husayni, "Sih firmān az Muḥammad Shāh barāyi Khushnīvisān-i Shīrāzī," *Hunar va Mardum*, no. 184 (1977): 83–85.

75. Kaempfer, *Am Hofe des Persischen Grosskönigs*, 177, and Cornelis Le Bruyn, *A New and More Correct Translation of Le Brun's Travels in Moscow, Persia and Divers Parts of the East Indies* (London, 1795), 297.

76. N. A. Kuznetsova, "Materialy K. Kharakteristicke remeslennogo proizvodstva viranskom gorode XVIII-nachala XIX veka. O genezise kapitalizma v stranakh vostoka CXV–XIXVV," in Issawi 1971, 336–60.

77. Lisan al-Mulk Sipihr 1875, 1965 ed., vol. 2, pp. 133–34.

78. Samia 1980. Kaempfer, *Am Hofe des Persischen Grosskönigs*, 175. Chardin himself had introduced two Frenchmen, a clock-maker and a jeweler in the shah's service. Chardin 1811, col. 9, pp. 343–44. Willem

M. Floor, "Dutch Painters in Iran during the first half of the 17th century," *Persica* 8 (1979). Massumeh Farhad, "Safavid Single Page Painting, 1629– 1666," Ph.D. dissertation, Harvard University, Cambridge, Massachusetts, 1987.

79. Mirza Abu'l Hasan, Persia's envoy to England, for example, recalls the following conversation after visiting an enamel workshop with Sir Gore Ouseley (in London) and talking with the master enameler: "I told the master-enameller that if he would agree to the journey with me to Iran, the Shah would place him in charge of an enamel-works among the many art workshops which he has commanded to be established." Abu'l Hasan Khan 1988, 122. Abu'l Hasan Khan Ilchi, *Ḥayratnāmeh: Safarnāmeh-i Abu'l Ḥasan Īlchī bih Landan* (1809–10 manuscript; ed. by Hasan Mursilvand Tehran, 1986) 184.

80. This multivolume manuscript is presently in the Gulistan Palace Library, Tehran (FIG. 3).

81. I'timad al-Saltaneh 1984, 63. Husayn 'Ali Khan Mu'ayyir al-Mamalik was appointed as its supervisor. I'timad al-Saltaneh 1984, vol. 3, p. 224.

82. In an effort to make Iran self-sufficient and independent of foreign powers, Amir Kabir generated an economic plan whereby he encouraged the creation of local factories and favored the activities of local artisans and craftsmen. To this end, he founded the Majma' al-Dar al-Sanayi'.

83. Dust 'Ali Khan Mu'ayyir 1982, 274.

84. "Sabzeh Maydān va Majma' Dār al-Ṣanāyi'," *Yādigār*, no. 9–10: 60–70. This article includes a plan of this craft center (1860) produced by Muhammad Husayn Khan Zanganeh, a Dar al-Funun graduate.

85. Ibid.

86. In the Dihkhuda dictionary, *nayrang* is defined as an underdrawing, preliminary sketch, or design using charcoal. Dihkhuda adds that this device was used by painters, designers, and architects. 'Ali Akbar Dihkhuda, *Lughatnāmeh-i Dihkhudā*, vol. 6, p. 991.

87. *Tazkirat al-Shuarā* or *Ganj-i Shāyigān*, quoted in Zuka 1963, 20.

88. Dust 'Ali Khan Mu'ayyir 1982, 275.

89. *Rūznāmeh-i Dawlat-i 'Illieh-i Īrān*, no. 518. 3 Shaval A.H. 1278/April 3, A.D. 1862.

90. Ibid.

91. Ibid.

92. Karimzadeh Tabrizi 1985–91, vol. 1, p. 292.

93. Dust 'Ali Khan Mu'ayyir 1982, 279.

94. Saravi 1992, 110. Muhammad Hashim Asaf 1969, 410. See also Razi Ahmad Munshi, *Tārīkh-i Qājār* or *Badāyi' al-Tavārīkh*, A.H. 1271/ A.D. 1854, Tehran University Faculty of Law, MSS 122,1B, 122,2B. Published in Zuka 1963, 24.

95. Afshar 1970, 169–70, and Fursat al-Dawleh Shirazi, *Āsār-i 'Ajam* (Bombay, 1896), 547. Throughout the *Āsār-i 'Ajam*, Fursat al-Dawleh reiterates the importance of adhering to well-defined principles, or *burhān*, as the Europeans do and claims that that is the reason why the Europeans are so advanced.

96. I'timad al-Saltaneh 1984, 268.

97. Adle and Zuka 1983, 249–80.

98. Abu'l Hasan's nephew, Abu Turab, who worked as an illustrator for the Ministry of Publications, is said to have produced lithograph portraits after photographs. "Nāmeh-i Zakā' al-Mulk bih Dr. Ghani," in Suhayli Khwansari 1989.

99. Later Muzzayin al-Dawleh also taught band music at the Dar al-Funun. For a short biography of this artist, see Ghulam Husayn Afzal al-Mulk, *Afzal al-Tavārīkh*, ed. by Mansureh Ittihadieh Nizam Mafi and Cyrus Sa'dvandian (1899 manuscript; Tehran, 1982), 198. He is said to have replaced Monsieur Constant, a French teacher of painting and French language at the school, who was recruited by Prime Minister Amin al-Dawleh on his mission to Paris in 1848.

100. Curzon 1892, vol. 1, pp. 494–95.

101. Dust 'Ali Khan Mu'ayyir 1982, 277.

102. *Rūznāmeh-i Sharaf*, no. 60.

103. Afzal al-Mulk, *Afzal al-Tavārīkh*, 180. Khalil Saqafi, "Yāddāshthā-yi Shakhṣī-yi Khalīl Saqafi va Monsieur Richārd," in *Maqālāt-i Gunāgūn* (Tehran, 1943), 163–66.

104. Inscription on a full-length painting of Nasir al-Din Shah in a private collection in London. The inscription reads: "'Amal-i kamtarīn Khānehzād Ja'far, tarbiyat yāfteh-i Madraseh-i Mubārakeh, A.H. 1291/A.D. 1874. The work of the humblest slave of the household Ja'far, trained at the celebrated school [Dar al-Funun]."

105. Suhayli Khwansari 1989, 179.

106. The academy remained at this location for sixteen years. *Firmān* issued by Hakim al-Mulk, Minister of Education, appointing Kamal al-Mulk as the director of the school is reproduced in Suhayli Khwansari 1989, 194.

107. Ibid.

108. Ibid.

109. Ibid., 81–83.

110. "Letter from Kamāl al-Mulk to Prime Minister Zakā' al-Mulk Furūghī," circa A.H. 1305/A.D. 1887, reproduced in Suhayli Khwansari 1989, 66–67.

111. Letter from Prime Minister Zakā' al-Mulk to Kamāl al-Mulk (director of the school), May 1926, reproduced in Suhayli Khwansari 1989, 67.

112. Ibid, 58.

113. Suhayli Khwansari 1989.

ART AND DIPLOMACY

Qajar Paintings at the State Hermitage Museum

ADEL T. ADAMOVA

THE STATE HERMITAGE Museum in Saint Petersburg possesses a small but fine and wide-ranging collection of works by Qajar artists. The majority of the works, which comprise 15 oil paintings, the same number of high-quality miniatures and drawings, 295 lacquers, and about 20 enamels, entered the Hermitage in 1924–25, when they were transferred there along with the rest of the collections of the Stieglitz Museum.[1] The acquisition of most of the oil paintings from Persia, however, dates back to diplomatic and cultural contacts in the first half of the nineteenth century and the two Perso-Russian wars of 1805–13 and 1826–28. The collection of paintings, which were executed in the first half of the nineteenth century, is of particular historical significance because of its correspondence to contemporary accounts by Russian diplomats and travelers. Some works in the Hermitage collection can, in fact, be identified with pictures mentioned in these memoirs.

The Qajar paintings came to the Hermitage by various routes. Five of the oils – two portraits of Fath 'Ali Shah (NOS. 39, 40), *Crown Prince 'Abbas Mirza and Court Officials* (NO. 50), *Female Dancer with Castanets* (NO. 59), and a half-length portrait of a man, presumably of 'Abbas Mirza's son, Muhammad Mirza (NO. 66) – evidently were royal gifts to the Russian tsars and ambassadors and entered the collection in 1931 from the Gatchina Palace Museum.[2] Two monumental canvases, *Military Review with Fath 'Ali Shah and 'Abbas Mirza* and *Battle of Prince 'Abbas Mirza with*

Russian Troops (NOS. 51, 52), were taken directly from Iran to the Winter Palace of the Russian tsars in Saint Petersburg in February 1828. One oil painting, *Woman Holding a Rose* (NO. 56), as well as numerous miniatures, including portraits of Nadir Shah, 'Abbas Mirza (FIG. 20), Muhammad Mirza (FIG. 21), Nasir al-Din Shah,[3] and the majority of lacquers, came from the Stieglitz Museum in 1924–25 and previously belonged to General-Major Piotr Vladimirovich Charkovsky, a Brigade commander of a Caucasian Cossack division. In 1886 Charkovsky's collection of Persian art was acquired for the Stieglitz Museum by Alexander Alexandrovich Polovtsov (1832–1909), a senator and state counselor, who was also president of the Council of the Central School of Technical Drawing founded by Stieglitz. Owing to Polovtsov's efforts, the Stieglitz Museum acquired rich art collections.[4] Three paintings – two small ones, *Boy Holding a Rose* and *Boy Holding a Falcon,* and *Khusraw Parviz*[5] – were transferred to the Hermitage in 1931 from the Society of Ancient Written Languages, in the same city. Three female portraits (see FIG. 25) and *Amorous Couple,*[6] all oils, were bought by the Hermitage from private collectors in the 1920s and 1960s.

The most important documents of the early nineteenth century relating to Qajar works at the Hermitage are the notes of General Alexey Petrovich Yermolov, head of the Russian Embassy to Persia in 1817, as well as the accounts of Moritz von Kotzebuë and Vasily Borozdna, also attached to that embassy.[7] For the time of the reign of Muhammad Shah (r. 1834–48), the most informa-

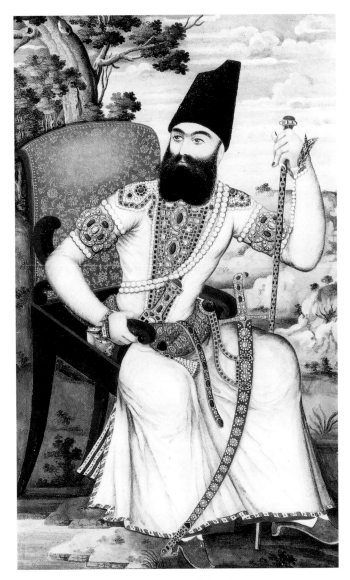

FIG. 20. *Miniature Portrait of 'Abbas Mirza.*
Attributed to Allahvirdi Afshar. Iran, circa 1820. Opaque watercolor
on paper, 9³/₈ x 5¹¹/₁₆ inches (23.8 x 14.5 cm).
STATE HERMITAGE MUSEUM, SAINT PETERSBURG, VR-666.

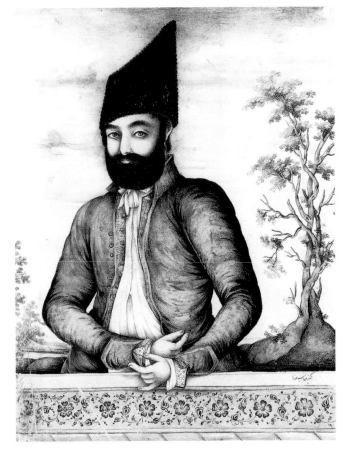

FIG. 21. *Miniature Portrait of Muhammad Mirza.*
Sayyid Mirza. Iran, circa 1828–30. Gouache on paper, 8⁹/₁₆ x 6³/₁₆
inches (21.8 x 15.7 cm).
STATE HERMITAGE MUSEUM, SAINT PETERSBURG, VR-691.

tive sources have proved to be the memoirs of Fedor Korff,
Alexey Soltykov, and Ivan N. Berezin.[8] Baron Korff, a
Russian official, worked in the Russian mission in Persia
in 1834–35. He accompanied the newly proclaimed
Muhammad Shah from Tabriz to Tehran in 1834 and
attended the ceremony of the latter's coronation in
January 1835, where he was awarded the Order of the Lion
and Sun. He also attended the ceremony in which the four-
year-old prince Nasir al-Din Mirza was proclaimed Na'ib
al-Saltaneh (Crown Prince) at Tabriz. Four years later,
in 1838, Prince Soltykov, a traveler and artist, visited Per-
sia and was received many times by Muhammad Shah;
Berezin, a well-known Russian orientalist and professor
at the University of Kazan, visited Persia in 1842.

The route to Tehran taken by the Russian travelers
and envoys was by way of Erivan, Tabriz, Ujan, Mianeh,
Sultanieh, and Sulaymanieh, and we find descriptions
of the paintings in the palaces and country residences
of the shahs and princes in their memoirs. Contemporary
Russian artists were often asked to execute portraits of
the shahs and princes. If one is to believe Korff, there ex-
isted a law prohibiting private persons from commissioning
their own portraits, so that only the royal family had
this right.[9] The Russian travelers' notes on how the shahs
posed for portraits, and what kind of corrections artists
were asked to make, add much to the understanding of the
tastes, aims, and artistic principles prevailing in Qajar court
art. In this connection the notes of Kotzebuë are reveal-
ing. According to Kotzebuë, when Fath 'Ali Shah realized
that there was a painter in the suite of General Yermolov,
he immediately asked him to paint two portraits of
himself, one to be sent to Europe and the other for Fath
'Ali Shah to keep: "The latter [Fath 'Ali Shah] immedi-

ately expressed a desire to sit for his picture, and sent for the artist, to whom he showed two portraits of himself, which he thought good likenesses, and he desired to be painted in the same style. This was very natural for the artist had flattered him in both instances. In short the shah did what he had never done before: he placed himself on his throne, assumed an easy attitude. . . . Our painter was the first mortal to have seen the Shah so closely and to have been seated in his presence."[10] Kotzebuë, as well as Borozdna and Yermolov, informs us that two full-length portraits of Fath 'Ali Shah were presented to the Russian mission – one for the emperor, the other for the ambassador. The Persians regarded the image of the monarch with the same reverence as the original: "The Ambassador directed that the pictures be carried to the camp by the gentlemen of the Embassy, which was accordingly done, amidst the same honours on the part of the troops and of the people, as if the King had been actually present."[11]

Muhammad Shah posed several times for Alexey Soltykov and he also asked the Russian traveler to make a likeness of his four-year-old son.[12] Soltykov describes his presentation at the Tabriz court in 1838 to the *vali'ahd,* the young prince Nasir al-Din Mirza, then seven years old and still living in the harem. He describes the prince's likeness and garments, especially noting the Russian Order of Saint Andrew on a rich diamond chain adorning his chest and the diamond plume attached to his lambskin hat, recently presented to him by the Russian tsar in Erivan.[13] The meeting of Nicholas I and the seven-year-old crown prince in 1838 was commemorated much later, in 1854, by Muhammad Isma'il, *naqqāshbāshī* of Nasir al-Din Shah, on a lacquer mirror case (NO. 73) that shows the prince wearing these rich presents and sitting on the tsar's knee.[14] The mirror indicates that, seventeen years after the event, this meeting was still important for the Persian monarch. At Tabriz, Soltykov was asked by the prince's mother to draw portraits of the crown prince "en habit de gala" (in ceremonial attire). Soltykov comments: "I made three watercolor copies of the crown prince's portrait in watercolor and gold, one for the queen mother, the other for Mohammad Shah the father and the third for myself. To conform to Persian taste, I modified my usual technique by adding brighter colors and greater detailing in the drawings I made."[15]

The Hermitage collection includes a number of paintings and drawings by Saint Petersburg artists that are not specifically mentioned in known written sources for the period although they nevertheless reflect diplomatic and cultural relations between Persia and Russia in the first half of the nineteenth century. Among them is a watercolor (see FIG. 22) dated 1816 by fifteen-year-old Prince Vladimir Soltykov, Alexey Soltykov's elder brother, which shows the ceremonial entry of the Qajar envoy Mirza Abu'l Hasan Khan to Saint Petersburg on December 20, 1815. The shah's envoy and members of his suite on horseback, escorted by cuirassiers, moved along the

FIG. 22. *Ceremonial Entry of Mirza Abu'l Hasan Khan to Saint Petersburg on December 20, 1815.*
V. Soltykov (Russian, active 1801–31). 1816. Watercolor on paper, 18⁷/₁₆ x 24¹⁵/₁₆ inches (47.3 x 63.3 cm).
STATE HERMITAGE MUSEUM, SAINT PETERSBURG, ERR-965.

Neva embankment in a picturesque procession with brightly painted elephants, whose legs were fitted with warm footwear. The collection also includes thirteen lithographs, executed by Karl P. Beggrov and other Russian artists after the drawings by Vladimir I. Moshkof, a painter of battle scenes attached to the Russian military staff. The lithographs were commissioned by General Ivan F. Paskevich, commander in chief of the Russian army in the Caucasus from 1827 to 1831. They represent military campaigns of the second Perso-Russian war, the first meeting of Prince 'Abbas Mirza and General Paskevich in Deikorgan (see FIG. 23), and the signing of the peace treaty at Turkmanchai on February 10, 1828. A black pencil drawing in the Hermitage collection showing the young prince Khusraw Mirza ('Abbas Mirza's son) on horseback in Saint Petersburg against the Saints Peter and Paul Fortress was executed by Eduard Hauser (1807–1864), who worked in Saint Petersburg in the late 1820s.[16] Khusraw Mirza was sent by Fath 'Ali Shah to head the Persian mission to the Russian tsar following the attack on the Russian mission in Tehran (February 11, 1829) and resulting murder of thirty-seven members of the mission and Alexander Griboyedov, a famous Russian playwright and diplomat, who had been appointed head of the Russian mission to Persia in 1828. Khusraw Mirza was granted audience on August 24, 1829. Among the gifts sent by Fath 'Ali Shah to Nicholas I were eighteen Persian manuscripts, including a magnificent manuscript of the *Dīvān-*

i Khāqān (*Anthology of Fath 'Ali Shah's Poetry*), copied by Aqa Muhammad Ja'far Isfahani, richly illuminated, and with a beautiful lacquer binding (Russian National Library, Saint Petersburg).[17]

These contemporary written and pictorial sources furnish a background against which the paintings can be better understood and more exactly dated and localized. The written sources are especially important because the development of Qajar painting thus far has been charted only in the most general way and attribution on stylistic grounds is often inadequate. Moreover, the majority of preserved Qajar paintings have no artists' signatures and dates. Painted on canvases, they were glued or pasted to the walls of palace apartments. Thus, paintings were still on the walls of some of the palaces built for Fath 'Ali Shah and his sons that Berezin saw abandoned, in ruins, in 1842.[18] Repairs at the edges of almost all the Qajar pictures, including those in the Hermitage collection, show that they must have been torn away from the walls, so that signatures and dates, usually written near the damaged edges, were lost.

All the oil paintings in the Hermitage collection are dated to the first half of the nineteenth century. Three of them bear signatures and dates, while others can be dated with the help of historical documentation.

Two life-size portraits of Fath 'Ali Shah painted by the chief court artist Mihr 'Ali in 1809–10 and 1813–14 (NOS. 39, 40) have been published extensively and are

FIG. 23. *The First Meeting of General Paskevich with Prince 'Abbas Mirza in Deikorgan.*
K. Beggrov (Russian) after V. Moshkof (Russian, 1792–1839). Lithograph, 12 x 17 11/16 inches (30.5 x 45 cm).
STATE HERMITAGE MUSEUM, SAINT PETERSBURG, ERG-26171.

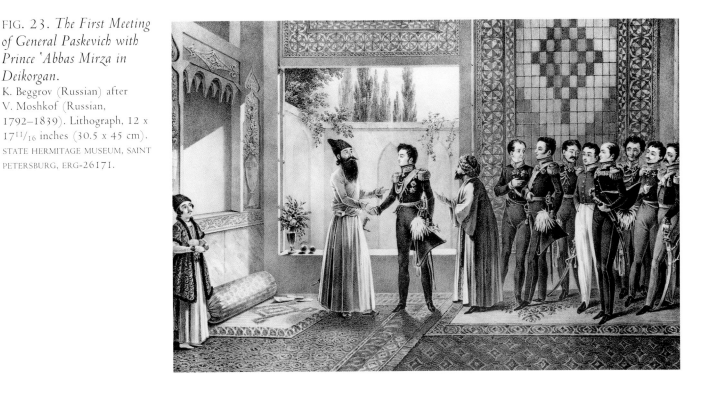

well known among specialists. They are fine specimens of Qajar painting, illustrating typical features of the official style developed at the court of Fath 'Ali Shah in Tehran. The portraits are emphatically formal and monumental in style, built on a compositional formula prescribed by the contemporary artistic canons. The earlier portrait is of particular interest because it was possibly the first to show the Persian monarch standing and holding a scepter: Mihr 'Ali's own inscription in the lower left corner reveals that the portrait was seen by Fath 'Ali Shah and accepted without any corrections (bidūn-i taghyīr). This type of portrait of Fath 'Ali Shah, shown standing with a scepter in his right hand, was repeated by Mihr 'Ali four years later, in 1813.[19] The same image was also enameled in the central gold plaque on a jeweled nephrite dish, presented on the shah's behalf to the Austrian emperor Franz I (r. 1792–1835) by the Persian ambassador Abu'l Hasan Khan. The dish (Kunsthistorisches Museum, Vienna) was painted by Ghulam Khanehzad 'Ali in 1818.[20]

Woman Holding a Rose and Female Dancer with Castanets (NOS. 56, 59), painted at the same time as the portraits of Fath 'Ali Shah, also give a good idea of the artistic canons, requirements, and taste of the first quarter of the nineteenth century as reflected in the art of painting in Tehran. The painters of NOS. 56 and 59 did not aim to create an image of an individual woman, but merely repeated a certain syncretic female ideal of beauty, a type probably well established by this time in Qajar court taste and painting. The static quality of composition, the absence of foreshortening and modeling, the local color, and the importance of ornamentation are characteristic of paintings of the period.

The treatment of the subject in these and other Qajar paintings of the first quarter of the nineteenth century is rather naive and simplified. Because the paintings are state portraits or idealized representations of women, the personalities of the models are not indicated. The object, instead, was to create colorful ornamental compositions, generally for the walls of palaces of the shah and of high nobility, that would be effective when viewed from afar.

A group of paintings in the Hermitage collection demonstrates regional tendencies and approaches, in contrast to those of the metropolitan court style. Two monumental paintings with many figures (NOS. 51, 52) are of particular interest. To begin with, they are the first published Qajar large-scale compositions of the type previously known from the mid-seventeenth and

mid-eighteenth-century paintings from the Chihil Sutun palace in Isfahan.[21] In addition, they are rare surviving examples of the many large canvases of enthronements and hunting and battle scenes (the main subjects in Qajar painting) seen by European and Russian travelers in royal palaces and pavilions. As B. W. Robinson wrote in his 1963 groundbreaking study of the paintings of Fath 'Ali Shah then known, "Others of these enormous canvases may perhaps survive elsewhere but it is to be feared that most of them have been either destroyed, cut up to be sold as separate pictures, or mounted in sections as screens."[22] Moreover, the Hermitage paintings can be identified with particular battle scenes noted by travelers; only one other work, showing a battle of Fath 'Ali Shah with Russians (FIG. XII), has been so identified.

The two Hermitage paintings represent Fath 'Ali Shah's son 'Abbas Mirza, the crown prince and governor of Azarbaijan, who had his capital at Tabriz and conducted the Iranian military campaigns. In one picture (NO. 52) he is commanding the Persian army in victorious battle against the Russians, while an English officer commands artillery in the very center of the composition; in the other he is kneeling before Fath 'Ali Shah, who is mounted on horseback.

Details in descriptions by Russian diplomats leave no doubt that the Hermitage canvases are the very pictures that decorated 'Abbas Mirza's palace at Ujan, near Tabriz. V. Borozdna writes of two canvases in the audience hall at the Ujan palace, where the Russian mission stayed in 1817 before meeting with Fath 'Ali Shah in Sultanieh. One of the paintings depicted a parade of the Persian army in the presence of the shah, shown sitting on horseback before the kneeling 'Abbas Mirza; while the other represented the victory in battle of the Persians, commanded by 'Abbas Mirza, over the Russians.[23] In a similar description, Kotzebuë mentions an English officer in the foreground of the battle scene and adds that the Persian troops are organized in a European manner.[24] From a third account, by General Yermolov, it can be deduced that the English officer is Major Lindsay from the East India Company and that the battle represents, as Yermolov learned from the Persians, the defeat of a battalion of the Troitsky regiment.[25] A nineteenth-century Russian historian, Nicolay F. Dubrovin, records the "sad fate" of a battalion of the Troitsky Musketeer regiment. It happened on February 1 old style (February 13), 1812, in a place called Sultan-Bud Kirchi, not far from the village of Shusha. Having been informed about a small Russian force located

there, 'Abbas Mirza with his army (10,000 cavalry, 8,000 infantry, 11 guns, and 100 falconets, for which the English officers were responsible) crossed the Aras river, moved to Sultan-Bud Kirchi, and attacked the Russians with all his forces. The Russian garrison counted 10 officers and 517 men of lower rank. They fought bravely in a square formation near their mud huts. Dubrovin mentions that both guns of the Russians were damaged. [26]

According to the English envoy James Morier, 'Abbas Mirza gathered his army in Mughan in the last days of January 1812: "Before he crossed the Aras, the prince had heard that 800 Russians, with two guns, were posted at the village of Sultanboot, not very distant from Shisheh, and determined to attack them. . . . The attack, under the command of Colonel d'Arcy, took place in the morning." Morier vividly relates how Fath 'Ali Shah in Tehran was informed about the great victory. He also mentions the beheaded corpse of an Englishman found after the battle.[27]

One more citation is from Denis Wright:

When the Russians renewed their attacks on the Caucasian provinces in 1812 four of the British officers — D'Arcy, Lindsay, Christie and George Willock — together with twelve sergeants of the Artillery and the 47th Regiment, accompanied the Persian soldiers into battle. They were delighted when, after a series of defeats, the Persians, albeit numerically greatly superior, routed a small Russian force after a four-and-a-half hour encounter at Sultanabad near the river Aras on 13 February 1812: about 500 Russians were killed or wounded for the loss of only 100 Persians and one British sergeant whose headless body was found the next morning. The Crown Prince . . . had insisted on leading his troops. He generously gave full credit for the victory to the British officers who had directed the operations. . . . Robert Gordon, of Ouseley's staff, wrote from Teheran to his brother, the twenty-eight-year-old Lord Aberdeen and future Prime Minister, that the victory "has elated us all beyond measure — the fact of the matter is that the Persians have hitherto fled from the Russians, 500 of whom have been known to keep a whole Persian army at bay! The merit, if there be any, is entirely due to ourselves. . . ."[28]

All the authors undoubtedly describe one and the same battle, and it is highly probable that the Hermitage picture represents this encounter, of which the Persians were so proud. Many details coincide in the descriptions and in the picture: mud huts, Russian infantry forces

fighting formed in a square, severed heads of the enemies, artillery, and an English officer commanding.[29]

The second canvas (NO. 51) may represent the review of the Persian army, which was described by Major Gaspard Drouville. A grandiose gathering of all the Persian military forces took place in the Ujan valley in August 1813, Drouville reports, with the aim of demonstrating the superiority of 'Abbas Mirza's regular troops trained in European ways. Fath 'Ali Shah arrived in Azarbaijan accompanied by thirty-six of his sons.[30]

The acquisition of the two monumental paintings dates back to the beginning of 1828, when the Russian army commanded by General Paskevich occupied Tabriz and then entered Ujan. They found the palace of 'Abbas Mirza abandoned with paintings still on the walls. Two large canvases were taken as trophies and sent to Saint Petersburg. These paintings, mute witnesses of two Perso-Russian wars, are particularly rich historical documents because they represent actual events soon after they occurred.

Datable to 1815–16 (see NOS. 51, 52) and created for 'Abbas Mirza's residence in Ujan, the paintings take on further importance because they bear the distinctive marks of a local style that was previously unknown. The works represent a deliberate attempt to portray actual events with documentary exactitude. The composition, including innumerable figures, is well organized in both pictures, with *Military Review with Fath 'Ali Shah and 'Abbas Mirza* (NO. 51) arranged in horizontal rows and the battle scene forming a circle. In a departure from the conventions of early nineteenth-century Qajar multifigured compositions by the court artists of Fath 'Ali Shah (as we know them from miniatures and lacquers), which usually put the shah's figure in the center and larger than the others, the principal personages here are comparable in scale to the other participants and distinguished only by compositional devices. The shah and princes are represented in traditional, rather stiff positions, but the remaining figures are portrayed in movement, showing a variety of natural free poses; the figures are also more three-dimensional than those in the paintings of the metropolitan court style and display a new individuality.

The paintings are unsigned, and at present it is difficult to propose an artistic attribution with any certainty. The two treatments of the figures and landscape bear a strong stylistic similarity, and the works are undoubtedly by one and the same master. Correspondences may be drawn to works by the painter Sayyid Mirza, whose

individual style in both oils and lacquers has already been noted by B. W. Robinson,[31] particularly *Hazrat-i Yusuf* (FIG. XVI), signed by the artist, and *Young Falconer*, attributed by B. W. Robinson to this master.[32] Especially notable is a distinctive soft modeling of the faces with characteristic shading below the lower eyelids and lightening of the cheeks.

Youth in Black, a painting in the Museum of Fine Arts, Tbilisi, bears a striking resemblance to the above-mentioned paintings by Sayyid Mirza as well as to the monumental Hermitage pictures.[33] Especially similar are the faces, both in type and in the peculiar play of light with darker tones under the eyes and lighter ones on the cheeks. It is likely that *Youth in Black* is an early work by Sayyid Mirza and shows 'Abbas Mirza as a young boy of about sixteen or seventeen, which would give the picture a date of about 1805–6.

A portrait by Sayyid Mirza in the Hermitage collection (FIG. 21) shows Prince Muhammad Mirza when he lived as heir apparent in Tabriz before acceding to the throne. Muhammad Mirza appears to be about twenty or twenty-two years old in the portrait, pointing to a date of 1828–30.

It seems likely that sometime between 1805 and 1828 Sayyid Mirza lived at Tabriz and worked for 'Abbas Mirza. The earliest known dated work by Sayyid Mirza is a lacquer box of 1803–4 made for Fath 'Ali Shah, and the last work is his *qalamdān* (penbox) of 1842, painted for Muhammad Shah.[34] The *qalamdān* is decorated with portraits of Europeans and with depictions of Napoleon's campaigns. Both the date and the subjects of this *qalamdān* give some grounds for the suggestion that its artist was the painter "Sayyid," whom Ivan Berezin met in 1842 in Tehran. Describing Sayyid as "the best Persian painter," who lived in Isfahan but had a studio in a Tehran caravanserai, Berezin noted that not a single Persian painter could surpass him and reported that he had managed to buy some of Sayyid's drawings, among them two drawings representing the siege of Herat by Muhammad Shah.[35]

'Abbas Mirza evidently had his staff of painters. Another one of them was surely Allahvirdi Afshar: in all his known works, the crown prince is represented.[36] *Crown Prince 'Abbas Mirza and Court Officials* from the Hermitage collection (NO. 50), painted by Allahvirdi Afshar in 1815–16, shows 'Abbas Mirza observing his regular troops practicing maneuvers in a valley (probably Ujan). The master employs various devices from European academic painting, using tonal gradations and following the laws of linear

and aerial perspective. This is a well-balanced composition, but the left half of the scene (showing the maneuvers of the troops) is represented rather schematically.

A miniature portrait, clearly of 'Abbas Mirza, in the Hermitage (FIG. 20) may be attributed to Allahvirdi Afshar on stylistic grounds (especially characteristic are the treatment of clouds and the execution of shading on the face and robe). In the miniature, 'Abbas Mirza is shown seated in a European chair against a landscape background. He wears a traditional long robe and holds his recognizable scepter. He appears here to be no older than thirty years old, which would mean that the miniature was executed between 1815 and 1820, when other known works of Allahvirdi Afshar were painted. This period seems to be the time of 'Abbas Mirza's most active patronage of the arts. In 1819–20 an alabaster mirror (NO. 43) was created with a fine half-length carved portrait of 'Abbas Mirza within a gilt decorated border. This very rare work of art was possibly inspired by the above-mentioned nephrite dish, commissioned by his father two years earlier.

'Abbas Mirza, determined to introduce Western ways into his country, evidently encouraged a European style of painting. In the early 1820s he sent the painter Muhammad Jáfar to study at the Academy of Fine Arts in Saint Petersburg. A contemporary Saint Petersburg periodical reported:

> For three years a Persian, Muhammed Jáfar, son of Aliasyier ['Alī-yi Siyār], an official at the court of the Persian crown prince, has been studying at the Academy of Fine Arts. . . . He is learning drawing and portrait painting. He is twenty-four years old. When he was fifteen years old, by his own wish he began to draw from English prints. At the time of the arrival in Tabriz of the Russian ambassador General Yermolov, Jáfar depicted the ceremonial reception of the ambassador. He attracted 'Abbas Mirza's attention with this picture and was sent by 'Abbas Mirza to Saint Petersburg. In the exhibition of 1824, Ja'far presented a full-length portrait of the crown prince 'Abbas Mirza painted in watercolors and three copies from different pictures in oils.[37]

A full-length watercolor portrait of 'Abbas Mirza against a landscape with very low horizon painted about 1824 is kept in the Academy's museum.[38] Traditional in conception and format, it demonstrates a good mastery of new methods, especially in rendering how the landscape melts into the horizon.

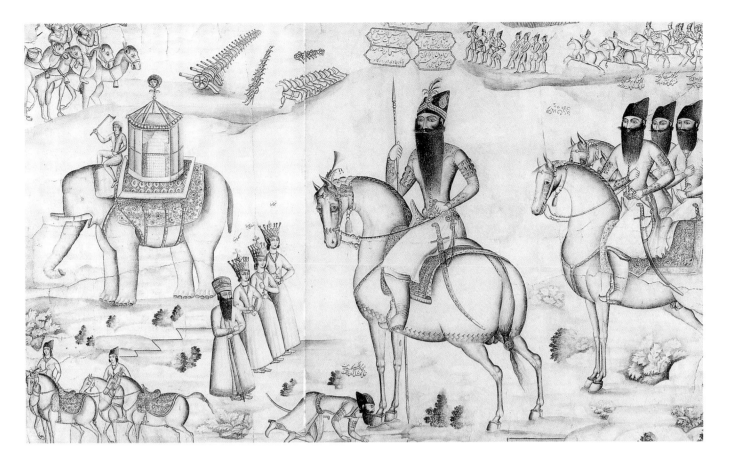

FIG. 24. *Military Review with Fath 'Ali Shah and Prince Husayn 'Ali Mirza.*
Artist unknown. Shiraz. Ink on paper, 20⅞ x 37¹³/₁₆ inches (53 x 96 cm).
STATE HERMITAGE MUSEUM, SAINT PETERSBURG, VR-1047.

Aside from the Tabriz school, influenced by Western aesthetic norms and European academic painting, another local school can be discerned in early Qajar painting – that of Shiraz. In 1963 B. W. Robinson suggested that Abu'l Qasim worked in Shiraz, noting that his style was distinctive and his technique finer than those of most of his contemporaries.³⁹ An ink drawing from the Hermitage (FIG. 24) may be assigned with certainty to Shiraz. It shows the same ritual encounter of Fath 'Ali Shah and a prince during a military review as in the oil painting (NO. 51). In the drawing, the prince, who has fallen to his knees before the shah, is identified by an inscription above his head with his title, Farmanfarma – that is, Prince Husayn 'Ali Mirza, Fath 'Ali Shah's son, who, appointed by the ruler, was governor of Shiraz for the period 1799–1835. Husayn 'Ali Mirza's three sons appear at the upper left, with their names – Akbar Mirza, Shahrukh Mirza, and Timur Mirza – inscribed above their heads. The careful rendering of all the details of the drawing suggests that it can hardly have been a preliminary sketch for a monumental canvas and must, rather, have been a copy after a picture commissioned by Husayn 'Ali Mirza for one of his palaces. This hypothesis is supported by its unusually large format (21 by 38 inches), for we know of no other Qajar drawing of such size.

The drawing might have been presented to Fath 'Ali Shah both to demonstrate the loyalty of Husayn 'Ali Mirza (whose separatist actions had aroused his father's displeasure more than once)⁴⁰ and to please the monarch, known for his love of the art of drawing.

To judge from this work, the Shiraz artists, unlike the painters working at the court of 'Abbas Mirza, followed the canons of court painting at the Qajar capital of Tehran, working in somewhat broader and more painterly style. The composition is conventional in that the shah, in all his magnificent attire, mounted on horseback, is in the center of the picture, dominating the composition and all those around him. As in Tehran painting, again, the shadows obey decorative principles: on the right side they fall from the right; and on the left side, from the left.

With the death of Fath 'Ali Shah in 1834, the official style of the Tehran school changed fundamentally, and its canons quickly deteriorated; the first period of

An oil portrait by an unknown artist (NO. 66) and the miniature portrait by Sayyid Mirza (FIG. 21) discussed above show Muhammad Mirza before his accession, when he lived as heir apparent at Tabriz. Bust portraits like these are not at all characteristic of Qajar painting of the first quarter of the nineteenth century, which generally favors full-length portraits. In the miniature portrait Muhammad Mirza is shown in European dress and without any jewelry, again outside the tradition of early Qajar portraits. Sayyid Mirza's approach here is much more European than in his other known works.

The portrait in oil was evidently painted from life and shows a free mastery of the medium, especially in the minutely depicted features such as the eyelids or the pupils rendered by touches of white. Despite the strong European influence, however, the painting's flat space, and characteristic decorative treatment of darks and lights and careful rendering of pattern on the *khal'at* (robe of honor or court robe), all point to the hand of a Persian artist.

The style, formulated at Tabriz no later than the second decade of the nineteenth century, assumed preeminence with the new reign of Muhammad Shah in Tehran. B. W. Robinson notes that the style of the painter Ahmad, known for his portraits of Fath 'Ali Shah of 1819 and 1823, became more Europeanized by the time of Muhammad Shah's reign.[41] Following his father's example, Muhammad Shah sent the Persian painter Abu'l Hasan Ghaffari on a course of study to Italy. A new approach to portrayal is noticeable even in the female portraits of the time of Muhammad Shah (FIG. 25): depicted with a great deal of individuality, in contrast to the idealized types of earlier paintings, they give the impression of having been done from life. To a large extent, these stylistic developments would determine later Persian painting.

The paintings from the Hermitage collection discussed here show that artistic life in Iran in the course of the first three decades of the nineteenth century was much richer and more varied than has previously been imagined, encompassing local schools as well as the metropolitan court style. These works also shed new light on the development of Persian painting in the period that followed. While the Europeanized painting of the 1840s may appear unexpected and "implanted," its evolution from the Tabriz style of the first third of the nineteenth century can now be seen as a logical development in the traditions of Qajar painting.

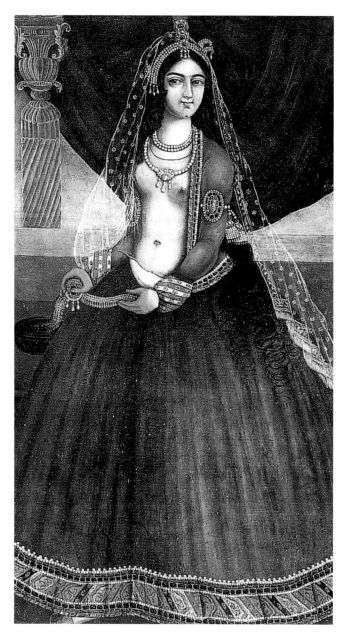

FIG. 25. *Woman Holding a Diadem.*
Artist unknown. Iran, mid-19th century.
Oil on canvas, 59¹/₁₆ x 35¹/₁₆ inches (150 x 89 cm).
STATE HERMITAGE MUSEUM, SAINT PETERSBURG, VR-1112.

metropolitan Qajar painting came to an end. In many works of the late 1830s, reality became a source of inspiration, and naturalistic features became dominant by midcentury. A key event contributing to this process seems to have been Muhammad Mirza's accession to the throne in 1834, the year after the death of his father, 'Abbas Mirza.

The author is deeply grateful to B. W. Robinson for much help and advice in her study of Persian painting.

1. For paintings and lacquers, of which 184 are playing cards, see Adamova 1996; for enamels, see Ivanov, Lukonin, and Smesova 1984, nos. 61–65, 67–75, 77–80, 82, 84.

 The Stieglitz Museum was founded in Saint Petersburg in the 1880s by Baron Alexander L. Stieglitz (1814–1884), a Saint Petersburg banker and patron of art, as part of the Central School of Technical Drawing (now the Saint Petersburg Academy of Decorative and Applied Art). The rich art collections (primarily applied arts and drawings) were gathered in the museum for educational purposes. After the Revolution of 1917, the Stieglitz Museum became a branch of the Hermitage.

2. In 1783 Gatchina was presented by Catherine II to her son and heir to the throne, Pavel Petrovich (Paul I, r. 1796– 1801). It had been an imperial summer residence, with the richest art collections housed there, until 1918, when it became the Gatchina Palace Museum.

3. Adamova 1996, nos. 43, 78, 80, 84, 88.

4. *Dnevnik gosudarstvennogo sekretaria A. A. Polovtsova. Redakzia, biograficheshy ocherk I kommentary professora P. A. Zaionchovskogo* (A. A. Polovtsov's diary. Ed. P. A. Zaionchkovsky) (Moscow, 1960), 391, for the year 1886: "General Charkovsky and his collection have been located in the Caucasus by the Bobrinskys. We are deciding to show it in the Museum with a view to arranging the details for its purchase."

5. Adamova 1996, nos. 61, 62, 83.

6. Ibid., nos. 85–87, 63.

7. Alexey Petrovich Yermolov, *Zapiski Petroicicha Ermolava. 1816–1827* (The notes of Alexey Petrovich Yermolov. 1816–1827) (Moscow, 1869); Kotzebuë 1819; Borozdna 1821.

8. Korff 1838; Soltykov 1849; A. Soltykov, *Voyage dans l'Inde et en Perse, par le prince Alexis Soltykov* (Paris, 1853); Berezin 1852.

9. Korff 1838, 95.

10. Kotzebuë 1819, 298.

11. Ibid., 302; see also: Borozdna 1821, 214.

12. Soltykov, *Voyage*, 356, 357, 360, 368. Lithographs from some of Soltykov's drawings are reproduced in Soltykov 1851.

13. Soltykov 1849, 42.

14. Robinson 1967, 5, pl. IV.

15. Soltykov, *Voyage*, 354.

16. The Hermitage, Oriental Department, acc. no. 3K II-1, 52 x 43 cm. Acquired in 1931. Inscribed: Khusraw Mirza. Signed: E. Hauser. 1829. For Eduard Hauser, see *Thieme-Becker Künstler Lexikon*, vol. 16, p. 140.

17. Among the manuscripts brought by Khusraw Mirza to Saint Petersburg were also a *Majma' al-Tavārīkh* of Hafiz-i Abru with the Timurid Prince Baysunghur's exlibris (Dorn 268); a *Shāhnāmeh* of Firdawsi, dated A.H. 1052–61/ A.D. 1642–51, with 192 miniatures (Dorn 333) and other mainly sixteenth-century poetry manuscripts (Dorn 262, 295, 301, 305, 336, 350, 362, 380, 390, 398, 409, 426, 471). See G. Kostygova, "Ob odnoy kollekzii persiskih rukopisey" (On a collection of Persian manuscripts), in *Sbornik. Iz istorii rukopisnyh i staropechatnyh sobrany. Issledovaniya. Obzory. Publikazii* (On the history of the collections of manuscripts and old printed books. Research. Surveys. Publications). Collected volume of the State Public Library (Leningrad, 1979), 85. The arrival of Khusraw Mirza, a sixteen-year-old youth "with a handsome face of the Persian type, charming eyes, and slender figure," became a remarkable event in Saint Petersburg, and found reflection in many Saint Petersburg periodicals. The doors of Saint Petersburg nobles' palaces opened for him and for the Persian poet Firuz Bayq, who always accompanied him, composing verses and inscribing them into the diaries of Saint Petersburg's young ladies. "Vospominaniya O. A. Przhetslavoskogo" (Memoirs of O. A. Przhetslavsky), in *Russkaya Starina* 39 (1883): 404–5. See also "Hosrov Mirza. Ocherk ego biografii" (Khusraw Mirza.

 Survey of his biography), compiled by Ad. P. Bergeh, in *Russkaya Starina* 25 (1879): 333–52, 401–4.

18. Berezin 1852, 82, 115, 135, 139, 140, 177; see also Korff 1838, 129, 191, 225; Soltykov, *Voyage*, 347–48.

19. Falk 1972, pl. 15.

20. Robinson 1969, ills. 119–20.

21. Babaie 1994.

22. Robinson 1964, 99.

23. Borozdna 1821, 131.

24. Kotzebuë 1819, 163.

25. Yermolov, *Zapiski*, 24. The Troitsky infantry regiment was formed in 1708. During the reign of Paul I (r. 1796– 1801) it became the Troitsky Musketeer Regiment. It participated in many battles in the first Perso-Russian war.

26. N. F. Dubrovin, *Istoria voin i vladychestva russkikh na Kavkaze* (The history of wars and sovereignty of Russians in the Caucasus), vol. 5 (Saint Petersburg, 1887), 440–46.

27. Morier 1818, vol. 1, pp. 401–6.

28. Wright 1977, 52.

29. Layla S. Diba has offered Qarabaq as another identification of the site of this battle. See Atkin 1980, 137.

30. Drouville 1819, vol. 2, p. 130.

31. Robinson 1989, 228. For Sayyid Mirza, see Robinson 1964, 104–5; Falk 1972, 42–45; Karimzadeh Tabrizi 1985–91, vol. 1, pp. 233–34.

32. See Falk 1972, pl. 37; and Robinson 1989, ill. 4.

33. Amiranashvili 1940, pls. XXIII–XXIV.

34. Paris 1972, no. 131, below; sale cat., Sotheby's, October 9, 1978, lot 180.

35. Berezin 1852, 248–50.

36. Maslenitsyna 1975, ill. 124; Karimzadeh Tabrizi 1985–91, 84, no. 140.

37. *Asiatsky Vestnik* 3 (March 1825): 226–27.

38. "Safaralieva D. Iranskii uchenik Akademii" (An Iranian student of the Academy), *Khudozhnik*, no. 8 (1991): 57–58.

39. Robinson 1964, 103.

40. Davis 1987; Lerner 1991.

41. B. W. Robinson, "Persian Painting in the Qajar Period," in Ettinghausen and Yarshater 1979, 341–42.

READING FOR GENDER THROUGH QAJAR PAINTING

AFSANEH NAJMABADI

THE SUBJECT OF WOMEN in Qajar painting presents us with a curious picture: We have an abundance of representations of women from the realm of male fantasy and pleasure but very few representations of real women.[1] On first consideration, the fact that nineteenth-century Qajar art seems to be largely devoid of social information might be a source of disappointment and frustration for historians of women.[2] On closer examination, however, paintings, manuscript illustrations, and lacquer works of the period indeed constitute a rich body of material for a study of gender relations in Qajar Iran.

To view representations of women from this perspective implies a double shift: first, a shift from women to gender. Instead of looking at women in Qajar art, we are looking at representations of gender as a relationship, which defines man and woman through socioculturally constituted differences that are perceived as natural and emanating from "sex." Using gender as a relational and analytic term also draws our attention to how gender signifies relations of power – a signification whose cultural work is all the more pervasive precisely because of gender's connection with the "naturalness" of sex.[3]

A second shift takes us away from the assumption of "art as mere reflection of reality" to considering art as constitutive of meaning. As Griselda Pollock has elaborated:

As Representation the term stresses that images and texts are no mirrors of the world, merely reflecting their sources. Representation stresses something refashioned, coded in rhetorical, textual or pictorial terms, quite distinct from its social existence. Representation can also be understood as "articulating" in a visible or socially palpable form social processes which determine the representation but then are actually affected and altered by the forms, practices and effects of representation. . . . Finally, representation involves a third inflection, for it signifies something represented to, addressed to a reader/viewer/consumer.[4]

If we start with the assumption that "the sexualized image of woman says little or nothing about women's reality, but is symptomatic of male fantasy and anxiety that are projected on to the female image," then women of artistic representations become detached from actual women, and "become attached to a new referent, the male unconscious."[5] We have learned over the past decades to "read" folktales, poetry, fiction – not to speak of dreams and jokes – as windows, always partial and opaque, to the world of the unconscious, individual and social, rather than as "reflections of reality." Visual texts of the nineteenth century and later – paintings, manuscript illustrations, photographs, and films – belong to the same domain; and as Mieke Bal has noted, this kind of reading could be particularly fruitful for works of art belonging "to an era still innocent of Freudianism – an innocence that makes [these works] a proper object

for a psychoanalytic criticism that wishes to avoid circularity."[6] Looking at Qajar art with an eye for gender representation, as distinguished from viewing them as images of reality or as a source for social history, would then offer us important reading possibilities.[7]

Ellison Findly, in her discussion of images of Nur Jahan in Mughal paintings, has speculated that these paintings suggest "that she may have been petite." This suggestion is based on the observation that in paintings where she is depicted with her husband, Jahangir, she is clearly a much smaller figure.[8] If we look at her image in paintings where she is portrayed on her own (fig. 10 of Findly's essay, for instance), however, she is far from a petite figure. Is it too far-fetched to suggest that her petiteness in works where she is framed with her husband signifies a gender relation rather than reflecting actual size? It is also possible that her "smallness" relative to her husband's "bigness" could point to the "small woman" as a figure of the desired female. We see a similar phenomenon in Qajar depictions of women of male fantasy — the celebrated ladies of pleasure whose frequent depiction has been noted by Qajar art historians. Their relative small size has prompted the prominent art historian B. W. Robinson to refer to them as the shah's "little ladies."[9] We have no evidence that these "little ladies" were in fact petite women. They are cut down to size to demonstrate their relative worth compared to their king and master, as if they were a visual representation of Virginia Woolf's observation, "Women have served all these centuries as looking-glasses possessing the magic and delicious power of reflecting the figure of man at twice its natural size."[10] In the painting reproduced in Robinson's article, the single shah is depicted with three "little" women. This numerical imbalance could be read simply as a statement of his famously large harem, but it could also be read as compensating for the perceived smallness of woman compared to man.[11]

The very large body of representations of women of male pleasure and fantasy in Qajar art is not unique to the period: the Safavid and Zand periods offer a comparable number.[12] A figure that appears repeatedly in Qajar art, however, is the bare-breasted woman (see NOS. 57, 58, 65).[13] Although nude females as well as females whose breasts are visible through sheer clothing do appear in Safavid and Zand art, the bare-breasted woman, or woman with breasts emphatically displayed through style of dress or association with fetishistic objects, seems to be a heavily accented theme in Qajar painting.[14] In Safavid art, for instance, the exaggeratedly décolleté woman represented European woman.[15]

The Qajar bare-breasted woman emerged as the eroticization of the breast reached its culmination, influenced by Iranian men's perception of women in Europe.[16] By the sixteenth century, nude breasts were displayed often in European paintings, and Safavid paintings of décolleté European women possibly were modeled on European representations that found their way to the court rather than on direct observation. By the early nineteenth century, however, there had been many Persian travelogues describing what the eye had seen. The breast came to signify European woman as the site of paradisiacal eroticism in the Persian male imagination. The eroticization of the breast may also be linked to orientalist eroticized representations of Iranian women in paintings of European travelers to Iran.[17] These powerful associations joined those of the feeding breast, still a common and accepted sight in public in Iran, making the breast a vivid condensation of eroticism and nurturance in the Qajar period.

The eroticized breast may have come from yet a different quarter: from the grafting of a European icon — the eroticized mother-Madonna with one bare breast — onto Irano-Islamic male fantasy of the period, producing a new contingent iconic meaning. The bare breast, standing for the Mother-Beloved, became more visible and displayable. The heterosexualization of love from premodern ambiguous, if not openly homoerotic, love is itself a nineteenth-century transformation. Love in classical Perso-Islamic literature is often male homoerotic. This is reflected not only in the celebration of male-male love couples, such as Mahmud and Ayaz, but also in books of advice with separate chapters on "love" (where the beloved is male) and "marriage," which are constructed as belonging to different domains.[18]

It is noteworthy that male homoerotic couples were represented amply in Safavid art but were less common in Qajar art. The full development of the Mother-Beloved in nineteenth-century political, artistic, and literary production was dependent on the preeminence of heterosexual love. The representation of women in Qajar art, which emphatically mapped the erotic mother as a young beloved, made the concept of a female beloved available in a new mode: as an earthly reality, rather than as a literary fantasy, thus making it available for political and literary discourses, as well.

The bare-breasted Qajar woman came to supplement and partially displace the earlier figure of the

exaggeratedly décolleté European woman. Whereas in earlier periods, the bare breast of the European woman was the gender mark of cultural difference between Europe and Iran, her displacement by Qajar women prefigured the cultural debates concerning the changing role of woman in Iranian society in the later nineteenth century.[19]

The Qajar bare-breasted woman often appears with fetishistic objects, including fruits – apples and pomegranates, both associated with sexuality and fecundity – birds, and flowers (see NOS. 57, 61). Women's bodily parts were often compared in Persian male prose and poetry to various fruits: peaches for cheeks, and apples and pomegranates for breasts, are perhaps the best-known examples, still used in Persian poetry as well as daily language.[20]

FIG. 26. *A Family Group.*
Artist unknown. Iran, circa 1810. Oil on canvas, 6¹/₈ x 4 inches (15.49 x 10.16 cm).
BODLEIAN LIBRARY, OXFORD, OUSELEY ALBUM 297, NO. 8.

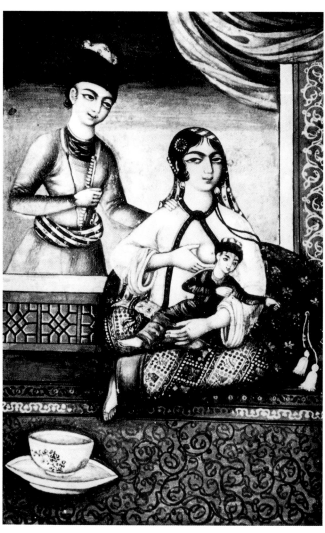

In addition to the many women of pleasure (dancers and acrobats, wine and food servers, musicians), bare-breasted women include representations of European women, and women reminiscent of the Virgin Mary in Madonna and Child paintings. This body of paintings has sometimes been a source of disguised pleasure or public embarrassment to Qajar art historians and art collectors. It has also been viewed as an unfortunate effect of European influence on Persian art.[21] Regardless of its origin – European or otherwise (discussed below) – the theme of the bare-breasted woman clearly was a resonant one for the male artistic imagination. Instead of lamenting this body of art, we may consider it as an invaluable source for the study of Qajar gender relations and ask what kind of visual field, or domain of visual fantasy, is constructed by these repeated female figures of pleasure, musicians and dancers, clothed and half-naked women with cats and parrots, offering sweetmeats and flower-bouquets?[22] As Margaret Miles has argued for the representation of the bare-breasted Virgin Mary in fourteenth-century Tuscan paintings, "[A] visual image repeatedly depicted may be assumed to ... relate to its ability to address ... strong anxieties, interests, and longings."[23] Within Qajar art, the bare breast stands at once for the comforts of maternal nourishment and for the anxieties of male heterosexual fantasy, a doubling of the Mother and the Beloved that was rooted in child-rearing practices of the period.

THE MALE FANTASY OF THE MOTHER-BELOVED

To open our examination of the bare breast as emblematic of the Mother-Beloved, let us turn to an early Qajar painting (circa 1810) described as "a family group" in the Bodleian Library catalogue (FIG. 26).[24] The "family group" that may come to a late twentieth-century viewer's mind is likely to be one of father, mother, and child; yet, considering what we know about kinship and marital relations in early nineteenth-century Iran, it is rather unlikely that a patron would have commissioned, or a painter would have chosen to create, a portrait of a "nuclear family" emphasizing the affective bonds within the triangle of husband-father, wife-mother, and child.[25] An alternative, more in tune with familial and child-rearing practices of nineteenth-century Iran, would be to read the "fam-

ily group" as a portrait of a man and a woman-as-wife and, at the same time, a portrait of a man-as-child with the woman-as-mother. The two male figures in the painting, in other words, stand for one man, who is shown as an adult desiring lover and again as a son. The single female figure, in contrast, doubles for Beloved and Mother. This reading is supported by the way in which the large male figure is an enlarged replica of the small male figure in many details.[26]

Whereas the mother and son belong to the same space, the adult man stands outside that frame. The frame marks the woman's space, the world of the mother to which the man belonged as a young boy. As a growing male child, he was expelled from that space, and as a lover, he remains outside that space. To understand the psychodynamics of this framing, of the outside and the inside figures, we need to look at the world of the young son more closely. Sons, like daughters, grew up in what may be called the women's world – not necessarily a physically segregated space (which would have been affordable to a fairly small fraction of the population), but rather a social and affective space created through female socializing practices. Even in the lower urban classes or peasant households, the common family space became a female domain during the day while the men were at work or in the fields. It became a male space when they returned and female members withdrew to the kitchen or corners of rooms. More important, the female social domain extended to neighbors and to alleys, where women of the neighborhood socialized in daytime, as well as to women's festivities, the public bath, and the women's quarter of the mosque. These spaces were all open to the son up to the "age of recognition" – a pre-puberty age, somewhere around eight or nine, that constituted a dramatic age of transition for sons. It was marked by their expulsion and exclusion from these hitherto accessible women's spaces. The moment of expulsion could occur at the women's bath, women's festivities, or the mosque.[27] It often happened at the taunting instigation of other women, who would berate the mother for having brought the "man" to a women's space – through such telling phrases as "Why don't you bring his father along next time?" The women may have felt under the "wrong" gaze of the growing boy, observed or imagined his sexual arousal, or felt the "wrong" touch or even a pinch in the bath. The grown-up man would recall this moment of loss and expulsion in many ways.[28] The memory of the lost mother's world, and in particular the women's bath, is evoked, for instance, in such artistic representa-tions as strange islands populated by naked women[29] and in narratives of paradise populated by countless female beauties.[30]

The women's bath as the site of "primal fantasy" is confirmed by the poetry that frames a painting of the ladies' bath (1850) by 'Abd al-Razzaq (FIG. 28b). The verses are addressed to "O' you who have not seen beauty/ except for when you look into the mirror" and sing praise of the beloved as a cypress-stature body with "grass in the middle." Though the poet would have seen the bath scene only as a son, he envisages it now as a lover, imagining his beloved there.

Upon expulsion from the world of women, the young boy faced challenges of entry into the domain of the father. Commonly at this stage, fear of rape was (and still is) cultivated in young children of both sexes. Girls are warned not to go to men's quarters and to stay close to Mother and women. Boys are expected to join the world of men, while they are warned of its dangers. Thus, the transition to manhood is a highly conflictual process. The fear of rape increases the desire for return to the world of women, to the safety of the domain of the mother, paradise lost. To become a man, the boy needs to fight off this desire for return, to become "manly" and brave.[31]

The experience of expulsion from the world of women is above all an experience of lost vision. Once the boy enters the world of men, moreover, his gaze becomes subject to *aḥkām-i nigāh* (rules of gazing encoded in books of ethics and religious regulations).[32] The limited occasions when the man may gain access to the sight of a woman's body become structured by regulations and social manners, to ensure that these occasions do not become moments of imaginary reunion with the world of Mother.

The trauma of expulsion from the world of women and Mother is also associated with the prominent theme of "the lustful stepmother" in classical Islamicate liter-ature.[33] As the reverse figure of the mother, the stepmother – in Persian, *nāmādarī* (literally, "not-mother") – was the desiring, insatiable woman. To distance and deny desire for the mother and for the world of women, the plot was inverted so that the son was the object of desire of the stepmother. It was not he who was longing to return to the world of women (having been expelled from that womanly paradise), it was not he who desired Mother, but the lustful "not-mother" who desired him. Joseph-like, he was forever running away from the scene of seduc-tion and temptation, proving his loyalty to the world of the father and his suitability to join the world of

men, attributing lust and guile to women. Fedwa Malti-Douglas has brilliantly discussed the "flight from women" in various genres of Arabo-Islamic literature.[34] It may be added here that the "flight" and its many repetitions in fact stand for denial of the man's desire to return to the world of women.[35]

In our Qajar "family group," the grown-up man reclaims this lost world of Mother, a world that he can now only fantasize, by imagining himself as a "shrunken" little man, as the son he once was. He intrudes into the woman's space by calling her into his space for sexual union. The twist of the boy's upper body and the thrust of his left arm are significant: the son's left arm is moving away, leaving the mother's body and marking his growing urge to be with, but also to leave, the maternal embrace. His twisted body reinforces this motion of flight. The adult man's posture is firm and secure; his left arm is on the woman's shoulder, pulling her to him, laying a claim on her body. The woman holding the boy establishes the maternal hold as her power over him, figuratively holding him back from flying away from maternal power and possession, preventing his flight from the world of Mother, postponing the scene of expulsion and exclusion as the rite of passage into the world of fatherhood and manhood. The grown man's hand over the woman's shoulder indicates that his earlier flight or expulsion from the world of Mother has prepared the stage for his reentry as an adult man to claim masculine power over his woman. The hierarchy established in the painting through the respective heights of the adult man, woman, and child reinforces the power dynamic of this gender triangle.[36]

The single female figure, who doubles as Beloved and Mother, is a larger figure than the adult male figure, in contrast with the "little ladies" of Fath 'Ali Shah. Her size perhaps speaks to the affective and erotic place of the Mother-Beloved in the male fantasy. To a female viewer, the doubling can represent a source of power or a double bind, in which male needs demand that she serve in both roles. The naked breast of the woman, signifying the nourishing mother in the eye of the infant son, is a symbolic condensation standing for the Mother-Beloved, and is at once the source of nourishment and the object of sexual desire.[37]

The doubling of the female figure is in fact emblematized in the cup and saucer at the lower left of the painting. The saucer is somewhat oddly pointed at the two ends rather than smoothly elliptical, suggesting a vaginal shape. The cup echoes the woman's breast, whereas the saucer's

vaginal shape mirrors the contour formed by her thumb and index finger holding the breast. While the woman offers her breast to the young boy as solace and nourishment, the cup and saucer (suggesting the Mother-Beloved double with its breast and vagina forms) will serve the adult man.[38]

The use of paired figures – one adult, the other child – occurs in other Qajar paintings. Again the two figures may stand for the same person, and the double representation may constitute a technique that makes it possible to expose parts of the body whose display was considered inappropriate. For instance, a young man is doubled with a young boy wearing a sheer garment, through which his little penis can be seen, while on the grown-up, fully clothed man a dagger or a sword substitutes for what cannot be shown (FIG. 27a). In other works (FIG. 27b, for example), a grown-up woman, fully clothed or, often, showing her breasts bare, doubles up with a young girl, whom she holds, sometimes covering her own vaginal area. The girl, naked or clothed in a sheer dress and with miniature breasts and exaggerated pudendum,[39] stands for the woman when she was much younger and displays what the adult woman may not.

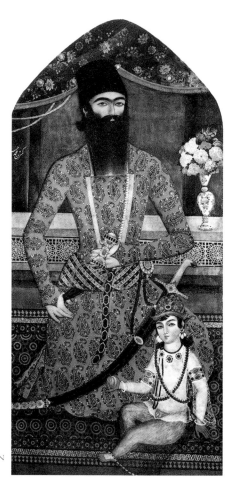

FIG. 27a. *A Prince and Child*. Muhammad Hasan. Iran, circa 1810–20. Oil on canvas, 75⁹/₁₆ x 36³/₁₆ inches (192 x 92 cm). FORMERLY NEGARESTAN MUSEUM, TEHRAN.

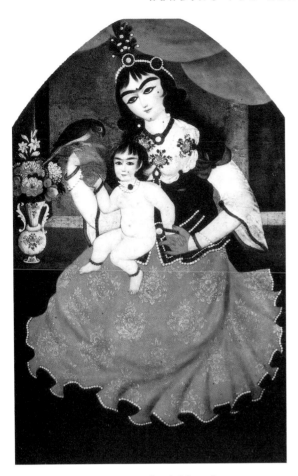

FIG. 27b. *A Woman and Child with a Parrot.*
Artist unknown. Iran, circa 1810–20. Oil on canvas, 46⁷/₁₆ x
22¹³/₁₆ inches (118 x 58 cm).
FORMERLY NEGARESTAN MUSEUM, TEHRAN.

Similarly, the bare breast presents the icon of comfort and sexuality but at the same time suggests the other part of the female body that was not to be displayed, except in pornographic (*alfieh-shalfieh*) paintings or in the later genre of photographs of prostitutes. Often photographed as the exact reverse of the woman in FIG. 27b, these prostitutes were fully clothed and covered but lifted their long skirts to display their bare genitalia.[40]

That the bare-breasted woman in Qajar art stands at once for maternal comfort and male heteroerotic pleasure is confirmed by some of the representations of the Madonna and Child from this period. From the Qajar artist Muhammad Ismaïl Isfahani, we have two very similar penboxes, both made in 1866. One is decorated by various scenes from the romantic-erotic adventures of Bahram Gur, a hero from the *Khamseh* of Nizami.[41] The other is almost identical, except that, at the center of the top of the case, is depicted an image of the Madonna and Child.[42] What are we to make of this?

This kind of painting is referred to as *farangisāzi* (Europeanizing). Contemporary art historians studying the Qajar period treat the question of the Europeanization of Persian art largely as a matter of imitation. Whether the "imitation" is considered poor and incongruous or artful and skillful, its artistic evaluation moves from the notion of an original European model, against which the Qajar piece is measured. The most successful works, by this account, would be those most accurately copied. The concept of imitation is entrapping, and can be inadequate for understanding the significance of *farangisāzi*. This author has argued elsewhere that grafting is a more productive concept than imitation for understanding the literary intertextualities of Iranian nationalist writings with European concepts, and grafting is equally useful in considering examples of Qajar art like the penbox cited above.[43] When a European icon is copied, or rather grafted, onto a Persian painting, it produces a different meaning – sometimes a hybrid meaning and at other times a completely new meaning. Its meaning, in other words, cannot be understood – nor its artistic success evaluated – solely in reference to the original site and meaning of that icon.

What meaning did this kind of grafting of the Madonna and Child onto an erotic composition produce for its viewers, who very likely did not look at it with reference to European church paintings, but saw it within their own imaginative world? The artist's inclusion of a Madonna and Child in the above-mentioned penbox's central frame, in place of an erotic scene, suggests that this image was for him an erotic scene: the scene of the son with the Mother-Beloved double in male psychosexual fantasy. The suggestion that the Madonna and Child could be grafted onto this seemingly incongruous world because of its erotic meaning is made more plausible if we look at other paintings of the period that depict both a bare-breasted Virgin Mary and Child or other bare-breasted women with children. The painting in FIG. 28a shows a woman holding her breast as if offering it to the child in her lap, while the female child holds the nipple of the other breast (and a fruit). The poses of the two are quite reminiscent of Madonna and Child iconography. By looking outside the frame of the painting at the painter or viewer, the woman offers the breast to him. Moreover, the child is female, thus bringing the painting closer to the adult-child doublings previously discussed, particularly with the connotations of fruit as a fetish object. The poses of mother and child also echo other depictions in

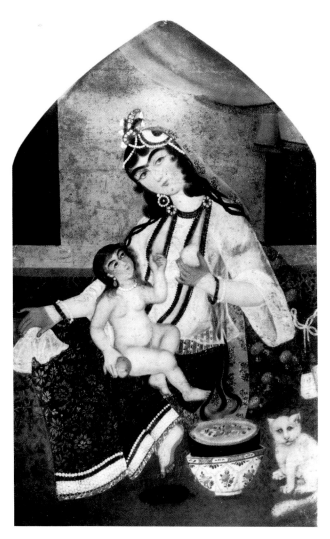

FIG. 28a. *A Woman and Child with a Cat.*
Artist unknown. Iran, circa 1810–20. Oil on canvas, 46⁷/₈ x 29¹/₂
inches (119 x 75 cm).
FORMERLY NEGARESTAN MUSEUM, TEHRAN.

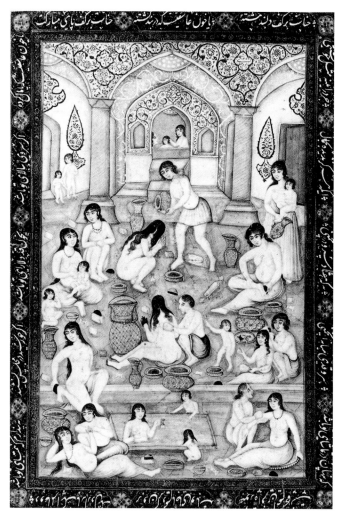

FIG. 28b. *Women's Bath.*
'Abd al-Razzaq. Iran, Safar 14, A.H. 1266/January 10, A.D. 1850.
Back of mirror case, papier mâché, painted and lacquered;
17⁵/₁₆ x 12³/₁₆ inches (44 x 31 cm).
PRIVATE COLLECTION.

Qajar art – significantly in scenes of the women's bath (see, for instance, FIG. 28b) – with their themes of the erotic mother and the bath scene as primal fantasy.

The eroticized Madonna and Child may have entered Qajar art directly from Europe, or it may have been mediated through Indian painting. We know that Iranian court painters visited the Mughal court from the Safavid period onward, and it is quite possible that European influence on Iranian art (at least until the mid-Qajar period, when artists began to travel to Europe) came in part by way of India.⁴⁴ Looking east to India, we do find examples of the bare-breasted, eroticized Madonna and Child.⁴⁵ Findly notes that Emperor Akbar of Mughal India was a keen collector of "pictures of Christ and the Virgin Mary," and that "Akbar's interest was passed on to his son Jahangir, who by temperament was aesthetically inclined

and drawn to maternal themes. Images of Christ and the Madonna quickly found their way into Jahangir's collections."⁴⁶ She also notes that during Jahangir's time (r. 1605–27), "a shift occurred in the content of the images brought – from idealized images of the Madonna, which reflected maternal intimacy and religious piety, to more realistic secular images, which high-lighted individual characterization and sexual expressiveness."⁴⁷ Did these more eroticized images of the Madonna and Child not influence their representations in Persian paintings, given the already existing cultural meaning of the Mother-Beloved as a condensed figure in male fantasy?

The bare-breasted woman may have entered Qajar gender representation not only from the centrality of the maternal-erotic breast standing for the Mother-Beloved double, but through yet another channel. As noted above,

European women were represented as bare-breasted in Safavid painting, and the figure of the bare-breasted European woman appears more frequently in Qajar painting. A favorite Qajar theme represents the European woman alongside the Christian maiden of the story of Shaykh San'an.

EUROPE AS A FEMALE FIGURE OF DESIRE AND THREAT

The well-known sufi tale of Shaykh San'an was immortalized through Farid al-Din 'Attar's (twelfth to thirteenth century) versified version in *Mantiq al-Tayr*.[48] Shaykh San'an, an old and highly respected sufi leader in Mecca, with some four hundred followers, dreams that he prostrated himself in front of an idol in Rum.[49] In search of the meaning of the dream, he and his followers set off for Rum, where he meets a Christian girl and falls passionately in love with her, willing to do anything for a union with her. She demands that he prostrate himself in front of an idol, burn the Qur'an, turn away from his faith, and drink wine. He refuses to do the first three but agrees to drink wine, whereupon, in his drunken ecstasy, he also does the other three. As an impoverished old sufi, he faces another obstacle: he has no money or other property to pay her as bride price. In lieu of a dowry, she demands that he look after her pigs for a year, free of charge, to which he agrees. One could hardly imagine a more abject figure than the old sufi, attending the despised and ritually unclean pigs for a whole year. Reduced to this state of abjection, the shaykh is abandoned by his followers, who return to Mecca. There they tell the story of their master's predicament to the shaykh's closest friend and disciple, who reproaches them for having abandoned him in the hour of his greatest need. To make up for this act of breaking their homosocial bond, the followers and the friend return to the shaykh and spend the next forty days and nights in prayer. Eventually, the friend dreams of the Prophet, whose beauty as a "moon with two locks of black hair" outshines and defeats the Christian girl, enabling the shaykh to leave the divisive Christian female Other and return to the homosocial space of Muslim sufi brotherhood. The Prophet informs the friend that from times past there had been a dust of darkness between the shaykh and his Lord, and that the darkness has now been removed

and "penance has replaced sin." The disciples rush to the shaykh and find him in a turbulent state, shedding tears of shame, joyful at his return to the path of faith and truth. The Christian girl also turns to Islam through another dream of her own.

Like any great story, this tale with its multilayered meanings has been put to different uses. Orthodox preachers often use the tale to point out the evil consequences of drinking wine. For sufis, it is a paradoxical tale, capable of being read in at least two almost contradictory ways: as a story about the power of love and the testing of faith, with the two themes competing and undoing each other's work. The Christian maiden (*dukhtar-i tarsā*) can be seen as the threatening figure of sexual seduction pulling men away from their homosocial world of sufi community and union with God. On the other hand, the kind of selfless love that she ignited in Shaykh San'an, inspiring a willingness to sacrifice everything for its fulfillment, could stand for the kind of love that a sufi aspires to, but with the Divine. The love of the Christian girl stands at once for the most desired and for the most deeply feared love.

Nineteenth-century retellings of this fable produced yet new layers of meaning. The story came to tell of the threat as well as the attraction of the European woman, who herself stood for Europe. In nineteenth-century transformations of the story and its visual depictions, the Christian maiden is supplemented, if not displaced, by the European woman (*zan-i farangī*), who expressed gender anxiety as well as national anxiety. The bare-breasted European woman, taking her place next to her historical sister, the Christian girl (see FIG. 29a), represented pleasure and fear.

Going to the land of Rum in the original story could be read as a journey to the domains of Byzantium or more specifically to Anatolia. Metaphorically, however, it was a journey to Christendom, outside Islam, only to return to Islam more completely and truthfully. Thus, the figure of woman became the utter outsider, the absolute abyss of passion and danger. The substitution of the European woman for the Christian girl is a double displacement, not only a geopolitical displacement of Christendom by Europe, but also of girl by woman, making the female figure more overtly sexual. Whereas *dukhtar-i tarsā* could have been a virginal figure, even a nun, *zan-i farangī* was a sexualized, nonvirgin figure. As a figure contaminated by sexuality, she was more threatening and potentially more morally corruptive. This figure links textually with the nineteenth-century "pornographic" descriptions of European women by Iranian male travelers as women

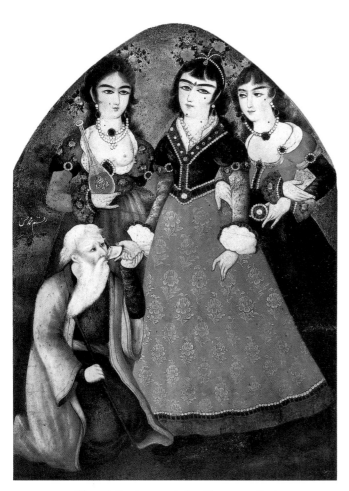

FIG. 29a. *Shaykh San'an and the Christian Girl.*
Muhammad Hasan. Iran, circa 1810–20. Oil on canvas, 41³/₄ x
31⁷/₈ inches (106 x 81 cm).
FORMERLY NEGARESTAN MUSEUM, TEHRAN.

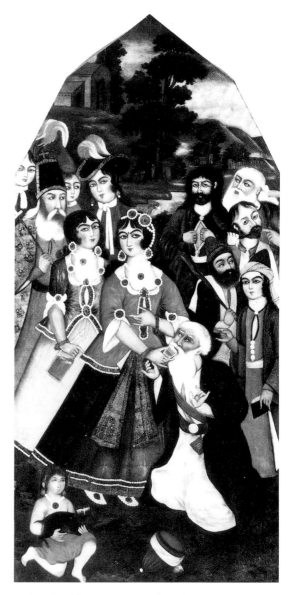

FIG. 29b. *Shaykh San'an and the Christian Girl.*
Iran, circa 1830. Oil on canvas, 64³/₁₆ x 20¹/₄ inches
(163 x 51.5 cm).
PRIVATE COLLECTION.

always in need of and engaged in union with a phallus
– truly a male heterosexual fantasy.⁵⁰

An important topic of Iranian writings about Europe
in the nineteenth century was that of gender relations,
particularly European women and their differences
from Iranian women.⁵¹ Persian travelogues of the period
described the European woman as both whore and *ḥūrī*
(the ever-virgin female beauties of paradise promised
to the truthful male believer).⁵² Some of the writings
about European women verged on pornographic pleasure
texts, constructing Europe as a "porno-paradise" and
European woman as possessed of unbridled sexuality.
Descriptions of European women as paradisiacal beauties
"with uncovered heads and bare breasts" were common.
Among the nineteenth-century travelers to Europe were
Qajar princes, some of whose written accounts are, for-
tunately, available to us.⁵³ Here is how one Qajar prince,
Riza Quli Mirza, described European women he had seen

in a theater in 1836: "In that house, over fifty thou-
sand moon-faced women and good-tempered virgin
girls appear in those spectator boxes, with every one of
their faces shining like a sun from the tower of beauty, all
with naked heads and displaying their breasts openly, dec-
orated with make-up and fine jewelry, pillaging our
heart and religion."⁵⁴ The "nakedness" and the "bare
breasts" of the European woman were signs of her sex-
ual availability in Iranian male fantasy, presenting a
sight at once deeply fearsome and highly desired.⁵⁵

Visual representations parallel this textual interest.
The frequent occurrence of the Shaykh San'an story in the
paintings and on penboxes of this period expresses an anx-

iety about the threat and attraction of gender relations perceived as radically different from those of one's own society.[56] The bare-breasted woman, who often stood next to her Christian sister who had captured the shaykh's heart and mind so thoroughly and subversively, represented Europe in the form of European woman. Posing threats and attractions to the viewer similar to those that the Christian girl had posed for the shaykh, she constituted at once an object of intense and forbidden desire, and a threat to be avoided if one was not to lose one's religion, mind, and soul – not to Christianity, this time, but to Europe. In FIG. 29b the Christian girl, her breasts covered but handing the fateful cup of wine to the old pious man, divides the painting into two figural groups. On the one side are the shaykh's followers – all male, ranging from a very young man (also a possible object of homoeroticism within the sufi fold) to a very elderly man in the back row, signifying the relevant homosocial group that constituted the world of Shaykh San'an. On the other side, the Christian girl is flanked by a mixed group of women and men, signifying the European society in which the two sexes commingled – a primary point of differentiation between "us" and "them" in the descriptions of travelers, and one of the sights that clearly had a deep impact on Iranian men in Europe.[57] The European men are depicted through their style of hat and scarves, while the European women are marked by their (almost) bare breasts.

Bare-breasted women are not the only representations of European women in Qajar art. Women are depicted beside men in more realistic dress at balls, at formal dinner settings, in carriages, and in parks, just as they are described with fascination in texts of the period.[58]

In addition to Europe as the European woman, other significant metaphoric figures – male and female – emerge in Qajar art. They include Iran as homeland (a Mother-Beloved); the female sun of the state emblem, the Lion and Sun; and Iran as nation (depicted as male). The gendered construction of these centrally important concepts of Iranian modernity was paralleled in visual representations, particularly in the pages of the press toward the end of the nineteenth century.[59]

Gender relations experienced significant transformations in the "long nineteenth century" of Iran – the Qajar rule of 1785 to 1925. These changes were expressed not only through political and social writings about women and men, but also in the creation of patriotic and national iconographies that were constructed through notions of gender. They in turn produced new meanings for man and woman, husband and wife, mother and child. Qajar art offers us a highly rich resource for studying these transformations. As we take pleasure in viewing these works, as we imagine how their original patrons, creators, and viewers may have enjoyed them, we can at the same time ponder what they tell us about women and men of the period.

Notes

An earlier version of this essay was extensively and critically commented on by Layla Diba, Maryam Ekhtiar, Joanna Ekman, Natalie Kampen, Kanan Makiya, Nancy Micklewright, Kaveh Safa-Isfahani, and Mohamad Tavakoli-Targhi. My entry into the world of Qajar art and the literature on the subject was made possible with great help from Layla Diba and Maryam Ekhtiar. I thank them all.

1. I do not want to imply that there is a neat, simply discernible line that divides these two categories of representation – women of fantasy and real women. As will be discussed here, the referent for the former is a different reality – that of the male sexual imagination and unconscious. These representations, unlike those of the second category, make little claim to realism.

 Toward the end of the nineteenth century and beginning decades of the twentieth, we do find more representations of real women and fewer of the fantastic. This development is partly related to movement of women into public spaces, which at once made them "more representable" and made public representations of fantasy women somewhat embarrassing. I have discussed this double movement in "The Eclipse of the Female Sun: Masculine State, Fantasmatic Females, and National Erasure," paper presented at the Center for Middle Eastern Studies, Harvard University, March 11, 1996. Unlike women of fantasy, real women (when depicted) were represented as totally covered and facially veiled early in the century, but more women with visible faces are found toward the latter part of the Qajar period. For examples of covered women, see the Poppy Harvest series, in *Dreaming of Paradise: Islamic Art from the Collection of the Museum of Ethnology*, exh. cat. (Rotterdam 1993), 186, 188, 189. For two representations of real Qajar women, one from the mid-nineteenth century and the other from the early twentieth, see NO. 91 and Abu'l-Hasan Ghaffari, *Portrait of Khurshīd Khānūm*, 1834, reprinted in Zuka 1963, part I. The subject of this essay is largely the first category of Qajar paintings – that of fantastic women.

2. See Layla S. Diba's observation regarding the Amery Collection in Diba 1989b. On the possibilities, problems, and challenges of using visual texts as an indispensable source for historians of women, see Margaret R. Miles, *Image as Insight: Visual Understanding in Western Christianity and Secular Culture* (Boston, 1985).

3. See Joan Wallach Scott, *Gender and the Politics of History* (New York, 1988), chapter 2, "Gender: A Useful Category of Historical Analysis." For a lucid explication of meaning of gender as a hierarchy of power and how it intersects with other hierarchies of power, such as age and race, and how it informs artistic representation, see Natalie Boymel Kampen, "Theorizing Gender for Roman Art," 14–25, in *I, Claudia: Women in Roman Art*, ed. by Diana E. E. Keiner and Susan B. Matheson, exh. cat., Yale University Art Gallery (New Haven, 1996).

4. Pollock 1988, 6. See also Linda Nochlin, *Women, Art, and Power and Other Essays* (New York, 1988).

5. Laura Mulvey, *Visual and Other Pleasures* (Bloomington, Indiana, 1989), xiii. As Mulvey notes, this is a particularly rewarding shift for a feminist critic, as it averts the gaze away from such sexualized images of women onto the male psyche (p. xiii). In the context of Qajar representations of women of male fantasy and pleasure, we assume that this body of art was produced by male artists for male patrons, and largely for their private consumption within the walls of their inner chambers. It is important, however, to be cognizant that women viewers may construct very different meanings from male-created representations of women. See Miles, *Image as Insight*, 64.

6. Mieke Bal, *Reading "Rembrandt": Beyond the Word-Image Opposition* (Cambridge, 1991), 10.

7. I do not offer these interpretations as the sole meanings provided by the visual texts concerned. They are rather offered as a reading possibility that may open up one layer of meaning sedimented in the works under discussion. For a visual text, like a literary text, is a sedimentation of layers of meaning, and my venture into the world of Qajar paintings is akin to that of an archaeologist who uncovers one particular layer of artifacts.

8. See Ellison Banks Findly, "The Pleasure of Women: Nur Jahan and Mughal Paintings," *Asian Art* 6, no. 2 (Spring 1993): 81–82, figs. 8, 9. Quote is from p. 79. Findly's essay is a very informative article that makes insightful analytical suggestions and generally succeeds in using Mughal art as a source for women's history of the period – something that has been lacking for Qajar art.

9. For one such depiction of Fath 'Ali Shah and three of his "little ladies," see fig. IV, p. 67, in Robinson 1950. For an Ottoman example of relative gender sizes, see portrait of Sultan Selim I, with a female consort in the background, a sixteenth-century painting by Nigari (Topkapi Palace Museum, Istanbul), reproduced in Ira Lapidus, *A History of Islamic Societies* (Cambridge, 1988), 321.

10. Virginia Woolf, *A Room of One's Own and Three Guineas*, ed. with an introduction and notes by Michèle Barrett (London and New York, 1993), 32.

11. As Riza Quli Mirza, a Qajar prince who traveled to Europe in 1836, explained to an English woman: "[O]ur Persian women are not like those of England – educated, accomplished, fitted to be companions to their husbands. . . . [O]ne English woman is worth at least ten Persian women, and so we take quantity to make up for quality." Quoted in Tavakoli-Targhi 1993, 79. In a similar way, in many paintings of the period when Fath 'Ali Shah is portrayed with his adult sons, the latter are depicted as somewhat smaller in size, displaying a hierarchy of age and royal status and power (see NO. 34, central panel).

12. For Safavid examples, see B. W. Robinson, "The Mansour Album," in London 1976. For Zand examples, see Falk 1972, 26–28, figs. 7–9.

13. For other representations, see fig. 9 in Diba 1989b; fig. 5 in Ekhtiar 1990, fig. 2 (p. 225) and fig. 10 (p. 230) in Ferrier 1989; and many of the reproductions of the paintings formerly in the Amery Collection in Falk 1972.

14. Similarly, in literary representations, we do not find the breast singled out as a particular site of praise of beauty or erotic attention. When the fifteenth-century poet Jami, for instance, describes Zulaykha's beautiful body, she is allegorized from head to toe, bit by bit. Moreover, similar and at times identical descriptive accounts are given for beautiful male bodies – a point related to the prevalence of homoeroticism in this literature. This poetic practice highlighted what male and female beautiful bodies had in common rather than their points of declared difference.

15. See, for instance, pl. 48, folio 93, Ali Quli Jabbadar, *Two Ladies with a Page*, 1674, in *The St. Petersburg Muraqqa* (Milan, 1996), described on p. 65.

16. The erotic breast in European art is itself

Paintings for the Mughal Court, exh. cat., Freer Gallery of Art (Washington, D.C., 1981), 210, no. 35, described on p. 211.

46. Findly, "The Pleasure of Women," 70. Philippa Vaughan relates the "excitement with which they [European paintings of the Virgin and Child brought to Akbar and Jahangir by the Jesuits] were received" to the general Mughal interest in mother and son scenes, in particular paintings depicting the birth of the ruler, which had proliferated in the sixteenth century. See Vaughan, "Begams of the House of Timur and the Dynastic Image," 117–34, in *Humayun's Garden Party*, ed. by Sheila Canby (Bombay, 1994); quote from p. 128.

47. Findly, "The Pleasure of Women," 72.

48. Farid al-Din 'Attar, *Mantiq al-ṭayr*, ed. by Muhammad Javad Mashkur (Tehran, 1962), 77–102. See Annemarie Schimmel, *Mystical Dimensions of Islam* (Chapel Hill, North Carolina, 1975), 305, for the importance of the story and its dissemination through other mystical poetries (such as Sindhi, Kashmiri, Malay, and Turkish), and 432 for the significance of the story as one of sufi love. For a very good English translation and informative introduction, see Farid ud-Din 'Attar, *The Conference of the Birds*, trans. with an introduction by Afkham Darbandi and Dick Davis (London, 1984). For the story of Shaykh San'an, see pp. 57–75.

49. On Rum, see "Rum," *Encyclopedia of Islam*, 1994, vol. 8, entries by Nadia El Cheikh and C. E. Bosworth. On Rum as Asia Minor (Anatolia) in the Fifth Land along with "land of Slavs," in premodern Irano-Islamic geographies, see Ahmet T. Karamustafa, "Cosmographical Diagrams," in J. B. Harley and David Woodward, *Cartography in the Traditional Islamic and South Asian Societies* (Chicago, 1992).

50. See Tavakoli-Targhi 1993.

51. For a discussion of this literature and the significance of the story of Shaykh San'an within it, see Tavakoli-Targhi 1993. A much-expanded version of this article ("*Nigarān-i zan-i Farang*") appears in Persian in *Nimeye Dīgar* 2, no. 3 (Winter 1997): 3–71. One may speculate that already by the seventeenth century, the interest in Shaykh San'an's story may have become geographically refocused from Rum onto Europe, after a number of Iranians who were officially sent to Europe in 1599 converted to Christianity. On these conversions, see Tavakoli-Targhi

1993, 74.

52. See Mernissi, *Women in Moslim Paradise*.

53. See Riza Quli Mirza Qajar, *Safarnāmeh-i Rizā Qulī Mīrzā naveh-i Fatḥ 'Alī Shāh*, ed. by Asghar Farmanfarmai Qajar (Tehran, 1982).

54. Riza Quli Mirza, *Safarnāmeh*, quoted in Tavakoli-Targhi, "*Nigarān-i zan-i Farang*," 30.

55. For a full analysis of these points, see the two essays of Tavakoli-Targhi cited in n. 51.

56. For partial description and reproduction of some of these works, see Karimzadeh Tabrizi 1985–91, vol. 1, pp. 4, 66, 70–71, 371; vol. 2, pp. 690, 785, 790–91, 981, 1020–21; vol. 3, p. 1379.

57. See Tavakoli-Targhi 1993, for some of these descriptions.

58. For partial description and reproduction of some of these works, see Karimzadeh Tabrizi 1985–91, vol. 1, pp. 66, 69–71, 74, 138, 264, 459, 462; vol. 2, pp. 690, 785; vol. 3, pp. 1369, 1378–81, 1550–51.

59. I analyze these constructions in my forthcoming book, *Male Lions and Female Suns: The Gendered Tropes of Iranian Modernity*.

POPULAR ARTS

Patronage and Piety

PETER CHELKOWSKI

HE QAJAR PERIOD was the era of the most dramatic development and flowering of the popular arts in Iranian history. Most of these arts sprang from the popular beliefs and rituals of Shi'ite Islam, which had been established as the state religion by the Safavid dynasty in the sixteenth century (1501–1722). This artistic movement changed the urban landscapes of Iranian towns and cities with the construction of *Husaynīeh*s, or *takīeh*s,[1] permanent edifices (often called open-air theaters by European visitors to Qajar Iran) in which popular Shi'ite rituals are performed to this day. These *takīeh*s and subsequently other architectural forms (such as *buq'eh*s, or tomb shrines, and *saqqākhāneh*s, or wayside shrines providing water for wayfarers) were decorated with murals, painted tiles, and canvases depicting the major personalities of the Shi'ite pantheon and their exploits. The building of religious edifices for theatrical performances and the decoration of these *takīeh*s and other structures with figurative representations of the holiest and most revered personalities, displayed for the public at large, was a startling new development in the history of Islamic art.

The flowering of popular rituals and the arts associated with them was in great measure owing to the support and active interest of the Qajar shahs, who built *takīeh*s and paid for their upkeep, as well as for the patronage of performers.[2] Thus, in the nineteenth century *takīeh*s became a major feature of Persian urban life. "Indeed, during the last half of the nineteenth century,

the pride of any Iranian community was its *takīeh*. . . ."[3] Mina Marefat calls the *takīeh*s "perhaps a unique Persian feature and certainly characteristic of the nineteenth century."[4] Emulating their monarchs, the well-to-do and the high-ranking dignitaries of Iran contributed significantly to this maturation of the Shi'ite rituals. Some *takīeh*s were built by the wealthy as a pious public service, others with contributions from the citizens of the local neighborhood or from the guilds such as the cloth merchants or the pharmacists. Their rapid proliferation would not have been possible, however, were it not for their tremendous hold on the imagination and affection of the common people.

For all social classes, the artistic movement associated with the *takīeh*s was triggered and inspired by the annual commemoration in Iran of the Karbala tragedy.[5] Toward the end of the year A.H. 60/A.D. 680, Husayn, beloved grandson of the Prophet Muhammad, broke with the newly installed Umayyad Caliph Yazid I (A.D. 680–83). Husayn refused to take the oath of allegiance to Yazid as a matter of religious and political principle. With his family and companions, he traveled from his native city, Medina, via Mecca to Kufa, in Iraq, where he had been invited to lead the local Shi'ite community. On the first day of the month of Muharram, Yazid's army intercepted Husayn, barring him access to the Euphrates with a ring of well-armed enemy forces, superior in number, and for the next ten days applied unrelenting physical and psychological pressure to force him to submit to Yazid, to no avail.

Finally, on 'Ashura, the tenth day of Muharram, the enemy attacked. Husayn and all but one of the males in his party were slain. Their severed heads were carried to Damascus, along with Husayn's captive womenfolk. The suffering and death of Husayn, the Third Imam of Shi'ite Muslims, is considered by Shi'ites to be the supreme act of suffering and redemption in history. Indeed, it is believed to transcend history and become metahistory, acquiring cosmic proportions. This view places the passion of the Imam Husayn at Karbala in a time that is no time and a space that is no space. In other words, it is as if what happened on 'Ashura, the tenth day of the month of Muharram in the year 61 of the Muslim era (A.D. 680) on the battlefield of Karbala, is taking place now, in the present, in any place where Shi'ites live, and especially wherever they are humiliated, deprived, and abused, allowing them to measure themselves against the principles and the paradigm of Husayn. Shi'ite communities regard it as their duty to fight against any injustice, tyranny, and oppression, so that they might be considered worthy of the sacrifice of Husayn, "Prince of Martyrs."

For thirteen centuries, the martyrdom of Husayn has been mourned by Shi'ites worldwide. In Iran the commemoration of Imam Husayn's passion and martyrdom has been emotionally charged to an extraordinary degree since the Safavids established Shi'ite Islam as the state religion.

The mourning rituals of Muharram and the following month of Safar, divided into the ambulatory and the stationary, have been performed in the open for centuries, whether along the main artery of a town, on a village common, at a major intersection in the bazaar, or in the courtyard of a mosque, a caravanserai, or a private house. To provide protection from the elements for the participants during stationary rituals, an awning is sometimes spread or a tent pitched.

Permanent structures for the Shi'ite mourning rituals[6] were not built until the nineteenth century, with the birth of the *ta'zieh*, the only form of serious drama ever developed in the Islamic world.[7] In the *ta'zieh* ambulatory and stationary rites that had coexisted separately for over a millennium (and which have continued to do so, independent of the *ta'zieh*s) were fused. The ambulatory ritual of the *dasteh* (procession) provided the *ta'zieh* with the basis for its costumes and movements. In the *dasteh* half-naked male penitents scourge themselves as they march, along with costumed men on foot or mounted on horses or camels representing the protagonists in the Kar-

bala tragedy; floats with various tableaux of Karbala may also be seen in these processions. The *ta'zieh* drew its dialogue from the stationary ritual of the *rawzeh-khwānī*, a public dramatic recitation devoted to characters and episodes in the Karbala tragedy. In addition to its religious significance as an act of expiation – according to popular belief, participation in the *ta'zieh* is a step toward redemption – the *ta'zieh* was to become a popular form of entertainment.

*Takieh*s were built for the staging of the *ta'zieh* and other stationary rituals such as the *rawzeh-khwānī*.[8] The *takieh* is also used as the rallying and culminating point of the Muharram procession.

Some *takieh*s were large, seating thousands of spectators, while others accommodated several hundred. Still others were only large enough for family and friends.[9] The most famous *takieh* was the Takieh Dawlat in Tehran (FIG. 30), built in the 1870s under Nasir al-Din Shah (r. 1848–96). Samuel Greene Wheeler Ben-

FIG. 30. *Takieh Dawlat.*
Muhammad Ghaffari, Kamal al-Mulk. Oil on canvas.
GULISTAN PALACE COLLECTION.

jamin, American envoy to Tehran, described the building in 1887:

> *On alighting from the carriage I was surprised to see an immense circular building as large as the amphitheater of Verona, solidly constructed of brick. . . . On looking over the vast arena a sight met my gaze which was indeed extraordinary. The interior of the building is nearly two hundred feet in diameter and some eighty feet high. A domed frame of timber, firmly spliced and braced with iron, springs from the walls, giving support to the awning that protects the interior from the sunlight and rain. . . . From the center of the dome a large chandelier was suspended, furnished with four electric burners — a recent innovation. A more oriental form of illuminating the building was seen in the prodigious number of lustres and candlesticks; all of glass and protected from the air by glass shades open on the top and variously colored, they were concentrated against the wall in immense glittering clusters. . . . I judged that there were upwards of five thousand candles in these lustres. . . . In the center of the arena was a circular stage of masonry, raised three feet and approached by two stairways. On one side of the building a pulpit of white marble was attached to the wall. . . . But I soon discovered that all the architectural details of this remarkable building were secondary to the extraordinary spectacle offered by the assembled multitude.*[10]

It is believed that the construction of the Takieh Dawlat was inspired by the Albert Hall in London. In 1873 Nasir al-Din Shah attended a concert there and was so impressed with its architecture that, upon his return home, he ordered a similar structure to be built in the royal compound in Tehran. The task was given to the master engineer, Mu'ayyir al-Mamalik.[11] According to some writers, the resemblance of the Takieh Dawlat to the Albert Hall was rather remote.[12] The main difference lay in its roofing. The architect failed to erect a proper dome over this gigantic circular building and instead covered it with canvas awnings placed over a framework of huge wooden arches. Although the architect consequently had to bear the brunt of the shah's displeasure, a canvas awning is more in harmony with the Muharram tradition and philosophy. Imam Husayn and his supporters were

protected from the burning sun in the desert of Karbala by the canvas of their tents and not by a brick dome. Thus, the majority of *takiehs* are protected from the elements not by a solid roof, but by an awning.[13] This is probably why Europeans thought of the *takiehs* as open-air theaters.

According to many Western visitors of the time, the dazzling splendor of the Takieh Dawlat and the intensity of the dramatic action staged within its walls far surpassed the spectacle of the great opera houses of Western capitals. Despite these glowing reports, the building's structure was fundamentally weak, and the entire edifice had to be torn down soon after World War II ended.

The Takieh Dawlat was the most visible endorsement by Nasir al-Din Shah of the popular Shi'ite rituals. Such royal patronage had a great impact on the development of the *ta'zieh* drama, but not on the architecture of *takiehs*. The *takieh* that seems to have had the greatest impact on the development of the architecture for these structures was the earlier *takieh* of Haji Mirza Aqasi, the grand vizier of Muhammad Shah (r. 1834–48). The floor plan of the Takieh Haji was based on that of a typical Iranian caravanserai — a rectangular courtyard surrounded by one or two tiers of arched terraces. All one had to do was set the stage in the center of the rectangle and stretch an awning over the whole courtyard. Several *takiehs* in Birjand, Na'in, and Natanz display this plan.

The most complete description of the Takieh Haji comes from the pen of a Russian diplomat and orientalist, I. N. Berezin, who was invited to attend the *ta'zieh* performances there in Muharram/January 1843:

> *The stone* takīeh *of Haji has a parallelogram shape, similar to that of a caravanserai: around it are two tiers of loges. In the middle of each side [of the* takīeh*] there are open vaulted halls the height of the building; instead of a roof, a canvas shaped like a tent is stretched. The sixty-four loges are of different sizes; they are brightly decorated. The floors are covered with straw mats. The stage* (takht) *is covered with felt carpets, while the* kursī[14] *is covered with cashmere shawls. The piers between the loges are all curtained with long, narrow cashmeres at thirty* tumāns *each; since the shawls are wider than the piers, the edges are tucked in and sewn up; more heavily pleated cashmeres are also hung under the loges. The shawls are all narrow, without a border, one-colored and hung*

symmetrically. All those shawls belong to the Malik al-Tujjar, the head of the Tehran merchants and director of the Takieh Haji.

Four large loges, or halls, are decorated with a special luxury and are not occupied by anyone during the performance.[15] One of these empty loges belongs to the Shirazians, another to the Isfahanians, the third to the Kashanians, and the last to the Malik al-Tujjar. Each owner tries to outdo the others in a display of every conceivable luxury. The richest loge is the Shirazians'; the most modest is the Kashanians; however the latter has cashmere shawls with golden embroidery. The walls and ceilings of the other three loges are covered with cashmere; both shawls and carpets at five hundred tumāns *each are hung from the top. In the Shirazian loge the back wall is decorated with red cloth covered with gorgeous golden embroidery. The price of this curtain is said to be four thousand paper rubles. In the loge of the Malik al-Tujjar, china and crystal are displayed, and above it a black velvet square with diamonds, rubies and pearls is sewn onto cashmere.[16]*

Among the smaller loges, those of the valī 'ahd *(the crown prince) and the Haji attract the most attention. They are located next to each other in the front of the* takīeh. *The walls of these loges are covered with cashmeres. The whole decoration of the* takīeh *is estimated at four hundred thousand paper rubles. . . . The* takīeh *has only one entrance, so at the end of a performance there used to be a terrible crush, because the Takieh Haji has always attracted crowds of spectators. By the order of the Haji, one of the loges was reserved for the Russian Embassy. For the noblewomen, eight loges over the entrance were designed and covered with transparent curtains through which the spectators could not see in.*

The seats for the common people down in the pit are enclosed with ropes. In the pit, women predominate; no less than a thousand at each performance. It should be noted that women are the most ardent admirers of ta'zīeh; *for most of them it is the only* tamāshā *[spectacle] during the whole year. No one reacts to the performance as emotionally as the Persian women, who often drown out the voices of the actors with their sobbing. . . . [17]*

FIG. 3I. *Performance stage, Husaynieh Mushir in Shiraz.* Built 1876.

Although a distinct *takīeh* architecture did not evolve in Iran,[18] some characteristics are common to almost all *takīehs* that preserve and enhance the dramatic interplay between actors and spectators in performances that are theater-in-the-round (see FIG. 3I). The main performing space is stark, without curtains, on a raised platform in the center of the building or courtyard. The shape of this central stage may vary from round to rectangular. The stage is surrounded by a broad circular strip, which is covered by sand. This latter space is used for battles on foot and on horseback, as well as for subplots and for action representing journeys, for the passage of time, and for changes of scene, the last being indicated when performers jump from the stage and circle it. As in Japanese Noh drama, the actor may announce to the spectators that he is going to a certain place; when he climbs back on the stage, it means he has arrived at his destination.

The action extends from the stage, through the sand-covered circle and into the audience. In *takīehs* without walls, skirmishes often take place behind the audience. This centrifugal movement of the action, from the stage in the center out to the *takīeh*'s periphery and back, envelops the spectators and draws them into the play's action by having them say a prayer together with the actors, for example, or help an actor mount a horse. Thus, the audience itself often becomes an essential protagonist. Some contemporary Western directors and producers, notably Peter Brook and Jerzy Grotowski, have looked to the *ta'zīeh* for devices to break down the barriers between actors and audience – the central stage and its extension into the audience space, the removal of the curtain, the direct participation of the spectators in the action.

In some provinces – above all, Yazd – the architecture of the *takīeh* is designed more like a reviewing stand and a parade ground than a theaterlike setting complete with central stage. In the Yazd region, the main event of the Muharram ritual is the carrying of the *nakhl*, which represents the bier on which Husayn's headless corpse was borne from the battlefield to its final resting place. With the passage of centuries, the *nakhl* lost any resemblance to the original bier and became a lattice-like structure of variable size shaped like a teardrop. Sometimes it takes as many as a hundred and fifty men to carry it.

Although Michele Membré, a Venetian envoy to the Safavid court (1539–42), reported that "the Sophians paint figures, such as the figure of 'Ali, riding on a horse with a sword,"[19] it was not until the nineteenth century that the *ta'zīeh* performances inspired painters to illustrate the Karbala tragedy in oils on large canvases. In turn, these narrative paintings, called *pardeh*, or *shamāyil*, became the focus of a ritual of narrative recitation called *pardehdārī*, or *pardehkhwānī*. The antecedents of the *pardehdārī* were observed by Membré: "In their squares there are many Persian mountebanks sitting on carpets on the ground; and they have certain long cards with figures; and the said mountebanks hold a little stick and point to one figure after another, and preach and tell stories over each figure."[20] This ritual came into being for the benefit of outlying villages in the countryside that could not participate in *ta'zīeh*s, which were usually performed in towns and required elaborate and considerable expense. The *pardehdārī* is a one-man show centered around a painting depicting scenes from the battle of Karbala, arranged from left to right, painted in panoramic style (see NOS. 94, 95). On the right side of the painting are scenes of the Hereafter, with Husayn's supporters enjoying the beautiful vista of Paradise while his opponents are tortured in Hell. This oil painting generally measures $3\frac{1}{2}$ by $1\frac{1}{2}$ meters and is easily rolled up for transportation.

The *pardehdār* (storyteller) goes from one locality to another, hangs the painting on a wall, and sings and recites the story, using a pointer to elucidate the scenes. The spectators gather in a semicircle in front of the painting, some squatting on the ground, others standing behind them. The storyteller utilizes the dramatic art of declamation to the full. He knows the significance of changes in tone and vocal quality, to convey minute details of characterization and to imitate sounds such as the noise of battle, and the effect of gesture. During the battle scenes, he describes the proceedings in a rough voice and at an accelerated pace. In order to stir up his public to the tragic fate of Husayn's family, he marches up and down, clapping his hands and twirling his stick in the air. If necessary, he even weeps.

Following the development of the *pardehdārī* ritual, narrative paintings were utilized in *takīeh*s as decorative wall hangings. Even in the Takieh Dawlat, these canvas paintings were utilized to increase the splendor and dramatic setting of the performance. Soon, the well-to-do of Qajar society became interested in the narrative paintings and commissioned them to decorate their residences; *Battle of Karbala*, painted by 'Abdallah Musavvar (NO. 95), is an example of such courtly *pardeh*.

The next step in the development of narrative painting took place in the latter part of the nineteenth century: scenes were pictured directly on the walls, thus giving rise to the first religious murals in the Islamic tradition.[21] One example is the Imamzadeh Shah Zayd in Isfahan. The wall paintings in this centuries-old shrine were begun in the second half of the nineteenth century and completed in the beginning of the twentieth century.[22] The paintings around the interior of the shrine follow the major events of the Muharram Karbala tragedy as performed in the *ta'zīeh* repertory.[23]

In one mural (FIG. 32), 'Abbas, Husayn's half brother and standard-bearer, one of the most chivalrous men in the Shi'ite tradition, charges the enemies on the Karbala battlefield. In order to show his greatness in relation to his opponents, the artist painted 'Abbas and his horse oversized – an ancient tradition in Persian art. To show the fighting prowess of 'Abbas, the painter made him seemingly fly on his horse, a tradition derived from classical Persian miniature painting. Here, as in the national Persian epic, the *Shāhnāmeh*, the horse and its rider are working in tandem, and that harmony is visible in the painting. Again, as in classical miniatures, the face of 'Abbas bears a serene expression, whereas the faces of the enemy are contorted and full of fear.[24]

That serenity is also visible on the face of Imam Husayn in the penultimate scene of the Karbala tragedy from the same mural. Husayn and his steed Zu'ljinah, riddled with enemy arrows, are offered help from non-Muslims and even from animals, represented by a lion. Husayn, however, rejects their offers of aid. In that moment in the *ta'zīeh* play, he says: "After the death of these youths [his sons, relatives, and supporters], to reign would be torture. The kingly crown would feel like a pan of fire upon my head."[25] A Baroque-looking angel is shown flying close

FIG. 32. *'Abbas Charges the Enemies.*
Wall painting, late 19th century.
IMAMZADEH SHAH ZAYD, ISFAHAN.

to his halo, but the background is traditionally Iranian, with birds and gazelles. The painter, still mindful of the tradition of not depicting the faces of the prophets and other holy people, paints a veil over Imam Husayn's face. This veil is transparent, however, and it highlights rather than conceals the face; thus, the beholder tries to see not what is hidden behind the veil, but what lies behind the perfect composure of Husayn's face – the determination to sacrifice his life for the sake of truth.

The same reflection of the *ta'zieh* performances can clearly be seen in the pediment of the Husaynieh Mushir in Shiraz, erected in 1876 as an act of piety and public service by a wealthy philanthropist, Mirza 'Abd al-Hasan Mushir al-Mulk.[26] The paintings of this pediment were rendered on tiles, which are considered by some art historians to be among the best produced in the nineteenth century (FIG. 33). The pediment overlooks the courtyard in which *ta'zieh* plays and other Muharram rituals are performed; it is situated immediately above the box for important spectators on the north side of the courtyard.

The scenes depicted on the pediment approximate those of the *pardeh* but differ primarily in the way that the Hereafter is divided from the battle of Karbala. In the pediment these two groups of scenes appear as two horizontal bands, which are separated by a frieze of eight cartouches containing a poem by Visal-i Shirazi, written in fine calligraphy in white letters on a dark blue background, about Husayn and Karbala. The tiles also differ from the *pardeh* in that there is no large central protagonist on a white horse.[27]

FIG. 33. *Pediment of Husaynieh Mushir in Shiraz* (detail).

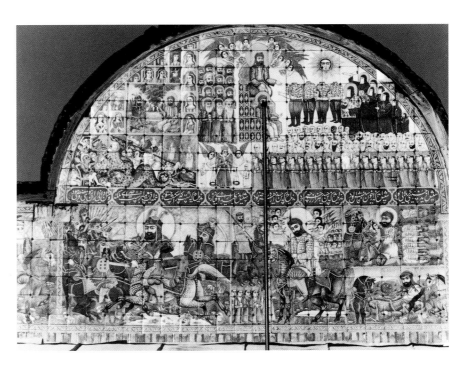

The best examples of rural Karbala wall paintings are to be found in the northern province of Gilan, on the exterior walls of *buqehs*, or tomb shrines. Gilan has been, throughout history, the most densely populated province of Iran, with the highest concentration of people and villages in the country. Almost every village in Gilan has its own *buqeh*, where the village founders, and local saints and notables are buried. A small or medium-size rectangular or square edifice, the *buqeh* very often plays the role of the village communal center. A characteristic feature of most *buqeh*s of Gilan is a portico that surrounds the building and protects the outer walls from the elements. Toward the end of the Qajar period, the outer walls of many *buqeh*s in Gilan were painted all over with scenes from the Karbala tragedy. These paintings, like those of the *takīeh*s, were inspired by the *ta'zīeh* productions.[28] The fact that the *buqeh* paintings are visible to a passerby who does not have to enter the building sets them apart from those of the *takīeh*s.

The Gilan *buqeh* style of painting is distinguished from that of the rest of Iran by the brightness of its colors. Sima Kuban writes of the Karbala scenes:

> *It is almost a rule that one wall of* buqeh *is devoted to 'Ali Akbar [the oldest son of Imam Husayn, martyred at Karbala], one to Qasim [the son of Husayn's older brother Imam Hasan, also martyred at Karbala], and one to 'Abbas. . . . The features of the protagonists in the paintings are not gloomy, but full of vigor and hope; they are vibrant and powerful.*[29]

FIG. 34. *Mural from Buq'eh Aqa Sa'id in Gilan showing Qasim catching up with the second fleeing son of Azraq Shami.*

A *buq'eh* wall devoted to Qasim can be seen on the northern side of the Buq'eh Aqa Sa'id in the village of Pincheh Astaneh.[30] It was Hasan's will that Qasim be married to Fatimeh, the daughter of Husayn. Qasim and Fatimeh, still in their teens, were among the besieged at Karbala. Husayn, realizing that their deaths were imminent and desiring to fulfill his promise to his brother, ordered their wedding. When the marriage rites were concluded and Qasim was preparing to consummate the marriage, he was called to the battlefield, where he attacked one of the enemy commanders, Azraq Shami, and his sons. The painting (FIG. 34) depicts Qasim catching up with the second fleeing son of Azraq Shami. Qasim grabs his enemy by the hair, lifts him bodily out of the saddle, and flings him over his head. In the mural, the second brother is flying through the air while the first is already lying in the dust. This deed is taking place before the eyes of Azraq Shami and a detachment of enemy soldiers. This episode and painting evoke similar episodes and miniature illustrations from the *Shāhnāmeh*.

In some *buqeh*s, as part of the aftermath of the Karbala tragedy, Hell is depicted as the final destination of the enemies of Husayn. In the *buqeh* of the village of Licheh Lashtanehshah, the *Sirat* bridge between Paradise and Hell appears with the sinners falling from it into the many maws of an infernal sea monster. In the Husaynieh Mushir in Shiraz and on *pardeh*, Hell always contains a devouring monster, but the Licheh Lashtanehshah creature is especially terrifying.[31]

Isolated images from episodes of Karbala also appear, on a smaller scale, on *saqqākhāneh*s. The *saqqākhāneh* is a niche in a wall, usually in the crowded maze of alleys in the bazaar or the old quarter of an Iranian town. Behind the niche wall is a water container, connected to a brass faucet out front. This niche is very often covered with a metal grill, to which one or more brass drinking cups are attached by chains. The niche is usually made of tiles; its background is decorated either with small-scale paintings on tiles or with paintings on glass or canvas. The *saqqākhāneh* is always dedicated to Husayn's standard-bearer 'Abbas, who is regarded as the water-carrier par excellence; the paintings typically represent his gallant attempt to fetch water from the Euphrates to Husayn's besieged encampment in the teeth of the enemy army.[32]

On a tile illustration from a *saqqākhāneh* in Isfahan, we can see 'Abbas fetching water from the Euphrates (FIG. 35). 'Abbas was not fated to succeed in bringing this water to Husayn's womenfolk and children; he was slain

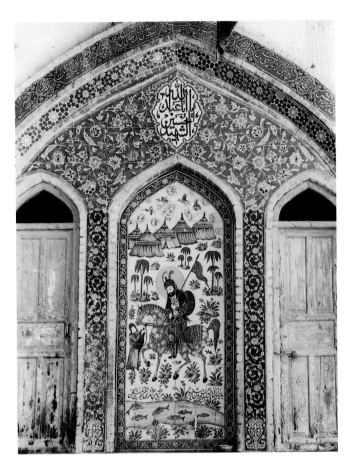

FIG. 35. *A tile panel from a* saqqākhāneh *in Isfahan.*

before he could reach their tents. To this day, when a Shi'ite wants a drink of water, he or she remembers the thirst of Karbala.[33]

The decoration of *takīeh*s, *buqeh*s, and *saqqākhāneh*s in the late Qajar period with paintings of beloved religious personalities for the masses constituted a major development in Islamic art. The life-size paintings on canvas, walls, and tiles mainly depicting the Shi'ite martyrology are often referred to as naive, folk, or *qahvehkhāneh* (coffeehouse) paintings. The "coffeehouse" narrative painting tradition persisted into the 1960s, coming to a close with the death of Muhammad Mudabbir, the last great painter of the genre, in 1966.[34] Its imprint can be seen in the contemporary graphic arts as well as in the award-winning films of Iran. The life-size paintings of this tradition may lack the refinement and the delicate touch of the miniature paintings of the Timurid and Safavid periods, which were intended for a small, privileged group, but they are a vibrant reflection of the aspirations and the world view of the common people.

1. These terms are used interchangeably. Sometimes either term becomes part of the proper name of a given edifice, such as Husaynieh Mushir or Takieh Dawlat.

 The term *Ḥusaynieh* appears in a seventeenth-century chronicle, but with a different connotation: "Sayyid Bayg Kamuneh and Mirza Ahmad Kufrani, who was *vazīr* and *ṣāḥib-i maqta'*, set themselves up inside the walls of the sanctuary of those sublime *Ḥusaynieh* sayyids, the *nāqibs* of that kingdom, which was referred to by everyone as the *Ḥusaynieh*, and which the people of that region, out of their great regard, considered as a *bast* sanctuary and a place of refuge in emergencies. They brought in musketeers and bowmen and set up a guard around the city and the *Ḥusaynieh*." Iskandar 1956, vol. 1, p. 359. Unpublished translation by Robert McChesney.

2. Nasir al-Din Shah (r. 1848–96), during whose reign the Muharram-related rituals reached their zenith, was a religious man, profoundly devoted to the Shi'ite imams as well as popular Shi'ite rituals. From the beginning of his reign, he spent vast sums on the restoration of the shrine complex at Karbala. He was to become the great patron of the *ta'zīeh* (see below).

3. Samuel R. Peterson, "The Ta'zīyeh and Related Arts," in Chelkowski 1979, 72.

4. Mina Marefat, "Building to Power: Architecture of Tehran 1921–1941," Ph.D. dissertation, MIT, 1988, 51.

5. See Peter Chelkowski, "Popular Shi'ite Mourning Rituals," *Alserat* 12 (1986): 209–33.

6. See Gustav Thaiss, "Husayniyah," *The Oxford Encyclopedia of the Modern Islamic World*, vol. 2 (New York and Oxford, 1995), 153–55, and Mahmud Tavasuli, "Ḥusaynīehhā, takieh, muṣallāhā," 81–90, in Muhammad Yusuf Kiani, *Mimari-yi Irān-i Dawreh-i Islāmī* (Tehran, 1987). There are *takiehs* with permanent solid roofs, but they are rather exceptions to the rule; see Peterson, "The Ta'zīyeh," 68–74.

7. During the Safavid period the term *ta'zīeh* was sometimes used instead of '*azadāri* (mourning), as in this excerpt: "During this time came the month of Muharram and the holy day of 'Ashura. The long prevailing custom of this royal family was for the padshah and all the amirs and notables of the army to perform a tazieh for the Lord of Martyrs and the others slain on the battlefield of 'pain and affliction' (*karb u balā*) and for this performance, with its accompanying passionate weeping (*sūz u baqā*), to take place in the presence of the shah. This particular performance was enacted in the mosque of the late padshah, Hasan Padshah, which stands on the north side of the Maydan of Sahibabad and all the amirs were there." Iskandar 1956, vol. 1, p. 298. Unpublished translation by Robert McChesney.

 However, from the late eighteenth century on, the term *ta'zīeh* (or more precisely, *ta'zīeh-khwāni*), has been used exclusively for the dramatic representation.

8. Peter Chelkowski, "Rawda-Khwani," *Encyclopaedia of Islam*, vol. 8, p. 465.

9. See Jean Calmard, "Le Mécénat des représentations de ta'ziye," Part 1, "Les Précurseurs de Nâseroddin Châh," in *Le Monde Iranien et l'Islam*, vol. 2 (Geneva, 1974), 73–126, and Part 2, "Les Débuts du règne de Nâseroddin Châh", in *Le Monde Iranien et l'Islam*, vol. 4 (Paris, 1976–77), 133–62.

10. Benjamin 1887, 382–88. Mina Marefat writes: "The ta'zia [*tazīeh*] was so favored by the shah and his court that Naseroddin Shah built the city's first large urban theater, the Takya Dawlat, in the south east corner of the *Arg* in 1873, thereby officially sanctioning this activity." Marefat, "Building to Power," 52. Marefat gives the date after I'timad al-Saltaneh 1984, 58. The year 1873, however, is the date when the shah issued the order to build the Takieh Dawlat, not the date of its construction. For Takieh Dawlat, see Peterson, "The Ta'zīyeh"; Zuka 1970; Bahram Bayzai, *Namāyish dar Īrān* (Tehran, 1965); Sadiq Humayuni, *Ta'zīeh va Tazīehkhwāni* (Tehran, 1975).

11. Dust 'Ali Khan Mu'ayyir 1983. See also Nasir Najmi, *Tihrān-i 'Ahd-i Nāṣiri* (Tehran, 1985).

12. Carla Serena, *Hommes et choses en Perse* (Paris, 1883), 172–73. For further reading of Western travelers to Iran who describe the Takieh Dawlat, see E. G. Browne, *A Year amongst the Persians* (London, 1887); Curzon 1892; Isabelle L. Bishop, *Journeys in Persia and Kurdistan* (London, 1891); Arthur Arnold, *Through Persia by Caravan* (London, 1887); Eustache de Lorey and Douglas Sladen, *Queer Things about Persia* (London, 1907).

13. The creation of a *takieh* awning is an art in and of itself. There are two types of awnings: one for winter and the other for summer. Both are intricately sewn and embroidered.

14. A *kursī* is a seat or chair. Here it indicates a *minbar*-like structure with several steps used by a *rawzeh-khwān*.

15. The veneration of empty places is an ancient Iranian tradition. The empty place stands for the deceased hero or heroes.

16. In addition to their decorative function, the china, crystal, and jewelry are symbolic gifts to the departed heroes – in this case, to Imam Husayn and other Karbala martyrs.

17. Berezin 1852, 300–302. Grateful acknowledgment is made to Elena Andreeva for her assistance in translation. A drawing of the Takieh of Haji Mirza Aqasi based on Berezin's description is provided in Calmard, "Le Mécénat," Part I, p. 108. Concerning the number of *takiehs*, Berezin writes: "During my stay in Tehran, about fifty-eight *takiehs* were organized in town, but not all at the same time. The troupe of actors, after finishing a ten day performance cycle, move to another newly decorated *takieh* and repeat the whole cycle of mystery plays. In this way, the month of Muharram passes. The nobility establish the *takieh* in their respective city quarters and pay for their upkeep. There is a competition among the nobles for the best *takieh*" (p. 299).

 According to the census of 1868, there were thirty-four *takiehs* in Tehran. Mansoureh Ettehadieh states that there were forty-four *takiehs* in Tehran in the year 1852–53 and only forty-one in the year 1902–3. Ettehadieh, "Patterns in Urban Development: The Growth of Tehran (1852–1903)," in Bosworth and Hillenbrand 1983, 199–212. The decrease in number of *takiehs* is misleading. Berezin's account of 1843 and M. Ettehadieh's statistic of 1852–53 count both temporary structures and permanent *takiehs*. According to Berezin, even the Russian and British missions maintained a temporary *takieh* on their respective premises. It seems that from the time of the 1868 census on, only the permanent *takiehs* were counted. A description of the Caspian Sea provided by G. Melgunof could serve as proof of the popularity of *takiehs*: "In Shahrud there are four *takiehs*, only one less than the separate number of mosques, baths and caravanserais; and in Rasht, thirty-six, in contrast to twenty-two mosques and thirty-four madrasehs." G. Melgunof, *Das Südliche Ufer des Kaspischen Meeres* (Leipzig, 1868), 39, as quoted by Peterson, "The Ta'zīyeh," 72.

18. In India the *takieh* (called *imāmbara* or '*āshurkhāneh*) did not evolve into a distinct architectural style, either. In both countries, one can pass a *takieh* and have no

idea what it is.

19. Membré 1993, 52.

20. Ibid.

21. Individual images and portraits, predating this period, in religious structures have been recorded. See essay herein by Layla S. Diba.

22. See Chelkowski 1989, 104.

23. Ibid., 98–111.

24. See Peter Chelkowski, "The Martyrdom of the Luminous Leader of the Bani Hashim, Hazrat Abu'l-Fazl al-'Abbas," *Alserat* 12 (1986): 234–64.

25. Anonymous author; Private collection.

26. Born in Shiraz, Mirza 'Abd al-Hasan Mushir al-Mulk (1811–1885) served as minister to the governors Manuchir Khan Mu'tamid al-Dawleh and Farhad Mirza. An important patron of architecture in Shiraz, he commissioned the construction of the Husaynieh Mushir and the Mushir al-Mulk and Vakil mosques, as well as several caravanserais, baths, and bazaars.

See Sadiq Humayuni, *Ḥusaynīeh Mushīr* (Tehran, 1992) (an excellent 64-page monograph with illustrations), 7–10.

27. Ibid. Unfortunately, as a result of the fire at Husaynieh Mushir in 1995, the tiles have been destroyed.

28. Gilan is famous for its *ta'zieh* troupes, but at the end of the nineteenth century, it was the *ta'zieh* troupes of the Taliqan valley in the Alburz mountain range that made the greatest impact on many localities in the province.

29. Chelkowski 1989, 108.

30. Manuchihr Sutudeh, *Az Āstārā tā Astarābād* (Tehran, 1972), vol. 2, pp. 188–91.

31. Ibid., vol. 1, pp. 434–35. One of these *buqeh* murals of Gilan is reproduced in the *National Geographic Magazine*, April 1921, p. 379.

32. See Peter Lamborn Wilson, "saqqa-khaneh," *Majmū'eh-i Parvīz Tanāvulī* (Tehran, n.d.), unpag. This is an excellent description of the function and meaning of *saqqākhānehs*.

33. An interesting development took place in the 1960s within the new generation of modern and even avant-garde Iranian painters primarily trained abroad. A group of artists calling itself the Saqqakhaneh school made use of the symbolism related to the Karbala tragedy and its rituals. See also Manuchihr Kalantari, "Le Livre des Rois et les peintures des maisons de thé," in *Objets et mondes: La Revue du Musée de l'Homme* (Paris) 11, fasc. 1, pp. 141–58.

34. See *An Exhibition of Coffee-House Paintings*, exh. cat., Iran-America Society (Tehran, 1967), a catalogue prepared by Karim Imami, in which Mudabbir is featured; and *Les Peintres populaires de la légende persane*, a catalogue for an exhibition of coffee-house paintings at the Maison de l'Iran in Paris (early 1970s). Several of Mudabbir's paintings were exhibited in Paris and his name is mentioned several times in the catalogue.

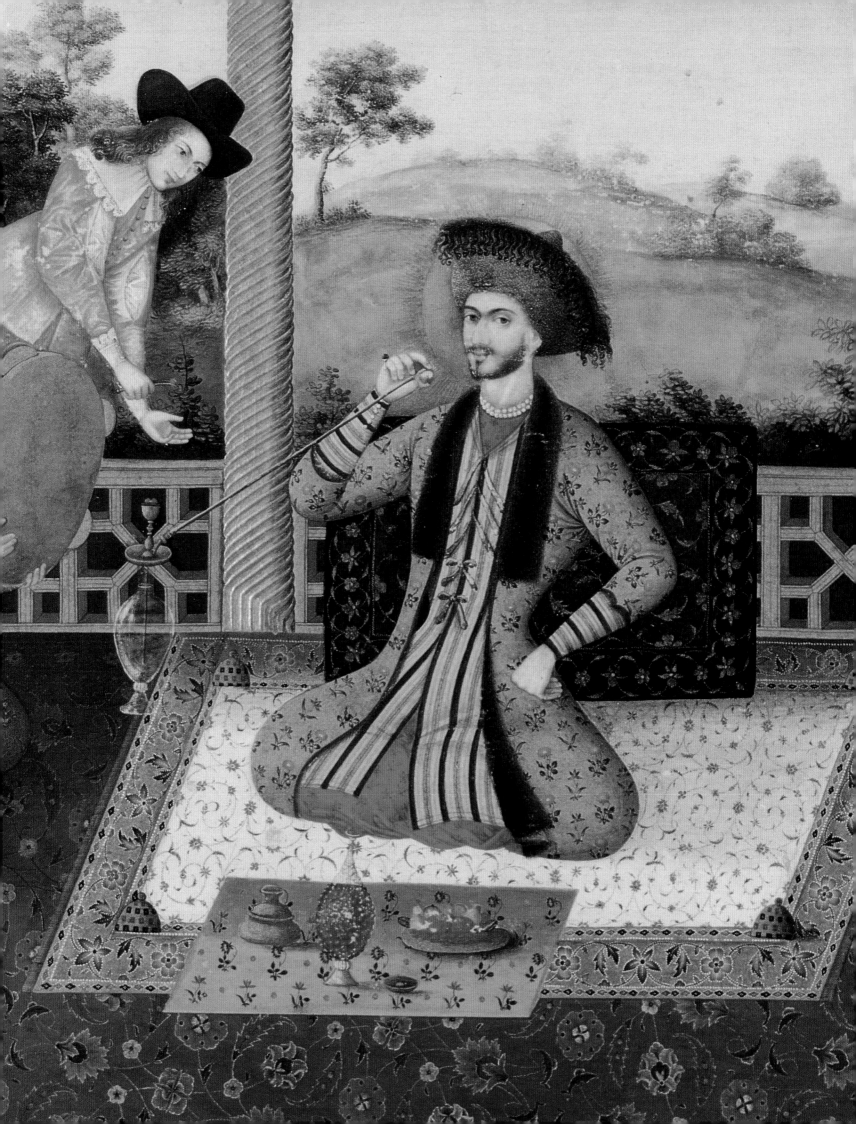

SAFAVID PERIOD

(1501–1722)

THE ART AND CULTURE of Qajar Iran evolved from traditions established during the latter part of the Safavid period. Safavid Persia, as Iran was then called, was one of the chief players, if not chief beneficiaries, of the global economy that followed the age of exploration and European commercial expansion in the sixteenth and seventeenth centuries. In the mid-seventeenth century, Isfahan, the capital of Safavid Iran established in 1598 by Shah 'Abbas I (r. 1588–1629), became a cosmopolitan center of trade and international diplomacy where a lavish court culture and artistic patronage flourished.

In the artistic sphere, the impact of European visitors, goods, and technologies on court and government patronage changed the course of Persian painting by fostering novel subject matter, stylistic innovations, and experimentation with new media. Traditionally, elegantly copied and magnificently illuminated Qur'ans and illustrated poetic manuscripts had been the principal spheres of Persian artistic endeavor. From the seventeenth century onward, the supremacy of epic and romantic texts embellished with narrative scenes and decorative designs executed in miniature detail was challenged by the popularity of single-page paintings depicting floral compositions or subjects taken from the multicultural mix of peoples in Isfahan. Artistic patronage, which until that time had been the exclusive purview of the court, spread to the wealthier members of the urban population, Armenian merchants living in Isfahan, foreign travelers, and even artists themselves.

Two modes of painting held sway during this period. The graceful, two-dimensional style of Riza 'Abbasi (active 1587–1635) and his followers was executed in a brilliant palette. The second mode, known as the Europeanizing style – here called Perso-European, to reflect the creative interaction of European and Persian artistic traditions – is characterized by a limited use of modeling and foreshortening, spatial recession, cast shadows, and a more subdued palette. The most significant innovation of this period was the introduction of a landscape style rooted no longer in the decorative idealized idiom of Persian manuscript painting, but in the conventions of the Dutch landscape and direct observation.

European artistic conventions were either mediated by Mughal adaptations, which preceded the Persian innovations, or transmitted directly through European painters and craftsmen who came to seek their fortune in Persia; European prints, primarily of Dutch origin; and printed books. Oil portraits of European rulers such as Louis XIII and Louis XIV of France and Charles I of England and their consorts[1] were kept in the royal treasuries and made available to the master craftsmen and painters of the royal workshops.

The new Perso-European mode was thus introduced by artists trained in the Mughal manner and in the adaptation of European sources. This new direction of

Persian painting is primarily associated with the court painters Shaykh 'Abbasi (active 1650–84), 'Ali Quli Bayg Jabbadar (active 1657–1716), Muhammad Zaman ibn Haji Yusif Qumi (active 1649–1700), and their followers. The beginnings of the style have been traced back as far as the reign of Shah Safi (r. 1629–42), although it emerged more prominently during the reign of Shah 'Abbas II (r. 1642–66), when Shaykh 'Abbasi and 'Ali Quli Jabbadar were in his employ. The new style flourished under Shah Sulayman (r. 1666–94), when precious sixteenth-century Safavid manuscripts were repaired and manuscripts, album pages, and lacquerwork in the Perso-European style were commissioned for the royal library and treasury.[2] The two modes were often used in conjunction in architectural decoration and in illustrated manuscripts.

During this period, figural representations were increasingly utilized for ceramics, tilework, textiles, and enamels. The versatility of Safavid painters is shown by their skill at working in many different media, sometimes concurrently.

Two features of seventeenth-century Safavid painting were critical to the subsequent evolution of Persian painting. On the one hand, following a long-standing tradition of figural representation for palace decoration, life-size imagery in both murals and oils on canvas was revived on a grand scale for palace and bazaar decoration in Isfahan and the royal summer retreats at Ashraf and Farahabad on the shores of the Caspian Sea. The reemergence of this monumental figural tradition – more than a thousand years after its preeminence during the Achaemenid and Sasanian dynasties – is best exemplified by the mural decoration of the Chihil Sutun palace, built during the reign of Shah 'Abbas II (FIG. 12).

On the other hand, small-scale "miniature" painting in the Perso-European mode under a lacquer varnish was introduced for the decoration of bookbindings, penboxes, and other decorative objects. According to Cornelis de Bruyn (1652–1726/27), a Dutch painter who visited Isfahan in 1702–4, Persian artists produced standishes (penboxes) meticulously painted with figures, animals, flowers, and all sorts of ornament.[3] Owing to the considerable number that have survived, lacquer paintings executed by artists trained in the Perso-European mode provide the principal evidence for the evolution of painting in the early eighteenth century.

LSD

- I -
Qur'an

Iran, late 16th–early 17th century
Opaque watercolor, gold, and ink on polished buff paper; gilt-stamped leather binding with filigree decoration.
Page 15 1/8 x 10 3/4 inches (38.4 x 27.3 cm) with 13 lines to a page; text 9 x 6 3/8 inches (22.8 x 16.2 cm).
Scripts: *Naskh* and *kufic*
THE METROPOLITAN MUSEUM OF ART, NEW YORK, GIFT OF HENRY G. MARQUAND, 1891, 91.26.14

From the beginning of the Islamic era (A.D. 622), calligraphy was considered the supreme art form of the Muslim world, since it was utilized to transcribe the word of God. Consequently, the principal focus of Muslim artisans' creativity became the invention of beautiful scripts and the embellishment of abstract illumination for Qur'ans. The Qur'an not only symbolized the triumph of the new faith, but represented political power as well. Sumptuous manuscript copies were commissioned by rulers and wealthy patrons for their libraries or as donations to shrines and mosques as a sign of piety and respect for religious authority.

By the late sixteenth century, the date of production of this manuscript of the Qur'an, the arts of the book had reached unprecedented heights of luxury and refinement, with illumination taking an equal position to calligraphy. This complete Qur'an still retains its original brown leather gilt-stamped binding.

The Qur'an commences with a lavish gold-ground medallion decorated with flowers including the title of the manuscript. The following double page contains elegantly illuminated frontispieces for the first sura, "Surat al-Fatihah" (illustrated) and the beginning of the second, "Surat al-Baqara." They are executed in blue, gold, and other colors. The text of the frontispieces – as is the case throughout the manuscript – is copied in *naskh* script reserved on a gold ground, in addition to the *kufic* used for the titles. The illuminated panels above and below and the border framing the text exhibit boldly delineated cartouches with pendants and reciprocal shield-shaped palmettes, respectively. The following chapters each exhibit illuminated headings and verse markers in the margins. The manuscript ends with another medallion.

LSD

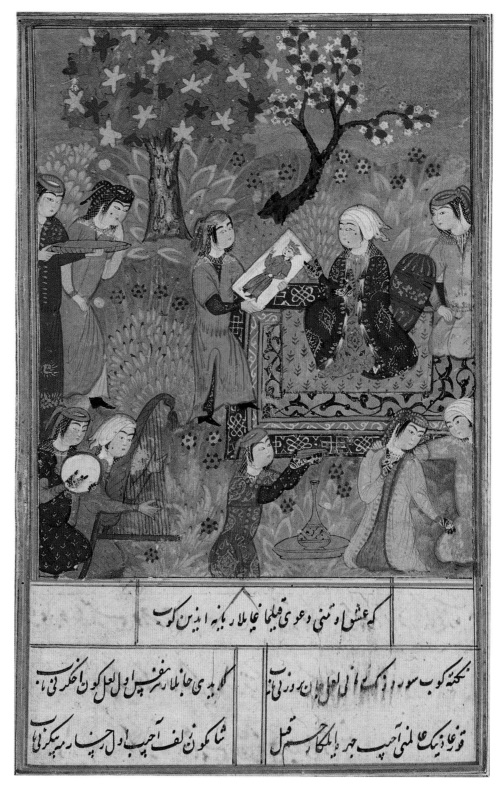

كه عشق او مني دعوى قيلما غايلار بابنه ايذبن كوب

بكمنه كوب سو هذكه الملل ان ورزيات كر بدى جانلار دفيش أو العل كون يا حكدرى بات

قوزعا دينك عللمنى آحيب جهر دايلكحار حسم قبل شاكون زلف آحيب او احيا رديكرناى

-2-

Shirin Examines Khusraw's Portrait

Artist unknown
Detached folio from a manuscript of the *Khamseh* of Nizami
Iran, late 15th century
Opaque watercolor, ink, mica and gold on paper, mounted on board; sheet 21 1/8 x 17 1/8 inches
(53.7 x 43.5 cm), image 4 1/2 x 3 11/16 inches (11.5 x 9.4 cm)
ARTHUR M. SACKLER GALLERY, SMITHSONIAN INSTITUTION; SMITHSONIAN UNRESTRICTED TRUST FUNDS, SMITHSONIAN
COLLECTION ACQUISITION PROGRAM, AND DR. ARTHUR M. SACKLER, S1986.140

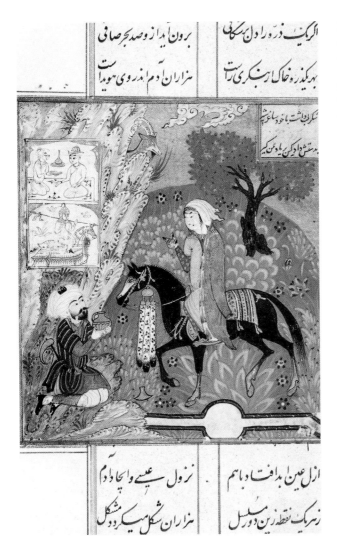

FIG. I. *Shirin Presents a Jug of Milk to Farhad.*
Artist unknown. Iran, late 15th–early 16th century. Opaque watercolor, ink, and gold on paper, $9^{11}/_{16}$ x $5^{11}/_{16}$ inches (24.7 x 14.5 cm).
ARTHUR M. SACKLER GALLERY, SMITHSONIAN INSTITUTION, S86.0179.

In the sixteenth century, painters and illuminators attained a status approximating that of calligraphers (although all were regarded as craftsmen). Traditionally, calligraphy had been considered a highly honored profession, but painting had not held an exalted position. According to both Shi'ite and Sunni commentaries on the Qur'an written after the second century of the Muslim era, the painter's art was blasphemous and painters were numbered among the sinners who would be punished on the Day of Judgment for usurping the creative role of God.[4] This injunction against painting was not applied consistently: if painting was not to be the handmaiden of religion as it was in Europe, figural imagery was often considered appropriate for palace decoration and for the illustration of nonreligious manuscripts, especially in the Iranian world. In the Safavid period figuration was accorded an increasing importance in the pantheon of the arts. Qazi Ahmad, the chief chronicler of the artistic life of sixteenth-century Safavid Iran, went so far as to equate the pens used by the calligrapher and by the painter.[5]

This illustration is executed in the style practised at the courts of the Turkoman rulers of western Iran (1380–1468). The image depicts the Christian princess Shirin of Armenia being offered a painting of her future lover, the Iranian king Khusraw, by one of her handmaidens. In this episode from Nizami's romance, Shirin falls passionately in love with the portrait itself and must be persuaded by the painter of the work, Shapur, that it is not a person, but only an image. This is one of a number of episodes from Nizami's text concerning painting and sculpture (see FIG. I). Nizami's text, written in the fourteenth century, and the subsequent popularity of this theme illustrate the slow upsurge in the acceptance of the art of painting in Iran.

LSD

Literature: Glenn D. Lowry and Milo Cleveland Beach, *An Annotated and Illustrated Checklist of the Vever Collection* (Seattle and London, 1988), 215.
Provenance: Henri Vever.

-3-

Royal Missive from Shah 'Abbas I to King Charles I of England

Iran, circa 1625–29
Ink on paper, *nastaʿlīq* script; 20³/₈ x 10⁷/₈ inches (51.8 x 27 cm)
COLLECTION OF PRINCE SADRUDDIN AGA KHAN, CALLIGRAPHY II

Written in fine *nastaʿlīq* script, this royal missive[6] issued by Shah 'Abbas I to King Charles I of England (r. 1625–49) belongs to a group of formal royal correspondences concerning commercial affairs exchanged between the two courts during the second and third decades of the seventeenth century.[7] It stands as testimony to Iran's prominent role in the flourishing silk trade with Europe at this time. Silk was one of the most important Persian exports to Europe, and Shah 'Abbas explicitly welcomed the English East India Company's interest in trade with Iran as a means of augmenting state revenues.

The parties of the missive are identified in both the opening of the letter, as well as in the seal on the back, as Charles, "the King of the Franks," and 'Abbas, "servant of the king of holiness." The correspondence of their reign dates confirms that the two parties are indeed King Charles I and Shah 'Abbas I.

In the opening of the missive, Shah 'Abbas showers King Charles with praise and diplomatic phrases of goodwill in florid Persian. The purpose of the letter was to ensure that Persian silk merchants would be granted the same favorable treatment when conducting business in England as English merchants had received in Persia. The words *ulfat* (amity) and *yigānigī* (union) are repeated several times in the missive, signifying Shah 'Abbas's desire to produce an atmosphere of diplomatic harmony between the two countries.

ME

Literature: Anthony Welch, *Prince Sadruddin Aga Khan Collection of Islamic Art*, vol. 2 (Geneva, 1972), Appendix; Welch 1973, 34, 66.

-4-
The Painter Riza 'Abbasi

Signed by Mu'in Musavvar
Isfahan, dated A.H. 1044 and 1084/A.D. 1635 and 1673
Opaque watercolor on paper; 7³/₈ x 4¹/₈ inches (18.8 x 10.4 cm)
MANUSCRIPT DIVISION, DEPARTMENT OF RARE BOOKS AND SPECIAL COLLECTIONS, PRINCETON UNIVERSITY LIBRARY,
PRINCETON, NEW JERSEY, GIFT OF ROBERT GARRETT, 1942

This well-known work by the leading exponent of the "Isfahan style" in the second half of the seventeenth century is a likeness of Mu'in's master, the celebrated artist Riza 'Abbasi. In a sensitive portrayal of old age, the artist is shown absorbed in his work, with a wizened face and eyes straining through a pince-nez. The serenity of a master at the height of his powers is skillfully conveyed by this elegant and restrained composition. Although Mu'in has attempted to render volume in the treatment of the figure, the handling of the red robe and tilted angle of books and papers conform to the flatness and stylization of the Persian manuscript mode of painting.

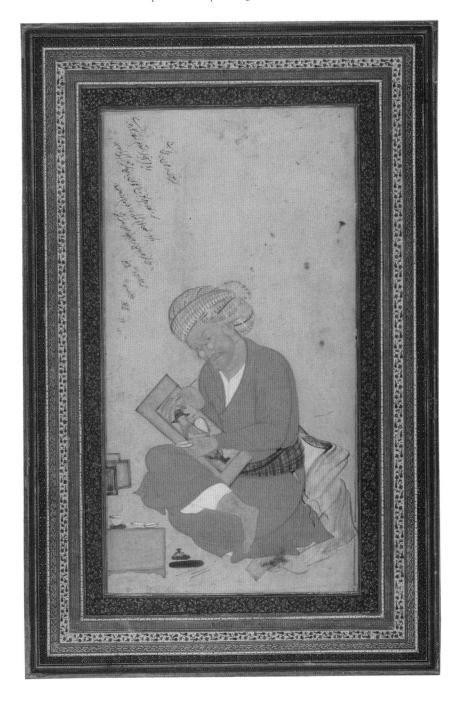

An inscription states that Mu'in embarked upon the work in 1635, that progress was interrupted by his master's death in the same year, and that Mu'in did not complete the painting until 1673. Although artists often kept unfinished compositions in their portfolios for later use, the practice is rarely as clearly documented as in this inscription. Portraits of artists are infrequently encountered in Persian art; such an honor was accorded to only the greatest masters. This commemorative portrait was probably executed for Mu'in's son, since it was he who urged Mu'in to complete the portrait, according to the inscription.

Mu'in executed another version of the same subject three years later, in 1676.[8] Subtle differences between the two versions include the image that Riza is shown painting. In the earlier version he paints a youth in European costume, in feathered hat, cape, and breeches, holding a large ceramic jar of a type used for refreshments or wine. The later example depicts an elderly man in Persian dress.

European subjects depicting figures drinking wine accompanied by dogs or engaged in amorous pursuits were a popular feature of Isfahan painting and eloquently reflect the mutual curiosity of Persians and Europeans living in Isfahan in this period. A. B. Sakisian has identified a similar figure as a Portuguese page and has suggested that the popularity of this theme was connected with the successful siege in 1622 of the Iranian port of Hormuz, a Portuguese stronghold, by the forces of Shah 'Abbas I.[9] Although Sakisian may be correct regarding the initial context of such images, they may be better understood as a generic type for foreigners in response to the continued presence of Europeans of many nationalities living in the capital.

Anthony Welch has made an intriguing suggestion that a comparable portrait of a European youth (Prince Sadruddin Aga Khan Collection), executed by Mu'in in 1673, is evidence of a lost original of the same subject by Riza.[10]

This painting, by virtue of its blend of traditional style, direct observation, and indirect reference to European subject matter, conveys the emergence of new artistic traditions, patronage, and subject matter after the mid-1630s.

LSD

Literature: B. W. Robinson, "A Survey of Persian Painting (1350–1896)," in *Art et société dans le monde iranien*, Institut Français d'Iranologie de Téhéran Bibliothèque Iranienne no. 26 (Paris, 1982), 68 (cited in Robinson 1993, 56), fig. 36; Massumeh Farhad, "Safavid Single Page Painting, 1629–1666," Ph.D. dissertation, Harvard University, Cambridge, Massachusetts, 1987, 325–26, no. 53 (ill.) (for complete bibliographical references); Ferrier 1989, fig. 40; Soudavar 1992, 134, fig. 45.

Provenance: Bernard Quaritch.

Inscriptions: In *shikasteh* script, upper left-hand corner: *Shabih-i ghufrān va riżvān ārā makān, marhūm-i maghfūr ustādam Riżā Muṣavvar 'Abbās, mashhūr bih Riżā 'Abbāsī — Aṣghar bih tārīkh-i shahr shavāl bih iqbāl sanah 1044 Ābrang gardīdeh būd kih dar shahr-i Zu'lqa'deh al-Ḥarām mazkūr az dār fanā bih 'ālam baqā riḥlat nimūd, īn shabih bād az chihil sāl dar chihārdahum-i shahr Ramażān al-Mubārak sanah 1084 ḥasb farmūdeh farzandī-yi Muḥammad Naṣīrā bih itmām risanīdeh, Mūin Muṣavvar, Ghafr 'anhū zunūbah.*

-5-

Manuscript of a "Khamseh" of Nizami

Copied by Wahabi Sajavandi
Text: Central Asia, Andhizan, dated shahr-i Sha'ban al-mubarak 2, A.H. 1005/March 21, A.D. 1597;
binding and illustrations: Isfahan, mid-17th century
Manuscript: Opaque watercolor, ink, and gold on paper;
binding: pasteboard, opaque watercolor and gold under lacquer, with French engravings by
François Mazot (French, active mid–late 17th century);
42³/₁₆ x 10 ¹³/₁₆ x 1¹/₂ inches
(107. 2 x 27.5 x 3.8 cm)
HYDROCARBON LOGISTICS

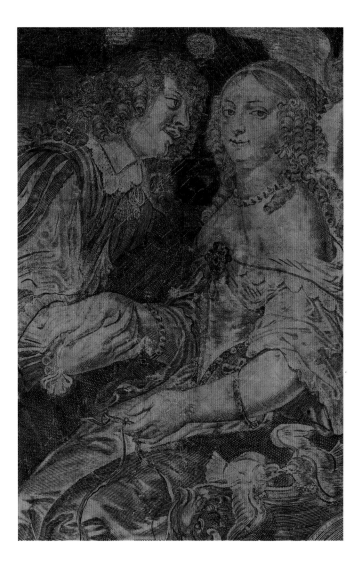

Although in Europe prints represented a cheaper form of imagery than oil paintings or watercolors, they acquired inordinate value as a trade item abroad. The gifts brought to Iran by a French diplomatic mission in May 1665 included a group of portrait prints of Louis XIV by the court painter Robert Nanteuil (1623–1678). The author of the account of the mission's trip recorded with amusement the avid interest aroused by the prints among Persian officials in Erzerum, at the frontier of Persia and Turkey, noting that, in spite of the reputed aversion of Muslims for portraiture and the Qur'anic prohibition against imagery, the customs agents commandeered almost every one of the prints for themselves and the local governor.[11] Prints also provided a practical and plentiful source of new imagery and played a decisive role in the formulation and widespread application of the Perso-European mode of decoration.

This manuscript, copied in the late sixteenth century by a Central Asian scribe, is included here primarily for its binding, which was most likely added, along with the illustrations, in Isfahan in the mid- to late seventeenth century. While the manuscript's illustrations are executed in the style of Riza 'Abbasi's followers, the upper and lower covers of the binding are decorated with two engraved scenes of amorous couples – signed by the French engraver and editor, François Mazot, a contemporary of Nanteuil – within a painted floral border. The eclectic pairing of European and Persian modes is a distinctive feature of Isfahani art and architectural decoration in the later seventeenth century.

At that time sixteenth-century manuscripts such as the 1539–43 *Khamseh* were refurbished and seventeenth-century manuscripts were illustrated by artists working in different styles (for instance, the Cochran *Shāhnāmeh*, dated A.H. 1104–9/A.D. 1693–98 [The Metropolitan Museum of Art, New York, 13.228.17]). The floral border with garlands of roses and large green blooms seen here is typically found on other works of the late seventeenth century.[12] To a European, such images of amorous couples functioned as allegories of Love and Fidelity. Although images often lose their meaning when transferred

FIG. II. *Amorous Couple.* Artist unknown. Isfahan, House of the Merchant Sukias, New Julfa, mid–late 17th century. Oil paint on plaster.

from one culture to another, allegories of Love were common in Persian painting and poetry. It may not be too far-fetched to suggest not only that such images were prized for their exoticism, but also that a measure of their original meaning found resonance among Persian collectors and artists.

 While the use of prints as source material for the compositions of Perso-European painters is well known, it is rare to find the original print directly transferred to a binding.[13] Furthermore, while most print sources have been identified as Dutch, this example documents the use of French prints by Isfahan artists. Perhaps more significantly, this binding provides for the first time conclusive evidence that such engravings were also copied for life-size paintings. This print was among the models used by the painters of the house of the Armenian merchant Sukias in New Julfa, where it is exactly replicated in the mural decoration of the principal reception room off the columned porch (FIG. II).

<div align="right">

LSD

</div>

Literature: *Fine Oriental Miniatures, Manuscripts and Persian Lacquer, part 2*, sale cat., Sotheby's, November 23, 1976, 45–46, lot 405; *Oriental Manuscripts and Miniatures . . .*, sale cat. , Sotheby's, October 19, 1994, 92–93, lot 115; Diba 1994, no. 90.
Inscriptions: Upper cover, bottom: *Saiellence*
Lower cover, bottom: *attouchement feminin*
Lower cover, corner quadrant, lower right: *Fr[ançois)]Mazot excudit cum privilegio*

<div align="center">

-6-
Presumed Portrait of Louis XIV in Armor

Signed by 'Ali Quli Bayg Jabbadar
Isfahan, circa 1660–90
Image: Opaque watercolor and gold on paper;
margins: opaque watercolors and gold-sprinkling on paper. Image 4¹³⁄₁₆ x 2¹³⁄₁₆ inches (12.2 x 7.1 cm)
MUSÉE NATIONAL DES ARTS ASIATIQUES-GUIMET, PARIS, MA2478

</div>

'Ali Quli, skilled in both watercolor and lacquer painting, was active in Isfahan during the reigns of Shah 'Abbas II, Shah Sulayman, and Sultan Husayn (1642–1716). 'Ali Quli was also among the most talented interpreters of European subjects. According to eighteenth-century Persian sources, he was of European origin,[14] but aspects of his works and biography still leave some uncertainty about his religious background and artistic training.

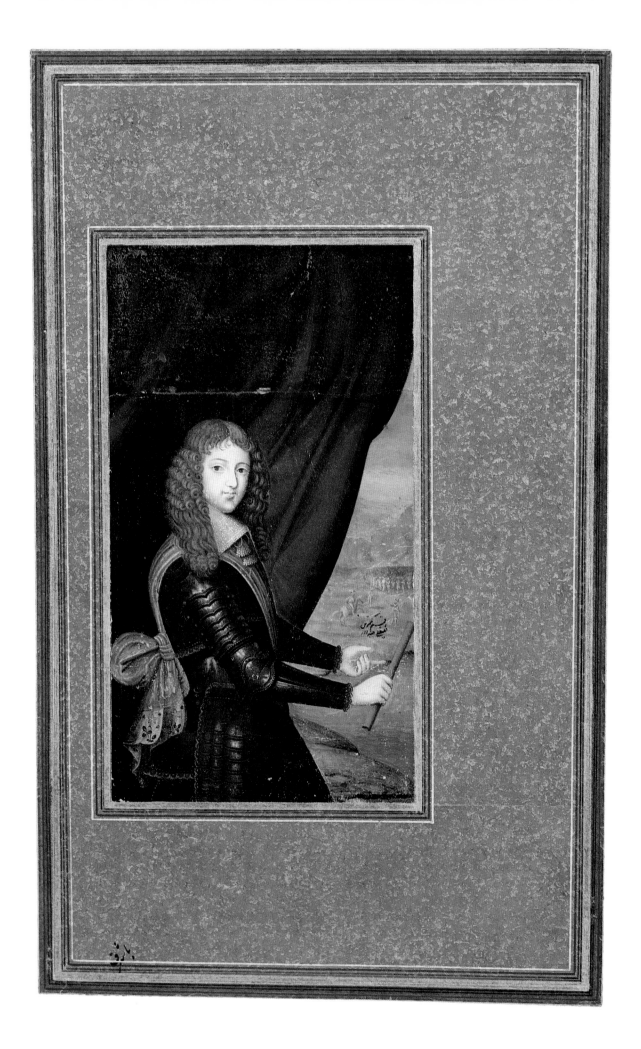

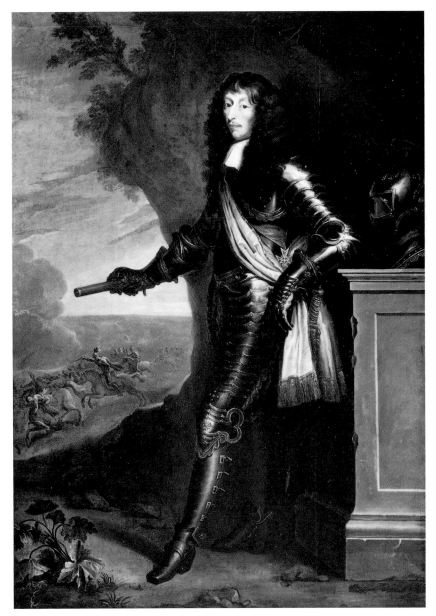

FIG. III. *Portrait of Louis III Bourbon, the Prince de Condé.*
Justus Van Egmont (Dutch, 1601–1674). Circa 1650.
Oil on canvas, 74³/₈ x 58¹/₄ inches (189 x 148 cm).
MUSÉE NATIONAL DE VERSAILLES ET DES TRIANONS, MV 3478.

This work illustrates how European paintings were adapted to appeal to Persian taste. Painters were rewarded for their skill at making copies, and a request for replication was a frequent test of the expertise of the artist as well as of the connoisseurship of the patron.

A young European prince or ruler, silhouetted against a deep green curtain, occupies the foreground of the painting. The figure is splendidly arrayed in a mid-seventeenth-century suit of armor enlivened by a delicate starched lawn collar and exquisite gold brocade sash. He carries a field marshal's baton in one hand, and with the other, invites the viewer to discover a distant landscape in which a military review takes place. The troops, ranged behind a lake, are rendered in minute scale and grisaille technique. Massed gray clouds and red-streaked skies complete the scene.

The use of aerial perspective in conjunction with the dark foreground as a repoussoir, cast light reflecting from the figure's armor, and treatment of the background figures evidence 'Ali Quli's understanding of European painting technique. For those familiar with Persian painting traditions, the dark palette, facial modeling, and delicate pastels of the landscape were fascinating innovations.

Nevertheless, costume details such as the gauze sash with a delicate gold border and purple flowers – known from both Safavid and Mughal textile production – allude to Isfahan fashion, and colors such the purple hue of the baton (in place of the plain wooden baton of European prototypes) and the dark green of the curtain – most likely the hue known as *nafti*[15] – are both associated with the Isfahani palette of the seventeenth century.

Intriguing questions are raised concerning the identity of the sitter and the European source. Both the prince de Condé (1621–1666) and the young Louis XIV (1638–1715) have been proposed as the subject of this image.[16] Both identifications are plausible since portraits in oil, prints and enamels, battle scenes, and countless decorative items were used as incentives by the European representatives – first the English and Dutch, and later the French – in their rivalry for the Persian silk trade. Such images conveyed European military power and wealth and even served as guarantors of the ruler's good faith in diplomatic negotiations.[17]

'Ali Quli could have based this image on oil portraits or engravings of Louis XIV by Pierre Mignard and other court painters, whose works were available in Isfahan in the decades of the 1660s–1680s. A letter of 1688 from the bishop of Babylon (residing in Hamadan in western Iran) mentions Persian visitors' fascination with a portrait of Louis XIV in armor, "so different from their Sardanapalus [Shah Sulayman]."[18] Although the young prince's features resemble those of the known portraits of Louis XIV as a youth, the composition is more closely based on the iconography of portraits of the prince de Condé, Louis's older cousin celebrated for his military prowess.

In either case, the subject's attributes were sufficiently altered by 'Ali Quli that precise identification is difficult. This portrait is probably another generic image of a European similar to the ubiquitous pages of Riza 'Abbasi and his followers, which 'Ali Quli could have based on portraits of either personage.

Both Dutch and French engravings have been proposed as prototypes for this work, yet the rendering of the light on the armor, the composition, and the coloring cannot be accounted for solely by a black-and-white print. Although 'Ali Quli may have been taught coloring by local missionaries or European painters living in Isfahan, it is intriguing to consider that he may have worked from a European oil-on-canvas original such as the one described by the bishop of Babylon. An extant portrait of the prince de Condé by the Dutch painter Justus Van Egmont (1601–1674), executed in the 1650s (FIG. III), provides a remarkably close parallel for 'Ali Quli's composition. Since at least six replicas of this painting were distributed to various courts in Europe, it is not inconceivable that a version of this portrait may have been sent to Isfahan as well.

This image conveys a dual message. On the surface, it is a portrait of Shah 'Abbas II's fellow ruler, Louis XIV, in whose features the shah had shown some interest.[19] On a deeper level, this composite image reflects the Safavid rulers' interest in modernizing their army and equipment. In addition to being a court painter, 'Ali Quli also held the post of Keeper of the Arsenal. The image of the ruler in armor may be taken as a visual pun intended to instruct as well as to amuse 'Ali Quli's royal patron.

The convention of a subject posed before a curtain opening onto a distant landscape, first utilized by 'Ali Quli in the mid-seventeenth century, was originally devised for sixteenth-century European state portraiture. It was also extremely popular in Iran and, once introduced, became the predominant mode of representation.

LSD

Literature: Martin 1912, vol. 1, pl. 172; *Collection Sevadjian*, sale cat., Hôtel Drouot, November 23, 1960, no. 92; A. Ivanov, "Kalamdan with a Portrait of a Young Man in Armor," *Reports of the State Hermitage Museum* 39 (1974): 56–59 (ill.), with bibliography of all earlier literature; Andrée Busson, "Note sur une miniature moghole d'influence européene," *Arts Asiatiques* 34 (1978):133–38; *From Beijing to Versailles: Artistic Relations between China and France*, exh. cat., Hong Kong Museum of Art and the Musée National des Arts Asiatiques-Guimet, Paris (Hong Kong, 1997), 173, no. 57.
Provenance: Collection Sevadjian.
Inscriptions: In *nasta'liq* script, right center: *raqam-i kamtarin 'Ali Quli Jubbehdār*

-7-
Penbox with Presumed Portrait of King Louis XIV

Iran, late 17th–early 18th century
Pasteboard, opaque watercolor and gold, under lacquer; 1 1/2 x 9 3/16 x 1 9/16 inches (3.8 x 23.3 x .4 cm)
STATE HERMITAGE MUSEUM, SAINT PETERSBURG, VR-125

This pasteboard penbox (*qalamdān*) with a sliding inner section holding an inkwell, quills (*qalams*), and instruments for quill-sharpening probably came into existence after 1650. Both the form and support continued for more than two centuries.

On the top of the penbox is a portrait of a youth in European armor. Early in this century, scholars learned of the existence of a miniature depicting a similar young man (NO. 6), then in F. R. Martin's collection. The miniature bears an attribution with the name of 'Ali Quli Bayg Jabbadar, but it differs from the painter's authentic signatures on the Saint Petersburg Muraqqa' (NO. 11).

An analysis of the costume and the hairstyle of the character in the portrait gives reason to believe that the original portrait was painted in 1645–50, but the prototype of this miniature has yet to be found. French engravings of Louis XIV do not bear a great deal of resemblance to the character in the miniature, but they usually show the king at an older age.

A greater resemblance can be found, however, in Dutch engravings of Louis XIV's portrait (such as F. Bouttats's engraving of Louis XIV as a young man at the State Hermitage Museum, Saint Petersburg), and it is very likely that such an engraving served as the prototype both for the portrait on the *qalamdān* and for the miniature. The authorship of 'Ali Quli Bayg is probable, though not firmly established.

It is also very likely that the miniature on paper was trimmed and glued on the *qalamdān*. Exactly when the penbox was made is not known.[20] In this writer's opinion, it was made from the late seventeenth to early eighteenth century, when the object was painted. Penboxes of that time usually have floral ornamentation on the side surfaces, whereas in the nineteenth century, portraits were painted on the lids and side surfaces.

AAI

Literature: A. Ivanov, "Kalamdan with a Portrait of a Young Man in Armor," *Reports of the State Hermitage Museum* 39 (1974): 56–59 (with bibliography of all earlier literature); *Islam: Art and Culture*, exh. cat., Statens Historische Museum (Stockholm, 1985), 150, no. 19; V. Lukonin and A. Ivanov, *L'art persan* (Bournemouth and Saint Petersburg, 1995), no. 240; Adamova 1996, 250–51, no. 38.
Provenance: Purchased in 1924, from the Museum of the Baron A. N. Stieglitz School of Technical Drawing.

-8-
Woman by a Fountain

Signed by 'Ali Quli Bayg Jabbadar
Isfahan, circa 1650–60
Opaque watercolor on paper; image 12 5/8 x 8 1/16 inches (32 x 20.5 cm), sheet 21 1/2 x 17 1/2 inches (54.6 x 44.4 cm)
THE ART AND HISTORY TRUST, COURTESY THE ARTHUR M. SACKLER GALLERY, SMITHSONIAN INSTITUTION,
LTS 1995.2.118

Wealthy connoisseurs of the late Safavid period enjoyed perusing albums with images of contemporary celebrities and beautiful women such as *Woman by a Fountain*. In 1664 the French jeweler Jean-Baptiste Tavernier described examining an album and two life-size oil paintings of European courtesans with Shah 'Abbas II. When the ruler questioned the jewel merchant on his criteria for female beauty, Tavernier responded that beauty was relative, citing as examples the Persian aesthetic ideal of joined arched eyebrows in contrast with the French fashion of tweezing the eyebrows into a fine line.[21] To judge by the features of this painting by 'Ali Quli Jabbadar, the attractions of European women were already sufficiently appreciated by Isfahan patrons.

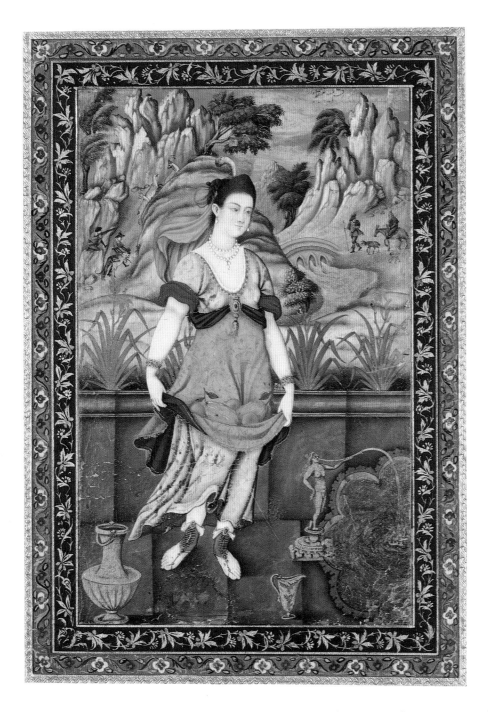

While Tavernier emphasized the aesthetic nature of the shah's interest, other visitors recorded a taste for overtly erotic paintings.[22] This allegorical figure suggestively holds up her garment to present ripe fruits. By virtue of its ambiguity, this image is emblematic of the interest in European exotica, particularly female, in Iranian court circles. *Woman by a Fountain* is the prototype for numerous such elegant representations in early nineteenth-century Qajar painting. In an ironic reversal, this work also presages nineteenth-century orientalist visions of Middle Eastern women by such artists as Jean-Léon Gérôme (1824–1904).

Such hybrid images were produced for both Mughal and Persian patrons in the sixteenth and seventeenth centuries. The genre of beautiful women with attributes suggesting fertility and abundance was common to both European and Indo-Persian Mughal and Persian painting traditions. Although the precise source of this composition remains to be identified, 'Ali Quli drew upon late sixteenth-century European prints of female allegorical subjects by Dutch engravers such as Otto Vaenius, Marco and Aegidius Sadeler, Crispin de Passe, and Martin de Vos. These prints were mined for the foreground beauty's classical costume, tiara, fountain, and precious ewers.[23] The genre of languid beauties in landscapes by followers of Riza 'Abbasi provided the Persian prototypes for her swaying posture, yet the theme of a

woman in allegorical garb also mirrors contemporary European conventions depicting ladies of the nobility in the guise of virtues such as Prudence and Charity.

This work also exhibits close affinities with an unsigned Mughal painting based on Dutch print sources executed some fifty years earlier. The painting – a detached folio from an album compiled for the Mughal emperor Jahangir (r. 1605–27) (Library of the Gulistan Palace), is one of a number of such figures utilized for margin decorations and independent compositions.[24] The complex allegorical allusions of the European model have been lost, as can be seen by the Persian verses above and below the image that identify her as a typical Persian beauty.

'Ali Quli may have utilized a print source to create this image, although it seems highly probable that he copied the Mughal version, as he did in a number of other cases.[25] The features and figural proportions of 'Ali Quli's women appear more refined and delicate than those of his contemporary Muhammad Zaman. The explanation may lie in the fact that Muhammad Zaman used mid-seventeenth-century Dutch prototypes, whereas 'Ali Quli based his figures on elegant early sixteenth-century Mughal paintings.

This work was probably executed early in the artist's career. The delicate shading of rocky hillocks based on sixteenth- and seventeenth-century Mughal and Deccani prototypes supports a dating of circa 1650–60, since 'Ali Quli's paintings of the 1670s onward exhibit a more atmospheric and consistent treatment of the landscape elements.[26]

The dating given here is supported by stylistic affinities with other signed works of the 1650s and 1660: those already noted by Abolala Soudavar, as well as a watercolor copy of Aegidius Sadeler's *Landscape with a Dutch Mill*, engraved by Roelandt Savary, dated A.H. 1059/A.D. 1669, which exhibits irises on the balustrade and similar vignettes of figures in European costume.[27] The work has not previously been attributed to 'Ali Quli, despite obvious similarities with his signed works, because the inscription identifies the artist as the son of a Muslim, thus contradicting eighteenth-century Persian biographical sources asserting that 'Ali Quli was a foreign artist who converted to Islam. These seeming discrepancies can be resolved if we consider that 'Ali Quli was a Muslim of Eastern European origin.

Despite the eclecticism of its sources, this is one of the more successful images in the Perso-European mode, owing to the delicate color scheme, the elegance of the figure, and the skillful rendering of jewelry and costume. Such imagery was not limited to albums for private delectation. A version of this figure is found on a velvet panel, one of three fragments (Cooper-Hewitt National Design Museum, Smithsonian Institution 1977-119-1) of the same period, depicting two pairs of female allegorical figures, and the Safavid palace of Ashraf was embellished with mural paintings of Diana with her nymphs.[28]

LSD

Literature: *Highly Important Oriental Manuscripts and Miniatures . . . of the Kevorkian Foundation*, sale cat., Sotheby's, December 6, 1967, lot 89; Welch 1973, no. 74; London 1976, 83, no. 61; Soudavar 1992, 370, fig. 148.
Provenance: Edwin Binney III Collection
Inscriptions: In *nasta'liq* script, upper right-hand corner: *raqam-i kamineh 'Ali Quli Jabbādār*

-9-

Penbox Depicting a Visit of a Prince to a Wise Man

Signed by Muhammad Zaman
Isfahan, dated A.H. 1084/A.D. 1673–74
Pasteboard, opaque watercolor and gold under lacquer; 2 x 9⅝ x 1½ inches (5 x 24.5 x 3.8 cm)
PRIVATE COLLECTION

Muhammad Zaman was probably the most prolific painter working in the Perso-European mode, and the one whose career and works are best documented. Much ink has been spilled over the career of this artist, particularly regarding the question of his reputed voyage to Italy.[29] It is known that he flourished from about 1671 to 1700 and numbered Shah Sulayman among his principal patrons. During the late 1670s and 1680s, Zaman executed exquisitely finished copies of Netherlandish

prints for royal albums. Zaman refurbished and added illustrations to two sixteenth-century manuscripts in the royal library in 1676. The hybrid style that he developed for royal commissions was applied by Zaman, his family, and pupils to the illustration of a *Khamseh* (Morgan Library, New York, 469) and a *Shāhnāmeh* (Nasser D. Khalili Collection of Islamic Art, London) for nonroyal patrons. The largest corpus of his work, as is the case with that of 'Ali Quli, may be found in an album in Saint Petersburg (see NO. 11).

This signed and dated penbox of the squared type, the most significant example of Zaman's work in lacquer form, is a document of critical importance for the patronage and evolution of this medium in the seventeenth century. The rim of the lid is painted with cartouches bearing an inscription in gold *nastàliq* script, alternating with roundels on a black ground. The poetic inscription informs us that this object – *davāt u qalam* (inkwell and pen) – was commissioned by Shah Sulayman himself and gives the date, deduced by counting the numerical equivalents of the letters, according to the *abjad* counting system.

Detail of signature and date, NO. 9

The penbox is embellished with a scene of a prince visiting a sage on the top; landscape and architecture scenes on the sides; and a hunting scene on the interior lid. The entire decorative scheme is rendered with a genuine delicacy of style and an evident mastery of the elements of "realistic" landscape: dark trees with bulbous roots and scattered stumps that act as repoussoirs; fields and trees that recede to a distant mountainous vista; ships with small figures that are moored at the shore to the right; and a cloud-streaked sky with birds in flight. To the right, the young seafaring prince and his attendants consult a sage seated in front of a cave with prayer beads in hand. Attendants and a rearing horse in the background draw the eye deep into the picture plane. Foliage and vegetation are rendered with painterly, almost impressionistic, brushstrokes. Indeed, the penbox evokes an arcadian atmosphere with its romantic mood, poetic treatment, and evocative use of ruins in the landscape background.

The decade of 1670–80 was decisive for the triumph of the Perso-European style at court, through the efforts of Zaman, 'Ali Quli, and their followers. Given that Muhammad Zaman's lacquer commissions preceded his extant major manuscript projects, his talent as a lacquerwork painter appears to have been instrumental in his success – underlining the importance of lacquerwork as a court art and its role in the introduction of the new mode.

A comparison of Muhammad Zaman's manuscript illustration with his lacquerwork demonstrates the appeal and advantages of the latter medium. In the tradition of the finest Persian lacquerwork, Muhammad Zaman's penbox retains the appeal of the "miniature" with its small-scale yet complex figural compositions, while the lacquer varnish clearly enhances its atmospheric and poetic qualities.

Fittingly, Zaman chose to illustrate the penbox, which holds tools for learning and knowledge, with a scene of a prince conversing with an elderly sage. Similar scenes in manuscripts of Nizami's *Khamseh* or Jami's *Haft Awrang* often depict the Greek ruler Alexander and his search for wisdom. Seventeenth-century royal Mughal portraiture frequently showed rulers seeking counsel from sufis and shaykhs.[30] Since the young prince here is shown wearing a turban wound in the Indian style, one may argue that Zaman was drawing on both royal Mughal and Persian artistic traditions. Additionally, in his inscription, Zaman includes a flattering reference to Shah Sulayman as the Solomon of the Age and cleverly links his own name with that of the ruler.

Muhammad Zaman's mastery of European painting principles was unprecedented in Persian painting: indeed, the subsequent evolution of this type of painting in the eighteenth century clearly showed an increasing standardization and simplification of the components of his style.

LSD

Literature: Soudavar 1992, 377, fig. 51; Diba 1994, 587–88, no. 65 (for complete bibiliographical reference). Inscriptions: In gold *nastáliq* script; within rectangular cartouches along the rim of the penbox lid: *Shāhanshāh-i 'ālām "Sulaymān-i" Sāni kih nāmash dahad rutbeh lawḥ u qalam rā; falak qadr-i shāhi kih dādast sha'nash bih khurshīd az ṣubḥ-i ṣādiq 'ilm rā; bih daf ʿadv zu'lfiqār-i vilāyat bih shamshīr-i 'adlash sipurdeh ast dam rā; bih farmānash īn bandeh-i bibiẓā'at chu kardam īn davāt u qalam rā; raqam zad pay-i sāl tārikh-i "tābi'" "bih amr-i Sulaymān," "zamān" zad "raqam rā."* (To the King of Kings of the world, Sulayman the Second/Whose name gives value to the tablet and pen/His royal aura is so great/that like the sun he gives light to the morning/He gave justice to the sword which defeats the enemies of Shi'ites/On his orders, this poor slave/Since I produced this inkwell and pen [holder]/I signed and dated it accordingly/On the order of Sulayman of the Age [both Shah Sulayman and the legendary Solomon] I [Zamān] signed this.)

-10-
Majnun Visited by His Father

Signed by Muhammad Zaman
Folio intended for the Shah Tahmasp *Khamseh* of Nizami
Ashraf, Mazandaran, dated A.H. 1086/A.D. 1676
Opaque watercolor and gold on paper; sheet 27^1/$_2$ x 21^1/$_2$ inches (69.8 x 54.6 cm)
THE ART AND HISTORY TRUST, COURTESY THE ARTHUR M. SACKLER GALLERY, SMITHSONIAN INSTITUTION,
LTS 1995.2.120

This watercolor exemplifies the adoption of the Perso-European style for illustrated manuscripts. *Majnun Visited by His Father* is one of four illustrations intended for the 1539–43 *Khamseh* (British Library, OR2265)[31] that boldly announces the conventions of the new style: the use of cast light for night scenes, single-point perspective and gray shading for architectural elements, figures seen from the back used as repoussoirs, heavily modeled faces and figures, and a new landscape vocabulary. The revolutionary nature of Zaman's achievement is apparent when these works are compared with Aqa Mirak's rendering in the Shah Tahmasp *Khamseh* of *Majnun in the Desert* (British Library, OR22655, folio 166 recto), which follows classical Persian conventions in its high horizon, golden skies and eternal springtime scene, and completely flattened picture plane.

In contrast, Zaman created a sense of space and time. He must have delighted his patron with the two imposing camels at rest delineating the foreground. In a device used to advantage in the positioning of the page in his illustration of the same year, *Bahram Gur and the Princess of the Black Pavilion* (British Library, OR22655, folio 221b), Majnun, his elderly father, and two attendants are shown smaller in scale and firmly positioned at the far right of the middle ground. The desolation of the desert and the unhappy fate of the melancholy lover are evoked by the withered trees, autumn leaves, and romantic ruined arches visible in the distance. The blue sky, no longer rendered by the illuminator's gold, is streaked with heavy clouds.

Some of the elements of Zaman's design of the penbox (NO. 9) – the principal figural group (in reverse), the rocky hillsides, tree types, crumbling arches and gateways with classical columns and capitals – have been skillfully adapted here to a vertical format. Many of these devices would be reused in other of Zaman's paintings, along with the scene of horsemen galloping toward a bridge on the penbox's interior lid.

The work of Zaman represents the most faithful adaptation of European conventions to Persian painting before the late nineteenth century. Given the lifelike Persian aesthetic ideal, Zaman's innovations earned him a place among the first rank of Persian masters, along with Mani and Bihzad. (Even Zaman was not infallible, however, as can be seen by the disproportionately small head of the camel driver and the missing left foot of Majnun.) Zaman himself could not resist a small pun: in a complete departure from Nizami's text, a little white puppy rests in the middle ground, one of his paws pointing to Zaman's inscription. It is tempting to suggest that this puppy, the visual equivalent of the deprecating epithet of "dog of the threshold," may represent the artist himself.

LSD

Literature: *Important Western and Oriental Manuscripts and Miniatures*, sale cat., Sotheby's, July 11, 1966, lot 31; Welch 1973, no. 71; London 1976, 83, no. 60; Robinson 1993, 59, fig. 38; Soudavar 1992, 374, fig. 151.
Provenance: Edwin Binney III Collection
Inscriptions: In *nastāliq* script, left center: *dar balādeh-i Ashraf bih raqam-i kamtarīn-i bandigān itmām yaft, Muḥammad Zamān* 1086

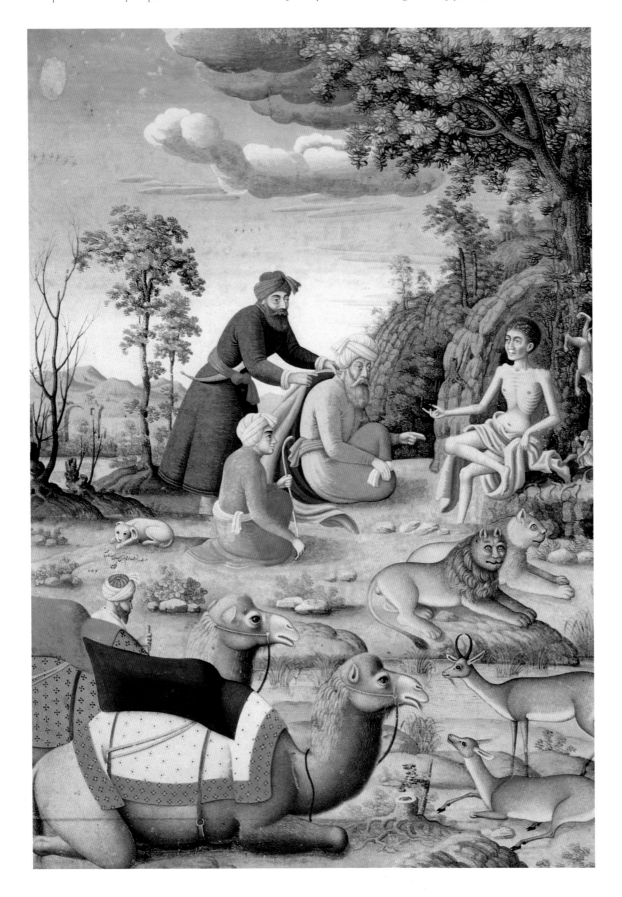

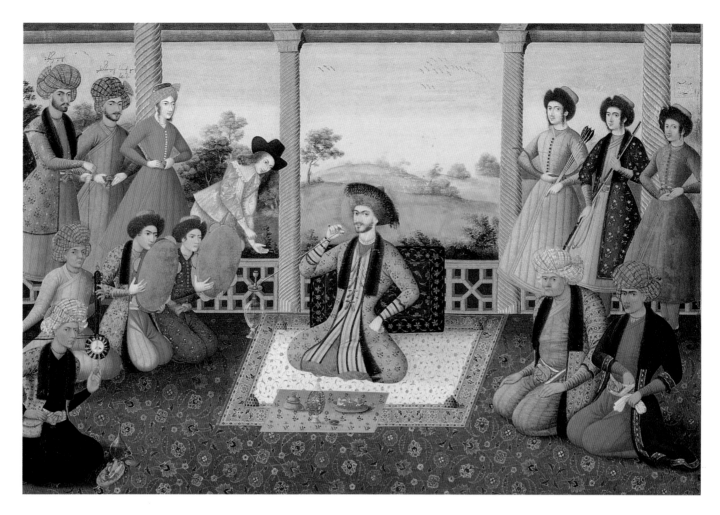

-11-
The Shah and His Courtiers

'Ali Quli Jabbadar
Folio 98a from an Album of Painting and Calligraphy
Isfahan, circa 1660s or 1670s
Opaque watercolor, silver and gold on paper; 11¹/₁₆ x 16⁵/₈ inches (28.2 x 42.1 cm)
THE SAINT PETERSBURG BRANCH OF THE INSTITUTE OF ORIENTAL STUDIES, RUSSIAN ACADEMY OF SCIENCES, E14

This painting depicts a young Safavid shah (probably Sulayman, r. 1666–94), sitting on the terrace of a palace pavilion with his favorite courtiers and musicians. The complex ceremonial composition conveys a certain constraint and tension. Distinctive characteristics of the artist's style can be discerned: slender figures of young men with unnaturally narrow waists and elongated faces; minute, realistic detail in the individual features, especially those of the aged dignitaries (possibly eunuchs); the massive tapering cloth headgear (*kulah*); the treatment of multicolored leaves and vegetation; and the clouds in the sky and hazy rolling hills in the background. The shah's head is encircled with a golden nimbus, a detail commonly used by contemporary Indian artists in depicting royal figures. It is known that the painter of this miniature occasionally copied miniatures by artists of the Mughal school of the seventeenth century. Above the heads of a group of courtiers standing to the left of the shah are two illegible inscriptions, using letters from the Georgian alphabet.

According to the inscription, the artist of this work is 'Ali Quli Jabbadar (see also NOS. 6–8). He apparently had a long and extremely fruitful career: his earliest extant work is dated A.H. 1068/A.D. 1657–58 and is a copy of the miniature *Majnun in the Desert*, originally the work of the Indian painter Govardhan, and his last surviving work, *Portrait of the Russian Ambassador*, is dated A.H. 1120/A.D. 1716–17.

It is likely that the main body of the Saint Petersburg Muraqqa', the album to which this painting belongs, was assembled in Iran sometime after 1739, followed by years of sporadic work. From the dated inscriptions on both binding covers, as well as those on the margins and frames of

the ninety-eight cardboard folios of the album, it is clear that in 1734–35 a very influential person named Mirza Mihdi commissioned a massive binding (20¼ by 13⅝ inches) for an album of his collection of miniatures and calligraphy and in 1738–39 the binding was finished. In 1747 work was started on designing the album as a whole. It was assembled and decorated with illuminated margins and frames before the end of the 1750s.

At least four masters of illumination were engaged in this work, three of whom (Muhammad Hadi, Muhammad Baqir, and Muhammad Sadiq) left their signatures with dates. Muhammad Hadi began work later than the other two. The margins of sixteen miniatures in the album are executed in a different style and cannot be regarded as the work of the aforementioned masters.

The decoration of the album was never completed. It can be assumed that it was interrupted abruptly, literally on a brushstroke (see folio 58 verso: frame drawn by Muhammad Baqir), and it appears that it was never resumed.

Most of the miniatures (more than 120) of the album in its present state were painted in India. They all are dated from between the end of the sixteenth century and the 1730s, and the vast majority are of the Mughal school.

The Deccan school is represented by two miniatures (folios 1 and 2 recto). The latter bears an attribution to Husayn Farrukh Bayg. There are thirty-three Persian miniatures, mainly painted between 1670 and the early eighteenth century, by artists of the Isfahan school. These painters are Muhammad Zaman ibn Haji Yusuf Qumi; 'Ali Quli Jabbadar; Haji Muhammad Ibrahim ibn Haji Yusuf Qumi; Muhammad Riza-yi Hindi; Muhammad Baqir; and Muhammad Sultani.

The reverse sides of ninety-seven of the ninety-eight cardboard folios contain between one and five samples of calligraphy, written by the great Persian master 'Imad al-Mulk Muhammad ibn Ibrahim al-Hasan al-Sayf al-Qazvin (1553–1615), known as Mir 'Imad. A total of 195 such samples are represented in the album, of which 16 are full-folio writing specimens, and 34 are exercise samples, including 25 in full folio.

OFA

Literature: Ivanov, Grek, and Akimushkin 1962; O. F. Akimushkin, *The St. Petersburg Muraqqa. Album of Indian and Persian Miniatures of the 16th–18th Centuries and Specimens of Persian Calligraphy of 'Imad al-Hasani* (Milan, 1994); *De Bagdad à Ispahan. Manuscrits islamiques de la Filiale de Saint-Pétersbourg de l'Institute d'Etudes orientales, Académie des Sciences de Russie*, exh. cat., Musée du Petit Palais (Paris and Lugano, 1995), 246–55, no. 52; M. C. Beach, "Characteristics of the St. Petersburg Album," *Orientations* 26, no. 1 (1995): 66–79; S. C. Welch, A. A. Ivanov, and O. F. Akimushkin (eds.), *The St. Petersburg Muraqqa. Album of Indian and Persian Miniatures from the 16th through the 18th Century and Specimens of Persian Calligraphy by 'Imad al-Hasani* (Milan, 1996).
Provenance: Purchased in Tehran in 1909 for Tsar Nicholas II by an agent of the Ministry of Finance in Persia, Royal Counselor Ostrogradsky, for 15,000 silver rubles. Transferred to the Museum of Alexander III (now State Russian Museum) in 1910, Department of Ethnography, to the Asiatic Museum (now Institute of Oriental Studies of the Russian Academy of Sciences, Saint Petersburg) in 1921. Folios 28 and 34 were transferred to the Leningrad History of Religions Museum in 1931 to be put on permanent exhibition.
Inscriptions: In *nasta'liq* script, upper right-hand corner: *Ghulām-i Qadīm,'Ali Qulī Jabbādār*

-12-
Penbox with Lovers, Musicians, and Poet in a Landscape

Attributed to Muhammad Zaman; signed Yā Ṣāḥib al-Zamān
Isfahan, dated A.H. 1109 /A.D. 1697
Pasteboard, opaque watercolor and gold under lacquer; 3⅜ x 13½ x 2⅝ inches (8.6 x 34.2 x 6.6 cm)
COLLECTION OF MRS. ESKANDAR ARYEH

Punning signatures invoking respect for artists' masters as well as their sufi or Twelver Shi'ite affiliations were common from the seventeenth century onward. The epithet of the twelfth, "Hidden," imām, Yā Ṣāḥib al-Zamān (O Lord of Time), was variously used as an authentic signature by Muhammad Zaman (as here); was added by others as an attribution to his authentic works; and was adopted by later emulators. Although the outstanding penbox shown here bears only this allegorical form of signature, its design exemplifies Muhammad Zaman's style. The upper surface of the lid is painted

with a *scène galante* of embracing lovers amid attendants and musicians familiar from a number of Zaman's illustrations executed for a *Khamseh* manuscript (Morgan Library, New York, 469), in 1675–76. Characteristically, the scene features trees with systematically modeled and distinctive trunks, low branches, and prominent roots; figures in the middle ground, rendered in light brown tones; and light blue mountains in the distance. All of these elements contribute to the creation of a realistically rendered landscape, and the placement of the figures in an elliptical format also enhances the impression of three-dimensional space.

The design of the inside lid provides further support for an attribution to Muhammad Zaman: the figure of the fallen horseman on the right, with his turban thrown to the ground, is a device familiar from the interior lid of the earliest penbox by Zaman, dated A.H. 1082/A.D. 1671 (Archaeological Museum, Tehran, 4372). In addition, the penbox illustrated here is dated to within Muhammad Zaman's lifetime, and the signature is in a clear black *nastáliq* script, comparable to that used in Zaman's signed works on paper.

Detail of inscription on book in hand of figure at right, NO. 12

A comparison with a penbox signed by Zaman's son Muhammad 'Ali and dated ten years later further supports the attribution.[32] On Muhammad 'Ali's penbox, the same lovers, locked in an embrace, are accompanied by attendants, who read poetry and serve wine, as well as a group of three male musicians. The landscape, again an important compositional element, is closely modeled on, though not directly transferred from, that of the penbox shown here. The scale of the figures was enlarged in the later example, giving a more crowded appearance to the composition. Additionally, Muhammad 'Ali simplified the landscape by eliminating the figures in grisaille depicted here behind the broken tree stump in the left background. He omitted the verses inscribed on the *safineh* from which the attendant on the right is reading, and the Persian beauty on his penbox, while still intertwined in an embrace with her lover, looks out boldly at the viewer, as in Muhammad 'Ali's other works, instead of being shown, as here, with downcast eyes.

The poetic associations of such images are usually not articulated in the composition, yet here the poet holds a scroll inscribed with verses in black *nastáliq* script that equates wine with the blood of lovers.

LSD

Literature: Diba 1994, 590–91, no. 67 (ill.) (for complete bibliographical reference).
Provenance: E. Hatoun, Beirut; Eskandar Aryeh Collection.
Inscriptions: In black *nastáliq* script, on top lid : *Yā Ṣāḥib al-Zamān, 119* (He! O Lord of Time 119); on the *safineh* held by the figure at the far right: *bā kih nūsh-i jān shud/khūn-i 'ashiqān nūsh.*

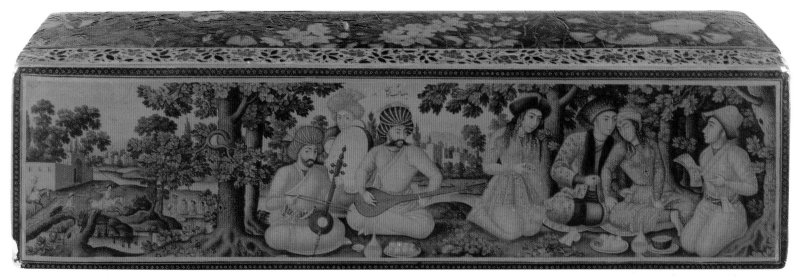

NO. 12

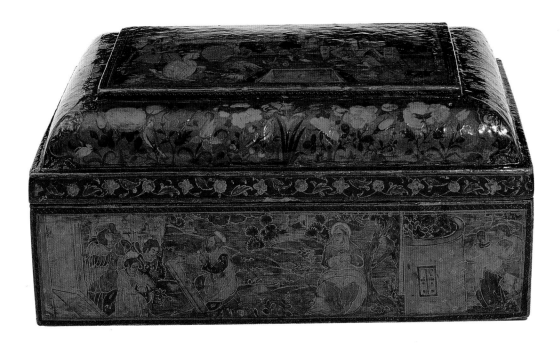

-13-
Casket with Scene of Ladies on a Terrace

Attributed to Muhammad 'Ali ibn Muhammad Zaman; signed Yā Ṣāḥib al-Zamān
Isfahan, dated A.H. 1126/A.D. 1714
Pasteboard or wood, opaque watercolor and gold under lacquer; 5³/₄ x 12³/₄ x 8³/₄ inches
(14.6 x 32.3 x 22.2 cm)
VICTORIA AND ALBERT MUSEUM, LONDON, 2405-1876

The hybrid style evolved by Muhammad Zaman continued unabated in eighteenth-century lacquerwork. This casket is dated fourteen years after Muhammad Zaman's death in 1700 and exhibits close affinities with the signed works of his son Muhammad 'Ali, lending credence to an attribution to that painter. Although Muhammad 'Ali is not recorded in sources of the time, his signed works indicate that he was active as a court painter from 1700 to the 1730s.

The lid of the casket is decorated in a style close to that of Muhammad Zaman himself with a scene of a lady admiring herself in a mirror while sitting on a porch with her attendants. The painting is rendered in rich but muted colors under a reddish varnish. Muhammad Zaman's *Bahram Gur and the Princess of the Black Pavilion* (1539–43 *Khamseh*, British Library, OR2265, folio 221b) displays a similar treatment – including the female musician half hidden behind her drum, the predilection for glass ewers of ruby red wine, and the draping of veils – yet the modeling of faces here is more delicate and the features more classically Persian than those of Zaman's heavy Flemish beauties, and the landscape is treated in an even more painterly manner than in his father's works, with delicately modulated shading. Additionally, the heavier torso and upper arms of the women and the hanging lappets decorating the chest of the woman at the left are typical features of eighteenth-century costume.

Muhammad 'Ali's work is notable for its expressive power. He was especially talented at rendering seductive erotic themes tinged with mystical associations in his lacquer penboxes. His style also shares features with that of 'Ali Naqi ibn Shaykh 'Abbasi; the two artists may have worked together on the illustrations of the Cochran *Shāhnāmeh*, produced some twenty years before this composition. Muhammad 'Ali's distinctive females with round, high cheeks, long curling lovelocks, graceful poses of feet, and direct gazes at the viewer support the attribution to him of the painting *A Lady on a Terrace* (The Metropolitan Museum of Art, New York, 30.95.174, folio 31), which is dated A.H. 1149/A.D. 1736 and thus suggests that he may have been active as late as the reign of Nadir Shah (r. 1736–47).

The sides of the casket are painted, probably by another hand, with Christian scenes,[33] reaffirming the curious cultural interplay between the East and Europe distinctive of late seventeenth- and early eighteenth-century Persian painting. The subject matter of the lid also reflects shared artistic and thematic traditions. The scene of a beauty gazing at herself in the mirror and inviting the viewer's admiration

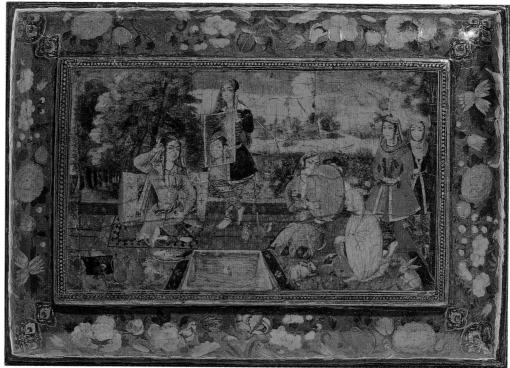

NO. 13, lid

may very well be based on direct observation of the elegant and highly visible courtesans of seventeenth-century Isfahan,[34] yet it was also a common theme of sixteenth- and seventeenth-century Venetian and European painting. Mirror imagery is a recurring metaphor for earthly and divine love in Persian mystical poetry, which would explain its appeal not only to Muhammad 'Ali, but to 'Ali Naqi ibn Shaykh 'Abbasi, Shaykh 'Abbasi, and followers of Riza 'Abbasi who popularized this theme in the later seventeenth century.

LSD

Literature: A. S. Melikian-Chirvani, *Le Perse et la France. Relations diplomatiques et culturelles du 17e au 19e siècle,* exh. cat., Musée Cernuschi (Paris, 1972), 80, no. 79; Diba 1994, 598, no. 73 (ill.) (for complete bibiliographical reference).
Provenance: Acquired for the museum by Major Robert Murdoch Smith from Jules Richard.
Inscriptions: In red *nastáliq* script in top center: *Yá (Ṣāḥib al-Zamān)* 1126

-14-
King Charles I

Anthony van Dyck (Flemish, 1599–1641). 1638
Oil on canvas; 86¼ x 51³/₁₆ inches (219 x 130 cm)
STATE HERMITAGE MUSEUM, SAINT PETERSBURG, 537

Portraits of King Charles I, Queen Henrietta Maria, and their children were presented in 1638 on behalf of the monarch to Shah Safi' by the English envoy, Thomas Merry. According to Merry's report, Shah Safi' examined the paintings at length and inquired the names of the queen and the children.[35] These paintings exemplify the type of state portraiture that commonly circulated among the rulers of seventeenth-century Europe, although these particular works were purchased by Catherine II in 1779 from the estate of Sir Robert Walpole.[36]

A watercolor (Private collection, London) of the three children of Charles I signed by 'Ali Quli Jabbadar with his court title, 'Abbasi (an honorific title associating the artist with Shah 'Abbas II), was executed probably in the 1650s or 1660s. The work was copied after a print or painting of the same subject by van Dyck. Although recent scholarship tends to identify print sources as prototypes, Merry's mission documents how actual oil paintings may have served as models for Persian court painters.

Although the oil-on-canvas prototype of the watercolor – *The Three Eldest Children of Charles I* – is now in the Galleria Sabauda, Turin, it is tempting to propose that another now-lost version may have been sent to Persia in the seventeenth century.[37]

This full-length painting of Charles I of England (r. 1625–49) shows the king standing in his armor. The mistake in the representation of the armor (both metal gloves are for the right hand) was probably the work of an assistant. Charles holds a baton and wears the so-called Lesser George – a gold locket bearing the likeness of Saint George and the Dragon – on a golden chain around his neck. Saint George is the patron saint of the Order of the Garter, and the medallion indicates that Charles appears here as the Garter Sovereign, at the head of his chivalrous knights. Charles wore his Lesser George constantly, and it was with him on the day that he died.

Other versions of the image include: *Charles I in Armor* (three-quarter length to the front; oil on canvas, Private collection, England; reproduced in *Anthony van Dyck*, exh. cat., National Gallery of Art [Washington, D.C., 1990–91], 295, no. 77). The portrait was engraved by Pieter van Gunst (1659–circa 1724), inscribed "P. v. Gunst sculp. ex exo Amstelodami Ant. V. Dyck pinx. 1638. Ex Museo Serenissimi Domini de Wharton," and by Josiah Boydell (1719–1804) in 1788 for the edition *A Set of Prints engraved after the most capital paintings . . . Lately in the possession of the Earl of Orford the Houghton Hall in Norfolk . . .* , vols. 1–2 (London, 1788).

NG/LSD

Literature: Maria Varshavskaya, *Van Dyck: Paintings in the Hermitage Museum* (Leningrad, 1963) (in Russian, with English summary), 122, no. 16; Musée de l'Ermitage, *Peinture de l'Europe Occidentale*, vol. 2 (Leningrad, 1981), 40; Erik Larsen, *The Paintings of Anthony van Dyck* (Freren, 1988), 312–13, no. 791.
Provenance (NOS. 14 and 15): Presented by Charles I to Philip, Lord Wharton (1613–1696), Winchendon, near Aylesbury, Buckinghamshire; 1725–45, collection of Robert Walpole, 1st Earl of Orford (1676–1745), Houghton Hall, Norfolk; 1745–79, collection of George Walpole, 3rd Earl of Orford (1730–1791), Houghton Hall, Norfolk; 1779, Collection of Empress Catherine II.
Inscriptions (NOS. 14 and 15): *P. Sr. Ant. Vandike*

-15-
Queen Henrietta Maria

Anthony van Dyck (Flemish, 1599–1641). 1638
Oil on canvas; 86⅝ x 51¹³/₁₆ inches (220 x 131.5 cm)
STATE HERMITAGE MUSEUM, SAINT PETERSBURG, 541

Van Dyck painted numerous portraits of Queen Henrietta Maria of England (1609–1669). This full-length portrait shows her standing in a cherry red silk dress. She rests her hand on a table, on top of which is a crown and a vase with roses. The queen's costume, which is in the fashion of the late 1630s, and the background were probably executed by van Dyck's assistants. The pose of the model and some details (the table with the crown and the vase of roses) resemble details in a portrait of Queen Henrietta Maria (Windsor Castle Collection); another example dated to 1636 is in the Nottingham University Art Gallery, 1960.N.16. The portrait was engraved by Pieter van Gunst (1659–circa 1724), inscribed "P. v. Gunst sculp. ex exo Amstelodami Ant. V. Dyck pinx. 1638. Ex Museo Serenissimi Domini de Wharton."

NG

Literature: Varshavskaya, *Van Dyck* (see NO. 14), 122–23, no. 17; Musée de l'Ermitage, *Peinture de l'Europe Occidentale* (see NO. 14), 40; Larsen, *The Paintings of Anthony van Dyck* (see NO. 14), 340, 867.
Provenance: See NO. 14.

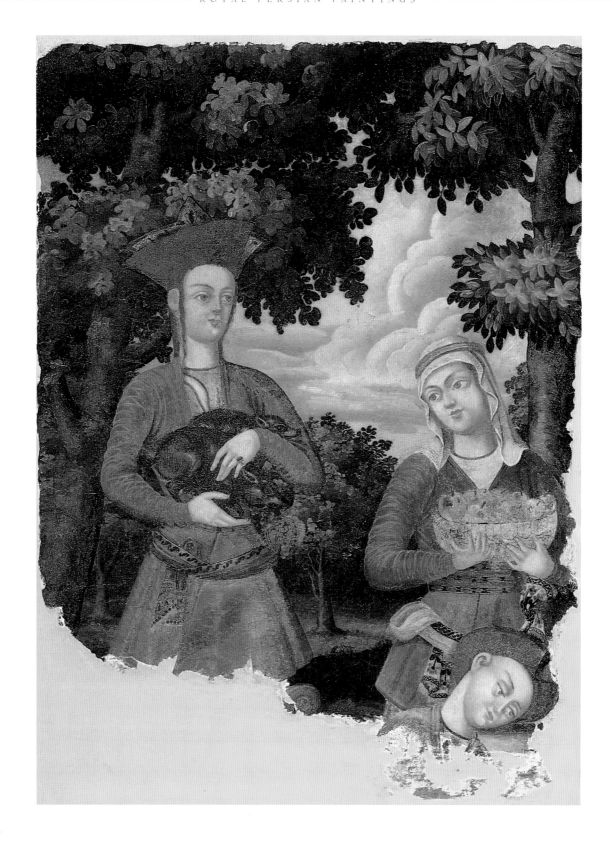

-16-
Attendants at an Outdoor Feast

Attributed to Muhammad Zaman or his atelier
Probably Isfahan, circa 1650–1722
Oil paint on plaster; 38³/₄ x 30⁷/₈ inches (98.4 x 78.4 cm)
THE ART AND HISTORY TRUST, COURTESY THE ARTHUR M. SACKLER GALLERY, SMITHSONIAN INSTITUTION,
LTS 1995.2.121

FIG. IV. *Amorous Couple and Attendant.*
Muhammad Zaman or his atelier. Probably Isfahan, circa 1650–1722.
Oil paint and gilding on plaster, 29⅝ x 21⅞ inches (76 x 56 cm).
PRIVATE COLLECTION.

This fragment of a mural painting and another from the same mural (FIG. IV) are the only known authentic examples of Safavid frescoes outside of Isfahan, and the only ones that can be attributed to Muhammad Zaman and his atelier.

The two attendants shown here bear wild pigs or boar and a bowl of fruit, while a third figure, probably a page or cup-bearer, is visible to the right. The fragment in FIG. IV depicts a woman, also wearing an Armenian-style veil and frogged, tight-fitting robe, seated in a chair.[38] She reads a volume of poetry to a standing youth in a rounded cap, gently leaning her hand on his shoulder. A female attendant is shown nearby. Taken together, these two scenes form a larger composition of rectangular or square format presenting a preferred theme of Isfahan painting: amorous couples in a landscape or banqueting at a table, accompanied by wine and poetry or music and served by attendants.[39]

The treatment of the couple in the other fragment is notable. In sharp contrast to the perception of the separation of the sexes in Persia, the man gazes affectionately at his companion as they share an intimate moment. Although the couple depicted is most likely Armenian, similar scenes with Persian protagonists were not uncommon in this period (see NOS. 12, 27).

Abolala Soudavar has attributed this painting to Muhammad Zaman himself.[40] Although the suggestion is convincingly argued, both Muhammad Zaman's son, Muhammad 'Ali, and 'Ali Quli Jabbadar's son 'Abd al-Bayg and grandson, Muhammad 'Ali, continued to work in a closely related style from the 1690s onward and were trained in the copying of European prints, which formed the nucleus of Zaman's style. While it is possible that these murals were executed by Zaman, they seem equally likely to be the work of artists trained by him or even of Armenian painters, since these murals share affinities with the wall paintings of the houses and churches of the Armenian quarter of Isfahan, New Julfa.

This fragment is particularly noteworthy for its landscape background. Landscapes in Persian manuscript and album painting were traditionally stylized and abstract. From this period onward, a new landscape style with naturalistically rendered trees (often with crackled bark), feathery leaves shaded to give a sense of depth and projecting into space, distant vistas of green fields, and cumulus clouds in voluminous forms would be incorporated into almost all forms of painting. After its culmination in the late seventeenth and early eighteenth centuries, Persian landscape painting became increasingly stylized, though never returning to the abstract, decorative mode that it replaced.

LSD

Literature: Soudavar 1992, 377, fig. 152; Ziai 1997, 27.
Provenance: André and Clara Malraux Collection, acquired in Iran or Afghanistan prior to 1930.

-17-
A Caucasian Youth in Court Dress

Artist unknown
Isfahan, 1650–1722
Oil on canvas; 61 x 31½ inches (155 x 80 cm)
COLLECTION OF F. FARMANFARMAIAN

This highly finished depiction of an elegant youth in an interior exemplifies the eclecticism character-istic of late Safavid life-size painting. The interior's tiled floor and vase of flowers are derived from Dutch sixteenth- and seventeenth-century paintings and engravings, the twisted column in Baroque style is of Italianate origin, and the balustrade is of a type unknown in Persia. Stylistic similarities have also been noted with seventeenth-century English court painting.[41] The rich, somber palette of maroons, dark greens, and grays utilized in this portrayal is characteristic of the Perso-European mode and contrasts with the palette used by the followers of Riza 'Abbasi. The modeling and facial features of these subjects – widely spaced, rounded eyes, eyelids, noses, and chins defined by shading – also differ from those of the Riza 'Abbasi style of arched eyebrows, almond-shaped eyes, and unmodeled cheeks and noses. The decorative treatment of the robe, the lack of cast shadows, and the two-dimensional rendering of space follow distinctively Persian conventions, however.

This work is one of a group of eleven detached oil-on-canvas portraits assigned to Isfahan and dated in the past to circa 1650–90[42] that are now dispersed in Iranian and European collections. Although unsigned, the paintings share features with signed and dated works by such celebrated masters of the Perso-European school as Muhammad Zaman and 'Ali Quli Bayg Jabaddar. Since paintings in this style continued to be executed in Isfahan by the sons and followers of these painters until the fall of the capital in 1722, the dating for life-size paintings of this school should be extended to the 1720s.

The richness of the subject's clothing, the jeweled dagger, and the bow and arrow identify him as a court official of the late seventeenth century. The stiff, flaring robe of patterned silk with tight-fitting torso that he wears was introduced during the reign of Shah 'Abbas II.[43] The fur-lined cap of bro-cade in lieu of the Safavid turban is a feature of Russian and Caucasian clothing of the seventeenth century and was primarily worn by the Georgians or Circassians in the service of the Safavid shahs, although women are also known to have worn similar caps. This headgear is depicted in numerous visual sources of the period (see NO. 11).

Paintings such as this one were often described in European sources of the second half of the sev-enteenth and early eighteenth centuries as a feature of the decoration of both royal palaces and residences of the Muslim elite and of the Armenian and European merchants.[44] A rare extant drawing (FIG. V) by a French traveler – datable to the 1670s – of the interior hall of the Ainehkhaneh (Mirror Palace) depicts life-size paintings of a turbaned man, a dancing girl, and group scenes set into mirrorwork. Com-parable extant representations (although arched at the top) for both this work and NO. 18 are found

FIG. V. *Interior View of the Ainehkhaneh Palace.*
G. G. Grélot, folio 246 from a manuscript of *The Journal and Travel of Ambrosio Bembo in Asia* (1671–75). Line drawing, 13 x 18 inches (33 x 45.7 cm).
JAMES FORD BELL LIBRARY, UNIVERSITY OF MINNESOTA, MINNEAPOLIS.

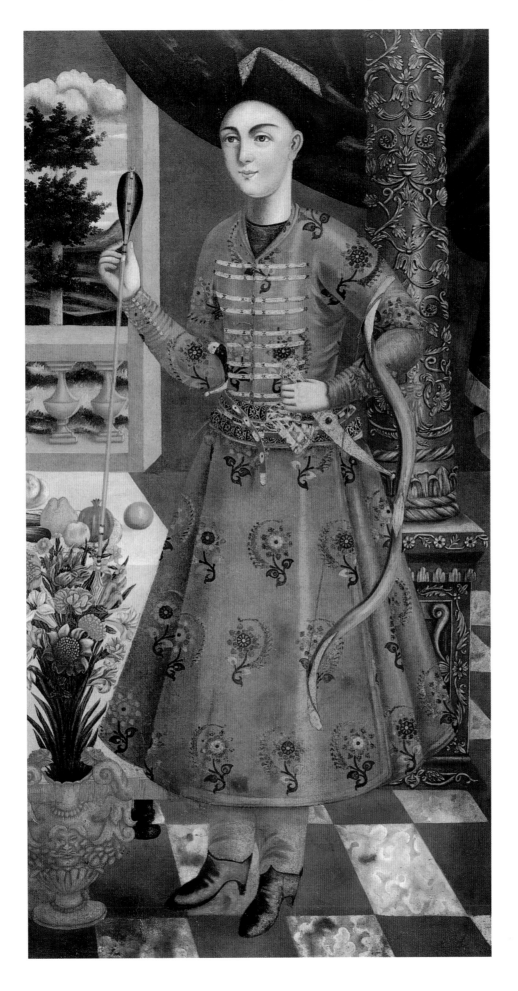

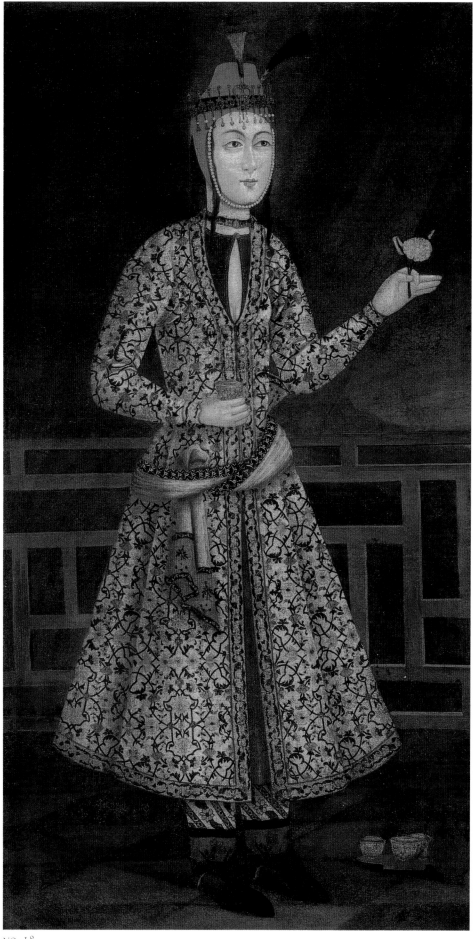

NO. 18

in the mural decoration of the house of the merchant Sukias in New Julfa.[45] The paintings, in three superimposed rows, decorate the side walls of the residence's columned porch. In the context of the original architectural setting, the difference between the Perso-European mode and its European models becomes apparent. Works such as *A Caucasian Youth* depicted ethnic types, rather than recognizable individuals, and were intended as components of decorative programs. The program of the Sukias porch, comprising more than twenty subjects, celebrated the leisure activities of the wealthy elites of Isfahan and conveyed the Armenian community's admiration for, and identification with, refined European lifestyles. A similar decorative program utilized in the side porches of the Chihil Sutun palace (dated to the mid-seventeenth century) conveys the international scope of Safavid power. The Europeans depicted there may be viewed as symbolic counterparts to the tribute bearers from foreign nations in the Persepolis bas-reliefs of two thousand years earlier (550–331 B.C.). In sum, this image and its counterparts communicate the awareness of different cultures and a curiosity about other peoples shared by the Persian and European communities of seventeenth-century Isfahan.[46]

LSD

Literature: Adle 1996, 353, fig. 13

-18-
A Lady with a Rose

Artist unknown
Isfahan, 1704–22
Oil on canvas; 65 x 35 inches (165.1 x 88.8 cm)
COLLECTION OF MRS. ESKANDAR ARYEH

The young woman in this painting, dressed as richly as the Caucasian youth in NO. 17, holds a delicate pink rose in one hand and a goblet in the other — attributes that allude to her feminine charms and her intoxicating beauty. At her feet are displayed blue and white drinking bowls and a gold jeweled long-necked ewer, characteristic of the rich vessels and regalia recorded by visitors to the Isfahan courts and frequently depicted in the visual sources. The woman wears a peaked scarlet cap (tied under her chin) embellished with a feather and necklet, indicating her high social rank and married status.[47] Her stature is also conveyed by the lavishness of the silk brocade patterned dress and trousers that she so charmingly wears.

The painting's subject projects a sense of modesty and dignity, in contrast to many of the female depictions of the period, which show scantily clad or seminude Persian courtesans in inviting attitudes with their veils slipping off their heads or bare-headed European women in classical or early seventeeth-century low-cut European gowns (see NO. 8).

A feature that invites comment is the background's red lacquered wood balustrade. A representation of the Armenian merchant Khwajeh Petros (Isfahan Cathedral Museum), executed in Madras by a painter trained in European techniques in 1737,[48] exhibits a similar balustrade. Owing to the extensive commercial network, paintings from western India may have been commissioned by the Armenian merchants of Isfahan in the seventeenth and eighteenth centuries, and may have provided the prototypes for the Chinese balustrade in this painting.

This painting forms a pair with a representation of a man in Persian costume (sometimes identified as Shah 'Abbas I), which features a similar balustrade. The provenance of these paintings dates back to the 1830s, when they were recorded in the collection of the Arnold-Foster family. According to family tradition, they belonged to an ancestor, George Booth, said to have served as ambassador to the Persian court at the time of Shah 'Abbas II. Two related seventeenth-century oil paintings can also be traced to an English collection in 1701.[49]

LSD

Literature: *Catalogue of the International Exhibition of Persian Art*, 3d ed. (London, 1931), 305, no. 768; *Oriental Manuscripts, Miniatures and Two Court Portraits in Oils, Isfahan, 1650*, sale cat., Christie's, July 11, 1974, 17–18, lots 42–43.
Provenance: Eskandar Aryeh Collection.

1. Germaine Guillaume, "Influence des ambassades sur les echanges artistiques de la France et de l'Iran du XVIIème au début du XIXème siècle." *Third International Congress of Iranian Art, Bulletin* (Moscow, 1939), 80; Ivan Stchoukine, *Les Peintures des manuscripts de Shah 'Abbas Ier à la fin des Safavis* (Paris, 1964), 21, 24, 32; and R. W. Ferrier, "Charles I and the Antiquities of Persia, the Mission of Nicholas Wilford," *Iran* 8 (1970): 55.

2. Martin 1912, pl. 173; Ivanov, Grek, and Akimushkin 1962, pls. 84, 85; Diba 1994, 255.

3. Corneille Le Brun, *Voyage de Corneille Le Brun par la Moscovie, en Perse, et aux Indes Orientales* (Amsterdam, 1718), vol. 1, p. 222.

4. Arnold 1928, 5–12.

5. Mir Munshi Qazi Ahmad, *Calligraphers and Painters: A Treatise by Qadi Ahmad, son of Mir-Munshi* (circa A.H.1015/A.D.1606), trans. by Vladimir Minorsky, Smithsonian Institution, Freer Gallery of Art Occasional Papers, vol. 3, no. 2 (Washington, D.C., 1959), 50.

6. The complete text, with the exception of the initial letters, which are missing, is legible, allowing us to establish that this document is a missive. It has, however, been referred to as an edict (*firmān*). See Welch 1973, 66.

7. For other examples, see R. W. Ferrier, "The Terms and Conditions under which English Trade Was Transacted with Safavid Persia," *Bulletin of the School of Oriental and African Studies* (University of London) 49, part I (1986): 48–66.

8. For an illustration see Soudavar 1992, 264–65, fig. 46.

9. Armenag Sakisian, "La miniature persane du 12ème au 17ème siècle," *Gazette des Beaux Arts* (September 1929): 137, pl. CXIX, fig. 178.

10. Anthony Welch and Stuart Cary Welch, *Arts of the Islamic Book: The Collection of Prince Sadruddin Aga Khan* (Ithaca and London, 1982), 124–25, fig. 40.

11. Guillaume, "Influence des ambassades," 82.

12. Diba 1994, nos. 76, 83.

13. For another example, see doublure of an album, India, Lucknow, circa 1780, British Museum, Stowe OR.16, 19746-17021.

14. See Ivanov, Grek, and Akimushkin 1962, 57; Karimzadeh Tabrizi 1985–91, vol. 1, p. 388; Diba 1994, 148; and Soudavar 1992, 369.

15. From the Persian oil (*naft*). See Stchoukine, *Les Peintures,* 20.

16. For the identification of the prince de Condé, see Martin 1912, 75. For the young Louis XIV, see A. Busson, "Le portrait moghol d'un prince français," *Connaissance des Arts*, no. 136 (1963): 49, followed by Ivanov 1972, 238; Andrée Busson, "Note sur une miniature moghole d'influence européene," *Arts Asiatiques* 34 (1978): 133.

17. In the second half of the century, the Dutch acquired the monopoly of the trade. By the time that the French did convince the Safavids to sign a treaty, in 1708, the empire was on the verge of economic and political collapse.

18. Guillaume, "Influence des ambassades," 82.

19. Jean Baptiste Tavernier, *The Six Voyages of Jean Baptiste Tavernier* (London, 1678), 182.

20. Layla S. Diba has offered another dating for the decoration of the upper surface of this *qalamdān*. She believes that 'Ali Quli's treatment of the subject in NO. 6 was so successful that another version was adapted for the upper surface of this penbox and refurbished with lush superimposed designs of gold-painted roses in the late nineteenth century, most likely by the illuminator Mahmud Shirazi. See Welch and Welch, *Arts of the Islamic Book*, 137, no. 146, for a binding dated A.H. 1313/A.D. 1895–96 by this artist utilizing a comparable combination of modeled and stippled roses with vine leaves and twisted scrolls. Such artistic recycling of valued earlier lacquer paintings by skilled nineteenth-century lacquer restorers (*naql kardan*) is praised by Husayn ibn Muhammad Ibrahim Tahvildar Isfahani, the late nineteenth-century authority on Isfahani crafts. See Husayn Muhammad Tahvildar-Isfahani, *Jughrāfiā-yi Işfahān* (The geography of Isfahan), ed. by Manuchihr Sutudeh (Tehran, 1963), 107, no. 103.

21. Tavernier, *The Six Voyages,* 182.

22. Le Brun, *Voyage,* 222–23.

23. Milo Cleveland Beach, "The Gulshan Album and Its European Sources," *Bulletin, Museum of Fine Arts, Boston* 63, no. 332 (1965): 63–91, nos. 1, 2; Mary McWilliams, "Allegories Unveiled: European Sources for a Safavid Velvet," in *Textiles and Trade*, Proceedings of the Textile Society of America, Biennial Symposium, September 14–16, 1990 (Washington, D.C., 1990), nn. 28, 32; *Il murakka di San Pietroburgo*, exh. cat., Fondazione Villa Favorita (Lugano,
1994), fol. 46a.

24. See *Allegorical Figure* (Brooklyn Museum of Art, TL1994.108); Soudavar 1992, 305–6, no. 128 a–d; Beach, "The Gulshan Album," nos. 1, 2, 4, 7; Milo Cleveland Beach, *The Grand Moghul. Imperial Painting in India. 1600–1660*, exh. cat., Sterling and Francine Clark Art Institute (Williamstown, Massachusetts, 1978), 51–59, 155–56; and *Il murakka di San Pietroburgo*, 59, fol. 46a.

25. *Art Islamique*, sale cat., Hôtel Drouot, Paris, June 23, 1982, lot 12; a folio from the Gulshan Album (Beach, "The Gulshan Album," no. 9) exhibits three separate images copied after European prints; the image on the upper right is signed 'Aliquli.

26. An accomplished work from the later period, which successfully integrates mounted hunters into a distant landscape with similarly elongated rocky hills and swaying trees, is a hitherto unrecorded penbox signed 'Ali Quli 'Abbasi, whose date has been misread as A.H. 1008/A.D. 1608, most likely for A.H. 1108/A.D. 1696–97. See J. W. Harrington, "Rare Old Lacquers from Persia," *International Studio* 83 (March 1926): 73.

27. Soudavar 1992, 370. The prominently placed inscription in the foreground of *Landscape with Dutch Mill* has been read as 'Ali Quli ibn Muhammad by L. T. Giuzalian (for illustrations, see Adamova 1996, 225; V. Lukonin and A. Ivanov, *L'Art persan* [Bournemouth and Saint Petersburg, 1995], 228, no. 235).

28. The cartoon for this panel has been assigned to 'Ali Quli or to one of the Dutch painters working at the Isfahan court, Philip Angel (McWilliams, "Allegories Unveiled," 143). See Ouseley 1819–32, vol. 3, p. 27, for the palace at Ashraf.

29. A. A. Ivanov, "The Life of Muhammad Zaman: A Reconsideration," trans. from the Russian by Michael Rogers, *Iran* 17 (1979): 65–66, and Diba 1994, 318–26.

30. Welch and Welch, *Arts of the Islamic Book*, 177, no. 59A; Beach, *The Grand Moghul*, 164, no. 61.

31. In the early nineteenth century, a new lacquer binding was commissioned by Fath 'Ali Shah, depicting the ruler in the guise of Bahram Gur (see FIG. 14a).

32. Diba 1994, 610, no. 82.

33. It has been suggested that these scenes are contemporary with the lid and are based on prototypes from an Armenian bible. See A. S. Melikian-Chirvani, *Le Perse et la*

France: Relations diplomatiques et culturelles du 17e au 19e siècle, exh. cat., Musée Cernuschi (Paris, 1972), 80. Two such bibles were commissioned in Amsterdam by the Armenian community in the 1640s and 1660s. The bibles were illustrated with engravings by Christobel Van Sichem, an artist whose works were frequently copied by Mughal and Safavid artists.

34. Massumeh Farhad, "Safavid Single Page Painting, 1629–1666," Ph.D. dissertation, Harvard University, Cambridge, Massachusetts, 1987, 244–45.

35. Ferrier, "Charles I and the Antiquities of Persia," 55.

36. Erik Larsen, *The Paintings of Anthony van Dyck* (Freren, 1988), vol. 2, pp. 312–13, 340.

37. For 'Ali Quli's watercolor, see *Art Islamique*, sale cat., Hôtel Drouot, lot 35. For van Dyck's prototype, see Arthur K. Wheelock et al., *Anthony van Dyck* (Washington, D.C., 1990), 284–86, fig. 74.

38. Technical analysis conducted during the Brooklyn Museum of Art's Curatorial-Conservation study of Qajar paintings, 1997, revealed the outline of the chair top at the lower edge of the painting.

39. For murals, see John Carswell, *New Julfa: The Armenian Churches and Other Buildings* (London, 1968), vol. 8, Babaie 1994, pls. 161–62, 170, 186–87; for penbox lid, see Diba 1994, no. 69.

40. Soudavar 1992, 377.

41. Sims in London 1976, 245.

42. Ibid., 233ff.

43. Layla S. Diba, "Costume: Safavid Persia to Qajar," in *Encyclopaedia Iranica*, vol. 5.

44. For examples, see Engelbert Kaempfer, *Am Hofe des Persischen Grosskönigs 1684–1685*, ed. by Walther Hinz (Leipzig, 1940), 173–74, and Carswell, *New Julfa*, 65–69.

45. Carswell, *New Julfa*, pl. XXX; Babaie 1994, pls. 191–92. For related wall paintings in the Chihil Sutun palace, see Babaie 1994, pls. 183–87.

46. For watercolor albums, executed by Persian painters for European travelers, depicting the trades and ethnic types, see London 1976, no. 142, 241–58, and Sheila R. Canby, *Persian Painting* (London 1993), 113–15, for Kaempfer Album, and similar illustrations of European travel accounts.

47. See Farhad, "Safavid Single Page Painting," 225, and Le Brun, *Voyage*, vol. 1, pl. 87.

48. Carswell, *New Julfa*, pl. 84.

49. *Oriental Manuscripts, Miniatures and Two Court Portraits in Oils, Isfahan 1650*, sale cat., Christie's, July 11, 1974, 17, lots 42, 43. See Sims in London 1976, 247.

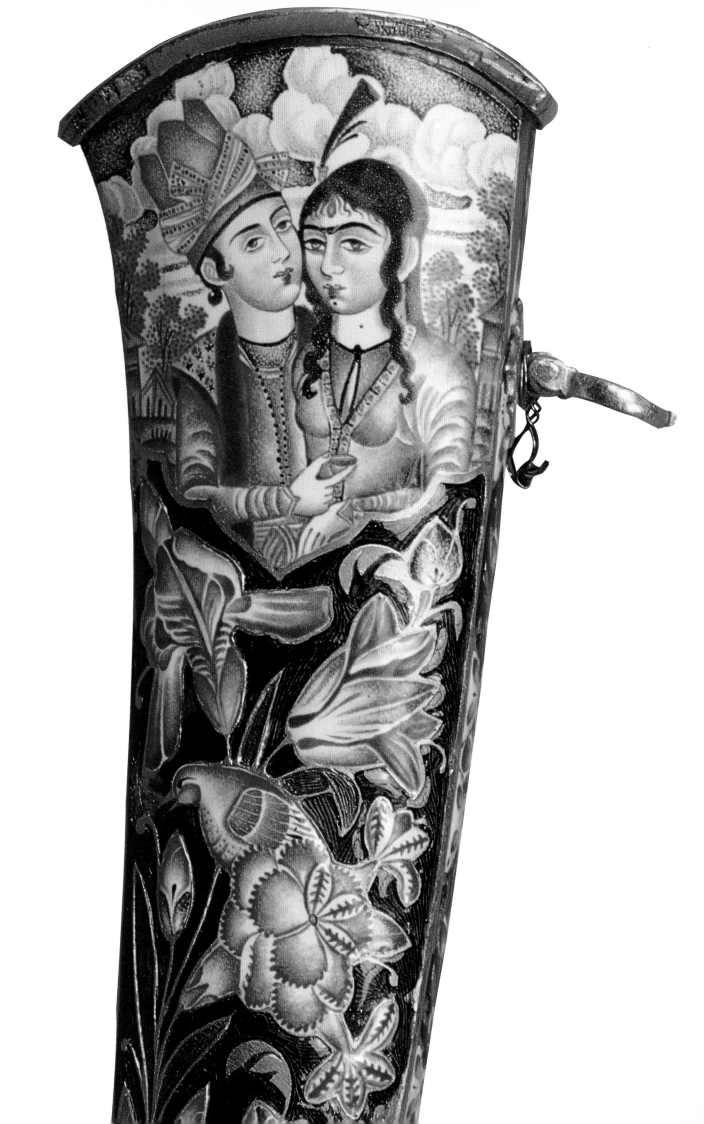

AFSHARID PERIOD

(1736–47)

ECAUSE of the internal strife and political upheaval that followed the fall of the Safavid empire to Afghan invaders in 1722, the Afsharid period has been little studied. Nadir Shah Afshar, a Khurasani tribal leader of peasant stock, rose to power in the 1720s and 1730s. Many of the territories lost to Afghan, Turkish, and Russian encroachments after the fall of the Safavids were restored under his brilliant military leadership, but Iran's economic situation declined. Nadir Shah's ambitions and vision extended well beyond the borders of Iran: by 1739 he had conquered the Mughal empire and imposed a return to Sunnism, perhaps as part of a grand design to establish an international Islamic empire with himself as ruler.[1]

Once Nadir Shah turned his attention to the glorification of his personal achievements and the events of his reign, he had available to him a skeleton staff trained by Safavid masters in the court workshop system.[2] As might be expected, the artistic production of the period was primarily restricted to royal commissions and retained the Perso-European themes and stylistic conventions of the late Safavid period virtually intact. With the decline in economic fortunes, gone was the patronage of the Armenian and international merchant community, as well as the wider base of urban Persian patronage. Court painters trained in the Perso-European mode, now isolated from direct contact with cosmopolitan trends except for Indian influences resulting from the conquest of Delhi, continued to faithfully reproduce late Safavid compositions with generally diminishing inventiveness and success.

Information on Nadir Shah's architectural programs is scant, and commissions for life-size paintings for palaces were few, since Nadir Shah spent most of his energies and the country's limited resources crisscrossing the country in endless military campaigns. The famed treasures of the Mughal empire – carted back to Iran on donkeys as spoils of war – had little direct impact on painting, yet Mughal influence may be discerned in the enamelwork and textile production of the period.

The image of Nadir Shah emerges as the most distinctive theme of paintings from this period. Oil portraits and a few detached watercolors of the ruler and his immediate entourage, executed by the second generation of Perso-European artists still surviving in Isfahan – Muhammad 'Ali, the son of Muhammad Zaman, and Muhammad 'Ali, the grandson of 'Ali Quli Jabbadar (active circa 1722–47) – form the nucleus of Afsharid production. The decoration of lacquerwork, which previously exhibited complex figural designs, was limited during this period to small-scale floral decoration, principally associated with the painter 'Ali Ashraf (active 1730s–1770s).

The Afsharid period itself was brief, and Nadir Shah, largely untutored, evinced little sustained interest in art or culture. The principal documents of his rule postdate his reign and were commissioned by cultured and literate court functionaries. An album of sixteenth- and seventeenth-century Mughal and Persian painting and Persian calligraphy (see NO. 11) was assembled between 1734 and 1758–59 in the royal ateliers, most likely for Nadir Shah's court historian, Mirza Mihdi Astarabadi. This sumptuous album was compiled and embellished by the artists 'Ali Ashraf, Muhammad Riza Hindi (active 1730s–1800), and the principal masters of the Zand school (1750–79). This work and a manuscript of Mirza

Mihdi's history of the reign of Nadir Shah, *Tārīkh-i Jahāngushā-yi Nādirī* (Private collection, Tehran), dated A.H. 1171/A.D. 1757–58 and featuring fourteen unsigned illustrations assigned to Muhammad 'Ali ibn 'Ali Quli Jabbadar, epitomize the imperial court style.[3]

The range of styles and patronage evidenced in the small corpus of other extant works executed in provincial centers and the proto-Safavid style of eighteenth-century Kashmir[4] eloquently testify to the political and economic fragmentation of the period and suggest that Persian artists emigrated abroad to find new patronage.

There is no question that Iran's cultural isolation from the international scene lasted until the early nineteenth century. The works exhibited here attest to the resonance of Safavid art and the creative adaptations of Indian motifs and themes, both of which laid the foundation for a renewed flowering of painting in Shiraz in the second half of the eighteenth century.

LSD

– 19 –

Nadir Shah

Possibly Muhammad Riza Hindi
Isfahan, circa 1740
Oil on canvas; $64^1/_{16}$ x $40^1/_8$ inches (162.7 x 102 cm)
LENT BY THE BOARD OF TRUSTEES OF THE VICTORIA AND ALBERT MUSEUM, LONDON,
GIVEN TO THE VICTORIA AND ALBERT MUSEUM BY G. F. WELSFORD, I.M. 20-1919

Although it is recorded that Shah Sultan Husayn (1696–1722), the last Safavid ruler, sat for his portrait by the Dutch painter Cornelis de Bruyn in 1704–5,[5] the earliest life-size royal portraits extant today are datable to the period of Nadir Shah. In addition to this painting, only one other extant oil-on-canvas portrait (India Office Library, London, Foster 44) of the monarch survives. Nevertheless, literary and visual references show that Nadir Shah took more of an interest in painting – as historical record and personal glorification – than previously thought.

In addition to his patronage of Persian artists, Nadir Shah commissioned portraits of himself from Indian painters, one of which was presented in 1740 to Richard Benyon, the English governor of Madras, by an Indian official.[6] In the early 1740s Nadir Shah, following Safavid precedent, also retained an Anglo-Prussian painter, Cassel, undoubtedly for his skill in life-size painting (see Layla Diba essay). Numerous extant watercolors and engravings, some perhaps commissioned by the ruler, testify to Nadir's patronage of painters on the one hand, and to the fascination he has held for later generations, on the other.[7]

The painter of this portrait was clearly trained in the Perso-European mode, as indicated by the modeling of the face and body, the shading of the hands, and the highlighting of the aquiline nose and piercing black eyes. The composition also shares with its Perso-European prototypes the attention to decorative detail, the rigidity of the seated pose of the ruler with his arms bent, and the tilted-up picture plane drawing attention to the intricate patterning of the floor covering.

The decorative treatment of the carpet and the rendering of the birds on the enameled hilts of the shah's dagger and sword bespeak the training of a manuscript illustrator pressed into service as a portrait painter, as does the awkward treatment of the background. The monochrome dark brown space, intended to simulate a tent with fringes, differs markedly from both the backgrounds found in late Safavid paintings and that of the India Office Library portrait. Late Safavid paintings feature landscapes with atmospheric blue skies or elaborate interiors with twisted columns, covered tables, and marble checkerboard floors, while the India Office Library portrait features a uniform background.[8] The tentlike effect of this painting is highly unusual. It was perhaps copied from the tents with gold fringes frequently found in eighteenth- and nineteenth-century Indian watercolors. Although the shah's portrait follows Perso-European conventions closely, the Indian decorative accents and the ruler's four-pointed cap identify this as a work of the Afsharid period.

This portrait may be assigned to Muhammad Riza Hindi. That artist's watercolor portraits of Nadir Shah (Imperial Library, Tehran, 1236) and of a young prince, most likely Nadir's son and heir

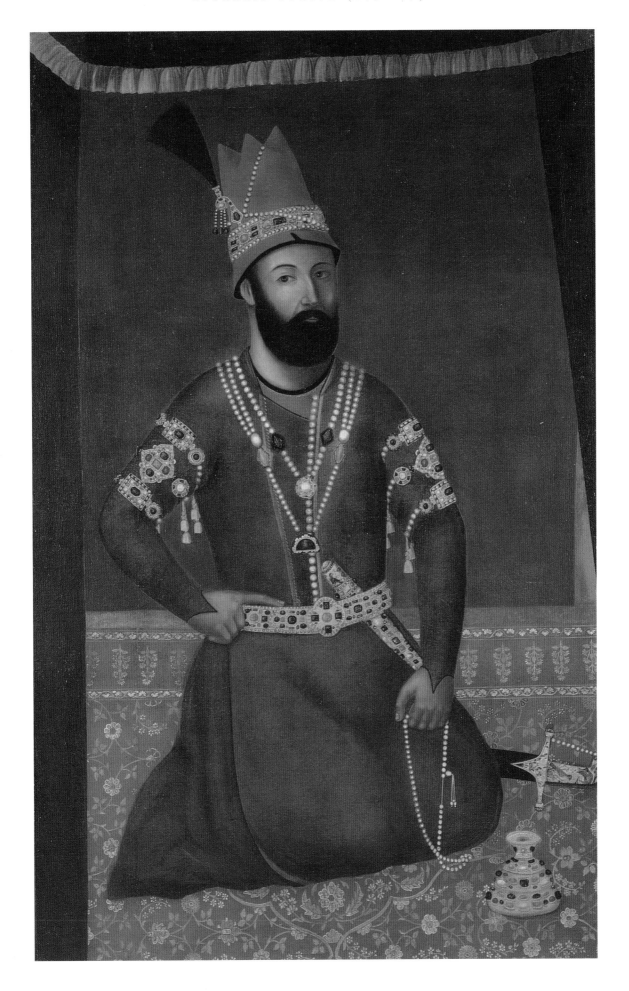

Riza Quli, dated A.H. 1666/A.D. 1752–53 (Saint Petersburg Public Library, Dorn 489), share stylistic features with this painting, such as the rendering of the tubular neck, the delicate features and elegant proportions of the figure, and the flat treatment of the cap and its jeweled band. Furthermore, the rendering of the birds on the sword and dagger recalls Muhammad Riza's exquisite draftsmanship in his signed paintings of birds and flowers.[9]

The portrait may be dated sometime after the conquest of India in 1739, since the ruler, who dressed modestly at the beginning of his reign, is shown wearing armbands in the Indian style, festooned with ropes of pearls set with emeralds, diamonds, and polished red spinels; holding pearl prayer beads; and sitting on a velvet floor covering or carpet of Mughal manufacture. The pearls may be the very same as those worn in numerous portraits by the Mughal ruler Shah Jahan and his son Emperor Jahangir. The Crown Jewels Collection in Tehran houses countless strands of pearls similar to these. The collection also contains an emerald, dated A.H. 1152/A.D. 1739 and engraved with Nadir Shah's name, of the same size and shape as that shown in the portrait, and similar spinels engraved with the names of Nadir Shah and later Mughal rulers.[10]

The regalia of the Mughal emperors have been cleverly utilized by the painter to suggest Nadir's imperial ambitions. Additionally, the new Afsharid rule is given visual form by the four-pointed red cap with the royal black heron feather. This compulsory head covering instituted by Nadir Shah replaced the twelve-gored cap associated with his Safavid predecessors. While the painting successfully conveys the attributes and abstract concepts of royal power, it fails to convey the very personal nature of Nadir's charisma.

LSD

Literature : L. Lockhart, *Nadir Shah: A Critical Study Based Mainly upon Contemporary Sources* (London, 1938), frontispiece; Robinson 1993, 61, fig. 39; Gavin Hambly, *Cities of Mughal India* (New Delhi, 1977), fig. 119; B. W. Robinson, *Persian Oil Paintings* (London, 1977), no.1 (in color); Layla S. Diba, "Visual and Written Sources: Dating Eighteenth-Century Silks," in *Woven from the Soul, Spun from the Heart: Textile Arts of Safavid and Qajar Iran*, ed. by C. Bier, exh. cat., Textile Museum (Washington, D.C., 1987), 91, fig. 34; Ferrier 1989, 226, fig. 3; Layla Diba, "Enamel," *Encyclopaedia Iranica*, forthcoming, pl. 2.
Provenance: Brought to England by Mrs. G. F. Welford's grandfather (Begberry Park, Kent).

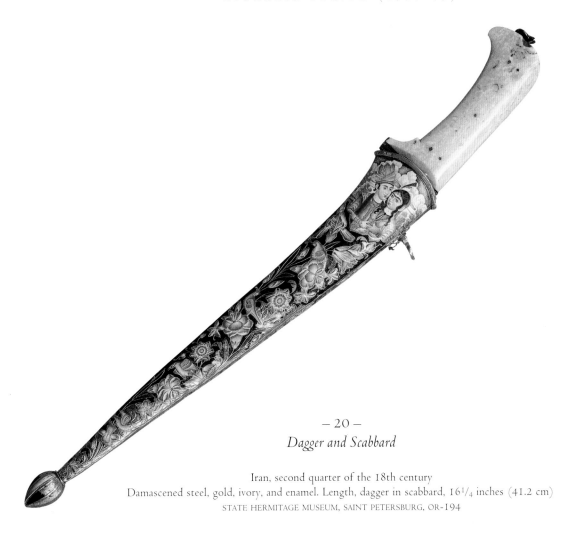

– 20 –
Dagger and Scabbard

Iran, second quarter of the 18th century
Damascened steel, gold, ivory, and enamel. Length, dagger in scabbard, 16¹/₄ inches (41.2 cm)
STATE HERMITAGE MUSEUM, SAINT PETERSBURG, OR-194

The blade of this dagger is made of tempered steel and decorated with golden floral ornament near the top, and the handle is fashioned of two ivory plates. Fastened to the end of the handle is an openwork steel medallion with the inscription "Yā, 'Ali!" The scabbard is covered with painted enamel design in slight relief; the ornament is in three colors.

A medallion depicting a young man and a maiden decorates the upper part of the scabbard. The youth wears very distinctive headgear: a round hat of thick felt, whose upper part is cinctured cross-wise in such a way as to form four protruding ends (only three of which are seen in the painting). This type of headgear, called the *tāj-i tahmāsi*, was introduced in the Iranian army in the early 1730s by Nadir Quli (the future Nadir Shah) when he was still the commander in chief under Shah Tahmasp II. There are many depictions of Nadir and various figures of his era wearing such hats, but they are very rarely found in miniature painting postdating Nadir's murder in 1747. On the basis of this evidence, one may assume that the dagger was probably made in 1730–50.

AAI

Literature: A. D. Tushingham, "Persian Enamels," in *The Memorial Volume, Fifth International Congress of Iranian Art and Archaeology* (Tehran, 1972), vol. 2, p. 220, pl. IX; Ivanov, Lukonin, and Smesova 1984, no. 58; *Masterpieces of Islamic Art in the Hermitage Museum,* exh. cat., Dar al-Athar al-Islamiyyah (Kuwait, 1990), no. 117 (with bibliography of all earlier literature); V. Lukonin and A. Ivanov, *L'art persan* (Bournemouth and Saint Petersburg, 1995), no. 250.
Provenance: Purchased in 1886 from the Arsenal of Tsarskoye Selo (present-day Pushkin).

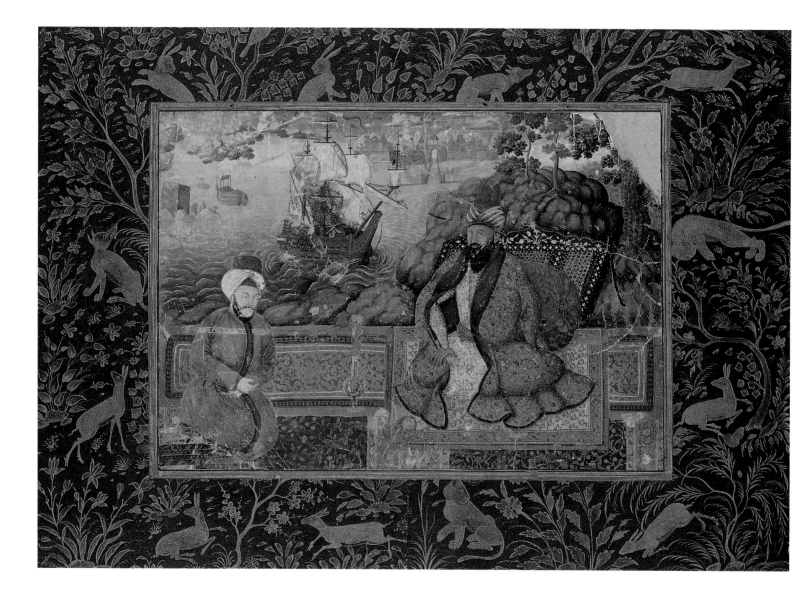

– 21 –

Nadir Shah Receiving an Ottoman Envoy

Possibly Muhammad Rashid Khan
Iran, 1730s–1740s
Opaque watercolor and gold on paper; sheet 12¹/₂ x 16¹/₂ inches (32 x 42 cm)
PRIVATE COLLECTION

One of Nadir Shah's most remarkable ambitions was the formation of a Persian navy, a dream that he pursued throughout his career with dogged persistence and little success. By the early eighteenth century, Nadir Shah had grasped the importance of sea power in the European world hegemony, purchasing ships from the Dutch and English East India companies and from Indian shipbuilders. In 1742 he even retained an Englishman, Captain John Elton, to build ships to navigate the Caspian Sea, which was then under Russian control. He also turned to sea power in the 1730s during his campaigns against the Ottomans in Baghdad and in the 1730s and 1740s in subduing rebellions in the Persian Gulf area.[11]

The subject of this composition nevertheless remains ambiguous, in the absence of epigraphic evidence (two explanatory inscriptions have been erased). The work may be interpreted as an imaginary scene in which Nadir is depicted as conqueror of the Ottomans, seated before the harbor of Istanbul and leaning against an Ottoman-style throne back. Alternatively, the painting may depict the conquest of the port of Basra and the Ottoman envoy sent to negotiate a peace treaty.[12]

In either case, this composition is the only representation to depict Nadir Shah's ambition of mastery over the seas. The painting follows the late Safavid convention of a ruler receiving a foreign envoy, yet the use of marine iconography is highly original. The painter was perhaps familiar with Mughal imperial portraiture, which utilized both marine iconography and allegory to devise flattering portrayals of imperial ambition. This painting shows affinities with the works of two painters of the Nadir Shah period, Muhammad Rashid Khan and Muhammad 'Ali ibn 'Abd al-Bayg ibn 'Ali Quli Jabbadar, although an attribution to the former seems more likely.[13]

The border, with its graceful illuminated animal design on a dark blue ground, epitomizes the innate Persian taste for selecting a frame that enhances the visual impact of such paintings.

LSD

Literature: *Oriental Manuscripts and Miniatures*, sale cat., Sotheby's, July 13, 1971, 84–85, lot 383; *Islamic and Indian Art, Oriental Manuscripts and Miniatures*, sale cat., Sotheby's, April 30, 1992, lot 310.

– 22 –
Battle Scene with Nadir Shah on Horseback

Possibly Muhammad 'Ali ibn 'Abd al-Bayg ibn 'Ali Quli Jabbadar
Isfahan, mid-18th century
Opaque watercolor and gold on paper; image 8⅝ x 6⅝ inches (22.5 x 16.7 cm);
sheet 18⅝ x 14⅝ inches (47.2 x 37 cm)
MUSEUM OF FINE ARTS, BOSTON, FRANCIS BARTLETT DONATION OF 1912 AND PICTURE FUND, 14.646

Although the subject of this fine painting is not identified by inscription, the attributes of the rider and the battle being waged in the far background leave no doubt that this is a depiction of Nadir Shah. The painting has been incorrectly assigned to India, eighteenth century,[14] and the battle misidentified as the sack of Delhi. The misattribution is understandable: equestrian portraiture depicting a ruler or general in the foreground with battles or troop reviews in the far distance is commonly found in seventeenth-century imperial Mughal painting,[15] as are the heavily modeled riders. The formula of sloping roofed houses of indeterminate European style is found as early as Abu'l Hasan's copies of European allegorical prints. Nonetheless, the work exhibits closer affinities with the Perso-European style, particularly in the treatment of the gnarled bark and broken branches of the tree, the use of cast shadows, and the sky with cumulus clouds and shading, instead of black outlines, to indicate modeling. The painting, which is unsigned, may therefore be assigned to a follower of 'Ali Quli Jabbadar or of Muhammad Zaman.

Muhammad 'Ali, grandson of 'Ali Quli Jabbadar, was court painter to both Shah Tahmasp II (Nadir Shah's predecessor) and Nadir Shah. Although the treatment of the dappled gray horse branded on his rump and the savage hand-to-hand combat scenes closely follows that employed by 'Ali Quli Jabbadar, the similarity of this composition to those in the *Tārīkh-i Nādir*, assigned to Muhammad 'Ali, strongly suggests that all these works were executed by the same painter.[16] If that is the case, this work was executed sometime before Muhammad 'Ali's death in the late 1750s.[17]

For identification of the battle, we may look to the headgear of the warriors in the distance: the Persian warriors wear helmets, while their adversaries are shown wearing turbans wound in the Ottoman manner. This headgear clearly precludes the sack of Delhi, depictions of which always feature elephants and soldiers wearing asymmetrically wound Indian turbans; it suggests, instead, a siege during the Ottoman campaigns of the 1730s and 1740s – perhaps Tiflis or Erivan.

Nadir Shah is shown astride a rearing horse, a European convention used here for the first time in Persian painting. The ruler forcefully restrains his powerfully modeled steed, skillfully communicating Nadir Shah's domination over Iran. Mirza Mihdi Astarabadi wrote that apart from fighting, Nadir took the most delight in, first, the watermelons of Balkh and Herat, and second, a good horse.[18] By showing the monarch enjoying at least two of his favorite things, the artist of this painting has produced the quintessential image of the "Oriental Conqueror."

LSD

Literature: P. W. Schultz, *Die Persisch-islamische Miniaturmalerei. Ein Beitrag zur Kulturgeschichte Irans* (Leipzig, 1914), pl. 181; A. K. Coomaraswamy, *Les Miniatures orientales de la Collection Goloubew au Museum of Fine Arts de Boston* (Brussels, 1929), 91, no. 155.
Provenance: Victor Goloubew.

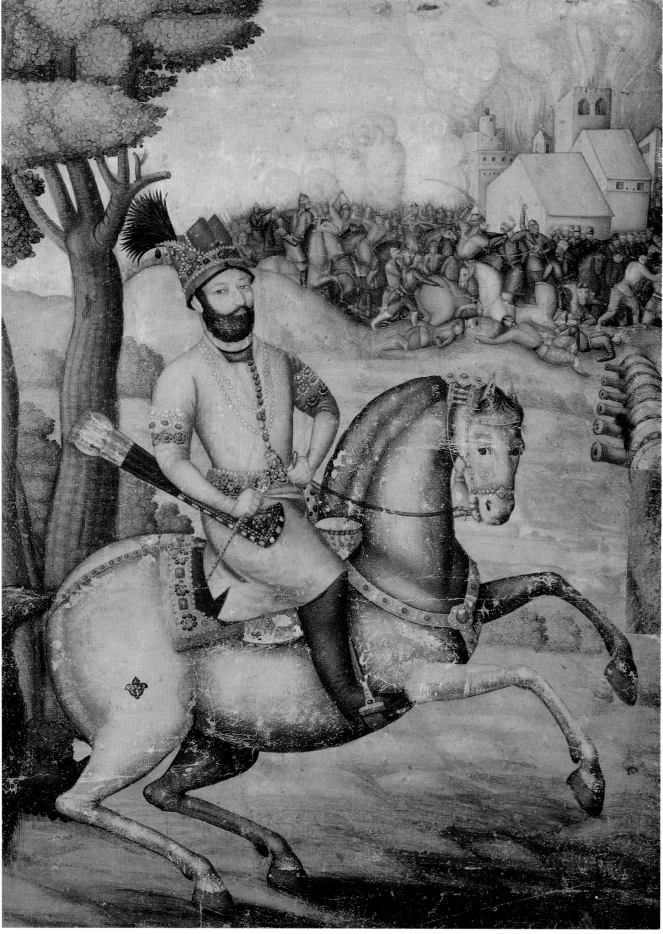

NO. 22

Notes

1. L. Lockhart, *Nadir Shah: A Critical Study Based Mainly upon Contemporary Sources* (London, 1938), 100.

2. A manual of administration written by Mirza Samia in 1725 contains a complete list of the royal workshops and the artists, calligraphers, and materials employed in the library and painting workshops. Samia 1980, 100.

3. Mirza Muhammad Mihdi Astarabadi, *Tārīkh-i Jahāngushā-yi Nādirī*, introduction by 'Abd al-'Ali Adib Burumand (Tehran, 1991), 3–8.

4. Diba 1989b, 151–53, Soudavar 1992, 383–85, no. 155 a–d. Khalili, Robinson, and Stanley 1996, vol. 22, part I, pp. 248–49, nos. 201–2.

5. Illustrated in Corneille Le Brun, *Voyage de Corneille Le Brun par la Moscovie, en Perse, et aux Indes Orientales* (Amsterdam, 1718), vol. 1, fig. 85, opp. p. 164.

6. Lockhart, *Nadir Shah*, 277.

7. Iraj Afshar, "'Akshā-yi Qadīmī va Máṟūf-i Nādir Shāh," *Jahān-i Naw* 4 (1949): 590–91.

8. John Carswell, *New Julfa: The Armenian Churches and Other Buildings* (London, 1968), pl. 79.

9. Ivanov, Grek, and Akimushkin 1962, figs. 94 and 103.

10. V. B. Meen and A. D. Tushingham, *Crown Jewels of Iran* (Toronto and Buffalo, 1968), 65–67, 77.

11. Lockhart, *Nadir Shah*, 67, 235, and 108–9, respectively. According to Willem Floor, "The Iranian Navy in the Gulf during the Eighteenth Century," *Iranian Studies* 20 (1981): 51, Nadir Shah's navy numbered fifteen ships in 1724.

12. A third possibility is that the work originally represented another personage entirely, since the principal figure wears a plain turban and sports a pointed beard in lieu of Nadir Shah's short round one. Latif Khan, Nadir Shah's admiral of the Persian Gulf (see Lockhart, *Nadir Shah*, 78ff) may have been the original subject of this composition.

13. See Muhammad Rashid Khan's portrait of Baqir Majlisi dated 1718, with similar perspectival rendering of architecture and superimposed decorative floor coverings, in B. W. Robinson et al., *Islamic Painting and the Art of the Book: The Keir Collection* (London, 1976), vol. 3, p. 212, no. 397, pl. 91.

14. A. K. Coomaraswamy, *Les Miniatures orientales de la Collection Goloubew au Museum of Fine Arts de Boston* (Brussels, 1929), 91, no. 155.

15. Martin 1912, pl. 204; Ivanov, Grek, and Akimushkin 1962, fig. 29.

16. For 'Ali Quli's *Shah and Horses*, see Ivanov, Grek, and Akimushkin 1962, fig. 100; for Muhammad 'Ali's *Battle with the Ruler of Khwarazm*, see Astarabadi, *Tārīkh-i Jahāngushā-yi Nādirī*, 257, fig. 13. Nevertheless, we cannot discount entirely the Zand court painter Muhammad Baqir, since he may have trained with Muhammad 'Ali and was extremely skilled in copying paintings by 'Ali Quli (see *Art Islamique*, sale cat., Hôtel Drouot, Paris, June 23, 1982, lot 8, *Susanna and the Elders* executed in 1764 and *A Sleeping Nymph* [Chester Beatty Library, London]).

17. Karimzadeh Tabrizi 1985–91 gives A.H. 1171/A.D. 1758; Abu'l Hasan gives A.H. 1169/A.D. 1756.

18. Cited in Lockhart, *Nadir Shah*, 273–74.

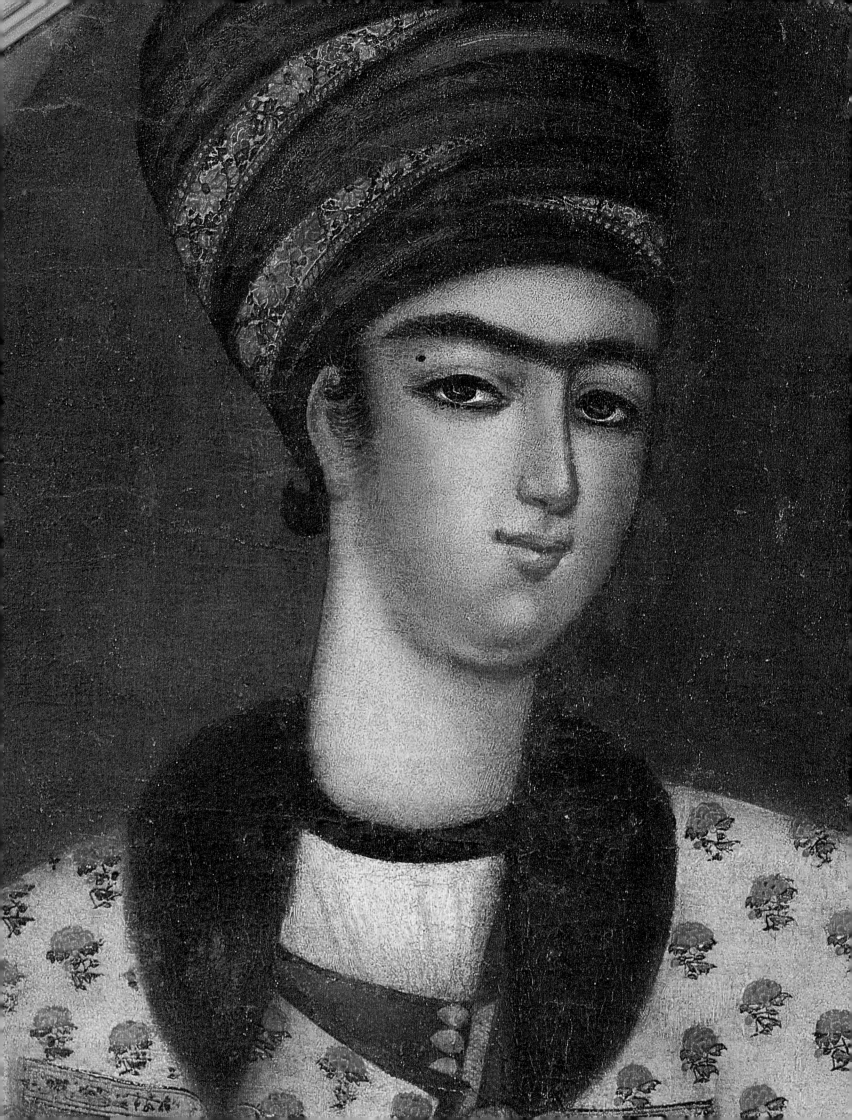

ZAND PERIOD

(1750–79)

*I*N 1765 SHIRAZ, the regional center of the Persian heartland, became the new capital of Iran. Under Karim Khan Zand, who ruled as regent in the name of one of the last Safavid descendants, Isma'il III, political stability and economic security returned to Iran. Shiraz was endowed with fortifications, palaces, mosques, and other civic amenities, emulating the splendor of Safavid Isfahan, albeit on a smaller scale. Karim Khan invited his kinsmen to establish themselves in Shiraz, and thousands of new residents were added to the population of the capital.[1]

Owing to the building programs connected with the ruler and his entourage, the tradition of life-size painting was reinvigorated. By the second half of the eighteenth century, a distinctively Shirazi painting style developed and themes that reflected Shiraz's reputation as the cradle of Persian poetry emerged.

The subject of Zand painting evolved from the cosmopolitan and imperial themes of the late Safavid and Afshar periods to poetic and intimate subjects. Paintings were now informed by a sense of lyricism and emotional expressiveness not seen since the heyday of Safavid painting. This poetic mood is exemplified by the only extant complete cycle of paintings from this period (see NOS. 29, 30).

Stylistically, although the modeling and dark palette of the Perso-European mode were retained, European features were discarded in favor of a return to the canons of Persian beauty and decorative patterning (for a comparison of these two styles, see NOS. 17, 26). Zand painting is characterized by a heavier silhouette, increased stylization of Perso-European landscape conventions, and livelier compositions.

The principal exponents of life-size painting are listed in a parahistory (covering the period 1796–1835) written by the chronicler Muhammad Asaf, known as Rustam al-Hukama. Asaf records the names of Muhammad Sadiq (active 1740s–1790s), Muhammad Baqir (active 1740s–1800), and Muhammad Zaman III (active 1750s–1790s). The names of two scribes, Mirza Muhammad and Mirza Hasan, are also given as court painters.[2] Mirza Muhammad may possibly be identified with Muhammad Kazim ibn Muhammad Riza Kirmani (active 1770s–1780s), copyist and illustrator of the *Gulshan* anthology (see NO. 31), the only extant illustrated manuscript of this period, which more than equals the lavishness of manuscripts produced for the Safavid courts. Mirza Hasan may be identified with the painter Abu'l Hasan Mustawfi Ghaffari Kashani (active 1780s–1790s), known from a number of extant watercolors of historical subjects. The youngest and perhaps most influential artist of this group, Mirza Baba (active 1789–1810), is best known for his work for the Qajar rulers.

Zand artists were as versatile as their predecessors. To the life-size paintings (both murals and oils on canvas), manuscript illustrations, watercolors, lacquer works, and enamels of the previous era, they added a new medium, that of wash drawing.

OPPOSITE: Detail, NO. 26

For the most part, the artistic legacy of the Zand period has been destroyed. Dynastic struggles broke out again following the regent's death in 1779. In 1794 Aqa Muhammad laid siege to Shiraz and ordered the destruction of the palace residential area.[3] Subsequent earthquakes demolished entire sections of the city.

Nevertheless, the contribution of Zand painters to the evolution of Persian painting cannot be overstated. Aqa Muhammad initially decorated his Tehran audience hall with Zand paintings looted from the Shiraz palace. This reign provided the foundation for the apogee of life-size painting under the Qajar dynasty. Although scenes of domesticity predominate in extant Zand works, a few rare monumental and historical paintings presage the use of life-size imagery for dynastic messages during the early Qajar period. Painters honed skills that they would subsequently apply brilliantly to the decoration of Qajar palaces of the 1780s and 1790s. Indeed, the great majority of dated paintings in the Zand style were produced during the last decade of the eighteenth century. Further, the return to the conventions of two-dimensionality characteristic of early Qajar painting was initiated in the Zand period. Finally, the interest in the expression of emotion and the psychological acuity of Zand painting contributed to the final efflorescence of late nineteenth-century Persian painting in the works of Abu'l Hasan Sani' al-Mulk and his pupils.

LSD

-23-

Shah 'Abbas II Receiving a Mughal Ambassador

Attributed to Abu'l Hasan Ghaffari Mustawfi Kashani
Shiraz, circa 1780–94
Opaque watercolor and gold on paper; 13³/₁₆ x 9⁵/₈ inches (33.5 x 24.5 cm)
COLLECTION OF PRINCE SADRUDDIN AGA KHAN, IRM 93

The adaptation of the Perso-European mode of Muhammad Zaman and his followers in the later eighteenth century is illustrated by this watercolor of a court reception of Shah 'Abbas II (the ruler is identified in the background inscription). The style had already evolved during the first half of the eighteenth century, when Zaman's followers utilized increasingly crowded compositions, heavier figural proportions, fuller turbans, and simplified European conventions and decorative devices (FIG. VI).

Although this painting has previously been assigned to Muhammad Zaman,[4] it shares many features with signed or attributable works of the Zand artist Abu'l Hasan. The lively composition, broad-shouldered figures, stiff turbans, and placid faces of the youths, derived from the early eighteenth-century painting style, are typical of Abu'l Hasan's work. Furthermore, at least two other known paintings of historical personalities by this artist utilize similar epigraphic panels in *thulth* script incorporated into arched bays (FIG. VII).[5] Abu'l Hasan's extant works, dated 1781–94, consist almost exclusively of historical personalities and portraits of his contemporaries.

Although chiefly known as a Zand historian, Abu'l Hasan apprenticed as a painter for two years before his distinguished family objected to his profession and he entered the service of Karim Khan Zand as court secretary. Abu'l Hasan's portraits were probably intended for inclusion in an album of historical personalities linking the artist's family with the Zand rulers and their predecessors (see NO. 35).

Abu'l Hasan's broad style perfectly interprets the ethos of his age, acting as a visual equivalent for the mock heroism of the contemporary parahistory *Rustam al-Tavārikh*.

LSD

Literature: Welch 1973, 85, fig. 63; Anthony Welch and Stuart Cary Welch, *Arts of the Islamic Book: The Collection of Prince Sadruddin Aga Khan* (Ithaca and London, 1982), 116, fig. 37; Falk 1985, 127, fig. 100; Diba 1989b, 156, fig. 7.
Inscriptions: In *thulth* script, on architectural panel: *al-khāqān al-khāqān . . . Ṣāḥibqarān al-Muzaffar Shāh 'Abbās-i Sānī Bahādur Khān khaldallah*

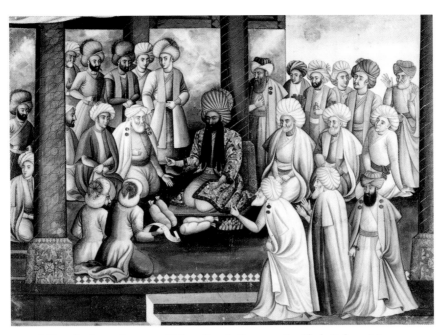

FIG. VI. *The Distribution of New Year's Presents by Shah Sultan Husayn.*
Muhammad 'Ali son of Muhammad Zaman. Isfahan, dated A.H. 1134/A.D. 1721.
Opaque watercolor and gold on paper, 9⁵/₈ x 13¹/₁₆ inches (24.5 x 33.1 cm).
BRITISH MUSEUM, LONDON, OA 1920.9-17.0299.

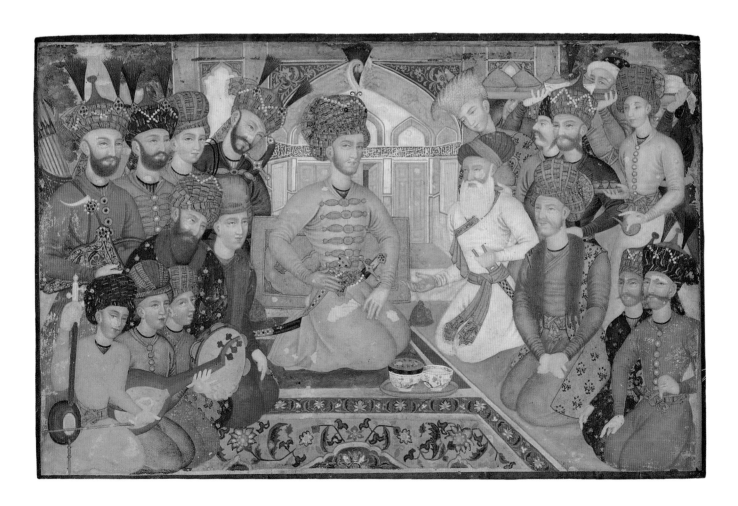

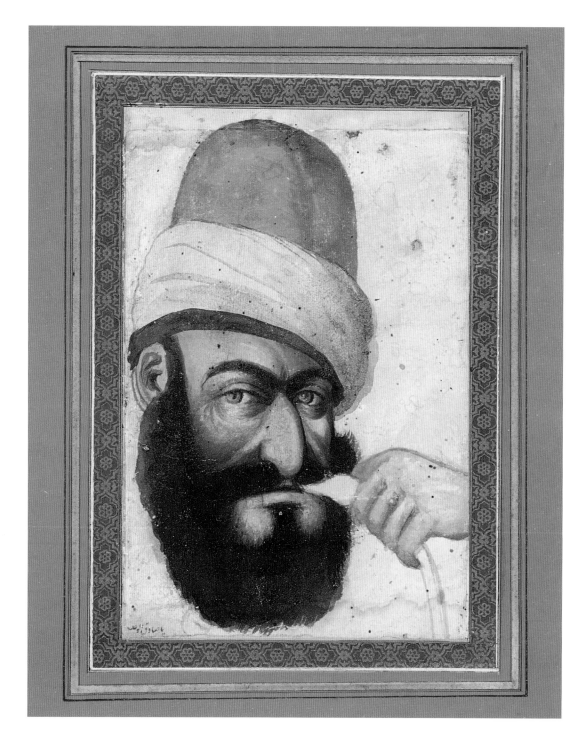

-24-

Karim Khan Zand with a Water Pipe

Signed by Muhammad Sadiq (Yā Ṣādiq al-Vaʿd)
Shiraz, circa 1770–79
Watercolor wash drawing; image 9⁷/₁₆ x 4⁵/₁₆ inches (24 x 11 cm); sheet 11¹⁵/₁₆ x 6⁵/₁₆ inches (30.4 x 16.1 cm)
MUSÉE DU LOUVRE, PARIS, SECTION ISLAMIQUE, MAO 796

Although the subject is not identified, this wash drawing of a bearded middle-aged man smoking a hookah
unmistakably portrays the regent. Of the known portraits of the ruler executed during his lifetime,⁶ this
is the most immediate and revealing. The ruler's face, shown in three-quarter view against a plain ground,
occupies the forefront of the picture plane. With this work, Sadiq, primarily known for his lyrical
subjects, revealed his great skills as a portraitist: he allowed nothing to detract from the intensity of

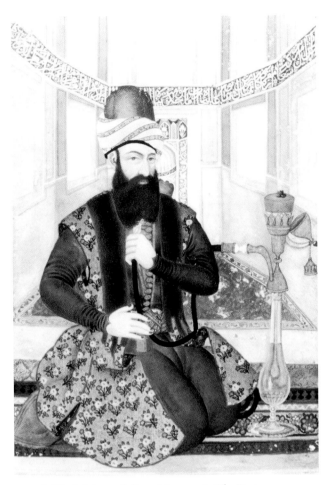

FIG. VII. *Mu'izz al-Din Mustawfi Ghaffari.*
Signed Abu'l Hasan Ghaffari. Shiraz, dated A.H. 1196/A.D. 1781–82.
Unfinished watercolor, 7¹/₈ x 5 inches (20 x 13.5 cm).
PRIVATE COLLECTION.

the image. Karim Khan's square jaw clenching the tobacco pipe, his tall domed Zand cap, and his piercing gaze capture the modesty and authority for which the ruler was known.

Karim Khan is portrayed in middle age: Sadiq's treatment of the face emphasizes his wrinkles and furrowed brow, joined heavy eyebrows, hooked nose, and deep-set hazel eyes, suggesting that the painter was working from life and that the work was executed late in the ruler's reign.

Also notable is the inscription at the lower left incorporating the artist's name. The use of metaphorical inscriptions introduced during the Safavid period remained current until the mid-nineteenth century. The inscription here may be accepted as a self-signature. Sadiq's works are signed, in a compact *naskh* script, with his proper name, Muhammad Sadiq, or with the formula Yā Ṣādiq al-Va'd (O thou who art true, referring to Ja'far al-Sadiq, the sixth imam). The latter is sometimes written with an elongated form of "Va'd." This inscription exhibits the same form and style of signature found in Sadiq's works of the late 1760s to 1780s (FIGS. VIII, XI).

Safavid drawings are celebrated for their draftsmanship and linear virtuosity. Although late Safavid artists such as Shafi' 'Abbasi and Jani Farangisaz added soft pastel washes to their drawings for detailing,[7] wash drawing was a late eighteenth-century innovation. Sadiq's handling of the white fabric wound around the red cap, the beard, and the delicate gradations of the red felt cap shows his skill in this new medium. Since the wash technique was foreign to Persian tradition, this innovation may be cited as further evidence of Persian artists' continued interest in foreign techniques.

LSD

Literature: Bernus-Taylor 1997, 41.
Inscriptions: In *naskh* script, lower left: Yā Ṣādiq al-Va'd (O thou who art true)

-25-
Karim Khan Zand and His Kinsmen

Attributed to Muhammad Sadiq
Shiraz, after 1779
Oil and metal leaf on canvas; 51 x 109 inches (129.5 x 276.8 cm)
COLLECTION OF MRS. ESKANDAR ARYEH

This monumental painting represents the archetypical Zand state image.[8] Even this official image of the
regent and his family is treated with a degree of informality not found in representations of Nadir
Shah or Fath 'Ali Shah. The ruler kneels on plain felt rugs, casually leaning forward as he smokes his
pipe. Wearing the Zand turban, unadorned by imperial regalia or royal attributes, Karim Khan sits in
a columned porch devoid of decoration except for marbleized dadoes and exposed brickwork. The
only indications of his rank are the respectful attitudes of the figures standing on either side of him
and the single great monolithic stone column, so closely associated with the palace architecture of his
reign. The ruler's strength is subtly conveyed by a pose that emphasizes the broad shoulders for
which he was celebrated.[9]

This work presents distinctive characteristics of the Zand style. Features are heavily modeled, and figural proportions sturdy. The depiction of the faces is highly expressive, verging on caricature, and some figures have been identified (such as the blind courtier to the ruler's right representing Karim Khan's brother, Sadiq Khan).[10] Although the realism of the image is enhanced by the dark palette emphasizing the olive flesh tones of the figures and the brown ground, the decorative tendency of Persian painting reasserts itself in the surface patterning, enlivened by graceful wound turbans, delicate floral designs, and an elaborate cut-glass water pipe.

Although unsigned, the work may be attributed to Muhammad Sadiq. The portrait of the ruler signed by Sadiq (NO. 24) in which the ruler's features are similarly treated may have served as a sketch for the finished painting. The attribution to Sadiq is further supported by the work's similarity to a portrait of Rustam Khan Zand (NO. 26) that is also signed by Sadiq with his metaphorical signature. The most apparent affinities are in the heavily shaded faces, turbans, small-scale floral patterns of the robe, and proportions. Furthermore, the highly finished detailing of *Karim Khan and His Kinsmen* recalls the decorativeness of female representations assigned to Sadiq.

The image has an overall tone of seriousness that does not correspond to reports of the coarse humor and jocularity prevailing at the court. The courtiers appear very serious, with frowning or saddened countenances. This painting may have been intended as a commemorative portrait, commissioned after the ruler's death.[11]

LSD

Provenance: Eskandar Aryeh Collection.

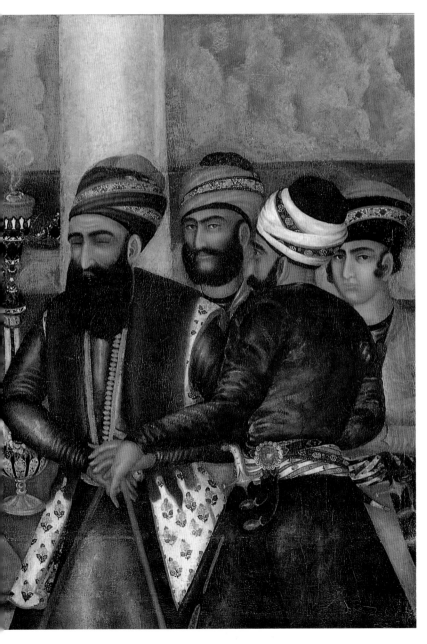

-26-

Rustam Khan Zand

Signed by Muhammad Sadiq (Yā Sadiq al-Va'd)
Shiraz, circa 1779
Oil on canvas; 58 x 35 inches (147.3 x 88.9 cm)
COLLECTION OF MRS. ESKANDAR ARYEH

This painting and NO. 27 were cut to fit pointed niches. The work depicts a young prince in Zand costume, previously identified as Rustam Khan Zand,[12] the grandson of Karim Khan's half brother, Zaki (r. 1779). The features (slight double chin, rosebud mouth, and wide-set, shadowed eyes), costume, and pose of this youth bear marked similarities with inscribed portraits of the last of the Zand rulers, the valiant and handsome Lutf 'Ali Khan (r. 1789–94), Karim Khan Zand's nephew.[13] Nevertheless, the identification with Rustam Khan is confirmed by the inscription to the figure's left, which reads: "likeness of Muhammad Rustam Khan."

Zaki Khan ruled for one year only, and the work was probably executed close to that time. This dating is consistent with the stylistic features of the work, which indicate a mature stage in the evolution of the Zand style. The heavy modeling of the face, elegant proportions of the figure, and dark palette are consistent with Sadiq's other signed life-size paintings of the 1770s and 1780s.

This rare historical portrait of an otherwise minor figure in the annals of the period exemplifies the Persian ideal of youthful masculine beauty. Furthermore, Sadiq's positioning of the figure against a background of horizontal and vertical patterning in geometric, arabesque, and floral designs confirms the decisive influence of Zand painting, particularly the style evolved by Sadiq and his followers, in the formulation of early Qajar life-size court painting.

LSD

Literature: *Zand and Qajar Paintings from Private Collections*, exh. cat.,
Iran-America Society Cultural Center (Tehran, 1974), fig. 4.
Provenance: Eskandar Aryeh Collection.
Inscriptions: In *nasta'līq* script, right-hand and left-hand center: *Yā Ṣādiq al-Va'd . . . shabīh-i Muḥammad Rustam Khān*

Details of signature (right) and inscription (left), NO. 26

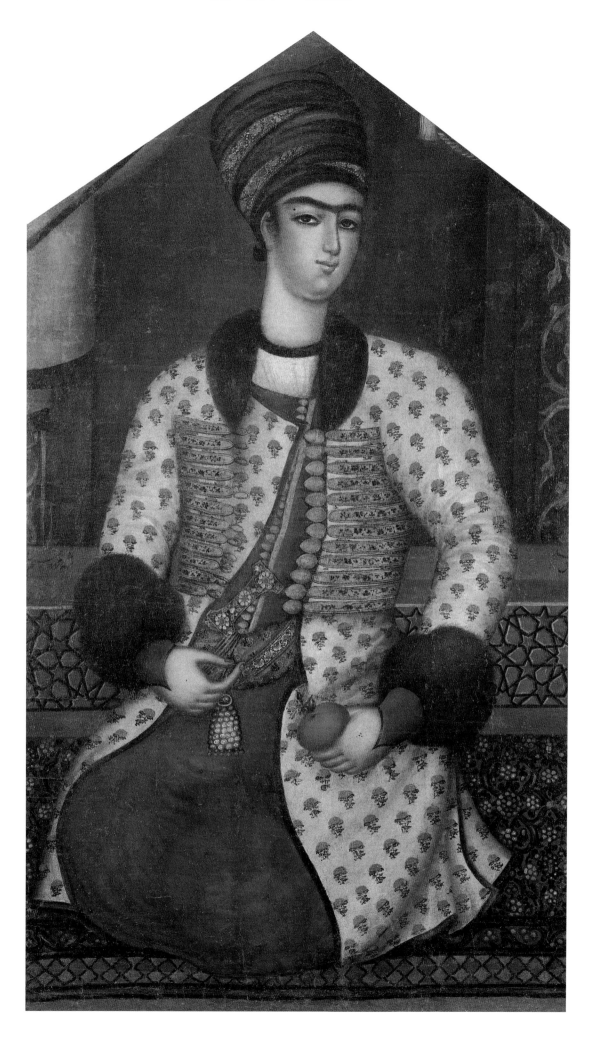

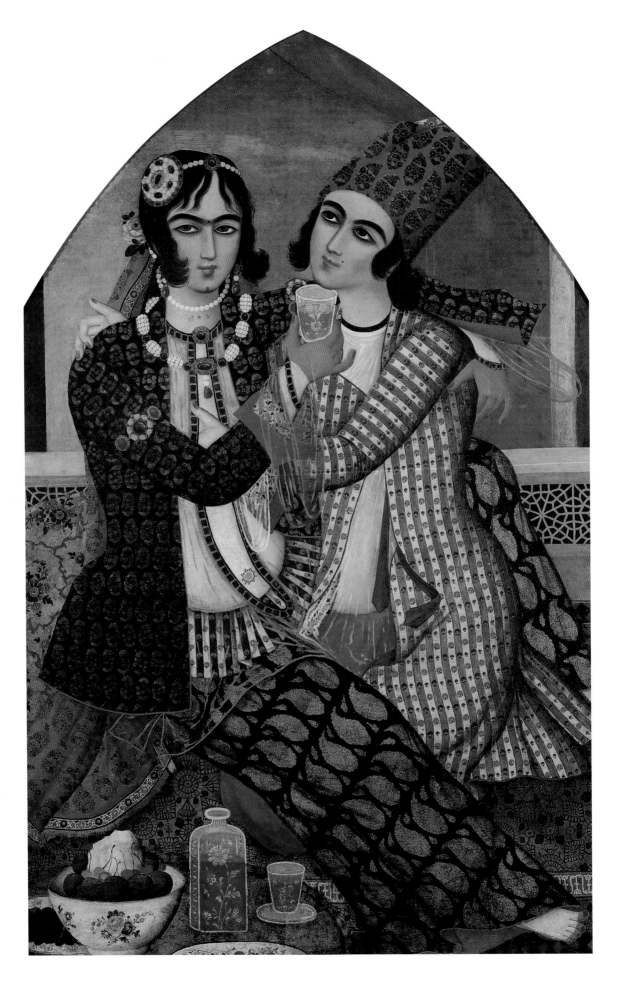

-27-

Embracing Lovers

Attributed to Muhammad Sadiq
Shiraz, circa 1770–80
Oil on canvas, 59 x 38 inches (149.8 x 96.5 cm)
COLLECTION OF MRS. ESKANDAR ARYEH

In this work, which epitomizes the lyricism and charm of Zand painting, two youthful lovers embrace, with their arms and legs intertwined, in a lavishly appointed interior. The woman gazes invitingly at the viewer as her companion admires her. In contrast to the impassive expression of figures in late Safavid representations of similar themes, a half-smile plays over the countenances of the lovers (cf. NO. 12). The directness of the woman's gaze, the informality of the lovers' pose, and the warm palette all contribute to the sense of intimacy created between the viewer and the painting. This image of a loving couple, although framed in the conventional terms of Persian poetic and artistic conventions, is nonetheless emblematic of the rarely seen sensual and erotic dimension of Persian private life.

An idealized image of the luxury and refinement of court lifestyle is conveyed by the rich fabrics, lavish gilt patterning, and impasto of the jewelry. Delicate cut-glass decanters of wine, fruits, and sherbets prominently displayed in the foreground also allude to the *dolce vita* of eighteenth-century Shiraz. In a broader sense, however, the image exemplifies the romanticism of Persian poetry.

The modeling of the faces and bodies is counterbalanced by the rich interplay between the striped and floral textile designs and the figures' limbs, which combine to form an abstract pattern. As in *Two Lovers Embracing* (The Metropolitan Museum of Art, New York, 50.164), a masterpiece of the Safavid painter Riza 'Abbasi, the design symbolizes the impending union of the lovers.

Zand painting canons were shared by the principal court artists, and it is particularly difficult to attribute idealized representations of women and lovers. Nevertheless, the arched eyebrows, aquiline noses, narrow kohl-rimmed eyes of the countenances, elongated body proportions, and stiff treatment of the wide trousers are also characteristic of other life-size paintings signed by Muhammad Sadiq (see FIG. VIII) and support an attribution to this painter. Moreover, the similarity to FIG. VIII strongly suggests that the two paintings were part of the same decorative cycle.

LSD

Provenance: Andy Warhol; Eskandar Aryeh.

FIG. VIII. *A Girl Playing a Mandolin.*
Muhammad Sadiq (signed Yā Ṣādiq al-Va'd).
Shiraz, dated A.H. 1183/A.D. 1769–70.
Oil on canvas.
FORMERLY COLLECTION OF M. FORUGI, TEHRAN.

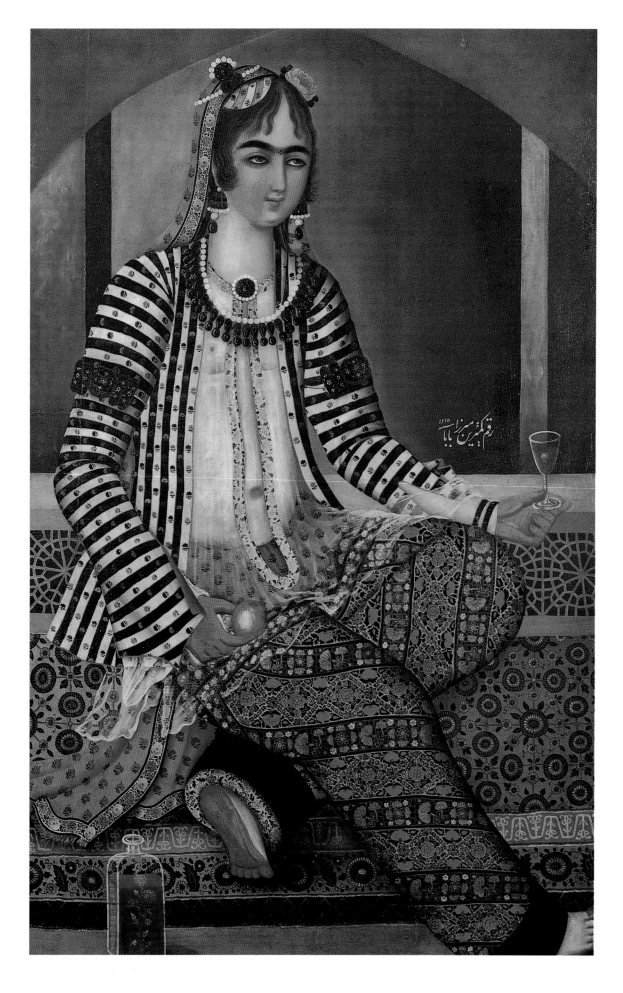

-28-
A Tipsy Lady

Signed by Mirza Baba
Possibly Tehran, dated A.H. 1215/A.D. 1800–1801
Oil and metal leaf on canvas, 57½ x 37 inches (146 x 94 cm)
COLLECTION OF MRS. ESKANDAR ARYEH

This representation of a charmingly tipsy lady, one of a dispersed series of frank and sensual images of women, exemplifies the eternal appeal of Zand painting by providing a glimpse behind the Persian woman's veil of seclusion. The lady's countenance and body correspond to the classical canons of Persian beauty as interpreted in the Zand period: her moon-faced visage, joined eyebrows, bow-shaped, doelike eyes, and flower-bud mouth are invitingly displayed. In her right hand she delicately holds a two-colored apple, and with the left, she extends a glass of wine to an absent lover. Both of these attributes act as visual equivalents for poetic metaphors: in Persian culture, apples represent love and fruitfulness, while wine is a favored metaphor for earthly and divine love. As in the previous work, such images had an undeniably strong erotic as well as aesthetic impact intended to fan the flames of male viewers' ardor.

The richly patterned and stiffly embroidered trousers and jacket of striped cashmere, diaphanous blouse, thick spit curls, bangs, and jauntily posed cap are characteristic of the late eighteenth-century figural style, which prevailed until the second quarter of the nineteenth century. The mix of two- and three-dimensionality is typical of Zand style: the pillar and openwork wooden balustrade are shown with cast shadows and the figure is posed obliquely with her foot tucked under her, while the carpet is treated as a flat pattern tilted up to the front of the picture plane.

To judge from similarities with NO. 27, Mirza Baba may have trained with the older master Muhammad Sadiq. Mirza Baba's skill as a painter is seen in the intricately detailed pattern of the trousers, in which each bud is individually painted, the delicate treatment of the subject's blouse, and the transparency of the stemmed glass that she holds.

By 1800 Mirza Baba had been in the service of the Qajar rulers for more than ten years. Mirza Sadiq Vaqayi'nigar records that in 1802 he designed the marble throne of the capital's audience hall. Since this work was executed shortly beforehand, it may have been intended for the decoration of one of Fath 'Ali Shah's palaces in the citadel.[14]

LSD

Provenance: Eskandar Aryeh.
Inscriptions: In *nasta'liq* script, right center: *raqam-i kamtarin Mirzā Bābā sanah 1215*

-29a–g, 30-
Pictorial Cycle of Eight Poetic Subjects

Artist unknown
Shiraz, mid-18th century
Oil on canvas; each approx. 39 x 36½ inches (99 x 91.4 cm)

These eight lyrical paintings constitute the only extant cycle of such works outside Iran. Collectively, they are valuable documents of the original architectural format and narrative program of eighteenth-century domestic interiors: these oil-on-canvas paintings were cut to fit small niches located in the upper walls of the reception room of a residence or a pleasure or hunting pavilion (see FIG. IX).[15]

The paintings depict beloved love stories from the classic works of celebrated Iranian poets such as Nizami and Jami, and hunting vignettes. The works acted as visual complements for poetry that the host, his guests, or storytellers would recite to entertain each other at convivial gatherings. The subjects range from biblical and Qur'anic episodes centering on Joseph and his brethren and the unrequited passion of the Egyptian queen Zulaykha; to the visit of Layla to her doomed lover Majnun in the desert; to episodes from the loves of the Sasanian ruler Khusraw and Shirin, the beautiful queen of Armenia.

FIG. IX.
*Reconstruction
of Zand
Pavilion.*
Produced by
Adrian Kitzinger.

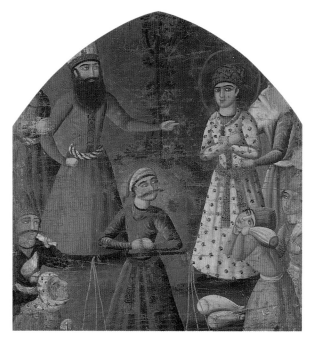

29a. *The King Appointing Joseph as Manager of the
Granaries of the Realm*

BROOKLYN MUSEUM OF ART, BEQUEST OF IRMA B. WILKINSON, 1997.108.3

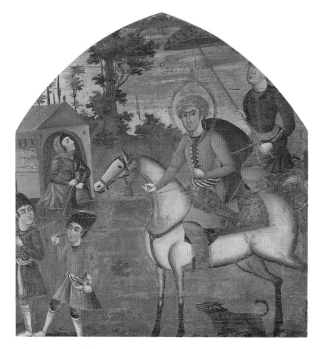

29b. *Sultan Sanjar and the Old Woman*

BROOKLYN MUSEUM OF ART, BEQUEST OF IRMA B. WILKINSON, 1997.108.4

Although the themes of these works are derived from manuscript painting, their treatment differs considerably: the scale of figures in relation to the background is larger, while the number of figures and degree of ornamental patterning is reduced. The palette is restricted to red, blue, cream, and brownish green hues, and unmodulated, broad passages of color predominate. The earliest extant poetic cycle of wall paintings in Na'in,[16] datable to the mid-sixteenth century, exhibits thematic and organizational features similar to those of this group, although the Na'in cycle adheres much more closely to the conventions of contemporary manuscript illustration.

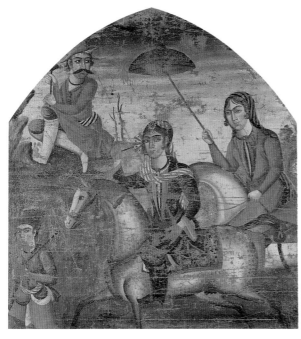

29c. *Queen Shirin Visiting the Sculptor Farhad*
BROOKLYN MUSEUM OF ART, BEQUEST OF IRMA B. WILKINSON, 1997.108.5

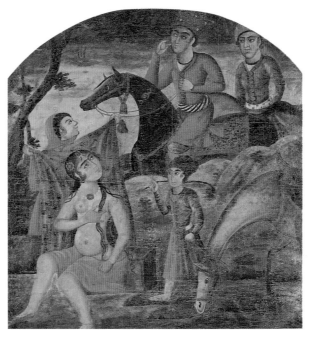

29d. *Khusraw Discovers Shirin Bathing*
BROOKLYN MUSEUM OF ART, BEQUEST OF IRMA B. WILKINSON, 1997.108.7

29e. *Bahram Gur and Azadeh*
BROOKLYN MUSEUM OF ART, BEQUEST OF IRMA B. WILKINSON, 1997.108.6

29f. *Hunter on Horseback Attacked by a Lion*
BROOKLYN MUSEUM OF ART, BEQUEST OF IRMA B. WILKINSON, 1997.108.1

29g. *Hunter on Horseback Attacked by a Mythical Beast*
BROOKLYN MUSEUM OF ART, BEQUEST OF IRMA B. WILKINSON, 1997.108.2

30. *Layla Visiting Majnun in the Desert*
THE METROPOLITAN MUSEUM OF ART, NEW YORK, BEQUEST OF CHARLES K.
WILKINSON, 1986, 1987.355.I

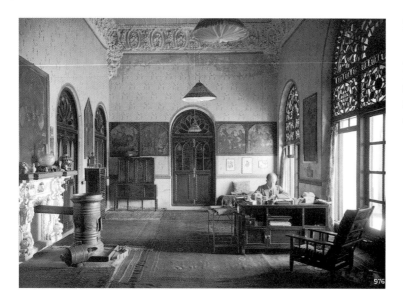

FIG. X. *Ernst Herzfeld in His Study in Tehran Surrounded by Eight Qajar Paintings.*
Photograph, Tehran, circa 1929.
FREER GALLERY OF ART, SMITHSONIAN
INSTITUTION, ARTHUR M. SACKLER GALLERY
ARCHIVES, ERNST HERZFELD PAPERS.

 Although the paintings are neither signed nor dated, they exhibit particularly close affinities with illustrated manuscripts of the 1780s produced in Isfahan and Shiraz and with paintings of related subjects signed or attributable to Mirza Baba that were painted in 1794.[17] These works exemplify the popular style of painting produced for wealthy urban elites and considerably broaden the repertoire of Zand painting.

 In contrast to many paintings of this period, the provenance of these works is well documented. Charles K. Wilkinson, Curator of Near Eastern Art at the Brooklyn Museum of Art from 1969 to 1974, acquired these paintings from the renowned archaeologist Ernst Herzfeld (FIG. X).

<div align="right">

LSD

</div>

Provenance: Ernst Herzfeld.

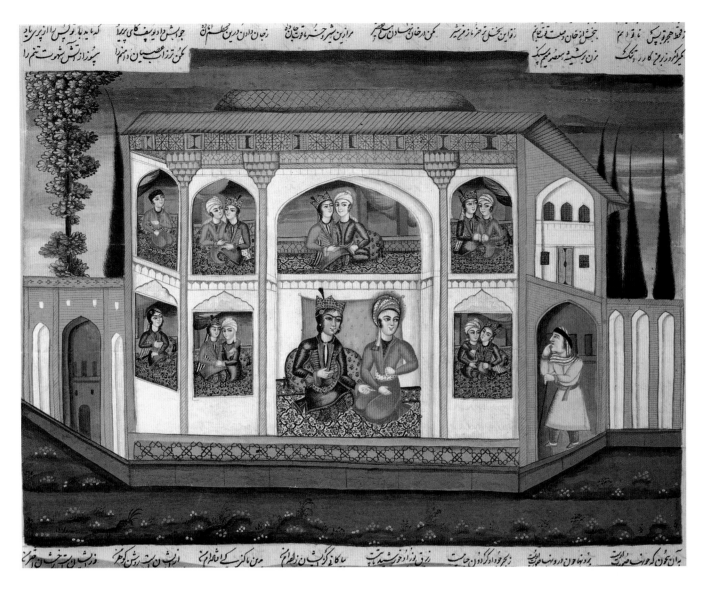

-31-

Manuscript of the "Gulshan" Anthology

Probably Isfahan, late 1780s–early 1790s
Opaque watercolor and gold on paper, *nasta'liq* script; 14½ x 10¼ inches (36.6 x 26 cm)
THE SAINT PETERSBURG BRANCH OF THE INSTITUTE OF ORIENTAL STUDIES, RUSSIAN ACADEMY OF SCIENCES, E12

This anthology's title, *Gulshan* ("small flower garden"), is given by the compiler in a small versified frag-
ment, or *qit'ah* (folio 334b). The compiler, Muhammad Kazim ibn Muhammad Riza Kirmani, was the
copyist of the whole manuscript and the author of seven poems (*masnavi*) and a number of small
poetry works. Muhammad Kazim's pen name was Mahjur, and we know from folio 380a, dated June
13, 1785, that he flourished in the 1780s. The only available information about him consists of his own
remarks and notations on this anthology. A literary man, poet, and artist who was undoubtedly highly
educated, he apparently was in the service of a khan of the Qajar tribal alliance. In any case, he found
it appropriate to place a fragment of a poem (folio 95b) written earlier, on the victory in southern Azarbai-
jan of Muhammad Husayn Khan Qajar (1715-1759) over Azad Khan Ghilza'i, the former comman-
der under Nadir Shah (murdered in 1747). On folio 334b the compiler inscribed that he compiled
the *Gulshan* anthology for a certain Navvab Khan, without naming his patron.

Muhammad Kazim worked on the anthology intermittently over a period of nearly eight years. A
unique example of an oversize secular manuscript, it is also distinguished by its range of genres and forms
of compositions, drawn from Persian poetry of the eleventh to eighteenth centuries. In fact, it is a
complete portable library in one volume. The manuscript was copied in parts and was presumably bound

later (which would account for the diversity of dates, ranging from 1777 to 1784, of individual works included). Forty-six pages are blank, indicating that the manuscript was not filled consecutively, page after page.

The anthology contains 103 poems and prose works of different length and style by forty-seven authors. The authorship of seventeen poems cannot be determined.

Besides the Persian authors' compositions, the collection includes works in Osmanli (Fuzuli, Khavari, Zamiri), Chaghatai (Nava'i), and Kurdish (Ahmad Khani Afrad). Fragments of long poems (those by Firdawsi, Nizami, and Nava'i, for example) are given, as well. The thoroughness of the compiler, whose texts are generally reliable, is notable.

The main scholarly value of the *Gulshan* anthology lies in the unusually rich representation of works of seventeenth- and eighteenth-century Persian poets working in Iran and India (more than half of the total), including small-scale poems (*masnavi*) celebrating actual events. This period witnessed an increased interest in such narrative *masnavi*. Poems were sharply shortened, themes became more ordinary, and more attention was paid to everyday human concerns and feelings, even in poems with traditional themes. The anthology offers rich material for the study of Persian seventeenth- to eighteenth-century poetry and the literary movement of Bazgasht, which was contemporary with the compiler.

The anthology is decorated with 100 miniatures; apparently no fewer than three Isfahan painters took part in this work. All miniatures are illustrations to the corresponding poetic works. Features typical of both the Afsharid (1736–47) and Zand (1750–79) periods can be observed. The miniatures are of rather large dimensions and exhibit a high level of professional craftsmanship rather than artistic individuality.

The painting illustrated, *Zulaykha Meeting Yusuf in Her Newly Built Palace* (folio 205b; one of ten illustrating the same poem) accompanies the poem *Yusuf va Zulaykha*, completed by 'Abd al-Rahman Jami (1414–1492) in 1483. This poem, the third part of the poet's famous *Khamseh* (Quintet), is a versified commentary on "the most beautiful tale" of the twelfth sura of the Qur'an entitled "Yusuf," composed in the vein of pure Muslim mysticism (*taṣawwuf*). Jami's poem offers his interpretation of the *taṣawwuf*'s notion of spiritual love. The Qur'anic story of Yusuf is treated by Jami in a symbolic and abstract way. Spiritual, nonsensual love for divine beauty is presented as the best means to comprehend God and to attain spiritual union with the Truth. Thus, Zulaykha, moving from her sensual passion for her slave Yusuf to purely spiritual love, ultimately attains true knowledge by adopting Islam.

Trying to win Yusuf's affection at any price, Zulaykha ordered a marvelous garden palace to be built with seven halls (*khāneh*) covered with paintings. Once the palace was completed, Zulaykha showed Yusuf one hall after another, talking of her passion and love. Despite her passionate prayers, ardent confessions, and threats to kill herself before Yusuf's eyes, she did not attain the love of Yusuf, who fled from the palace. The painting depicts the very moment when Zulaykha and Yusuf were in the seventh hall, decorated with portraits of the lovers embracing passionately. Zulaykha entreats Yusuf (with a golden halo around his head) with pleas to allay her passion, indicated by the symbolic gesture of her left hand.

This subject was depicted much less frequently than others from the poem (such as Zulaykha presenting Yusuf to the Egyptian women or the merchant Malik extracting Yusuf from the well). As a rule, miniatures of this subject may be seen only in eighteenth- and nineteenth-century Kashmiri copies of Jami's poem.

The miniature is eclectic in style. Though it displays a two-dimensional flatness, it also contains elements typical of the Isfahan school of the mid-seventeenth to mid-eighteenth century, with its devices of European painting such as modeling, chiaroscuro, and perspective, and those of late Zand miniatures. If the former is reflected in the interpretation of the tree's leaves at the left side of the building, in the thin, lightly curved cypress silhouettes, in the presentation of the sky in separate blue brushstrokes, as well as in the awkward use of chiaroscuro and perspective to show the building's volume, the latter is displayed in the bright, colorful palette of the figures, the headdress shapes, the robes fitted at the waist, and the visible absence of expensive jewelry.

OFA

Literature: O. F. Akimushkin, *Opisaniye persidskikh i tajikskikh rukopisei Instituta vostokovedeniya Rossiyskoi Akademii Nauk* (A descriptive catalogue of the Persian and Tajik manuscripts in the Institute of Oriental Studies of the Russian Academy of Sciences), no. 10 (Moscow, 1993), no. 11, pp. 55–100.
Provenance: Donated by the People's Commissariat of Foreign Affairs in 1919.

-32-
Mirror Case

Signed by Muhammad Sadiq (Yā Ṣādiq al-Vaʿd)
Shiraz, dated A.H. 1189/A.D. 1775–76
Pasteboard, opaque watercolor and gold under lacquer; 10¹/₄ x 7¹/₄ inches (25.6 x 18.2 cm)

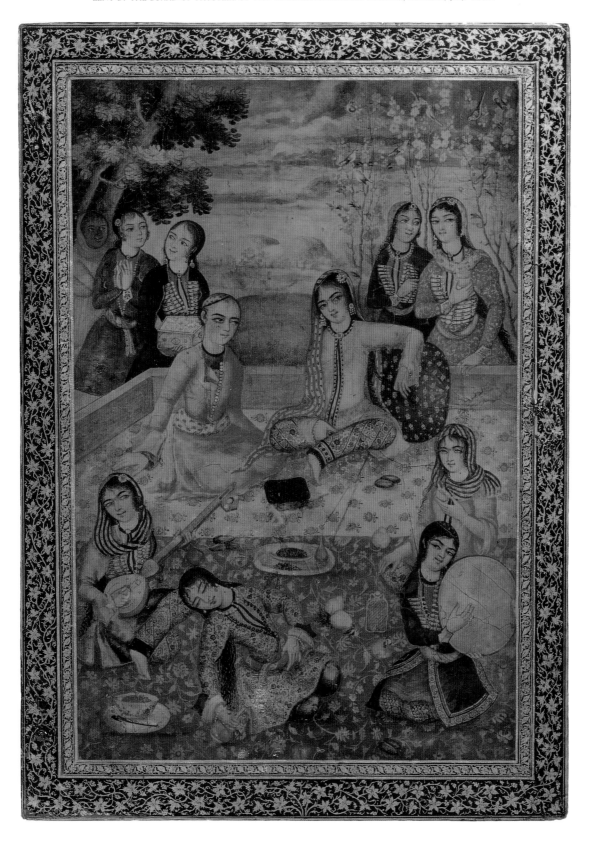

FIG. XI. *Penbox.*
Muhammad Sadiq (signed Yā Ṣādiq al-Vaʿd). Shiraz, dated A.H. 1144/A.D. 1780–81.
Pasteboard, opaque watercolor and gold under lacquer.
FORMERLY NEGARESTAN PALACE MUSEUM, TEHRAN.

Although the body of eighteenth-century manuscripts and detached single-page paintings is meager, the tradition of small-scale exquisite figural compositions for which Persian painting is renowned reached new heights in Zand painted lacquerwork. Here, the master Aqa Sadiq expertly replicated in miniature scale the hunting and lyrical themes of wall painting. In both details and overall composition, Sadiq's work (see also FIG. XI) closely follows Perso-European prototypes, particularly the work of Muhammad Zaman (for the figure of the falling horseman and the elliptical composition of the hunting scene, cf. NO. 9; for the setting, figural poses, and groupings of the amorous scenes on the reverse, cf. NOS. 12 and 13). The gracefulness of Sadiq's figures and his skill in rendering complex compositions frequently surpassed that of his models.

LSD

Literature: Robinson 1967, 123, pl. 95; Diba 1989a, 248, fig. 6; Diba 1994, 641, no. 104.
Provenance: Acquired in Tehran on April 16, 1888, by Colonel Robert M. Smith from Dr. W. W. Torrence.
Inscriptions: In *nastʿalīq* script, within cartouche on inner lid: *Yā Ṣādiq al-Vaʿd 1189*

Notes

1. Perry 1979, 274; Varjavand 1974, 8–9.
2. Muhammad Hashim Asaf 1969, 1986 trans., vol. 2, p. 679.
3. Although Sami 1958, 27, claims that all of Karim Khan's buildings were still standing in the 1920s, the destruction of the quarter of Muradieh, where the Zand rulers resided, is recorded in the sources. See Varjavand 1974, 88.
4. Anthony Welch and Stuart Cary Welch, *Arts of the Islamic Book: The Collection of Prince Sadruddin Aga Khan* (Ithaca and London, 1982), 117. For a dissenting view, see A. A. Ivanov, "The Life of Muhammad Zaman: A Reconsideration," translated by Michael Rogers from the Russian, *Iran* 17 (1979): 68.
5. See Diba 1989b, 155, fig. 6, for Shah Safi (r. 1629–42); Yedda Godard, in *Iran: Pièces du Musée de Tehran*, exh. cat., Musée Cernuschi (Paris, 1948), 74–75, no. 152, for Jahanshah Qaraquyunlu; and Mustawfi 1950, fig. 1, for others. The background design of this work replicates the facade and tile panel with *thulth* inscription of the *khudakhaneh*, a stone building in the center of Shiraz's congregational mosque, built in A.H. 752/A.D. 1351. Sami 1958, 83, ills. (unpag.).
6. See Adamova 1996, 38, fig. 8; Mustawfi 1950, 37, fig. 4, and Robinson 1991, fig. 1.
7. Sheila R. Canby, *Persian Painting* (London, 1993), 108, fig. 72, and 115, fig. 79, respectively.
8. The arched shape of the painting, which was altered at a later stage to a rectangular format, documents that the work was intended for display in the niche of a reception room or pavilion. A number of versions are recorded: see Perry 1979, fig. 7, for a signed version by Ja'far in the Pars Museum, Shiraz, and a late nineteenth-century copy in The Ethnographic Museum, Tehran. Another version is housed in the Malik Library, Tehran. During recent treatment, the Malik painting revealed a figure in late nineteenth-century costume underneath the figure of Karim Khan Zand. Oral communication, Mrs. Ezzat Soudavar.
9. See Perry 1979, 275, for an anecdote about Karim Khan's physical strength.
10. Personal communication of Farrukh Ghaffari to the author.
11. This was not uncommon: Perry 1979, 287, notes that Karim Khan commissioned a portrait of his favorite courtesan after her death. This would explain also the depressed aura noted in the watercolor of Shah Sultan Husayn (FIG. VI).
12. Tehran 1974, fig. 4.
13. Mihdi Bahrami, "Taṣvīr-i Luṭf ʿAlī Khān Zand," *Yādigār* 1, no. 5 (1944): 65.
14. Vaqayi'nigar n.d., 382–85.
15. Technical examinations conducted during the Brooklyn Museum of Art's Curatorial-Conservation study of Qajar painting revealed that oil-on-canvas paintings were directly attached to the wall with glue or plaster, or nailed; they were also nailed to a wooden framework. Canvases of plain cotton fabric were sometimes pieced together: the canvas support of *Khusraw Discovers Shirin Bathing* (NO. 29d), for instance, is stitched together from two pieces of fabric (see Appendix in this volume).
16. Ingeborg Luschey-Schmeisser, "Der Wand und Deckeschmuck eines Safavidischen Palastes in Nain," *Archaeologische Mitteilungen aus Iran* (1969).
17. See Yuri Petrosyan et al., *Pages of Perfection*, exh. cat., Musée du Petit Palais, Paris (Lugano, 1995), 294–95, no. 58; *Treasures of Persian Art after Islam*, exh. cat., The Mahboubian Collection (New York, 1970), no. 298; Maslenitsyna 1975, no. 128; Falk 1985, no. 184, respectively.

EARLY QAJAR PERIOD

(1785–1834)

THE CORONATION of Aqa Muhammad Khan Qajar in 1785 ushered in a period of political stability, lasting more than a century, that was characterized by a revival of cultural and artistic life. The visual arts flourished, particularly during the long reigns of Fath 'Ali Shah (1798–1834) and his grandson Nasir al-Din Shah (1848–96). The consolidation of Qajar power and the establishment of the dynasty from the 1780s onward was accompanied by spectacular building programs and the production of dynastic rock reliefs throughout the country (see map, FIG. 7). As in the Zand period, imperial patronage resulted in a focus on life-size painting and imagery, but on an even grander scale.

OPPOSITE: Talar-i Takht-i Marmar, Tehran

The patronage and personality of Fath 'Ali Shah and, to a lesser extent, of the royal family[1] were pivotal to the continued prominence of life-size painting. In his direct involvement as both subject and patron, Fath 'Ali Shah recalls his Safavid predecessor Shah Tahmasp, perhaps the most influential patron and connoisseur of Persian painting. Fath 'Ali Shah himself, however, would have preferred comparison with Sultan Mahmud (998–1030) and other Ghaznavid rulers, who commissioned mural paintings of battle and feasting for their palaces in eastern Iran and present-day Afghanistan.

At its best, early Qajar painting conveys a vision of imperial grandeur combined with an immediate visual and sensual appeal. A magnificent painting of Fath 'Ali Shah and his troops defeating the Russian army (FIG. XII) (one of five surviving early nineteenth-century monumental

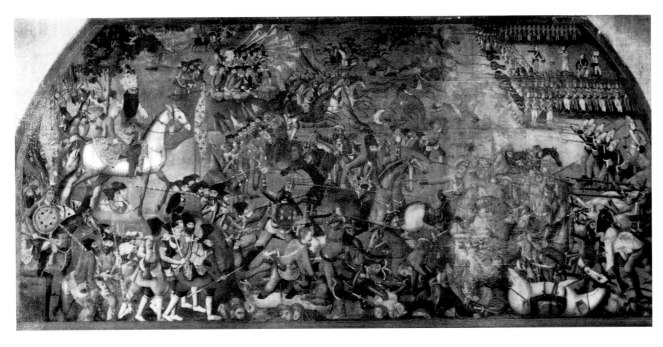

FIG. XII. *Battle of Fath 'Ali Shah with the Russians.* Tehran, early 19th century. Oil on canvas, 216⁹/₁₆ x 3546⁵/₁₆ inches (550 x 900 cm). ARCHAEOLOGICAL MUSEUM, TEHRAN.

paintings of hunting and battle) originally decorated the public audience hall of the Ashratayn palace in Tehran. In its epic scale and ambitious composition, this painting epitomizes the heroic ideals and pageantry of Fath 'Ali Shah's reign.

The hieratic stylization of painting of the second and third decades of the nineteenth century marks a decisive break with the neo-Safavid style of the Zand period and is partly derived from the imperial art of the Sasanian and Achaemenid dynasties.[2] In contrast to the Safavid period, renewed contact with Europe did not have a significant impact on artistic styles and themes (cf. NOS. 6, 41), with the notable exception of Russian and Georgian influence in Azarbaijan painting of the first quarter of the nineteenth century (see NOS. 50–53). It did, however, spur the production of paintings of the ruler and regalia intended as diplomatic gifts.

Thematically, the depiction of poetic and lyrical subjects associated with the Zand school was discarded in favor of dynastic imagery. Most noticeably absent are depictions of amorous couples, although the still lifes with landscapes introduced in the late Safavid period remained in favor for domestic interiors. The principal themes of this period – hunting, battle, and enthronement – reflect court life, whether in monumental "set-pieces" or cycles of narrow paintings of single subjects, as do the frequent depictions of ladies of the harem and paradisiacal angels.

By the second decade of the nineteenth century, early Qajar painting had evolved stylistically from the soft modeling and shading of Zand conventions to a crisper linear treatment of form dominated by saturated local colors and lavish gilding. Hieratic postures and frontality, and increasingly bold ornamental patterning replaced the informal poses and groupings, and the subtler decoration of the Zand style. The uniformity mandated by the court may be seen in innumerable static compositions balancing vertical and horizontal elements in which the subject is framed in open windows or arches within minutely patterned interiors. A new figural ideal evolved that conformed to the elongated proportions and pallid coloring, aquiline noses, heavily delineated arched eyebrows, and almond-shaped eyes of the Qajars. Long black beards, carefully groomed and dyed, and hennaed nails, hands, and feet are also typical for this period.

The variety of shapes, scale, and supports – another striking feature of early Qajar painting – reflects the decorative function of these works. Murals and oil paintings on canvas, wooden and canvas ceilings, and reverse-glass painting were embellished with an array of figural subjects. A distinctive innovation of this period is the production of rock reliefs, sculpture, and bas-reliefs.

Biographical information on early Qajar artists is scarce. In spite of copious inscriptions, artists' signatures no longer provide patronymics or information on artists' origins and student-teacher relationships. B. W. Robinson has identified more than ten principal court painters active during this period: Mirza Baba (1780s–1810), 'Abdallah (active 1812–circa 1850), and Mihr 'Ali (1798–1815) were the most accomplished, closely followed by Ahmad, Sayyid Mirza, and Muhammad Hasan in the second and third decades of Fath 'Ali Shah's reign. Allahvirdi Afshar and 'Abd al-Razzaq were also painters active in the second decade of the nineteenth century in Tabriz and the Caucasus. Court artists were required to be extremely versatile and produced works in lacquer, enamel, and watercolor in addition to life-size painting and sculpture. Persian sources record that court poets such as Fath 'Ali Khan Saba and Mijmar of Isfahan were talented painters and manuscript illustrators.[3]

Questions of chronology are relatively clear, since many works are signed and dated. Since few paintings remain in situ or bear place names, however, local styles of painting are difficult to identify. The extent of regional patronage by princes and governors remains to be investigated. Furthermore, painters of the imperial court at Tehran were often commissioned to decorate regional palaces for Fath 'Ali Shah's use; for example, Mihr 'Ali and, later, Sayyid Mirza, were dispatched to decorate the 'Imarat-i Naw and Hasht Bihisht palaces in Isfahan.[4]

Regrettably, the emphasis on life-size painting and, to a lesser extent, on tilework ultimately resulted in a decline in manuscript painting from which Persian painting never recovered. Imperial regalia and diplomatic gifts flourished, however. In exchange for the sumptuous European wares that the Persian court craved, imperial workshops produced exquisite enameled diplomatic orders and luxury objects embellished with small-scale bird, flower, and figural designs. The production of high-standard enamel and lacquer continued unabated and arguably culminated technically in the late nineteenth century. The quality of extant paintings and regalia of this period testifies that Fath 'Ali Shah was unsurpassed as a patron of the arts.

Further, the painting style developed during the reign of Fath 'Ali Shah was remarkably durable. While

change was beginning to affect the visual arts produced in the capital and Tabriz by the end of his reign, the early Qajar painting style remained current in regional painting well into the two succeeding reigns (see NO. 48).

Early Qajar painting represents the culmination of a long-standing tradition of life-size imagery and "miniature" painting. This was recognized by Charles Texier, who described the painting of this period as "the true Persian school of painting" in comparison with the more Europeanized style that gained favor during the reign of Fath 'Ali Shah's successor.[5] In many of these paintings, the search for identity in Iran's historic past is a notable theme, with which many modern viewers can identify.

LSD

-33-
*Manuscript of the "Shāhanshāhnāmeh" (Book of the King of Kings)**

Copied by Muhammad Husayn al-Haqir Bahar ibn Hasiballah
Iran, circa 1810–18
Manuscript: 438 folios in *nasta'liq* script; 26 illustrations on European laid paper, opaque watercolor, ink and gold on paper. *Binding*: pasteboard, opaque watercolor and gold under lacquer.
Page 15³/₈ x 10¹/₄ inches (39 x 26 cm); image 11¹/₁₆ x 6⁷/₈ inches (28 x 17.5 cm)
ÖSTERREICHISCHE NATIONALBIBLIOTHEK; HANDSCHRIFTEN-AUTOGRAPHEN UND NACHLASS-SAMMLUNG, VIENNA, A.F.1

This manuscript of Fath 'Ali Khan Saba's (d. 1822/23) epic poem recounting the feats of the Qajar rulers is one of four extant copies sent by Fath 'Ali Shah to English, Russian, and Austrian rulers.[6] According to the Österreichische NationalBibliothek's accession records, this manuscript (originally housed in a gold brocade cover) was donated in 1818. It was presented to the Austrian emperor Franz I (1768–1835), along with an exquisite enamel portrait of the Persian monarch in a nephrite frame (Kunsthistorisches Museum, Vienna, 3223). According to Haj Mirza Hasan Husayni Fasa'i, the Qajar historian, the envoy was Mirza 'Abd al-Husayn Shirazi, nephew of Abu'l Hasan Shirazi, Fath 'Ali Shah's ambassador to England.[7]

The illustrations begin with three images of Fath 'Ali Shah in battle, enthroned on the Sun Throne, and receiving gifts from a vizier (FIG. XIII); continue with scenes of Qajar victories over rival claimants to the throne; and end with three scenes depicting the young Baba Khan in battle with his uncle Aqa Muhammad (folio 217a, illustrated).

This impressive tome exemplifies the early Qajar manuscript style. Although the illustrations follow the conventions of Zand manuscript painting, they are characterized by thinner watercolor washes, further stylization of the landscape, repetition of stock motifs, and more elegant figural proportions and features. Although the historical figures depicted are idealized and are therefore of little value as portraiture, this manuscript and its illustrations proclaim in no uncertain terms the military might of the Qajars and the consolidation of the dynasty.

LSD

Literature: Dorothea Duda, *Islamische Handschriften. I Persische Handschriften. Österreichische Akademie der Wissenschaften Philosophisch-Historische Klasse Denkschriften* (Vienna, 1983), vol. 167, pp. 13–15 (and bibliography therein).
Provenance: See text above.
*Not in exhibition

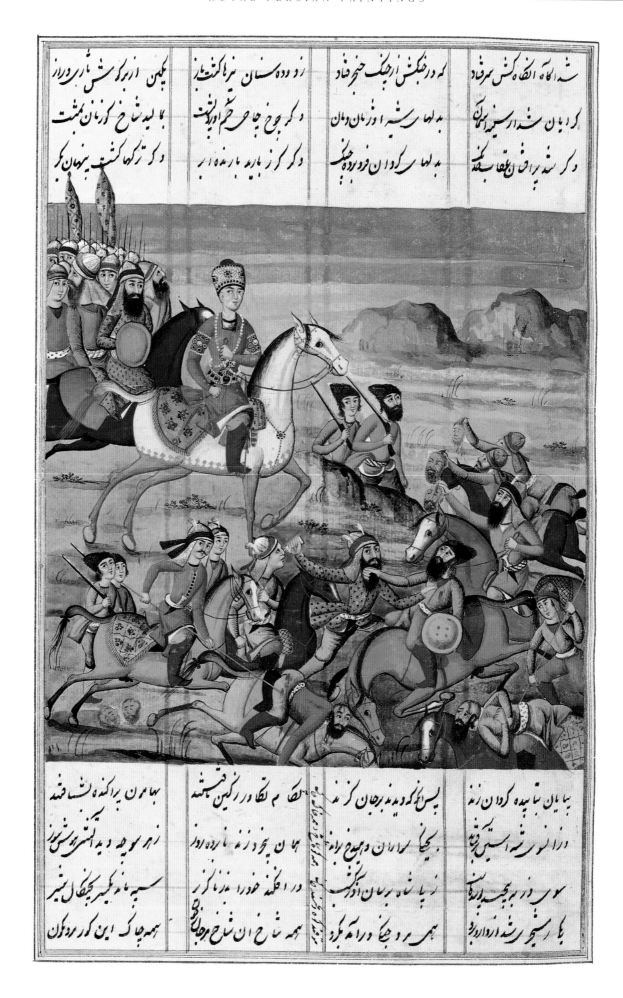

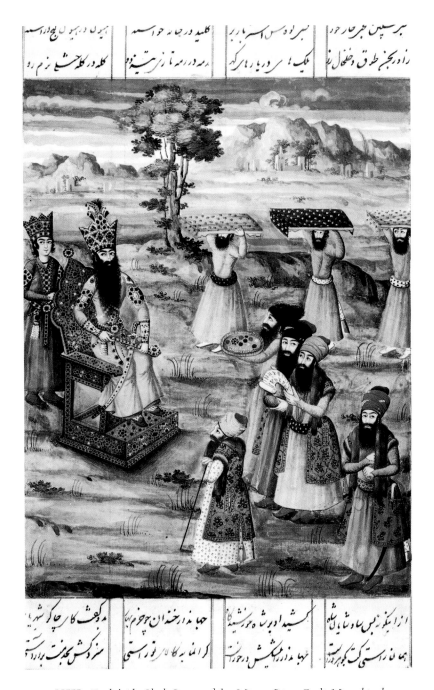

FIG. XIII. *Fath 'Ali Shah Received by Mirza Riza Quli Munshi al-Mulk in Sawdasht.*

Folio 61a from a manuscript of the *Shāhanshāhnāmeh*. Iran, circa 1810–18. Opaque watercolor, ink, and gold on paper, 15³⁄₈ x 10¹⁄₄ inches (39 x 26 cm).

ÖSTERREICHISCHE NATIONALBIBLIOTHEK, VIENNA.

-34a–c-
The Court of Fath 'Ali Shah

Artist unknown
Tehran, circa 1815
Opaque watercolor and gold on paper; central panel 23 x 20¹/₁₆ inches (60 x 52 cm);
side panels 13¹/₄ x 54 inches (33 x 135 cm)
THE ART AND HISTORY TRUST, COURTESY THE ARTHUR M. SACKLER GALLERY,
SMITHSONIAN INSTITUTION, LTS 1997.5.1–3

With its exquisite detailing, lavish gilding, and saturated colors, this image in miniature scale evokes
the powerful impression of monumental imperial enthronement scenes. The watercolor is one of a series
of reduced copies of life-size wall paintings in the Negarestan palace outside Tehran.[8] The original
wall paintings represented an imaginary New Year's reception at the court of the monarch. The
murals were completed in 1812–13 for the reception hall of the palace by a team of artists under the
supervision of 'Abdallah Khan.[9] Shown flanking the central image of Fath 'Ali Shah enthroned with
his sons and retainers (FIG. XIV) in the lower section are foreign envoys, who had actually been
received on different occasions. England, Russia, and France initiated a flurry of diplomatic activity with
the Persian court in the early nineteenth century. The Negarestan mural and its copies depict the envoys
of France and Great Britain along with the ambassadors from the kingdom of Sind, Arabia, and the
Ottoman Empire, reflecting the Persian court's perception of these envoys as symbols of the submission
of rulers of the world to the mighty Shahanshah.

The copies — undated and unsigned, and executed in opaque watercolor, oil, and engraving — were
produced sometime between the completion of the mural in 1812–13 and 1834, the year of Fath 'Ali
Shah's death.[10] A number of such fine small-scale versions of life-size paintings were probably com-
missioned by the ruler (along with copies of his poetic anthology and of manuscripts of the *Shāhanshāhnāmeh*)
as diplomatic gifts, but a close examination of two surviving versions from this series bearing inscrip-
tions suggests another use.

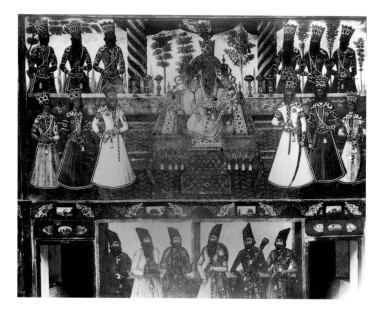

FIG. XIV. *Central
Section of the Salaam of
Fath 'Ali Shah.
Negarestan Palace.*
Salt print, late 19th century.
BROOKLYN MUSEUM OF ART,
PURCHASE GIFT OF LEONA
SOUDAVAR IN MEMORY OF
AHMAD SOUDAVAR,
1997.3.261.

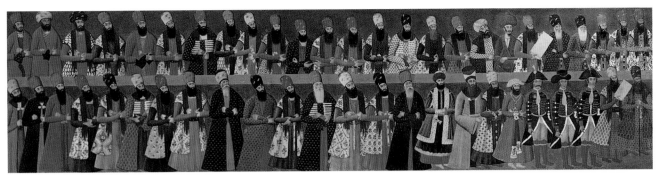

Side panel

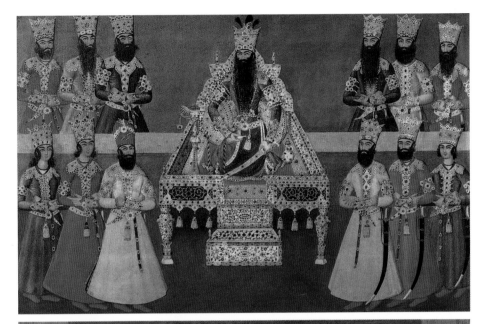

Central panel

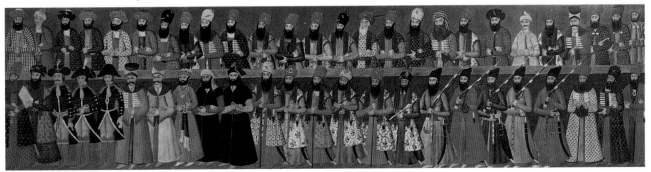

Side panel

In the original murals, each of the 118 figures was identified. Of the extant small-scale copies, only two are inscribed: a tempera and oil-on-canvas version of the left-hand panel (Archiginnasio Library, Bologna, A.2925) bears the names of forty-nine figures. Furthermore, two of the principal court officials – the court treasurer, Mirza Riza Quli, Munshi al-Mamalik, and the vizier Mirza Buzurg, Qa'im Maqam – hold inscribed though illegible documents.[11]

Fortunately, the documents held by the same figures on another surviving oil painting (Private collection), also of the left-hand side, are legible, and the phraseology suggests that they were petitions addressed to the ruler.[12] The document held by Mirza Buzurg mentions Aqa Jani, the court architect second only to 'Abdallah Khan, and both Aqa Jani and 'Abdallah Khan are depicted among the courtiers. Persian artists sometimes submitted self-portraits holding humble requests for payment or petitions for patronage. Thus, these small-scale paintings appear to commemorate the completion of the Negarestan palace and its paintings.

LSD

Literature: Soudavar 1992, 393, fig. 160; *Fine Oriental Miniatures, Manuscripts, and Qajar Paintings,* sale cat., Sotheby's, December 9, 1975, lot 291; Carol Bier (ed.), *Woven from the Soul, Spun from the Heart: Textile Arts of Safavid and Qajar Iran,* exh. cat., Textile Museum (Washington, D.C., 1987), 253–55.

-35-
Muraqqa' (album) of Portraits and Calligraphies

Artist unknown
Tehran, early 18th–early 19th century
Opaque watercolor, gold leaf, and ink on paper; binding: pasteboard, opaque watercolor under lacquer;
11¹/₂ x 7³/₄ inches (29.3 x 19.7 cm)
COLLECTION OF PRINCE SADRUDDIN AGA KHAN, MS 23

This early nineteenth-century *muraqqa'* (album) is of the traditional accordion format, with pages hinged together so that they can fold out consecutively. Presenting a series of twelve portraits and twenty fine calligraphies dating from 1715 to 1819, the album is a visual compendium of Persian kingship and dynastic succession. It documents the early Qajar rulers' reliance on portraiture to chronicle their dynastic lineage by locating themselves in the pantheon of powerful and prestigious Iranian kings – legendary, ancient, and modern. This practice continued into the second half of the nineteenth century, in illustrated lithographed books such as Prince Jalal al-Din Mirza's *Nāmeh-i Khusravān* and Fursat al-Dawleh Shirazi's *Āsār-i 'Ajam.*

Folio 3v (illustrated here), a watercolor representation of Fath 'Ali Shah seated on the Sun Throne (Takht-i Khurshīd) in full regalia, is the first in the album. It is followed by an imposing image of Aqa Muhammad Khan, the formidable founder of the Qajar dynasty. The remainder of the paintings, which are not organized chronologically, have been identified as Shah 'Abbas I (r. 1587–1629); Shah 'Abbas II (r. 1642–66); Jamshid, a legendary hero from the *Shāhnāmeh*; Kay Kavus, also a hero from the *Shāhnāmeh*; Ismail I (r. 1501–24), the founder of the Safavid dynasty; Nadir Shah, the founder of the Afsharid dynasty (r. 1736–47); Chingiz Khan, the founder of the Mongol dynasty (r. 1167–1227); a central Asian ruler, possibly Timur (r. 1336–1405); Karim Khan Zand, the founder of the Zand dynasty (r. 1750–79); and Kay Kaus, another legendary hero from the *Shāhnāmeh.*[13]

B. W. Robinson has argued that the album reiterates the same themes as a series of life-size historical portraits commissioned by Fath 'Ali Shah and executed by the court painter Mihr 'Ali for the 'Imarat-i Naw palace in Isfahan. Ouseley described these historical paintings as life-size portraits of ancient kings, each identified by an inscription.[14] Charles Texier wrote that he counted more than sixty such portraits of historic personages in Isfahan.[15]

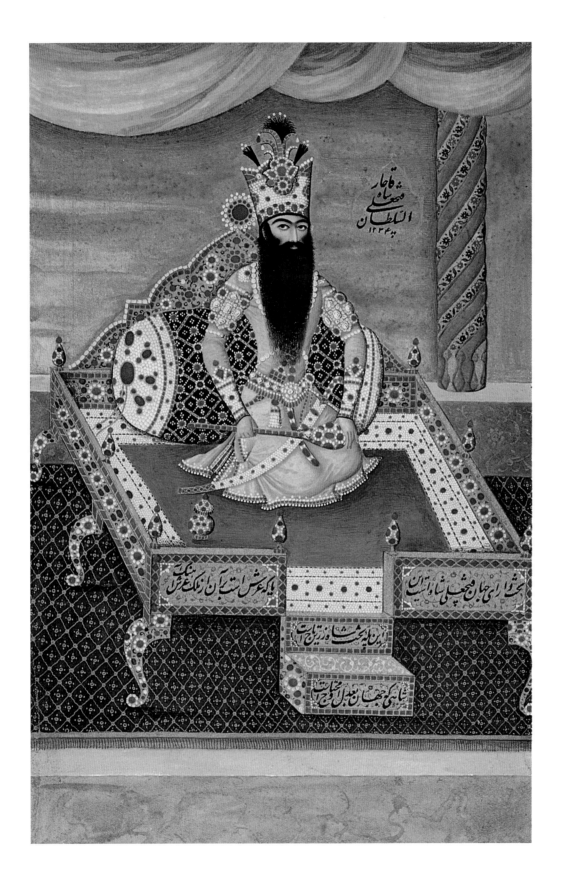

FIG. XV. *Two pages of* shikasteh *script.*
Folios 2b and 3a from NO. 35.

The twenty pages of calligraphy in the *muraqqa'*, several of which have sumptuously illuminated floral borders, are fine examples of *naskh, nasta'liq, thulth,* and *shikasteh* scripts. FIG. XV shows examples in *shikasteh*, the "broken script" devised in Iran in the sixteenth century that gained popularity during the Qajar period and was used primarily for correspondence and documents. It is characterized by undulating motions whereby words rise and fall. The pages featured here exhibit the fluidity and grace of the *shikasteh* script. Although the patron of the *muraqqa'* has not been identified, the panegyric tone of the verses inscribed on the throne suggests that the album was either commissioned by the shah himself or by a prince or wealthy court official as a gift.

ME

Literature: Anthony Welch, *Prince Sadruddin Aga Khan Collection of Islamic Art* (Geneva, 1972–77), vol. 4, pp. 98–99; Anthony Welch, *Calligraphy in the Arts of the Muslim World* (Austin and London, 1979), no. 67; Anthony Welch and Stuart Cary Welch, *Arts of the Islamic Book: The Collection of Prince Sadruddin Aga Khan* (Ithaca and London, 1982), 132–34.
Inscriptions: In *nasta'liq* script, right-hand corner: *Fatḥ 'Alī Shāh al-Sulṭān-i Qājār, 1234;* on the Sun Throne: *Īn takht dārā-yi jahān-i Fatḥ 'Alī Shāh ast / yā 'arsh ast bar ān malik-i 'arsh-āhang; Īn pilleh-i shāh-i zarrīntāj ast / shāhī kih jahān bi-'adl ū muḥtāj ast*

-36-

Casket with Image of Fath 'Ali Shah Hunting with a Prince and Courtiers

Artist unknown
Iran, early 19th century
Pasteboard or wood, opaque watercolor and gold under lacquer; silver clasp;
$7^1/_2$ x $15^1/_2$ x $10^3/_4$ inches (19 x 39.4 x 27.3 cm)
COLLECTION OF MRS. ESKANDAR ARYEH

The royal hunt is the principal theme represented on the fourteen surfaces of this finely painted casket. Hunting as the royal pastime *par excellence* had its origins in pre-Islamic Iran. It was a sport strictly reserved for royalty and the elite, since only the wealthiest could afford to indulge in rearing wild boar, lions, gazelles, falcons, and rabbits solely for this purpose. Iranian rulers and princes of all dynasties, particularly the Qajars, partook in the hunt and were always portrayed favorably, displaying prowess in archery or swordsmanship and surrounded by admiring courtiers.

The raised lid of this casket shows Fath 'Ali Shah in full regalia mounted on the royal steed, hunting with one of his sons, probably his heir, 'Abbas Mirza, as a boy roughly ten years of age,[16] with his courtiers. The hunt takes place in a landscape of trees and buildings; hunting dogs accompany the royals on their expedition.

The surrounding convex surfaces consist of rectangular panels, depicting episodes from the prince's hunting expedition, interspersed with medallions with images of maidens in décolleté gowns and men in European costume. An area of gold illumination on a red or black ground frames each panel. In a number of the panels, the prince is represented in the guise of a literary hero from the *Khamseh* of Nizami or the *Shāhnāmeh*. On the right convex surface, for example, he is portrayed as King Khusraw spying on Shirin while she bathes. The back convex surface portrays the prince visiting a sage, while the left convex surface shows him as Bahram Gur piercing a gazelle with an arrow.

The sides of the casket depict the prince, with attendants and dogs, hunting various animals with different weapons such as lances, daggers, swords, or rifles set against a backdrop of a landscape with buildings and trees. The casket interior portrays the prince hunting gazelles with six courtiers, two of whom hold falcons. This image is enclosed in a concave border of vignettes of hunters in landscapes, demonstrating the painter's skill in rendering architecture and his ability to instill his compositions with delicacy and charm.

The prototype for such hunting scenes on lacquer objects can be found in a series of monumental oil paintings portraying Fath 'Ali Shah and his sons in a chase. Commissioned for palaces in Tehran, Isfahan, Fin (near Kashan), and Sultanieh, these paintings were described by English and French envoys and

travelers such as James Morier, George Keppel, Charles Texier, and George Curzon.[17] The only extant example now occupies the ceiling of the Rashtrapati Bhavan in New Delhi (see FIG. 14b). The finest representation of Fath 'Ali Shah and his sons in a hunt in lacquer can be found on the Qajar binding of circa 1825 to the 1539–40 *Khamseh* manuscript at the British Library (OR 2265, FIG. 14a) signed by Sayyid Mirza and Muhammad Baqir. In contrast, the casket featured here singles out only one prince as the focus of the entire work.

Although the casket is unsigned, the quality of workmanship suggests that it was painted by one of the fine painters in the service of the court. Since the majority of the scenes present the prince as the ultimate hunter and warrior, Fath 'Ali Shah may have intended this casket as a gift to his most favored son.

ME

Provenance: Eskandar Aryeh.

-37-

Fath 'Ali Shah Seated

Attributed to Mirza Baba and an anonymous painter
Tehran, circa 1798
Oil on canvas; 68 x 40½ inches (172.7 x 104.1 cm)
PRIVATE COLLECTION

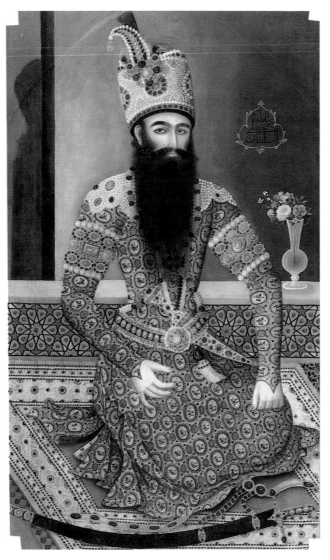

Probably more images of Fath 'Ali Shah have survived than of any other Persian ruler, although this artistic record may seem somewhat out of proportion to his historical importance. More than twenty fine extant paintings of the monarch are known, six of which are featured in this publication. When portrayed alone, the ruler was most frequently depicted seated on a jeweled floor covering. In other instances, he was shown standing with his staff of state or clad in ceremonial armor.

In keeping with its early date, the composition follows the conventions of the Perso-European school (see NO. 19 for the pose of the arms, spitoon, and elaborate jeweled regalia). Further, the overall design and the ruler's features are based on Mirza Baba's 1798–99 portrait of Fath 'Ali Shah (FIG. 6). Here, Mirza Baba probably painted the face, rendered with his distinctive soft modeling and heavily shaded eyes, and assigned another painter to complete the rest of the painting.

A dating very close to the 1798 original is suggested by a number of features. Fath 'Ali Shah wears the royal cap (*kulāh*) of Aqa Muhammad (see also FIG. 10, painted by Mirza Baba in the same year), instead of the even grander imperial crown, the Taj-i Kiyani, commissioned upon his accession in 1798. The monarch was originally painted wearing a turban (as in FIG. 6) and holding a rope of pearl prayer beads in his left hand (as in NO. 19).[18] The relatively informal manner of the ruler's depiction and his unbuckled sword, datable to 1798,[19] also support an early date.

Mirza Baba's skill as a colorist may be seen in the brownish gold tones of the patterned robe that har-

monize with the tones of the inlaid-wood background panel. The artist also experimented with cast light and perspective – a rare occurrence in early Qajar painting. The ruler's pose and the decorative treatment of his robe conform to the two-dimensional conventions of "miniature painting": the oblique angle of the carpet, however, suggests spatial recession, and the ruler's shadow on the shutter implies a light source to the right. Typically, the rendering of shadows is not consistently applied: the glass vase in the background casts a shadow to the right.

Alterations to this painting and NO. 38 are typical of many Qajar paintings. Both sides of the painting have been cropped and enlarged at the top to conform to the rectangular format of European easel painting.

LSD

Literature: *Egyptian, Classical, Western Asiatic Antiquities and Islamic Works of Art*, sale cat., Sotheby's New York, May 30, 1986, lot 118.
Inscriptions: In *thulth* script, upper right: *Fatḥ 'Alī Shāh Sulṭān*

-38-
Fath 'Ali Shah Seated on a Chair Throne

Attributed to Mihr 'Ali
Tehran, circa 1800–1806
Oil on canvas; 88¹¹/₁₆ x 51¹/₈ inches (227.5 x 131 cm)
MUSÉE DU LOUVRE, PARIS, SECTION ISLAMIQUE, ON LOAN FROM THE MUSÉE NATIONAL DE VERSAILLES, MV638

This painting, intended as a gift to Emperor Napoleon, was presented by Fath 'Ali Shah to the French envoy Amédée Jaubert, on July 11, 1806, in the encampment of Sultanieh and must have been executed shortly beforehand.[20] The work is one of three extant life-size paintings showing the ruler seated in a jewel-encrusted and enameled chair throne (a guise in which he was frequently depicted in manuscript illustrations), which often accompanied the ruler on tours of inspection or hunting trips.[21]

In conformity with the function of a state image intended for public display and designed to inspire a sense of awe in the viewer, Mihr 'Ali depicted Fath 'Ali Shah impassive, rigidly posed, and ablaze with jewels. The image epitomizes poetic descriptions of the ruler's imperial aura and sunlike splendor, to which the sun-shaped roundel surmounting the throne back alludes.

In addition to the throne (an interpretation of the Marvelous Throne [Takht-i Nadir]), each element of the ruler's attire symbolizes his imperial nature: the Taj-i Kiyani crown, surmounted by an exquisitely fashioned aigrette with black heron feathers; the sword of state covered in priceless pearls and hardstone gems; the royal armbands set with the two most celebrated table diamonds, the Sea of Light and the Mountain of Light; and the long belt attachment typically associated with the Qajar tribe.[22] The severity of this iconic image is skillfully counterbalanced by the grace of the ruler's features and the lacelike delicacy of the panel; the gracefulness of the ruler's features and delicacy of his tiny feet, shod in floral-patterned hose and upturned slippers, combine to create an elegant image with just a touch of humanity.

The attribution to Mihr 'Ali proposed by B. W. Robinson may be retained.[23] From 1798 to 1815, the date of his last recorded work (NO. 41), in addition to the decoration of the 'Imarat-i Naw palace of Isfahan, Mihr 'Ali executed more than twelve life-size oil and reverse-glass paintings of Fath 'Ali Shah. His hand may be discerned in the thin arched eyebrows and elongated eyes enhanced with kohl; in the skillful rendering of the silky sheen of the ruler's robe and the flash of the jewels; and the exquisite combination of arabesque ornament of the piers and carved wooden panel behind the ruler. The background design must have pleased the monarch, since Mihr 'Ali used the balustrade in at least one other painting of Fath 'Ali Shah (NO. 40).

LSD

Literature: Pierre Amédée Jaubert, *Voyage en Arménie et en Perse* (Paris, 1821), 307; B. W. Robinson, "Persian Painting in the Qajar Period," in Ettinghausen and Yarshater 1979, 336, fig. 225; Robinson and Guadalupi 1990, 85.
Provenance: See text above. Transferred in 1972 from the Musée National de Versailles.

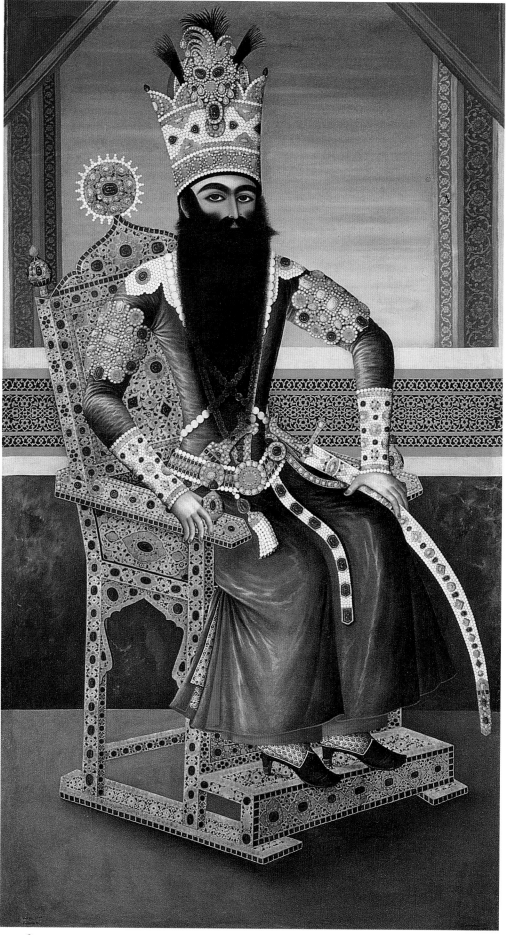

NO. 38

-39-
Portrait of Fath 'Ali Shah Standing

Signed by Mihr 'Ali
Iran, dated A.H. 1224/A.D. 1809–10
Oil on canvas; 99⁵/₈ x 48¹³/₁₆ inches (253 x 124 cm)
STATE HERMITAGE MUSEUM, SAINT PETERSBURG VR-1107

Fath 'Ali Shah is shown standing and holding in his right hand a jeweled scepter, surmounted by Solomon's hoopoe. The monarch's name is written beside his crown in a cartouche, under which is inscribed a quatrain praising the king.[24] The signature of the artist – Mihr 'Ali – is in the form of a long inscription at the lower left corner. This work is the earliest known portrait of Fath 'Ali Shah standing: evidently Mihr 'Ali suggested here a new type of royal portrait. Four years later, in A.H. 1228/A.D. 1813, Mihr 'Ali repeated this composition almost exactly.[25] On the later portrait, however, Fath 'Ali Shah's dress is of gold brocade, the carved panel behind him has another pattern, and a different quatrain is inscribed within the panels. These evidently newly composed verses also appear on another portrait of Fath 'Ali Shah from the Hermitage collection, painted in 1813–14 (NO. 40).

This portrait of Fath 'Ali Shah, as well as NO. 40, may be counted among the most accomplished works by Mihr 'Ali. They exemplify the canons of the "official metropolitan court" style of Qajar painting of the first three decades of the nineteenth century.

ATA

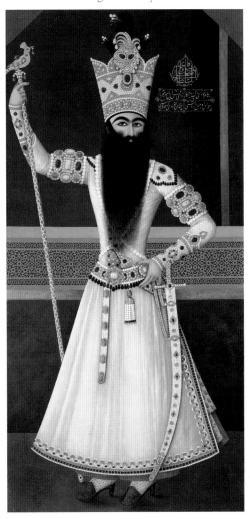

Literature: Amiranashvili 1940, pl. XXXIV; A. T. Adamova, "Two Portraits of Fath 'Ali Shah from the Hermitage Collection and Qajar Official Style," in *Soobshchenia Gosudarstvennogo Ermitazha*, no. 33 (1971): 85–88. 86, ill.; Falk 1972, fig. 14; Karpova 1973, no. 5; Adamova 1996, no. 64.
Provenance: From the Gatchina Palace Museum in 1932.
Inscriptions:
In *thulth* script, beside crown, in a cartouche: *al-sultān Fath 'Ali Shāh Qājār*
In *nastaliq* script, under cartouche, within panels: *Bih kām-i pāk-i parvardigār, zadī naqsh īn nāmvar shahrīyār/Chu īn āfarīnish bar ārāstī, chunān āfarīdī kih khud khwāstī*
In *nastaliq* script, lower left corner: *īn pardeh tasvir-i timsāl-i shamāyil-i shāhanshāh bihmāl ast; kih dar huzūr bāhir al-munavvar aqdas mulāhizeh; shamāyil muhr māyil mubārak shudeh va bidūn-i taghyir raqamzad-i kilk-i khujasteh salk shud; kamtarīn ghulām Mihr 'Ali āmad, fī sanah 1024.*

Detail of inscription at lower left, NO. 39

-40-

Portrait of Fath 'Ali Shah Seated

Signed Mihr 'Ali
Iran, dated A.H. 1229/A.D. 1813–14
Oil on canvas; 99⅝ x 46⁷⁄₁₆ inches (253 x 118 cm)
STATE HERMITAGE MUSEUM, SAINT PETERSBURG, VR-1108

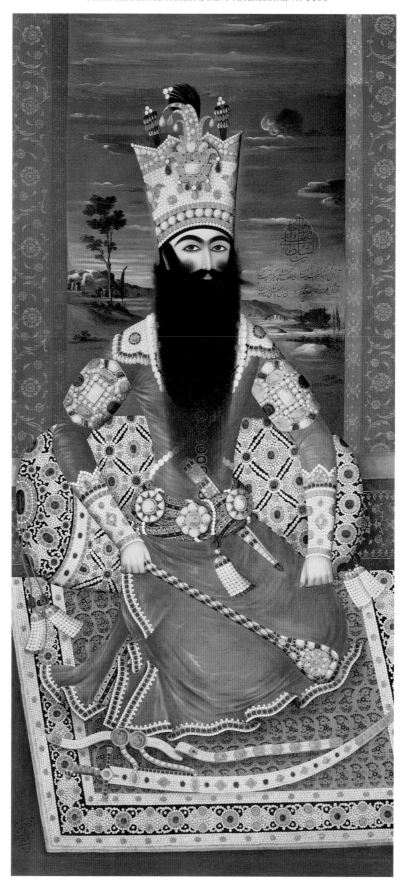

This portrait is more traditional than NO. 39 in that the monarch is shown seated on a carpet with a cushion behind him, holding a mace. As in the other canvas, to the right of the shah's crown there is an inscribed cartouche and rectangular panels with panegyric verses. The artist's signature (at the lower left corner) is in his usual form.

The Hermitage portrait is the latest in a series of dated paintings depicting Fath 'Ali Shah seated on a carpet. Here Mihr 'Ali repeated in reverse the composition of one of his earlier portraits.[26] The artist demonstrates his talent as a colorist: the juxtaposition of the cold blue tonality of the landscape background and the bright red color of the shah's robe and gold-toned crown is very effective.

In one of the two portraits given to General Yermolov in 1817, the shah was shown enthroned, and on the other he was depicted sitting on a carpet.[27] The work illustrated here may be the seated portrait. The location of the other picture is unknown.

ATA

Literature: Amiranashvili 1940, pl. XXXV; Robinson 1964, pl. XXXVI; A. T. Adamova, "Two Paintings of the Early Qajar Period" (in Russian), in *Sredneya Azia I Iran* (Leningrad, 1972), 87, ill.; Falk 1972, fig. 13; Karpova 1973, no. 6; B. W. Robinson, "Persian Epic Illustration: A 'Book of Kings' of 1436–37," *Apollo* (September 1982): fig. 42; *Oriental Manuscripts and Miniatures*, sale cat., Sotheby's, April 26, 1991, lot 186; Adamova 1996, no. 65.
Provenance: From the Gatchina Palace Museum in 1932.
Inscriptions:
In *thulth* script, to right of crown in a cartouche: *al-Sultān Fath 'Alī Shāh Qajār*
In *nastaʿliq* script, below cartouche: *Timsāl-i shāhanshāh-i falakjāh ast īn, Yā talʿat mihr u paykar māh ast īn/ Timsāl nigar kih har kih binad gūyad, daryā-yi jahān-i Fath 'Alī Shāh ast īn.*
In *nastaʿliq* script, lower left corner: *Raqam-i kamtarīn ghulām Mihr 'Alī. sanah 1229* (The work of the humble slave Mihr 'Ali in the year 1229)

-41-

Fath 'Ali Shah in Armor

Signed by Mihr 'Ali
Tehran, dated A.H. 1230/A.D. 1814–15
Oil on canvas; $89^5/_8$ x $41^3/_{16}$ inches (224 x 103 cm)
THE ART AND HISTORY TRUST, COURTESY THE ARTHUR M. SACKLER GALLERY, SMITHSONIAN INSTITUTION,
LTS 1995.2.122

In the second decade of his rule, images of Fath 'Ali Shah were increasingly idealized, figural proportions elongated, and background detail reduced. This work and NO. 42 show the ruler against a dark brown background design of horizontals and verticals that acts as an effective foil for his pale visage, splendid military attire, and red robe and shawl. The ruler's countenance is flatteringly framed by the striped shawl wound around his helmet, embellished with jeweled aigrettes and white feathers.

Although Fath 'Ali Shah's military prowess (which was far from noteworthy) had been glorified in manuscript illustration and monumental wall painting since the turn of the century, extant images of the ruler in full armor date from the second decade. In 1812 'Abdallah Khan had decorated the palace of Sulaymanieh in Karaj with a mural of Aqa Muhammad surrounded by Qajar tribal leaders in armor. The success of the composition presumably led Fath 'Ali Shah to commission a similar image from Mihr 'Ali shortly thereafter.[28]

This exemplary image of a warrior king testifies to Mihr 'Ali's skills as an image maker. The painting evokes the triumphant Qajar rise to power and identifies Fath 'Ali Shah with the legendary hero Rustam, whose leopard coat is recalled in the exceptionally beautiful coat-of-mail and sleeves (see also NO. 33). Ironically, the military attire also brings to mind the harsh realities of Persian defeats in the Perso-Russian wars.

LSD

Literature: *Fine Oriental Miniatures, Manuscripts, and Qajar Paintings*, sale cat., Sotheby's April 4, 1978, lot 84; Soudavar 1992, 388, fig. 158.
Inscriptions: In *nastaʿliq* script, upper right corner: *Sultan Fath 'Alī Shāh Qājār*; lower left: *raqam-i kamtarīn ghulām Mihr 'Alī fī sanah 1230*

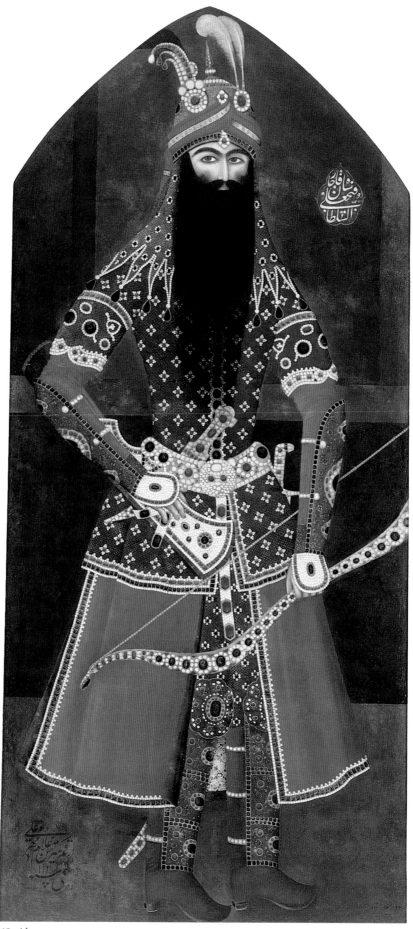

NO. 41

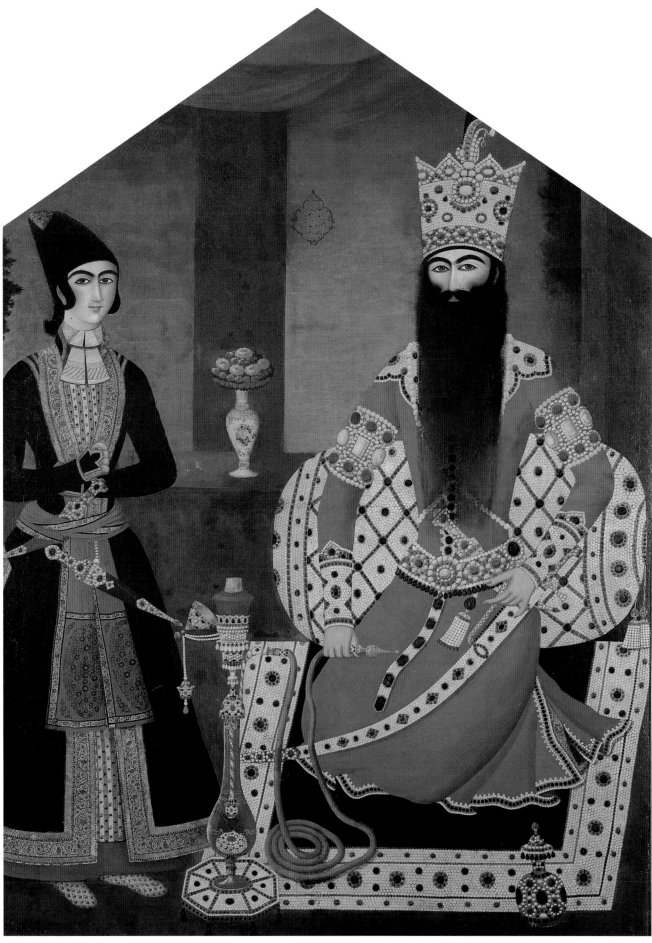

-42-

Fath 'Ali Shah Attended by a Prince, Smoking a Water Pipe

Attributed to Mihr 'Ali or Muhammad Hasan
Iran, second quarter of the 19th century
Oil on canvas, 87⅝ x 64 inches (222.5 x 162.5 cm)
COLLECTION OF MRS. ESKANDAR ARYEH

This unsigned work raises a number of questions. The painting shares many affinities with the style of Mihr 'Ali, to whom the majority of imperial portraits have been assigned. Nevertheless, the tall white porcelain vase with floral pattern and the striped border and paisley patterned belt of the young prince's costume are typically found in the works of his younger contemporary, Muhammad Hasan.[29]

Fath 'Ali Shah was frequently depicted with his numerous sons. He is shown here with a single handsome youth wearing a dark robe, pointed black karakul cap and cravat of fine lawn fabric tied in the European manner. Since the royal princes were always depicted crowned, the identity of this youth is intriguing. The figure may represent the young Muhammad Mirza, son of Crown Prince 'Abbas Mirza, who was generally portrayed wearing cravats and a military uniform, cut in the European style, following his accession in 1834.

This hypothesis is supported by a rock relief of the monarch dated circa 1825, in which the enthroned ruler is flanked by a bearded figure identified as Crown Prince 'Abbas Mirza and another personage identified as his son, who is almost identical in costume and demeanor to the youth depicted here.[30] Since Muhammad Mirza was born in 1808 and the youth depicted here is fifteen or twenty years of age, an identification with Muhammad Mirza would suggest an approximate dating of 1823–28 for this work.

The painting may have originally included 'Abbas Mirza or, alternatively, formed part of a larger cycle. In either case, this painting may represent more than an elegant image of the private life of the Qajars. In keeping with the importance accorded by the Qajars to life-size painting, this work may be read as a statement of the legitimate line of succession.

LSD

Literature: *Fine Oriental Miniatures, Manuscripts, and Qajar Paintings*, sale cat., Sotheby's, July 7, 1975, lot 230.
Provenance: Eskandar Aryeh.
Inscriptions: Erased in cartouche to the left of the ruler's head.

-43-

Mirror in Frame

'Ali al-Husayni al-Qazvini and Abu'l Qasim al-Shirazi
Iran, dated A.H. 1235/A.D. 1819–20
Alabaster, glass, and gold; 17¼ x 11⅛ inches (43.8 x 28.3 cm)
STATE HERMITAGE MUSEUM, SAINT PETERSBURG, VR-1057

The mirror case shown here exemplifies the art of the Qajar court in the early nineteenth century. The wide, rectangular alabaster frame with an arched top is decorated with floral ornament on both sides. The front of the frame is carved with gilt inscriptions in Persian and Arabic, which give blessings upon Muhammad and his lineage as well as proverbs (upper half) and the names of the masters (lower half). The first master, 'Ali al-Husayni al-Qazvini, was probably a stone carver; the second, Abu'l Qasim al-Shirazi, was a calligrapher who executed the inscriptions. Nothing is known about his life.[31]

On the reverse side of the frame, the oval medallion in the middle contains a portrait of Crown Prince 'Abbas Mirza (1789–1833) with an inscription over his head that reads "Na'ib al-Saltaneh 'Abbas Mirza." In the corners between the oval and the border of the frame are carvings of the Lion and Sun.

The wide border of the oval is filled with floral ornament. The narrow borders around the edges of the frame, and those next to the mirror and the oval on the reverse side, are decorated with gold floral ornament.

AAI

Literature: Adamova 1996, 316 (reverse ill. in color), 365, no. 42.
Inscriptions:
In *nasta'līq* script, in cartouche above carved portrait of 'Abbas Mirza: *'Abbās Mirzā Nā'ib al-salṭaneh*
In *thulth* script (in Arabic) framing the carved image of 'Abbas Mirza: *Allāhumma ṣalli 'alā, bismillāh al-raḥmān al-raḥīm, Muḥammad wa āl Muḥammad; Allāhumma kamā ḥasanta khalqī fa-ḥasina khalqī wa rizqī, al-ḥamdulillāh alladhī; khalaqanī bi aḥsan khalqī wa ṣūratī; al-ḥajrah Muḥammad 'Alī al-Ḥusaynī al-Qazvīnī, katabahū Abul Qāsim al-Shīrāzī, sanat 1235. Fa-aḥsanū ṣūratī wa zāna minnī sha'n min ghayrī wa akramanī bil-islām ya arḥam al-rāḥimīn.*

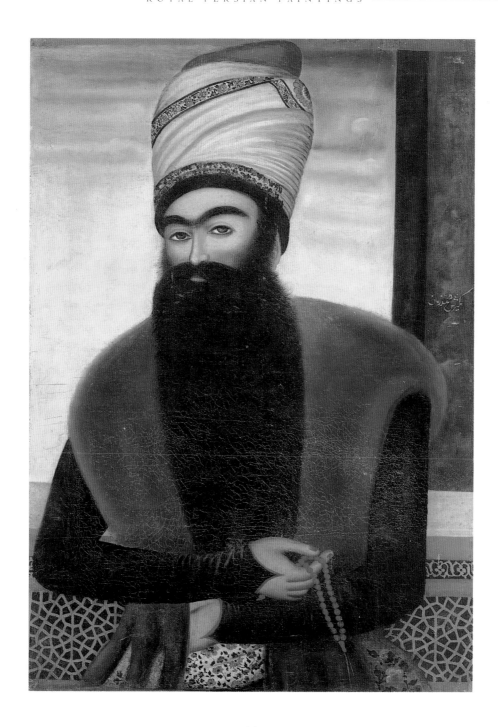

-44-

Portrait of a Nobleman Wearing a Zand Turban

Muhammad Zaman III
Possibly Shiraz, circa 1795
Oil on canvas; 38 x 26³/₄ inches (96.5 x 67.9 cm)
COLLECTION OF MR. AND MRS. DARA ZARGAR

This half-length portrait of a nobleman in Zand costume reflects the continuation of Zand style during the last years of the eighteenth century and early years of the nineteenth. The sitter, perhaps one of the Qajar leaders before the accession of Aqa Muhammad Khan in 1796, is seated in front of a window, looking straight out at the viewer with a pensive gaze. Wearing a Zand-style white turban with floral trim and a long fur collar over his shoulders, he holds a set of coral prayer beads. With its casual pose and simple costume, this portrait closely resembles other representations of Zand royalty. The correspondence is not surprising, since many Zand painters are known to have served the early Qajars.

An inscription at the right side of the painting identifies the artist as Muhammad Zaman III (active 1758–95), a painter cited in the Zand history *Rustam al-Tavārikh*, who appears to have served at the court of Lutf 'Ali Khan Zand (r. 1789–94).[32] Primarily a lacquer painter, Muhammad Zaman (who also used the signatures Aqa Zaman and Yā Ṣāḥib al-Zamān) was not only a fine painter of birds and flowers, figural scenes of feasting and fighting, and poetic romances, but a portraitist of great talent. This painting demonstrates his ability to capture the intensity and mood of the sitter and to render minute details of costume, such as the luxuriant texture of the prince's fur collar. Since his exact life dates are unknown, it is not certain which early Qajar leader he served. Other extant signed oil paintings by the artist are a work in the Zand style of *Shirin Bathing* from the *Khamseh* of Nizami,[33] a painting of Yusuf and Zulaykha's encounter,[34] and a painting of Bahram Gur watching Fitneh carrying a cow on her back.[35] A comparison of the signatures and decorative details in these paintings reveals a strong affinity, especially in the distinct handling of the facial features, floral patterns of the textiles, and details of costume.

ME

Inscriptions: In *nasta'liq* script on the right hand of painting, above shoulder: *kamtarin Muḥammad Zamān*

-45-
Prince Muhammad 'Ali Mirza, Dawlatshah (1788–1821)

Signed by Ja'far
Probably Tehran, dated A.H. 1236/A.D. 1820
Oil on canvas; 81 1/8 x 41 3/4 inches (208 x 107 cm)
THE ART AND HISTORY TRUST, COURTESY THE ARTHUR M. SACKLER GALLERY,
SMITHSONIAN INSTITUTION, LTS 1995.2.123

An inscription in a cartouche at the upper right-hand corner of this painting identifies the sitter as Fath 'Ali Shah's eldest son, Muhammad 'Ali Mirza, known as Dawlatshah. He is seated on a jeweled chair throne with lion-shaped arms in full regalia complete with gem-studded armbands and pearl-embroidered cuffs and epaulets. He wears a Zand-style red turban trimmed with colorful floral accents. In keeping with the iconography and details of court costume in the capital, this painting closely resembles portraits of Fath 'Ali Shah himself. Muhammad 'Ali Mirza's full-length bifurcated beard, pearl-embellished saber, and highly ornamented royal garb emphasize his virility and might as a warrior, as well as the splendor of his court.

Fath 'Ali Shah bypassed Muhammad 'Ali Mirza in favor of his younger brother 'Abbas Mirza for the position of heir apparent and entrusted him instead with protecting the strategically sensitive western frontiers of the empire. As governor of Kirmanshah, Luristan, Khuzistan, and Hamadan, Muhammad 'Ali Mirza participated in several battles against the Russians and Ottoman Turks. One of the ablest and most powerful of all governors of the empire, he soon emerged as a serious threat to other governors and even to the shah himself; the traveler and diplomat James Baillie Fraser noted with astonishment how Fath 'Ali Shah showed little sign of grief when the news of his eldest son's death reached Tehran.[36] Sources also refer to Muhammad 'Ali Mirza as a patron of the arts, a poet of talent, and a man of intellect.[37]

The painting is signed by Ja'far, probably not the Zand painter of the same name (see NO. 25, n. 8) who executed the famous mural of Karim Khan Zand and his courtiers in the Pars Museum in Shiraz. No other signed works of the Qajar period signed "Ja'far" are known; artists serving the provincial courts were seldom recorded in the histories of the period. Iconographically and stylistically, the painting corresponds to a rock relief at Taq-i Bustan representing Muhammad 'Ali Mirza seated on a chair throne accompanied by a prince and two attendants.[38] It is therefore likely that this portrait was painted by another "Ja'far" who was a hitherto unknown early Qajar multicrafted artist working at the prince's court. The latter part of the inscription, "Chākir-i Dawlat" (humble slave of Dawlat; probably implying Dawlatshah), also helps to identify Ja'far as one of Dawlatshah's court painters.

ME

Literature: Ansari 1986, 103–4; *Islamic Manuscripts, Miniatures and Works of Art*, sale cat., Sotheby's, April 14, 1978, lot 86; Karimzadeh Tabrizi 1985–91, vol. I, pp. 130–31; Soudavar 1992, 390–91.
Inscriptions:
In *thulth* script, upper right-hand corner in two cartouches: *Navvāb Muḥammad 'Ali Mīrza [Shāh] Qājār, fī shahr-i Rajab al-murajjab, Sanah 1236.*
In *nasta'liq* script, under the throne: *Raqam-i Ja'far, Chākir-i Dawlat*

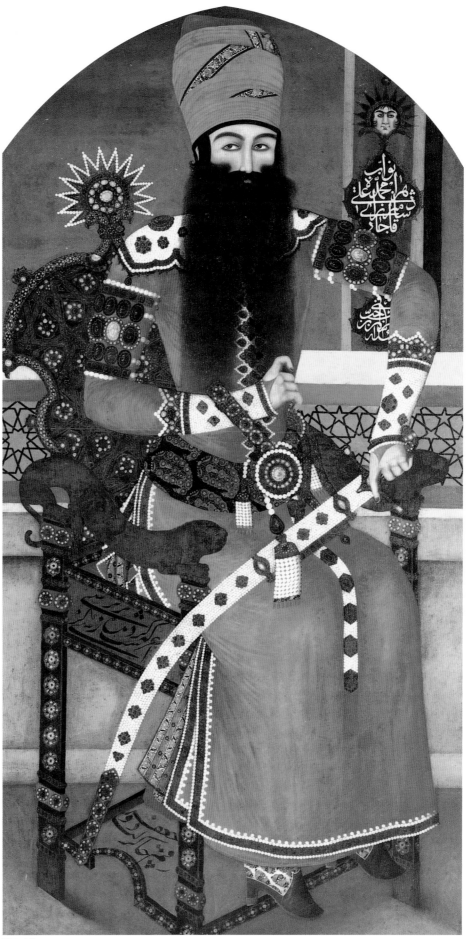

NO. 45

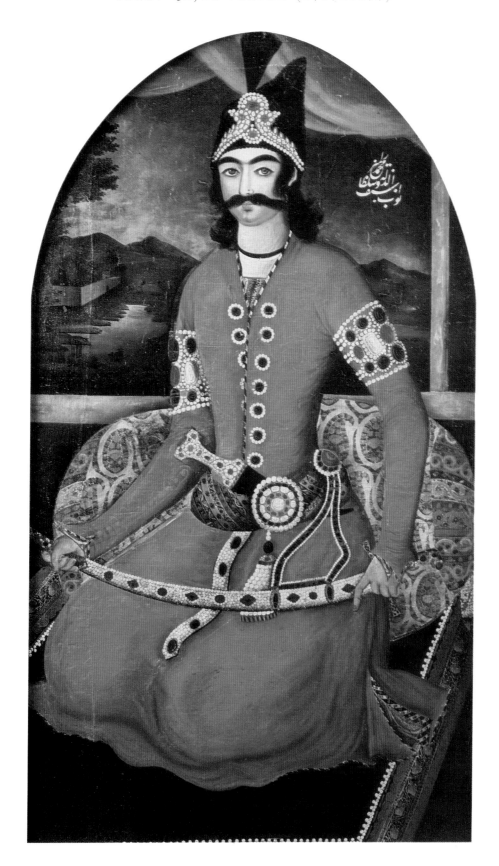

-46-

Portrait of Sultan Muhammad Mirza, Sayf al-Dawleh

Attributed to Sayyid Mirza
Tehran or Isfahan, circa 1835
Oil on canvas; 62¼ x 35⅛ inches (158 x 89 cm)
PRIVATE COLLECTION

An inscription at the upper right corner of this portrait identifies the sitter as Sultan Muhammad Mirza, known as Sayf al-Dawleh (b. 1813), the thirty-eighth son of Fath 'Ali Shah. Appointed governor of Isfahan in 1835, Sayf al-Dawleh was removed from office shortly after Muhammad Shah's accession to the throne. Here he wears a red robe embroidered with pearls and other precious stones and is seated in a chamber overlooking a landscape of hills and a river. His jewel-studded armbands, tiara, dagger, and sword indicate the opulence of his court at Isfahan.

At least two other portraits of Sayf al-Dawleh survive: a half-length portrait of him as a young boy (Collection of Mr. and Mrs. Dara Zargar, New York) and a portrait dated 1829 (Private collection) signed by the multicrafted artist, Sayyid Mirza, who served at the courts of Fath 'Ali Shah and Muhammad Shah.[39] A comparison between these works and NO. 46 reveals that this portrait is also the work of Sayyid Mirza. The roundness of the face, almond shape and hazel tint of the eyes, and overall execution of facial features are all hallmarks of this artist's style. Sayyid Mirza's extraordinary skill in landscapes is matched by few other early Qajar artists. In its approach to rendering landscape, this painting closely corresponds to *Joseph with a Pair of Gazelles* (FIG. XVI) and a watercolor portrait of Muhammad Shah as a youth (State Hermitage Museum, Saint Petersburg, VP-691), both signed by Sayyid Mirza, further confirming this attribution.

ME

Literature: Karimzadeh Tabrizi 1985–91, vol. I, pp. 233–34; *Fine Oriental Miniatures, Manuscripts, Qajar Paintings and Lacquer*, sale cat., Sotheby's, April 24, 1979, lot 225; *Islamic Manuscripts, Miniatures and Works of Art*, sale cat., Christie's, October 10, 1989, lot 281. Inscriptions: In *nasta'liq* script, upper right corner: *Sulṭān Muḥammad Mīrzā Navvāb Ṣayf al-Dawleh*

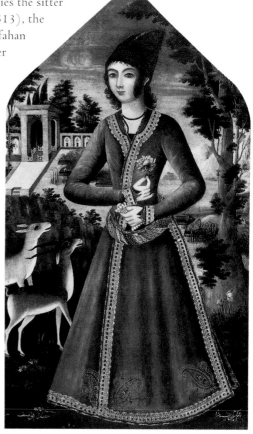

FIG. XVI. *Joseph with a Pair of Gazelles.* Sayyid Mirza. Iran, early 19th century. Oil on canvas, 61¼ x 36¼ inches (157 x 93 cm). SADABAD MUSEUM OF FINE ARTS, TEHRAN.

-47-

Prince Yahya

Attributed to Muhammad Hasan
Iran, circa 1830
Oil on canvas; 67 x 35 inches (170.2 x 89.9 cm)
BROOKLYN MUSEUM OF ART, GIFT OF MR. AND MRS. CHARLES K. WILKINSON, 72.26.5

Prince Yahya, born in 1817, was the forty-third son of Fath 'Ali Shah. A minor political figure in comparison with his powerful older half brothers, Prince Yahya at the age of five was appointed governor of Gilan, where he was assisted by Manuchihr Khan Mu'tamid al-Dawleh (see NOS. 70, 71). The prince's name and title are inscribed in a cartouche at the upper left. He wears the crown and jeweled ornaments appropriate to his rank, including the Order of the Lion and Sun. The insignia was instituted by Fath 'Ali Shah in imitation of European orders and decorations, and was liberally awarded for services rendered to the crown to both foreign diplomats and Persian princes and officials (see NO. 55). Prince Yahya is also recorded as a poet, along with his father and many other princes of the royal house.[40]

This painting exemplifies the standardization of court painting toward the end of Fath 'Ali Shah's reign. On the basis of the depiction of Prince Yahya as a beardless youth of fifteen or twenty with rosy cheeks, the painting may be dated to the 1830s. Attempts at perspective, atmospheric rendering, and modeling of the late Zand and early Qajar period have been discarded in favor of flat patterning, and illumination-style decoration has been replaced with simplified designs. The three-dimensional wooden balustrade with hexagonal marquetry is now a flat strip, and floor coverings formerly depicted

obliquely are now parallel with the picture plane. Although the prince's heavily jeweled crown and robe have been built up with gesso underneath to make them stand out in relief, they appear flatter and more decorative than those depicted in the previous decade.

This cut-down portrait closely resembles the work of Muhammad Hasan, both in the pattern in the rug guard stripes and in the wooden balustrade and in the delicate rendering of physiognomy (see FIG. 27a).

LSD

Literature: Ekhtiar 1989a, ill. (unpag.); Ekhtiar 1989b, 46, fig. 1.
Provenance: Possibly Ernst Herzfeld.
Inscriptions: In *nasta'līq* script, in a cartouche at upper left corner: *Shāhzādeh Navvāb Mirzā Yahyā* (His Highness Prince Yahya)

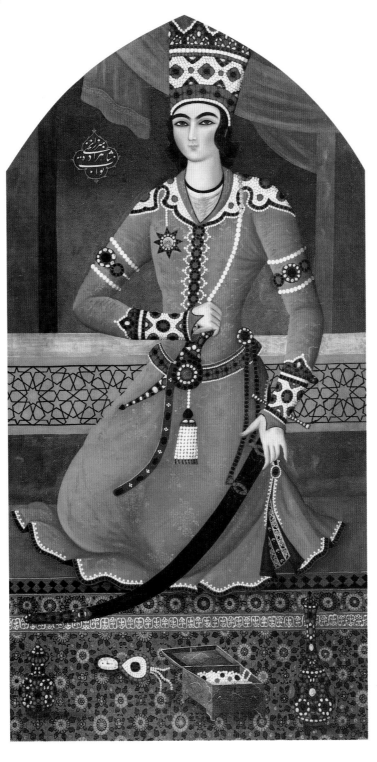

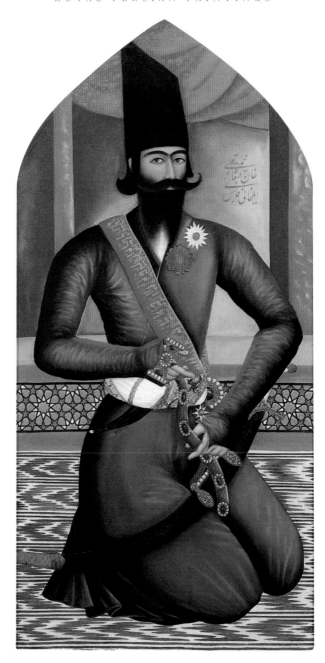

-48-

Portrait of Muhammad Quli Khan, the Ilkhānī of Fars

Attributed to Mirza Buzurg Shirazi
Probably Shiraz, circa 1853
Oil on canvas; 44⅞ x 37 inches (114 x 94 cm)
PRIVATE COLLECTION

An inscription in *nasta'līq* script at the upper right corner of this painting identifies the sitter as Muhammad Quli Khan (1809–1867),[41] the Qashqai *ilkhānī* (lord of the tribal confederacy) of the province of Fars. Carrying a jeweled dagger, which is tucked into his sash, and a sword, he is kneeling on a blue-and-white *jājim* (pileless rug or blanket with geometric designs woven by the Qashqai nomads) in front of a green wall with a red gathered curtain. He is portrayed as a handsome chieftain in his mid-twenties with a waxed mustache and a neatly groomed beard, wearing an astrakhan hat with a slanted top. The solid indigo of his woolen robe, which is held together by a cotton printed sash, complements the blue-flame pattern of the *jājim*, while the red curtain and velvet strap of the costume provide a striking contrast. The two royal orders decorating his robe were most likely included to demonstrate his political allegiance to the central court in Tehran.

Muhammad Quli Khan replaced his older brother Muhammad 'Ali Khan as the Qashqai *ilkhānī* of Fars after the latter's death in 1853. Muhammad Quli Khan took an active role in quelling quarrels among the Qashqai khans and mobilizing his troops to participate in the 1856 battle against the British in Bushihr.[42]

In Qajar society the tribal lords enjoyed great privilege and power, and acted as virtual rulers of their own local governments, holding considerable expanses of land in the areas that they inhabited. Deriving their power from the tribal military forces loyal to them, they were often called upon by the shah to provide military support. Although they were appointed by the shah, in practice their offices were hereditary. By appointing *ilkhānī*s and *ilbaygī*s (tribal leaders), the ruler was able to bring the tribes, at least nominally, within the bureaucratic organization of the state. In order to transact their business and safeguard their interests, the *ilkhānī*s often found it advantageous to have representatives in the capital.[43]

Enjoying a life of comparative luxury, Muhammad Quli Khan was a patron of the arts and commissioned paintings and lacquerware.[44] This portrait has been attributed to the multicrafted Shirazi artist Aqa Buzurg Shirazi, who served both Muhammad Shah and Nasir al-Din Shah. Its dating and attribution are based on stylistic comparison with a signed lacquer penbox by the artist dated A.H. 1269/A.D. 1851–52 (Museum of Decorative Arts, Tehran) depicting the eminent personages of Shiraz.[45] Although Muhammad Quli Khan is portrayed on the lid of the penbox as an older, middle-aged, man, it is likely that the two works were produced at the same time (circa 1852–53) to celebrate Muhammad Quli Khan's appointment as the new *ilkhānī* of the Qashqais of Fars.

ME

Literature: Pierre Oberling, *The Qashqai Nomads of Fars* (The Hague, 1974), 244, fig. 3; *Islamic Works of Art*, sale cat., Hapsburg Feldman, New York, 1990, lot 66.

Inscriptions: In *nasta'līq* script, upper right corner: *Muḥammad Quli Khān Īlkhānī-yi Fārs*

-49-
Portrait of Persian Envoy Abu'l Hasan

Sir Thomas Lawrence (English, 1769–1830). 1810
Oil on canvas; 35 x 27¼ inches (88.9 x 69.2 cm)
FOGG ART MUSEUM, HARVARD UNIVERSITY ART MUSEUMS, CAMBRIDGE, MASSACHUSETTS,
BEQUEST OF WILLIAM M. CHADBOURNE, 1964.100

This half-length portrait of Abu'l Hasan Khan, the first Persian diplomatic envoy to England since 1626, is one of two oil portraits of the ambassador by an English artist (see FIG. XVII).[46] Sir Gore Ouseley, Abu'l Hasan's official host (*mihmāndār*), commissioned Sir Thomas Lawrence to execute this portrait of the ambassador extraordinary in 1810. Ouseley, who regarded Lawrence as the best portrait painter in London, intended it as a gift for Abu'l Hasan upon his return to Iran. Abu'l Hasan's diary of his sojourn in England, *Ḥayratnāmeh*,[47] is replete with observations of European portrait paintings and accounts of his frequent visits to Lawrence's studio during the production of this portrait. The diary also mentions that the portrait was originally intended to be full-length; but owing to a shortage of time, it was decided that a half-length portrait would suffice.[48]

Abu'l Hasan arrived in London in 1809 in the hope of settling a number of unresolved matters in the preliminary treaty between Britain and Iran. His mission was to act as Fath 'Ali Shah's representative in these negotiations and to assure the British of Iran's good faith. He was selected for the post because he had spent several years in India and was familiar with British ways. Known for his good looks, exotic clothes, and engaging manners, Abu'l Hasan quickly became the darling of London's high society.[49] English newspapers of the time were filled with entertaining accounts of the Persian envoy's exploits.

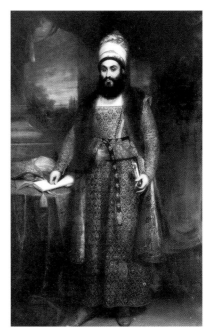

FIG. XVII. *Portrait of Envoy Extraordinary, Mirza Abu'l Hasan Khan.*
Sir William Beechey (English, 1753–1839). Circa 1809. Oil on canvas, 92 x 53 inches (234 x 135 cm).
BRITISH LIBRARY, ORIENTAL AND INDIA OFFICE COLLECTIONS, FOSTER 26, LONDON.

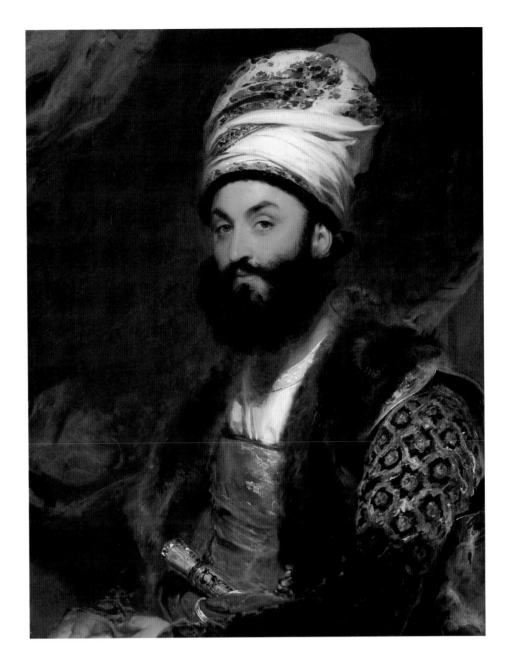

Here Lawrence captures Abu'l Hasan's vivacious personality and handsome countenance by accentuating his flowing black beard, sparkling eyes, and olive complexion. The subject, whose upper body fills almost the entire surface of the canvas, gazes directly at the viewer as though eager to make a lasting impression. He is portrayed in early nineteenth-century Persian court garb and wears a white embroidered turban with colorful accents, a long, heavily embroidered tunic held together by a sash, and a silk brocade vest trimmed with fur. Lawrence used Abu'l Hasan's robe to create an overall palette of browns, scarlet, and gold. Although the choice of subject and the dark palette are unusual in Lawrence's work, the skillful handling of paint (especially in the face and turban), the energetic brushstrokes delineating the details of costume, the deep shadows, and the vitality and impact are all highly characteristic.

Lawrence's uncanny accuracy of observation and his interest in expressing the vitality of his sitters distinguished him from early Qajar painters,[50] who were more concerned with conveying opulence, splendor, and decorative detail than with producing an exact likeness. This was not the first painting of a statesman in exotic Persian costume painted by a European artist; van Dyck's painting of Sir Robert Shirley (FIG. XVIII) may have inspired this rendition by Lawrence, who studied van Dyck and was his great admirer throughout his career.

Charles Millard has noted that the brushwork in the robe, curtain, and hands – in contrast to that of the finely painted face and turban – is "tentative" and "structureless," and suggests that these segments were painted by Lawrence's assistants.[51] This is a feasible suggestion since Lawrence is known

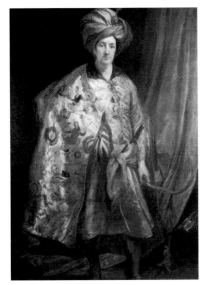

FIG. XVIII. *Sir Robert Shirley*.
Anthony van Dyck (Flemish, 1599–1641).
Circa 1622. Oil on canvas, 80 x 53³/₈ inches
(200 x 133.4 cm).
THE NATIONAL TRUST, LONDON.

to have often accepted too many commissions and left the completion of many paintings to his assistants.[52] Through his technical mastery and skilled draftsmanship, Lawrence captured the charm so characteristic of Abu'l Hasan's personality yet portrayed him as a dignified and refined historical figure.

ME

Literature: E. E. William, *The Life and Correspondence of Sir Thomas Lawrence* (London, 1831), vol. 2, pp. 55–56; Kenneth Garlick, *Sir Thomas Lawrence* (London, 1954), pl. 65; Charles Millard, "A Diplomatic Portrait: Lawrence's 'The Persian Ambassador,'" *Apollo* (February 1967); Abu'l Hasan Khan 1988, 254, 275; Kenneth Garlick, *Sir Thomas Lawrence: A Complete Catalogue of the Oil Paintings* (Oxford, 1989), 133, no. 8; Edgar Peters Bowron, *European Paintings before 1900 in the Fogg Art Museum: A Summary Catalogue including Paintings in the Busch-Reisinger Museum* (Cambridge, Massachusetts, 1990), no. 37; Kenneth Garlick, *Sir Thomas Lawrence Portraits of an Age: 1790–1830* (Alexandria, Virginia, 1993), no. 1.

Provenance: Sir Gore Ouseley; to Sir Frederick A. Gore Ouseley; to Saint Michael's College, Tenbury; sold by A. T. Barber & Co., Ltd., Windsor, to Vicars Bros., Ltd., London; sold in 1927 to Leggatt Bros.; sold by Jacques Seligmann & Co., Paris, to William B. Chadbourne, New York, October 1927; to the Fogg Art Museum, 1964.

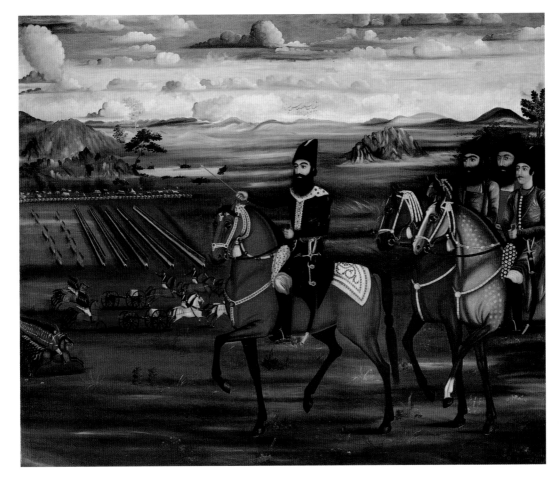

-50-
Crown Prince 'Abbas Mirza and Court Officials

Signed Allahvirdi Afshar
Iran, dated A.H. 1231/A.D. 1815–16
Oil on canvas; 59⁷/₈ x 73¹/₄ inches (152 x 186 cm)
STATE HERMITAGE MUSEUM, SAINT PETERSBURG, VR-1115

The central figure in this composition is Prince 'Abbas Mirza, as inscribed above his head. Three horsemen who ride close behind him are, according to the inscriptions, Amir Khan Qajar, Ibrahim Khan, and Muhammad Baqir Khan Qajar.

'Abbas Mirza (1789–1833), as governor of Azarbaijan, lived in Tabriz. From there he conducted the Iranian military campaigns against the Russians in the course of the Perso-Russian wars of the early nineteenth century. With the help of French and, later, English military advisers, he tried to organize his army along European lines. Here 'Abbas Mirza, on a prancing horse and with a staff in his right hand, demonstrates his regular-army troops to the princes accompanying him. The maneuvers of the troops are shown at the left side of the picture. In the upper background his military camp is seen; the whole scene perhaps takes place in the Ujan valley.

Allahvirdi Afshar is the only known name of a painter who worked for 'Abbas Mirza. Judging from his known works, his forte was portraiture. This painting, the only multifigured composition known by the artist, is traditional in that 'Abbas Mirza is represented at the very center of the picture and that the faces of the princes are depicted in three-quarter view. At the same time, it clearly shows the painter's facility with European technique and demonstrates his remarkably strong sense of color.

ATA

Literature: Adamova 1996, no. 77.
Provenance: From the Gatchina Palace Museum in 1932.
Inscriptions:
In *nastaliq* script, above head: *shabih-i nā'ib al-salṭaneh 'Abbās Mīrzā dar sinn-i bist u hasht sāligi* (portrait of Crown Prince 'Abbas Mirza at the age of twenty-eight years)
In *nastaliq* script, in front of horse's leg: *raqam-i kamtarin Allāhvirdi Afshār, 1231* (the work of the humble Allahvirdi Afshar, in the year 1231)

-51-
Military Review with Fath 'Ali Shah and 'Abbas Mirza

Artist unknown
Iran, circa 1815–16
Oil on canvas; 79^{15}/$_{16}$ x 163^{3}/$_{8}$ inches (203 x 415 cm)
STATE HERMITAGE MUSEUM, SAINT PETERSBURG, VR-1121

This picture represents the ritual of the greeting of Fath 'Ali Shah by Crown Prince 'Abbas Mirza, who is shown kneeling before his father, who in turn sits on horseback in his parade robe and wearing his royal crown. The procession with the shah and his magnificent suite — including princes on horseback, musicians on camels, and young footmen (*shāṭirs*), easily recognizable by their peculiar dress — moves to the right between two ranks of soldiers clad in European uniforms. In the background, at the top of the picture, are religious men (*'ulamā*) in *khal'ats* and turbans, as well as a group of people slaughtering lambs in a ceremonial sacrifice. An old man in a white robe, standing apart not far from the shah, is evidently an astrologer (a personage often depicted in miniatures of battle scenes). Thus, the review of the Persian troops by the shah took place immediately before starting the military campaign, guided by the predictions of the astrologer and approved by the *'ulamā*. The picture may represent an actual event: the review of the Persian army that took place in the Ujan valley in July 1813, as described by Gaspard Drouville.[53]

This canvas and NO. 52 were seen by General Yermolov, Moritz von Kotzebuë, and Vasily Borozdna in the Ujan palace of 'Abbas Mirza in 1817, which is the latest date for the pictures. It is worth noting that neither William Ouseley, who left Iran in 1813, nor James Morier, who left in 1815, mentions the paintings, although they both were in Tabriz and Ujan many times. Moreover, Yermolov in 1817 wrote that Ujan castle had been built by 'Abbas Mirza recently and its decoration had not been completely finished.[54] All this evidence suggests a date of about 1815–16 for the pictures.

Brought to Saint Petersburg for the Russian emperor directly from Ujan in February 1828, the paintings were permanently installed at the Hermitage (and in 1929 were transferred to the Oriental Department). The canvases were kept rolled up for about 170 years, but they are now restored and exhibited at the Hermitage.

ATA

Literature: Adamova 1996, no. 75.
Provenance: From the Picture Gallery of the Hermitage in 1929.

-52-
Battle of Prince 'Abbas Mirza with Russian Troops

Artist unknown
Iran, circa 1815–16
Oil on canvas; 90⁹/₁₆ x 155¹/₂ inches (230 x 395 cm)
STATE HERMITAGE MUSEUM, SAINT PETERSBURG, VR-1122

'Abbas Mirza is seen on horseback in the left part of the picture, pointing with his right hand to the severed heads of enemies. The battle itself, shown in the right half of the picture, appears to take place in the territory of the Russian military camp: the tents can be seen between the fighting sol-

diers, and the soldiers hold banners with the emblem of the Russian empire, the two-headed eagle. Around the battlefield appear groups of fighters holding Persian banners with the Lion and Sun. The Persians undoubtedly won the battle, which may have been that fought at Sultanabad near the river Aras on February 13, 1812.

According to Drouville, banners and standards in the Persian army were replaced with ones of European type after the review of Persian regular troops in Ujan in 1813[55] (see NO. 51). This picture, as well as NO. 51, was painted about 1815–16, or two to three years after the war had ended – so this contradiction may not have been considered very important. These two pictures support Abolala Soudavar's observation that there was an even stronger desire in Iran "to project an image of grandeur" after the defeats in 1813.[56]

ATA

Literature: Adamova 1996, no. 74.
Provenance: From the Picture Gallery of the Hermitage in 1929.
Inscriptions: In *nastaliq* script, lower right corner, on Persian banner: *fawj-i muzaffar va rashidim* (we are victorious and valiant troops)

<h2 style="text-align:center">–53–</h2>

Dish with the Royal Iranian Emblem of the Lion and Sun

Signed by Muhammad Jafar
Tehran, dated A.H. 1233/A.D. 1817–18
Enameled gold; diam. 12⅝ inches (32.1 cm); weight 79 ounces (2241.1 g)
LENT BY THE BOARD OF TRUSTEES OF THE VICTORIA AND ALBERT MUSEUM, LONDON, M.97–1949

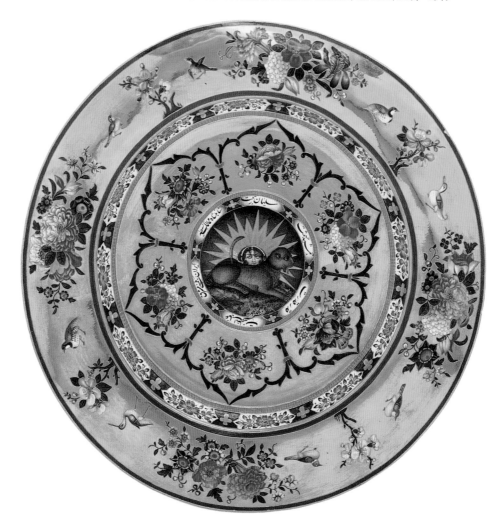

Qajar court painters excelled at gold enameling. Originating in the Safavid period, Persian enamel-work initially imitated European examples, but these adaptations soon surpassed their prototypes owing to their brilliant coloring and exquisite figural and floral designs. Persian artists favored the techniques of champlevé and repoussé enamel painting.[57]

More than nine representations of Fath 'Ali Shah in this medium survive.[58] Owing to the monarch's patronage, this art form equaled or perhaps even surpassed that of life-size painting. Gold enameling, often inlaid with precious jewels, was preferred for imperial regalia, vessels, water pipes for smoking tobacco (and perhaps opium), and diplomatic orders.

During the early nineteenth century, many court artists, including Mirza Baba, devoted their talents to enamel painting. Muhammad Ja'far was among the most accomplished exponents of this art, and at least twelve works have been assigned to him (including this one and NO. 55).[59] Ja'far's refined design features a central medallion with the imperial emblem of a crouching lion surmounted by a setting sun with a female face, a band of dedicatory inscriptions, surrounded by floral bouquets and birds, with the whole design set off by the sheen of the gold ground.

This dish was presented by the Persian ambassador Mirza Abu'l Hasan (see NO. 49) to the East India Company on his second mission to England.

LSD

Literature: Robinson 1950 (cover ill.); Robinson 1969, 202, fig. 130 (detail 131); Karimzadeh Tabrizi 1989, vol. 2, fig. 51; Abu'l Hasan Khan 1988, 112, pl. 20; Robinson 1991, fig. 6; Layla Diba, "Enamel," *Encyclopaedia Iranica*, forthcoming.
Provenance: East India Company; India Office Library, transferred in 1879.
Inscriptions:
In *nasta'liq* script, in central medallion: *raqam-i Muḥammad Ja'far 1233*
In *nasta'liq* script, within cartouches around the central medallion, reading counterclockwise from upper left:
shahānshāh mamālik-i 'illieh-i Īrān, bih cumpānī-yi mashriq, 'ināyat-i 'alāḥaẓrat, qadr-i qudrat, Jamshīd-ḥishmat sulaymān rutbat
Engraved on the base of the dish: *A token of Favor from his Majesty Fatah Ali Shah King of Persia to the East India Company presented to the Court of Directors Assembled Campbell Marjoribanks Esqr Chairman and George Abercrombie Robinson Esqr Deputy Chairman by His Majesty's Ambafsador His Excellency Mirza Abul Hasan Khan, on Friday the 18th of June 1819*
Engraved on the underside of the dish: *Muhammad Jaffar fecit A.H. 1233 A.D.1817 Wt 6lb 2dwt Troy*

-54-
Dagger and Sheath

Artist unknown
Tehran, circa 1800
Blade: watered steel and gold inlay; *dagger*: solid gold with enameling, set with diamonds and rubies;
sheath: gold cased wood enameled in relief. 14⁷/₈ x 2³/₈ x 1⁵/₁₆ inches (37.8 x 6 x 3.3 cm)
LENT BY THE BOARD OF TRUSTEES OF THE VICTORIA AND ALBERT MUSEUM, LONDON, 888–1874

Iran's strategic importance and the Perso-Russian wars resulted in the presence in Iran of French and English officers engaged to modernize the Persian army and European diplomats who represented these countries' often conflicting interests. The lasting impression that they created is commemorated by their inclusion in the life-size paintings executed for the palaces of the Negarestan and Qasr-i Qajar near Tehran and the governor's palace in Shiraz.[60]

Sir John Malcolm (1768–1833), envoy of the East India Company, negotiated the first Anglo-Persian treaty of the Qajar period. Malcolm's success was owing in no small part to the superb gifts that he distributed during his three visits from 1800 to 1810. In recognition of his efforts, this magnificent dagger and sheath (for a depiction of Fath 'Ali Shah wearing a similar dagger, see FIG. 6) was presented to Malcolm, along with a sword inlaid with precious stones, by Fath 'Ali Shah on the envoy's departure from Iran in 1800. Aqa Muhammad and, to a lesser extent, Fath 'Ali Shah were known for their avarice, yet huge sums from state coffers were expended, in a game of diplomatic one-upmanship, on lavish diplomatic gifts.[61]

LSD

Literature: Fasa'i 1972, 95; Robinson 1950, 67, cover ill.; V. B. Meen and A. D. Tushingham, *Crown Jewels of Iran* (Toronto and Buffalo, 1968), 90; Shirley Bury, *Jewelry Gallery Summary Catalogue*, exh. cat., Victoria and Albert Museum (London, 1983), no. 58.

-55-
Order of the Lion and Sun

Signed by Muhammad Jáfar
Iran, dated A.H. 1242/A.D. 1828
Enameled gold set with precious stones; *plaque*: 3¹/₈ x 3¹/₂ inches (8 x 9 cm);
collar: 13⁷/₈ x 9¹⁵/₁₆ inches (35.6 x 25.4 cm); *star*: 5⁷/₈ x 4⁷/₈ inches (15.2 x 12.5 cm).
NASSER D. KHALILI COLLECTION OF ISLAMIC ART, JLY 1631

Although Sir John Malcolm claimed that Fath 'Ali Shah instituted the Order of the Lion and Sun in his honor, Sir Dennis Wright has shown that Malcolm's award was based on a preexisting star-shaped order of similar form. That order, which was modeled on the French Legion of Honor and which had been awarded to the French envoy General Gardane in 1807, proved unacceptable to the English diplomat since the French and English were at war. The modified order, which entitled the recipient to use the initials *KLS* (for "Knight of the Lion and Sun") and was greatly coveted by Europeans, was bestowed on Malcolm by Fath 'Ali Shah in July 1810.

This insignia of the order comprises not only the star, but a semicircular plaque and collar. Such elaborate versions of the order were offered to only a select few, including Sir John Kinneir Macdonald (1782–1830), East India Company's envoy to Persia, who had played a crucial role in arranging the final treaty of Turkmanchai with Russia in 1828.⁶² It is less well known that Macdonald had been of great assistance financially to the defeated Prince Abbas Mirza during his retreat after the loss of Tabriz to Russian forces.

Many variations of the order were commissioned throughout the Qajar period. One of the more interesting was the version ordered by Prince Muhammad 'Ali Dawlatshah, the governor of Kermanshah, for foreign officers in his employ. According to George Keppel, the order's image depicted two lions on either side of a crown, representing the rival princes Muhammad 'Ali Mirza and Crown Prince 'Abbas Mirza.⁶³

LSD

Literature: *Persian and Islamic Art*, sale cat., Spink & Son Ltd., London, April 21, 1977, 37, fig. 94; Denis Wright, "Sir John Malcolm and the Order of the Lion and Sun," *Iran* 17 (1979): 139, pl. III; Denis Wright, "The Order of the Lion and Sun," *Iran* 19 (1981): 179–80.
Inscriptions: In *nashkh* script, on medallion below lion: *Muḥammad Jáfar sanah 1242*

-56-
Woman Holding a Rose

Artist unknown
Iran, first quarter of the 19th century
Oil on canvas; 72⁷/₁₆ x 37 inches (184 x 94 cm)
STATE HERMITAGE MUSEUM, SAINT PETERSBURG, VR-1113

The style of *Woman Holding a Rose* points to its having been painted in the first quarter of the nineteenth century. The woman's clothing – her long-sleeved striped jacket with jeweled armbands, worn over the transparent shirt with one slit open to the navel, full trousers with large *butteh* pattern, jeweled *jiqqeh* (royal aigrette) on her head, and string of pearls under her chin – reflects the early nineteenth-century fashion.⁶⁴

This picture might be, like *Female Dancer with Castanets* (NO. 59), one of a series of beauties' portraits. Its shape suggests that it may have been designed to be placed into an archlike space on the wall of a palace room. The background for the figure of the young woman in this and many other early Qajar pictures – with red curtain, green wall, and blue sky – is evidently meant to produce an illusionistic impression of a window. The decorative conception of these paintings is derived from their role as essential elements of architectural design.

ATA

Literature: Amiranashvili 1940, pl. XXVI; A. T. Adamova, "Two Paintings of the Early Qajar Period" (in Russian), in *Sredneya Azia I Iran* (Leningrad, 1972), fig. 2; Karpova 1973, no. 19; *Islam: Art and Culture*, exh. cat., Statens Historiska Museum (Stockholm, 1985), 159–60, no. 6; Adamova 1996, no. 67.
Provenance: From the Stieglitz Museum (P. V. Charkovsky's collection, 1886) in 1925.

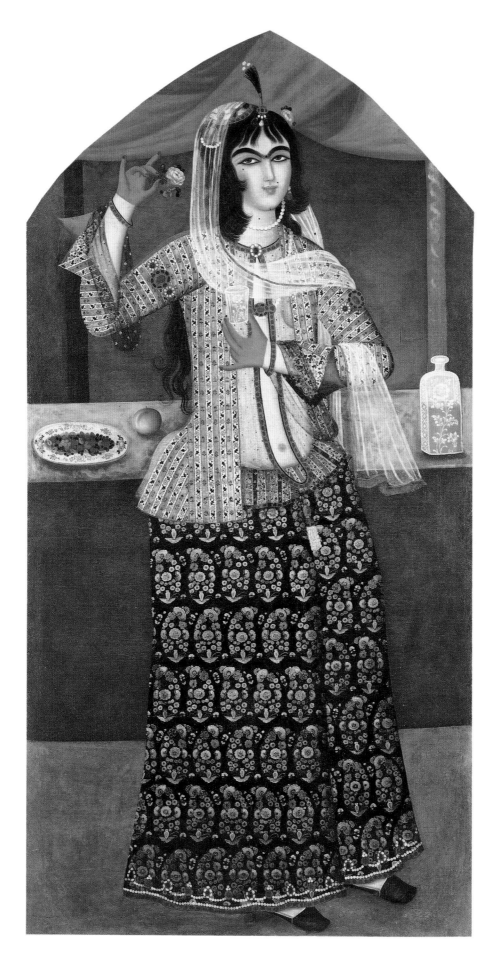

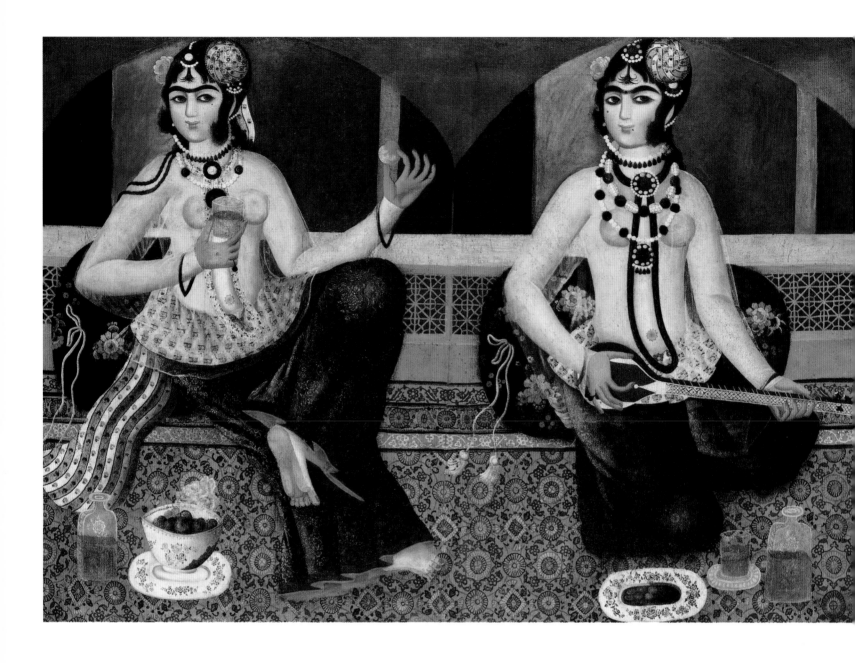

-57-
Two Harem Girls

Attributed to Mirza Baba
Iran, circa 1811–14
Oil on canvas; 41³/₄ x 64⁵/₈ inches (106 x 164.2 cm)
COLLECTION OF THE ROYAL ASIATIC SOCIETY, LONDON, 01.002

Images such as this one provide a glimpse into the private rhythms of Fath 'Ali Shah's harem. The painting depicts two beautiful harem girls entertaining themselves in a moment of leisure. They are shown unveiled, wearing wide embroidered trousers and transparent chemises exposing their breasts; one holds an apple the same size as her breasts and a glass of sherbet, while the other plays a *tār* (a Persian stringed instrument). Each has carefully coiffed hair, adorned with flowers and pearl ornaments, and a little striped cap pinned to the side of her hair. The warm hues of brown and yellow contribute to the sensual ambiance of the painting. The figures sit on an elaborately patterned rug on what appears to be a verandah in front of a wooden balustrade, with each girl framed by an arch. The half-filled crystal decanter and porcelain tableware filled with piping-hot delicacies typically appear in representations of women during this period.

The role and status of women entertainers in Middle Eastern societies is a perplexing phenomenon. Performing, especially in front of men, was not regarded as a highly respectable profession, although its practitioners were not necessarily considered outcasts. In many instances women entertainers were professionals brought into the harem to perform on special occasions; or sometimes they were actual members of the harem, usually concubines of the rulers, who were trained in the arts of singing, music, poetry, and dancing.[65] The two girls depicted here probably belong to the latter category, since it is unlikely that outside professionals would have been wined and dined in the manner portrayed in the painting.

The facial features of the two girls with their joined eyebrows, almond-shaped eyes, puckered lips, and flamboyant hairdos reflect the late Zand–early Qajar ideal of beauty. The static quality, as well as the striking resemblance between the two figures, suggests that the artist was not interested in portraying them as individuals, but as stock types that would blend into the painting's decorative setting.

Sir Gore Ouseley, Ambassador Extraordinary to the Persian court and founder of the Royal Asiatic Society, either purchased or acquired this painting directly from the artist during his stay in Iran sometime between 1811 and 1814. S. J. Falk thus suggested that Ouseley was able to observe the production processes of the artist. Falk believes that the canvas was most likely cut down from a much larger panel consisting of several female figures enclosed within arches. This conclusion is based on the fact that this is the only painting of two women on a single canvas in horizontal format (such paintings frequently occur as single figures).[66] The symmetrical axis of each figure within the arch and the distinct pauses in paint marking the end of one arch and the beginning of another, which may indeed point to the demarcation line for cutting the canvas, support this hypothesis.

It is somewhat difficult to assign this unsigned painting to a particular artist, since many early Qajar painters painted in a similar style. Although it has been attributed to Sadiq on stylistic grounds,[67] the treatment of the faces, handlebar eyebrows, seductive eyes looking to the side, ornate hairdos, and small breasts, as well as the peculiar pose of the figures, are strikingly similar to paintings by Mirza Baba depicting harem girls (see NO. 28 and *Young Man and Woman Drinking Wine*, signed and dated 1793, L. A. Mayer Institute for Islamic Art, Jerusalem).[68] Since Mirza Baba trained with Sadiq, it would be natural for him to have adhered to the same canon.

ME

Literature: *Persian and Islamic Art*, sale cat., Spink & Son Ltd., April 21, 1977, 31, pl. 78; S. J. Falk, "A Qajar Painting of Two Girls," in *The Royal Asiatic Society: Its History and Its Treasures,* ed. by Stuart Simonds and Simon Digby (Leiden and London, 1979), 110, pl. XIII; *Islamiske vaben I dansk privateje* (Copenhagen, 1982); Raymond Head, *Catalogue of Paintings, Drawings, Engravings and Busts in the Collection of the Royal Asiatic Society* (London, 1991), 4, fig. 2.
Provenance: Sir Gore Ouseley; to the Royal Asiatic Society in May 31, 1828.

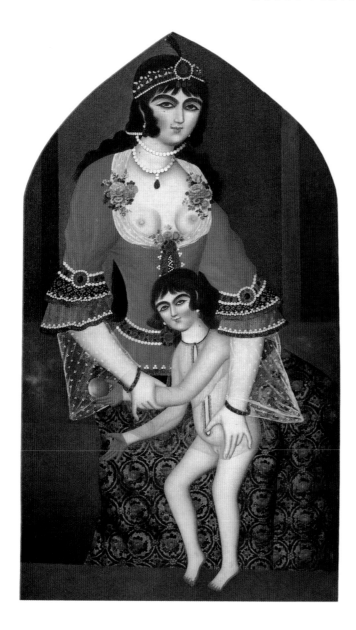

-58-
Mother and Child

Attributed to Muhammad Hasan
Iran, second or third decade of the 19th century
Oil on canvas; 52 x 31 inches (132.1 x 78.2 cm)
HASHEM KHOSROVANI QAJAR COLLECTION

Images of seductively garbed European women were favored by Persian painters from the mid-seventeenth century on (see NO. 8). Group compositions of one or more women depicted with children and attendants constitute a subtheme that drew upon Christian iconographic types of the Madonna and Child and the Holy Family. In this work, the artist has reinterpreted the Christian Madonna as a luscious court beauty gently holding a young girl, who plays with an apple. The composition focuses on the figures, set against a dark background. The flattering red costume, luxuriant coiffures, half-closed eyes, and carefully rendered creamy skin are skillfully handled to create a sensually charged image.

The painting may be assigned to the artist Muhammad Hasan, noted for his graceful compositions of idealized, doe-eyed maidens wearing low-cut Regency period gowns. A comparison of this work with Muhammad Hasan's paintings *Shaykh San'an and the Christian Girl* (FIG. 29a) and *A Prince and Child* (FIG. 27a) reveals close affinities in the delicate facial features and forehead bangs, the double strand of pearls worn under the chin, and the nosegays attached to the figure's décolletage.

On one level, the treatment of the subject alludes to motherhood and fertility. On another, the composition's erotic message is conveyed by the mother's tight-fitting bodice and deep décolletage, emphasizing her small, rounded breasts framed by delicate floral bouquets, and by the little girl's transparent shift, which barely hides her nudity. An unsettling ambiguity between religious iconography and sublimated eroticism pervades this work and contributes to its compelling beauty.

LSD

Provenance: Eskandar Aryeh.

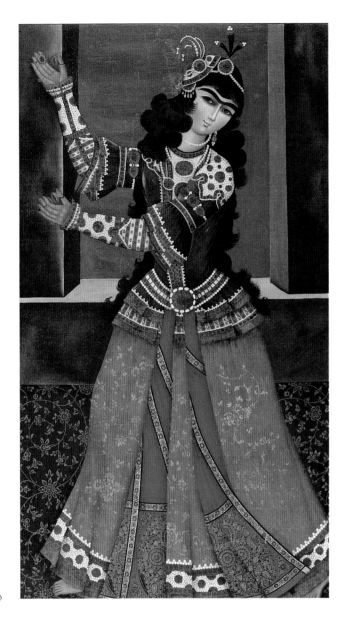

-59-

Female Dancer with Castanets

Artist unknown
Iran, first quarter of the 19th century
Oil on canvas; 62³/₁₆ x 35⁷/₁₆ inches (158 x 90 cm)
STATE HERMITAGE MUSEUM, SAINT PETERSBURG, VR-1110

This picture is a fine example of a favorite subject of Qajar court painting – representations of young female dancers, musicians, and acrobats. As is usual for Qajar paintings of beauties, the picture is neither signed nor dated, but its style and the young woman's clothes, which correspond to descriptions by European and Russian travelers and diplomats,[69] belong to the first quarter of the nineteenth century. Moreover, the picture came to the Hermitage from the Gatchina Palace Museum with four other paintings, all of which are from the period of Fath 'Ali Shah's reign.

Like many other Qajar canvases showing women, *Female Dancer with Castanets* seems to be one of a series of paintings that once decorated a palace. Two other pictures from this series, showing a dancing girl and a musician, are in the State Museum of Fine Arts in Tbilisi, Georgia (856, 857). The same facial type is repeated in these three canvases, which were clearly created by the same artist. The women are shown against an open window with the same pattern of lights and darks, and the canvases are of the same size and format.

ATA

Literature: Amiranashvili 1940, pl. XXVII; A. T. Adamova, "Two Paintings of the Early Qajar Period" (in Russian), in *Sredneya Azia I Iran* (Leningrad, 1972), fig. 1; Karpova 1973, no. 20; Adamova 1996, no. 66.
Provenance: From the Gatchina Palace Museum in 1932.

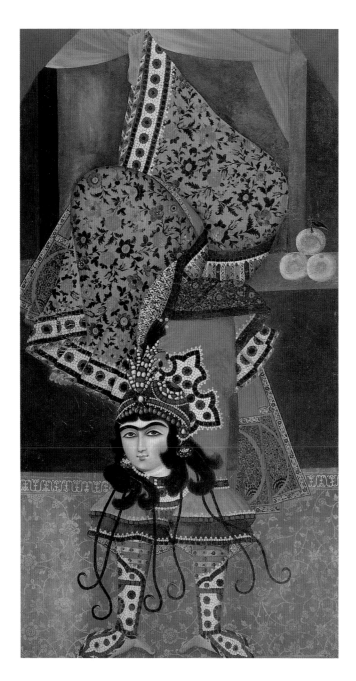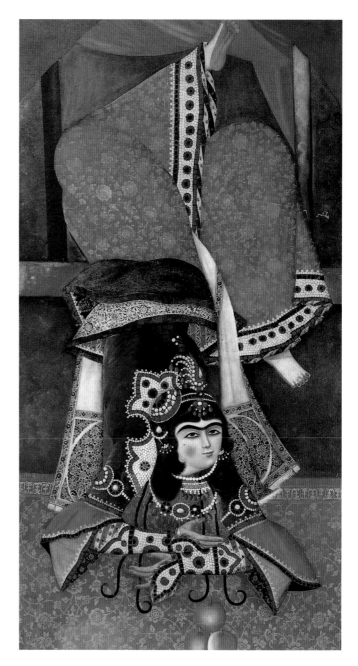

-60, 61-
Two Paintings of Female Acrobats

Attributed to Ahmad
Tehran, second or third decade of the 19th century
Oil on canvas; 59⅝ x 31¹¹/₁₆ inches (151.5 x 80.4 cm)
LENT BY THE BOARD OF TRUSTEES OF THE VICTORIA AND ALBERT MUSEUM, LONDON, 719–1876, 720–1876

Acrobats and tumblers number among the most striking images from the Persian painter's repertoire of female types. These two highly original paintings were intended for display together, in a configuration similar to that employed for the salon of the French mission in Tehran (FIG. XIX). According to a letter dated October 1875 from Colonel R. Murdoch Smith, of the Telegraph Department, Tehran, these paintings were originally in the Gulistan palace and belong to the period of Fath 'Ali Shah. Murdoch Smith was able to acquire them as a result of redecorations during the 1860s to 1880s.

The acrobats' bodies are flattened against the picture plane, twisted like pretzels to maintain a balance that flouts all laws of gravity and perspective. The figure on the left is impossibly poised above a pyramidal still life of apples.

The anonymous painter has devised a completely assured and peculiarly modern-looking composition of shifting planes juxtaposed with writhing lines (the subjects' spit curls and long plaits), broken surfaces, and layered patterning (including at least seven or eight designs in differing directions in the figures' garments) that recalls the energy and bravura of Synthetic Cubism. The visual excitement of the paintings is further enhanced by the brilliant palette of black, white, scarlet, and deep turquoise.

Although Qajar representations of women were rarely signed or dated, these paintings present marked affinities with similar subjects executed by the painters Ahmad and Muhammad, providing a dating range from the late 1820s to the early 1840s. More specifically, the bravura treatment of pattern, the use of white to delineate the eyelids and forehead, and the bold palette point to an attribution to Ahmad.

As the salon of the French mission shows (FIG. XIX), these paintings were displayed in the public as well as private quarters of palaces and residences. Such representations, in a society where women were secluded from the male gaze, understandably puzzled nineteenth-century European observers, who failed to grasp the abstract nature of these representations and mistook them for actual portraits.[70]

LSD

FIG. XIX. *View of the Salon of the French Mission in Tehran.*
Jules Laurens (French, 1825–1901). 1846–48. Watercolor, 12⁷/₁₆ x 17¹¹/₁₆ inches (31.6 x 44.9 cm).
ÉCOLE DES BEAUX-ARTS, PARIS, EBA 2179.

Literature: Robinson and Guadalupi 1990, 115, fig. 117 (NO. 60).
Provenance: Acquired in Tehran sometime before 1875 by R. Murdoch Smith.

-62-
Covered Bowl, Saucer, and Spoon with Astrological Motifs

Signed by Muhammad Baqir
Iran, early 19th century
Enameled gold; bowl 2 x 3 inches (5.1 x 7.6 cm); cover 2¹/₂ x 3¹/₂ inches (6.4 x 8.9 cm);
diam. saucer 5 inches (12.7 cm); length spoon 5¹/₄ inches (13.3 cm)
PRIVATE COLLECTION

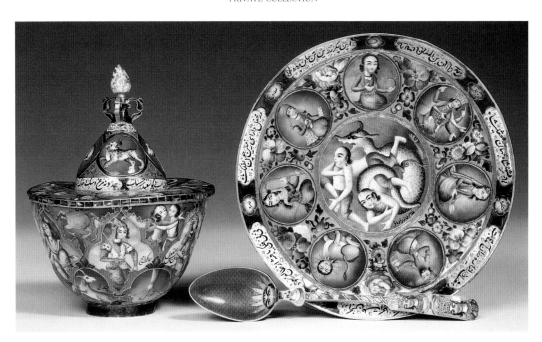

This magnificent set is decorated on every surface with a remarkably detailed and exquisitely painted design based on the twelve signs of the zodiac; the six major constellations; Sino-Japanese zodiacal animals; the seven planets; and, in the saucer of the dish, a combat between two wrestlers and a dragon. All the scenes are identified by minutely copied inscriptions, except the last. This image undoubtedly held a personal message for the ruler, perhaps alluding to his astrological sign, or served a talismanic function. A lengthy dedicatory poem extols the object and its patron.

The Crown Jewels Collection in Tehran and the Treasury of the State Hermitage Museum house a few enameled gold objects of comparable quality, and jeweled bowls of similar form are frequently depicted in paintings of the early Qajar period (see NO. 34). This set exemplifies not only the high standards demanded of court masters such as Muhammad Baqir, but also the combination of erudition, complexity, and unmatched luxury that characterize works commissioned by the ruler. Such objects of personal use evoke the lavish yet isolated life that the ruler led within his harem and the significance that the ruler attached to astrology and superstition (see NO. 65).

<div align="right">LSD</div>

Literature: Robinson 1969, 196, fig. 121; Robinson 1976b, 25–31; B. W. Robinson, "Persian Painting in the Qajar Period," in Ettinghausen and Yarshater 1979, 343, fig. 228; Robinson 1989, 229, fig. 6; Robinson 1991, fig. 6.

Inscriptions: For a complete reading and interpretation of the inscriptions, see Robinson 1976b, 318–21. In *nastaʿliq* script, in the saucer medallion below the wrestling group: *ghulām Khānehzād Bāqir*

<div align="center">

-63a,b-

Pair of Reverse-Glass Paintings from a Pictorial Cycle

Artist unknown
Iran, early 19th century
Glass, painted in reverse, and painted and carved wood; approx. 29 x 20½ inches (73.6 x 52.1 cm)
KHALILI FAMILY TRUST

</div>

Reverse-glass painting, or églomisé, introduced during the early Qajar period, probably evolved from the mirrorwork in geometric and vegetal patterns that had been favored for palace interiors since the Safavid period. As was the case with enamelwork, reverse-glass painting was first practised in the court ateliers, where imported models were readily available. Inspiration for this technique may have come from either East or West, since églomisé paintings were produced in Europe, primarily Germany, as well as in China.

Reverse-glass paintings comparable in quality and scale to these examples are rare, since most surviving works, small-scale and in a popular idiom, are datable to the late nineteenth or early twentieth century. Although these works are neither signed nor dated, their style follows the prevailing mode of the early to mid-Qajar period, in which richly garbed and jeweled youths and court coquettes are framed against landscape backgrounds with winding streams, tall leafy trees, and cloud-streaked skies. The palette of opaque hues in light blue, pink, and lavender is also typical for this period. A number of fine paintings of similar style have been assigned to Mirza Baba,[71] to whom the cycle of reverse-glass paintings of European subjects in the Marble Throne Hall of the Gulistan palace in Tehran may also be attributed. The exuberantly painted and carved frames, displaying a complex design of maiden suns, floral arrangements, and dragon-and-bird scrolls, testify to the excellence of early Qajar craftsmanship.

<div align="right">LSD</div>

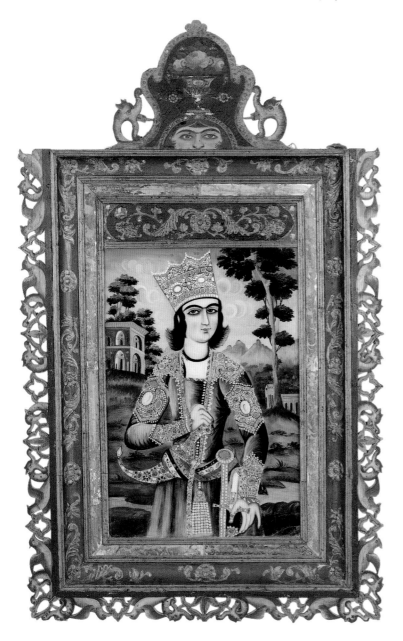

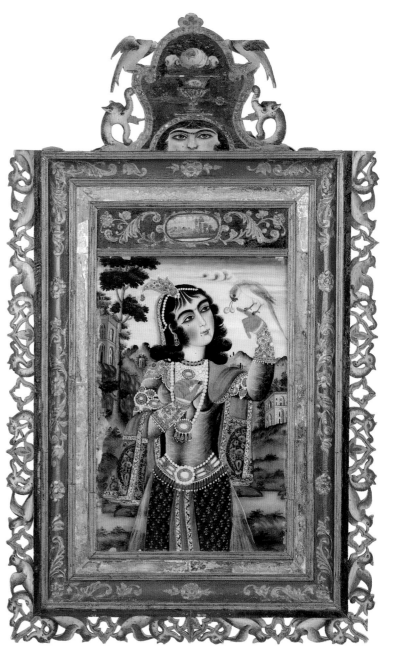

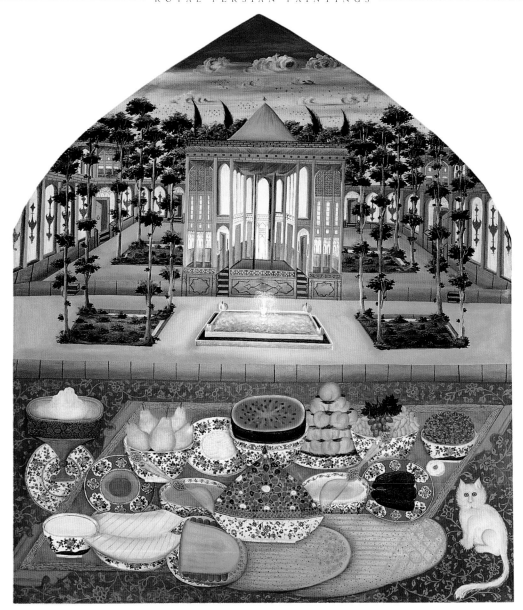

-64a,b-
a) *Still Life in Front of Palace Garden with Cat*
b) *Still Life in Front of Palace Garden with Birds and Rabbit*

Artist unknown
Iran, early to mid- 19th century
Oil on canvas; 61 x 54 inches (152.5 x 135 cm)
HASHEM KHOSROVANI QAJAR COLLECTION

A new genre of still life with landscape was introduced in Iran in the eighteenth century. In contrast to the well-documented evolution, location, and format of official life-size painting, little is known about the development of still-life painting, which held scant interest for Iranian chroniclers or European diplomats. The finest existing examples were painted in the late eighteenth century by Mirza Baba. Once introduced, the composition of still life in the foreground with landscapes in the middle ground and far distance evolved very little in the course of the following century.

Such subjects were most appropriate, singly or in groups, for reception rooms and garden pavilions. By way of example, a photograph of the Fin garden pavilion at Kashan (FIG. XX), itself probably dating from the second decade of the century, depicts two such mural paintings (from a cycle of probably eight) within the arch of the vault. The still lifes are set within strapwork bands with arabesque designs and schematic, small-scale landscapes with pavilions, bridges, boats, and lakes in Safavid style, suggesting that the independent genre of still life ultimately evolved from seventeenth-century prototypes.

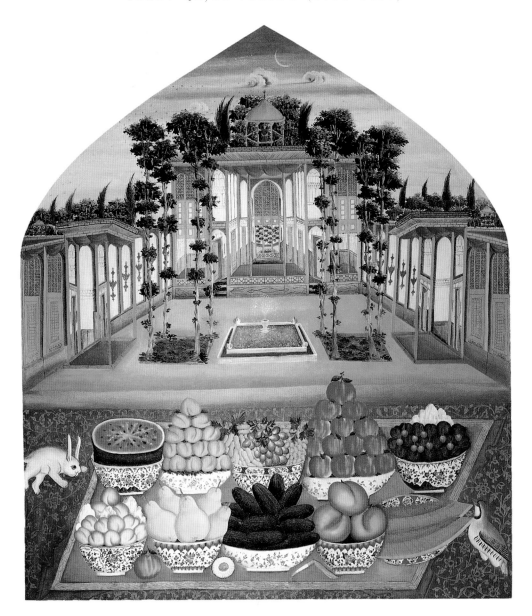

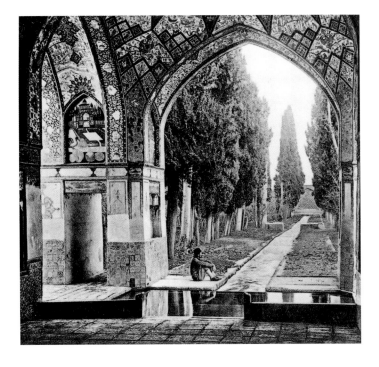

FIG. XX. *Pavilion in the Royal Garden of Fin, Kashan.*
Photograph, Kashan, late 19th century.

This pair of paintings follows the compositional formulas established by Mirza Baba yet is exceptional within the known examples of this genre for the scale, mathematically precise rendering of perspective and recession, delicate palette, and superb detailing. The paintings present a view from a verandah onto an interior garden. In the foreground, an inviting still life of vividly colored ripe fruits from a local garden and cool sherbets is displayed in delicate floral ceramics, Chinese famille rose and blue-and-white export porcelain or expert local imitations. A tame rabbit and pheasant and a quizzical cat add charming touches of animation to the scenes. The fine quality of the porcelain, the lavishly jeweled lid of one of the bowls, and the use of gilt suggest a royal origin for these paintings.

The elaborate background presents a formal garden with three-storey pavilions, pools with gurgling fountains, and tall, leafy trees in a delicate palette of blues, earth colors, and soft green. The niches, balustrades, and decorative woodwork of the structures are minutely depicted, as are the pointed roofs known as *kulāh farangī*, after the peaked headgear of European travelers.

A close examination of the paintings reveals that two different times of day are depicted: the afternoon scene, indicated by the blue skies lightly streaked with clouds, features the principal meal with hot dishes, vegetables, flat bread, and sherbet; the twilight scene, when the crescent moon has risen in the dark skies and the muezzin calls to prayer, is accompanied by a lighter collation of fruits. In sum, these paintings admirably convey the paradisiacal delights of the classic Persian garden celebrated by its poets: shade, peace, and luscious repasts.

LSD

Provenance: Eskandar Aryeh.

-65-
Ceiling

Artist unknown
Shiraz?, dated A.H. 1263/A.D. 1846
Oil on canvas; 271 1/4 x 111 7/8 inches (689 x 284 cm)
STAATLICHE MUSEEN ZU BERLIN PREUSSISCHER KULTURBESITZ, MUSEUM FÜR ISLAMISCHE KUNST, D.1181

This superbly painted ceiling is probably the finest example of its type in existence and illustrates the continued preference for the early Qajar style even in the mid- to late nineteenth century.

The intricate and skillfully executed carpetlike composition presents a field design of an elongated central medallion with a symmetrical scrolling-vine system marked by two portrait ovals at the center. Spandrels with four seminude female angels amid scrolls and maiden-sun quarter-medallions occupy the four corners. The medallion features a single maiden sun surrounded by the twelve signs of the zodiac on a ground of arabesques and three pendants, two of which are inscribed with the date and Qur'anic verses. The scroll system emanating from the center bears twelve paired angels floating on a ground of arabesques with birds and dragon heads amid flowers.

The cities of Shiraz and Isfahan are especially rich in superb private residences decorated with lavish ceilings. This ceiling is probably from Shiraz, since a similar example is still located in the late nineteenth-century house of Nasr. Strong support for a Shiraz origin is provided by the magnificent ceiling painted with signs of the zodiac commissioned in 1843–44 (only two years before this example) by Farhad Mirza (1817–1888), Mu'tamid al-Dawleh, Muhammad Shah's brother and governor of Shiraz, for his garden complex of Farhadabad.[72]

Although the earliest existing ceilings with figural designs date from this period, they represent the end of a long-standing tradition of domed, vaulted, and flat ceilings decorated with paradisiacal and cosmological decorative schemes. Astrological themes in particular seem to have been in vogue in this period (see NO. 62) and were reinterpreted by Qajar painters with refreshing inventiveness and creativity.

LSD

Literature: Klaus Brisch, "A Persian Painted Ceiling of 1846," in *Jahrbuch der Preussischer Kunstsammlung* 19 (1982): 319–29.
Inscriptions: In *nasta'liq* script, cartouches on either side of central medallion with image of the maiden sun: *bismillah al-rahmān al-rahim* 1263 (part of verse 13, surah 31); *nasr min allāh w'al fathun qarīb*

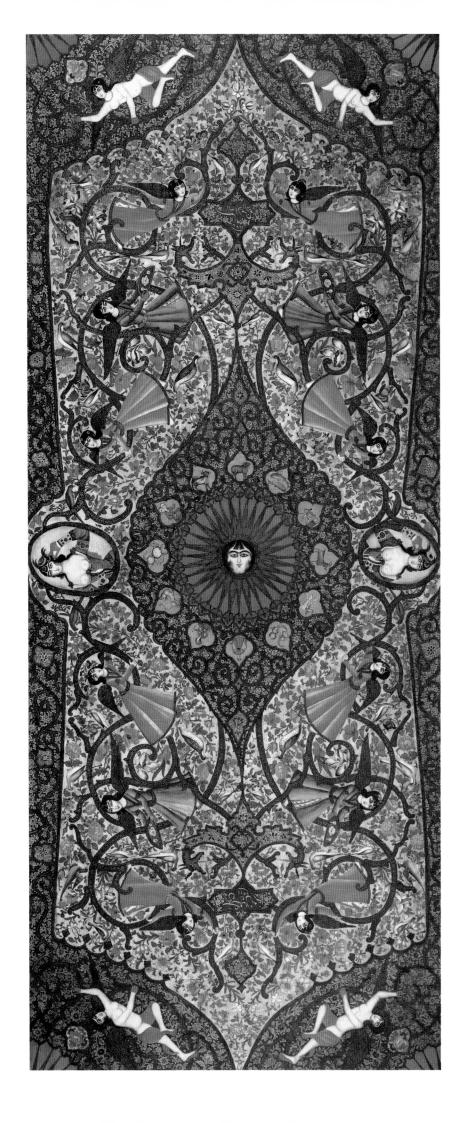

1. Crown Prince 'Abbas Mirza, for instance, commissioned paintings (NOS. 50–52, and Maslenitsyna 1975, no. 124) and artworks (see NO. 43 and B. W. Robinson, "Persian Painting in the Qajar Period," in Ettinghausen and Yarshater 1979, 202, no. 129, for enameled box), a number of which appear to have coincided with the years 1815–16, when his heir apparency was challenged by his half brother Muhammad 'Ali Mirza Dawlatshah. I wish to thank Abbas Amanat for this information.

2. See Diba essay in this volume for the function and impact of early Qajar life-size images.

3. See Jan Rypka, *History of Iranian Literature*, ed. by Carl Jahn (Dordrecht, 1968), 327–28.

4. See essays by Diba and Ekhtiar in this volume.

5. Texier 1842, 45.

6. Robinson 1976a, 244–49. A later copy is embellished with illustrations by Muhammad Hasan Afshar, dated A.H. 1237/A.D. 1821 (*Fine Oriental Miniatures, Manuscripts, and Islamic Works of Art*, sale cat., Sotheby's, New York, December 10, 1981, lot 173). See also Robinson 1950, 68, and Adamova 1996, 85.

7. Fasa'i 1972, 155. The envoy returned in the same year with a letter of friendship and gifts (ibid., 159).

8. For oil-on-panel copy, see Maslenitsyna 1975, fig. 126; for watercolor copies, see Robinson 1976a, 250–53; *Antiquities and Islamic Art*, sale cat., Sotheby's, New York, November 29, 1989, lot 197; Maria Christina Pudioli, "La Memoria degli affreschi perduti: Una copia dal Negarestan all'Archiginnasio di Bologna," *L'Archiginnasio, Bulletin of the Public Library of Bologna*, year LXXXIV (1989): 293–301 ; for engravings, see *Fine Oriental Miniatures, Manuscripts, and Qajar Paintings*, sale cat., Sotheby's, December 9, 1975, lot 283, and Kalpana Ghose, "Qajar Portraiture in the Memorial Collection," *Bulletin of the Victoria Memorial* 13 (1979): 28–30; and others in private collections.

9. See Diba essay in this volume for a description of the painting.

10. The dating of the copies is documented by the completion date of the palace, the use of English paper watermarked with the date 1816, and a dated 1834 engraving of the mural executed by the English artist Robert Havell (Robinson 1976a, 250, nos. 1239–42, and *Fine Oriental Miniatures*, sale cat., Sotheby's, December 9, 1975, lot 203, respectively).

11. Pudioli, "La Memoria," 297. See Gulmuhammadi 1971, 102, for a self-portrait of the court poet and scribe, Nishat, holding a decree that he had drafted. See Ahmad Suhayli Khwansari, "The Negarestan Palace and Garden," *Hunar va Mardum* 144 (1974): 31–37, for identification of the figures. A copy of the mural executed in 1904 does not record the inscriptions on the documents.

12. *Antiquities and Islamic Art*, sale cat., Sotheby's, lot 197.

13. See Anthony Welch and Stuart Cary Welch, *Arts of the Islamic Book: The Collection of Prince Sadruddin Aga Khan* (Ithaca and London, 1982), 132–34; Anthony Welch, *Prince Sadruddin Aga Khan Collection of Islamic Art* (Geneva, 1972–77), vol. 4, pp. 98–99.

14. Ouseley 1819–32, vol. 3, p. 26.

15. Texier 1842, 129.

16. If we assume that this is indeed 'Abbas Mirza as a ten-year-old boy, we can date the casket to circa 1799, the date of his appointment as crown prince, heir apparent, and governor of Azarbaijan.

17. B. W. Robinson, "A Pair of Royal Book-Covers," *Oriental Art* 10 (1964): 32–34.

18. Revealed by the x-radiography of the work taken during the Brooklyn Museum of Art's Curatorial-Conservation study of Qajar painting.

19. An almost identical sword dated 1798 (see Ivanov, Lukonin, and Smesova 1984, no. 63) further supports the proposed dating.

20. Iradj Amini, *Napoléon et la Perse* (Paris, 1995), 105. Amini notes that Jaubert also received a group of fine manuscripts, now in the Bibliothèque Nationale, Paris.

21. See Robinson 1964, 103.

22. For a discussion of Qajar chair thrones, the Sun Throne, and extant regalia, see V. B. Meen and A. D. Tushingham, *The Crown Jewels of Iran* (Toronto and Buffalo, 1968), 53, 55, 58, 73–75, 79.

23. First proposed by Robinson "Persian Painting," 336.

24. The same verses are inscribed on two other portraits of Fath 'Ali Shah by Mihr 'Ali: Karpova 1973, no. 10; *Oriental Manuscripts and Miniatures*, sale cat., Sotheby's, April 26, 1991, 72–73 (a reading and English translation of the verses is provided on p. 76), lot 186.

25. Falk 1972, pl. 15.

26. Robinson, "Persian Painting," fig. 224.

27. Kotzebuë 1819, 263; Borozdna 1821, 214.

28. A portrait in armor was also commissioned in 1815 from the painter Ahmad,

29. Robinson 1964, 100, 103.

29. In addition, a very similar 1823 composition showing the ruler with his water pipe by Ahmad (British Embassy, Tehran) suggests that Fath 'Ali Shah commissioned at least two versions of this subject, one for himself and one as a gift, as he did in other instances.

30. Lerner 1991, 40.

31. Mihdi Bayani mentions his works in vol. 4 of *The Biographies and Works of Calligraphers*. Bayani, *Aḥvāl va Āsār-i Khushnivīsān* (Tehran, 1979).

32. Muhammad Hashim Asaf 1969, 410.

33. *Art d'Orient*, sale cat., Hôtel Drouot, Paris, December 12, 1975, lot 199. See Karimzadeh Tabrizi 1985–91, vol. 2, pp. 816–20, fig. 85.

34. *Oriental Manuscripts and Miniatures*, sale cat., Sotheby's, London, October 16, 1996, lot 75.

35. *Oriental Manuscripts and Miniatures*, sale cat., Sotheby's, London, April 23, 1997, lot 161.

36. James Baillie Fraser, *Narrative of a Journey into Khorasan in the Years 1821–22* (London, 1825), 148.

37. I'tiżād al-Saltaneh 1991, 188.

38. Sarre Herzfeld, "Rhages, Relief des Feth Ali Schah," in *Iranische Felsreliefs* (Berlin, 1910), vol. 2, fig. 115.

39. See Ph. W. Shulz, *Die persisch-islamische Miniaturmalerei* (Leipzig, 1914), vol. 2, pl. 185.

40. See Lisan al-Mulk Sipihr 1875, 1965 ed., vol. 1, p. 348, vol. 2, p. 153; and the anthology "Gulshan-i Maḥmūd," in "Tārikh-i Sāḥibqirānieh," manuscript (British Museum, London, 2876), for examples of Prince Yahya's poetry.

41. Bamdad 1968–74, vol. 3, p. 471.

42. Fasa'i 1972, vol. 2, p. 49, and Muhammad Jáfar, Khurmuji, *Tārikh-i Qājār*, ed. by Husayn Kadivjam (Tehran, 1984), 204–9.

43. Lambton 1987, 95–96.

44. Muhammad Quli Khan was also the patron of a lacquer mirror case dated 1865 by Lutf 'Ali in the Nasser D. Khalili Collection, LAQ 348; see Khalili, Robinson, and Stanley 1996, 210–11.

45. Karimzadeh Tabrizi 1985–91, vol. 1, pp. 3–4.

46. See FIG. XVII. Other European commissions included a hand-colored lithograph by Maxim Gauci (1774–1854) at the Victoria and Albert Museum and a portrait bust by Bacon. See Robinson 1950, 66–68.

47. *Ḥayratnāmeh: Safarnāmeh-i Abu'l Ḥasan Īlchi bih Landan*, ed. by Hasan Mursilvand

(Tehran, 1986). Translated as Abu'l Hasan Khan 1988.

48. Abu'l Hasan Khan 1988, 254, 257.

49. Denis Wright, *The Persians amongst the English* (London, 1985), 57–60.

50. See Michael Levey, *Sir Thomas Lawrence* (London, 1979), 15. I thank Lisa Rotmil, research associate, Department of European Painting and Sculpture, Brooklyn Museum of Art, for her helpful suggestions.

51. Charles Millard, "A Diplomatic Portrait: Lawrence's 'The Persian Ambassador,'" *Apollo* (February 1967): 117.

52. Kenneth Garlick, *Sir Thomas Lawrence: A Complete Catalogue of Oil Painting* (Oxford, 1989), 18.

53. Drouville 1819, part 1, p. 165.

54. Alexey Petrovich Yermolov, *Zapiski Alekseja Petrovicha Ermolava. 1816–1827* (The notes of Alexey Petrovich Yermolov. 1816–1827) (Moscow, 1869), 22.

55. Drouville 1819, part 2, pp. 125–26.

56. Soudavar 1992, 388, 393.

57. In champlevé, the solid metal is hollowed out to hold the enamel (translucent or opaque). In painted enamels, an opaque color is fused to the metal, to which designs in vitreous colors are applied and subsequently fired. In repoussé the metal is raised into ornamental relief by hammering from the reverse.

58. Robinson 1969, 188.

59. For two related dishes, see *The Palace Collections of Egypt: Catalogue of the Highly Important Collection of Works of Art in Precious Metals*, sale cat., Sotheby's, March 1954, lot 867 (for dish presented to the English ambassador Sir Gore Ouseley on his departure in 1814); and Ivanov, Lukonin, and Smesova 1984, no. 72.

60. Stuart 1854, 196; J. S. Buckingham, *Travels in Assyria, Media and Persia* (London, 1830), 296–97.

61. Precious stones were preferred gifts; but crystal basins, mirrors, china, and rifles were also deemed acceptable. In return, the Persian court sent paintings, coins, enamels, brocades, and precious stones; see Fasa'i 1972, 147, 139; Kotzebuë 1819, 208–10. See Abu'l Hasan Khan 1988, 1135, 238, 243, for Abu'l Hasan's purchases (including a carriage, porcelain, and cut-glass water pipes) in London.

62. Sir John Kinnear Macdonald (1782–1830) accompanied Malcolm's second and third missions and was appointed envoy to Iran (1824–30); see Wright 1977, 18.

63. Keppel 1827, 16–17.

64. Layla Diba, "Clothing in the Safavid and Qajar Periods," *Encyclopaedia Iranica*, vol. 5.

65. Sarah Graham-Brown, *Images of Women* (New York, 1988), 174.

66. S. J. Falk, "A Qajar Painting of Two Girls," in *The Royal Asiatic Society: Its History and Its Treasures*, ed. by Stuart Simmonds and Simon Digby (Leiden and London, 1979), 109–10.

67. Ibid.

68. Norman A. Rubin, "Bible Tales in Islamic Painting," *Oriental Art* (Autumn 1992): 165–68, fig. 4.

69. Borozdna 1821, 120; Morier 1818, vol. 2, p. 48; Drouville 1819, 72.

70. Texier 1842, 127.

71. Robinson 1989, 230, fig. 9.

72. Fasa'i 1972, 273.

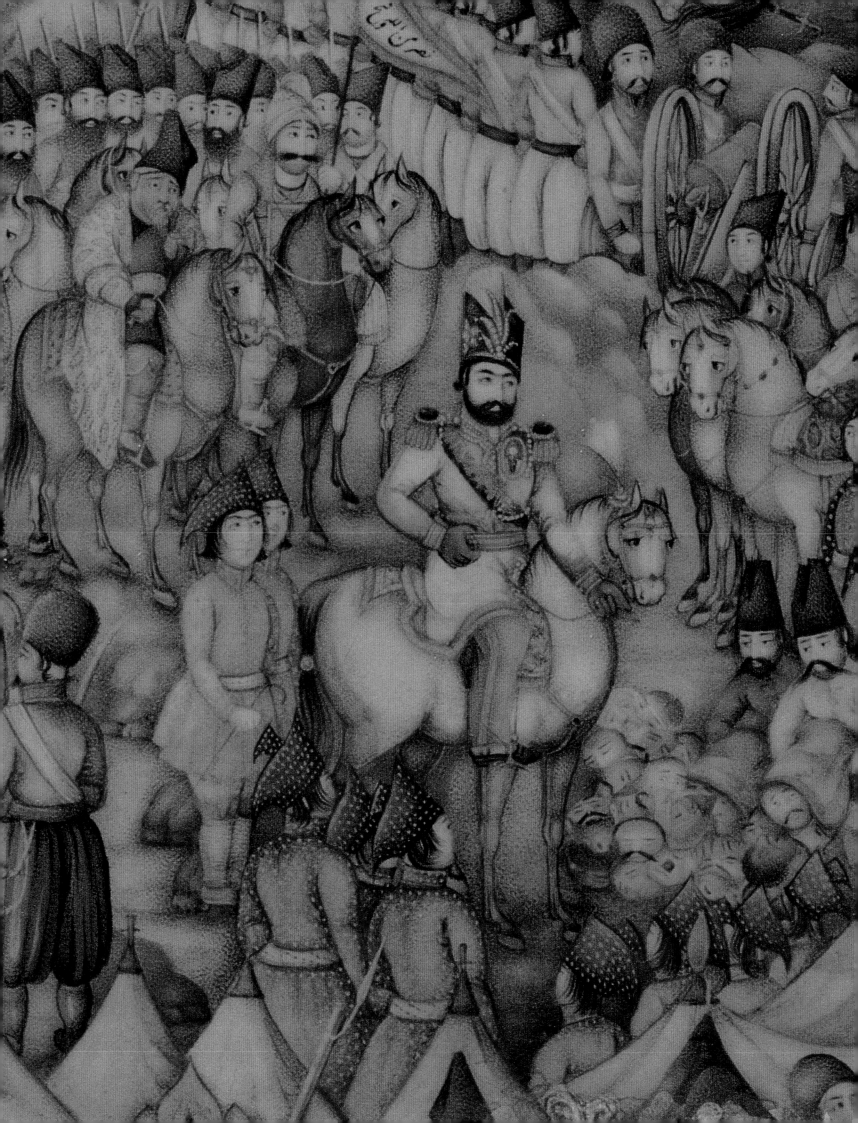

MUHAMMAD SHAH PERIOD

(1834–48)

ATH 'ALI SHAH'S successor, Muhammad Shah (Prince 'Abbas Mirza's eldest son), was crowned in 1834 in the Negarestan audience hall amid 'Abdallah Khan's splendid paintings of the imperial court. During his fourteen-year reign, Muhammad Shah never emerged from the shadow of his grandfather. Short, stout, suffering from gout and a limp, he did not cut much of a figure. Frustrated in his military ambitions, Muhammad Shah paid only desultory attention to the glorification of the monarchy and deferred to the mystic tendencies of his unpopular vizier, Haji Mirza Aqasi.

In regard to artistic patronage, Muhammad Shah possessed neither the discernment, the funds, nor the desire for self-glorification of his illustrious predecessor. His reign was a period of transition, notable chiefly for the sporadic appearance of new trends that would bear fruit in the subsequent reign.

During this period, commissions of monumental paintings of enthronement, hunting, and battle declined. The ruler's architectural projects were primarily of a religious nature, and the only palace constructed during his reign, the Muhammadieh in Tehran, was destroyed shortly after his death.[1] After a phase of experimentation with the more innovative style current in Tabriz (see NO. 67), a modified version of 'Abdallah Khan's imperial court style prevailed. Painters active in the second and third

decades of the century, such as Ahmad and Sayyid Mirza, attempted with varying success to develop a style suited to the more subdued social and political climate of the 1830s and 1840s. Muhammad Shah's painter laureate, Muhammad Hasan Afshar (active 1818–78), produced impressive life-size portraits of the ruler and his successors. In these compositions, closely modeled on similarly grandiose European prototypes, the subject dominates the front of the picture plane and is silhouetted against distant landscapes and open skies.

The waning of court patronage of life-size painting resulted in a shift to small-scale painting in lacquerwork, whose principal exponents were Najaf 'Ali (active 1815–56), his brother Muhammad Isma'il Isfahani (active 1847–71), and their family. During this period lacquerwork became a popular medium for the depiction of European themes and significant contemporary events. This new trend is exemplified by five of Muhammad Isma'il's finest works, which illustrate an ever-increasing complexity and adoption of European ornaments and figural motifs (NOS. 70–73, 84).

Numerous European painters, both professional and amateur, traveled to Iran during this period. Their sketches and drawings constitute a remarkably vivid visual legacy of Iranian society, its principal monuments, and important personalities. Prince Alexey Soltykov, Jules Laurens, Eugene Flandin, and F. Colombari were invited to paint the ruler and his entourage, often spending many hours in relative informality with their subjects (see FIG.

15). No evidence of contact between European artists and their Iranian counterparts has been recorded, except for a brief meeting between Hommaire de Hell, Jules Laurens, and Muhammad Hasan; Laurens's presence must have contributed, if only indirectly, to subsequent advances in portraiture, however.

Finally, Muhammad Shah and his contemporaries were well aware of the necessity of introducing European military and technological innovations to Iran. Beginning in the early nineteenth century, travel abroad afforded Iranians the opportunity of comparing Persian painting with its European counterparts,[2] and talented Iranians were sent abroad to learn the process of lithography. In fact, the earliest lithographed Persian books illustrated with simple line drawings were produced in the late 1840s.[3]

This atmosphere of limited cultural exploration produced a favorable climate for change in the field of painting. By way of example, the translation of the *Thousand and One Nights* from Arabic into Persian was commissioned by Muhammad Shah, though the luxuriously illustrated manuscript was not completed until his son's reign. Additionally, the artist in charge of this project, Abu'l Hasan Ghaffari, Sani' al-Mulk (active 1842–66), began his career at the court of Muhammad Shah and was sent abroad by the ruler (1845–48) to study lithography and painting in Europe, an event that decisively influenced the evolution of later Qajar painting.[4] Abu'l Hasan's works executed before his European trip illustrated his remarkable skills as a portraitist.[5] Copies of these works by other court painters reveal Abu'l Hasan's early impact on contemporary painting. It would take an artist of Abu'l Hasan's caliber and the active patronage of Nasir al-Din Shah for Qajar painting to emerge from the past for a final, glorious flowering.

LSD

-66-
Portrait of Prince Muhammad Mirza

Artist unknown
Iran, early 1830s
Oil on canvas; 36¼ x 29¹⁵/₁₆ inches (92 x 76 cm)
STATE HERMITAGE MUSEUM, SAINT PETERSBURG, VR-1099

The man with a short, full black beard represented in this portrait against a red curtain with repeating royal Lion and Sun emblem is undoubtedly Fath 'Ali Shah's grandson and successor, Prince Muhammad Mirza, who came to the throne in 1834 at age twenty-six and ruled until 1848.[6] The portrait depicts him in a khalat of Chinese(?) silk with patterns resembling pagodas and feathers. A jeweled dagger is tucked into his sash. He wears a black lambskin Qajar hat (*kulāh*), of the form worn during the reign of Fath 'Ali Shah until the late 1830s, which is decorated with an enormous jeweled ornament set with diamonds but without the heron's feather that designated the imperial crown.[7] The absence of this detail suggests that the portrait may have been executed before Muhammad Mirza's accession to the throne, about 1833–34.

If this dating to the early 1830s is correct, the painting is a very important work that shows a new approach to the portrait. The face is rendered with a high degree of individuality. The modeling of the face reveals a knowledge and understanding of European academic painting, and the blue sky with clouds at the upper right suggests spatial recession. The picture already shows the marks of a new artistic spirit that would continue in the second half of the nineteenth century in the works of Abu'l Hasan Ghaffari and other masters of his school.

ATA

Literature: Adamova 1996, no. 81.
Provenance: Transferred from the Gatchina Palace Museum in 1932.

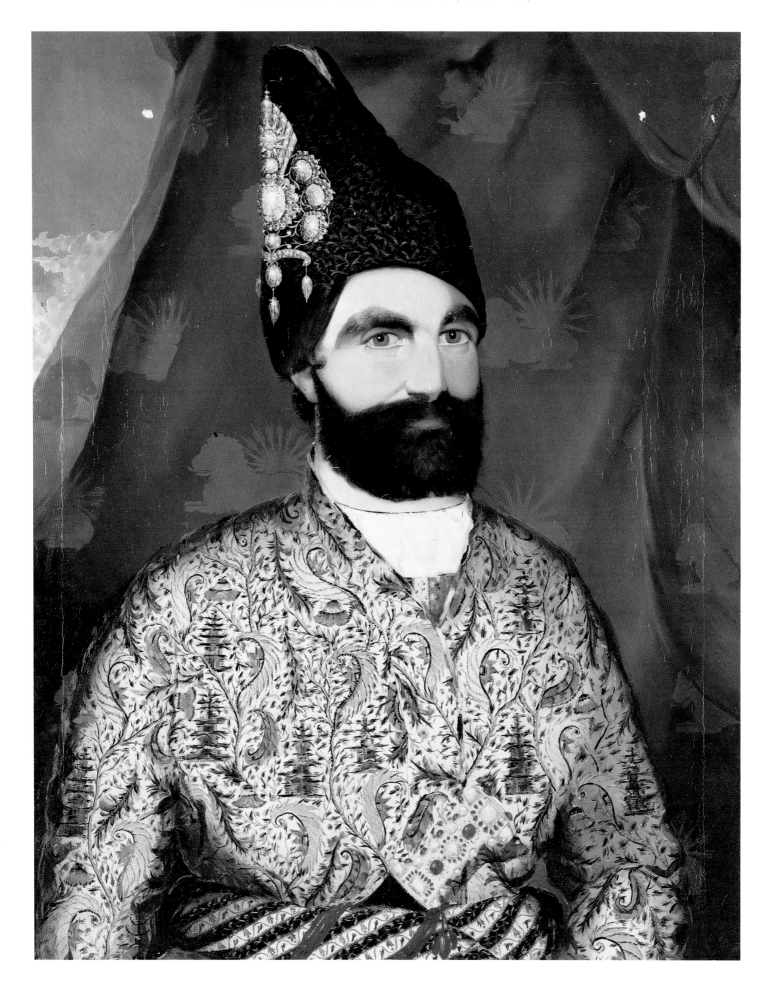

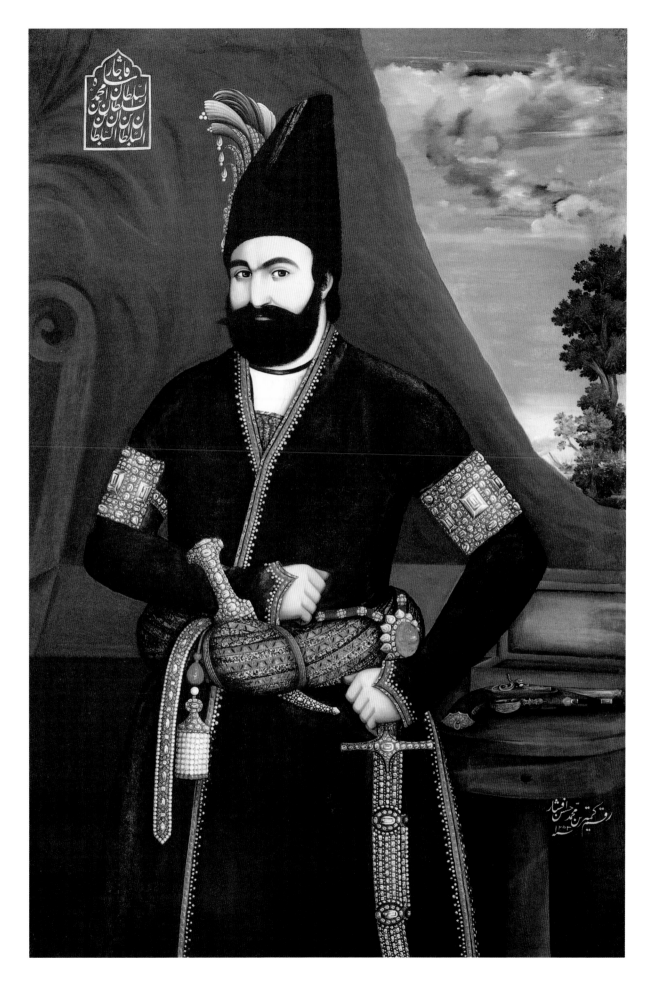

-67-
Portrait of Muḥammad Shah

Muhammad Hasan Afshar
Tehran or Tabriz, dated A.H. 1252–53/A.D. 1835–36
Oil on canvas; 60⅝ x 41 inches (154 x 104 cm)
MUSÉE DU LOUVRE, PARIS, SECTION ISLAMIQUE, ON LOAN FROM THE MUSÉE NATIONAL DE VERSAILLES, MV 6700

This painting of the ruler was executed a year after his accession. Although the painting's history is unknown, its presence in the French royal collections suggests that it was offered as a parting gift to a French envoy. A comparison with the richly patterned and brilliantly colored painting of Fath 'Ali Shah presented to Jaubert (NO. 38) reveals the increasing influence of European painting traditions.

Muhammad Shah stands before a curtain in three-quarter profile with his hand on his belt in the type of authoritative pose utilized for images of his grandfather. He wears the imperial regalia, a richly striped shawl, and a belt embellished with a massive cabochon emerald. The young ruler's impressive lineage is prominently inscribed in a cartouche at the upper left.

In contrast to the earlier portraits with similar pose, the dominant palette here is dark and the decorative impact of the painting mitigated by the airy, cloud-streaked sky and naturalistically rendered trees in the background. The ruler's attributes are also subtle indicators of change. A European-style table displays a pistol of European manufacture and its case. The monarch's head is turned so that the royal aigrette in his astrakhan cap is barely visible; even the diamonds of the ruler's armbands are set in less showy mounts.

Muhammad Hasan Afshar Urumieh (active 1818–78), known as the Mute, was active as court painter during the reigns of Fath 'Ali Shah, Muhammad Shah, and Nasir al-Din Shah. In the course of his career, his painting evolved from the traditional mode of the court of Fath 'Ali Shah to the more innovative style seen here, which utilized aerial and linear perspective, and greater modeling of form. Muhammad Hasan was also a gifted calligrapher, illuminator, designer, caricaturist, and lacquer painter. One of his finest works is undoubtedly a penbox embellished with scenes of heaven and hell and the campaigns of Emperor Napoleon. The work in progress, along with Muhammad Hasan's caricature of a favorite of Haji Mirza Aqasi, was seen in 1846 by Hommaire de Hell and Jules Laurens when they met the painter, then forty years old, in Tabriz. The European visitors keenly appreciated the minuteness of the depictions and imaginative composition of the penbox.[8]

This previously unknown work is the earliest in a series of royal portraits executed by Muhammad Hasan. Its close affinities with Tabriz and Georgian painting of the first quarter of the nineteenth century[9] suggest that Muhammad Hasan received his early training in Azerbaijan. Furthermore, Muhammad Hasan may have been trained by Allahvirdi Afshar (see NO. 50), Prince 'Abbas Mirza's court painter, who shared his tribal affiliation.

This elegant and restrained type of state portrait was not to remain in favor: subsequent examples by Muhammad Hasan and Ahmad revert to the formal compositions, brilliant palette, and rich patterning of the previous reign.

LSD

Literature: Ansari 1986, 68–69.
Provenance: Transferred from Musée National de Versailles, Paris, in 1972.
Inscriptions:
In *thulth* script, within cartouche: *Muḥammad Shāh Qājār Sulṭān ibn Sulṭān ibn Sulṭān ibn Sulṭān*
In *nastáliq* script, lower right: *raqam-i kamtarin Muḥammad Ḥasan Afshar, sanah 1253*.

-68-

Dust 'Ali Khan Mu'ayyir

Signed by Mirza Baba al-Isfahani al-Imami
Tehran, dated A.H. 1263/A.D. 1846
Opaque watercolor; 15⁹/₁₆ x 10 inches (39.5 x 25.4 cm)
MUSÉE DU LOUVRE, PARIS, SECTION ISLAMIQUE, MAO 774

Dated two years before the death of Muhammad Shah, this watercolor exemplifies the increased interaction of Persian and European painting in the 1840s. No longer presenting an ideal image, as in the previous reign, this painting was intended to provide a faithful depiction of an individual. The inscription on either side of the figure identifies the subject as Dust 'Ali Khan (1819–1873), Mu'ayyir al-Mamalik (Assayer of the Realm). The text not only gives the artist's name and date, but specifies his age as twenty-one.[10]

 Dust 'Ali Khan, son of Husayn 'Ali Khan, Mu'ayyir al-Mamalik (d. 1857) and scion of a family of court statesmen prominent since the Afsharid period, held numerous lucrative posts under both Muhammad Shah and his successor. He inherited his father's title upon the latter's death and was responsible for the construction of the Shams al-'Imareh palace and Takieh Dawlat theater, and the completion of the *Thousand and One Nights* manuscript project. Enjoying the favor of Nasir al-Din Shah, Dust 'Ali Khan amassed a large fortune, which he spent on lavish mansions and palaces and a celebrated art collection. Here Dust 'Ali Khan is portrayed early in his career as a young dandy, sporting the modified European costume worn at the court of Muhammad Shah and accompanied by a puppy undoubtedly based on a European prototype.

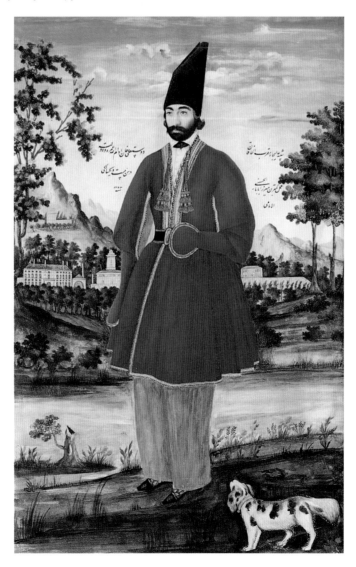

– 226 –

Figures silhouetted against landscapes were a favored portrait convention in the seventeenth and eighteenth centuries. Reinvigorated by the availability of European eighteenth- and nineteenth-century prototypes, this type gained renewed favor for court portraiture from the 1830s onward, in place of the subject posed before a curtain or in an interior. Mirza Baba's painting shows his skill at working in an idiom primarily associated with the painters Muhammad Hasan Afshar and Sayyid Mirza (see also FIG. XXVII). Dust 'Ali Khan's features are sensitively rendered, and the opaque, vivid hues of his attire contrast strikingly with the delicate watercolor washes of the mountainous landscape and the pointillistic treatment (*pardāz*) of the leafy trees. The buildings in the far distance, including Western-style residences, a small mosque, and a pigeon tower, vividly evoke the area of the Shimiranat at the foot of the Alburz range, where rulers and nobility built summer residences. In particular, the structure at the right may represent the Mu'ayyiri palatial summer home, the Baq-i Firdaws.

Mirza Baba (active 1842–56), a member of a prominent Isfahani family of painters,[11] has hitherto been considered a minor figure in Qajar painting compared to contemporaries such as Abu'l Hasan Ghaffari. The skill with which he combined nineteenth-century European conventions with indigenous painting traditions in this little-known work, however, suggests that he may have played a more significant role than previously recognized.[12] Furthermore, this painting confirms that the extensive use of European prototypes, usually dated later in the century, may have commenced considerably earlier.

LSD

Literature: *7000 Years of Iranian Art*, exh. cat., Freer Gallery of Art (Washington, D.C., 1964–65), 112, 725c; Paris 1989, 259, fig. 198; Diba forthcoming.

Inscriptions: In black *nastālīq* script, on either side of the subject: *shabīh-i 'ālijāh muqarrab al-Khāqān; 'amal-i Kamtarīn Mīrzā Bābā al-Ḥusaynī al-Imāmī; Dūst 'Alī Khān idām allāh 'umruhū va dawlatuhū* (may his life and fortune be continued). . . *dar sinn-i bīst u yik sāligī 1263*

-69-

Woman with a Veil

Attributed to Muhammad
Iran, circa 1845
Oil on canvas; 58 x 32½ inches (145 x 81 cm)
HASHEM KHOSROVANI QAJAR COLLECTION

This idealized painting of a beautiful Qajar princess attributed to Muhammad, or the "Shirin painter," an artist associated with the reign of Muhammad Shah, is one of several of a series (see FIG. XXI).[13] B. W. Robinson has attributed this painting to Muhammad based on the artist's distinctive treatment of facial features, namely the round face with almond-shaped eyes and puckered lips, and meticulous rendition of pearl designs on the princess's garment and accessories, all of which are characteristic of the artist's one extant signed and dated painting[14] and others assigned to him. Although the painting is somewhat more refined than those of Muhammad's style, we will retain this attribution for the present, in the absence of other evidence.

The princess is draped in a full-length black veil, or *chādur*, with gold-embroidered accents, which she has gathered around her left arm. Under the black veil she wears a voluminous richly patterned calico skirt[15] with pearl borders and a pearl-embroidered vest over a sheer chemise with a V-shaped collar with pearl accents. Staring coyly at the viewer and gracefully pushing aside the *pīcheh* (white face covering) of her veil, she reveals a glimpse of what lies underneath. She is adorned with an ornate headdress and a pearl-studded necklace and armbands that are indicative of her privileged status. In contrast to the many rep-

FIG. XXI. *Dancing Girl.*
Artist unknown. Iran, circa 1840. Oil on canvas, 57¾ x 33¹⁵/₁₆ inches (148 x 87 cm).
PREUSSISCHER KULTURBESITZ, MUSEUM FÜR VÖLKERKUNDE, VIENNA, IB 382.

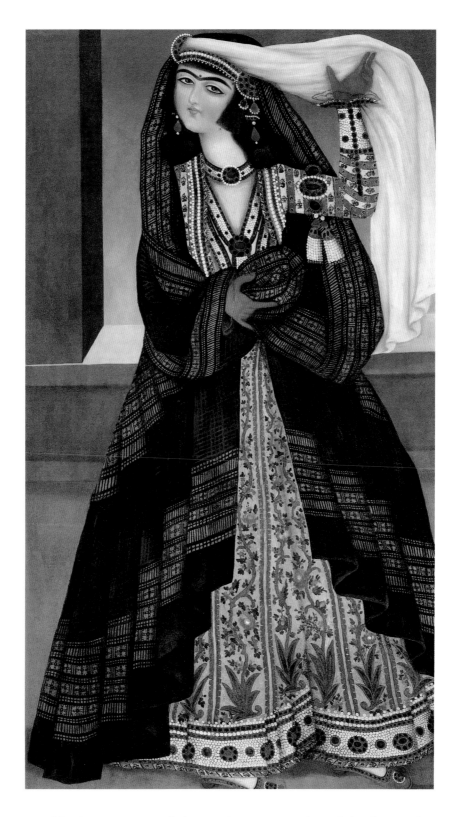

resentations of female entertainers in the harem, who are portrayed unveiled and in revealing costume, this princess is fully covered.

It was customary for Iranian women to conceal their faces and bodies with various types of veils and coverings, especially when they left the privacy of the royal harem or their homes. The veil thus acted as a portable form of seclusion when *nā-maḥram*, or forbidden men, were present.

ME

Literature: Falk 1985, 196, fig. 185; B. W. Robinson, "The Kingdom of Qajar: Persian Portraiture of the Nineteenth Century," *FMR*, no. 13 (July–August 1985): 71; Karimzadeh Tabrizi 1985–91, vol. 2, pp. 614–15.

-70-

Penbox with Portrait of Manuchihr Khan Muʿtamid al-Dawleh

Signed by Muhammad Ismaʿil
Isfahan, dated A.H. 1264/A.D. 1847
Pasteboard, painted with opaque watercolor under lacquer; length 9½ inches (24.1 cm)

-71-

Mirror Case with Portrait of Manuchihr Khan Muʿtamid al-Dawleh

Attributed to Muhammad Ismaʿil
Isfahan, circa 1847
Pasteboard, opaque watercolor and gold under lacquer; 9 x 5½ inches (22.8 x 13.9 cm)

The lacquer penbox (NO. 70) and mirror case (NO. 71) are the work of the celebrated painter Muhammad Ismaʿil Isfahani (active 1847–71). Descended from a family of lacquer and enamel painters, Muhammad Ismaʿil was the son of a painter of Isfahan named Aqa Baba and the younger brother of the eminent lacquer painter Najaf ʿAli of Isfahan, whose dated works span the period 1815–56. Known for his paintings of Christian subjects, Najaf ʿAli was responsible for reviving the Safavid and Zand styles at a time when they were dying out.[16] These two lacquer objects represent the early phase of the artist's career under the patronage of Manuchihr Khan, the Georgian eunuch known as Muʿtamid al-Dawleh, who served as *bayglarbaygi* (viceroy) of Kirmanshah, Luristan, and Khuzistan, and later as governor of Isfahan under Muhammad Shah Qajar (appointed 1839–40). The works characterize the marked decline of life-size portrait painting of royal personages and statesmen in the mid-nineteenth century in favor of painting on small-scale lacquer objects.

 The subject of the painting on the penbox, Manuchihr Khan, was purchased in childhood in Tiflis as a slave, brought to Iran by Aqa Muhammad Khan Qajar in 1794, and castrated. Owing to his remarkable administrative abilities and shrewdness, he rose through the ranks of court administration,[17] reaching the highest posts by gaining Fath ʿAli Shah's favor and confidence. He was given the title

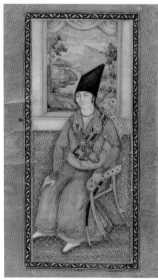

Interior, NO. 71

Mu'tamid al-Dawleh by the Shah in 1824. Feared and hated for his cruelty, Manuchihr Khan was known for his talent for inventing new and ingenious forms of punishment and torture.[18]

In the 1840s Manuchihr Khan was considered one of the most powerful men in the country. He had at his disposal an elaborate court administration with all its accoutrements, which included the service of fine artists such as Muhammad Ismaïl. It is said that on one occasion Manuchihr Khan was summoned to Tehran by Muhammad Shah, who remarked, "I have heard that you are like a king in Isfahan," to which he replied, "Yes, Your Majesty, that is true, and you must have such kings as your governors, in order to enjoy the title of King of Kings."[19] As a viceroy of much of central and southwestern Iran, Manuchihr Khan achieved prominence in the political life of the period. His close relationship with the court in Tehran[20] may have inspired his reliance on portraiture as a means of augmenting his legitimacy over his vast domain of influence.

The penbox is Muhammad Ismaïl's earliest extant work. It depicts Manuchihr Khan in full regalia kneeling in a traditional frontal pose on a small rug, holding his jewel-studded sword with one hand and his sash with the other. Seated in front of a window, Manuchihr Khan is surrounded by twenty-six of his courtiers, who stand humbly in attendance, their hands joined in front in a gesture of utmost respect. Several courtiers are identified by inscriptions; among them are 'Alijah Sulayman Khan Sarhang, Haji Mulla Ahmad Nadim, Mirza Davud Khan, 'Alijah Mirza Gurgin Khan, and Mirza Yusuf.[21] They all wear long tunics of the finest cashmere, some with brocaded vests tied with sashes. The courtiers as well as the governor himself wear tall astrakhan hats with a slanted top typical of those seen during the reign of Muhammad Shah Qajar. Manuchihr Khan is decorated with numerous medals; two that figure prominently are a portrait of Fath 'Ali Shah and a seated portrait of Imam 'Ali, champion of the Shi'ites and son-in-law of the Prophet Muhammad. That the governor wears these medals attests to his religious and temporal allegiances and reflects his desire to be regarded legitimately as a servant of the government, as well as a devout follower of Shi'ite Islam. On the sides of the penbox are generic hunting scenes.

The mirror case (NO. 71) also portrays Manuchihr Khan Mu'tamid al-Dawleh in full regalia, but here he is seated on an elaborately jewel-inlaid chair in front of a window looking onto a garden. He possesses the physical traits commonly associated with a eunuch: he is beardless and has a smooth, pale face with hanging cheeks. Sir Henry Layard, who met Manuchihr in the late 1830s, noted, "His features have a wearied and listless appearance devoid of expression and animation."[22] As on the penbox, Manuchihr Khan is dressed in the typical costume of his day with a tunic of cashmere and carries a jeweled sword. Two velvet bands of medals are wrapped diagonally around his torso in the form of an X. The exterior surfaces of the mirror case are covered with bird and flower designs, not necessarily by the same hand.

Unlike the penbox, the mirror case is neither signed nor dated. Nevertheless, the resemblance of the portraits of Manuchihr Khan on both works, their iconography, and the handling of the facial features and details of costume suggest that the mirror case was most likely painted by Muhammad Ismaïl sometime in the late 1840s.

The lacquerwork produced under the patronage of Manuchihr Khan Mu'tamid al-Dawleh is representative of the early years of Muhammad Isma'il's career, before he entered the service of Nasir al-Din Shah and earned the title of *naqqāshbāshī*, or painter laureate. During this early period Muhammad Ismaïl was apparently less interested in experimenting with new styles and subjects than in his later works.

ME

(NO. 70)
Literature: *Catalogue of Persian Objects in the South Kensington Museum* (London, 1876), 51; Wilfrid Blunt, *Isfahan: Pearl of Persia* (New York, 1966), title page; Robinson 1989, 133, fig. 6; Ekhtiar 1990, 132, fig. 3.
Provenance: Collection of Jules Richard; to Major Robert Murdoch Smith.
Inscriptions:
In *nastālīq* script, above Minuchihr Khan's shoulder: *raqamahū Ismaïl 1264*
In *shikasteh* script, next to each figure (from right to left): *Mīrzā Jàfar, 'Ālijāh Mīrzā Yuszf, 'Ālijāh Mīrzā Gurgin Khān, Manūchihr Khān Mu'tamid al-Dawleh al-'Illieh al-'Ālieh, 'Ālijāh Mīrzā Dāvūd Khān, 'Ālijāh Sulaymān Khān Sarhang, Hāji Mullā Ahmad Nadīm*
(NO. 71)
Literature: Robinson 1989, 134, fig. 7; Ekhtiar 1989b, 48, fig. 2; Ekhtiar 1990, 133, fig. 4; Layla S. Diba, "The Rose and the Nightingale in Persian Art," *Arts of Asia* 26, no. 6 (1996): fig. 92.
Provenance: Collection of Charles K. Wilkinson.

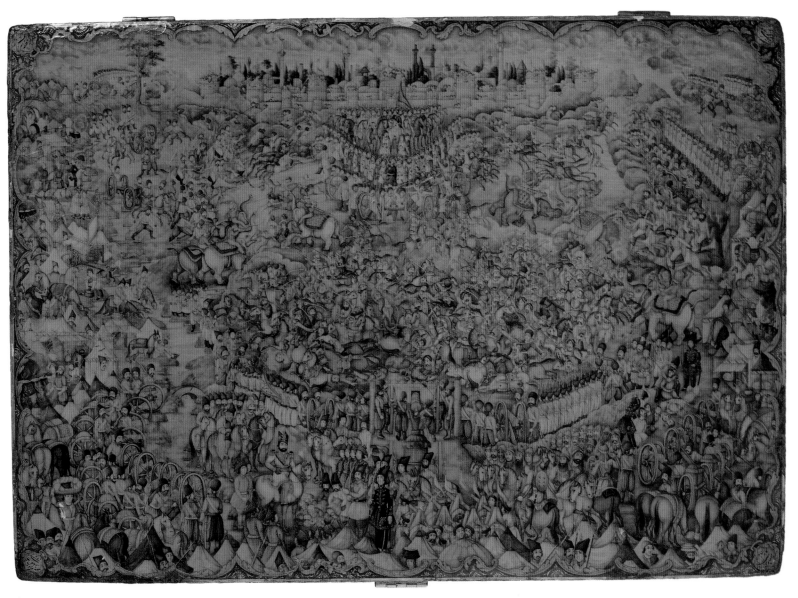

Lid, NO. 72

-72-
Casket Depicting Muhammad Shah's Siege of Herat

Muhammad Ismaïl Isfahani; signed Muhammad Ismaïl Naqqāshbāshī
Iran, dated A.H. 1282/A.D. 1865
Wood, opaque watercolor and gold under lacquer; $12^{11}/_{16}$ x $10^{3}/_{8}$ x $4^{9}/_{16}$ inches (32.3 x 26.3 x 11.6 cm)
BERNISCHES HISTORISCHES MUSEUM, ABT. VÖLKERKUNDE, BERN, 71/1913

On the lid of this casket, Muhammad Ismaïl Isfahani, painter laureate under Nasir al-Din Shah, captured
a triumphal moment in Muhammad Shah's siege of Herat in 1838.[23] Determined to make up the ter-
ritorial losses suffered by Iran at the hand of Russia under Fath 'Ali Shah's rule, Muhammad Shah chan-
neled his energies into recovering terrain that had been lost to the Afghans during the eighteenth century,
especially Herat. In the summer of 1838, his troops marched into Herat and seized the city for
approximately three months. This advance was carefully monitored by British authorities in India.
The British soon sent troops to the island of Kharg in the Persian Gulf and threatened the shah with
an attack if he failed to end the siege, which was lifted in autumn of the same year.

Muhammad Ismaïl's rendition of this panoramic view of the siege of Herat is composed of
hundreds of tiny figures tightly arranged in a coherent program of symmetrical diagonals. The battle
appears to take place on the outskirts of Herat in front of the city walls. In the center of the compo-
sition is a detailed depiction of the two armies in battle, with the Persian troops and their artillery

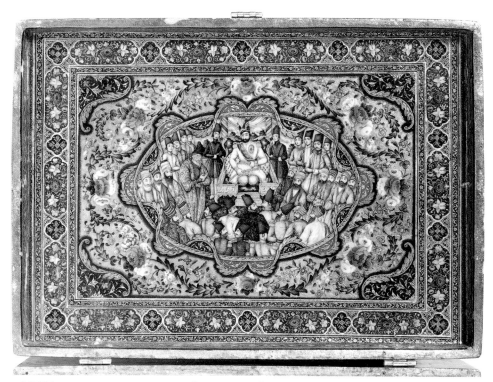

FIG. XXII. *Interior view of* NO. 72 *depicting Muhammad Shah surrounded by courtiers.*

lined up on either side. In the immediate foreground, the shah is seen on horseback proudly receiving a tribute of mutilated heads of Afghan soldiers. In keeping with conventions of Persian miniature painting, Muhammad Isma'il presents an ordered and well-balanced composition with little evocation of the harsh realities of war.

The Qajar preoccupation with military reform is clearly reflected in this scene. Muhammad Shah's troops stand in ordered rows with the most up-to-date military gear and equipment, while the Afghan troops are portrayed haphazardly riding elephants and carrying swords.

Framed within an oval medallion, the image on the interior of the lid (FIG. XXII) portrays Muhammad Shah enthroned surrounded by his courtiers and accompanied by his second prime minister, Haji Mirza Aqasi. Because of his sufi tendencies, the shah was known to have had a close bond with Haji Mirza Aqasi and relied heavily on his advice. Emblematic of Muhammad Shah's reign, this image

FIG. XXIII. *Side view of* NO. 72 *depicting Mirza Muhammad Khan Qajar.*

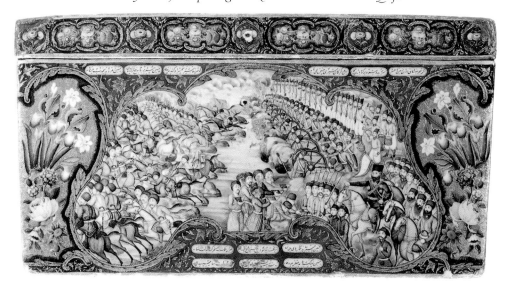

combines Persian and European stylistic elements, costumes, and iconography. For example, Muhammad Shah is depicted in European-style uniform yet is seated on a throne in traditional pose, much like that assumed by his uncle Fath 'Ali Shah, holding his sword with one hand, and his belt with the other. He was, in fact, the first Qajar monarch to abandon traditional royal garb in favor of European-style military uniform.

The inscriptions on the front and back surfaces as well as on the two sides of the casket identify scenes from other related military campaigns of the period. The front depicts Muhammad Shah at a military review and the back, the Persian bombardment of Ghorian (1837), in present-day Afghanistan, which took place shortly before the siege of Herat. The two sides of the casket, however, are painted with scenes from what appears to be Mirza Muhammad Khan Qajar's expedition against the Turkomans in Gurgan, some twenty-five years after the siege of Herat (1863; FIG. XXIII). [24] The inclusion of the title *sipahsālār* (commander in chief) in the verses has aided the identification of these scenes. Mirza Muhammad Khan Qajar was in fact the only statesman of the period who both held this title and fought against the Turkomans in Gurgan.

Although the intent of this casket is unclear, it was probably commissioned by Nasir al-Din Shah. Like his father, Muhammad Shah, he persistently pursued the goal of reannexing Herat to Iran. It is likely that he commissioned a work commemorating his father's victory at Herat as well as other successful campaigns of his father's reign. The casket may have been intended as a gift to Mirza Muhammad Khan upon his return from his campaign against the Turkomans and at the time of his appointment as commander in chief and prime minister in 1864–65. [25]

In celebrating a few short but victorious moments in the history of modern Iran and preserving it for posterity, Muhammad Isma'il produced an ingenious work that B. W. Robinson has called the most elaborate example of Persian lacquer in existence.

ME

Literature: Robinson 1970, pl. 1; Karimzadeh Tabrizi 1985–91, vol. 1, pp. 74–75; Diba 1989b, 251; Ekhtiar 1990, 136–37; B. W. Robinson, "Persian Painting under the Zand and Qajar Dynasties," in Avery, Hambly, and Melville 1991, fig. 24; Balsiger and Kläy 1992, 147–50.
Provenance: Formerly collection Henri Moser-Charlottenfels.
Inscriptions: In *nastaʿlīq* script, lower left corner: *Muḥammad Ismaʿil Naqqāshbāshī, 1282*
Front: *Taṣvir-i ṣaff-ārā'ī kardan/ Muḥammad Shāh Qājār ṭāb sarāh*
Back: *Taṣvīr-i jang-i Muḥammad Shāh Qājār ṭāb sarāh dar Ghūriān*
Sides: *Chu shahrīyār-i javān khwāst naẓm-i dawlat u dīn/ kamar bibast bih naẓm-i jahān sipahsālār*
Sipah kishīd va fitneh bast va qalʿeh gushūd/namand fitneh va āshūb dar bilād u diyār
Bih chishm-i Turkamanān, tang shud zamāneh chunān/kih rāh-i dam zadan ānjā []/Bisūkht ānkeh zi āsār-i ḥaq []/kih bar nayārad az ān pas dirakht-i ḥanẓalbār
Zi pīsh āb va zi pas ātash, īn ʿajab bāshad/kaz ān mīyāneh kasī zindeh jān burd bih kinār
Bih dāsht-i Gurgān, gurgān ādamī-khwārand/naūzbillāh, az āshūb-i gurg-i ādamkhwār
Agar shajar binshānī dar ān zamīn, ḥashar/sar burīdeh shavad, barg u bār ān ashjār
Bi daf gurgān, shīrī chinīn hamī bāyad/kih sharzeh shīr zi shamshīr kunad zinhār
Khunīn haẓh bar bibāyad bi-daf gardiman/chunīn zi mard bi aẓh-i dīdeh-i damār
Chunīn amīr bibāyad bih karhā chunān/Chunīn nahang bibāyad bih qalzam va khār
Zi bakht-i shāh būd īn khujasteh fatḥ-i buzurg/[]
Hizār malik maskhar kunad, bih dawlat-i shāh/ [] Sipahsālār

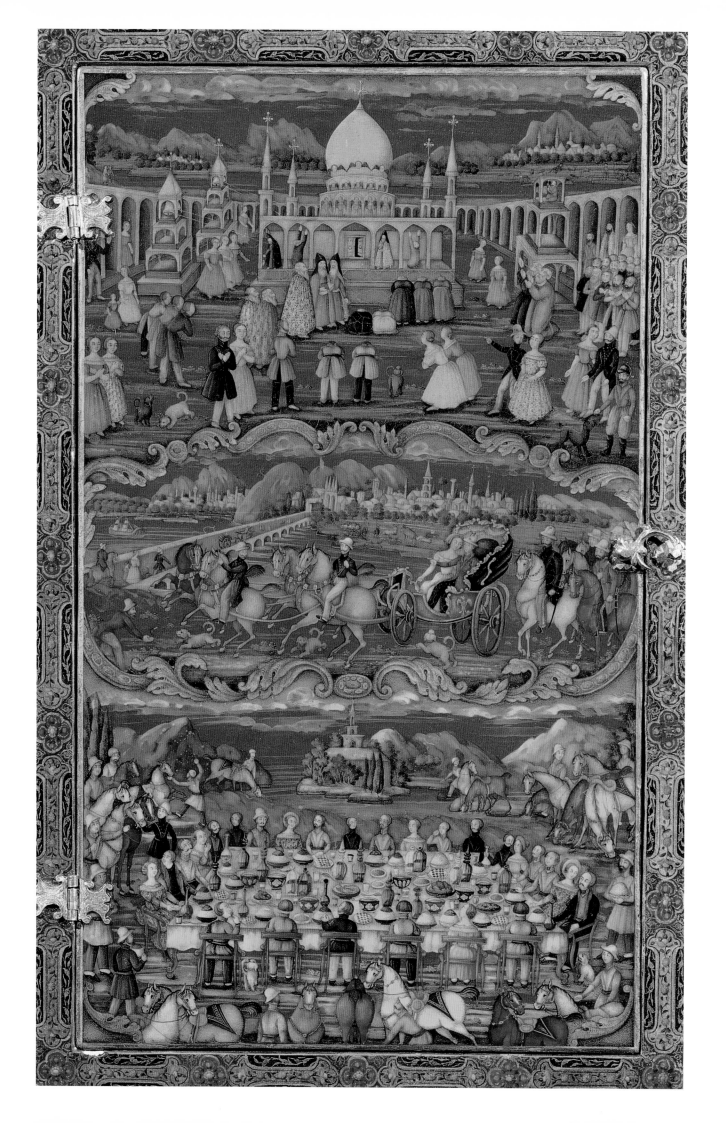

-73-

Mirror Case Depicting Meeting of Nasir al-Din Mirza and Tsar Nicholas I

Muhammad Isma'il Isfahani
Tehran, dated A.H. 1270/A.D. 1854
Pasteboard, opaque watercolor and gold; 10 x 6¹/₂ inches (25.5 x 16.5 cm)
HASHEM KHOSROVANI QAJAR COLLECTION

This highly detailed work reflects a shift in taste during the mid-nineteenth century, when "monumental painting" was eclipsed by history painting in small-scale format. Muhammad Isma'il (active 1847–71), considered the most outstanding lacquer painter of his generation, had the rare ability to paint historical scenes with countless figures on small lacquer objects, including this mirror case. With nine scenes, three on each surface, framed in Rococo-style scrollwork, it exemplifies the middle part of the artist's career. The scenes pertain to Perso-Russian diplomatic relations in the third phase of the nineteenth century.

The central scene on the interior of the cover (FIG. XXIV) depicts Prince Nasir al-Din Mirza (the heir apparent) as a seven-year-old boy seated on the lap of Tsar Nicholas I (r. 1825–56) in what seems to be a palace *tālār*, or porch closed on three sides, overlooking a courtyard. Outside the meeting place (a palace in Erivan), Armenian, Persian, and Russian attendants stand guard.

Nasir al-Din Mirza's first diplomatic function was a trip to Erivan in September–October 1838 to meet the tsar, who was touring the newly conquered Caucasian provinces. The young prince was accompanied by a small entourage,[26] but only two members were present at the meeting. Nasir al-Din Mirza was sent to represent his father, Muhammad Shah, who was occupied with the Herat campaigns. This meeting between the tsar and the heir apparent was a carefully thought-out gesture on Muhammad Shah's part, since Armenia had been lost to the Russians less than a decade earlier. Gifts

FIG. XXIV. *Interior view of* NO. 73 *depicting Nasir al-Din Mirza meeting Tsar Nicholas I.*

FIG. XXV. *Back view of* NO. 73 *depicting the Ottoman Emperor Mahmud II and Tsar Nicholas I.*

were exchanged during the encounter – an indication of the tsar's desire to establish congenial relations between the two powers. The gifts were also seen as tokens of Russian support for Muhammad Shah's Herat campaigns.[27]

Above the image of the meeting is a representation of the walled city of Erivan, where both Russian and Persian attendants camp. Below it is an encampment scene, in which Persian officers stand guard. The members of the Persian mission appear to have been more comfortable in their own tents than in the quarters assigned to them by the Russians in the citadel. [28]

The top section of the back exterior of the cover depicts an imaginary vision of the Cathedral of Etchmiadzin, the residence of the Patriarch, Saint Gregory, surrounded by priests and worshippers, several of whom are bowing in reverence. The cathedral was the first stop on the tsar's tour.[29] The central image presents a view of Saint Petersburg with a Russian couple riding in an open carriage; and the bottom image represents a feast for Russian dignitaries and their wives. These three scenes reflect Muhammad Ismaïl's preoccupation with the various events of this trip, which he renders in a Westernizing style, earning him the epithet *farangīsāz*, or "Europeanizer."

The middle image portrays the Ottoman Emperor Mahmud II (r. 1808–39), another critical player in Persian political and diplomatic events of the period, mounted on a white horse, inspecting a detachment of artillery (FIG. XXV). He is accompanied by guards and followed by his veiled wife on horseback. This image may have been included to highlight the Persian admiration for Ottoman efforts at military reform during the period and is especially significant since Persian officials frequently looked to the Ottoman Empire as a model.

The bottom scene represents yet another image of Tsar Nicholas I, seated in a chair as three of his attendants raise their hats to him. In the background a military exercise takes place between a detachment of artillery and an army paddle ship.

The prominence given to the events surrounding this momentous meeting points to the possibility that the mirror case was intended to commemorate Nasir al-Din Mirza's first diplomatic encounter with the Russians. That a work dedicated solely to this event was commissioned signifies the importance of the meeting in court circles. Muhammad Ismaïl's visual representation of the event in the form of an unfolding narrative suggests that the painter could have been informed by corresponding passages in Qajar histories of the period, such the *Nāsikh al-Tavārīkh*.[30] Thus, the mirror case not only documents, but also celebrates this important event in Perso-Russian history with artistic mastery and refinement.

ME

Literature: Robinson 1967, pls. 1–3; B. W. Robinson, "Persian Painting in the Qajar Period," in Ettinghausen and Yarshater 1979, 132, fig. 230; Karimzadeh Tabrizi 1985–91, vol.1, pp. 73–74; *Fine Oriental Manuscripts and Miniatures*, sale cat., Sotheby's, May 23, 1986, lot 183; Robinson 1989, 137, fig. 11a–c; Ekhtiar 1990, 134, fig. 5; Amanat 1997, 34, fig. 1.
Provenance: Professor R. A. Dara; Mrs. Batul Amini.
Inscriptions: In *nastāliq* script: *'amal-i kamtarīn Ismā'il 1270*.

1. Bamdad 1968–74, vol. 3, pp. 257–62.

2. See Mirza Mustafa Afshar (Baha al-Mulk), *Safarnāmeh-i Khusraw Mīrzā* (Tehran, 1980), 269–70, for the negative comparison of Persian royal images with European portraits.

3. B. W. Robinson, "The Tehran Nizami and Other Qajar Illustrated Books," *Islam in the Balkans. Persian Art and Culture of the 18th and 19th centuries* (Edinburgh, 1979), 61–74.

4. Zuka 1963, part 1, pp. 16–21.

5. See Maslenitsyna 1975, no. 122, for Abu'l Hasan's 1845 portrait of Haji Mirza Aqasi, and Diba 1997 for his 1843 portrait of Lady Khurshid.

6. Cf. known portraits of Muhammad Shah: D. N. Wilber, *Four Hundred Forty-six Kings of Iran* (Shiraz, 1972), 187, pl. 59; *Arts d'Orient*, sale cat., Hôtel Drouot, Paris, July 2, 1993, 64, no. 190; Karimzadeh Tabrizi 1985–91, vol. 3, pp. 1499, 1522.

7. Ouseley 1819–32, vol. 3, p. 132.

8. See Hommaire de Hell 1855–56, vol. 2, pp. 18 (for the penbox), 92 (for the caricature). The penbox was completed after Muhammad Hasan Afshar's death by the court painter Isma'il Jalayir. It was subsequently sold for the record price of 1,000 *tūmāns* to a European collector (see Dust 'Ali Khan Mu'ayyir 1982, 279).

9. Maslenitsyna 1975, no. 124; and Amiranashvili 1940, pls. XXI–XXIII.

10. The inscription contains a factual error, however: Dust 'Ali Khan, born in 1819, would have been twenty-one in the year 1841, not 1846 as noted here.

11. Karimzadeh Tabrizi 1985–91, vol. 3, pp. 1286–87.

12. Dust 'Ali Khan Mu'ayyir (1982, 278), (grandson of the subject of this work), praises Mirza Baba's expertise in using European engravings and paintings for his background landscapes, specifically in relation to this painting. See also Rainer Schoch, *Das Herrscherbild in der Malerei des 19 Jahrhunderts* (Munich, 1975), figs. 92–94, for official French and German state portraits of the first three decades of the nineteenth century.

13. See: B. W. Robinson, "Lacquer Oil Paintings and Later Arts of the Book," in Falk 1985, 196, no. 185; Robinson 1964, 104–5; Falk 1972, 42–53; Karimzadeh Tabrizi 1985–91, vol. 2, pp. 610–15. There are two other known versions of this painting not necessarily by the same hand: one in the collection of the Staatliche Museen zu Berlin: Museum für Völkerkunde, IB 382, and one in a private collection in Geneva.

14. This painting is signed "Yā Muḥammad" and dated A.H. 1258/A.D. 1842.

15. According to Layla Diba, the pattern resembles Chinese printed cottons found in the East Indies trade.

16. Diba 1989a, 245.

17. Chief Eunuch of the Harem; *ishīkāqāssibāshī* (master of ceremonies); minister to Yahya Mirza, governor of Gilan; minister to Sayf al-Dawleh, governor of Isfahan; and finally governor of Isfahan. This brief biographical account has been culled from the following sources: Sir A. Henry Layard, *Early Adventures in Persia, Susiana and Babylonia* (London, 1894); Bamdad 1968–74, vol. 4, pp. 159–63; James Baillie Fraser, *A Winter's Journey from Constantinople to Tehran (1838)* (New York, 1973), 16–23; Gavin Hambly, "Iran during the Reigns of Fath 'Ali Shah and Muhammad Shah," in Avery, Hambly, and Melville 1991, 144–73.

18. Layard, *Early Adventures*, 115–16.

19. E. G. Browne, *A Year amongst the Persians* (Cambridge, 1893), 219.

20. Manuchihr Khan's close relationship with the court in Tehran is further documented in an inscription on an 1849 penbox commissioned by Muhammad Shah referring to Manuchihr Khan as "his son." Karimzadeh Tabrizi 1985–91, vol. 1, p. 69.

21. Muhammad 'Ali Karimzadeh Tabrizi, *Aḥvāl va Āsār-i Naqqāshān-i Qadīm-i Irān* (London, 1985), vol. 1, pp. 67–68.

22. Layard, *Early Adventures*, 11.

23. Robinson 1970, 48–49. See also Ekhtiar 1990, 138.

24. B. W. Robinson and Yahya Zuka originally made this identification but did not provide any supporting explanation. See Robinson 1970, 49. Muhammad Khan Qajar was chief of the royal bodyguards (*sarkishīkchī-bāshī*) under Nasir al-Din Shah and later he rose in the ranks and was appointed commander in chief and subsequently prime minister.

25. See Bamdad 1968–74, vol. 3, pp. 228–32. It was not unusual for a Qajar ruler to commission a work honoring one of his statesmen. An inscription on an 1849 penbox indicates that Muhammad Shah commissioned the object to honor his governor, Manuchihr Khan, Mu'tamid al-Dawleh. See Karimzadeh Tabrizi 1985–91, vol. 1, p. 69.

26. The entourage included Muhammad Khan Zanganeh Amir Nizam, Mirza Taqi Khan Vazir-i Nizam (later Amir Kabir), Muhammad Hakim, Haji Muhammad Tabrizi Nizam-i 'Ulama, Mirza 'Ali Akbar Tabrizi (the dragoman), and Muhammad Tahir Khan Qazvini (later Vakil al-Dawleh). Robinson 1967, 4.

27. Amanat 1997, 36, 38.

28. Ibid., 34. See Lisan al-Mulk Sipihr 1875, 1965 ed., vol. 2, p. 262. Hidayat 1960, vol. 10, p. 199.

29. Lisan al-Mulk Sipihr 1875, 1965 ed., vol. 2, p. 262.

30. Ibid.

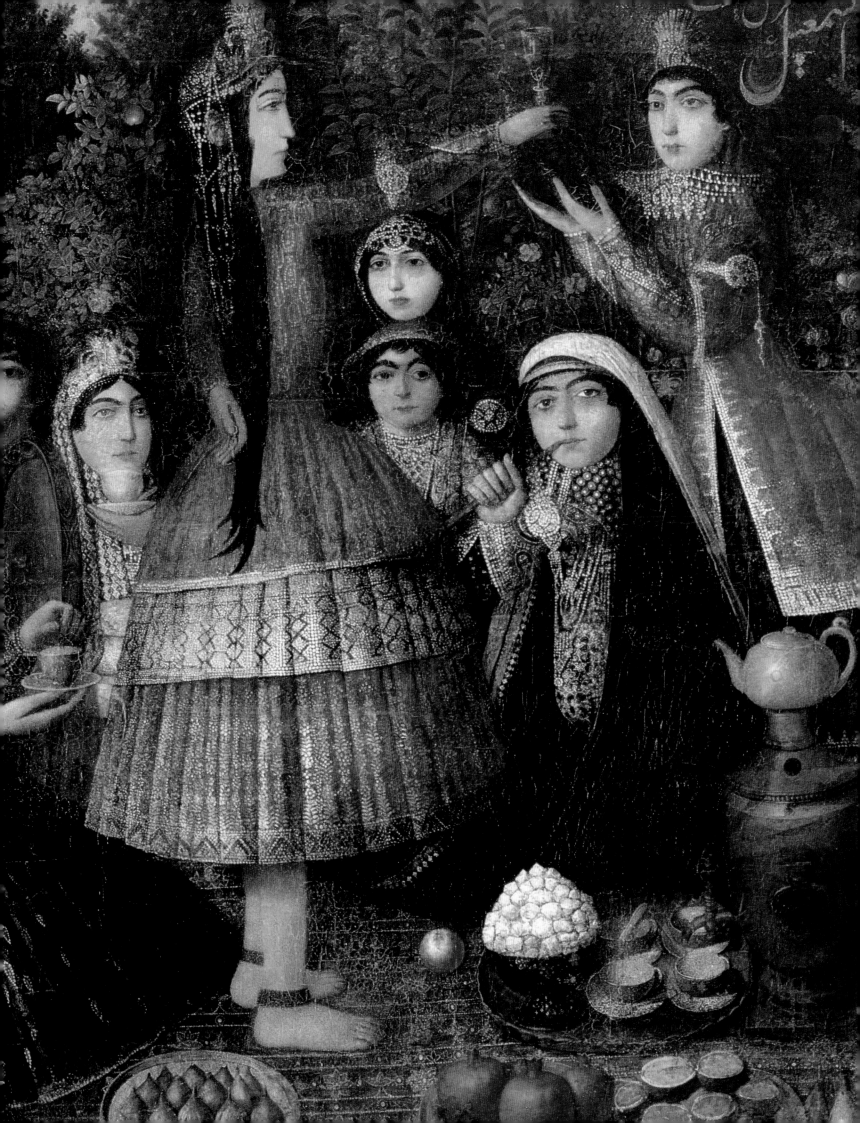

NASIR AL-DIN SHAH PERIOD

(1848–96)

QAJAR SOCIETY was marked by rapid change in the second half of the nineteenth century. In an attempt to meet the challenge of the increasing domination of European powers, reforms were implemented, new institutions modeled on Western prototypes such as the Dar al-Funun Academy (1851) were created, and aspects of European material culture were introduced. These changes ranged from the most incongruous adaptations – ballet skirts for Nasir al-Din Shah's harem and the reputed use of London's Albert Hall as the prototype for the Takieh Dawlat, the royal theater for *ta'zieh*s, or Shi'ite passion plays – to useful innovations such as modernization of the military and the employment of foreign experts to build roads and telegraph lines. Critical cultural and social shifts transformed the imperial painting of Fath 'Ali Shah into a kaleidoscope of new themes, genres, and media.

Like his grandfather, Nasir al-Din Shah (1831–1896) actively controlled and initiated change through his extensive patronage of artists and building programs. Whereas Fath 'Ali Shah promoted the revival of traditional Persian kingship and court culture, using poetry, painting, and sculpture as his principal vehicles, Nasir al Din Shah fostered an image of monarchy that combined modernity with conservatism. If painting of the Fath 'Ali Shah period can be seen as the culmination of an indigenous tradition of life-size imagery, the painting and visual arts of the Nasiri period represent the fruition of an equally long-standing tradition of Persian experimentation and assimilation of European innovations and technologies originating in the late Safavid period.

From 1867 onward, the city of Tehran was considerably improved with new city walls and gateways, broad avenues, and electricity. The ruler's extensive renovations to the Gulistan palace (1867–92) unfortunately resulted in the destruction of a number of early nineteenth-century palaces and their magnificent monumental paintings (see FIG. XII, NOS. 60, 61). Nasir al-Din Shah's additions to the citadel, such as a new audience hall or the Shams al-'Imareh palace, were no longer decorated with monumental paintings by Persian court painters, but with European easel paintings,[1] now subordinated to mirrorwork and lavish carved plaster decoration in Victorian taste (see NO. 79).

Nasir al-Din Shah relied to a lesser extent than his predecessor Fath 'Ali Shah on Persian court painters to create dynastic images or record historical events (the latter was largely delegated to photography and lithographed court newspapers), but charged them with producing European-style academic portraits and landscapes. Painters were trained in Western techniques at the Dar al-Funun or sent abroad.[2] Artists also provided illustrations for court newspapers and books, and designs for tilework decoration in revival and contemporary styles (NO. 83a,b). Although Nasir al-Din Shah collected European artworks for his private museum and the decora-

tion of his new residences, he actively supported and encouraged the most talented Persian artists: this patronage resulted in the emergence of a local school of portraiture, primarily in small-scale format, of unprecedented expressive power. Royal and court patronage drew artists to Tehran, to be apprenticed to Abu'l Hasan Khan Ghaffari (circa 1814–1866), the painter laureate of the first part of Nasir al-Din Shah's reign.

A few outstanding corpuses of small-scale portraiture have survived: a collection of watercolors, drawings, and photographs by nine of the most talented contemporary court artists acquired for the British Museum in 1874 by Sidney Churchill (BL 4938);[3] and an equally impressive corpus of twenty-five works at the Musée du Louvre, some published here for the first time (NOS. 24, 74, 75, 78, 81, 82).

The nobility followed Nasir al-Din Shah's lead in architecture and artistic patronage. Their principal residences were located in the capital center, and summer residences were constructed in the foothills of the Alburz mountains to the north, in imitation of Nasir al-Din Shah's summer palaces. Although these structures and their decoration, like those of the early nineteenth century, have largely perished, lithographed illustrations in court newspapers and photographs document the emergence of a new Perso-European style, influenced by nineteenth-century Turkish, Russian, and European prototypes.

For those patrons who could not afford European paintings, local artists decorated palaces in a new style of painting that assimilated, with varying degrees of success, the conventions of European nineteenth-century painting. These palaces included Kamranieh, the residence of Nasir al-Din Shah's son, Prince Kamran Mirza (1855–1927); Park-i Atabak, the residence of Mirza 'Ali Asghar Khan, Amin al-Sultan (1858–1907), later known as Atabak, last premier of Nasir al-Din Shah; and most notably, Nizamieh, the palace of the premier Aqa Khan Nuri (1851–58).[4]

An exceptional series of seven life-size paintings of Nasir al-Din Shah shown with eighty-four princes of the blood, court officials, and envoys was commissioned for the audience hall of Nizamieh by Nuri, an admirer of Fath 'Ali Shah.[5] The last great monumental paintings of the Qajar period were modeled on 'Abdallah Khan's celebrated composition for the Negarestan palace (NO. 34, FIG. XIV). The two-year project was completed in 1856 by a team of painters working under the direction of Abu'l Hasan Sani' al-Mulk.[6]

Information on the arts of this reign is more plentiful and precise than for any other period of Persian history: chronology and places of production are well documented, and the range of biographical information on patrons and artists unprecedented. Artistic life was arguably dominated for two generations by the talented members of the Ghaffari family of Kashan: Abu'l Hasan (appointed painter laureate in 1850); his brother Mirza Buzurg (not to be confused with Mirza Buzurg Shirazi [active 1840s–1860s; see NO. 48]); and Aqa Buzurg's sons, most notably Muhammad Ghaffari, Kamal al-Mulk (1852–1940), and his brother Abu Turab (1863–1889). The principal court artists such as Isma'il Jalayir (d. circa 1868–73), Mirza Mahmud Khan, Malik al-Shu'ara (1813–1893), grandson of the court poet Fath 'Ali Khan Saba, and the Ghaffari family members were trained at the Dar al-Funun. Other artistic dynasties such as the Imami family of Isfahan and the Muhammad Kazim family of Tehran, specializing in lacquerwork and enamel painting respectively, were associated with the bazaar workshop system, and continued to flourish.

The florescence of life-size painting and small-scale portraiture was accompanied by the propagation of new media, more diverse subject matter, and experimentation with new techniques. Although the production of lavish illustrated manuscripts continued sporadically, lithographic prints and photographs provided a more popular form of imagery, broadening the base of patronage and resulting in a wider dissemination of figurative art than ever before.

The increased use of figural tilework for city gateways, arsenals, baths, shrines, and mausoleums also expanded the public presence of imagery.[7] An interest in religious painting coincided with the emergence of local shrines and the popularity of ta'zieh performances. The court, the nobility, and powerful merchants commissioned life-size and miniature paintings of religious subjects (see NOS. 84, 85). Popular forms of painting and imagery proliferated in shrines, bazaars, and coffee- and teahouses.

In sum, the Nasiri era, previously considered by some historians as a period of decline, gave birth to a virtual artistic renaissance. In the works of Abu'l Hasan and his contemporaries, an outstanding school of portraiture developed that took the human image as its principal theme. Even in a magnificent royal commission such as the *Thousand and One Nights* manuscript (FIG. 3), considered a masterpiece of its type, Abu'l Hasan significantly altered the idealized and decorative conventions of Persian manuscript illustration. Persian painting had

never aspired to be historically accurate, but by transferring the setting from nineteenth-century Baghdad to urban Tehran, Abu'l Hasan injected a degree of realism and social commentary rarely seen in Persian art.

Muhammad Ghaffari, who studied with the French Salon painter Henri Fantin-Latour (1836–1904), completely assimilated the conventions of European naturalism. Although considered competent but derivative by Western scholars, Ghaffari's work is held in the highest esteem by Iranians, who view his style of photographic realism (FIGS. 30, XXVI) as the culmination of Persian art, and the source of the "modern" school of Persian painting.

LSD

FIG. XXVI. *The Hall of Mirrors, Gulistan Palace.*
Muhammad Ghaffari, Kamal al-Mulk. Tehran, 1888. Oil on canvas.
GULISTAN PALACE COLLECTION.

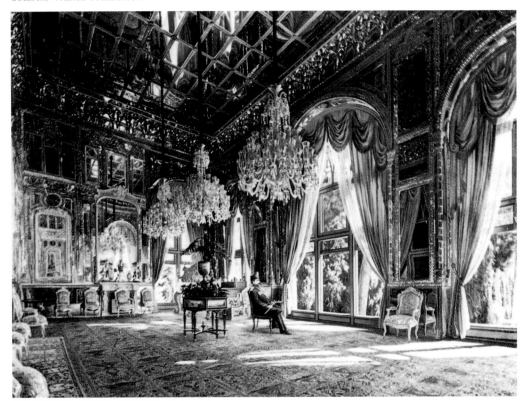

-74-
Apotheosis of Nasir al-Din Shah

Signed by Abu'l Hasan Ghaffari
Tehran, dated A.H. 1275/A.D. 1858
Opaque watercolor on paper; 12¹⁵/₁₆ x 9⁹/₁₆ inches (32.8 x 24.3 cm)
MUSÉE DU LOUVRE, PARIS, SECTION ISLAMIQUE, MAO 777

This hitherto unrecorded work and the following two (NOS. 75, 76) testify to the new conventions for official portraiture devised by Nasiri court painters. Images of the ruler convey his cautious modernity, luxurious tastes, and autocratic yet melancholy character. Abu'l Hasan's painting, presented to the shah in 1858 (see inscription), reflects a mid-nineteenth-century Iranian conception of majesty framed in the language of European religious iconography.

A comparison with a painting of the ruler executed ten years earlier by 'Abdallah (FIG. XXVII) illuminates the new style of painting forged by Abu'l Hasan and his contemporaries: the outmoded hieratic stance, fully developed landscape, and emphasis on jeweled decoration and weaponry have been discarded in favor of an informal seated pose, set against a plain ground. The ruler's authority is now subtly conveyed by the intensity of his gaze, accentuated by the slightly tilted angle of his head and his rich yet understated clothing and regalia. Additionally, his lineage is proclaimed in the inscription to

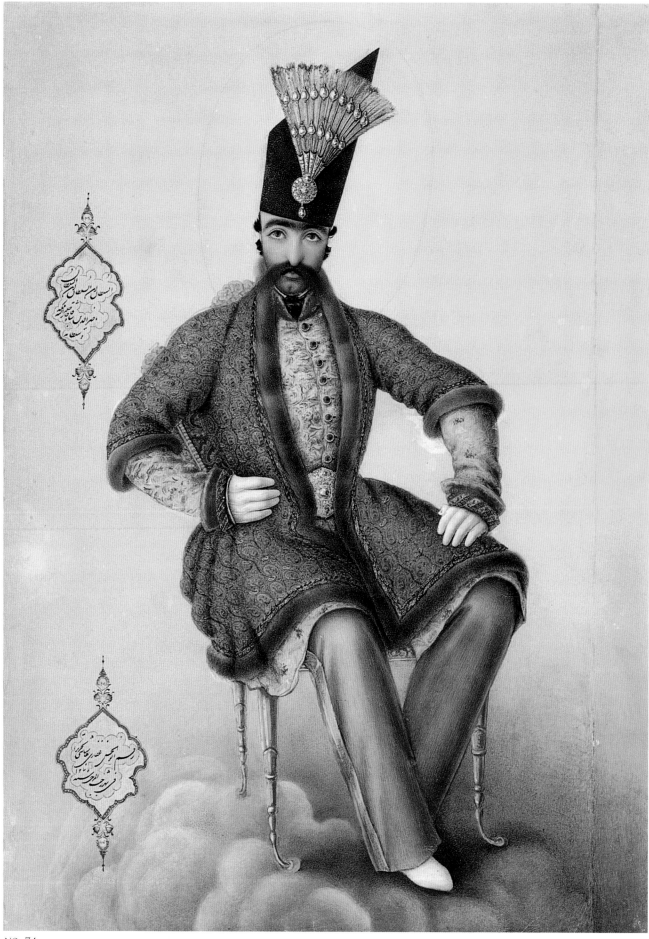

NO. 74

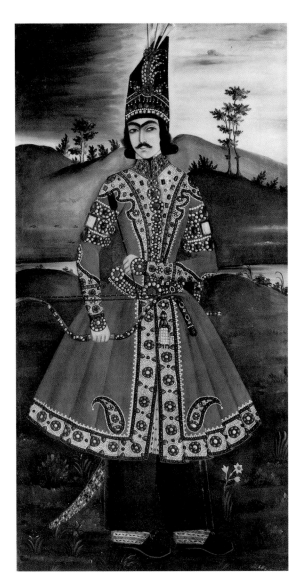

FIG. XXVII. *Nasir al-Din Shah as a Youth.*
Attributed to 'Abdallah. Tehran, circa 1848. Oil on canvas,
70¼ x 37 inches (180 x 95 cm).
COLLECTION OF MRS. ESKANDAR ARYEH.

the shah's left, which identifies him as the fourth ruler of the Qajar line (see Inscriptions, below). The monarch's power is further emphasized by his erect posture, the positioning of his hands, and the tall lambskin hat and imperial aigrette.

Scholars have identified Renaissance paintings, primarily the works of Raphael, as the principal sources for the cloud bank beneath the ruler's chair and the nimbus around his head, the most distinctively European symbolic devices of this painting. These formulas continued to be favored for European state portraits throughout the eighteenth and nineteenth centuries, however, and Abu'l Hasan was probably aware of these later prototypes as well.[8]

Abu'l Hasan (circa 1814–1866), descended from a Kashan family of court officials, artists, and historians (see NO. 23), was drawn to the capital as a young man in the late 1820s, and was apprenticed to the court painter Mihr 'Ali. Owing to his extraordinary promise, he was sent to Italy and France, where he not only studied the Renaissance masters, but attained proficiency in lithographic printing. His gifts as an artist and courtier elevated him first to painter laureate (1850), and after the successful completion of more than a thousand illustrations for the *Thousand and One Nights* manuscript (1855) and of the Nizamieh paintings (1856), he was awarded the title of Sani' al-Mulk (Exalted Craftsman of the Kingdom) in 1861, in recognition of his remarkable contributions to the fields of art education and lithographic illustration.[9]

This watercolor was executed eight years after the artist's triumphant return from Italy in 1850 and stands as testimony to his preeminence among Nasiri artists. Uniquely gifted, he combined the love of minutiae and color sense of the miniaturist (evident in the rendering of the fine pattern of the coat, soft brown fur, and airy blue clouds) with the psychological acuity of the portrait painter probably inherited from his great-uncle Abu'l Hasan I. In contrast to photographs of Nasir al-Din Shah that mercilessly reveal the ruler's badly shaved beard and ill-cut clothing, Abu'l Hasan's painting is a flattering yet modern image of majesty that successfully expressed the monarch's desire to be perceived on an equal footing with European rulers. Given the artist's perceptiveness, however, the very precarious balance of the young ruler in his elegant yet spindly chair in the clouds may allude to the equally delicate political balance of the 1850s, which witnessed attempts at reform, the Babi revolts, and the young ruler's decision to order the assassination of Amir Kabir, his too-powerful reformist prime minister.

LSD

Inscriptions: In black *shikasteh-nasta'liq* script, upper cartouche: *Al-Sulṭān, ibn al-Sulṭān, ibn al-Sulṭān Nāṣir al-Dīn Shāh Qājār Khaldallāh mulkuhū*; lower cartouche: *raqam-i Abu'l Ḥasan Ghaffārī Naqqāshbāshī; taḥrīr fī shahr rajab, marḥama sanah 1275*

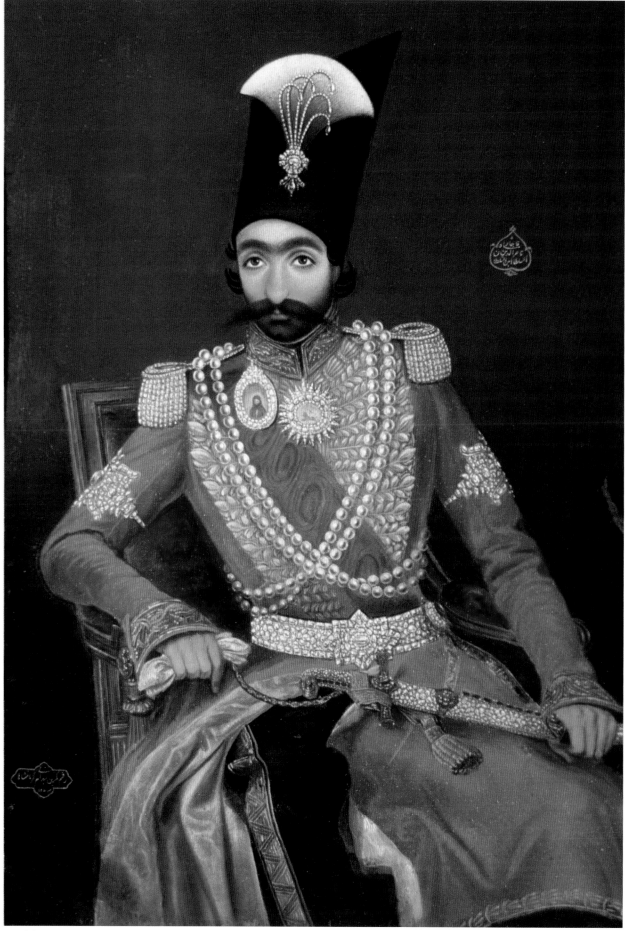

NO. 75

-75-
Nasir al-Din Shah Seated in a European Chair

Signed by Bahram Kirmanshahi
Tehran, dated A.H. 1274/A.D. 1857
Oil on copper; 14³/₁₆ x 10¹/₁₆ inches (36 x 25.5 cm)
MUSÉE DU LOUVRE, PARIS, SECTION ISLAMIQUE, MAO 776

Nasir al-Din Shah was himself an amateur artist and frequently sketched members of his own entourage. His role as the subject and catalyst of Nasiri painting cannot be underestimated: the numerous royal portraits documenting his appearance throughout his life testify to his importance (although by the 1880s photography was the preferred medium).

During the most creative phase (1850s–1870s) of Nasiri painting, the ruler was portrayed in multiple guises and settings: as an Abbasid ruler (FIG. 3), or in contemporary garb, silhouetted against landscapes, and enthroned (like his grandfather Fath 'Ali Shah) or on horseback. The chair or settee, an attribute of rulership since the Safavid period, was especially favored for his portraits, and as here, multiple versions of the same composition were often executed.[10]

Bahram Kirmanshahi, a contemporary of Abu'l Hasan, seems to have been an exceptionally skilled copyist.[11] This hitherto unpublished small-scale portrait of the monarch uses the unusual medium of oil paint on copper to admirably capture the luminosity, texture, and highly finished surface of early nineteenth-century European oils on canvas. Furthermore, Nasir al-Din Shah's pose of casual elegance, hitherto unprecedented for Persian royal imagery, reflects European portrait conventions, originating in the eighteenth century, when the English painter Sir Joshua Reynolds (1723–1792) introduced an air of languor and ease into his portraits of the nobility.[12]

LSD

Inscriptions: In gold *nasta'liq* script, medallion upper right: *Nāṣir al-Dīn Shāh Qājār, Sulṭān ibn al-Sulṭān*; in cartouche lower left: *raqam-i kamtarīn Bahrām Kirmānshāhī sanah 1274*.

-76-
Nasir al-Din Shah and a Cannon

Attributed to Akop Ovnatanian
Tiflis or Tabriz, circa 1860–70
Oil on canvas; 92¹⁵/₁₆ x 58¹¹/₁₆ inches (236 x 149 cm)
ÖSTERREICHISCHE GALERIE BELVEDERE, VIENNA, 2691

This fine painting is a rare surviving example of the ruler's patronage of non-Persian painters. First published by B. W. Robinson, the painting was probably originally sent as a gift to the Austrian emperor Franz Josef I (1830–1916).[13] The composition, in which the figure of Nasir al-Din Shah occupies the foreground before a mountainous landscape, closely adheres to the pictorial conventions of mid-nineteenth-century royal portraiture.

Nasir al-Din Shah was a complex man: seasoned diplomat and politician who maintained Iran's national integrity, yet undistinguished military leader; reformist monarch and absolutist. This painting conveys such dual aspects of his personality.

The massive cannon behind the ruler and the jeweled spyglass that he holds allude to his military aspirations and the Qajars' preoccupation with modernizing the army. Compositions featuring cannons and artillery had gained currency during the two previous reigns. Indeed, Iranian fascination with European artillery and military superiority is reflected in Persian painting from the mid-seventeenth century on.

Additionally, the medal the ruler wears around his neck refers to his somewhat unorthodox religious practices. In an effort to consolidate his position with the conservative elements of society, the ruler showed an exaggerated reverence for Imam 'Ali and the other Shi'ite imams that was at odds with

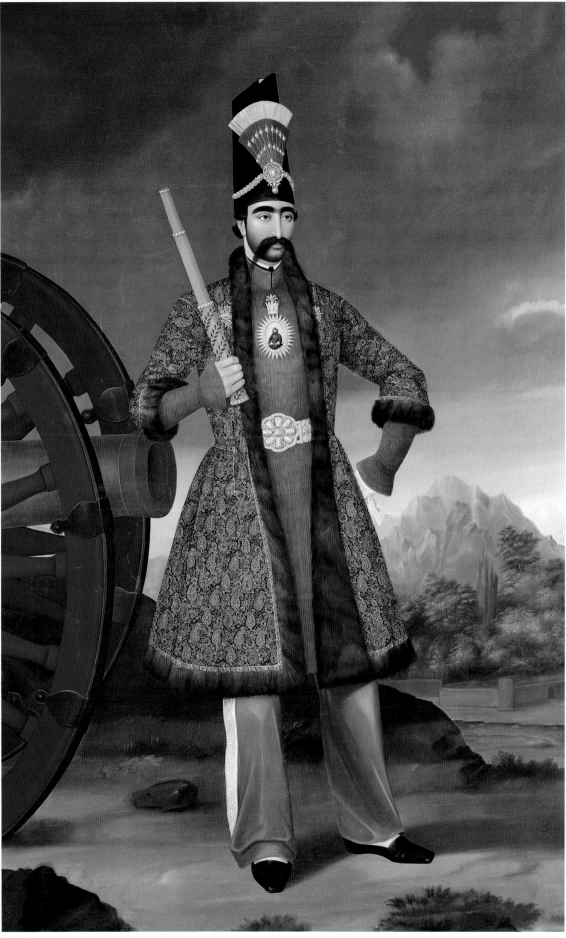

NO. 76

his often profligate and self-indulgent lifestyle. Prior to the fall of Herat, a painting purporting to be a portrait of Imam 'Ali was sent as a gift to the ruler. Nasir al-Din Shah visited the painting daily and ordered a medallion to be created with his image. Sources record that he commissioned at least two versions, one from Abu'l Hasan, and the other from an Armenian painter from Tiflis. Its completion in 1856 was commemorated by elaborate ceremonies.[14]

Akop Ovnatanian (1806–1881/84),[15] a sixth-generation Georgian painter, was active in Tiflis in the mid-nineteenth century and is credited with founding the local school of portraiture. His recorded works, primarily dated to the 1850s and 1860s, include portraits of the Russian tsar Alexander II (1818–1881), of E. Golovin, governor of Georgia, and of Nasir al-Din Shah and Crown Prince Muzaffar al-Din Mirza on horseback. In about 1870, after a decline in his fortunes, he joined a daughter living in Tabriz. Ovnatanian may have enjoyed the patronage of the Persian court before his move in 1870. Sources record that he was awarded the title of painter laureate and that he executed at least nine paintings while in Tabriz. This painting may now be added to the corpus of his known works. Further, it is possible that he was the aforementioned Armenian painter, and that the medallion depicted in this portrait is his creation.

To judge from Akop's extant works, this painting is one of his finest efforts. It reveals the close affinities between Georgian, Russian, and late nineteenth-century Persian court painting and documents the international spread of the European nineteenth-century state portrait.

LSD

Literature: Robinson 1983, 299, pl. 8.
Provenance: Transferred in 1921 from the Kunsthistorisches Museum, Vienna (formerly The Imperial Gallery).
*Not in exhibition

-77-
Equestrian Portrait of 'Ali Quli Mirza, I'tizad al-Saltaneh

Ustad Bahram Kirmanshahi
Tehran, dated A.H. 1281/ A.D. 1864
Oil on canvas; 36¹/₂ x 29¹/₂ inches (92.7 x 74.9 cm)
PRIVATE COLLECTION

Equestrian painting in Iran dates back to pre-Islamic times. The Parthian and Sasanian rulers were commonly portrayed on bas-reliefs and on gold and silver vessels sitting astride horses, aiming at game with bows and arrows. The horse in Persian painting thus gradually emerged as a ubiquitous royal accoutrement, accompanying rulers, princes, and legendary heroes in battle and in the royal chase. This tradition continued well into the nineteenth century; Fath 'Ali Shah was frequently depicted on horseback engaged in a hunt or leading his troops into battle.

This equestrian portrait depicts Prince 'Ali Quli Mirza (known as I'tizad al-Saltaneh ; 1822–1881), Fath 'Ali Shah's forty-seventh son. An enlightened and learned man, he was appointed Minister of Higher Education and dean of the newly founded Dar al-Funun in 1858.[16] The painting was probably inspired by eighteenth- and nineteenth-century Western European and Russian equestrian portraits and statues of military commanders riding majestic horses rather than by indigenous prototypes.

For centuries in Western culture, the equestrian portrait has been perceived as a symbol of strength, intelligence, nobility, and authority. The horse was admired for its free spirit and understood as a metaphor for the people, while the rider was perceived as the one who disciplines and contains the horse.[17] The origins of European-style equestrian portraiture in Iran can be traced to the Afsharid period (see NO. 22). If the artist intended to use the same metaphor here, his image of 'Ali Quli Mirza, I'tizad al-Saltaneh, a prominent pedagogical figure, astride a trotting horse can be read as "education taming and guiding the people."

Mounted on a white stallion, 'Ali Quli Mirza wears a wool robe of *tirmeh* over a bright green coat, a diamond-studded belt, a black bow tie, white gloves, and black leather boots, and holds a black velvet embroidered powder horn. In contrast to the equestrian portrait of Nadir Shah mentioned above, in this painting both 'Ali Quli Mirza and the horse assume composed, even static poses. The figure is set against a background of trees and a blue sky with clouds.

The artist, Ustad Bahram Kirmanshahi, one of Nasir al-Din Shah's court painters, maintained a workshop in the Majma' al-Dar al-Sanayi', the arts-and-crafts center established by Amir Kabir, Nasir al-Din Shah's first prime minister.[18] Karimzadeh contends that Ustad Bahram probably studied academy-style painting in Russia and was responsible for executing the paintings in the shah's private quarters.[19] He worked in a variety of media and also executed portraits on copper (see NO. 75). Ustad Bahram probably gained exposure to Russian and Austrian equestrian portraits both in Iran and on his trips abroad. In this painting, his training in the academic tradition is reflected in his earnest attempt to adhere to European canons of proportion and his attention to the accurate rendering of the horse's musculature.

ME

Inscriptions: In *shikasteh* script next to horse's leg: *Ustād Bahrām Kirmānshāhī, 1281*

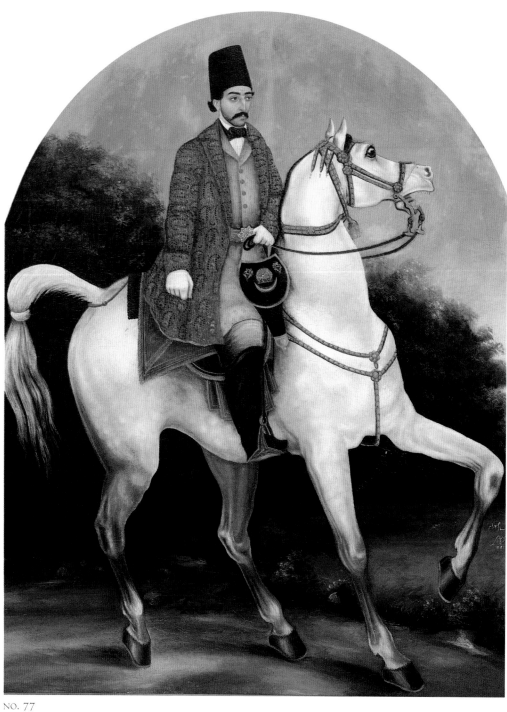

NO. 77

-78-

Prince Ardishir Mirza, Governor of Tehran

Abu'l Hasan Ghaffari
Tehran, dated A.H. 1271/ A.D. 1854
Opaque and transparent watercolor on paper; 12⁷/₁₆ x 8 inches (31.6 x 20.4 cm)
MUSÉE DU LOUVRE, PARIS, SECTION ISLAMIQUE, MAO 788

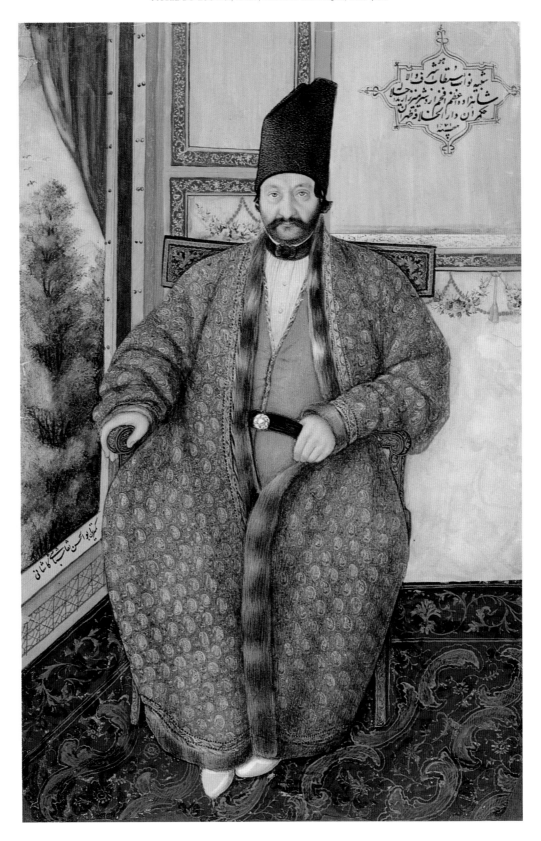

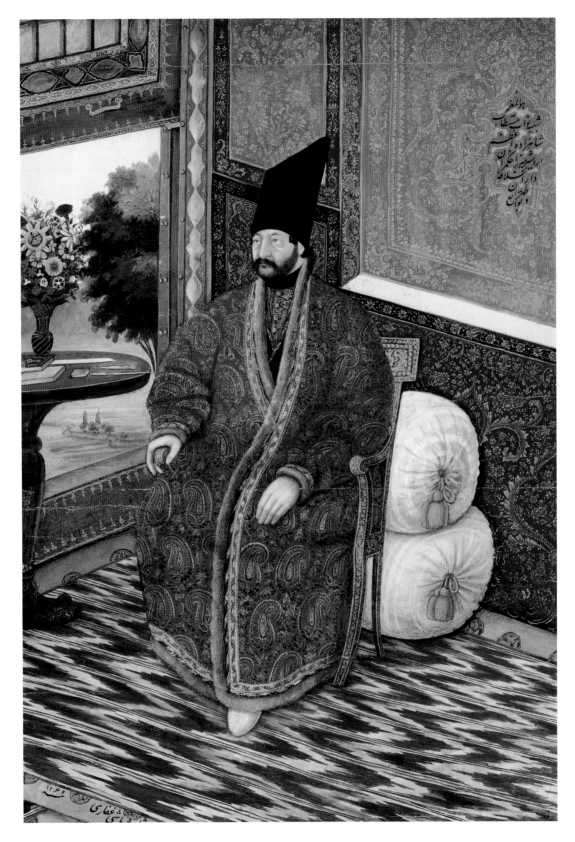

-79-
Prince Ardishir Mirza, Poet and Prince-Governor

Signed by Abu'l Hasan Ghaffari
Tehran, dated A.H. 1269/A.D. 1852–53
Opaque watercolor on paper; 17 x 12 inches (43.2 x 30.5 cm)
HASHEM KHOSROVANI QAJAR COLLECTION

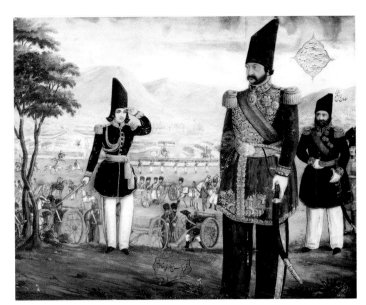

FIG. XXVIII. *Ardishir Mirza and Sulayman Khan Saham al-Dawleh Reviewing Troops.*
Abu'l Hasan Ghaffari. Tehran, 1851–52. Opaque watercolor and ink on paper.
LOCATION UNKNOWN.

NOS. 78 and 79 (and FIG. XXVIII) by Abu'l Hasan exemplify the fashion among Nasiri nobility of commissioning the finest painters to record important events of their political careers. Prince Ardishir Mirza (1805–1866), Rukn al-Dawleh,[20] the ninth son of Crown Prince 'Abbas Mirza and uncle of Nasir al-Din Shah, was a faithful and capable military commander who helped to ensure the accessions of both Muhammad Shah and Nasir al-Din Shah. Ardishir Mirza was rewarded with the governorship of Gilan (1834), acted as regent in Tehran during the Herat campaign, and was appointed governor of Mazandaran (1835–42) and Luristan and Khuzistan (1846), where he crushed severe local insurrections with his vizier Sulayman Khan Masihi Saham al-Dawleh. His later posts included governor of Mazandaran and Tehran (1853–56), viceroy of Azarbaijan, and governor of Gilan.

This influential political figure was also a poet and art patron. Abu'l Hasan executed at least three portraits of the prince. A photographic print of the first, dated 1851 (FIG. XXVIII), is preserved in a photograph album formerly belonging to the prince. Ardishir Mirza stands on a hilltop, accompanied by Saham al-Dawleh and saluted by a young officer inviting him to review his troops.[21] The artillery is lined up in the middle ground, infantry maneuvers are depicted in the distance, and a lengthy inscription identifies the event depicted as the Luristan campaign. Although Abu'l Hasan's fame rests on his incisive portraiture, primarily his portrait-head studies, this work exemplifies his skills at complex, multi-figured compositions, most evident in his dramatic illustrations of noteworthy urban events for the court gazette *Rūznāmeh-i Dawlat-i 'Illieh-i Iran* (1861–66). Those powerful illustrations are reminiscent of the images of Francisco Goya.

This commission was followed shortly thereafter by two more, in both of which Ardishir Mirza is identified by his elaborate titulature as governor of Tehran. The earlier example depicts the governor seated in an interior lavishly painted in Victorian style. On a table by his side, pens, paper, and books allude to his literary accomplishments under his pen name of Agah. As in all Abu'l Hasan's authentic works, meticulous attention has been paid to detail and patterning, and the rendering of volume, particularly in the pleated and gathered sleeves of robes (in his portraits no two sleeves are alike). The somber yet rich palette of dark red and deep blue with touches of velvety black and cream is particularly appropriate to the dignity and high social status of his subject. Since Abu'l Hasan generally enveloped his sitters in voluminous robes, the countenances and their particular physiognomies are dramatically emphasized. This is even more evident in the hitherto unpublished portrait illustrated here executed in 1852–53. The prince is still a commanding presence, but his sunken eyes and swollen cheeks hint at the lifetime of hard campaigning and heavy drinking that were soon to take their toll.

These paintings testify to the beneficial effect of photography on Persian painting, in contrast to its impact in Europe, where it supplanted portraiture. Aesthetically, Persian artists had always aspired to depict their subjects as realistically as possible. The advent of photography finally provided talented artists like Abu'l Hasan with the means not only to produce accurate compositions, but also to capture the essence of their sitters.

LSD

NO. 78
Literature: *7,000 Years of Iranian Art*, exh. cat., Freer Gallery of Art (Washington, D.C., 1964–65), 112, no. 725d.
Inscriptions: In black *nasta'līq* script, window sill: *kamtarīn Abu'l Ḥasan naqqāshbāshī*; cartouche in upper right: *Hū, Shabīh-i navvāb mustaṭāb-i ashraf-i vālā shāhzādeh-i 'aẓam va afkham Ardishīr Mīrzā azyad jalāluhū, ḥukmrān-i Dār al-khalāfeh-i Tehrān, sanah 1271*.

NO. 79
Literature: *Important Islamic, Indian and Southeast Asian Manuscripts, Miniatures and Works of Art*, sale cat., Christie's London, October 11, 1988, lot 24.
Provenance: Prince Ardishir Mirza; J. A. Churchill, British Consul General in Tehran, circa 1900; and thereafter by descent.
Inscriptions: In black *nasta'līq* script, cartouche to the sitter's right: *hū al-maqar shabīh-i navvāb mustaṭāb shahzādeh-i 'aẓam, Ardishīr Mīrzā Ḥukmrān-i Dār al-Khalāfeh-i Tihrān va Tavābi'*; edge of carpet, bottom left: *raqam-i Abu'l Ḥasan naqqāshbāshī Ghaffārī sanah 1269*

-80-
Imam Quli Khan 'Imad al-Dawleh

Attributed to Abu'l Hasan Ghaffari
Tehran, circa 1855–66
Oil on canvas; 28^{11}/$_{16}$ x 24^{1}/$_{2}$ inches (72.8 x 62.3 cm)
HASHEM KHOSROVANI QAJAR COLLECTION

Among the gallery of historical figures of the Qajar period, this work and the two following paintings exemplify the expressive power and physical accuracy achieved by Nasiri painters. Although uninscribed, this exceptional half-length portrait may be assigned to Abu'l Hasan. The work exhibits close affinities – in the rendering of the countenance, patterning of the robe, and imposing presence of the figure – with Abu'l Hasan's signed works dated to the 1850s and 1860s. Further, it is the only known oil-on-canvas work attributable to this artist apart from the Nizamieh panels (Archaeological Museum, Tehran).

At first glance, this work strikes the viewer as quasi-photographic realism, but this impression is deceptive: in fact, Abu'l Hasan has devised a truly perceptive interpretation of another determined and prominent personality. By placing the figure close to the picture plane, emphasizing his broad shoulders and wide frame, and focusing on his intense gaze (accentuated by the same tilt of the head used for his portrait of Nasir al-Din Shah, employed here to much greater effect), Abu'l Hasan has captured the sitter's massive force of personality and truly memorable intensity.

The subject of this painting may be identified as Prince Imam Quli Khan (1814–1875), 'Imad al-Dawleh, on the basis of a comparison with inscribed watercolor portraits and lithographed illustrations by Abu'l Hasan.[22] Imam Quli was the sixth son of Muhammad 'Ali Mirza, Crown Prince 'Abbas Mirza's valiant rival, who ruled as prince-governor in Kermanshah and Khuzistan until his death in 1821. Imam Quli inherited his father's post and lands, and was awarded the title 'Imad al-Dawleh and subsequently appointed to the Council of State in 1852–53.[23] In this work he appears to be about forty-five, which would accord with a dating of 1850s–1860s for this work. A prominent figure, Imam Quli was responsible for coming to the aid of the capital during a famine by sending a large shipment of grain from the province of Kermanshah. The event was recorded in an issue of *Rūznāmeh Dawlat-i 'Illieh-i Īrān* in 1860–61 and illustrated with his portrait wearing the pointed dagger (*qameh*), awarded in recognition of his services.[24]

LSD

Literature: *Important Indian and Islamic Miniatures*, sale cat., Christie's, October 11, 1979, 23, lot 69; *Islamic, Indian, Southeast Asian Manuscripts, Miniatures and Works of Art*, sale cat., Christie's, November 22–23, 1984, lot 71; Robinson and Guadalupi 1990, 25.

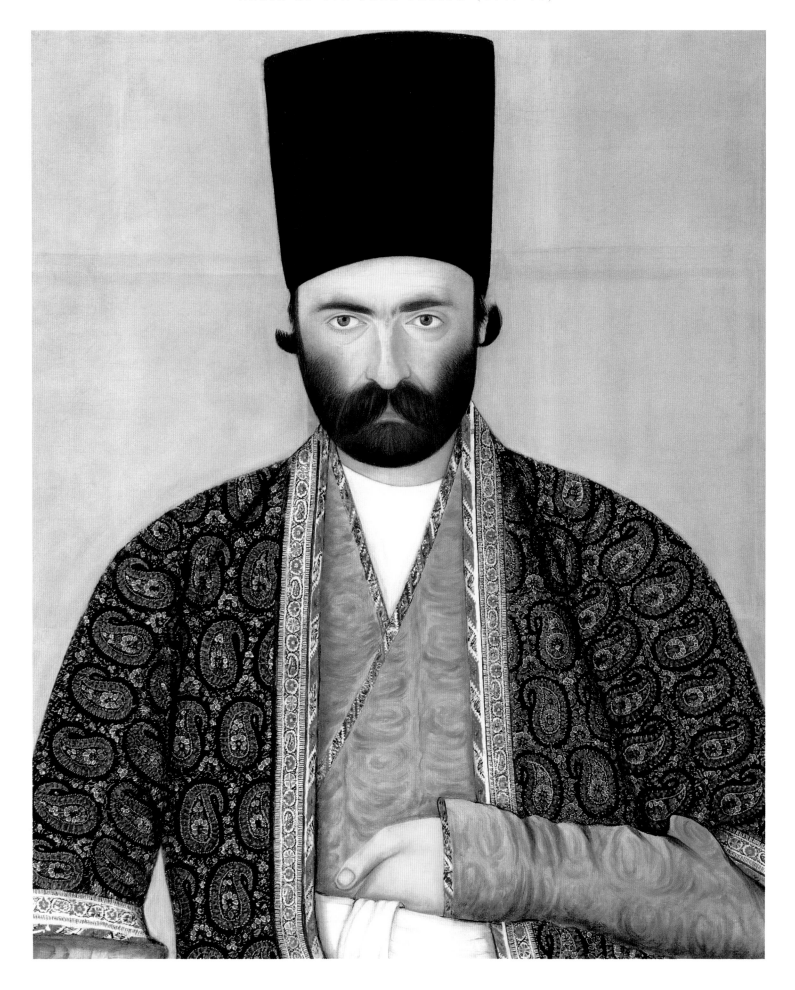

FIG. XXIX. *Portrait of Rukn al-Mulk Shirazi.*
Mirza 'Abd al-Javad, after Abu Turab. Isfahan, late
19th century. Ceramic tile, polychrome mineral
pigments under transparent glaze.
RUKN AL-MULK MOSQUE, ISFAHAN.

-81-
Haji Mirza Sulayman Khan, Rukn al-Mulk

Signed by Abu Turab Ghaffari
Tehran, 1880–89
Watercolor on paper; 15³/₈ x 10⁵/₈ inches (39 x 27 cm)
MUSÉE DU LOUVRE, PARIS, SECTION ISLAMIQUE, MAO 775

Abu'l Hasan's legacy of expressive portraiture was maintained in the works of the gifted painter and lithographer Abu Turab, Muhammad Ghaffari's elder brother and Abu'l Hasan's nephew. Abu Turab (1863–1889) trained at the Dar al-Funun and was awarded important commissions by the early 1880s, specializing in portraits of the ruler and dignitaries, and architectural views for the newspaper *Sharaf* (see NO. 89). His promising career was cut short by suicide from an overdose of opium at the age of twenty-seven.[25]

The subject of this image, Haji Mirza Sulayman Khan (1838–1912), served as chief secretary to Mas'ud Mirza (1850–1918), Zill al-Sultan, the eldest son of Nasir al-Din Shah and prince-governor of Fars and Isfahan, who subsequently appointed him vice-governor of Isfahan. Under his pen name of Khalaf, Haji Mirza wrote poetry and established a press in Isfahan for religious texts. On his death, Haji Mirza was buried in the mosque that he had endowed in Isfahan. Portrait tiles of Haji Mirza based on this very portrait were incorporated into the tilework on either side of the entrance portal of the mosque, constructed between 1900 and 1906 (FIG. XXIX).[26]

Following Abu'l Hasan's precedent, Abu Turab depicted his subject against a plain ground and concentrated the full force of his talent on the sitter's countenance, the texture of the cap and beard, and the knife-sharp pleats of his robe. The subject's stern look and furrowed brow convey his authority and contribute to the impact of the image. Haji Mirza's modest attire, prayer beads, and staff — conventions usually associated with depictions of the clergy — allude to his piety and good works, and the two fruits placed in front may refer to his poetry. The exquisite rendering of the full black beard (the

Haji's only ornament) and the accuracy of the depiction suggest that Abu Turab used a photographic source for the head and that either the work was done in two stages or it was completed by another artist. This is supported by the awkward placement of the head and its evident lack of proportion to the rest of the figure.

This ink-and-wash drawing and its tilework copy exemplify the broadening of patronage in the later Qajar period. They also are illustrative of the process by which imagery was replicated in different formats and disseminated throughout the country – a practice that was arguably similar to, but on a larger and more systematic scale than, that used in the late Safavid period (see FIG. II).[27]

LSD

Literature: Bernus-Taylor 1997, 50.
Inscriptions: In minute black *nasta'liq* script, bottom left underneath sitter's robe: *Abū Turāb Ghaffārī*

-82-
Portrait of a Religious Figure

Attributed to Abu Turab Ghaffari
Tehran, 1880–90
Watercolor on paper; 11¹/₂ x 8 inches (29.2 x 20.3 cm)
MUSÉE DU LOUVRE, PARIS, SECTION ISLAMIQUE, MAO 784

This hitherto unpublished painting of a religious figure is one of the most charismatic images of Qajar painting known. The subject seems to fix the viewer with an almost hypnotic stare. His deep-set eyes emerge from beneath a mass of wrinkles, and deep folds of skin etch dark grooves into his fearful countenance. His hallucinatory visage emerges from beneath a turban and a voluminous sheepskin robe that cascades in ripples and folds in a pyramidal composition. A neatly stacked pile of books and staff in the foreground allude to his status as a religious authority, although the significance of the fruits carefully placed on either side of the books is unclear.

The unease induced by the intensity of this image is somewhat mitigated, even here, by the Persian artist's aesthetic impulse. The masterful treatment of the cloak combines linear draftsmanship with modeling and shading (in the folds and creases) and meticulous execution (in the carefully individualized hairs of the lining in black and white tones).

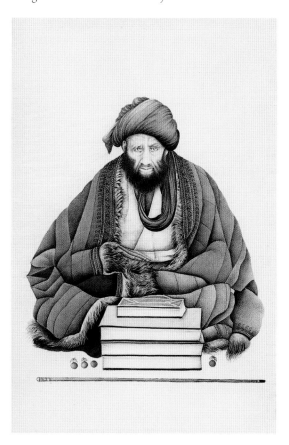

Although unidentified, the subject appears to be a learned scholar and seasoned veteran, a type well known in urban culture and the bazaar. This work exemplifies the diversification of subject matter (see NO. 93) and the increasingly objective, not to say caricatural, style of portraiture evolved by Abu'l Hasan Ghaffari and his contemporaries in the late Nasiri period.

LSD

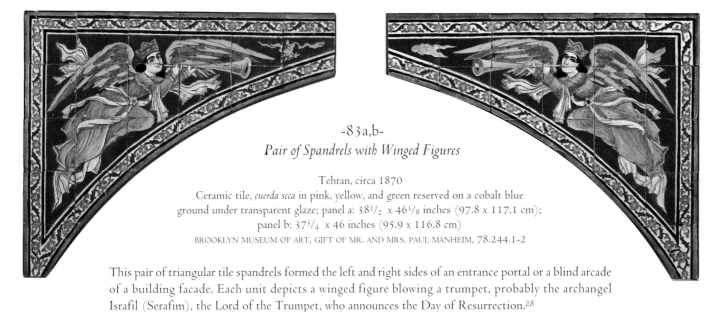

-83a,b-
Pair of Spandrels with Winged Figures

Tehran, circa 1870
Ceramic tile, *cuerda seca* in pink, yellow, and green reserved on a cobalt blue
ground under transparent glaze; panel a: 38½ x 46⅛ inches (97.8 x 117.1 cm);
panel b: 37¾ x 46 inches (95.9 x 116.8 cm)
BROOKLYN MUSEUM OF ART, GIFT OF MR. AND MRS. PAUL MANHEIM, 78.244.1-2

This pair of triangular tile spandrels formed the left and right sides of an entrance portal or a blind arcade of a building facade. Each unit depicts a winged figure blowing a trumpet, probably the archangel Israfil (Serafim), the Lord of the Trumpet, who announces the Day of Resurrection.[28]

The figures wear long-sleeved robes and crowns, and their handsome features are rendered in heavy black outline. Each life-size figure, shown in flight, occupies the entire field of the spandrel. The design is both skillful and graceful: the fluttering belt, scarves, and skirt of the robes that hug the figures' legs convey the angels' flight and weightlessness. Curling Chinese-style cloud bands used as decorative fillers also suggest movement. The blended glazes employed for the shading of drapery folds and modeling of the limbs, and the rich array of green and yellow hues in the outspread wings combine to create a painterly effect. Black hatching is applied sparingly, only in the body of the trumpet. Although the deep cobalt and intense hues used in reserve are found in early nineteenth-century dated mosques, the spandrels were probably produced considerably later.[29] In particular, the spandrels exhibit marked affinities with the lithographed illustrations of a copy of *Tales of the Prophets* (FIG. XXX) and the winged cupid tilework figures added to the Gulistan palace between 1867 and 1882.[30]

Winged figures, commonly referred to as genies or angels, were favored as decorative motifs in many media from the Timurid period on. In particular, winged genies are found in portals and spandrels of the Seljuk, Timurid, and Safavid periods.[31] They apparently held both secular and religious associations. This theme appears to have had a strong revival in mid- to late nineteenth-century tilework, which exhibits similar figures with a wide range of attributes and executed in differing styles. The stance of the figures here and rendering of their robes suggest that the artist may have used the winged figures of Victory at Taq-i Bustan as his immediate prototype (FIG. XXXI).

LSD

FIG. XXX. *The Destruction of Lot's City of Qum, Iran.*
Illustration from *Tales of the Prophets* (Tabriz, 1850). Lithograph, 11 x 6½ inches (27.9 x 16.5 cm).
PRIVATE COLLECTION.

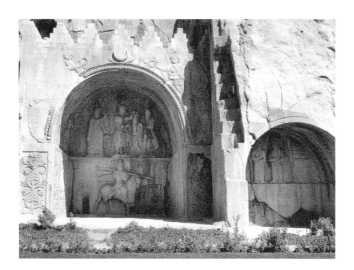

FIG. XXXI. *Great Grotto of Taq-i Bustan (circa A.D. 591–628), near Kermanshah.*

-84-
Mirror Case with Portrait of 'Ali

Muhammad Isma'il
Iran, A.H. 1288/A.D. 1871
Pasteboard, opaque watercolor and gold under lacquer; 10½ x 6¾ inches (27 x 17.3 cm)
BERNISCHES HISTORISCHES MUSEUM, ABT. VÖLKERKUNDE, BERN, 73/1913

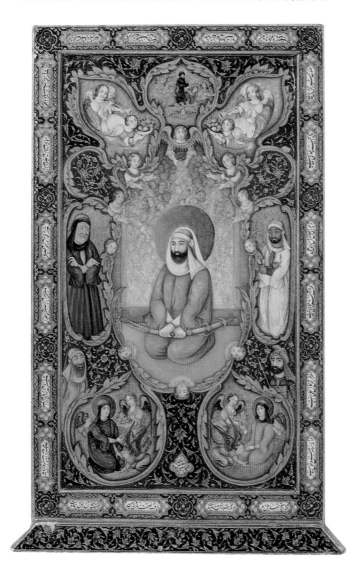

Muhammad Isma'il's last extant work, this finely painted mirror case offers a rare instance of Shi'ite religious portraiture on a small lacquer object. It contains a haloed portrait of 'Ali, cousin and son-in-law of the Prophet Muhammad and the first Shi'ite imam, on the inner surface and floral designs and scrollwork on the cover and exterior.

To the Shi'ites, 'Ali has always been considered the second link in the spiritual chain after the Prophet, and the embodiment of divine truth and mystical insight. 'Ali is depicted kneeling as he holds his forked sword, Zu'lfiqar' with both hands. Muhammad Isma'il places him at the center of the composition against a glory of angels in *grisaille* like those that surround the Virgin and Child or other Christian holy personages in paintings and altarpieces, and frames him in an oval medallion of scrollwork delineated by human heads, which resembles an abstracted *mandorla*, the almond-shaped glory of light surrounding the figure of God, Christ, or the Virgin Mary, or occasionally a saint. Additional scenes surrounding the central image are also enclosed in similar medallions. B. W. Robinson has identified the two figures at either side of 'Ali as Abu Talib ('Ali's father) and Abyssinian Bilal (one of the first Muslims appointed to chant the call to prayer).[32] Below 'Ali, his sons Hasan and Husayn, both with haloes, are accompanied by angels. Two half-figures, one of whom has been identified as Mukhtar (the avenger of the slaughtered innocents), are represented.[33]

The composition has been referred to as an Islamic altarpiece by one scholar, as it evokes large European altarpieces of the Renaissance period and other Catholic works of art.[34] Muhammad Isma'il clearly experimented with reinterpreting Shi'ite subjects within the format of Christian altarpieces. He was undoubtedly familiar with the altarpieces in the Armenian churches in New Julfa, in his native Isfahan, and may have in fact seen the altarpiece in the early eighteenth-century Church of Saint Nerses. Here the haloed image of 'Ali is surrounded by attendant angels, just as the Virgin Mary is depicted on an altarpiece; 'Ali is flanked on each side and below by other prominent figures in Shi'ite theology, just as the Virgin is flanked by representations of specific saints; the figures of Hasan and Husayn are enclosed in medallions, as in predella panels of an altarpiece; and the composition is crowned by an image of the Prophet's night journey to heaven, the *Mi'raj*, just as an image of the Holy Trinity crowns an altarpiece.[35]

A rectangular border containing ten couplets of rhyming poetry in fine *nasta'liq* script frames the entire composition. The poetry reads: "This is a portrait of the Lord of Divine Truth, friend of God; After one glimpse at his countenance; He was called a mirror reflecting God/His countenance is the epitome of light and Divine Truth; He is the embodiment of the secret of Divine Truth/Although he is not the essence of God, his soul is as pure as the pearls of the sea of Heaven; The dust of hooves of Qambar's [a freedman of 'Ali] horse emanate honor; And illuminate even the gaze of an angel/Holding his 'Zu'lfiqar/He is brave like a lion and the dragons; The reflection of this countenance imparts light and brilliancy to the sun; It bestows life to heaven and earth/ He is the painter of heaven and earth; Nasir al-Din Shah has the good fortune of seeing his beautiful countenance; May grace be upon him and may the evil eye always be blind and remote from him."

Despite the prominence of the Shi'ite subject matter on this mirror case, the rendition is characteristic of Muhammad Isma'il's thoroughly European later style in its experimental attempts at modeling, use of light and shade, Rococo-style scrollwork framing the various scenes, and composition. In fact, B. W. Robinson suggested that this image was probably inspired by an oil painting depicting 'Ali flanked by angels by Abu'l Hasan Ghaffari, Sani' al-Mulk, in the Museum of Decorative Arts, Tehran. Muhammad Isma'il may have also used European prints and other artworks circulating in the royal atelier of the time as models for this work.[36]

Like the casket depicting the siege of Herat (NO. 72), this mirror case bears a signature with the title *naqqashbashi*, or painter laureate. It was thus most likely commissioned by Nasir al-Din Shah as a devotional piece to 'Ali, the champion of the Shi'ites, and his followers, and it may have been intended to protect the ruler from the evil eye, almost as an amulet.

ME

Literature: Robinson 1970, pl. 5; B. W. Robinson, "Lacquer, Oil Paintings and Later Arts of the Book," in Falk 1985, 184, fig. 163; Ekhtiar 1990, 140, fig. 11; Balsiger and Kläy 1992, 151.
Provenance: Collection of Henri Moser Charlottenfels.
Inscriptions: *Muḥammad Ismā'il Naqqbshbāshī, 1288.*

Poetic verses:

Ṣūrat-i shīr-i ḥaq, valī-i khudāst/Yā kih āineh-i khudāi namāst

Dīd chun 'aql, naqsh rūy-i 'Alī/ Guft ā'ineh-i jamāl-i khudāst

Maẓhar-i nūr-i ḥaq, jamāl-i 'Alīst/ Va andar ū sirr ṣun'-i ḥaq, paydāst

ānkeh az partaw-i shamāyil-i ū/Jurm khurshīd rā furūgh u ziyāst

Bā'is-i khilqat-i zamān u zamīn/ naqshband-i nuqqūsh-i arẓ u samāst

Zāt-i ū garcheh nīst zāt-i khudāi/Līk īn durr-i pāk, az an daryāst

Gard-i na'layn-i Qambarash zi sharaf/ Rawshanībaksh-i dīdeh-i hūr ast

Zu'lfiqārash bidast aẓhdar dar/Hamchu, dar chang-i shīr, aẓhdarhāst

Dīdeh-i bakht-i shāh Nāṣir al-Dīn/Tā kih bar īn shamāyil zibāst

Jāvdān az jamāl-i dawlat-i ū/Chashm-i bad dūr u kūr u nābīnāst

-85-
Nur 'Ali Shah

Isma'il Jalayir (d. circa 1868–73)
Tehran, circa 1865
Oil on canvas; 35 x 27¼ inches (88.9 x 69.2 cm)
COLLECTION OF MRS. FERESHTEH MASSOUDI HEDAYAT

FIG. XXXII. *Nur 'Ali Shah.*
Isma'il Jalayir. Oil on canvas.
PRIVATE COLLECTION.

This hitherto unpublished painting of Nur 'Ali Shah is one of three (see FIG. XXXII) [37] of the young dervish by the multicrafted artist Isma'il Jalayir, a Dar al-Funun graduate, instructor, and notable court painter of the second half of the nineteenth century. Jalayir depicted Nur 'Ali Shah in an exotic paradisiacal garden of blossoming trees, wearing a long cloak and conical cap with twelve folds (each fold representing one of the twelve Shi'ite imams). Jalayir made the image of Nur 'Ali Shah more accessible by allowing it to fill nearly the entire canvas and by bringing it forward on the picture plane. The figure kneels on one leg while holding a jeweled bird-headed *mantāsheh* (cudgel used by dervishes for defense against harmful animals) in one hand, and the chain of a carved *kashkūl* (alms bowl that symbolizes the individual's passive receptivity to God) in the other. Framed by long, flowing locks, his effeminate face displays a childlike innocence and a meditative gaze.

The Edenic quality of the landscape surrounding the image of Nur 'Ali Shah is a hallmark of Jalayir's style. The illusionistic and mystical quality of the painting is accentuated by Jalayir's adaptation of the age-old technique of *siyāh qalam* (a picture drawn in black), whereby he avoided using color and relied on the subtle gradations of black, gray, and white to convey a sense of weightlessness and the ephemeral. According to Dust 'Ali Khan Mu'ayyir, in addition to indigenous techniques, Jalayir was inspired by European prints and photographs, often using them as models. [38]

Life-size paintings of dervishes with their symbolic accoutrements reached their culmination in the second half of the nineteenth century. This development coincided with an invigorating revival of sufism, particularly that of the Ni'matallahi order, which had gained a popular following among government officials and royalty. An examination of the corpus of Jalayir's works reveals a preoccupation with sufi subjects. It is possible that Jalayir had an affiliation with the Ni'matallahi sufi order.

Of all these images of dervishes, none has figured more prominently than that of Nur 'Ali Shah (d. 1797), an eighteenth-century leader of the Ni'matallahi order who had attracted a following of thousands in Kirman and Shiraz, and who also produced a prolific body of literature in both prose and verse. He was persecuted, expelled from Shiraz by Karim Khan Zand, and later poisoned. Nur 'Ali Shah's portrait appears in a wide variety of media, including oil on canvas, reverse-glass painting, watercolor, and rugs. Throughout the centuries, many leaders of the order had been tortured and killed by the conservative *'ulamā*, giving rise to a "cult of martyrs."

Like most of Jalayir's works, this painting is undated. It was, however, presented by the artist to 'Ali Quli Khan, Mukhbir al-Dawleh, librarian and dean of the Dar al-Funun, and Minister of Higher Education (after 1880). Although the date of production is unknown, it is likely that Jalayir presented this portrait to Mukhbir al-Dawleh sometime in the 1860s, during his most prolific period, when Mukhbir al-Dawleh was still serving as librarian at the school.

ME

Literature: *Iran in the 19th Century: The Private World of the Qajars,* exh. checklist, Ashmolean Museum (Oxford, 1992), 17.
Provenance: Collection of 'Ali Quli Mirza Mukhbir al-Dawleh Hidayat, Hidayat Family Collection.

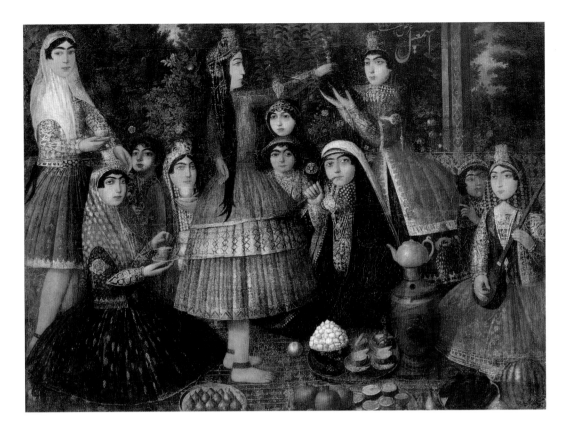

-86-

Ladies around a Samovar

Isma'il Jalayir
Tehran, third quarter of the 19th century
Oil on canvas; 56¹/₂ x 78¹/₂ inches (143.8 x 195 cm)
LENT BY THE BOARD OF TRUSTEES OF THE VICTORIA AND ALBERT MUSEUM, LONDON,
GIVEN TO THE VICTORIA AND ALBERT MUSEUM BY LADY JANET CLERK, P.56-1941

This painting by the late nineteenth-century painter Isma'il Jalayir of a group of harem ladies entertaining themselves around a samovar reflects the warm, intimate ambiance of a Qajar royal harem (*andarūn*). In this idealized image, the women are gathered for afternoon tea on a verandah overlooking a lush garden of fruit trees. The soothing sound of the bubbling water pipe (*qaliān*), sweet music of the *tār*, aroma of the freshly brewed tea, and the rich colors and elaborate costumes all convey the sensuality and luxury of the harem setting.

In contrast to Jalayir's portrait of Nur 'Ali Shah (NO. 85), which is painted in black and white, *Ladies around a Samovar* is painted in a rich palette of reds, greens, and browns. Jalayir's reliance on warm colors as well as his skillful rendition of minute details of costume and headdress create a true "feast for the eyes." Traditionally, the harem was like a grand stage set, with the players performing in an extravagant costume drama. Affluence and privilege are suggested in this painting by the inclusion of the tray of fruit, the sweetmeats and delicacies laid out in the foreground, the European tea set, and the teapot that sits on top of the samovar.

The color and design of court attire, from headdress to shoes, often differentiated the members of the royal household according to rank and duty. Each ceremony or gathering was an occasion for displaying the most splendid costumes. In many ways this painting can be viewed as a compendium of late Qajar royal costume. In contrast to portraits of harem entertainers and odalisques of earlier periods, the women here are modestly clothed and covered in various types of veils. The princesses appear unveiled, with jewel-studded tiaras, while the other women wear patterned veils (*chārqads*) that fasten under their chins. Only the figure smoking the water pipe is completely veiled, wearing a full black veil (*chādur*) and a long white face covering (*rūbandeh*). The princesses are decked out in colorful multilayered ensembles of brocade edged with silver embroidery, while the other figures wear pearl-embroidered waistcoats (*nīmtaneh*) and short crinoline mini-shirts (*shalīteh*).

The women, who look out at the viewer, appear to have been interrupted at a dramatic moment. Also included are two very young girls and a boy (approximately five years old), who also peer out at the viewer. Young boys were the only males (other than eunuchs and the harem master) who would have been permitted into the harem quarters.

In the harem, eating was a ritual, an opportunity for congregating and reciting poetry, historic legends, or love stories. Storytelling, in all its forms, was one of the major pastimes of harem members. In this scene the harem ladies enjoy their afternoon tea as they are entertained by music and a private staging of poetic drama.[39] While providing a glimpse into a traditional Persian royal harem of the late nineteenth century, this painting reveals the personal idiosyncrasies of the artist (accentuated by the artist's inscription, "Isma'il, the intention is to leave behind this image [as my legacy]"), and conveys a melancholic quality, which perhaps alludes to the transitory nature of life in the rapidly changing society of late nineteenth-century Iran.

ME

Literature: B. W. Robinson, *Persian Oil Paintings* (London, 1977), fig. 9; Ansari 1986, 143–44; Robinson 1989, 231; B. W. Robinson, "Court Painting in Persia," in Robinson and Guadalupi 1990, 201; Layla S. Diba, "Clothing: Safavid and Qajar Periods," *Encyclopaedia Iranica*, vol. 5; Taj al-Saltaneh 1993, cover.
Provenance: Collection of Lady Janet Clerk.
Inscriptions: In *nasta'liq* script at the top: *Isma'il, gharaz naqshist kaz mā mānad* (Isma'il, the intention is to leave behind this image [as my legacy])

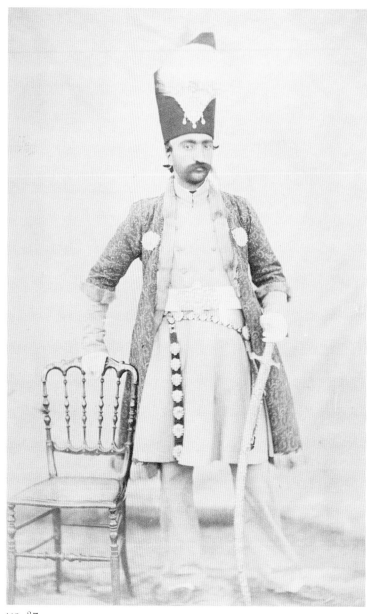

NO. 87

-87-

Portrait of Nasir al-Din Shah

Photographer unknown
Tehran, circa 1852–55
Salt print; 13¹/₈ x 8¹/₄ inches (33.7 x 21.2 cm)
THE METROPOLITAN MUSEUM OF ART, NEW YORK, GIFT OF CHARLES WILKINSON, 1977, 1977.683.22

-88-

Portrait of Nasir al-Din Shah

Artist unknown
Tehran, circa 1855
Opaque and transparent watercolor on paper; 11³/₄ x 7⁹/₁₆ inches (29.8 x 19.2 cm)
MUSÉE DU LOUVRE, PARIS, SECTION ISLAMIQUE, MAO 778

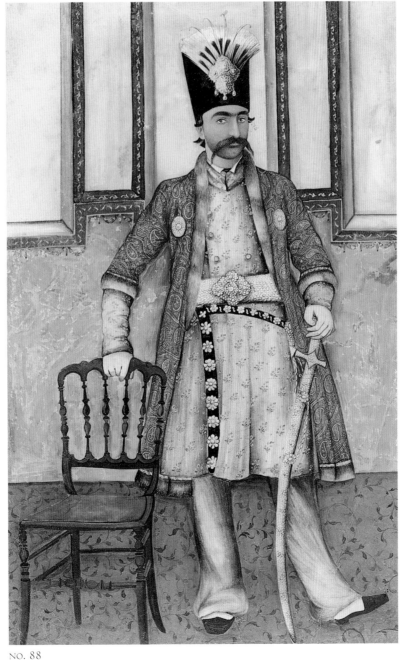

NO. 88

Photography had a profound impact on the development of later Persian painting.[40] In a statement outlining the close relationship between the two, Nasir al-Din Shah's Minister of Publication, I'timad al-Saltaneh, claimed that photography had greatly served the art of portraiture and landscape by reinforcing the use of light and shade, accurate proportions, and perspective.[41]

Soon after photography was introduced in Iran by European photographers in the 1840s, Iranians promptly adopted the new technology. The daguerreotype appeared in Iran in 1844, only a few years after its presentation to the Académie de Science in Paris.[42] The first daguerreotypes taken between 1844 and 1854 of members of Muhammad Shah's royal household in Tehran by the Frenchman Jules Richard (1816–1891) coincided with the initial experiments in photographic techniques by Fath 'Ali Shah's son Malik Qasim Mirza (1807–1862) in Azarbaijan.

By the second half of the nineteenth century, however, photography in Iran was dominated by indigenous photographers. To ensure its progress and dissemination, the field was introduced into the Dar al-Funun curriculum in 1860 under the aegis of the department of chemistry. By 1888, its use had become so widespread that, according to I'timad al-Saltaneh, "the very number of photographers and their workshops in the capital, Tehran, and other major cities of Iran would make their enumeration a most arduous task."[43]

Among the most renowned native Iranian photographers was Nasir al-Din Shah himself, whose albums of his own work eventually comprised more than twenty thousand photographs of a wide range of subjects including photographs of his favorite wives and concubines in erotic poses.[44] The shah's encouragement of photography in Iran inspired his courtiers, as well as Dar al-Funun students, to take up the art; some were even given the opportunity to refine their skills on government-sponsored training missions to Europe. Upon completion of their training, many proudly called themselves "engineer" (*muhandis*), and the most talented were honored with the title "court photographer" (*'akkāsbāshī*). Photographs thus began to compete with paintings as valued possessions and became the chief prototypes for portrait paintings and landscapes in all media.

The salt-print photograph of Nasir al-Din Shah by an unidentified photographer shown here (NO. 87) served as the prototype for the accompanying watercolor portrait (NO. 88). Combining Western and Persian elements of costume, the photograph portrays the young shah wearing a fitted robe of *tirmeh* (a brocade fabric with paisley patterns produced primarily in Kirman) lined with fur over a European-style frock coat and wool trousers. He holds a saber and wears an astrakhan hat with a slanted top typical of the mid-Qajar period, decorated with the royal aigrette (*jiqqeh*). Leaning on a small spindle chair, he looks straight out at the camera.

Photography added a highly personal and candid quality to Persian portraiture. Although probably unfinished, the watercolor portrait (NO. 88) vividly reflects the artist's effort to copy the photograph with exactitude yet also reveals his exercise of the prerogative to tailor color and decorative detail to his patron's wishes.

The photograph belongs to an album containing seventy-five salt and albumen prints by Luigi Pesce, M. de Blocqueville, and several unidentified photographers.[45] The album appears to be one of two compiled by Pesce, a Neapolitan colonel who came to Iran in 1848 to assume the position of commander in chief of the Iranian infantry. An amateur photographer, Pesce compiled several albums of monuments and cityscapes, which he sent back to Italy in 1861. The present album was originally the property of Ardishir Mirza (uncle of Nasir al-Din Shah and governor of Arabistan, Luristan, and Bakhtiaristan).[46]

ME

Literature: Donna Stein, "Three Photographic Traditions in Nineteenth-Century Iran," *Muqarnas* 6 (1989): pl. 4.; Stein 1983, 258; Layla Diba, "Clothing: Safavid and Qajar Periods," *Encyclopaedia Iranica*, vol. 5. Provenance: Ardishir Mirza, Charles K. Wilkinson.

-89-

Equestrian Statue of Nasir al-Din Shah

Abu Turab Ghaffari (d. 1890)
From the newspaper *Sharaf* (Tehran), no. 50 (January 1888)
Lithograph; 15 x 10 inches (38.1 x 25.4 cm)
PRINCETON UNIVERSITY LIBRARY, NEAR EAST COLLECTION, PRINCETON, NEW JERSEY

Soon after the initial issue of the first official state-sponsored lithographed newspaper, *Rūznāmeh-i Vaqāyi' Ittifāqieh* (*Newspaper of Current Events*) in Iran, Nasir al-Din Shah appointed his painter laureate Abu'l Hasan Ghaffari its chief editor and illustrator. The illustrations included fine portraits of royalty and eminent political personages, and images of royally commissioned architecture and momentous political events. The publication of this newspaper further stimulated the proliferation of newspapers and gazettes in Tehran and in the provinces.

NOS. 89, 92, and 97 represent the development of the illustrated newspaper over the course of the late Qajar period. The medium was initially used by the government and Qajar ruling elite as an effective vehicle of political consolidation and centralization, and an economical tool for disseminating and popularizing the royal image. It was also used to verify the actions of the government and avert unfounded rumors and assumptions, as well as to introduce readers to the outside world, especially the technological advancements of Western Europe. During the Constitutional Revolution, however, the lithographed newspaper was gradually appropriated by dissidents and the opposition to convey nationalistic and controversial political messages.

This image depicts an equestrian statue of Nasir al-Din Shah in military uniform by the artist and Dar al-Funun graduate Abu Turab Ghaffari (Abu'l Hasan's nephew). The image, from the illustrated newspaper *Sharaf*, is accompanied by an elaborate announcement in fine *nasta'liq* script that describes the statue and outlines the progress of the arts, crafts, and industry during the reign of Nasir al-Din Shah, especially advancements in the royal arsenal, the statue's site of production. It states that the statue was commissioned by Aqa Riza Khan, Iqbal al-Saltaneh, the chief of the royal arsenal; was executed solely by Iranian craftsmen; and was distinguished for its quality of realism, proportions, masterly details, and ingenious craftsmanship, equaling only the best European statues of its kind. The announcement recounts the shah's visit to the arsenal to unveil the statue and distribute honors to its craftsmen, and notes his desire to install the statue in an appropriate place with wide public access. The work stood in the Bagh-i Shah (Royal Park) until the beginning of the reign of Riza Shah Pahlavi (1925–41), when it was brought down and destroyed.[47]

According to the historian Mirza Ghulam Husayn Khan Afzal al-Mulk, a detailed inscription on the base, which appears to have been added several months after the completion of the statue, read: "On the occasion of the hundredth anniversary of Qajar rule and the fortieth anniversary of His Highness Nasir al-Din Shah's reign, whose just rule has resulted in our security and comfort, the arts and industries have progressed steadily and great works have been produced. The shah's trips to Iraq and Europe, gilding of the dome of Hazrat-i 'Abd al-'Azim, installation of telegraph lines, introduction of photography, electricity, kerosene lamps, establishment of post offices, hospitals, police forces, mints, railroads, parks, new roads, impressive buildings, military schools, and the production of modern weapons and other military equipment, have all helped to create a better life in Tehran and the provinces. This statue, completed in Muharram 7, 1306 (September 13, 1888), in the Royal Arsenal, was erected to celebrate the countless accomplishments of His Highness the Shah."[48]

Because of the anti-iconic attitudes of the religious elite with regard to figural sculpture, the display of this statue was bound to raise controversy and stir up resentment.[49] It was, after all, the first example of a life-size sculpture of a Persian shah to appear so prominently in public view. It was originally intended to be installed on Lalehzar Avenue, one of the most fashionable streets of Tehran, but because of the shah's fear that it would trigger a negative public response in conservative religious circles, it was soon moved to Bagh-i Shah.[50]

ME

Inscriptions: In *nasta'liq* script below image of statue: *Mujassameh-i Humāyūnī*; left-hand corner: *Abū Turāb Ghaffārī*

Notes

1. See *Rūznāmeh Dawlat-i 'Illieh-i Īrān*, no. 227, 1991 ed.; Zuka 1970, 144, 274–75; Amanat 1997, pl. 7.
2. See Ekhtiar essay in this publication.
3. For Churchill's biography, see Wright 1977, 81. For the album, see Robinson 1967, 81–83, no. 102; Robert Hillenbrand, *Imperial Images in Persian Painting. A Scottish Arts Council Exhibition*, exh. cat., Scottish Arts Council Gallery (Edinburgh, 1977), 43–44, nos. 82–84.
4. Dust 'Ali Khan Mu'ayyir 1982, 275.
5. Amanat 1997, pl. 22.
6. See Zuka 1963, part II, nos. 10–11, 17–19, for discussion and illustrations; and *7,000 Years of Iranian Art*, exh. cat., Freer Gallery of Art (Washington, D.C., 1964–66), 111–12, for preliminary studies of court officials and royal butlers, nos. 720–25 (Archaeological Museum, Tehran).
7. Jennifer Scarce, "Tilework," in Ferrier 1989, 293, no. 33; for figural tilework of the Takieh Mu'avin al-Mulk, see Peterson 1981, figs. 43–60.
8. Zuka 1963, part II, nos. 10–11, 30, and Rainer Schoch, *Das Herrscherbild in der Malerei des 19. Jahrhunderts* (Munich, 1975), figs. 157–60, 215.
9. See Zuka 1963, parts I and II, for a detailed study of his life and works; and Ekhtiar essay in this publication. For the Ghaffari family history, see Diba 1989b, 154–57.
10. Another version of this composition representing Husayn Khan Muqaddam Adjudanbashi is reproduced by Bamdad 1968–74, vol. 5, unpag. ill. to biographical entry on the sitter in vol. 1, p. 426. Only a close comparison of the two works will reveal the original, although judging from the reproduction, the Adjudanbashi portrait appears to be a work of European origin.
11. See NO. 77 for Bahram's biography and B. W. Robinson, "Persian Painting in the Qajar Period," in Ettinghausen and Yarshater 1979, 69, for his lithographic production.
12. I wish to thank Lisa Rotmil, Research Associate, Department of European Painting and Sculpture, Brooklyn Museum of Art, for sharing her insights into the relationship of Nasiri paintings and European prototypes.
13. Unlike his grandfather, Nasir al-Din Shah did not send his portraits abroad in great numbers. Another example sent to Berlin is recorded in the shah's diary of his 1878 trip to Europe, and may yet be located. *A Diary kept by His Majesty The Shah of Persia During his Journey to Europe in 1878*, trans. from the Persian by Albert Houtum Schindler and Baron Louis de Norman (London, 1879), 130.
14. See Algar 1969, 159, for a discussion of the paintings, and Amanat 1993, 205, for the order.

15. The artist's biography is culled from M. Kazarian, *The Ovnatanian Family of Artists* (Moscow, 1968), especially 13–35.
16. He also was the author of several books and participated in a joint venture to translate Descartes's *Discours sur la Méthode et les Méditations*. Joseph Arthur de Gobineau, *Les Religions et les philosophies de l'Asie Centrale* (Paris, 1928), 113–14.
17. Walter Liedtke, *The Royal Horse and Rider: Painting, Sculpture and Horsemanship: 1500–1800* (New York, 1989), 19, 61.
18. Karimzadeh Tabrizi 1985–91, vol. 1, pp. 104–6.
19. Ibid. See Dust 'Ali Khan Mu'ayyir 1982, 279.
20. See H. Mahbubi Ardakani, "Ardashīr Mīrzā," in *Encyclopaedia Iranica*, vol. 2.
21. Possibly his nephew Dust Muhammad Khan, whose military education was entrusted to Ardishir Mirza, his maternal uncle. See Tavakoli Tarqi, "Mu'ayyir, Dūst 'Ali Khān," *Encyclopaedia Iranica* (forthcoming).
22. *Important Islamic and Indian Manuscripts and Miniatures*, sale cat., Christie's, October 11, 1979, 23, lot 69.
23. For his biography, see Bamdad 1968–74, vol. 1, pp. 160–62.
24. *Rūznāmeh Dawlat-i 'Illieh-i Īrān*, no. 185–86.
25. For his career, see Bamdad 1968–74, vol. 1, pp. 71–72; Karimzadeh Tabrizi 1985–91, vol. 1, pp. 19–20; and Diba 1997.
26. Hunarfar 1965, 805 ff.
27. For a similar case from the 1880s, in which photographs were used to produce portrait tiles of Robert Murdoch Smith, a director of the Telegraph Company, see Jennifer Scarce, "Ali Mohammad Isfahani – Tilemaker of Tehran," *Oriental Art*, n.s. 3 (Autumn 1976): 278–88.
28. A. J. Wensinck, "Israfil," *Encyclopedia of Islam*, new ed., 1978.
29. Jennifer Scarce, "Tilework," 290–91.
30. I am grateful to Jennifer Scarce for drawing this parallel to my attention.
31. See Ingeborg Luschey-Schmeisser, *The Pictorial Tile Cycle of Hasht Behesht in Isfahan and its Iconographic Tradition* (Rome, 1978), pl. XXXII B.
32. Robinson 1970, 47–50.
33. Ibid., 49.
34. Francis Guy Bondurant, "Persian Lacquer Cases of the Qajar Period," Master's thesis, City University of New York, Hunter College, 1974, 57. I also want to thank Lisa Rotmil for her helpful suggestions regarding this analysis.
35. Bondurant, "Persian Lacquer Cases," 57.
36. Robinson 1970, 49.
37. One of the other two is in the Leipzig Museum; the other is in the Sa'dabad Museum, Tehran.
38. Dust 'Ali Khan Mu'ayyir 1982, 277.

39. Abbas Amanat has suggested that this is the marriage scene from the Qur'anic love story of Yusuf and Zulaykha, but the iconography does not correspond. See Taj al-Saltaneh 1993, colophon. I am grateful to Afsaneh Najmabadi for her comment on this subject. On the hand-cutting scene, see Karen Merguerian and Afsaneh Najmabadi, "Zulaykha and Yusuf: Whose 'Best Story'?" *International Journal of Middle Eastern Studies* 29, no. 4 (November 1997).
40. For the relationship between painting and photography, see Ken and Jenny Jacobson, *Étude d'Après Nature: 19th Century Photographs in Relation to Art* (Petches Bridge, 1996). For the history of photography in the Middle East, see Paul E. Chevedden, *The Photographic Heritage of the Middle East: An Exhibition of Photography of Egypt, Palestine, Syria, Turkey and Iran 1849–93*, exh. cat., UCLA Research Library (Malibu, 1981), and Louis Vaczek and Gail Buckland, *Travelers in Ancient Lands* (Boston, 1981).
41. I'timad al-Saltaneh 1984–88, 168.
42. Chahryar Adle, "Daguerreotype," *Encyclopaedia Iranica*, vol. 6.
43. I'timad al-Saltaneh 1984–88, 94. Translation from Iraj Afshar, "Some Remarks on the Early History of Photography in Iran," in Bosworth and Hillenbrand 1983, 261–90. See also Adle and Zuka 1983.
44. See Badri Atabay, *Fihrist-i Ālbumhā-yi Kitābkhāneh-i Salṭanatī* (Tehran, 1978); Donna Stein, "Three Photographic Traditions in Nineteenth-Century Iran," *Muqarnas* 6 (1989): 112–30; A. M. Piemontese, "The Photographic Mission to Persia: Summer 1862," *East and West* 22, no. 3–4 (September–December 1972): 262; and Iraj Afshar, "Some Remarks on the Early History of Photography," 266.
45. One was possibly Luigi Montebone, an Italian photographer who visited Iran in 1862 and took photographs of the Italian mission to Iran including views of cities, famous monuments, palaces, and men from all levels of society. See Stein 1983, 262.
46. His ownership has been derived from an inscription on a photograph in the album of a painting depicting Ardishir Mirza (FIG. XXVIII).
47. Ahmad Suhayli Khwansari, "Nasb-i Nukhustin Mujassameh dar Tehrān," *Vaḥīd*, no. 9 (December 1972): 1042–47.
48. Mirza Ghulam Husayn Khan Afzal al-Mulk, *Afẓal al-Tavārīkh*, reprint ed. by Cyrus Sa'dvandian (1899 manuscript; Tehran, 1982), 401–2.
49. See Diba essay in this volume for detailed discussion.
50. Suhayli Khwansari, "Nasb-i Nukhustin," 1045–46.

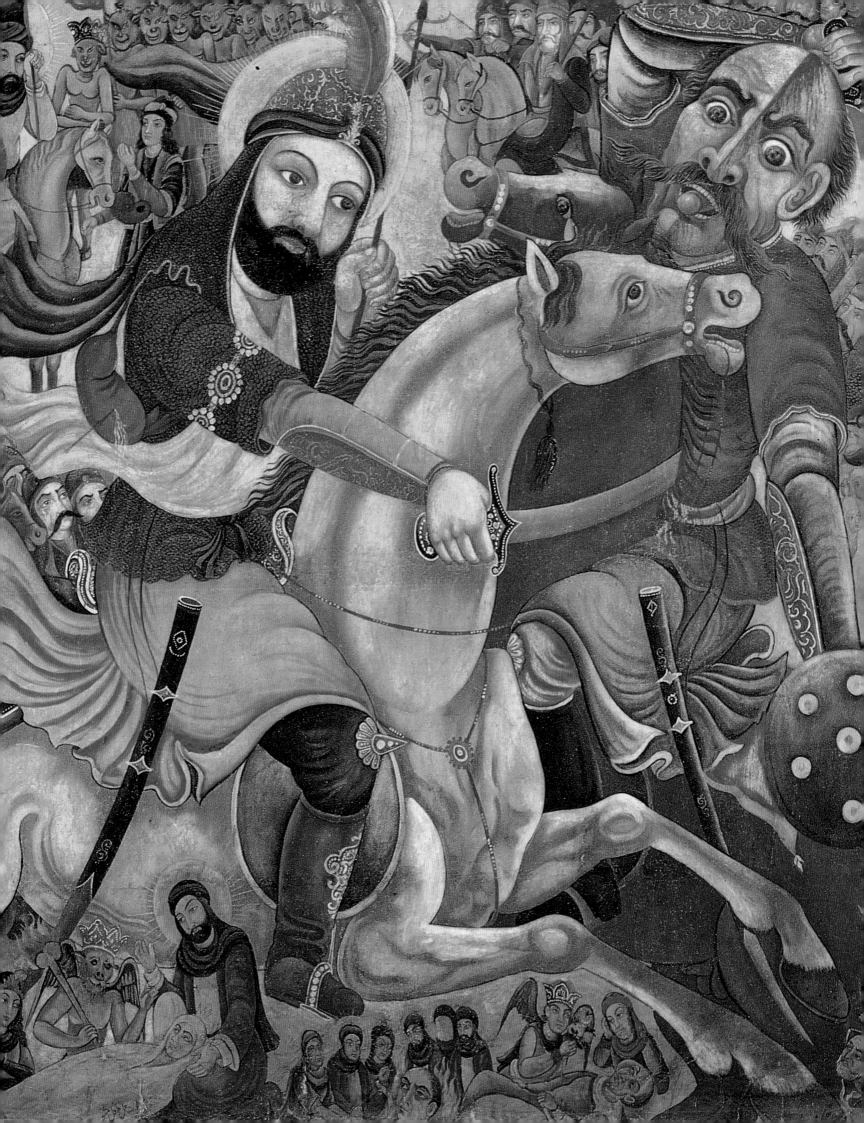

THE LAST QAJARS AND THE CONSTITUTIONAL PERIOD

(1896–1925)

ALTHOUGH THE waning years of Qajar rule were marked by political and social ferment, they also bore witness to the enduring vitality of Qajar painting. With the passing of Abu'l Hasan and the assassination of his patron Nasir al-Din Shah in 1896, the system of court patronage of official art that had endured since the late Safavid period finally collapsed.

Muhammad Ghaffari (1852–1940) and his pupils, reflecting the changing mood of the Iranian educated elite, championed not only a new mode of painting, but a new independence of spirit. Ghaffari's naturalistic painting style, heavily influenced by European academic painting, was considered the essence of modernity. This style prevailed in Iran as Post-Impressionism and Cubism spread throughout Europe, not only for court portraiture but also for the representation of genre scenes; the latter theme increasingly dominated the work of Ghaffari's pupils.[1]

By the late nineteenth century, life-size and monumental paintings, which had dominated Persian court painting since the late Safavid period, were painted in a vernacular idiom. Faithful replicas of Safavid historical paintings testify to the continued influence of the historical past as a creative source, and vigorous and vibrant *qahvehkhāneh* (coffeehouse) narrative paintings illustrate the appropriation of heroic and epic themes for popular audiences.

At the dawn of the twentieth century, a lively tradition of caricature developed in the press of the Constitutional period. This art form, diametrically opposed to the imperial grandeur of early nineteenth-century court painting, provided a fitting epitaph to the last phase of Qajar painting.

LSD

Opposite: Detail, NO. 95

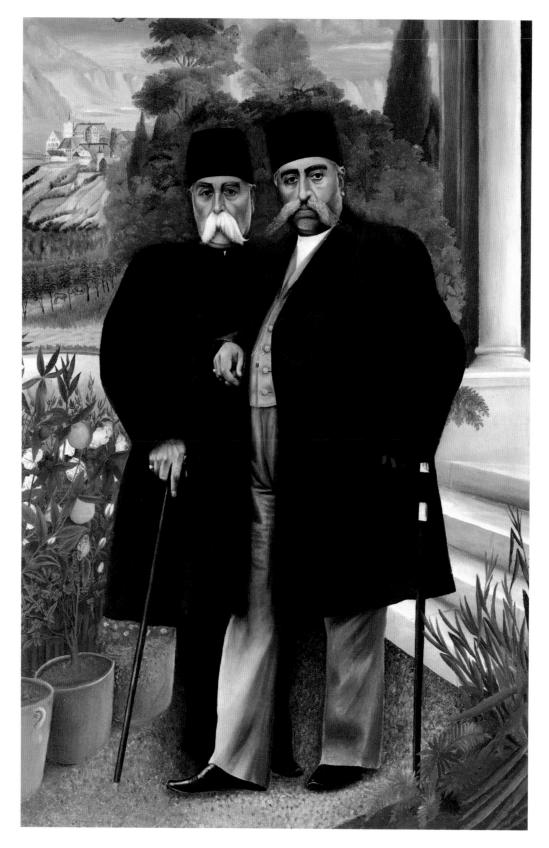

-90-

Portrait of Muzaffar al-Din Shah and Premier 'Abd al-Majid Mirza, 'Ayn al-Dawleh

'Abd al-Husayn (Sani' Humayun)
Tehran, early 20th century
Oil on canvas; 49¼ x 31½ inches (125 x 80 cm)
PRIVATE COLLECTION

Executed by Muzaffar al-Din Shah's painter laureate, 'Abd al-Husayn, known as Sani' Humayun (1859-1921), this hitherto unpublished portrait is one of the few extant oil paintings by the artist.[2] The painting depicts Muzaffar al-Din Shah (r. 1896-1907) and his premier, Prince 'Abd al-Majid Mirza, 'Ayn al-Dawleh, standing arm-in-arm at the foot of steps leading to a columned verandah.

The two figures are dressed in almost identical dark gray frock coats and identical black astrakhan fezzes, and each holds a walking stick. Their faces also bear a strong resemblance, with similar expressions and drooping white mustaches.

In striking contrast to paintings of the shah's father, Nasir al-Din Shah, and early Qajar portraits, Sani' Humayun has made no attempt here to display the splendor of the ruler's court or accentuate the richness of his regalia. In fact, the similar attire and portrayal of the two figures suggests a relationship of camaraderie and union.

Seriously ill throughout most of his reign, Muzaffar al-Din Shah relied heavily on 'Ayn al-Dawleh to conduct affairs of state; the premier censored the shah's correspondence and controlled his meetings with others. The painting represents the shah as unhealthy and exhausted, standing upright only with the aid of a walking stick. The walking sticks in this composition may symbolize the frail state of the court and government during Muzaffar al-Din Shah's rule. 'Ayn al-Dawleh also had a tumultuous political career;[3] he became Muzaffar al-Din Shah's premier, or Sadr 'Azam, in 1904, after engineering Prime Minister Amin al-Sultan's fall from power. His premiership coincided with the climax of the Constitutional movement, though he was a staunch royalist and an anticonstitutionalist.

This painting has a particularly Victorian quality. Its highly finished surfaces, naturalistic detail (especially in the execution of the mountainous landscape in the background, perhaps the Alburz mountains north of Tehran), and emphasis on the individual traits and psychological nuances of the subjects all indicate that Sani' Humayun was inspired not only by the work of Victorian painters, but by contemporary photographs as well.

ME

Inscriptions: In red *nastáliq* script, lower left corner: *Bandeh-i Dargāh Naqqāshbāshī Ṣanī' Humāyūn Qalamahū*

-91-
Portrait of Princess Taj al-Saltaneh (1884–1936)

Artist unknown
Tehran, circa 1910
Oil on canvas; 35 x 27 inches (88.9 x 68.6 cm)
COLLECTION OF MOHAMMAD AND NAJMIEH BATMANGLIJ

This oval painting of the Qajar princess Taj al-Saltaneh (meaning "Crown of the Monarch")[4] by an unknown artist portrays her as a bluestocking and is a typical turn-of-the-century image of an enlightened Persian royal woman. Taj, who spent her childhood in the royal harem, became one of its harshest critics. Her memoirs are replete with insightful observations of her experiences and the plight of women living within the confines of the harem.[5] Seeking refuge from her secluded and idle life, she filled her time by reading European classics on diverse subjects.

Following the Constitutional period, Taj became one of the founding members of the reform movement Anjuman-i Hurriyat-i Zanan (Society for the Emancipation of Women), through which she came into contact with several American missionaries. Mary Jordan, the wife of the American Presbyterian missionary Samuel Jordan, left a particularly deep impression on Taj.[6]

In this painting Taj is seated in front of a plant stand holding a tightly wrapped package, perhaps containing some folded political petitions, documents, or pamphlets, as she positions her arm gently on a table in front of a carefully arranged bouquet of fresh flowers. She is dressed in a Victorian dress of dusty blue velvet and lace with black velvet accents. Her erect posture, serious and somewhat severe demeanor, and direct gaze exude a sense of self-confidence that contradicts the stereotypical image, commonly associated with earlier periods, of the segregated harem beauty. A comparison of this

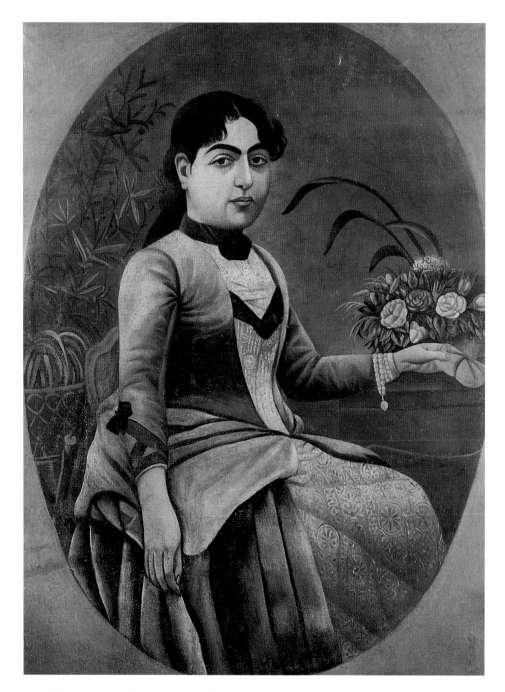

portrait of Taj al-Saltaneh with Isma'il Jalayir's *Ladies around a Samovar* (NO. 86) visually demonstrates some of the developments affecting the status of women brought on by the Constitutional movement.

Although Taj is portrayed unveiled, she wears a set of prayer beads (a symbol of religious piety) around her wrist. This subtle duality indicates a certain ambivalence, mirroring Iran's ambiguous relationship with the West at the time, as it was caught between the adherence to established codes of behavior and religious morals, and the motivation to adopt "modern" Western ways. The highly controlled, finished quality of the painting and the use of background props in this portrait of a woman as an individual suggest the possible use of a photograph as a model.

The artist's ultimate objective was to make a profound statement about the changing fortunes of Qajar royal women and their new role in early twentieth-century Iranian society. Thus, it is possible that the painting was commissioned by Taj al-Saltaneh herself, since she was among the most adamant advocates of a woman's right to education and emancipation.

ME

Literature: Taj al-Saltaneh 1993, frontispiece.

-92-

Portrait of Kamal al-Mulk

Mihdi Musavvar al-Mulk
From the newspaper *Sharāfat* (Tehran), no. 60 (December 1901)
Lithograph; 15 x 9³/₄ inches (38.1 x 24.7 cm)
PRINCETON UNIVERSITY LIBRARY, NEAR EAST COLLECTION, PRINCETON, NEW JERSEY

This fine lithograph portrait from the newspaper *Sharāfat* depicts the late nineteenth-century court painter and father of academy-style painting in Iran, Muhammad Ghaffari, known as Kamal al-Mulk (Perfection of the Kingdom). *Sharāfat* was largely devoted to illustrated biographies of royalty and eminent personages of Muzaffar al-Din Shah's rule. Executed by the artist Mihdi Musavvar al-Mulk, who was primarily a newspaper illustrator, this portrait shows Kamal al-Mulk as a middle-aged man and exemplifies the artist's refined style, skill, and command over the medium. The realism and subtle use of light and shade indicate that this portrait was very likely executed after a photograph. Like all the portraits in *Sharāfat*, this example is accompanied by a detailed biographical account in fine *nastāliq* script outlining Kamal al-Mulk's early education, accomplishments, appointment as painter laureate, and service to the "science of painting."

ME

Literature: Suhayli Khwansari 1989, 26–29.
Inscriptions: In *nastāliq* script below portrait: *Muṣavvar al-Mulk, Jināb-i Jalālat ma'āb Kamāl al-Mulk Naqqāshbāshī-yi Makhṣūṣ-i Huẓūr-i Humāyūn*

-93-
Exorcist and Clients

Attributed to Muhammad Ghaffari, Kamal al-Mulk, or his circle
Tehran, circa 1900
Oil on canvas; 22³/₄ x 29 inches (57.8 x 73.7 cm)
PRIVATE COLLECTION

In contrast to earlier paintings, which idealize royalty and nobility, those of the early twentieth century often record the world of common people. This unsigned work portraying a family visiting the home of an exorcist depicts real human beings, complete with physical imperfections. The exorcist's coarse features and deformed fingers are indicative of his humble roots.

Seeking relief from disease or misfortune, many Iranian families of humble origins often turned to popular ritual practices such as exorcisms. Such practices were seldom represented visually, making the subject matter of this painting a rare instance. The setting for the exorcism is a room in the modest traditional home of an Iranian commoner. Typical of domestic interiors of the period, the room has undecorated white plaster walls with niches and wooden doors overlooking an open courtyard with a small pool at the center. The printed cotton curtains are gathered to allow the afternoon light to penetrate the room. The floors of the room are covered with pile and flat-weave rugs (*qilims*). The figures, whose groceries are laid out in a tray in the foreground, appear to be completely engrossed in the exorcism. The father participates in the event by reciting passages from a book, probably the Qu'ran.

An amusing element in the painting is the presence of small, mischievous spirits (*jinns*) chasing one another with bows and arrows around the room. Fantastical elements like these, reminiscent of the Flemish painter Hieronymus Bosch, were a new iconographic convention in Persian art. The painting appears to mock the rampant superstition of the time; indeed, many members of the Qajar elite, including painters, actively rejected superstition in favor of reason, science, and education.

A complete catalogue raisonné of the paintings of Muhammad Ghaffari, Kamal al-Mulk, has not yet been undertaken.[7] Since many of his paintings served as models for the works of his contemporaries, a large number of paintings may have been incorrectly attributed to him. Although *Exorcist and Clients* appears to have been inspired by the subject matter of Kamal al-Mulk's *The Fortune Teller* (Sad-abad Museum, Tehran), its somewhat flat and two-dimensional approach to space and perspective, as well as its playful humor and satirical note, is not commonly associated with the master's signed paintings. It could thus be either an unsigned early painting by Kamal al-Mulk or a work by a painter

FIG. XXXIII.
Alchemist and Clients.
Muhammad Ghaffari, Kamal al-Mulk, or atelier. Iran, circa 1900. Oil on canvas.
MALIK LIBRARY, TEHRAN.

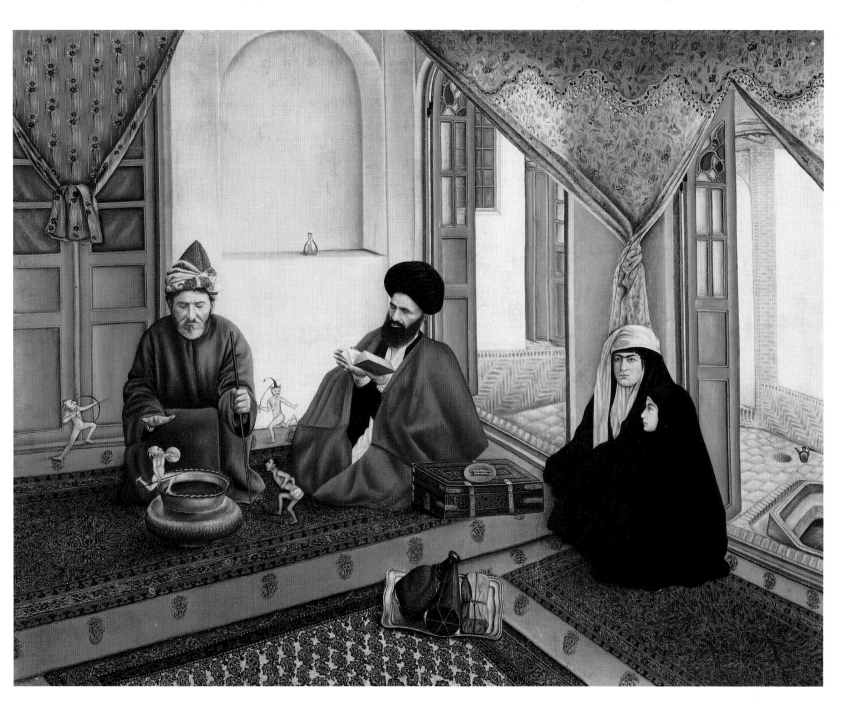

in his circle. Stylistic parallels with an unsigned painting of an alchemist's workshop attributed to Kamal al-Mulk (FIG. XXXIII) can also be seen in the artist's handling of architectural interiors, approach to perspective, and rendering of objects such as bottles and trays.

ME

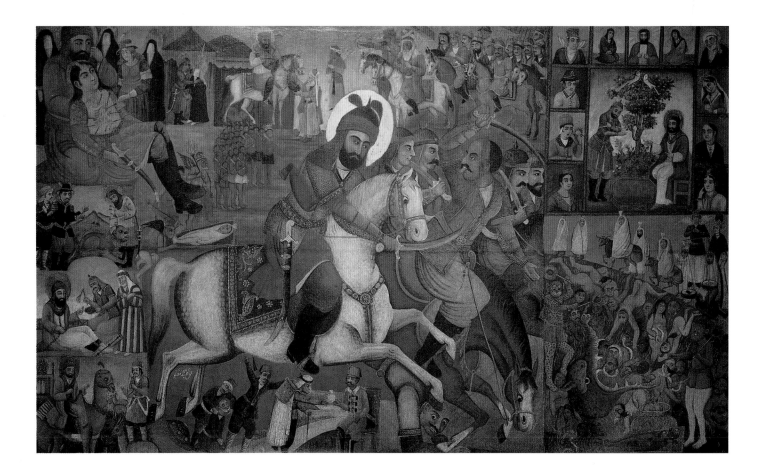

-94-
Battle of Karbala

'Abbas al-Musavi
Isfahan, late 19th–early 20th century
Oil on canvas; 72 x 118 inches (182.9 x 299.7 cm)
COLLECTION OF K. THOMAS ELGHANAYAN

Religious paintings such as NOS. 94 and 95 exemplify the continuity and vitality of the tradition of monumental painting as it was reinterpreted for a popular audience during the late nineteenth and early twentieth centuries. These narrative paintings belong to a group commonly referred to as *qahvehkhāneh,* or "coffeehouse" paintings.

The subject represented lies at the heart of Shi'ite belief. The Karbala tragedy commemorates the martyrdom of Imam Husayn[8] at the hands of the Sunni caliph Yazid in the Karbala desert (seventy miles from Kufa in present-day Iraq) on the tenth of the month of Muharram, A.H. 61 (October 10, A.D. 680). The reenactment of Husayn's martyrdom at Karbala provided the impetus for the emergence of the *tàzīeh,* the indigenous drama of Iran. Recent scholarship has firmly established the binding relationship between *tàzīeh* performances and Karbala narrative painting.[9] These canvases can thus be viewed as visual analogues to the *tàzīeh* theatrical performances, used as *pardeh*s (curtains, or portable paintings used as backdrops) to recitations of the Karbala tragedy. The *pardehdār* (reciter) would nail the painting on a wall of a given building, whether a caravanserai, a *takīeh* (structure built for *tàzīeh* performances), or a local coffeehouse, and point to each relevant event as he told the story of Husayn's martyrdom.

As in most Karbala narrative paintings, these works depict individual episodes from the battle of Karbala, as well as scenes from the life of Imam Husayn (FIG. XXXIV). The episodes are arranged from left to right somewhat haphazardly, in a composition with little logical progression. The focal point of the narrative is a scene in which 'Abbas (Husayn's half brother and standard bearer), mounted on a white horse, brutally stabs one of the members of Yazid's army. The wounded

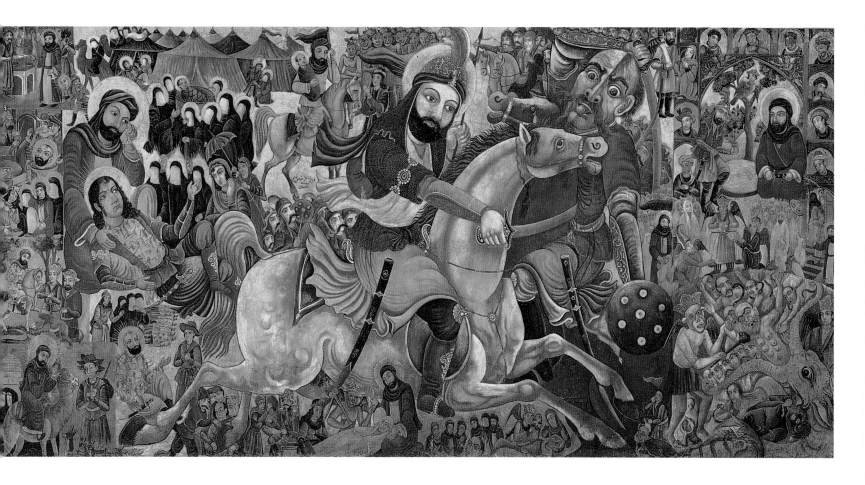

-95-
Battle of Karbala
'Abdallah Musavvar (d. 1931)
Isfahan, late 19th–early 20th century
Oil on canvas; 67½ x 114 inches (171.5 x 289.6 cm)
COLLECTION OF LEILA TAGHINIA-MILANI HELLER

FIG. XXXIV.
Iranian Pardehdār,
outside Masjid-i
Jum'eh Zavareh.

party is depicted as an ugly thug, whose phallic-shaped tongue protrudes from his open mouth. On the right, images of the underworld are portrayed below corresponding images of paradise. Husayn and his followers are represented in the paradise scenes, while the supporters of Yazid are included in the images of hell. The scenes depicting the underworld feature a grotesque representation of Husayn's murderer emerging from the mouth of an octopus-like creature. The conflict of dualities and the triumph of good over evil or justice over tyranny constitute the underlying message of the two paintings.

The other episodes of the tragedy vary slightly in the two canvases. The upper left corner of each canvas represents Husayn riding in front of the women's encampment, bidding farewell while holding the thirsty infant 'Ali Asghar in his right arm. In NO. 94 Husayn is portrayed below, comforting the wounded Qasim (son of his elder brother). The martyrdom of 'Ali Akbar (Husayn's eldest and favorite

Detail of inscription at upper right, NO. 95

son) is depicted at the bottom, while in NO. 95 this scene is represented in the upper left-hand corner. All these scenes express the agonies suffered by Husayn and his followers during the course of the battle as they were cut off from water and died. The emotional power of the drama depicted lies in the audience's involvement with the events they witness.

There are distinct stylistic variations among Karbala narrative paintings. With its minute details and extensive use of metallic embellishings in the haloes and details of costume,[10] NO. 95, by the early twentieth-century Isfahan painter 'Abdallah Musavvar, is decoratively appealing and jewel-like. The two-dimensional quality, which echoes manuscript illustrations of earlier periods, and the complete absence of emotion or suggestion of the harsh realities of the gory battle contribute to its decorative effect. This lavish canvas was probably commissioned by a wealthy patron, perhaps a merchant, who was able to afford such luxurious materials.

In contrast, NO. 94 is a particularly expressive and emotionally charged example of this popular genre. It contains two important inscriptions: the name of the patron and city of production (Darvish 'Abbas Uvaysī, Isfahan), as well as the name of the artist ('Abbas al-Mūsavī), who also worked in the early twentieth century.[11] This compelling image is distinctive for its narrative immediacy and raging emotions, tensions, somewhat unrefined approach, successful attempts at modeling in the folds of the garments and musculature of the horse, and vibrant colors. The artist's rendition of the gory details of the battle, as well as the exaggerated vulgarity of the enemy and his men, was designed to elicit an emotional response from the audience.

ME

Literature: (NO. 94) *Islamic Works of Art*, sale cat., Hapsburg Feldman, June 19, 1990, lot 61. (NO. 95) Chelkowski 1989, 100, fig. 2; *Fine Islamic, Persian and Indian Works of Art*, sale cat., Hapsburg Feldman, October 25, 1989, 36, lot 66.
Provenance: (NO. 95) Collection of Firaydun Hoveyda.
Inscriptions:
(NO. 94) In *nastáliq* script, bottom left corner: *'Abbās al-Mūsavī*; in center of painting: *Farmāyish-i Darvīsh 'Abbās Uvaysī, Isfahān*
(NO. 95) In *nastáliq* script, under horse's hind legs: *'amal-i 'Abdallah Muṣavvar*

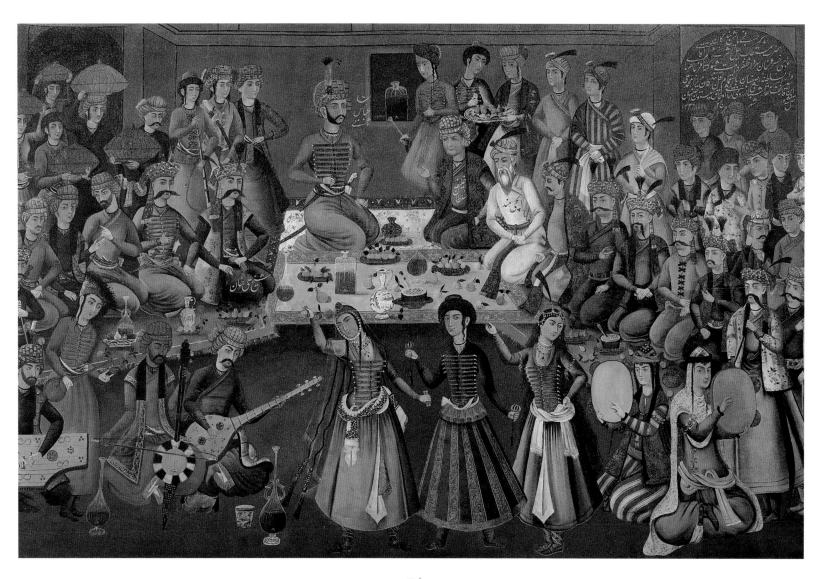

-96-

Shah 'Abbas II and the Indian Ambassador

Signed by Muhammad 'Ali ibn Najaf 'Ali
Isfahan, dated A.H. 1330/A.D. 1911–13
Oil on canvas; 59½ x 92½ inches (151 x 235 cm)
COLLECTION OF K. THOMAS ELGHANAYAN

In the nineteenth century, the celebrated mural paintings of the Safavid period of the Chihil Sutun palace in Isfahan (FIG. XXXV) came to embody the glory of Persian civilization for both Iranians and foreigners, and were frequently replicated in both large and small formats.[12] Some of the finest examples, such as this one, were executed by Muhammad 'Ali (active early twentieth century), a younger son of the renowned lacquer painter Najaf 'Ali.[13] This version, one of a series of life-size replicas of the four principal paintings of the audience hall executed by the artist, is distinguished by its monumental scale and fidelity to the original (although decorative patterning is considerably reduced in comparison with its model). The variety of the blue-and-white ceramics depicted here appears to be a hallmark of the artist.

A lengthy inscription in the upper right-hand corner provides the date of the work and the names of the artist and patron. Commissioned from Muhammad 'Ali by Haji Khusraw Khan, an Isfahani official or military commander, the work was possibly intended, along with the other replicas, for a government residence. Further, stylistic features (such as the dark tonality, flat background treatment, and elongated figural proportions) and the artist's period of activity support the early twentieth-century dating given by the inscription.

FIG. XXXV. *Shah 'Abbas II and Nadr Muhammad Khan, Ambassador of Turkestan.*
Artist unknown. Isfahan, 1647. Wall painting.
CHIHIL SUTUN PALACE, ISFAHAN.

During the second decade of the twentieth century, Iran was divided into spheres of influence by the British and Russian powers. The painting and its accompanying dedicatory inscription exemplify the continued patronage of revival-style history painting by Iranians and eloquently illustrate the resonance of Persian cultural ideals even during Iran's darkest hours.

LSD

Literature: *The Carimati Collection of Persian Art*, sale cat., Sotheby's, New York, January 28, 1943, lot 217.
Inscriptions: In cream *nastáliq* script, upper right corner: *bar ḥasb-i farmāyish-i bandigān haẓrat-i mustaṭāb-i ajal-i ashraf-i 'ālam, Āqā-yi Ḥājī Khusraw Khān Sardār-i Zafar, dāmat shawkatahū farmānfarmā-yi dār al-Salṭaneh-i Iṣfahān bih itmām-i aqal-i bandigān Mīrzā Muḥammad 'Alī ibn Āqā Najaf Naqqāshbāshī az rūy-i naqqāshī-yi utāq-i Chihil Sutūn, Iṣfahān naql shudeh shahr Jamādī al-Sānī 1330*; identifying figures within the composition: *Shaykh 'Alī Khān Shāh 'Abbās-i Sānī, Īlchī-i Hind Khalīfeh Sulṭān.*

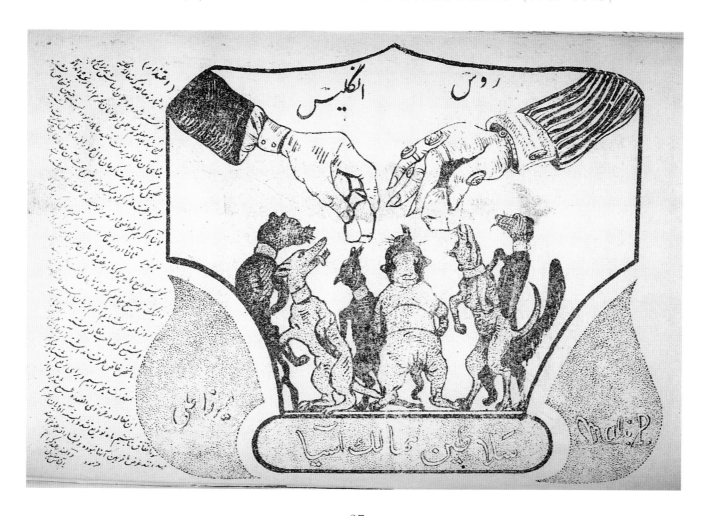

-97-

Asian Rulers Represented as Dogs Being Fed Scraps by the Imperial Powers, Great Britain and Russia

Mirza 'Ali
From the newspaper *Kashkūl* (Tehran), no. 29 (1907)
Lithograph; 9¹/₂ x 6¹⁵/₁₆ inches (24.1 x 17.6 cm)
PRINCETON UNIVERSITY LIBRARY, NEAR EAST COLLECTION, PRINCETON, NEW JERSEY

This cartoon from the gazette *Kashkūl* illustrates how the art of caricature and cartoon created a new set of symbols and opened new avenues for visual expression during the Constitutional period in Iran.[14] At this time, satirical images were used to convey a wide variety of controversial political messages. Bridging the gap between literate and illiterate culture, these artistically simple and unsophisticated images expressed the anxieties engendered by despotic rule, the dogmatism of the *'ulamā* (religious authorities), women's-rights initiatives, and foreign domination. Although satire had a long history in Iran predating such gazettes, the Iranian Constitutional press found its models in the Turkish, Egyptian, and Western European (particularly French and English) press. In contrast to the refined and aesthetically appealing portraits of Abu'l Hasan Ghaffari and Kamal al-Mulk, this image emphasizes message, function, and immediacy. Such illustrations were often accompanied by narrative captions, but here the caption bears little relation to the text that it accompanies; it is, rather, an apologetic response to a political announcement in the previous issue. The image communicates the vehement reaction on the part of nationalistic Iranians to European imperialism and foreign hegemony. In such illustrations, Western conventions were effectively used to convey anti-Western sentiments.

ME

Inscriptions: In *nastáliq* script as well as in Latin script on either side of image: *Mirza 'Ali*; under image of dogs: *Salaṭīn-i mamālik-i Asīa*; above two hands: *Rūs, Ingilis*

1. See Ekhtiar essay in this publication; Emami 1987; *Maktab-i Kamāl al-Mulk* (Tehran, 1986) (with English summary).

2. Sani' Humayun, who descended from a prominent family of painters from Isfahan, is better known for his works on lacquer and watercolor than his oil paintings. See Karimzadeh Tabrizi 1985–91, vol. 1, p. 320.

3. Parviz Afshari, *Ṣadr 'Aẓamha-yi Dawreh-i Qājārieh* (Tehran, 1993), 265–73.

4. Taj al-Saltaneh was the daughter of Nasir al-Din Shah and Turan al-Saltaneh, a Qajar princess.

5. For a translation of her autobiography, see Taj al-Saltaneh 1993.

6. Ibid., 94.

7. The most recent biographical study of the artist is Suhayli Khwansari 1989.

8. Husayn was the grandson of the Prophet Muhammad and son of 'Ali, the first Shi'ite imam.

9. See Chelkowski 1989; and Samuel R. Peterson, "The Ta'ziyeh and Related Arts," in Chelkowski 1979, 74–84.

10. The Andrew W. Mellon Curatorial-Conservation study confirmed that metallic embellishings were also used in the painting by 'Abbas al-Musavi but more subtly than in the painting by 'Abdallah Musavvar. Metal powder is sometimes blended in with other pigments to produce a shimmer and to add texture, enhancing foliage patterns or defining each link in the mail of the battle costume.

11. At least two other canvases by this Isfahan-based artist are known: one in the Riza 'Abbasi Museum in Tehran and another now in a private collection. See Hadi Sayf, *Naqqāshī-yi Qahvehkhāneh (Coffeehouse Painting)* (Tehran, 1990), fig. 65. The second was confirmed by Peter Chelkowski through oral communication.

12. Texier 1842, vol. 2, p. 129, and Holtzer 1975, 55–56. See Eleanor Sims, "The 17th Century Safavid Sources for Qajar Painting," in *Islam in the Balkans, Qajar Art and Culture* (Edinburgh, 1979), 102, n. 12, for other versions of the work. The lack of explanatory inscriptions in the Chihil Sutun paintings has led to considerable debate regarding the themes and identification of personages depicted. Here we have retained the identification of the subject proposed by Sussan Babaie (Babaie 1994, 140, n. 4) but have selected a more general title for the 1911–12 copy that reflects the later painting's epigraphic information.

13. See Karimzadeh Tabrizi 1985–91, vol. 2, pp. 915–16, for his works.

14. For a discussion of the Iranian Constitutional press, see Afary 1996, "Journalism, Satire and Revolution: Exposing the Conservative Clerics, Denouncing the Western Powers," 116–45, and Shiva Balaghi, "Political Culture in the Iranian Revolution of 1906 and the Cartoons of *Kashkūl*," in *Political Cartoons: Cultural Representation in the Middle East*, ed. by Fatma Muge Göçek (Princeton, 1998), 51–73. For a detailed discussion of cartoons in the Ottoman revolutionary press with parallels in the Iranian context, see Palmira Brummett, "Dogs, Women, Cholera, and Other Menaces in the Streets: Cartoon Satire in the Ottoman Revolutionary Press, 1908–11," *International Journal of Middle East Studies* 27 (1995): 433–60.

APPENDIX

MATERIALS OF A GROUP OF PERSIAN PAINTINGS

As part of an ongoing series of joint Curatorial and Conservation research projects at the Brooklyn Museum of Art endowed by The Andrew W. Mellon Foundation, a one-year study of the materials and methods used in painting during the Qajar dynasty was carried out. The purpose of the study was to obtain information through individual analyses and through comparison with paintings of earlier Persian tradition. The study included thirty paintings dating from the Safavid through the late Qajar period. The technical examination was carried out in the conservation laboratory using standard laboratory equipment such as the stereo-binocular microscope, ultra-violet illumination, infrared photography, infrared color photography, infrared reflectography, x-radiography, polarized light microscopy with ultraviolet light examination capabilities, and microchemical testing. Selected for further study of paint media and pigment identification, cross-section samples were taken from nine paintings, six of which are included in the exhibition *Royal Persian Paintings: The Qajar Epoch 1785–1925*. Samples were analyzed by Richard Newman of the Department of Objects Conservation and Scientific Research, Museum of Fine Arts, Boston, using gas-chromatography-mass-spectroscopy (GC/MS), Fourier-transform infrared microspectroscopy (FTIR), and electron-beam microprobe with energy dispersive x-ray fluorescence (EPMA). Initial findings of this preliminary study are summarized in the following chart, which was compiled by Nadia S. Ghannam, Richard Kowall, and Carolyn Tomkiewicz.

ARTIST/PAINTING	*Attendants at an Outdoor Feast,* attributed to Muhammad Zaman or his atelier (NO. 16)	*A Lady with a Rose,* artist unknown (NO. 18)	*Hunter on Horseback Attacked by a Lion,* artist unknown (NO. 29f)
DATE	Probably Isfahan, circa 1650–1722	Isfahan, 1704–22	Shiraz, mid-18th century
SUPPORT/NO. OF PIECES OF FABRIC	Plaster substrate: contains fine-grained calcium carbonate with larger angular calcium carbonate inclusions.	Finely woven plain-weave cotton. Thread count: approx. 42 x 46/in². One piece of fabric.	Finely woven plain-weave cotton, arched format. Thread approx. 44 x 50/in². Two pieces of fabric stitched toge
UNDERDRAWING	None apparent.	None apparent.	None apparent.
GROUND	Plaster substrate.	Red ochre mixed with a small amount of lead white. Among the larger grains are quartz and calcium carbonate and clumps that are rich in iron (iron oxide red, probably hematite). Medium: oil.[3] A thin but not usually continuous light brown layer containing lead white with some earth pigments and black particles observed directly over red ground. May be imprimatura layer that was unevenly applied.	Red earth containing kaolinite, quartz, iron oxide, and c carbonate. Medium: plant gum.[10] A layer of unpigmented medium, which appears to be a oil, is present just above the ground layer.[11]
BLUE	(Blue sky) smalt and lead white.[1]	(In dress) smalt. (In background) Prussian blue.[4]	(Blue sky) lead white and Prussian blue.
GREEN	(Green foliage) copper green that is possibly a copper resinate.	(Green glaze in border of jacket) green medium-rich layer containing copper.[5] (Green curtain in background) medium-rich layer tinted by a copper resinate type material. Also, mixture of Prussian blue and yellow ochre.[6] (Gray-green in background) copper resinate type material and numerous particles of smalt. Also Prussian blue, bone black, and scattered red and yellow ochre pigments.	(Green foliage) lead white, earth pigment, some orpime Prussian blue, and yellow ochre.
RED	(Dark brown layer in sample from green foliage) iron-oxide red detected as a probable component. (Yellow-brown layer) red lead detected as a component in the sample. Other red pigments not identified.	(Highlight layer in sample from balustrade) vermilion and red ochre. (Red glaze in crown) medium rich layer with lead white and vermilion. (Red in crown) vermilion, lead white, and some iron oxide red.	(Red in cuff of sleeve) vermilion.
YELLOW/OCHRE	(Dark brown layer in sample from green foliage) yellow ochre detected as a component.	(Pale mustard yellow layer in sample from balustrade) lead white, silica, and yellow ochre.	(Ochre color in lion's tail) orpiment, some lead white, some yellow ochre, some calcium carbonate and gypsum
BLACK/GRAY	(Gray layer in sample from green foliage) angular black particles (probably charcoal) detected as a component.	(Black layer in sample from border of jacket) carbon black. (Black feather in crown) Layer mainly consists of smalt.[7] (Gray layer in gray-green background) lead white, calcium carbonate (calcite), and smalt. (Gray layer in green curtain) bone black, brown earth or umber, and lead white.	Pigments not analyzed.
BROWN	(Dark brown layer in green foliage sample) brown umber and brown earth detected as probable components.	(Dark brown layer in sample from balustrade) lead white and brown earth or umber. (Brown layer from sample of background) lead white, some ochre, and bone black.	Pigments not analyzed.
WHITE	(Dark brown layer in green foliage sample) calcium carbonate, calcium sulfate, and minor quantities of lead white detected as components.	(White in jacket) lead white with scattered angular black particles (not identified). Lead white and calcium carbonate identified as components in many samples.	Lead white and calcium carbonate identified as compone many samples.
METAL LEAF	Traces of metal leaf are present on the waistband and crown of the male figure with overlying red and green glazes. The composition of the metal leaf and glazes was not identified.	(Gold in crown) gold leaf (single layer) over a medium-rich layer.[8] A subsequent medium-rich layer above the gold leaf contains traces of ochre, and a varnish or glaze above that contains particles of lead white and vermilion.	(Red glaze over metal leaf in shirt button) metal and gl not analyzed. (Green glaze over metal leaf in saddle) metal and glazes analyzed.[12]
BINDING MEDIA	Linseed oil, not heat-bodied.[2]	Linseed oil, which was not substantially heat-bodied, with traces of a conifer resin.[9]	Partially heat-bodied linseed oil.[13] Layers of unpigment medium containing drying oil are found above the grou and in between some of the paint layers.[14]
NOTES	1. EPMA. 2. FTIR spectra of isolated paint layers suggest the binder is linseed oil. Traces of methyldehydroabiete (oxidation product of conifer resins) as well as straight chain hydrocarbons (typical of waxes as paraffin or ceresin) detected at low levels may be contaminants.	3. FTIR analysis suggests that the binding medium is oil. GC/MS confirms linseed oil, not substantially heat-bodied. 4. Prussian blue was not available until after 1704. R. Gettens and G. Stout, *Painting Materials* (New York, 1966.) 5. A scraping of this layer contained very few discernible pigment particles, mostly consisting of isotropic pale greenish material. The FTIR spectrum of this scraping more closely resembles reference spectra of verdigris than copper resinate. The conclusion is that the layer contains copper salts apparently dissolved in an oil-containing medium, but the exact nature of the salts is not certain. 6. See n. 4 above. 7. The layer contains no pigment in detectable amounts besides smalt. The layer appears very dark in cross section. Perhaps the appearance is owing to the discoloration of the medium or deterioration of the smalt. 8. EPMA. 9. GC/MS analyses.	10. Staining tests gave positive results for both lipid and carbohydrate in th The FTIR spectrum indicated that the binder is a plant gum to which a sm amount of oil may have been added. GC/MS analysis of a sample of groun a low level of drying oil. It is also possible that a small amount of drying oi may have penetrated the ground from the overlying layer. 11. This unpigmented layer has a strong UV fluorescence and may be an is layer. Its FTIR spectrum closely matches that of a drying oil. 12. Metal leaf is estimated to be gold leaf based upon its appearance in cro 13. The FTIR analysis suggests that the binding medium of the paint layer 14. Although these layers may have been applied as isolating layers, their e purpose has not been defined (see n. 20).

Khusraw Discovers Shirin Bathing, artist unknown (NO. 29d)	Fath 'Ali Shah Seated, attributed to Mirza Baba and an anonymous painter (NO. 37)	Female Musician with a Drum, artist unknown — NEWARK MUSEUM, GIFT OF THE JAENE COLLECTION, PE41.1237
Shiraz, mid-18th century	Tehran, circa 1798	Iran, early 19th century
Finely woven plain-weave cotton; arched format. Thread count: approx. 42 x 42/in². Two pieces of fabric stitched together.	Finely woven plain-weave cotton; arched format. Thread count: approx. 60 x 56/in². Three pieces of fabric stitched together, plus two added spandrels (not original).	Finely woven plain-weave cotton, arched format. Thread count: approx. 41 x39/in². Two pieces of fabric stitched together.[29] Dimensions: 53 1/4 x 24 1/2 in.
None apparent.	An underdrawing is not readily apparent; X-ray examination reveals compositional changes.[21]	Infrared light photography reveals a black dry-stick sketch.
Red earth containing kaolinite, quartz, iron oxide, and calcium carbonate. Medium: plant gum.[15] A layer of unpigmented medium is present just above the ground layer, which appears to be a drying oil.[16]	Red earth with scattered calcite grains, gypsum, silicate, and some large quartz grains. Medium: linseed oil, not heat-bodied, with traces of conifer resin.[22] Creamy white ground in added spandrels contains calcium carbonate with little lead white present. Medium: most likely not an oil.[23]	Single white layer containing lead white and calcium carbonate (calcite). Medium: oil.[30]
(Blue layer in sample from water) Prussian blue, lead white, and calcium carbonate.	(Blue background) Prussian blue, lead white, calcite grains, and orpiment.[24]	(Blue background) Prussian blue and lead white. (Blue in jacket) Prussian blue.
(Greenish-gray layer in sample from saddle) Prussian blue, yellow ochre, lead white, calcium carbonate, and silicate minerals.	(Green glaze over gold in crown) medium-rich layer with copper containing pigment and lead white.[25]	(Light green in skirt) Prussian blue, lead chromate yellow, and lead white.
(Red in Shirin's skirt) vermilion. Isolated particles of red lake found in some samples.	(Red in crown) vermilion, with some lead white, calcite, and red ochre.	(Red flower) vermilion. (Red glaze) red lake.[31]
(Orange in robe of female attendant) principal pigment found is orpiment. Yellow ochre pigment identified as a component in some samples.	(Blue background) orpiment[26] and yellow ochre.	(Pear) lead chromate yellow, orpiment, and lead white.[32]
Small black particles found as components in some samples were not identified.	Pigments not analyzed.	(Black hair) carbon black, lead white, and calcium carbonate.
Pigments not analyzed.	Pigments not analyzed.	Pigments not analyzed.
Lead white and calcium carbonate identified as components in many samples.	Lead white, calcite, and a silicate material identified as components in many samples.	(White beading on arm) lead white and calcium carbonate. (Flesh color on face) lead white, calcium carbonate, red ochre, vermilion, and black.[33] Lead white and calcium carbonate identified as components in many samples.
(Red glaze over metal leaf in crown) metal and glazes not analyzed. (Green glaze over metal leaf in crown) metal and glazes not analyzed.[17]	(Metal leaf in crown) single layer of gold leaf over a medium-rich layer.[27]	(Gold on skirt, various samples) brass leaf, 1–2 layers on top of a medium-rich layer with no more than a very minor inorganic component.[34]
Partially heat-bodied linseed oil and linseed oil that was not heat-bodied.[18] Drying oil may include a wax component.[19] Layers of unpigmented medium containing drying oil are found above the ground layer and in between some of the paint layers.[20]	Linseed oil that is not heat-bodied, with traces of conifer resin (possibly pine).[28]	Linseed oil that has been heat-bodied.[35]

FIGS. a,b. Photomicrographs of paint cross sections from an area of blue water in the background of *Khusraw Discovers Shirin Bathing* (NO. 29d) photographed in reflected light (a) and ultraviolet light (b), under the microscope at 100x magnification. Each photomicrograph shows: 1) red ground; 2) layer of medium; 3) light blue paint layer; 4) varnish layer or layers; 5) green paint layer (not original); 6) varnish layer or layers.

15. Staining tests gave positive results for both lipid and carbohydrate in this layer. The FTIR spectrum indicated that the binder is a plant gum to which a small amount of oil may have been added. GC/MS analysis of a sample of ground indicated a low level of drying oil. It is also possible that a small amount of drying oil medium may have penetrated the ground from the overlying layer. (see figs. a, b)
16. This unpigmented layer has a strong UV fluorescence and may be an isolating layer. Its FTIR spectrum closely matches that of a drying oil.
17. Metal leaf is estimated to be gold leaf based upon its appearance in cross section.
18. FTIR analysis.
19. The FTIR analysis suggests that the binding medium of the paint layers is oil.
20. Although these layers may have been applied as isolating layers, their exact purpose has not been defined. (see figs. a, b)

21. Headdress formerly a shorter, wrapped turban.
22. FTIR and GC/MS analyses.
23. Appearance of calcium carbonate would be translucent in an oil medium.
24. Pigments identified were found in paint layer beneath restoration.
25. Probably copper salts; FTIR spectrum most closely resembles that of verdigris but no distinct particles were detected under polarized light.
26. Polarized light microscopy.
27. EPMA.
28. FTIR and GC/MS analyses.

29. Fragments of wall plaster, identified by micro-chemical spot tests as gypsum (plaster of Paris), were found on the verso attached to residues of adhesive. It appears that an adhesive material applied by hand or spatula was used to attach the painting directly to a wall. Similar fragments of adhesive and gypsum were found on the backs of NOS. 29a–c, e, g.
30. FTIR spectrum similar to what would be expected for an old lead white/oil film.
31. Although the layer is mainly organic in nature, low levels of several elements were detected by microprobe analysis.
32. EPMA and FTIR analyses.
33. Morphologically angular black particles could be charcoal or bone black.
34. EPMA.
35. GC/MS and FTIR analyses.

ARTIST/PAINTING	*Dancing Girl,* artist unknown COLLECTION OF BARBARA COOPER FENDRICK, WASHINGTON, D.C.	*A Royal Encampment,* Muhammad Ghaffari or his circle PRIVATE COLLECTION	*Battle of Karbala,* 'Abdallah Musavvvar (NO. 95)
DATE	Iran, circa 1840	Iran, A.H. 1299/A.D. 1881	Isfahan, late 19th–early 20th century
SUPPORT/NO. OF PIECES OF FABRIC	Finely woven, plain-weave cotton. Thread count: approx. 58 x 64/in². One piece of fabric. Dimensions: 57¼ x 33¾ in.	Finely woven, plain weave cotton. Thread count: approx. 64 x 52/in². 1 piece of fabric. Dimensions: 25 x 38 in.	Finely woven, plain-weave cotton. Thread count: approx. 56 x 70/in². One piece of fabric.[45] Dimensions: 66¼ x 132 in.
UNDERDRAWING	Infrared-light photography reveals a brush-applied black underdrawing and compositional changes.[36]	None apparent.	A black dry-stick applied underdrawing is visible on top of the ground layer in some areas of paint loss. Minor compositional changes are visible using an infrared vidicon camera.
GROUND	Light brown, contains calcium carbonate.[37]	Translucent amber-colored ground contains gypsum. Medium: Heat-bodied walnut oil with the addition of some non-drying oil or fat.[43]	Single off-white layer containing barium sulfate white, zinc white, and a small amount of yellow ochre. Medium: oil.[46]
BLUE	(Blue in skirt) Prussian blue and lead white. (Blue layer in sample from crown) Prussian blue and lead white.[38]	(Blue water) Prussian blue, lead white, and barium sulfate white.	(Blue in small figure) Prussian blue, barium sulfate white, and lead chromate yellow. (Light blue in background) Prussian blue, barium sulfate white, some zinc white and angular black particles (possibly charcoal).[47]
GREEN	(Green glaze on crown) verdigris or copper resinate. (Green curtain) Prussian blue, yellow earth, and barium sulfate white.[39]	(Green foliage) Prussian blue, yellow ochre, lead white, barium sulfate white, and gypsum. (Yellow-green foliage) lead chromate yellow and Prussian blue.	(Light green turban) Prussian blue, lead chromate yellow and barium sulfate white.[48]
RED	(Red in jacket) vermilion and an organic-rich layer containing red lake and lead white. (Red layer in crown) red ochre, yellow ochre, and calcium carbonate.[40] (Red glaze layer in crown sample) red ochre, yellow ochre, vermilion, and red lake.	Small pigments resembling iron-oxide red and red ochre identified as minor components in some samples.	(Red in crown of a small figure and red blood from head of main figure) barium sulfate white, silica (probably quartz), and an organic red pigment.[49]
YELLOW/OCHRE	(Green curtain) yellow ochre in the form of yellow hydrated iron oxide.[41]	(Yellow-green foliage) lead chromate yellow. (Green foliage) yellow ochre.	Lead chromate yellow and yellow ochre in the form of yellow iron oxide were identified as components in many samples.
BLACK/GRAY	(Gray sky) layer contains angular black particles that are probably charcoal black, lead white, and earth pigments.	Small angular black particles, either charcoal or bone black identified as components in many samples.	Pigments not analyzed.
BROWN	(Brown in corner of table) brown earth, red earth, and lead white.	Pigments not analyzed.	Pigments not analyzed.
WHITE	Lead white and barium sulphate white identified as components in many samples.	(White in background) lead white with scattered inclusions of calcium sulfate, and calcium silicate. Kaolinite, lead white, gypsum, and barium sulfate white identified as components in many samples.	Barium sulfate white and zinc white were identified as components in many samples; (red blood from head of main figure) calcium carbonate and calcium sulfate identified.
METAL LEAF	None present.	None present.	(Metallic color in armor of slain figure) aluminum leaf (as many as 15 layers) in a layer of tinted medium.[50] Metallic powder (composition not analyzed) was used to delineate the links of mail on top of the aluminum leaf and in other selected areas.
BINDING MEDIA	Linseed oil that has not been heat-bodied. Oil and protein present in a sample of red paint from the crown and from a tan-colored layer in a sample taken from the blue skirt.[42]	Linseed oil, perhaps partially heat-bodied with the addition of some non-drying oil or fat.[44]	Linseed oil that has been somewhat heat-bodied. A second sample indicated the presence of both linseed and walnut oil. Traces of a conifer resin were also detected.[51]
NOTES	36. A drawing for a "necklace" or chiffon voile clasp is visible under infrared reflectography that was not painted in the finished version. Changes to the shape of a column in the background are also visible. 37. Fragmentary medium-rich layer, appearing brownish and containing a little calcium carbonate, was found at the bottom of many cross sections. 38. FTIR analysis. 39. FTIR analysis. 40. FTIR analysis. Medium in this red layer contains both oil and protein component. 41. Remnants of a yellow pigment found outlining the transparent voile resemble orpiment. Analysis not carried out. 42. FTIR and GC/MS analysis.	43. FTIR and GC/MS analyses. 44. FTIR and GC/MS analyses.	45. Holes found along the top of the canvas may be evidence of the attachment of the canvas to a type of auxiliary support. 46. FTIR analysis. 47. FTIR analysis. 48. A scraping of the yellow-green layer contained white particles, irregularly distributed, fine-grained yellow particles, and some patches of blue stain-like material, appearing nearly green at times because of the associated yellow pigment. FTIR analysis of the blue and greenish regions of the samples showed barium sulfate white, lead chromate yellow and Prussian blue. 49. The red in these samples is an organic pigment that could not be specifically identified. 50. Metal leaf identified with EPMA. The medium seems to contain no inorganic pigments, and it is not certain whether it was intentionally tinted. 51. FTIR and GC/MS analyses.

BIBLIOGRAPHY

ABU'L HASAN KHAN 1988
Mirza Abu'l Hasan Khan. *A Persian at the Court of King George 1809–1810: The Journal of Mirza Abu'l Hasan Khan*. Edited and translated by Margaret Cloake. London, 1988.

ADAMIYAT 1969
Adamiyat, Firaydun. *Amir Kabir va Īrān*. Tehran, 1969.

ADAMOVA 1996
Adamova, Ada T. *Persian Painting and Drawing of the 15th–19th Centuries from the Hermitage Museum*. Saint Petersburg, 1996.

ADLE 1996
Adle, Chahryar. "Découverte et identification des peintures à l'huile du Palais des Sardar à Erivan, Arménie." In *Archéologie et arts du monde iranien, de l'Inde musulmane et du Caucase d'après quelques recherches récentes de terrain, 1984–1995*. Paris, 1996.

ADLE AND ZUKA 1983
Adle, Chahryar, and Yahya Zuka. "Notes et Documents sur la photographie Iranienne et son histoire: Les Premiers Daguerreotypistes." *Studia Iranica* 12 (1983): 249–80.

AFARY 1996
Afary, Janet. *The Iranian Constitutional Revolution 1906–1911: Grassroots Democracy, Social Democracy and the Origins of Feminism*. New York, 1996.

AFSHAR 1970
Afshar, Mustafa Baha al-Mulk. *Safarnāmeh-i Khusraw Mirzā bih St. Petersburg*. Manuscript circa 1829. Edited by Muhammad Gulbun, Tehran, 1970.

AFSHAR 1983
Afshar, Iraj. "Some Remarks on the Early History of Photography in Iran." In Bosworth and Hillenbrand 1983.

AFSHAR 1992
Afshar, Iraj. *Ganjineh-i 'Akshā-yi Īrān*. Tehran, 1992.

AFZAL AL-MULK 1982
Afzal al-Mulk, Ghulam Husayn Khan. *Afzal al-Tavārikh*. Edited by Mansureh Ittihadieh and Cyrus Sa'dvandian. Tehran, 1982.

ALGAR 1969
Algar, Hamid. *Religion and State in Iran, 1785–1906: The Role of the Ulama in the Qajar Period*. Berkeley and Los Angeles, 1969.

AMANAT 1993
Amanat, Abbas. "Russian Intrusion into the Guarded Domain." *Journal of the American Oriental Society* 113 (1993): 35–56.

AMANAT 1997
Amanat, Abbas. *Pivot of the Universe: Nasir al-Din Shah Qajar and the Iranian Monarchy, 1831–1896*. Berkeley and Los Angeles, and London, 1997.

AMIRANASHVILI 1940
Amiranashvili, Sh. *Iranskaya stankovaya zhivopis* (Iranian oil painting). Tbilisi, 1940.

ANSARI 1986
Ansari, Faramarz, M. "Die Malerei der Qajaren (1796–1925)." Ph.D. dissertation, Universität Tübingen, 1986.

ARNOLD 1928
Arnold, Thomas, *Painting in Islam*. Oxford, 1928.

ATABAY 1976
Atabay, Badry. *Fihrist-i Dīvānhā-yi Khaṭṭī va Kitāb-i Hizār u Yik Shab-i Kitābkhāneh-i Salṭanatī*. Tehran, 1976.

ATKIN 1980
Atkin, Muriel. *Russia and Iran, 1780–1828*. Minneapolis, 1980.

AVERY, HAMBLY, AND MELVILLE 1991
Avery, Peter, Gavin Hambly, and Charles Melville, eds. *The Cambridge History of Iran*, vol. 7. Cambridge, 1991.

AZUD AL-DAWLEH 1976
Azud al-Dawleh. *Tārīkh-i 'Azudī*. 1888. Reprint, edited by 'Abd al-Husayn Nava'i, Tehran, 1976.

BABAIE 1994
Babaie, Sussan. "Shah 'Abbas II, the Conquest of Qandahar, the Chihil Sutun, and Its Wall Paintings." *Muqarnas* 11 (1994): 125–42.

BALSIGER AND KLÄY 1992
Balsiger, Roger N., and Ernst J. Kläy. *Bei Schah, Emir und Khan: Henri Moser Charlottenfels (1844–1923)*. Schaffhausen, 1992.

BAMDAD 1968–74
Bamdad, Mihdi. *Sharḥ-i Ḥāl-i Rijāl-i Īrān dar Qarn-i 12, 13, 14 Hijri*. 6 vols. Tehran, 1968–74.

BELTING 1994
Belting, Hans. *Likeness and Presence: A History of the Image before the Era of Art*. Chicago and London, 1994.

BENJAMIN 1887
Benjamin, S. G. W. *Persia and the Persians*. Boston, 1887.

BEREZIN 1852
Berezin, I. N. *Puteshestvie po Sievernoy Persii*. Kazan, 1852.

BERNUS-TAYLOR 1997
Bernus-Taylor, Marthe. "Chefs-d'oeuvre du musée du Louvre." *Dossier de l'Art*, no. 36 (March 1997): 40–51.

BOROZDNA 1821
Borozdna, V. *Kratkoye opisaniye puteshestviya rossiysko-imperatorskogo posolstva v Persiyu v 1817 godu* (A short description of the travels of the Russian Imperial Embassy to Persia in 1817). Saint Petersburg, 1821.

BOSWORTH AND HILLENBRAND 1983
Bosworth, E., and C. Hillenbrand, eds. *Qajar Iran: Political, Social and Cultural Change*. Edinburgh, 1983.

BROWNE 1959
Browne, Edward G. *A Literary History of Persia*. 1928. 4 vols. Reprint, Cambridge, 1959.

BURKE 1992
Burke, Peter. *The Fabrication of Louis XIV*. New Haven, Connecticut, 1992.

CALMARD 1996
Calmard, Jean. "Shi'i Rituals and Power II. The Consolidation of Safavid Shi'ism: Folklore and Popular Religion." In *Safavid Persia*, edited by Charles Melville. London, 1996.

CANBY 1990
Canby, Sheila R., ed. *Persian Masters: Five Centuries of Painting*. Bombay, 1990.

CHARDIN 1811
Chardin, Jean. *Voyages en Perse*. 1711. Reprint, Paris, 1811.

CHELKOWSKI 1979
Chelkowski, Peter, ed. *Ta'ziyeh: Ritual and Drama in Iran*. New York, 1979.

CHELKOWSKI 1989
Chelkowski, Peter. "Narrative Painting and Recitation in Qajar Iran." *Muqarnas* 6 (1989): 98–111.

CURZON 1892
Curzon, George N. *Persia and the Persian Question*. 2 vols. London, 1892.

DAVIS 1987
Davis, Charles Edward. "Qajar Rule in Fars Prior to 1849." *Iran* 25 (1987): 125–53.

DIBA 1989A
Diba, Layla. "Laquerwork." In Ferrier 1989.

DIBA 1989B
Diba, Layla S. "Persian Painting in the Eighteenth Century: Tradition and Transmission." *Muqarnas* 6 (1989): 147–60.

DIBA 1994
Diba, Layla S. "Lacquerwork of Safavid Persia and Its Relationship to Persian Painting." Ph.D. dissertation, New York University, 1994.

DIBA 1997
Diba, Layla S. "Yahya Ghaffari, Abul Hasan-i Sales: His Life and Times." In *Pembroke Papers*. London, 1997.

DIBA FORTHCOMING
Diba, Layla. "Dust 'Ali Khan Mu'ayyir's 'Painters of the Nasiri and Muzaffari Periods': A Little-Known Document for the Study of Artists and Patrons of the Qajar Period." In *Essays on Qajar History and Culture (in Honor of Hafez Farmanfarmaian)*. Austin, forthcoming.

DROUVILLE 1819
Drouville, Gaspard. *Voyage en Perse pendant les années 1812 et 1813*. Paris, 1819.

DUNBULI 1972
Dunbuli, 'Abd al-Razzaq (Maftun). *Ma'āsir al-Sulṭānīeh*. 1825–26. Reprint in Persian, edited by Ghulam Husayn Sadri Afshar, Tehran, 1972. Translated by Harford Jones Brydges as *Dynasty of the Kajars*. London, 1833. Reprint, New York, 1973.

DUST 'ALI KHAN MU'AYYIR 1982
Dust 'Ali Khan Mu'ayyir al-Mamalik III. "Naqqāshān-i Dawrah-i Nāṣirī va Muzaffarī." In *Rijāl-i 'Aṣr-i Nāṣirī*. Tehran, 1982.

DUST 'ALI KHAN MU'AYYIR 1983
Dust 'Ali Khan Mu'ayyir al-Mamalik III. *Yāddāshthā-ī az Zindigānī-yi Khuṣūṣī-yi Nāṣir al-Dīn Shāh*. Tehran, 1983.

EKHTIAR 1989A
Ekhtiar, Maryam. *The Art of Qajar Iran* (Checklist of the Brooklyn Museum of Art's holdings with an annotated bibliography). New York, 1989.

EKHTIAR 1989B
Ekhtiar, Maryam. "The Qajar Visual Aesthetic: Highlights from the Brooklyn Museum Collection." *Orientations* 20, no. 7 (July 1989): 46–53.

EKHTIAR 1990
Ekhtiar, Maryam. "Muhammad Ismā'īl Isfahani: Master Lacquer Painter." In Canby 1990.

EKHTIAR 1994
Ekhtiar, Maryam. "The Dār al-Funūn: Educational Reform and Cultural Development in Qajar Iran." Ph.D. dissertation, New York University, 1994.

EMAMI 1987
Emami, Karim. "Art in Iran: Post Qajar." *Encyclopaedia Iranica*, vol. 1.

ETTINGHAUSEN AND YARSHATER 1979
Ettinghausen, Richard, and Ehsan Yarshater, eds. *Highlights of Persian Art*. Boulder, Colorado, 1979.

FALK 1972
Falk, S. J. *Qajar Paintings: Persian Oil Paintings of the 18th and 19th Centuries*. London, 1972.

FALK 1985
Falk, S. J. *Treasures of Islam*. Geneva, 1985.

FASA'I 1972
Fasa'i, Haj Mirza Hasan Husayni. *Fārsnāmeh-i Nāṣirī*. Edited by Mansur Rastigar Fasa'i. Tehran, 1895. Translated by Heribert Busse as *History of Persia under Qajar Rule*, New York, 1972. Also reprinted Tehran, 1988.

FERRIER 1989
Ferrier, R. W. *The Arts of Persia*. New Haven, Connecticut, 1989.

FLANDIN AND COSTE 1845–54
Flandin, Eugene, and Pascal Coste. *Voyage en Perse*. Paris, 1845–54.

FRASER 1838
Fraser, James Baillie. *A Winter's Journey from Constantinople to Tehran*. 2 vols. London, 1838.

FREEDBERG 1989
Freedberg, David. *The Power of Images*. Chicago and London, 1989.

GRAY 1961
Gray, Basil. *Persian Painting*. Geneva, 1961.

GRAY 1979
Gray, Basil. "The Tradition of Wall Painting in Iran." In Ettinghausen and Yarshater 1979.

GULMUHAMMADI 1971
Gulmuhammadi, Hasan. *Dīvān-i Kāmil-i Fatḥ Alī Shāh Qājār*. Tehran, 1971.

HAMBLY 1972
Hambly, Gavin. "A Note on Sultaniyeh/Sultanabad in the Early Nineteenth Century." *Art and Archaeology Research Papers* (December 1972): 89–98.

HAMBLY 1991
Hambly, Gavin. "The Traditional Iranian City in the Qajar Period," 542–89. Chapter 15 in Avery, Hambly, and Melville 1991.

HIDAYAT 1960
Hidayat, Riza Quli Khan. *Tārīkh-i Rawẓat al-Ṣafā-yi Nāṣirī*. Edited by Nasrallah Sabuhi. Tehran, 1960.

HOLTZER 1975
Holtzer, Ernst. *Persien vor 113 Jahren*. 1863. Translated from German into Persian by M. Asemi, Tehran, 1975.

HOMMAIRE DE HELL 1855–56
Hommaire de Hell, Xavier. *Voyage en Turquie et en Perse exécuté en 1846–48*. Paris, 1855–56.

HUNARFAR 1965
Hunarfar, Luftallah. *Ganjīneh-i Āsār-i Iṣfahān*. Isfahan, 1965

INGRAM 1979
Ingram, E. *The Beginning of the Great Game in Asia, 1828–1834*. Oxford, 1979.

ISKANDAR 1956
Iskandar, Bayg Munshi. *Tārīkh-i 'Ālam Ārā-yi 'Abbāsi*. 1629. Reprint, Tehran, 1956.

ISSAWI 1971
Issawi, Charles. *The Economic History of Iran, 1800–1914*. Chicago, 1971.

I'TIMAD AL-SALTANEH 1878
I'timad al-Saltaneh, Muhammad Hasan Khan. *Mir'āt al-Buldān*. Tehran, 1878.

I'TIMAD AL-SALTANEH 1984
I'timad al-Saltaneh, Muhammad Hasan Khan. *Ma'āsir v'al Āsār*. 1888–89 manuscript. Edited by Iraj Afshar, Tehran, 1984.

I'TIMAD AL-SALTANEH 1984–88
I'timad al-Saltaneh, Muhammad Hasan Khan. *Tārīkh-i Muntaẓam-i Nāṣiri*. 1881–83 manuscript. Tehran, 1984–88.

I'TIZAD AL-SALTANEH 1991
I'tizad al-Saltaneh, 'Ali Quli Mirza. *Iksir al-Tavārikh*. 1837–42 manuscript. Edited by Jamshid Kiyanfar, Tehran, 1991.

IVANOV, GREK, AND AKIMUSHKIN 1962
Ivanov, A. A., T. V. Grek, and O. F. Akimushkin. *Albom Indiyskikh I Persidskikh Miniatyur* (Album of Indian and Persian miniatures). Edited by L. T. Giuzalian. Moscow, 1962.

IVANOV, LUKONIN, AND SMESOVA 1984
Ivanov, A. A., V. G. Lukonin, and L. S. Smesova. *Iuvelirnuye izdeliya Vostoka. Drevniy Isrednevekovuy periody* (Oriental jewelry. Ancient and medieval periods). Moscow, 1984.

JAHANGIR MIRZA 1948
Jahangir Mirza. *Tārīkh-i Naw*. Circa 1900. Reprint, edited by 'Abbas Iqbal, Tehran, 1948.

KARIMZADEH TABRIZI 1985–91
Karimzadeh Tabrizi, Muhammad 'Ali. *Naqqāshān-i Qadim-i Īrān*. 3 vols. London, 1985–91.

KARIMZADEH TABRIZI 1989
Karimzadeh Tabrizi, Muhammad 'Ali. *Asnād va Firāmīn Muntashir Nashudeh-i Qājār*. London, 1989.

KARPOVA 1973
Karpova, N. K. *Stankovaya zhivopis Irana XVIII–XIX vekov* (Oil painting of Iran of the eighteenth and nineteenth centuries). Moscow, 1973.

KAZARIAN 1968
Kazarian, M. *The Ovnatanian Family of Artists*. Moscow, 1968.

KAZEMZADEH 1968
Kazemzadeh, Firuz. *Russia and Britain in Persia, 1864–1914: A Study in Imperialism*. New Haven, Connecticut, 1968.

KEPPEL 1827
Keppel, G. T. *Personal Narrative of a Journey from India to England*. London, 1827.

KER PORTER 1821
Ker Porter, Robert. *Travels in Georgia, Persian Armenia, Ancient Babylonia, etc.* 2 vols. London, 1821.

KEYVANI 1982
Keyvani, Mehdi. *Artisans and Guild Life in the Later Safavid Period: Contributions to the Social-Economic History of Persia*. Berlin, 1982.

KHALILI, ROBINSON, AND STANLEY 1996
Khalili, Nasser D., B. W. Robinson, and Tim Stanley. *Lacquer of the Islamic Lands*. Part one, vol. 22 of *The Nasser D. Khalili Collection of Islamic Art*, edited by Julian Raby. London, 1996.

KLEISS AND VON GALL 1977
Kleiss, Wolfram, and Hubertus von Gall, "Der Qajaren-Pavillion Suleimaniyeh in Karadj." *Archaeologische Mitteilungen aus Iran* 10 (1977): 325–39.

KORFF 1838
Korff, F. *Vospominaniya o Persii. 1834–1835* (Memoirs of Persia. 1834–1835). Saint Petersburg, 1838.

KOTZEBUË 1819
Kotzebuë, Moritz von. *Narrative of a Journey into Persia in the Suite of the Imperial Russia Embassy in the Year 1817*. Paris, 1819.

LAMBTON 1987
Lambton, Ann K. S. *Qajar Persia*. London and Austin, 1987.

LENTZ 1993
Lentz, Thomas. "Dynastic Imagery in Early Timurid Wall Painting." *Muqarnas* 10 (1993): 252–65.

LERNER 1976
Lerner, Judith. "British Travellers' Accounts of Shiraz." *Bulletin of the Asia Institute of Pahlavi University*, no. 1–4 (1976): 205–74.

LERNER 1991
Lerner, J. A. "Rock Relief of Fath Ali Shah in Shiraz." *Ars Orientalis* 21 (1991): 31–43.

LISAN AL-MULK SIPIHR 1875
Lisan al-Mulk Sipihr, Muhammad Taqi. *Nāsikh al-Tavārīkh*. 1875. 4 vols. Reprint, edited by M. B. Bihbudi, Tehran, 1965.

LONDON 1976
Persian and Mughal Art. Exh. cat., P & D Colnaghi. London, 1976.

MALCOLM 1815
Malcolm, John. *The History of Persia*. 2 vols. London, 1815.

MALTI-DOUGLAS 1991
Malti-Douglas, Fedwa. *Woman's Body, Woman's Word: Gender and Discourse in Arabo-Islamic Writing*. Princeton, New Jersey, 1991.

MARTIN 1912
Martin, F. R. *The Miniature Painting and Painters of Persia, India, Turkey*. 2 vols. London, 1912.

MASLENITSYNA 1975
Maslenitsyna, S. *Iskusstvo Irana v sobraniyah Gosudarstvennogo Muzeya narodov Vostoka* (Art of Iran in the collections of the Museum of Oriental Art). Leningrad, 1975.

MASSÉ 1938
Massé, Henri. *Croyances et Coutumes Persanes*. Vol. 6 of *Les Littératures populaires de toutes les nations* series. Paris, 1938.

MEMBRÉ 1993
Membré, Michele. *Mission to the Lord Sophy of Persia (1539–1542)*. Circa 1539–40. Reprint, translated by A. H. Morton, London, 1993.

MEREDITH 1971
Meredith, Colin. "Early Qajar Administration: An Analysis of Its Development and Functions." *Iranian Studies* (Spring–Summer 1971): 59–84.

MORGENSTERN 1979
Morgenstern, Laure. "Mural Painting." In *A Survey of Persian Art*. 1939. Reprint, Tehran, 1979.

MORIER 1818
Morier, James. *A Second Journey through Persia, Armenia and Asia Minor to Constantinople between the Years 1812 and 1816*. London, 1818.

MUSTAWFI 1992
Mustawfi, 'Abdallah. *Sharḥ-i Zindigānī-yi Man*. 3 vols. 3d. ed. Tehran, 1992.

MUSTAWFI 1950
Mustawfi, Muhammad Taqi. "Chand Nasl-i Hunarmand dar Chand Sad Sāl-i Kāshān." *Naqsh va Nigār* 7 (1950): 30–44.

MUHAMMAD HASHIM ASAF 1969
Muhammad Hashim Asaf, Rustam al-Hukama. *Rustam al-Tavārīkh*. Circa 1794 manuscript. Reprint, edited by Muhammad Mushiri, Tehran, 1969. Translated by Birgitt Hoffman as *Persische Geschichte 1694–1835 erlebt, erinnert und erfunden: Das Rustam at-Tawarikh in deutschen Bearbeitung*. 2 vols. Berlin, 1986.

OUSELEY 1819–32
Ouseley, Sir William. *Travel into Various Countries of the East, particularly Persia*. London, 1819–32.

PARIS 1972
La Perse et la France. Relations diplomatiques et culturelles du XVIIe au XIXe siècle. Exh. cat., Musée Cernuschi. Paris, 1972.

PARIS 1989
Arabesques et jardins de paradis: Collections françaises d'art islamique. Exh. cat., Musée du Louvre. Paris, 1989.

PERRY 1979
Perry, John R. *Karim Khan Zand, A History of Iran, 1747–1779*. Chicago and London, 1979.

PETERSON 1981
Peterson, Samuel. "Shi'ism and Late Iranian Arts." Ph.D. dissertation, New York University, 1981.

POLAK 1865
Polak, Jacob Eduard. *Persien das Land und seine Bewohner*. Leipzig, 1865.

POLLOCK 1988
Pollock, Griselda. *Vision and Difference: Femininity, Feminism and Histories of Art*. London, 1988.

ROBINSON 1950
Robinson, B. W. "The Royal Gifts of Fath Ali Shah." *Apollo* (September 1950): 66–68.

ROBINSON 1958
Robinson, B. W. *A Descriptive Catalogue of the Persian Painting in the Bodleian Library*. Oxford, 1958.

ROBINSON 1964
Robinson, B. W. "The Court Painters of Fath Ali Shah." *Eretz-Israel* 7 (1964): 94–105.

ROBINSON 1967
Robinson, B. W. "A Lacquer Mirror-case of 1854." *Iran* 5 (1967): 1–6.

ROBINSON 1969
Robinson, B. W. "Qajar Painted Enamels." In *Paintings from Islamic Lands*, edited by R. Pinder-Wilson. Columbia, South Carolina, and Oxford, 1969.

ROBINSON 1970
Robinson, B. W. "Persian Lacquer in the Bern Historical Museum." *Iran* (1970): 47–50.

ROBINSON 1976A
Robinson, B. W. *Persian Painting in the India Office Library*. London, 1976.

ROBINSON 1976B
Robinson, B. W. "The Mansour Album." In London 1976.

ROBINSON 1981
Robinson, B. W. "Qajar Lacquer." *Muqarnas* 6 (1981): 131–46.

ROBINSON 1983
Robinson, B. W. "Persian Royal Portraiture and the Qajars." In Bosworth and Hillenbrand 1983, 291–311.

ROBINSON 1989
Robinson, B. W. "Painting in the Post Safavid Period." In Ferrier 1989.

ROBINSON 1991
Robinson, B. W. "Persian Painting under the Zand and Qajar Dynasties." In Avery, Hambly, and Melville, 1991, 870–89.

ROBINSON 1993
Robinson, B. W. *Studies in Persian Art*. 2 vols. London, 1993.

ROBINSON AND GUADALUPI 1990
Robinson, B. W., and G. Guadalupi. *Qajar: Court Painting in Persia*. Milan, 1990.

ROSE 1986
Rose, Jacqueline. *Sexuality in the Field of Vision*. London, 1986.

RŪZNĀMEH-I DAWLAT-I 'ILLĪEH-I ĪRĀN
Rūznāmeh-i Dawlat-i 'Illieh-i Īrān, nos. 475–650. Reprint, edited by J. Kiyanfar, 2 vols., Tehran, 1991–93.

SABA 1962
Saba, Fath 'Ali Khan. *Dīvān-i Malik al Shu'ara Fath 'Ali Khān Ṣabā*. Edited by Muhammad 'Ali Nijati. Tehran, 1962.

SALIH SHIRAZI 1984
Mirza Salih Shirazi. "Safarnāmeh-i Iṣfahān, Kāshān, Qum, Tihrān." In *Majmūeh-i Safarnāmehhā-yi Mirzā Ṣāliḥ Shīrāzī.* 1812. Reprint, edited by Ghulam Husayn Mirza Salih, Tehran, 1984.

SAMI 1958
Sami, 'Ali. *Shirāz.* Shiraz, 1958.

SAMIA 1980
Mirza Samia. *Tadhkirat al-Mulūk.* 1725 manuscript. Translated by V. Minorsky as *A Safavid Manual of Administration.* E. J. W. Gibb Memorial Series. Cambridge, 1980.

SARAVI 1992
Saravi, Muhammad Fathallah. *Tārīkh-i Muḥammadi.* 1781 manuscript. Edited by Ghulam Riza Tabataba'i Majd, Tehran, 1992.

SCARCE 1983
Scarce, Jennifer. "The Royal Palaces of the Qajar Dynasty. A Survey." In Bosworth and Hillenbrand 1983, 329–51.

SCHLUMBERGER 1952
Schlumberger, Daniel. "Le Palais Ghaznavide de Lashkari Bazar." *Syria* 29 (1952): 51–70.

SOLTYKOV 1849
Soltykov, A. *Puteshestviye v Persiyu. Pisma.* (Travel to Persia. Letters). Moscow, 1849.

SOLTYKOV 1851
Soltykov, A. *Voyage en Perse.* French translation of Soltykov 1849, Paris, 1851.

SOUDAVAR 1992
Soudavar, Abolala. *Art of the Persian Courts.* New York, 1992.

STEIN 1983
Stein, Donna, "Early Photography in Iran." *History of Photography: An International Quarterly* 7, no. 4 (1983).

STUART 1854
Stuart, Charles. *Journal of a Residence in Northern Persia.* London, 1854.

SUHAYLI KHWANSARI 1989
Suhayli Khwansari, Ahmad. *Kamāl-i Hunar: Aḥvāl va Āsār-i Muḥammad Ghaffāri Kamāl al-Mulk.* Tehran, 1989.

TAJ AL-SALTANEH 1993
Taj al-Saltaneh. *Crowning Anguish: Memoirs of a Persian Princess from the Harem to Modernity.* Edited with an introduction by Abbas Amanat. Translated by Anna Vanzan and Amin Neshati. Washington, D.C., 1993.

TAVAKOLI-TARGHI 1993
Tavakoli-Targhi, Mohamad. "Imagining Western Women: Occidentalism and Euro-eroticism." *Radical America* 24, no. 3 (February 1993): 3–87.

TEHRAN 1974
Zand and Qajar Paintings from Private Collections. Exh. cat., Iran-America Cultural Society. Tehran, 1974.

TEHRAN 1978
Religious Inspiration in Iranian Art. Exh. cat., Negarestan Museum. Tehran, 1978.

TEXIER 1842
Texier, Charles. *Description de l'Arménie, la Perse, et la Mésopotamie.* Paris, 1842.

VAQAYI'NIGAR, n.d.
Vaqayïnigar, Mirza Sadiq Marvazi. "Tarikh-i Rutāb al-Lisān." Manuscript circa 1808. National Library, Tehran, no. 1107.

VARJAVAND 1974
Varjavand, Parviz. "Khāneh-i Zaki Khān, banā-i zibā az sabk-i mīmāri-yi dawrān-i Zandieh dar Shīrāz." *Barrisihā-yi Tārīkhi* 9, no. 2 (1974).

WAELE 1986
Waele, E. de. "Trois Reliefs Rupestres de Pol-i Abgineh." *Iranica Antiqua* 21 (1986): 167–88.

WARING 1807
Waring, Edward Scott. *A Tour to Sheeraz. . . to which is added a History of Persia. . .* London, 1807.

WELCH 1973
Welch, Anthony. *Shah 'Abbas and the Arts of Isfahan.* New York, 1973.

WRIGHT 1977
Wright, D. *The English amongst the Persians.* London, 1977.

ZIAI 1997
Ziai, Asiyeh. "La Miniature Persane de la fin des Safavides à la dynastie Qadjar." *Dossier de l'Art,* no. 36 (March 1997).

ZUKA 1963
Zuka, Yahya. "Mirzā Abu'l Ḥasan Khān Ṣani' al-Mulk Ghaffāri." *Hunar va Mardum,* nos. 10–11 (1963), part I (July–August); part II (September–October).

ZUKA 1970
Zuka, Yahya. *Tarikhcheh-i Sākhtimānhā-yi Arg-i Salṭanati.* Tehran, 1970.

PHOTOGRAPH CREDITS

Unless otherwise specified, photographs are courtesy of the institutions given in the captions. Author-date citations are used for sources included in the Bibliography.